map:satellite

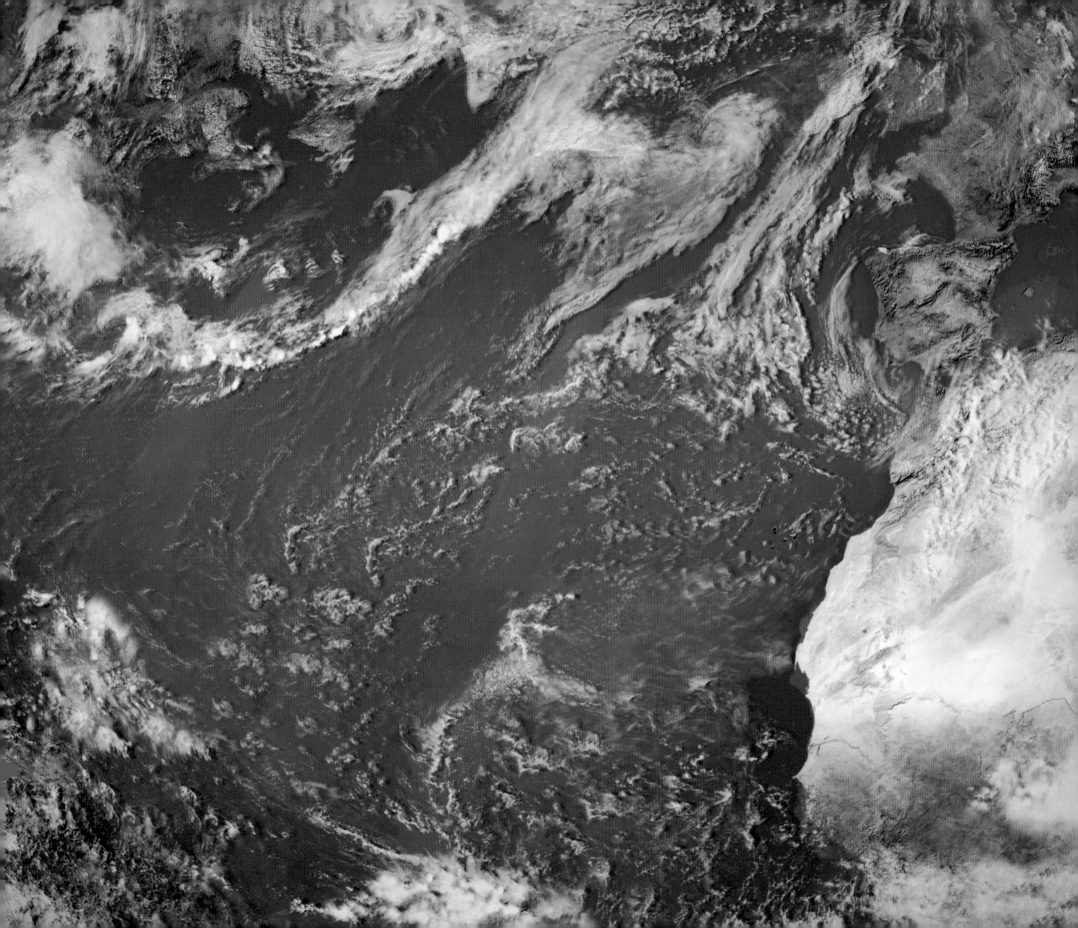

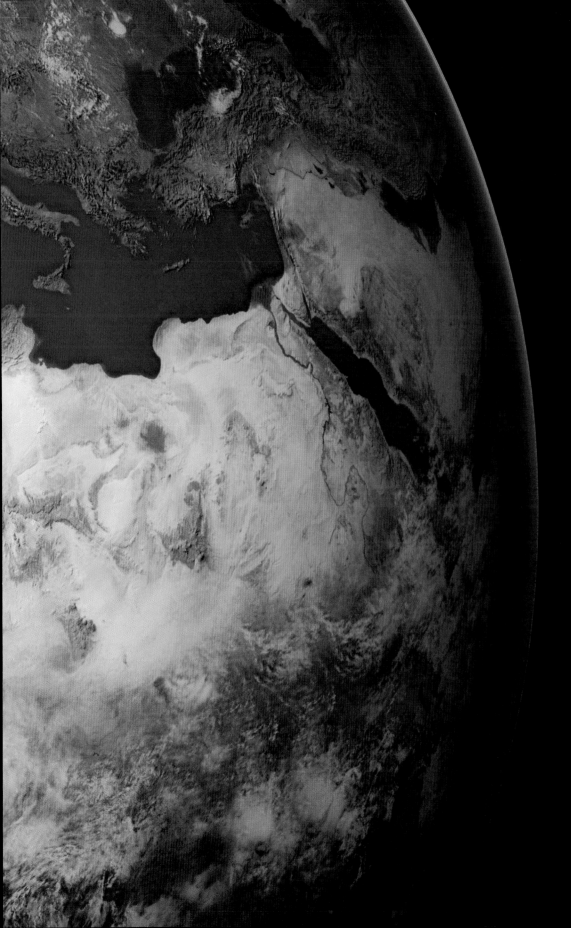

# Foreword

As we enter the third millennium we find ourselves the first generation that can enjoy views of our planet which were beyond the dreams of our forefathers. As recently as 4 October 1957, the first artificial satellite, the Soviet Union's Sputnik 1, was launched amd immediately captured the world's attention. The next twenty years saw an intense rivalry as the United States and the Soviet Union entered into the 'Space Race', developing parallel space programmes in an attempt to keep one step ahead of the other both militarily and in terms of national pride.

The great advances in satellite technology were driven by the military advantages gained through being able to monitor the Earth as well as the propaganda value of these achievements. Today this technology has been put to more benign scientific and commercial use, with many more countries directly involved in the collection of Earth images and monitoring change.

The first edition of *DK Map:Satellite* brings together the latest developments in digital cartography with spectacular cloud-free imagery of the entire globe, assembled from many thousands of observations into a single seamless resource. It provides a breathtaking record of the beauty and diversity of our home planet and celebrates and explains some of the most remarkable natural and manmade environments.

**LONDON, NEW YORK, MELBOURNE,
MUNICH AND DELHI**

**Author**
Philip Eales

**Managing Editor**
David Roberts

**Editors**
Roger Bullen • Andrew Heritage, Heritage Editorial, UK • Simon Mumford

**Cartographic Editors**
Roger Bullen • Tony Chambers • John Dear

**Cartographers**
Advanced Illustration, Congleton, UK • Paul Eames • Ed Merritt
Simon Mumford • John Plumer • Rob Stokes • Iorwerth Watkins

**Designers**
Yak El-Droubie • Mark Lloyd, On Fire, UK

**Systems Co-ordinator**
Philip Rowles

**Jacket Designers**
Lee Ellwood • Mark Lloyd, On Fire, UK

www.planetaryvisions.com

**Satellite Images** provided by Planetary Visions
**Map Projections and 3D Graphics** Andrew Wayne
**Picture Research and Image Processing** Tim Wilkinson
**Satellite Imagemap of the World** created by Kevin Tildsley and Philip Eales © 1996-2006 Planetary Visions Limited
**Satellite Imagemap of Europe** © 2005 Planetary Visions / German Aerospace Center (DLR)
**Facilities** provided by the Department of Geomatic Engineering, University College London www.ge.ucl.ac.uk

**Production Controller**
Elizabeth Warman

**Publishing Director**
Jonathan Metcalf

**Art Director**
Bryn Walls

First published in Great Britain in 2007 by Dorling Kindersley Limited, 80 Strand, London WC2R ORL

A Penguin Company

A CIP catalogue record for this book is available from the British Library

ISBN: 978-1-4053-1762-7

Reprographics by MDP Ltd, Wiltshire, UK
Printed and bound by Star Standard, Singapore
Cover lenticular by Hung Hing, China

**See our complete catalogue at  www.dk.com**

# MAP KEY

## Elevation

Above 4000m

3000–4000m

2000–3000m

1000–2000m

500–1000m

250–500m

0–250m

Below sea level

Sea

△ Mountain

⏢ Volcano

⋈ Pass

▽ Depression

## Boundaries

▬▬▬ Full international border

▬ ▬ ▬ Disputed de facto border

· · · · · Territorial claim border

✕—✕—✕ Ceasefire line

——— Internal administrative border

——— Maritime border

## Settlements

■ ◉ ◉ Over 1 million

■ ◎ ◎ 500,000–1 million

■ ◉ ⊙ 100,000–500,000

■ ◎ ○ 50,000–100,000

■ ◦ ○ Less than 50,000

A red square indicates a national or dependency capital

An orange square indicates a provincial or federal capital

## Transport

▬▬ Highway/motorway

······· Highway/motorway in tunnel

▬ ▬ ▬ Highway/motorway under construction

——— Major road

------- Major road in tunnel

- - - - - Major road under construction

——— Other road

——— Railway

------- Railway in tunnel

- - - - - Railway under construction

✈ Airport

## Surface and ice features

Sandy desert

Marsh/wetland

▲▲▲ Limit of summer pack ice

▲ ▲ Limit of winter pack ice

Permanent ice cap

## Drainage

——— Coast

——— Major river

——— Minor river

------- Seasonal river

——— Canal

 Lake

 Reservoir

Seasonal lake

Salt lake

Seasonal salt lake

# CONTENTS

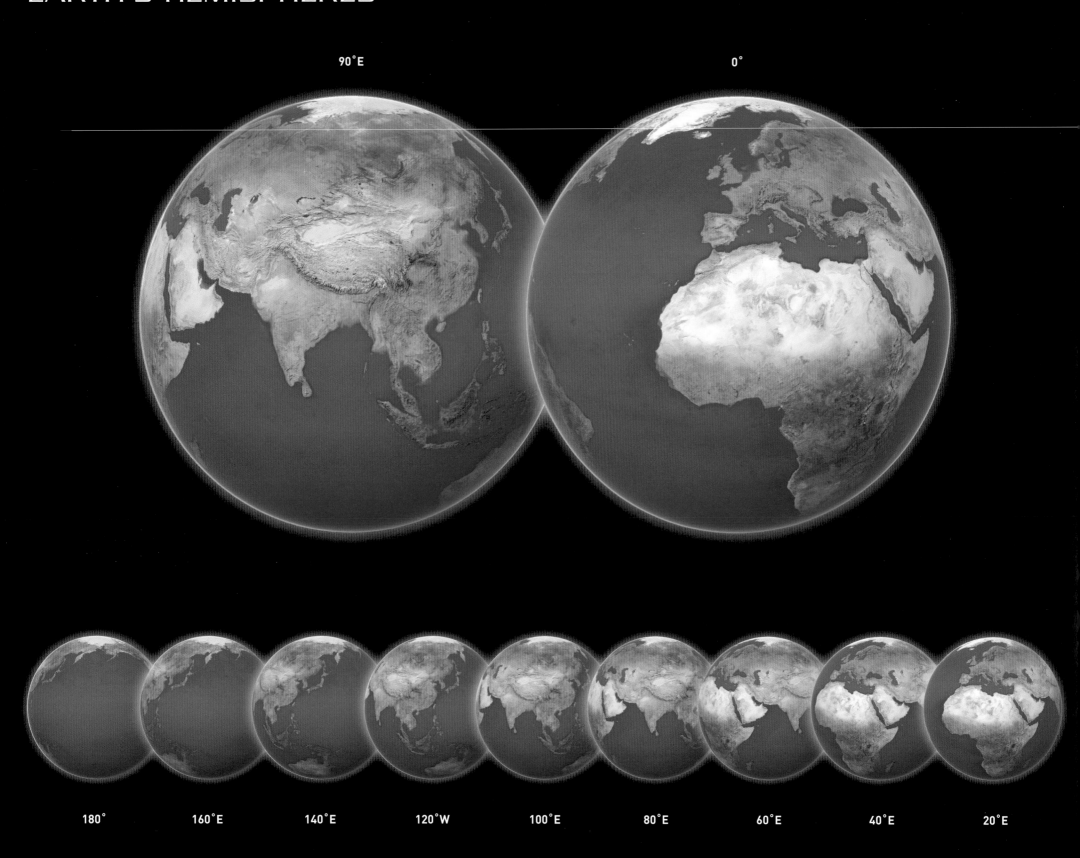

90°E

0°

180°    160°E    140°E    120°W    100°E    80°E    60°E    40°E    20°E

Earth observation satellites carry camera systems that continually capture images of the territory beneath their orbit, helping us to forecast the weather, check the health of crops, and find oil or minerals. As human activity alters the face of the planet, satellites are increasingly relied upon to track changes to the land, the ocean and the atmosphere, and to monitor the state of the environment at local and global scales.

This satellite imagemap of the world was compiled from a database of more than 30,000 digital images taken by polar-orbiting weather satellites over several years. A global picture of the Earth's surface was gradually built up through gaps in the ever-changing cloud cover. This mosaic of visible and infrared images was then transformed into natural colours so that areas of forest, mountain, desert, ocean and ice are easily recognised.

Each point on the imagemap represents the most cloud-free view of that location, usually corresponding to the most vigorous vegetation growth in the summer months. Snow cover is thus minimised in both the northern and southern hemispheres. Seasonal variations are shown in the maps on pages 12 and 13.

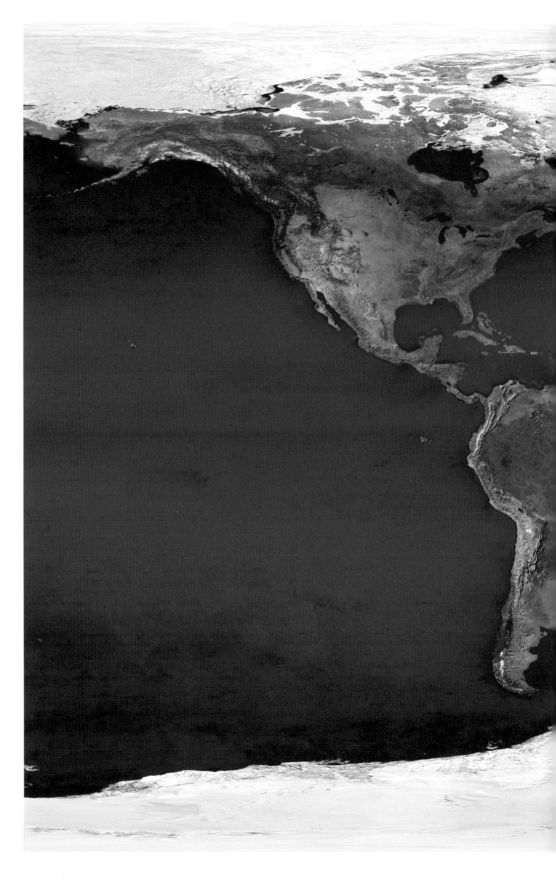

## Satellite Imagemaps

Biogeographical regions and land features

| | | | | | | |
|---|---|---|---|---|---|---|
|  |  |  | | | | |
| sandy desert | rocky desert | savannah | temperate grassland | mediterranean | glacier | deep ocean |
|  |  |  |  |  | | |
| tropical rainforest | dry woodland | broadleaf forest | needleleaf forest | mountains | shelf ice | coral reefs |
|  |  |  |  |  | | |
| mountains | mountain tundra | volcanoes | lava plateau | dry lake | sea ice | irrigated land |
|  |  |  |  |  |  |  |
| river | wetland | perennial lake | seasonal lake | oasis | coastal water | urban area |

These key items have been sampled from the global satellite imagemap; the samples are taken from specific locations but these may be used as a general guide to interpreting the satellite imagemaps throughout the atlas.

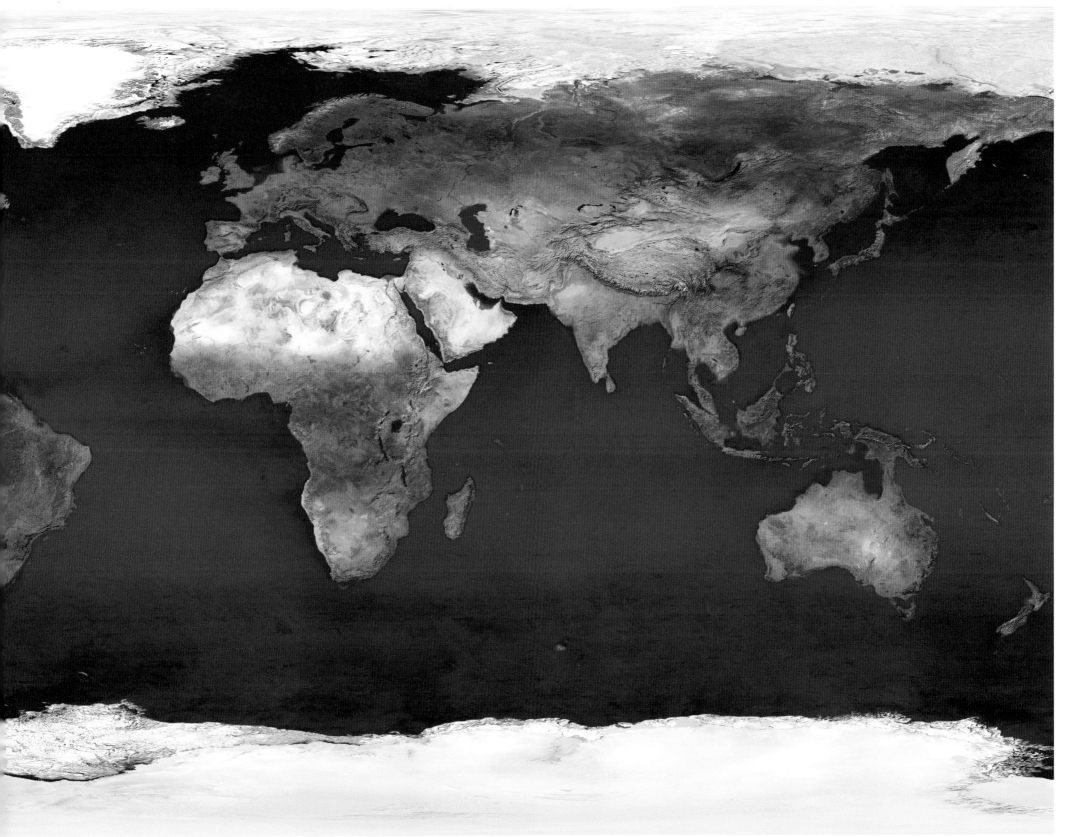

(sources: NOAA/AVHRR data from US Geological Survey; Terra/MODIS and Nimbus-7/CZCS data from NASA Goddard Space Flight Center; DMSP/OLS data from NOAA National Snow and Ice Data Center; GTOPO30 digital terrain data from USGS EROS Data Center)

At night, light from the world's cities shines out and is recorded by an orbiting camera sensitive enough to take pictures of clouds illuminated by moonlight. This cloud-free night-time mosaic, compiled from images taken by a military weather satellite, shows permanent light sources such as streetlights in towns and industrial zones, as well as transient sources (in orange) such as oil fields and even fishing vessels. The image gives an impression of human settlement patterns and economic activity across the world.

Major cities are visible on all the continents except Antarctica. In North America, minor towns can be seen forming a grid pattern that traces the highway network. In Russia, towns are strung out along the Trans-Siberian Railway. In North Africa, the fertile Nile Valley glows, home to 95% of Egypt's population. In the far east, political divisions are highlighted as the prosperous cities of South Korea shine out in contrast to the darkness of neighbouring North Korea.

The orange glow of gas flares shows the location of oil and gas fields in Siberia, the Middle East, the North Sea and West Africa. In the Sea of Japan (East Sea), lights have long been used by fishermen to attract squid to the surface at night. A nocturnal fishing fleet is visible in the south Atlantic.

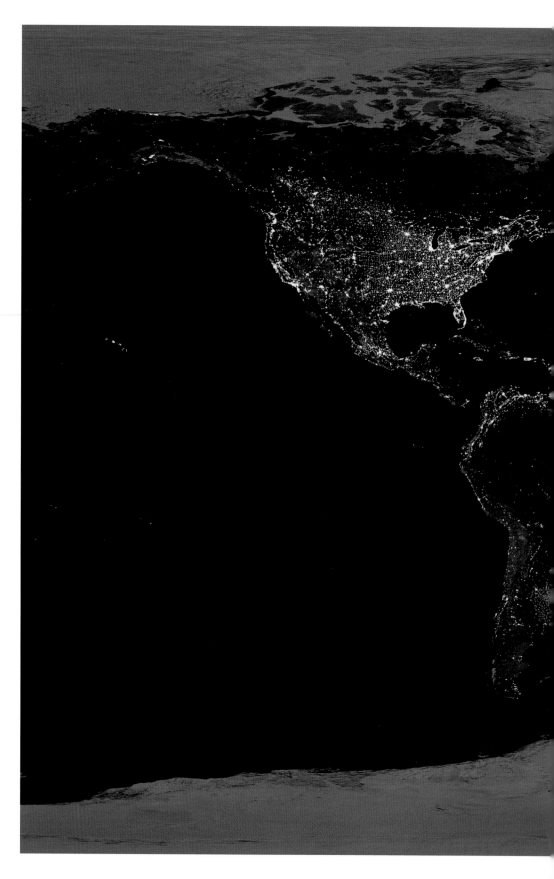

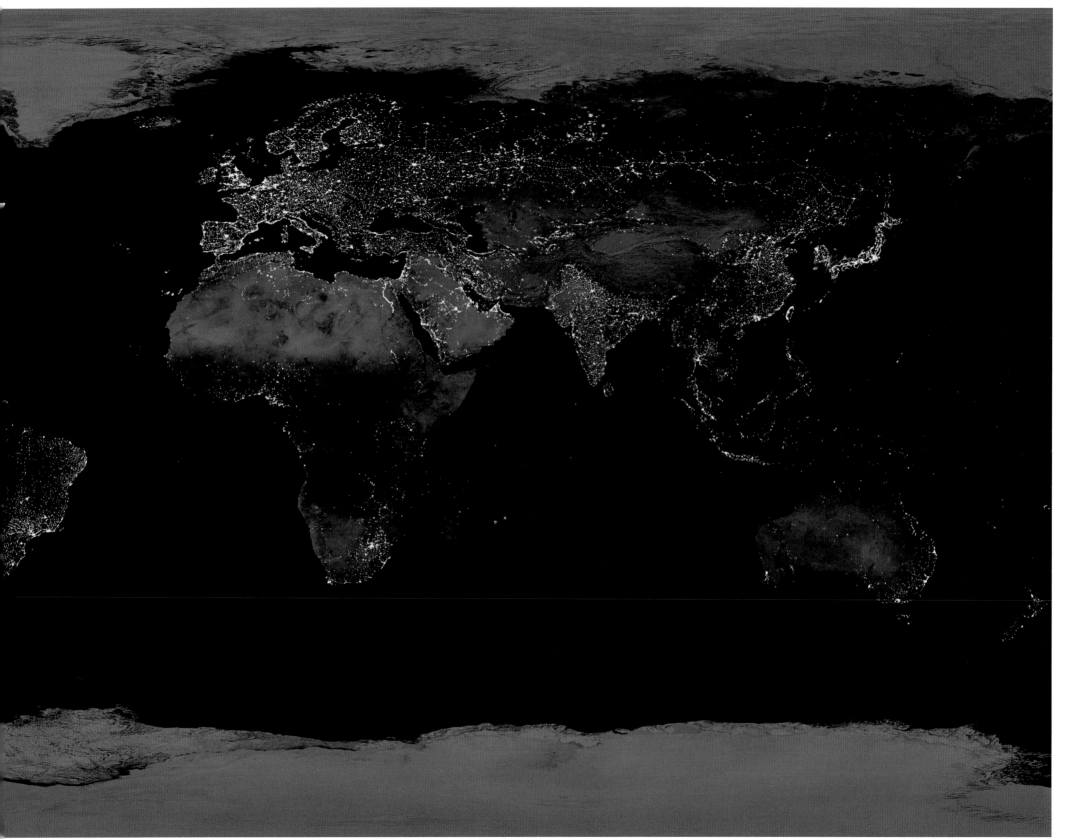

[source: DMSP/OLS data from NOAA National Geophysical Data Center]

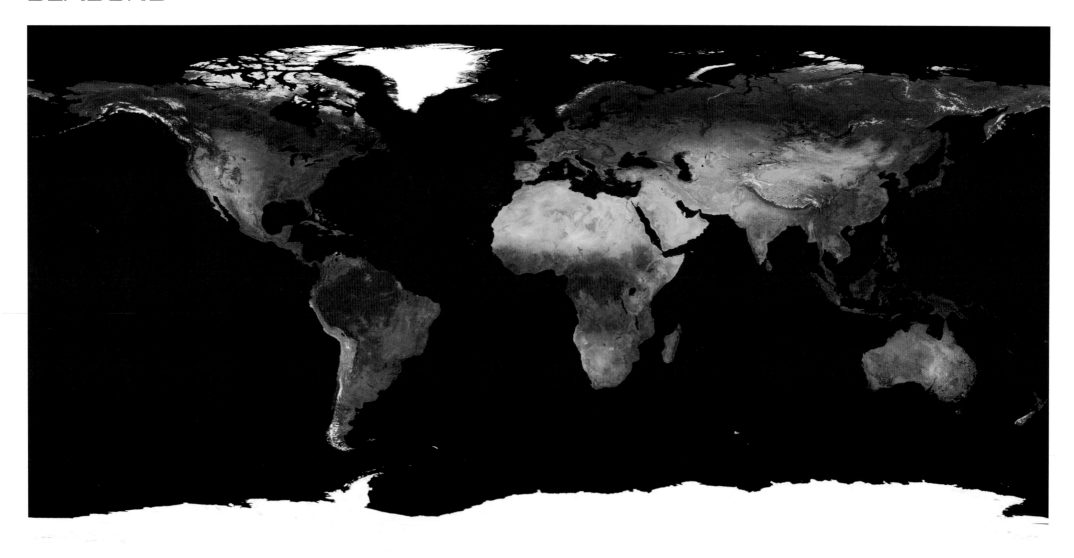

## AVERAGE JUNE TEMPERATURES

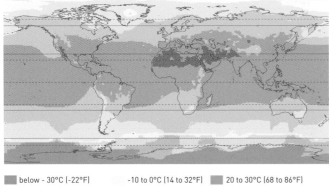

- below - 30°C (-22°F)
- -30 to - 20°C (-22 to -4°F)
- -20 to - 10°C (-4 to 14°F)
- -10 to 0°C (14 to 32°F)
- 0 to 10°C (32 to 50°F)
- 10 to 20°C (50 to 68°F)
- 20 to 30°C (68 to 86°F)
- above 30°C (86°F)

## The Earth In June

The face of the Earth changes with the seasons. Its axis of rotation is tilted at an angle of 23.5° compared with the plane of its orbit around the Sun (see diagram, right), producing a seasonal variation in the amount of sunlight received at higher latitudes. Air and ground temperatures rise and fall with the energy received from the Sun (left), with weather and vegetation patterns responding in turn.

In June, the northern hemisphere is green as vegetation responds to the longer hours and higher levels of sunlight. Some high mountains remain cold, with permanent snow cover, which is otherwise restricted to the islands around the Arctic Ocean shore. In the south, it is winter, with vegetation dying back in southern Africa and the Brazilian Highlands. There is not much land at mid-latitudes in the south so extensive snow cover is restricted to the mountains and plains of Patagonia and New Zealand.

## JUNE 21st

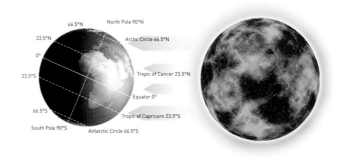

66.5°N
23.5°N
0°
23.5°S
66.5°S
South Pole 90°S

North Pole 90°N
Arctic Circle 66.5°N
Tropic of Cancer 23.5°N
Equator 0°
Tropic of Capricorn 23.5°S
Antarctic Circle 66.5°S

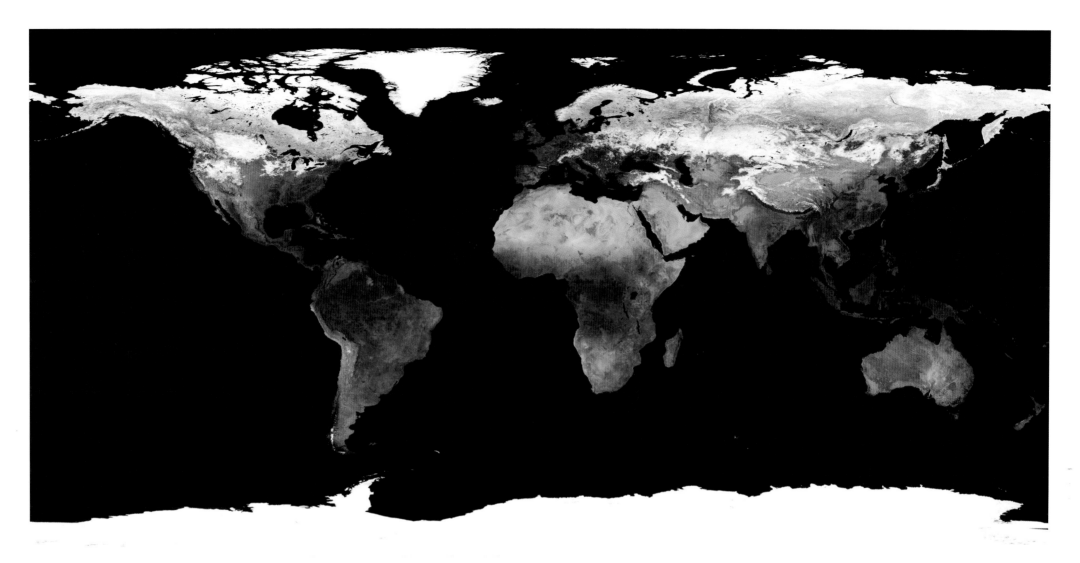

## DECEMBER 21st

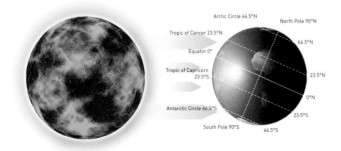

Arctic Circle 66.5°N
North Pole 90°N
Tropic of Cancer 23.5°N
66.5°N
Equator 0°
23.5°N
Tropic of Capricorn
23.5°S
0°N
Antarctic Circle 66.5°S
23.5°S
South Pole 90°S
66.5°S

## The Earth in December

On 21st December, the Sun reaches its lowest point in the northern sky and its highest in the south. Temperatures north of the Equator are much lower and large parts of the northern continents are covered with snow. Western Europe is spared the worst ravages of winter by the warm waters of the north Atlantic's Gulf Stream. Other mid-latitude areas, such as the east coast of the US and coastal China, are noticeably browner than they were in the summer. In Africa, the Sahel too is browning off as the 'green wave' of blooming vegetation follows the Sun south.

The Equatorial regions of Africa, South America and maritime Southeast Asia remain intensely green throughout the year, receiving more consistent sunshine and rainfall than the higher latitudes. It is the polar regions which experience the largest range of temperatures. Here, the sea ice expands and contracts through the year, as shown on pages 20 and 21.

## AVERAGE DECEMBER TEMPERATURES

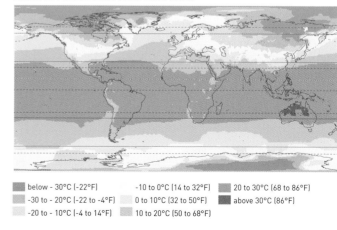

below - 30°C (-22°F)
-30 to - 20°C (-22 to -4°F)
-20 to - 10°C (-4 to 14°F)
-10 to 0°C (14 to 32°F)
0 to 10°C (32 to 50°F)
10 to 20°C (50 to 68°F)
20 to 30°C (68 to 86°F)
above 30°C (86°F)

(source: Terra/MODIS data from NASA Earth Observatory)

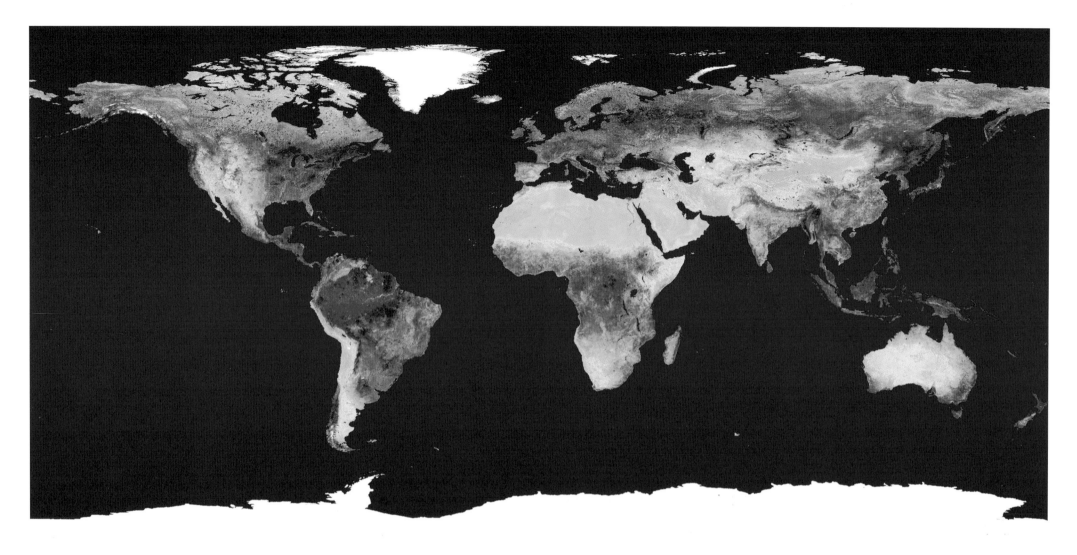

Normalized Difference Vegetation Index

| -0.05 | 0.009 | 0.06 | 0.12 | 0.17 | 0.233 | 0.287 | 0.347 | 0.404 | 0.461 | 0.518 | 0.575 | 0.632 | 0.689 | 0.746 | 0.803 | 0.860 | 0.912 |

## Vegetation Index

Satellites are routinely used to monitor the health of natural vegetation and crops. Growing plants absorb visible light to fuel photosynthesis, but they strongly reflect infrared light, making them appear bright in an infrared image. Multi-spectral cameras are used to compare the brightness of the land at visible and infrared wavelengths. The brightness values at each wavelength are then used to calculate the 'vegetation index' – a measure of the vigour of plant growth.

With multi-spectral cameras mounted on satellites, the plant life of a whole continent can be given a health check every few weeks. If areas appear less green than expected (a low vegetation index), it could be a sign of drought, which may lead to a low crop yield. Forecasts of crop yield are used by financial markets to set commodity prices, and by governments to anticipate crop failures, which may result in humanitarian crises.

(source: NASA Goddard Space Flight Center)

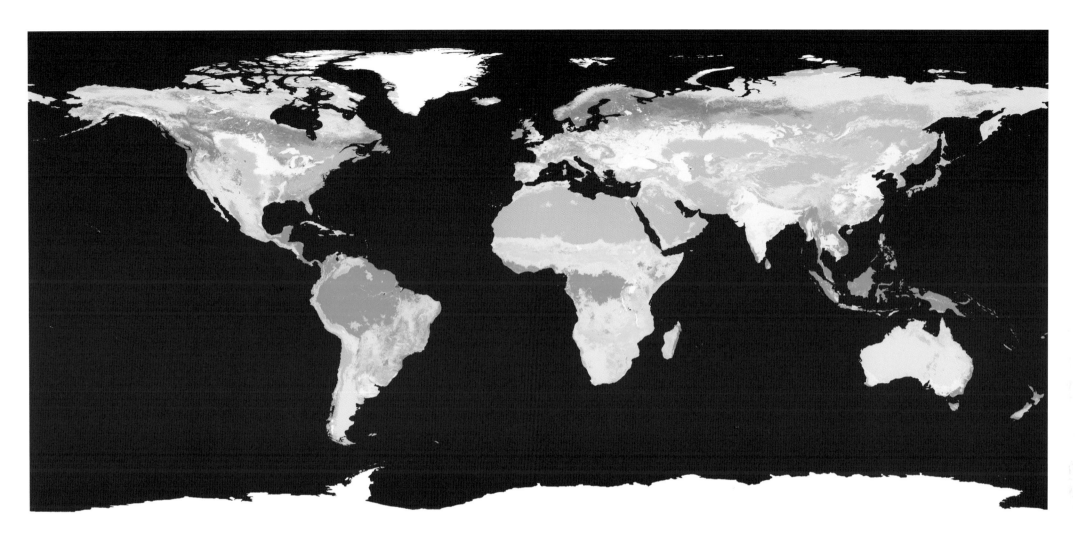

## Land Cover Type

The vegetation index map (opposite page) changes throughout the year. Individual plant species grow at different rates, and they reach maturity at different times of the year in different parts of the world. Each species has a characteristic vegetation index curve through its growing season. By analysing changes to the vegetation index through time, it is possible to estimate the dominant vegetation type in each part of the world.

This land cover map was generated by analysing 12 months of data from NASA's Terra satellite, and assigning each 0.6x0.6 mile (1x1 km) area of the land surface to one of 17 land cover types. Maps such as this are used to track changes in land use, and in scientific studies of the interaction between the land and the climate.

**Forests**

- Evergreen needleleaf forest
- Evergreen broadleaf forest
- Deciduous needleleaf forest
- Deciduous broadleaf forest
- Mixed forest

**Shrublands and Grasslands**

- Closed shrubland
- Open shrubland
- Woody savannah
- Grassland
- Savannah

**Agriculture, Barren and Urban**

- Cropland
- Cropland and natural vegetation
- Barren or sparsely vegetated
- Urban areas

**Water**

- Water
- Wetland
- Snow and ice

(source: Boston University and NASA Goddard Space Flight Center)

# TOPOGRAPHY

Our knowledge of the topography of large areas of the world's surface has been dramatically improved in recent years thanks to measurements made from space. These measurements enable us to produce a more detailed picture than ever before of the peaks, troughs, folds and plains of both the land surface and the sea floor.

## Land Topography

The land component of the topographic map shown here is the result of a short but highly significant mission flown by the Space Shuttle in February 2000. For 11 days the shuttle Endeavour orbited the Earth carrying the SIR-C/X-SAR radar system – the Shuttle Radar Topography Mission (SRTM). As the radar's two antennae illuminated the Earth's surface, the shuttle's crew spent much of their time feeding data tapes in and out of the instrument. A staggering 9,000 gigabytes (9 terabytes) of raw data were gathered by the mission, which took four years to process. SRTM used a technique known as interferometry, which allows height to be measured using two radar images, not unlike stereo photography. Because radar penetrates cloud cover, most of the world was covered in one short mission. The result is an accurate digital terrain model covering 80 per cent of the

Earth's land mass with a grid spacing of 295 ft (90 m), enabling many areas of the developing world to be mapped in detail for the first time.

## Ocean Bathymetry

The floor of the deep ocean cannot be seen from space, nor can radar penetrate the water to make a direct distance measurement. But the depth of the sea floor can be estimated from the height of its surface. Surprising as it may seem, the sea is not flat: water piles up over 'gravity anomalies' produced by ocean features such as seamounts, causing variations in the ocean surface which are much larger than those created by tides, winds and ocean currents. The distance from a satellite to the sea surface can be measured with a radar altimeter (similar to the devices used by aircraft for terrain avoidance), which bounces radar pulses off the sea surface and very precisely times their return. By comparing this distance against a reference height (the geoid), the depth of the sea floor can be estimated. New maps of the sea floor produced in this way have revealed previously unknown seamounts, ridges and troughs, which have given scientists a clearer understanding of how the plates of the Earth's crust fit together.

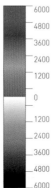

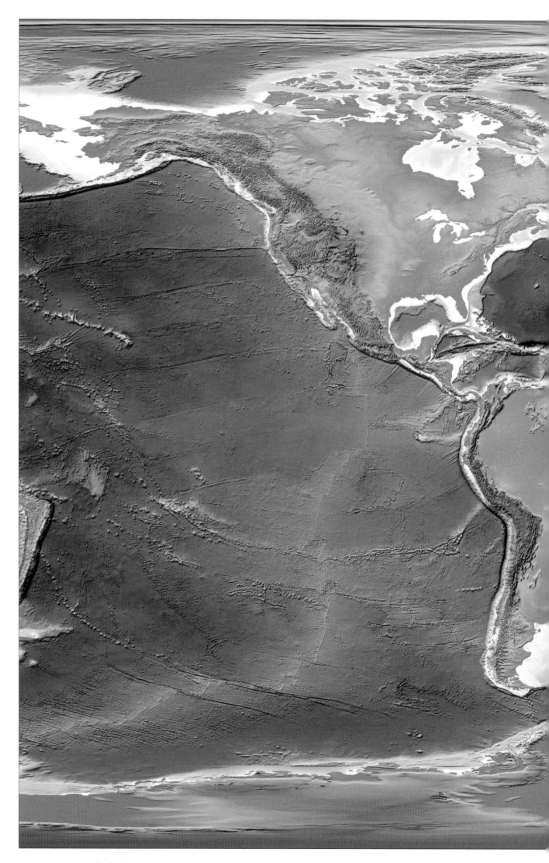

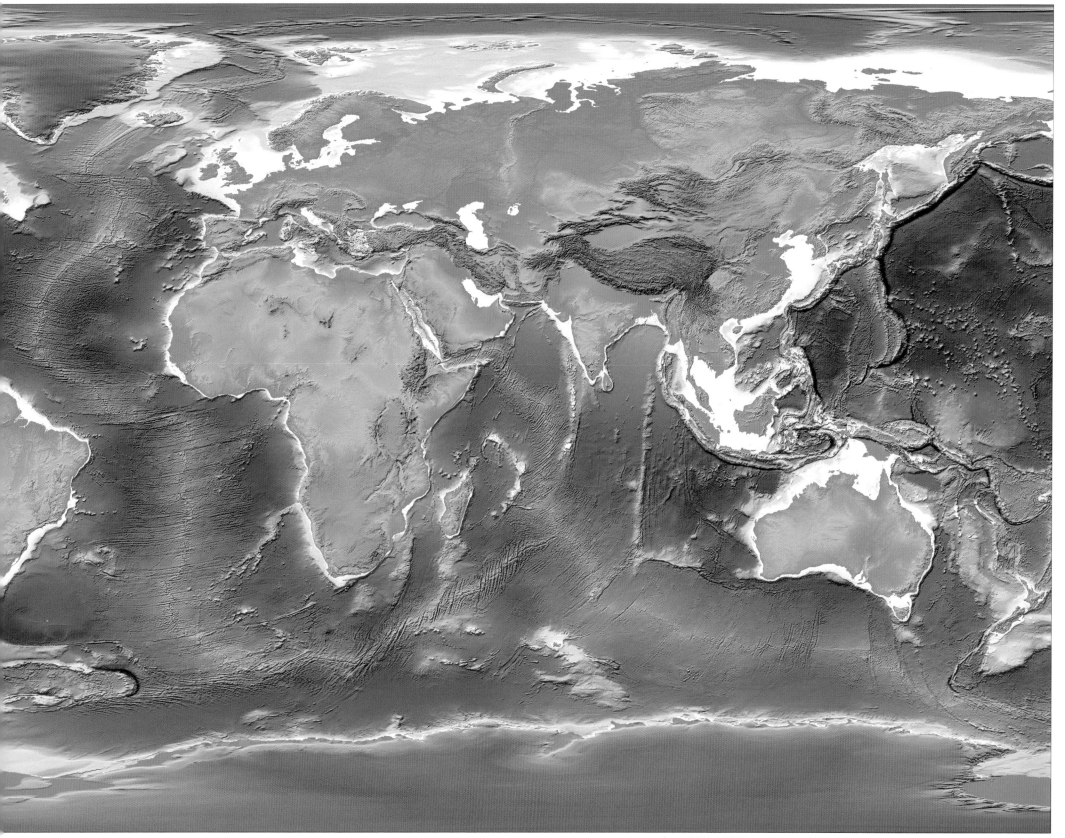

(sources: SRTM3 and GTOPO30 digital terrain from USGS EROS Data Center; ETOPO2 bathymetry from NOAA National Geophysical Data Centre)

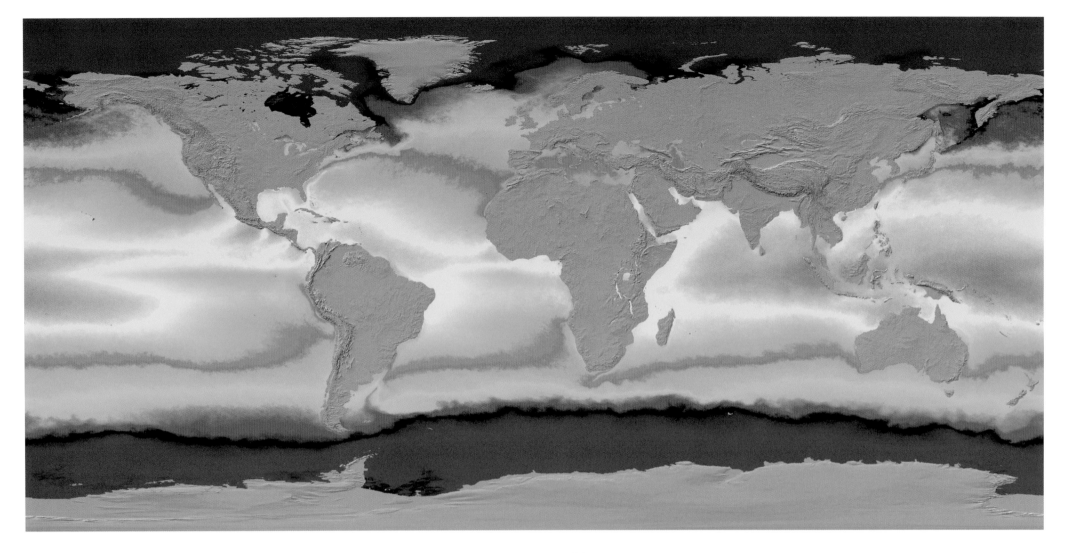

Sea Surface Temperature (ºC)

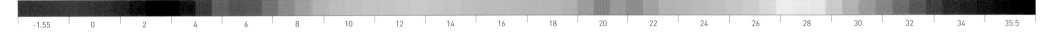

| -1.55 | 0 | 2 | 4 | 6 | 8 | 10 | 12 | 14 | 16 | 18 | 20 | 22 | 24 | 26 | 28 | 30 | 32 | 34 | 35.5 |

## Sea Surface Temperature

Until the arrival of satellite observations, study of the Earth's oceans was limited to very sparse measurements by a small number of scientific vessels or commercial 'ships of opportunity'. Satellites allowed oceanographers to observe an entire ocean basin with just a few images and to do so at regular intervals to build up a picture of ocean dynamics. One of the key physical parameters of the ocean is its surface temperature, and this can be measured by looking at thermal infrared wavelengths, where the Earth emits more energy than it reflects.

This temperature map was generated from daily observations by NASA's Aqua satellite taken during 2005 and represents the average temperature of the sea surface over the year. Cold and warm currents, areas of upwelling and ocean fronts can be monitored to help with weather forecasting, fishery management and ocean and climate research.

(source: Terra/MODIS Sea Surface Temperature from the SeaWiFS Project, NASA Goddard Space Flight Center)

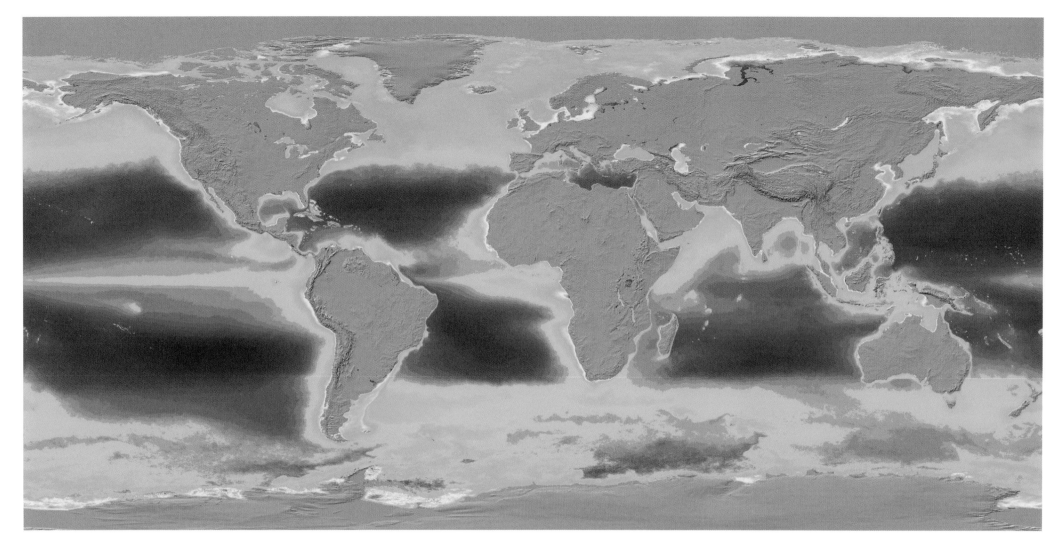

**Chlorophyll a Concentration (mg/m³)**

| 0.01 | 0.02 | 0.04 | 0.1 | 0.2 | 0.4 | 1.0 | 2.0 | 3.0 | 5.0 | 10 | 20 | 30 | 50 |

# Chlorophyll Concentration

Life in the oceans depends on energy from the sun and on the
presence of nutrients in the water. At the bottom of the food
chain, photosynthesising plants – phytoplankton – contain
chlorophyll, just like their counterparts on land. The concentration
of chlorophyll can be measured by analysing the colour of ocean
water. In coastal regions this is complicated by the presence
of suspended sediment, but useful maps can be made using the
data from satellite-borne ocean colour cameras. These maps
are used to find fish feeding grounds, to assess water quality
and in marine biology.

(source: Aqua/MODIS Chlorophyll Concentration from the SeaWiFS Project, NASA Goddard Space Flight Center)

About 7 per cent of the world's sea surface is covered with sea ice, the areas frozen around the North and South poles waxing and waning with the seasons. Historically, the area covered in the Arctic Ocean has expanded from about 2.7 million sq miles (7 million sq km) in summer to 5.8 million sq miles (15 million sq km) in winter. The range in the Southern Ocean around Antarctica is 1.1–17.3 million sq miles (2.8–18.8 million sq km). Satellites are the only way of observing sea ice across these remote oceans throughout the year and they have monitored the extent of sea ice at the poles since November 1978. The maximum and minimum extents in January and September 2005 are shown in the maps on the right, where the red line represents the average extent across the year.

## ▼ Ice Edge

The edge of the Arctic icepack retreats north of Svalbard in the summer. Thin ice at the edge is broken up by wind and wave action into individual floes. Larger floes will survive the summer melt and go on to become 'multi-year' ice, which can build up over several years to a depth of a few metres.

**January 2005**

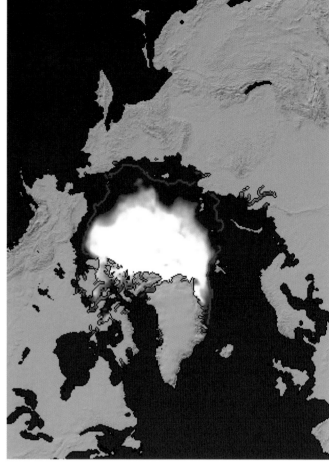

**September 2005**

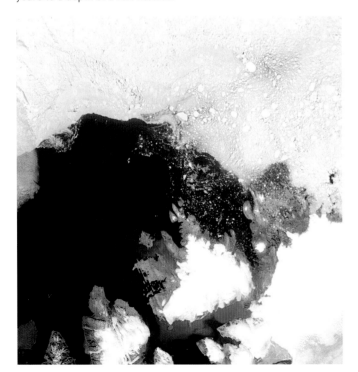

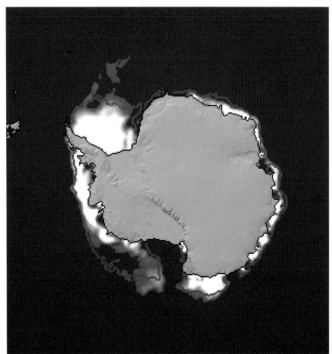

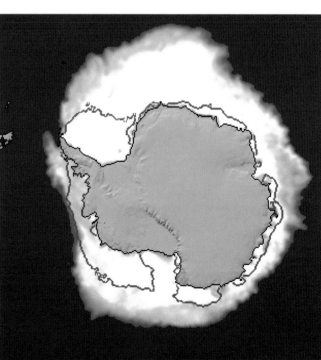

## ▶ Arctic Ice Anomalies

Ice anomaly maps show where there is a higher or
lower percentage of the sea surface covered with
ice, compared with the average conditions measured
between the start of satellite monitoring in 1979
and 2000. While some areas show higher than usual
concentrations of ice (red), the maps show increasing
areas of lower concentration (blue), meaning that
overall the area covered by ice is shrinking. The
minimum winter extent was recorded in 2006 (left
image) and the minimum summer extent was recorded
in 2005 (right image), 20 per cent below the historical
average. If the recent trend of accelerating ice loss
continues, it is possible that the Arctic Basin will be
clear of ice in the summer by the end of the century.

## ▼ Icebergs

In contrast to sea ice, which is no more than a few
metres thick, icebergs can be several hundred metres
thick. They are calved from the floating fronts of glaciers
or ice shelves when their weight causes them to break
off. The image below shows several large fragments of
Antarctica's Ross Ice Shelf adrift in the Ross Sea.
Earth-observing satellites are the primary source for
tracking the large tabular icebergs of the Southern
Ocean, which can drift thousands of kilometres north
before they melt away.

**Anomaly %**

| |
|---|
| >50 |
| 45 |
| 40 |
| 35 |
| 30 |
| 25 |
| 20 |
| 15 |
| 10 |
| 5 |
| 0 |
| -5 |
| -10 |
| -15 |
| -20 |
| -25 |
| -30 |
| -35 |
| -40 |
| -45 |
| <-50 |

January 2006

September 2005

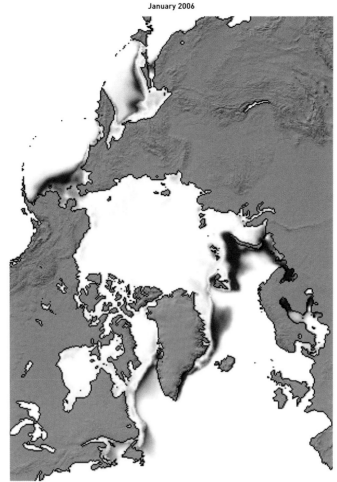

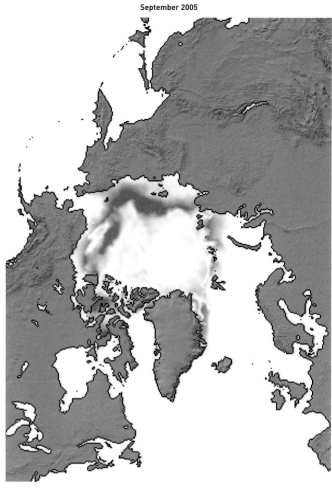

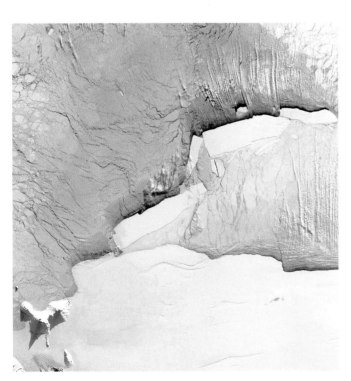

1979

2003

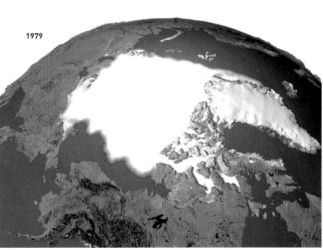

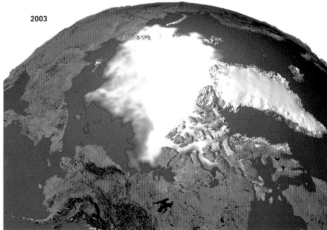

## Shrinking icecap

Simulated views of the Arctic Basin show the change in sea ice
cover between the summers of 1979 (left) and 2003 (right)

(source: Ice Concentration and Ice Anomaly maps from NOAA National Snow and Ice Data Center, based on DMSP/SSMI passive microwave data)

## Cloud Cover

One of the most familiar uses of Earth observation satellites is seen every day on our television weather forecasts. The ability to detect distant clouds and track their motion has greatly improved the accuracy of weather forecasting over the last forty years, and the early warning of approaching hurricanes and cyclones has saved many lives.

This imagemap represents a snapshot of the World's cloud cover taken over two days in 2002. A series of frontal systems is making its way east across the north Atlantic. In the Pacific, a typhoon is sweeping across the Philippines and Taiwan. Near the Equator, an undulating band of clouds – the inter-tropical convergence zone – marks the junction between circulation patterns of the northern and southern hemispheres, with thick thunderstorm clouds building over the rainforests of Africa and South America.

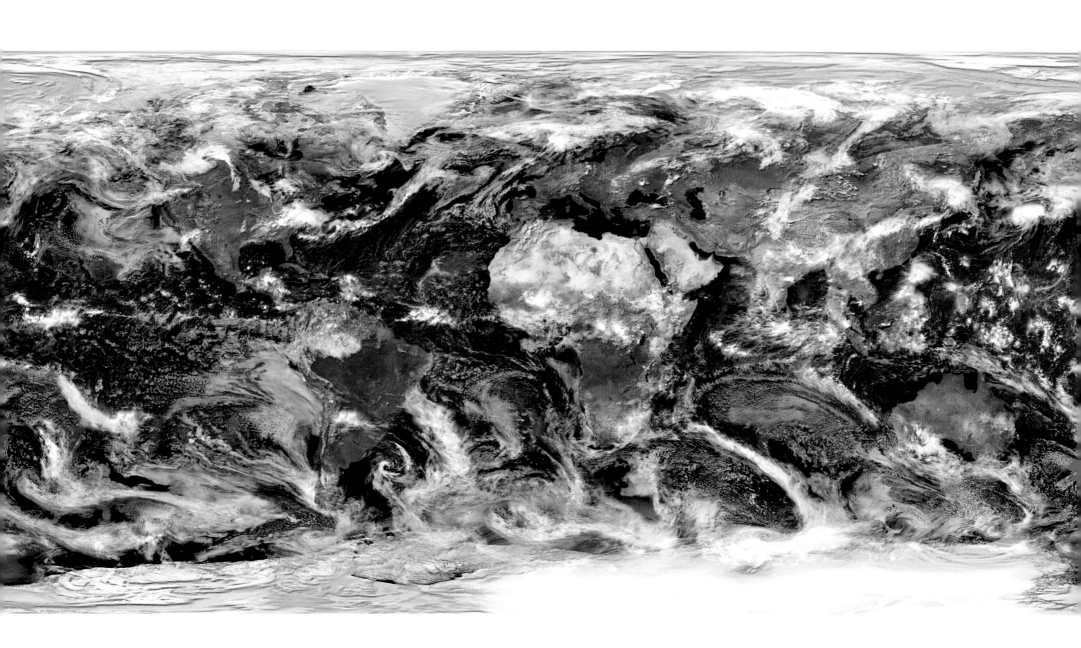

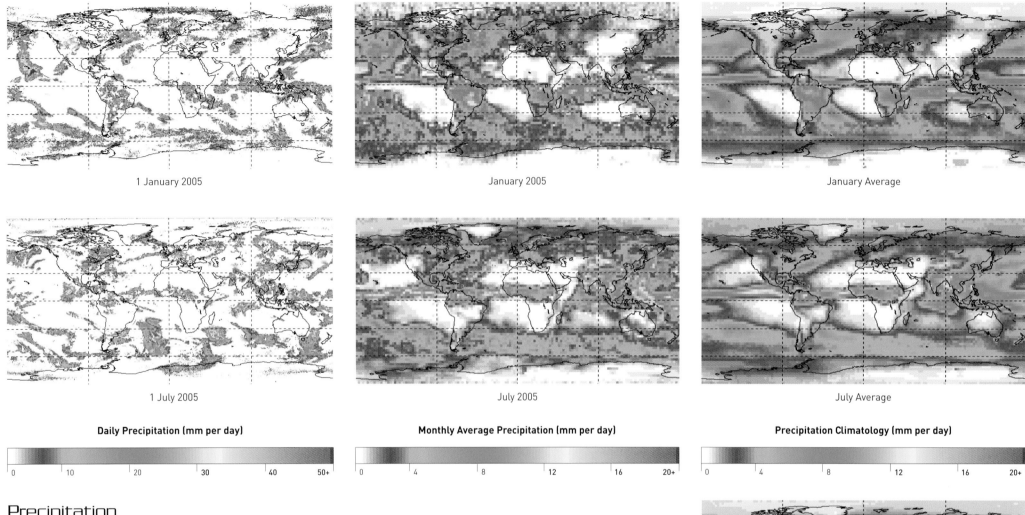

1 January 2005 · January 2005 · January Average

1 July 2005 · July 2005 · July Average

**Daily Precipitation (mm per day)**

0 · 10 · 20 · 30 · 40 · 50+

**Monthly Average Precipitation (mm per day)**

0 · 4 · 8 · 12 · 16 · 20+

**Precipitation Climatology (mm per day)**

0 · 4 · 8 · 12 · 16 · 20+

## Precipitation

Although radar systems can 'see' through clouds, some microwave wavelengths are blocked by liquid water in the atmosphere. These wavelengths have been used for many years by ground-based and aircraft weather radar to detect the presence of rain. In recent years, research satellites have used the same technique to detect rain on a global scale. Their data can be combined with that from other weather satellites and weather stations on the ground to produce daily global rainfall maps.

The daily images show rain patterns for the 1 January and 1 July 2005. By building up daily observations into monthly averages, we can start to see where is wet or dry in different seasons. Observations from the same month over several years show the typical rainfall patterns which form part of the climate of each location. The final image (right) is the average rainfall across all months and years, which shows the wettest and driest parts of the world.

**Climatology** Annual Average

(source: Global Precipitation Climatology Project, Laboratory for Atmospheres, NASA Goddard Space Flight Center)

Although damaging to the human respiratory system at ground-level, ozone high in the stratosphere is a life-saver. Here, the ozone layer forms a biological shield around the planet, absorbing the Sun's ultraviolet radiation, which is damaging to the DNA in all living cells. Prolonged exposure to ultraviolet radiation can cause skin cancer, eye cataracts and a weakened immune system. Levels of stratospheric ozone started to drop in the 1970s as a result of a build-up in the atmosphere of manmade chemicals such as chloroflourocarbons (CFCs), which were used in aerosol cans, refrigerators and some industrial processes. The use of CFCs was phased out after the signing of the Montreal Protocol in 1987, but these chemicals are very long-lived and ozone levels are not expected to fully recover until about 2065.

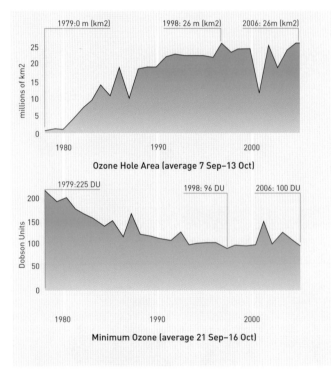

## ▶ Southern Hemisphere Ozone 'Hole'

In 1979, an experimental satellite measured atmospheric ozone concentrations over Antarctica that were so low they were dismissed as an instrument error. Only when scientists of the British Antarctic Survey recorded similar levels using weather balloons were the satellite measurements taken seriously. Daily ozone maps compiled from satellite data now form the basis of global ozone monitoring.

The time sequence (right) shows Antarctic stratospheric ozone concentration every five years for the period 1980-2005. Ozone maps are compiled for every day, and we have shown here the date with the largest ozone hole each year, usually occurring at the beginning of October.

## ▶ Ozone Distribution

Ozone is not evenly distributed through the atmosphere. Most is found in the stratosphere (6–30 miles [10–50 km] high), with highest concentrations in the ozone layer between 12–15 miles (20-25 km). Ozone distribution also varies with latitude, with the polar regions usually having higher concentrations than the Equatorial regions. Around the south pole, however, atmospheric conditions over Antarctica conspire to destroy stratospheric ozone in the southern spring (September-November). Strong westerly winds form a polar vortex which isolates air over the south pole and keeps it very cold – good conditions for ozone-destroying chemicals to do their work, resulting in an annual 'hole' in the ozone layer. The hole is a local magnification of the worldwide thinning of the ozone layer.

The amount of ozone in the atmosphere is expressed in Dobson Units (DU), where one DU represents a layer of ozone 10 microns thick at standard atmospheric temperature and pressure. The ozone 'hole' is the area in which the ozone level drops below 200 DU, which is two-thirds of the typical value of 300 DU seen over Antarctica prior to 1975. Ozone levels dropped through the 1980s and 1990s, with a larger and 'deeper' hole developing until it stabilised around the turn of the century.

Total Ozone
Dobson Units

550
440
330
220
110

**Double 'Hole'**
The extent of the ozone hole varies from day to day. A double ozone 'hole' was charted on 24 September 2002.

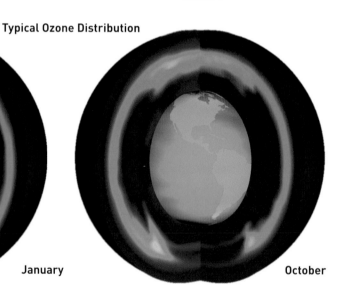

**Typical Ozone Distribution**

**January**

**October**

**1980**

**1985**

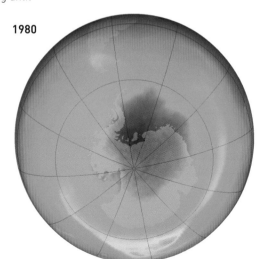

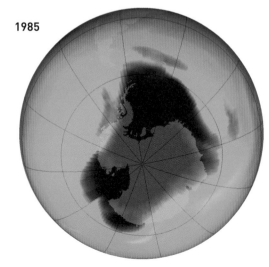

Ozone

Hydrogen Chloride

Nitric Acid

Water Vapour

Temperature

# ◄ Ozone Chemistry

Ozone is an allotrope of oxygen consisting of three oxygen atoms ($O_3$) rather than the usual two ($O_2$). It is produced when an oxygen molecule absorbs high energy ultraviolet light (UV-A) and splits into two oxygen atoms (O). The loose oxygen atoms then combine with $O_2$ molecules to give $O_3$. The ozone in turn absorbs low energy ultraviolet light (UV-B) and splits back into its $O_2$ and O components, with the O atom quickly recombining to make more ozone. This cycle of ozone creation and splitting produces a balance between $O_2$ and $O_3$ molecules. In the presence of certain catalyst chemicals, however, the balance is disrupted and ozone combines further instead of splitting, forming two $O_2$ molecules and leaving no free oxygen atoms. Without the free oxygen atoms no more ozone can be created, so the levels of ozone become depleted. Chlorine is one of the most powerful ozone-destroying catalysts, with a single chlorine atom from a CFC molecule being able to destroy many thousands of ozone molecules.

Several chemicals important to stratospheric ozone can be measured by satellite instruments (left): hydrogen chloride is a reservoir gas for the chlorine atoms which can destroy ozone; nitric acid and water vapour form polar stratospheric clouds, which provide a surface on which the benign chlorine in hydrogen chloride can be turned into the highly-reactive ozone-destroying form. Polar stratospheric clouds only form at extremely cold temperatures.

# ► Northern Hemisphere Ozone

Atmospheric circulation in the northern hemisphere is more complex than over Antarctica and the ozone-depleting chemicals are not concentrated in the same way. Ozone levels are therefore more variable and do not reach such low values as they do in the south. Nevertheless, significant depletion can occur and ozone levels are used to calculate the 'UV Index' reported in weather forecasts across Europe and North America.

**Northern Hemisphere**
Ozone concentration for 14 March 2000.

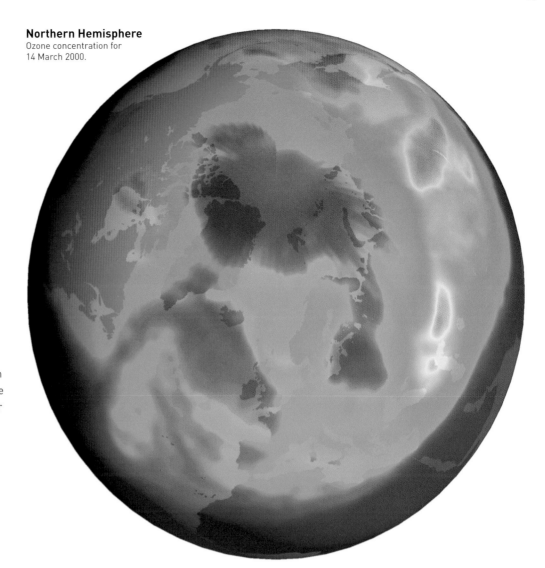

**1990**  **1996**  **2000**  **2005**

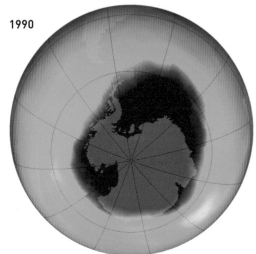

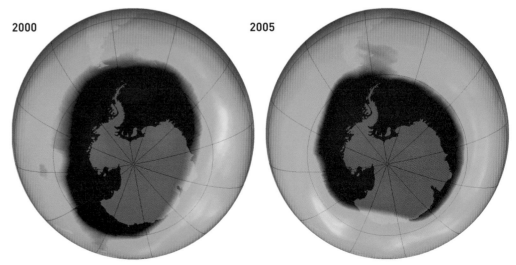

(sources: Ozone Concentration maps from the Laboratory for Atmospheres, NASA/GSFC, based on data from the TOMS sensor on Nimbus-7, Meteor 3 and Earth Probe, and the OMI sensor on Aura; Ozone Chemistry maps and cross-sections from the Scientific Visualisation Studio, NASA/GSFC, based on Aura/MLS and Earth Probe/TOMS data.)

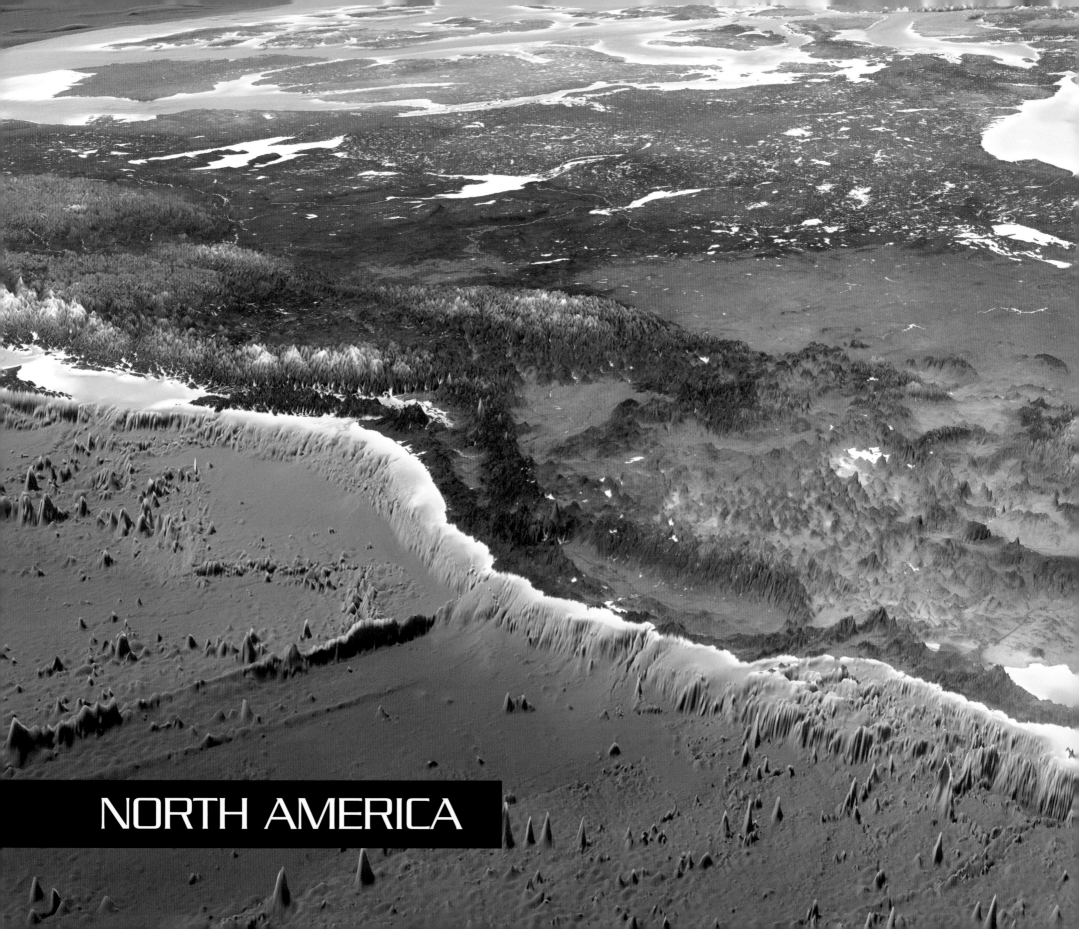

NORTH AMERICA

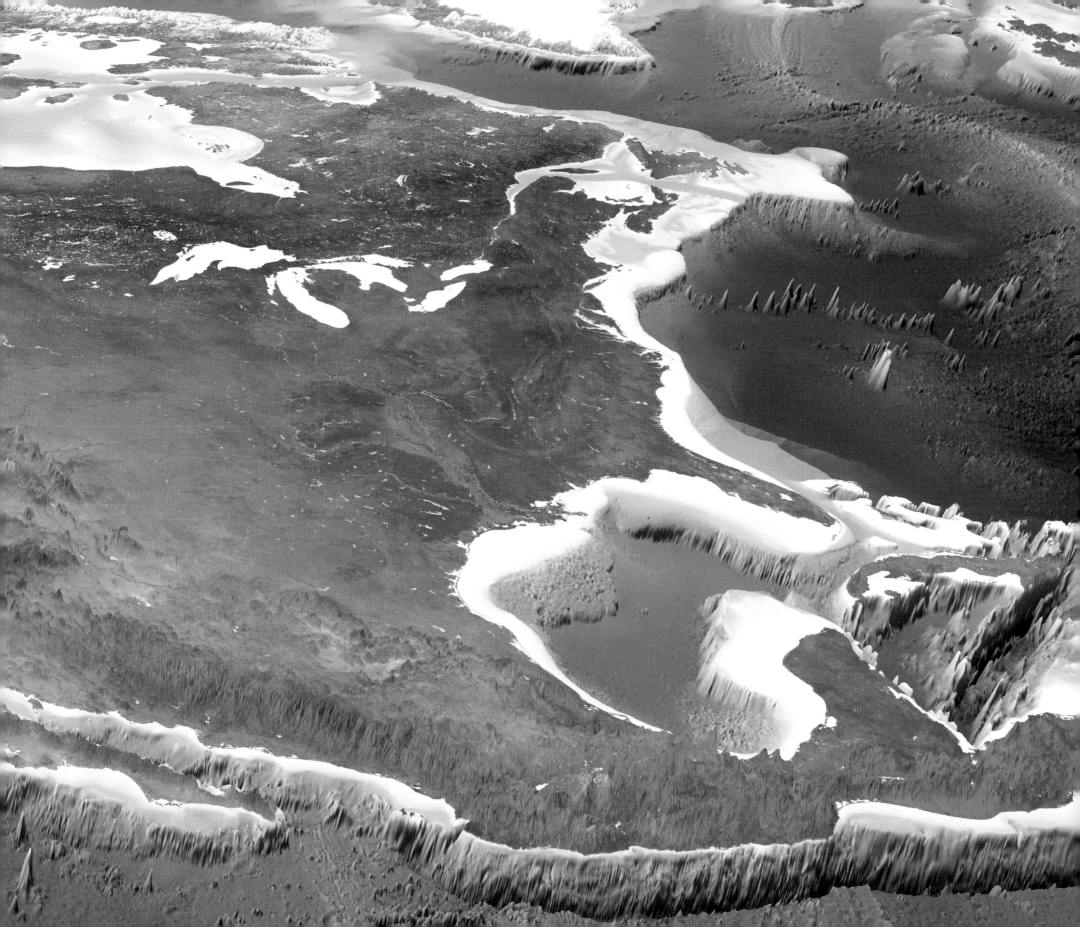

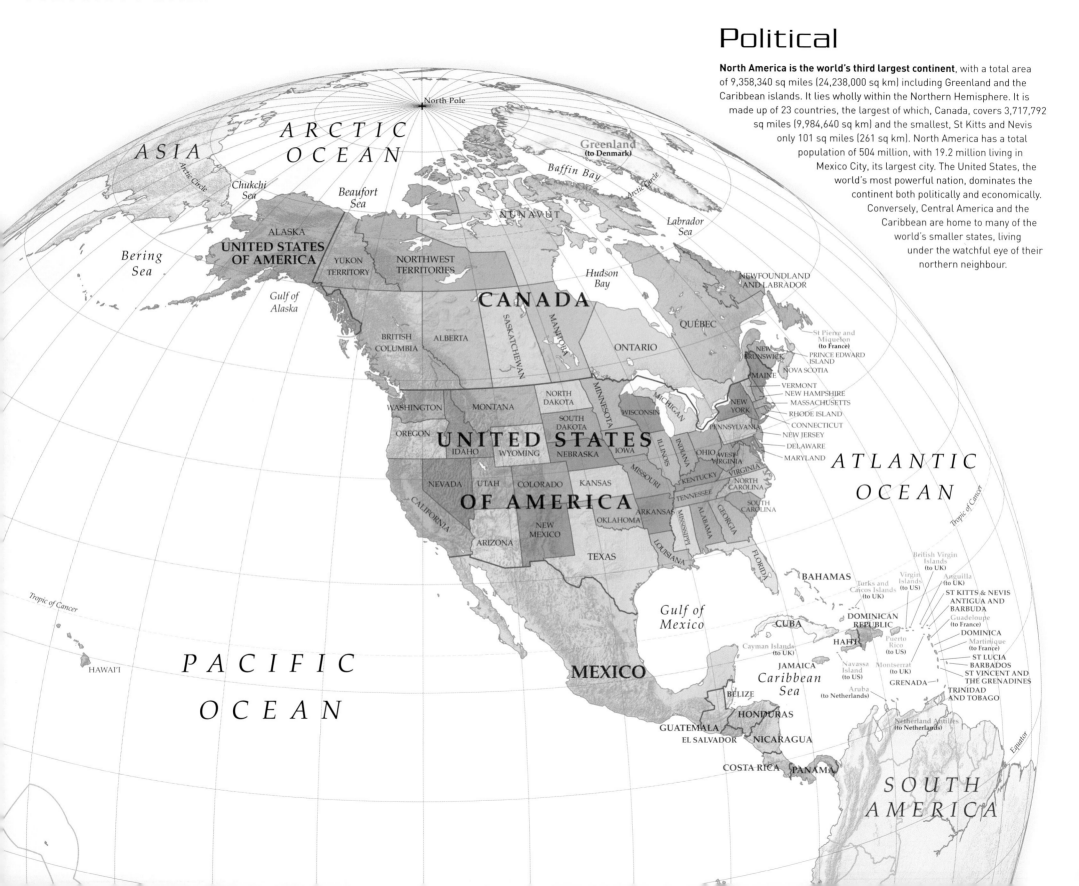

## Political

**North America is the world's third largest continent**, with a total area of 9,358,340 sq miles (24,238,000 sq km) including Greenland and the Caribbean islands. It lies wholly within the Northern Hemisphere. It is made up of 23 countries, the largest of which, Canada, covers 3,717,792 sq miles (9,984,640 sq km) and the smallest, St Kitts and Nevis only 101 sq miles (261 sq km). North America has a total population of 504 million, with 19.2 million living in Mexico City, its largest city. The United States, the world's most powerful nation, dominates the continent both politically and economically. Conversely, Central America and the Caribbean are home to many of the world's smaller states, living under the watchful eye of their northern neighbour.

# Physical

**North America** encompasses an astonishing variety of geographical features. The Rocky Mountains run down the western edge of the continent from Alaska to Mexico, sprinkled with volcanoes that can be spurred into action as the Pacific Plate dives below the North American Plate. In the north, the endless plains of the Canadian Shield have been worn flat by billions of years of glacial erosion. The Great Plains and the Mississippi–Missouri river basin form the fertile heart of the continent while in the east, the ancient Appalachian Mountains slowly wear away. Volcanic ranges continue south through Mexico to tropical Central America, its land bridge tenuously linking to South America. The Caribbean islands are volcanic too, lining the boundary of the Caribbean Plate.

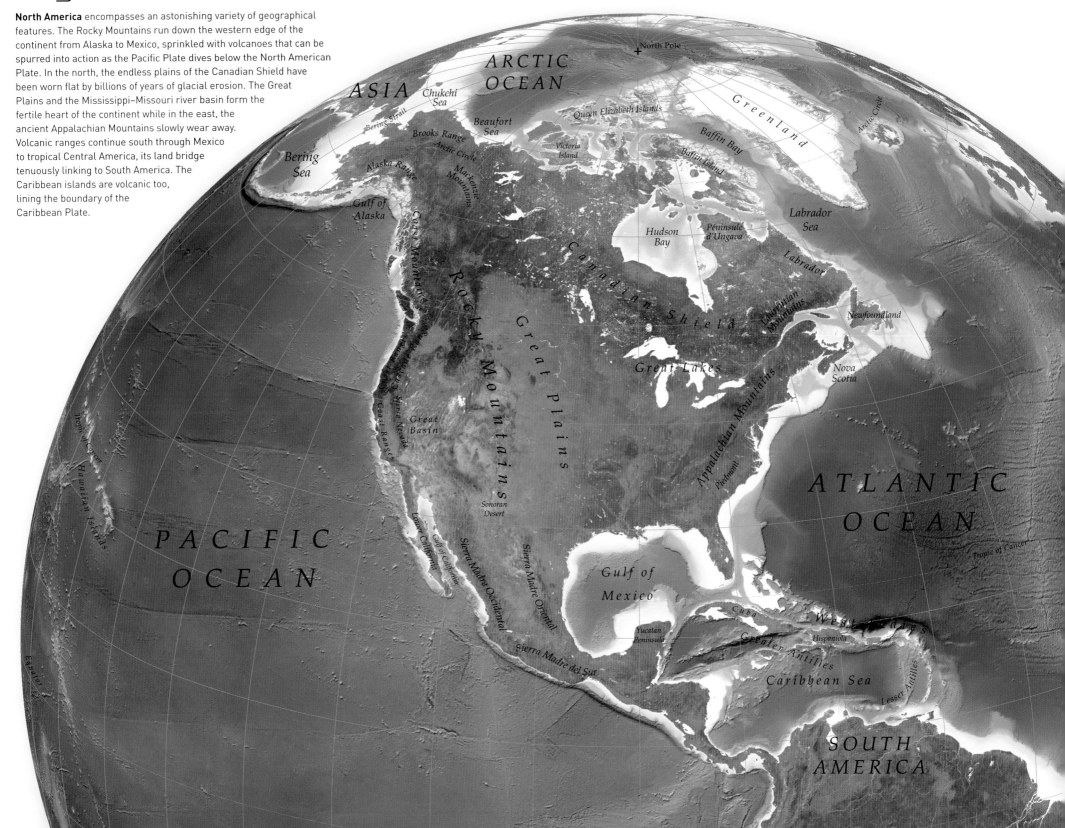

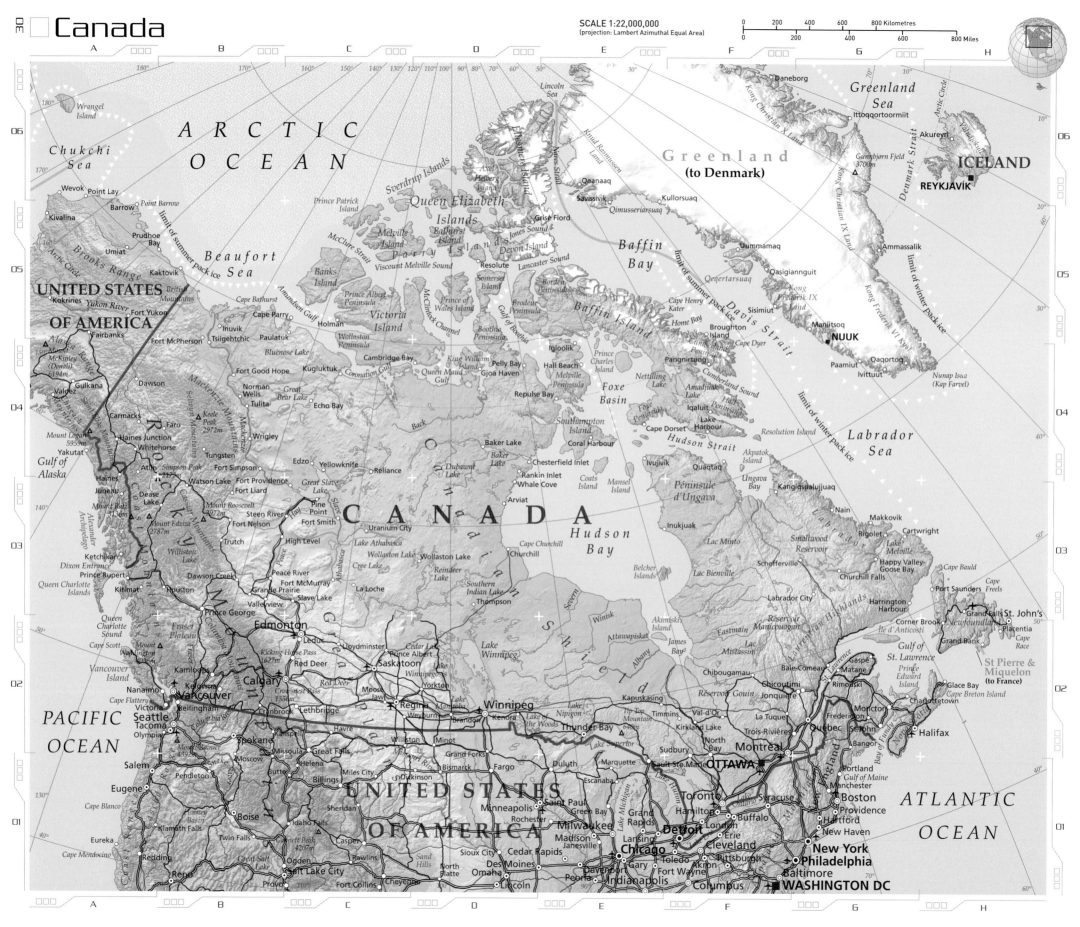

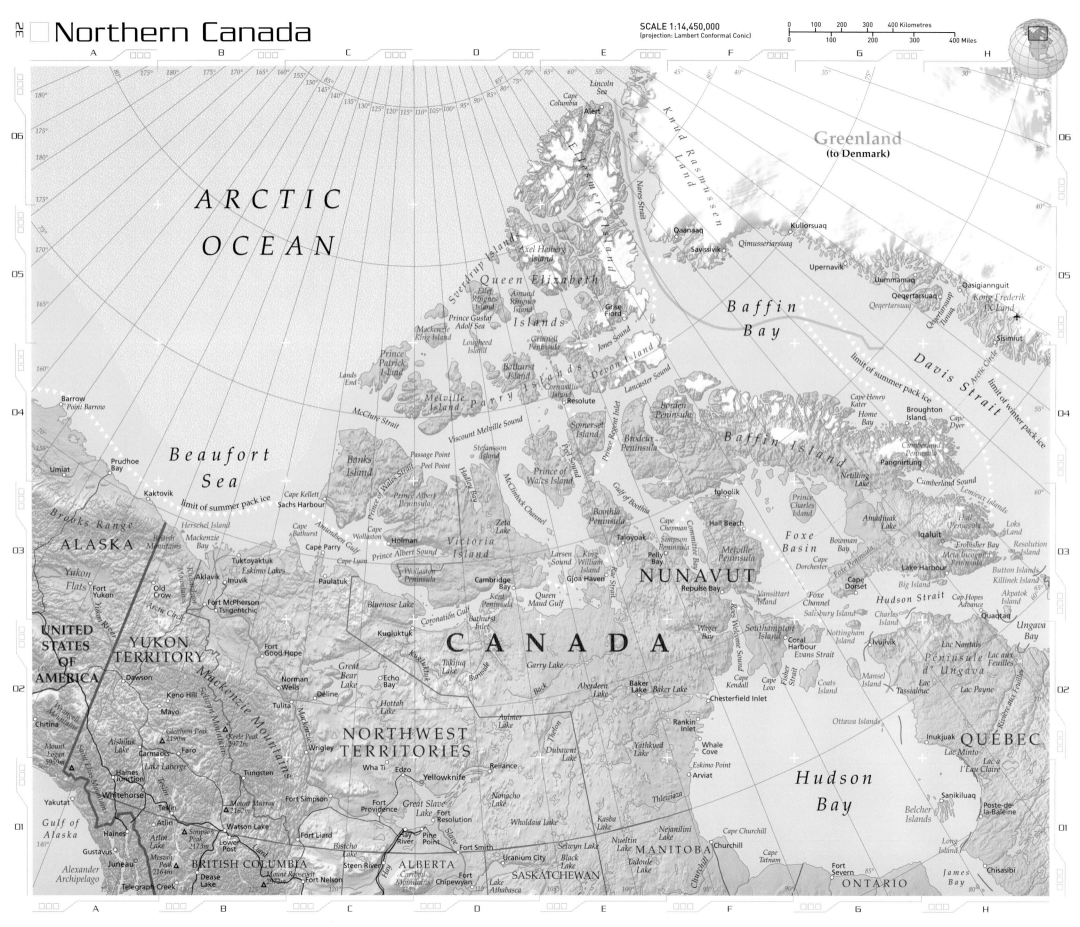

# Northern Canada

SCALE 1:14,450,000
(projection: Lambert Conformal Conic)

| 0 | 100 | 200 | 300 | 400 Kilometres |
| 0 | 100 | 200 | 300 | 400 Miles |

ARCTIC

OCEAN

Greenland
(to Denmark)

*Baffin*

*Bay*

Beaufort

Sea

*Davis Strait*

ALASKA

NUNAVUT

UNITED
STATES
OF
AMERICA

YUKON
TERRITORY

CANADA

QUÉBEC

NORTHWEST
TERRITORIES

*Hudson*

*Bay*

BRITISH COLUMBIA

ALBERTA

SASKATCHEWAN

MANITOBA

ONTARIO

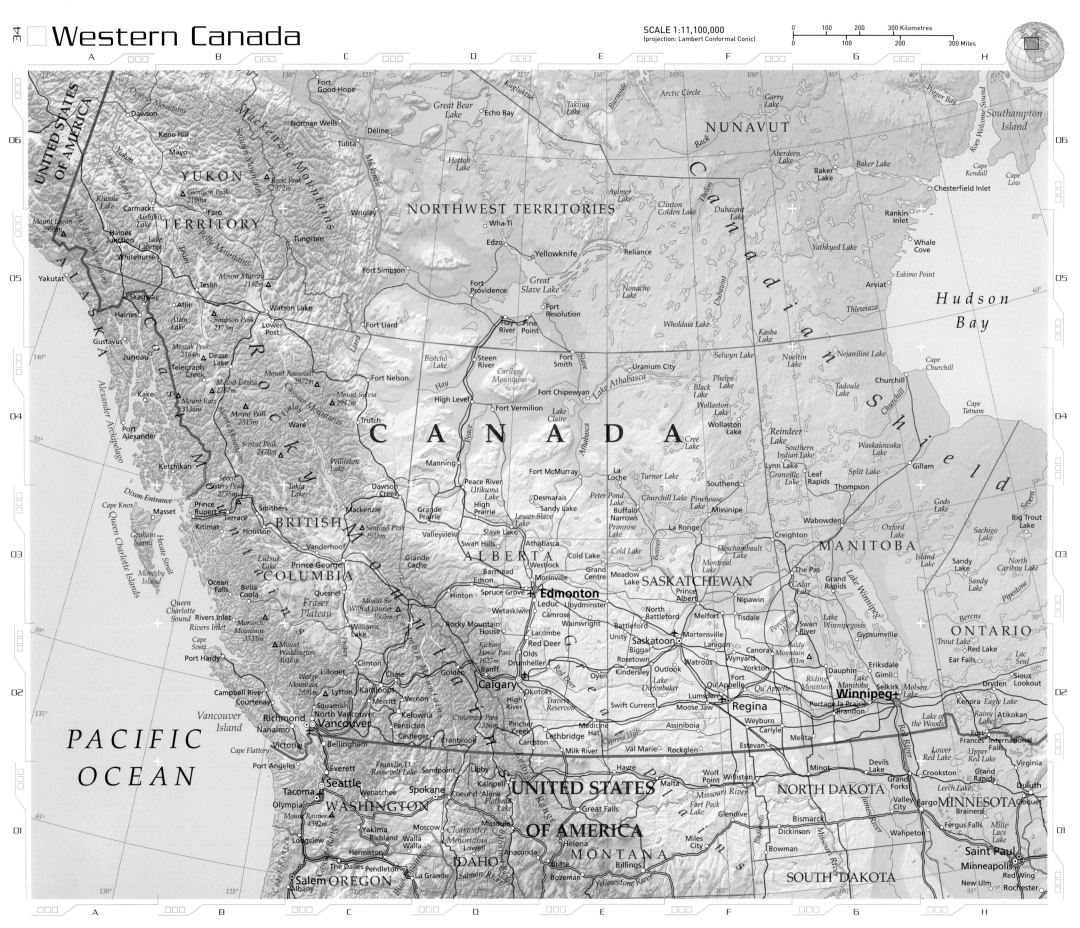

# Western Canada

SCALE 1:11,100,000
(projection: Lambert Conformal Conic)

0    100    200    300 Kilometres
0    100    200    300 Miles

**PACIFIC OCEAN**

**Hudson Bay**

**NUNAVUT**

**NORTHWEST TERRITORIES**

**C A N A D A**

**YUKON TERRITORY**

**ALASKA**

**UNITED STATES OF AMERICA**

**BRITISH COLUMBIA**

**ALBERTA**

**SASKATCHEWAN**

**MANITOBA**

**ONTARIO**

**Canadian Shield**

**UNITED STATES OF AMERICA**

**WASHINGTON**

**OREGON**

**IDAHO**

**MONTANA**

**NORTH DAKOTA**

**SOUTH DAKOTA**

**MINNESOTA**

Arctic Circle

Great Bear Lake

Great Slave Lake

Lake Athabasca

Vancouver Island

Queen Charlotte Islands

Edmonton

Calgary

Vancouver

Seattle

Winnipeg

Regina

Saskatoon

Saint Paul
Minneapolis

# VANCOUVER

## 49°13'N, 123°06'W

Canada's main Pacific seaport and the commercial centre of British Columbia, the city of Vancouver lies on the eastern side of a deepwater sound between the mainland and Vancouver Island, just north of the border with the USA. Originally a coastal Native North American settlement, Vancouver is now the major trading port for Canada's west coast timber, fish-processing and grain industries, and is becoming one of the most important ports of the Pacific Rim economic zone. It has developed south from its original site on the southern side of the Burrard Inlet to occupy much of the delta at the mouth of the Fraser river.

point for financial and cultural activities. The large white building in the bottom right corner of the image is BC Place Stadium, a 60,000 seat venue with the world's largest air supported roof. A large passenger liner can also be seen moored at the Cruise Ship Terminal on Burrard Inlet.

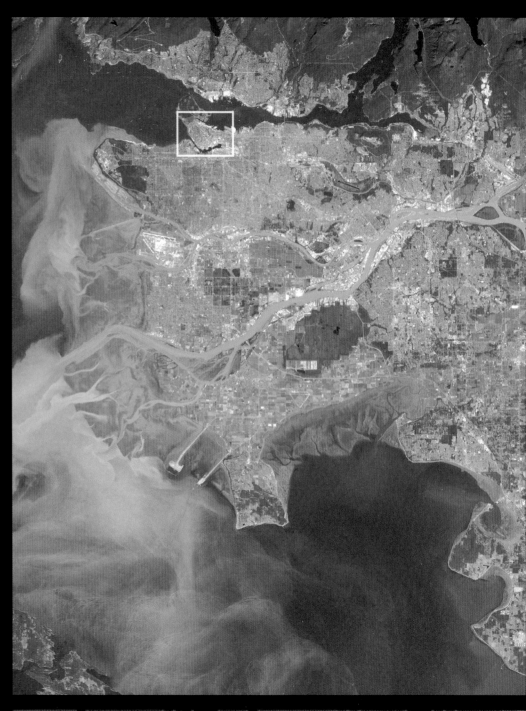

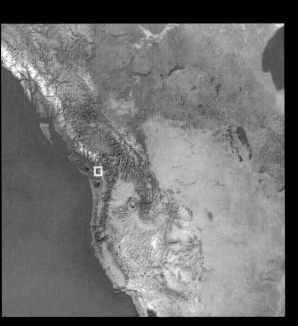

▶ **Like many North American cities**, Vancouver expanded rapidly during the 19th and 20th centuries on a gridplan basis, clearly shown on this image. The irregular landscape of the city's hinterland is a mixture of uninhabitable outcrops, now forming parks, and increasing areas of reclaimed coastal mudflats.

**SATELLITE:** LANDSAT 7   **INSTRUMENT:** ETM+   **HEIGHT:** 438 MILES (705 KM)   **DATE:** 15 JUN 2001

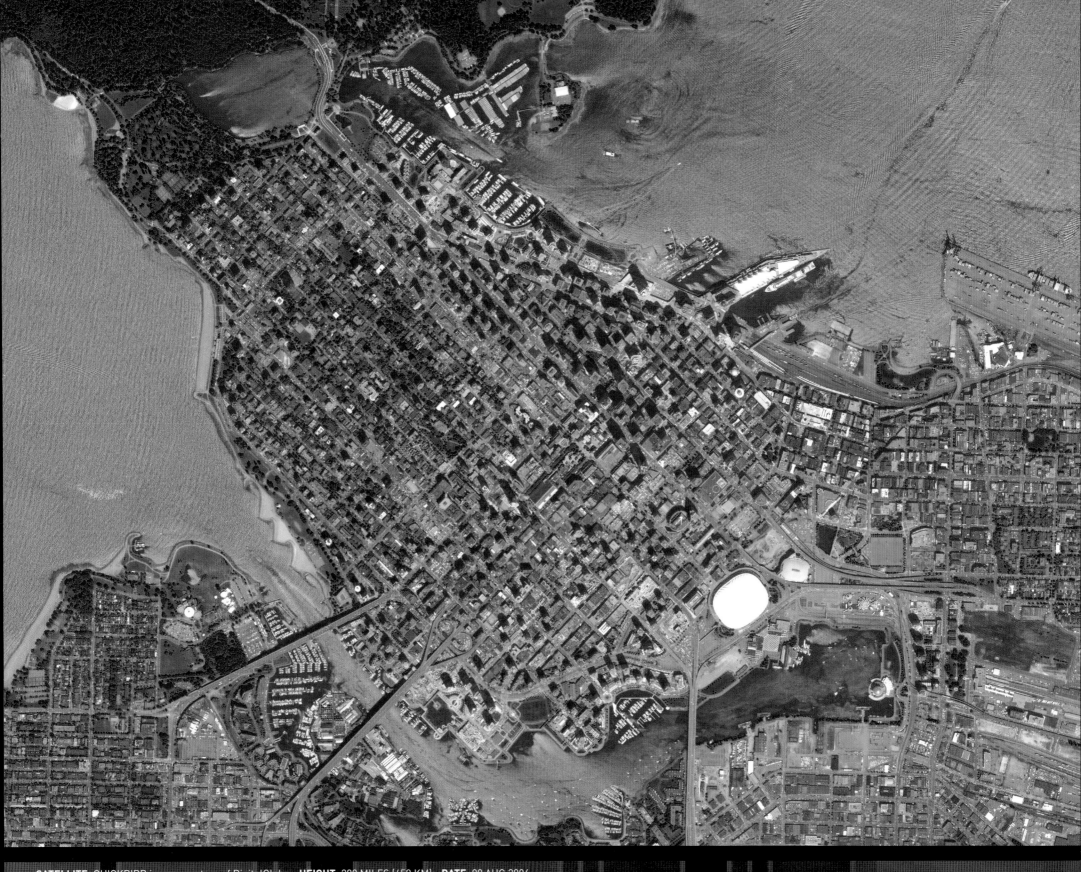

# ROCKY MOUNTAINS

## 50°N, 114°W

North America's western cordillera, popularly known as the Rocky Mountains (or Rockies), forms an all but impenetrable mountain barrier between the plains of the continental heartland and its Pacific fringe. They stretch south from Alaska, through Canada and the USA to Mexico. The highest point in the Canadian section is Mount Robson 12,972 ft (3954 m) in British Columbia. The Rockies are relatively young mountains, still growing due to tectonic pressure from the Juan de Fuca Plate. They were sculpted by the Cordilleran Ice Sheet during the last ice age, leaving high ridges separated by long, deep, flat-bottomed valleys, often occupied by lakes. The high mountains and reliable snowfall make the Canadian Rockies a popular destination for outdoor recreation, particularly winter sports.

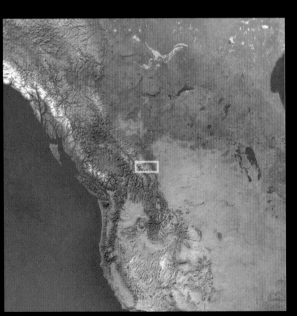

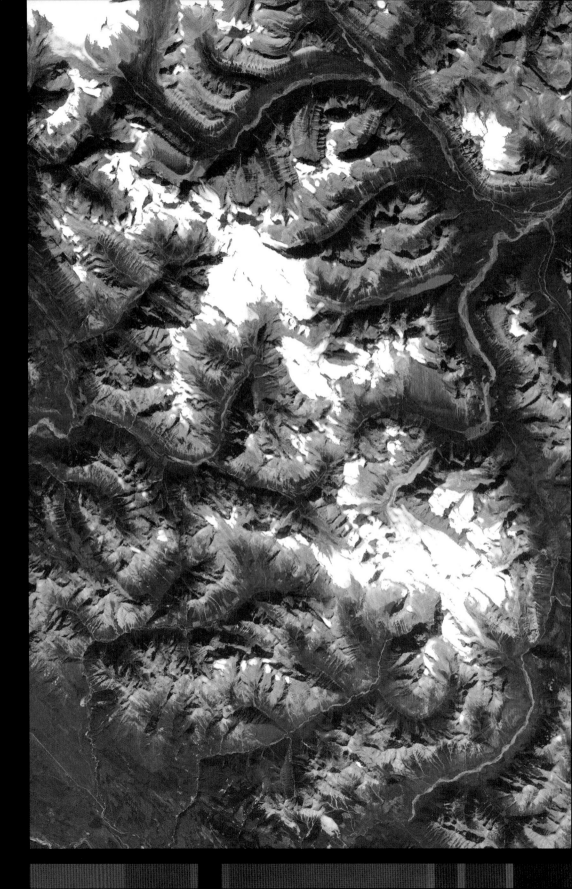

▶ **The Canadian Rockies** between Jasper and Lake Louise are shown in this mosaic of Landsat images. The land rises from the forested hills in the east to the bare rock and icefields on the border between Alberta and British Columbia in the west. The bright azure colour of the lakes on the valley floor indicates they are fed by glacial meltwater, containing finely-ground rock particles. In the northwest corner, glacier-topped Mount Columbia is the highest point in Alberta at 12,283 ft (3744 m).

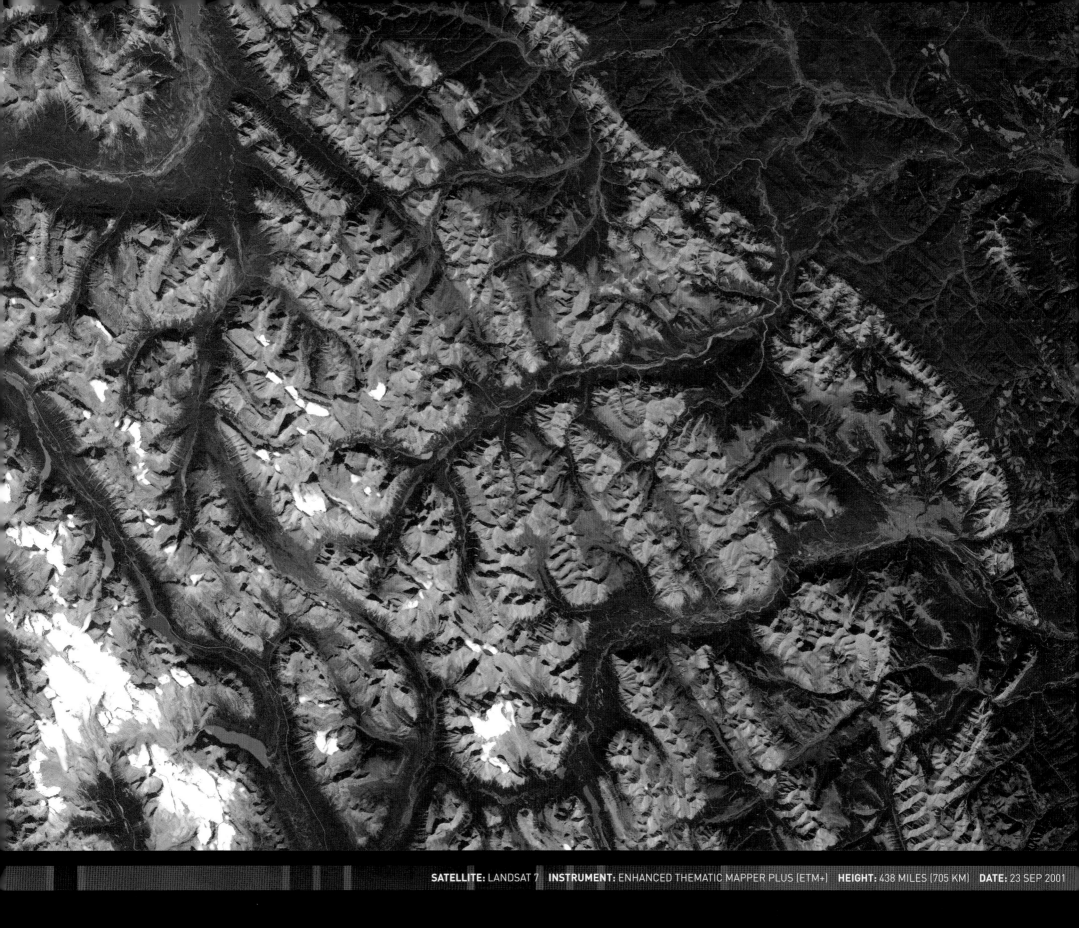

**SATELLITE:** LANDSAT 7   **INSTRUMENT:** ENHANCED THEMATIC MAPPER PLUS (ETM+)   **HEIGHT:** 438 MILES (705 KM)   **DATE:** 23 SEP 2001

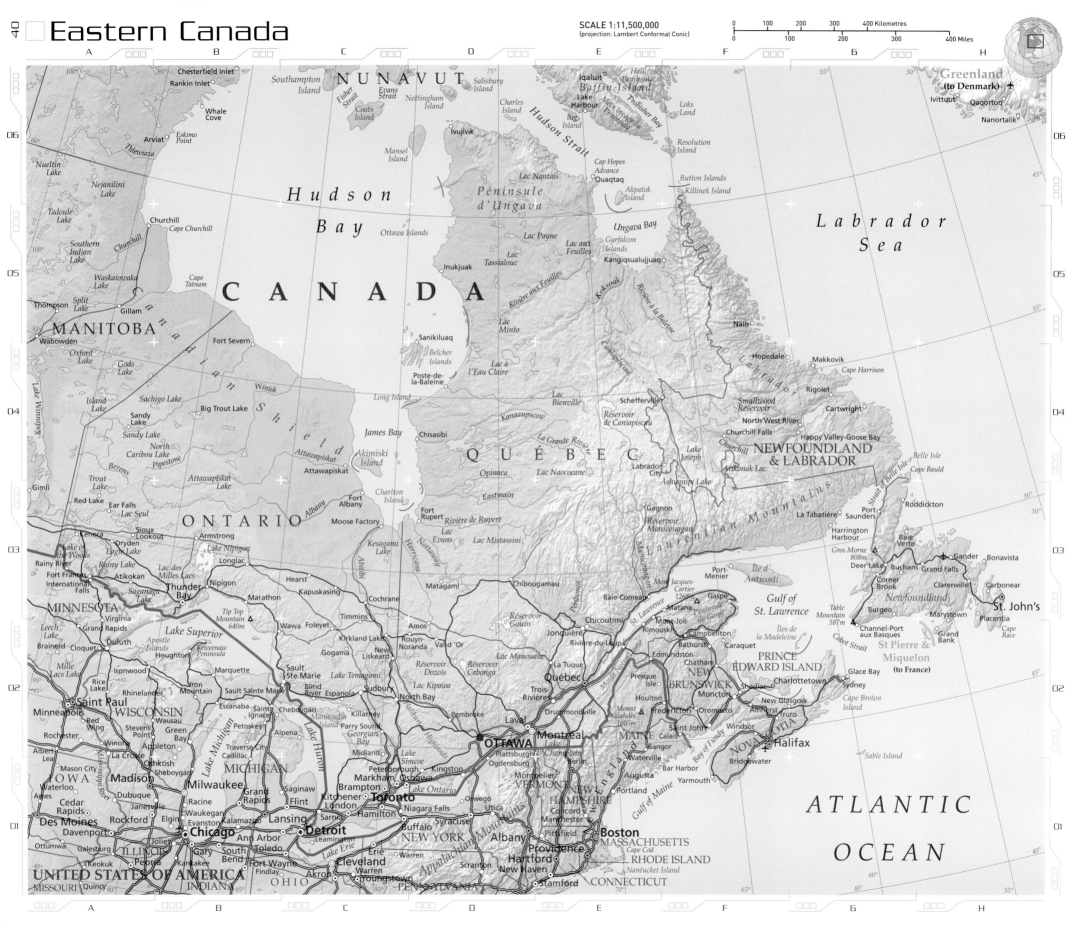

SCALE 1:11,500,000
(projection: Lambert Conformal Conic)

| 0 | 100 | 200 | 300 | 400 Kilometres |
| 0 | 100 | 200 | 300 | 400 Miles |

**Eastern Canada**

Greenland (to Denmark)

Ivittuut
Qaqortoq
Nanortalik

NUNAVUT

Southampton Island
Chesterfield Inlet
Rankin Inlet
Whale Cove
Arviat
Eskimo Point
Nueltin Lake
Nejanilini Lake
Tadoule Lake
Thlewiaza

Fisher Strait
Coats Island
Nottingham Island
Evans Strait
Salisbury Island
Mansel Island

Baffin Island
Iqaluit
Hall Peninsula
Lake Harbour
Frobisher Bay
Loks Land
Meta Incognita Peninsula
Big Island
Charles Island
Resolution Island
Button Islands
Killinek Island

Hudson Strait
Cap Hopes Advance
Quaqtaq
Akpatok Island

**Labrador Sea**

Ungava Bay
Gyrfalcon Islands
Kangiqsualujjuaq
Nain
Hopedale
Makkovik
Cape Harrison
Rigolet
Cartwright

**Hudson Bay**

Churchill
Cape Churchill
Cape Tatnam
Fort Severn

MANITOBA
Thompson
Split Lake
Gillam
Wabowden
Oxford Lake
Gods Lake
Southern Indian Lake
Waskaiowaka Lake
Churchill

**CANADA**

Ottawa Islands
Inukjuak
Sanikiluaq
Belcher Islands
Poste-de-la-Baleine
Lac à l'Eau Claire
Long Island
James Bay
Akimiski Island
Attawapiskat
Chisasibi
Charlton Island
Fort Rupert
Rivière de Rupert
Moose Factory
Fort Albany

Péninsule d'Ungava
Lac Nantais
Lac Payne
Lac aux Feuilles
Rivière aux Feuilles
Lac Tassialouc
Lac Minto
Lac Bienville
Kanaaupscow
La Grande Rivière
Opinaca
Lac Naococane
Eastmain

QUÉBEC

Caniapiscau
Schefferville
Réservoir de Caniapiscau
Labrador City
Ashuanipi Lake
Atikonak Lac
Churchill Falls
Smallwood Reservoir
North West River
Happy Valley-Goose Bay
Lake Joseph

NEWFOUNDLAND & LABRADOR

Laurentian Mountains
Strait of Belle Isle
Belle Isle
Cape Bauld
Roddickton
Port Saunders
Harrington Harbour
Baie Verte
Gros Morne 808m
Deer Lake
Buchans
Gander
Grand Falls
Bonavista
Corner Brook
Clarenville
Carbonear
Newfoundland
Burgeo
St. John's
Marystown
Placentia
Cape Race
Grand Bank
Channel-Port aux Basques
Table Mountain 587m
Cabot Strait
St Pierre & Miquelon (to France)

Canadian Shield

ONTARIO

Sachigo Lake
Big Trout Lake
Sandy Lake
North Caribou Lake
Attawapiskat Lake
Pipestone
Winisk
Island Lake
Trout Lake
Berens
Gimli
Red Lake
Ear Falls
Lac Seul
Sioux Lookout
Kenora
Dryden
Eagle Lake
Lake of the Woods
Rainy River
Fort Frances
International Falls
Saganaga Lake
Rainy Lake
Atikokan
Thunder Bay
Nipigon
Armstrong
Longlac
Lac des Mille Lacs
Lake Nipigon

Albany
Kesagami Lake
Harricana
Abitibi
Nottaway
Matagami
Lac Evans
Lac Mistassini
Chibougamau
Réservoir Gouin
Amos
Val d'Or
Rouyn-Noranda
Lac Manouane
La Tuque
Réservoir Cabonga
Réservoir Kipawa
Réservoir Dozois
New Liskeard
Kirkland Lake
Timmins
Cochrane
Kapuskasing
Hearst
Foleyet
Gogama
Wawa
Marathon

Tip Top Mountain 640m
MINNESOTA
Virginia
Grand Rapids
Duluth
Brainerd
Cloquet
Leech Lake
Ironwood
Houghton
Apostle Islands
Keweenaw Peninsula
Marquette
Escanaba
Iron Mountain
Rhinelander
Sault Ste. Marie
Sault Sainte Marie
Blind River
Espanola
Sudbury
North Bay
Killarney
Pembroke
Sault Ste.Marie

Lake Superior

WISCONSIN
Rice Lake
Wausau
Stevens Point
Green Bay
Appleton
Oshkosh
Sheboygan
Madison
Milwaukee
Racine
Kenosha
Janesville
Waukegan
Elgin
Evanston

MICHIGAN
Cadillac
Traverse City
Petoskey
Cheboygan
St. Ignace
Alpena
Grand Rapids
Saginaw
Flint
Lansing
Kalamazoo
Ann Arbor
Detroit
Toledo
Leamington

Lake Michigan
Lake Huron
Georgian Bay
Manitoulin Island
Parry Sound
Midland
Lake Simcoe
Barrie
Peterborough
Kingston
Oshawa
Markham
Brampton
Kitchener
Toronto
Hamilton
London
Sarnia
Niagara Falls
Buffalo
Lake Ontario
Lake Erie
Erie

St. Lawrence
Québec
Trois-Rivières
Drummondville
Laval
Montréal
OTTAWA
Pembroke
Baie-Comeau
Matane
Mont-Joli
Rimouski
Rivière-du-Loup
Jonquière
Chicoutimi
Mont Jacques-Cartier 1268m
Gaspé
Port-Menier
Île d'Anticosti
Péninsule de Gaspé
Gulf of St. Lawrence
Îles de la Madeleine
Campbellton
Bathurst
Caraquet
Edmundston
Chatham
PRINCE EDWARD ISLAND
Charlottetown
Summerside
New Glasgow
Sydney
Cape Breton Island
Glace Bay
Gagnon
Réservoir Manicouagan
La Tabatière

Monts Notre Dame
NEW BRUNSWICK
Moncton
Fredericton
Oromocto
Saint John
Presque Isle
Houlton
MAINE
Calais
Waterville
Augusta
Bar Harbor
Bangor
Portland
Yarmouth
Gulf of Maine
Mont Katahdin 1605m
Amherst
Truro
NOVA SCOTIA
Windsor
Bridgewater
Halifax
Sable Island
Shediac

Plattsburgh
Ogdensburg
Montpelier
Berlin
VERMONT
NEW HAMPSHIRE
Concord
Manchester
Portsmouth
Lake Champlain
Utica
Syracuse
Oswego
Albany
NEW YORK
Hartford
New Haven
Providence
Boston
MASSACHUSETTS
Cape Cod
RHODE ISLAND
Nantucket Island
CONNECTICUT
Stamford
Springfield
Pittsfield
Worcester
Scranton

Des Moines
Davenport
IOWA
Cedar Rapids
Waterloo
Ames
Mason City
Albert Lea
La Crosse
Winona
Dubuque
Rockford
Elgin
Joliet
Chicago
Gary
South Bend
ILLINOIS
Peoria
Galesburg
Kankakee
INDIANA
Fort Wayne
Findlay
OHIO
Akron
Cleveland
Warren
Youngstown
PENNSYLVANIA
Erie
Minneapolis
Saint Paul
Red Wing
Rochester
Mississippi River
MISSOURI
Quincy
Ottumwa
Keokuk
Saginaw
Mille Lacs Lake

Appalachian Mountains
New England
Bay of Fundy

**UNITED STATES OF AMERICA**

**ATLANTIC OCEAN**

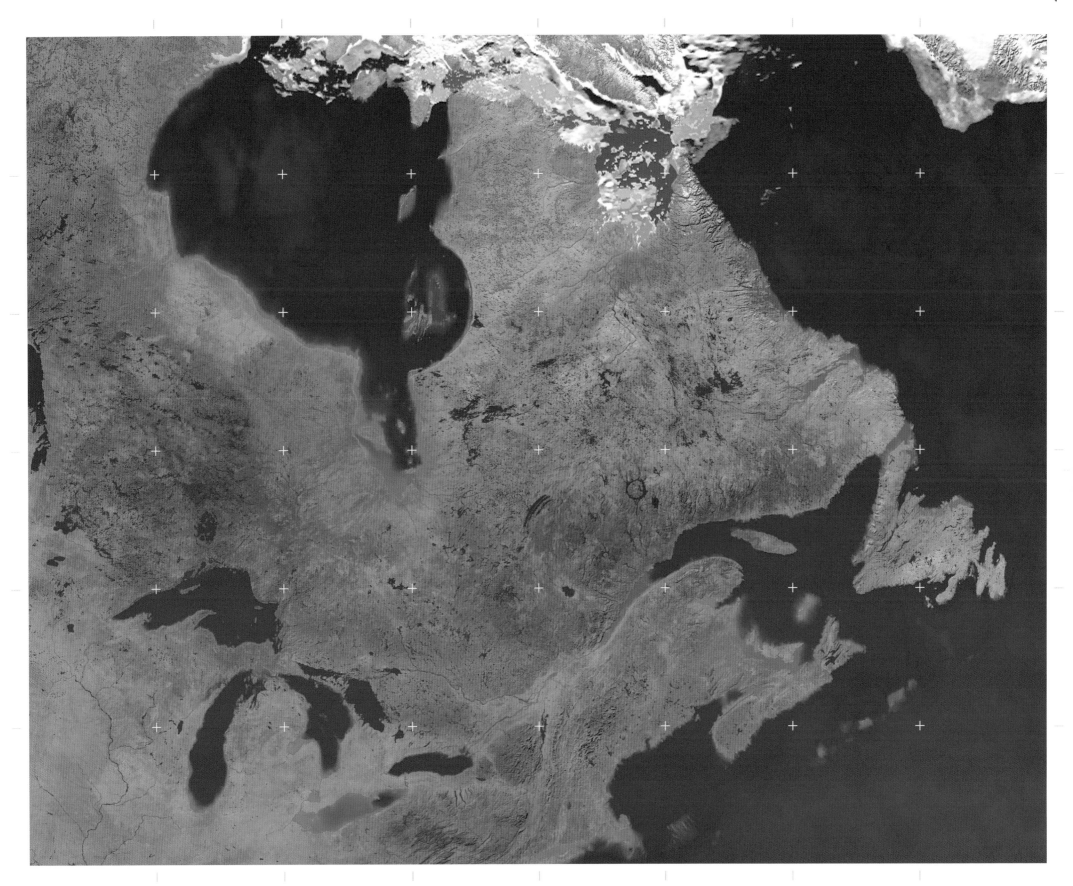

# TORONTO

## 43°42'N, 79°25'W

The capital of the Canadian province of Ontario, and Canada's largest city with a population of over 5 million, Toronto is a major industrial and commercial centre. Situated in a relatively flat area, the city's location on the shore of Lake Ontario provides a spectucular setting. Originally occupied by the Seneca tribes, a French trading post, Fort Rouillé, was established here around 1750. In 1793, the city was founded by Americans loyal to the British, and soon became the administrative centre of Upper Canada. At first it was called York but, upon receiving its city charter in 1834, its name was changed to Toronto. It became the capital of Ontario in 1867. The city has long been a major Great Lakes port, shipping grain and meat from the prairies eastwards through the St. Lawrence. It has become a showcase for spectacular modern architecture.

**▼ The modern metropolitan municipality** of Toronto spreads for many miles along the northwest shore of Lake Ontario, and it is the urban focal point of the Canadian province of Ontario.

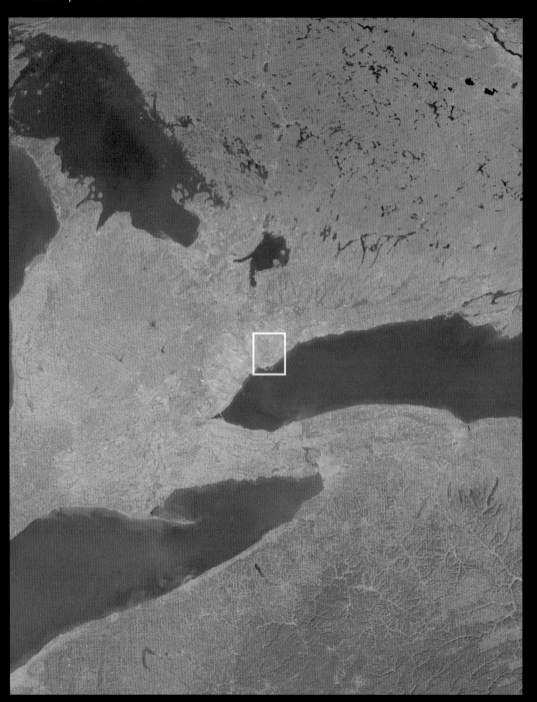

**SATELLITE:** TERRA (EOS AM-1)   **INSTRUMENT:** MODIS   **HEIGHT:** 438 MILES (705 KM)   **DATE:** 2005

▼ **Toronto is in many ways** an archetypal North American city, growing outwards from its historic heart as a lakeshore port in a relatively symmetrical grid pattern, whilst preserving green recreational areas along the banks of the rivers that flow through it.

▼ **The old dock area** has been considerably redeveloped, and provides the home for the innovative Skydome and the adjacent CN Tower which, at 1815 ft (553 m), is the world's tallest freestanding structure.

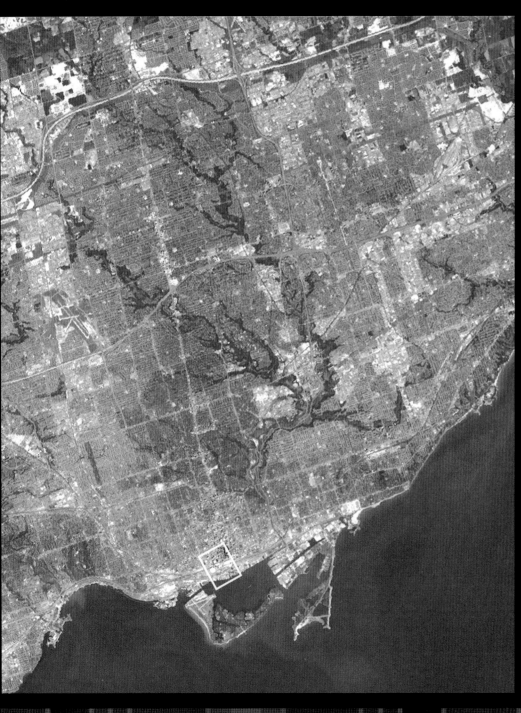

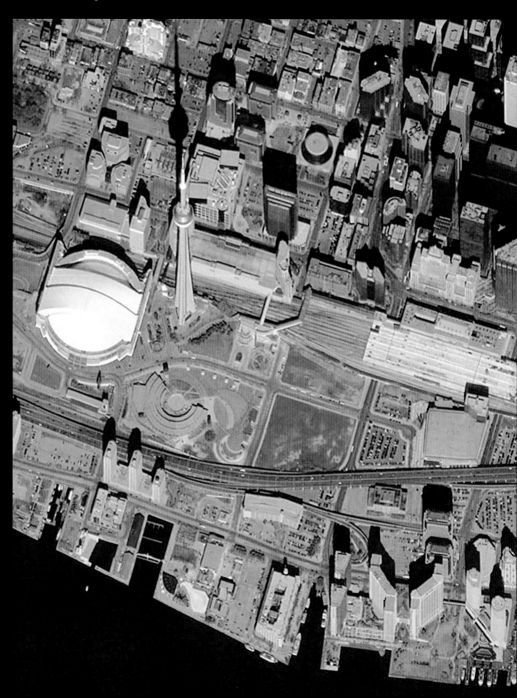

**SATELLITE:** LANDSAT 7   **INSTRUMENT:** ETM+   **HEIGHT:** 438 MILES (705 KM)   **DATE:** 10 AUG 2002

**SATELLITE:** IKONOS image courtesy of GeoEye   **HEIGHT:** 423 MILES (681 KM)   **DATE:** 18 MAR 2000

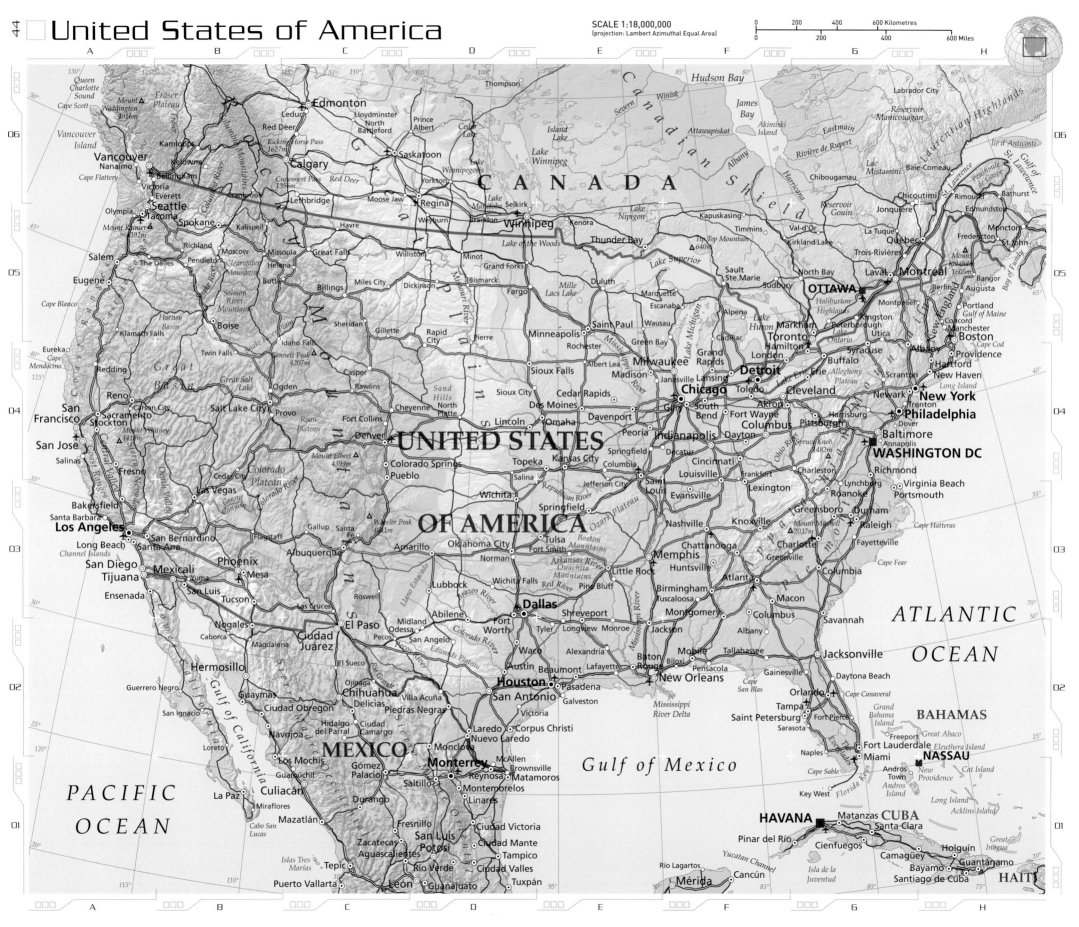

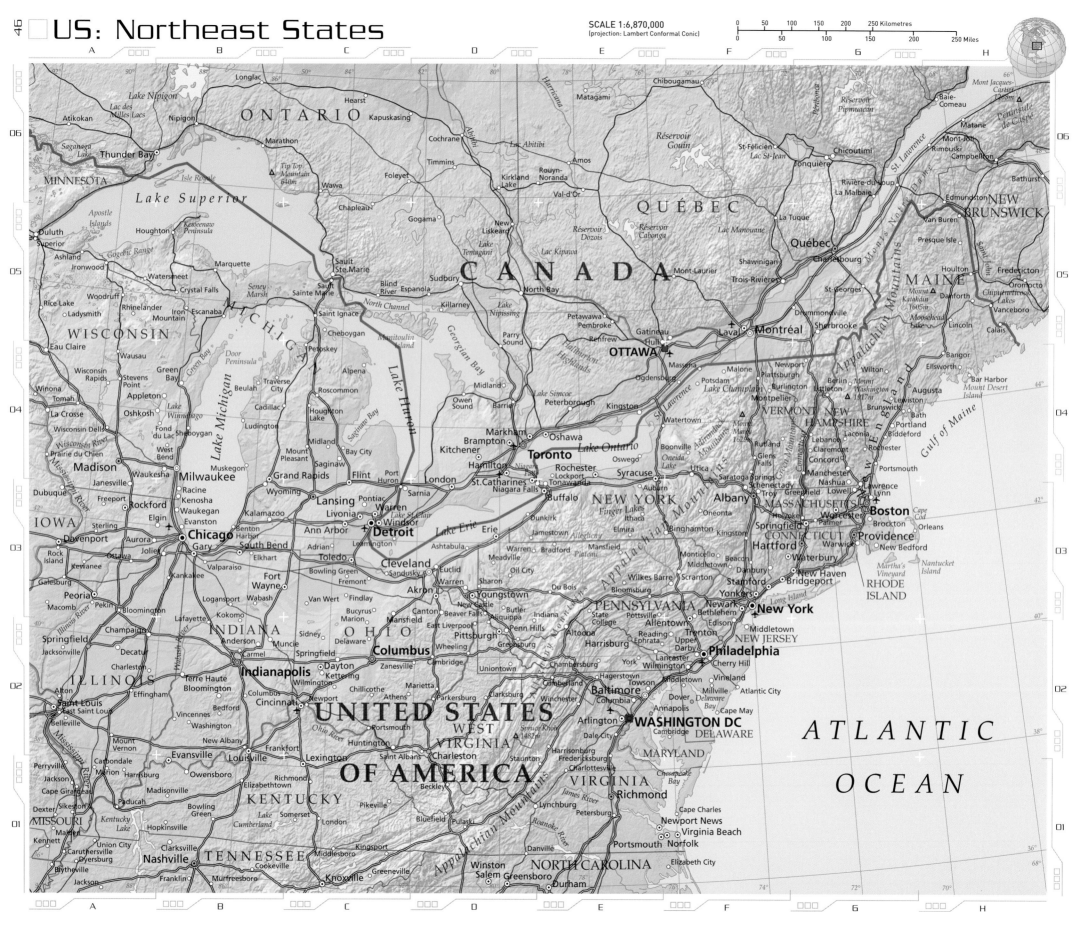

SCALE 1:6,870,000
(projection: Lambert Conformal Conic)

0   50   100   150   200   250 Kilometres
0   50   100   150   200   250 Miles

# NIAGARA FALLS

## 43°04'N, 79°04'W

The Niagara River marks the border between Canada and the United States as it flows from Lake Erie into Lake Ontario. Over ten thousand years, the river has cut a narrow gorge back through the Niagara Escarpment, producing phenomenal waterfalls. Their broad width and large volume of water make the Niagara Falls a spectacular sight. The Horseshoe Falls are 2600 ft (792 m) wide, and here the bulk of the river tips vertically over a 157 ft (48 m) ledge. The American Falls are 1060 ft (323 m) wide, carrying only 6% of the river's volume through a stepped descent of 170 ft (52 m). Flow over the falls is reduced, particularly at night, as water is diverted upstream to drive a hydroelectric power scheme.

▶ **The Niagara River** runs from right to left (south to north) in this detailed satellite image. Goat Island separates the American Falls and Bridal Veil Falls from the Horseshoe Falls on the Canadian side. Downstream, one of the Maid of the Mist sight-seeing boats can be seen manoeuvring between the Whirlpool Rapids and the spray from the American Falls.

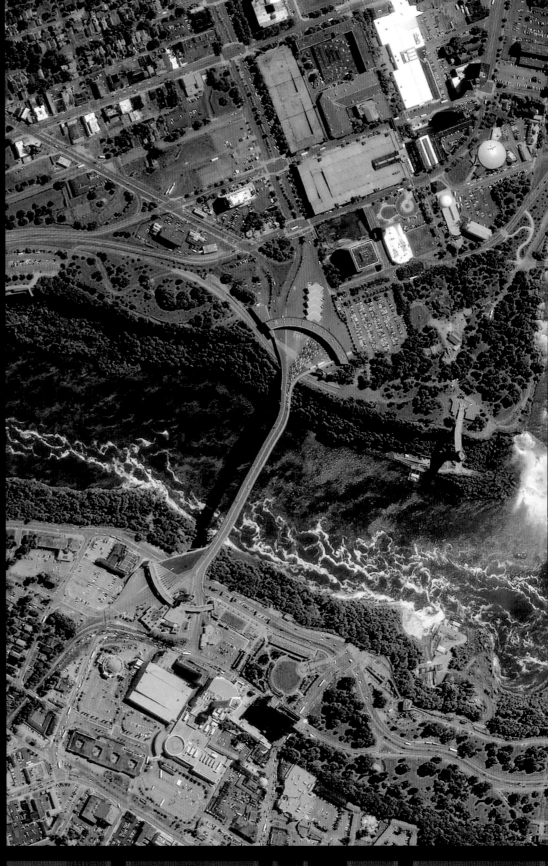

**SATELLITE:** IKONOS image courtesy of GeoEye　　**HEIGHT:** 423 MILES (681 KM)　　**DATE:** 02 AUG 2004

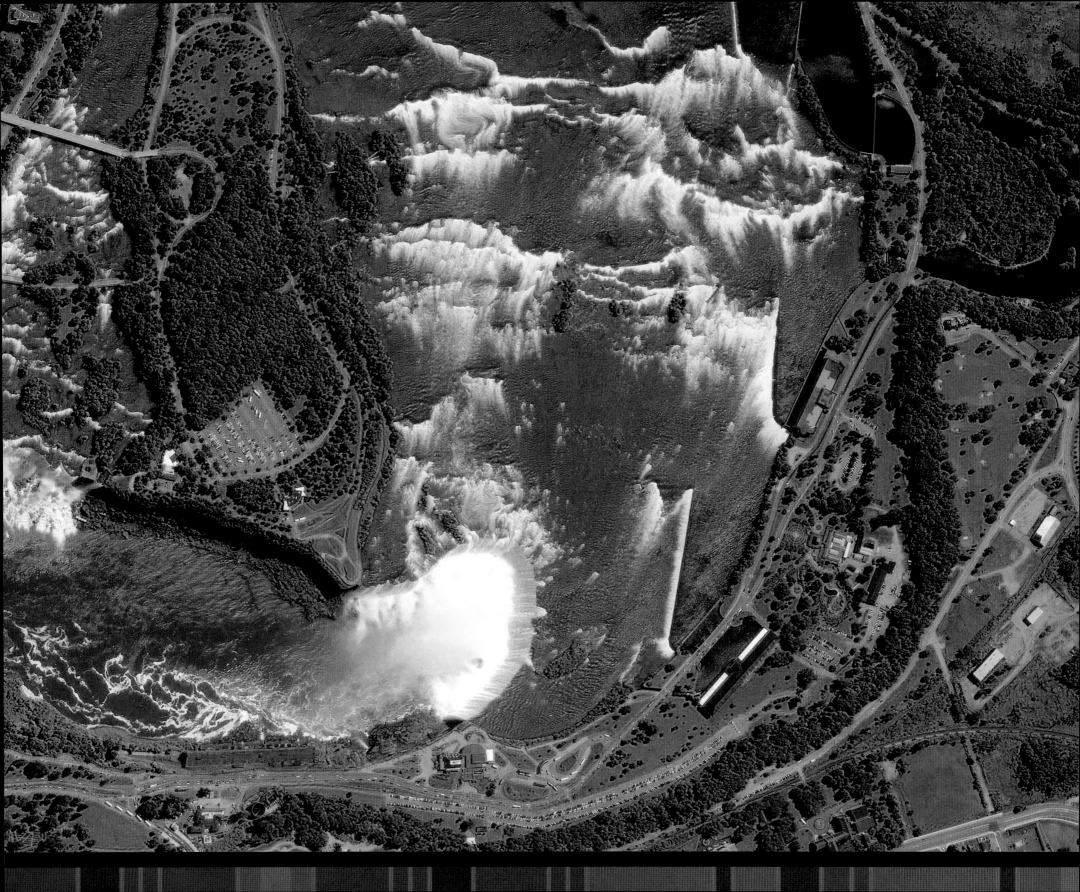

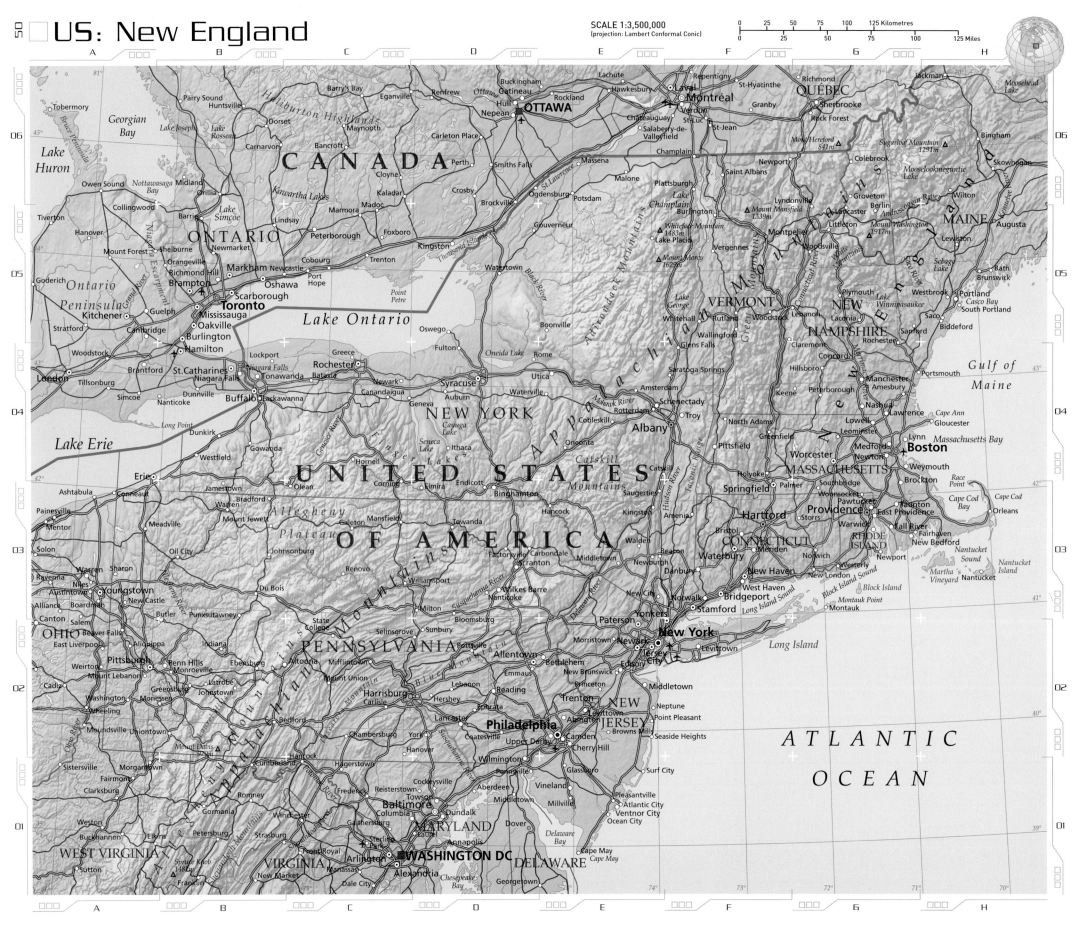

# NEW YORK

## 40°44'N, 73°57'W

With a population of 21.9 million people the New York metropolitan area is one of the largest urban areas in the world. 'The Big Apple' has spread far beyond the original Five Boroughs clustered on the east of Manhattan Island (centre). At one time the capital of the newly formed United States, New York has always been a dynamic city at the forefront of trade and commerce, epitomised by the skyscrapers that grew ever taller in response to the cities relentless appetite for growth. Now covering some 6720 sq miles (17,405 sq km) the New York metropolitan area is a magnet for business, finance, entertainment and culture, with an amazing variety of museums, galleries and theatres making this one of the most exciting city's in the world.

▶ **The city of New York** is served by no less than three international airports, the enormous complex of John F Kennedy Airport, built on the Atlantic-facing salt flats can be seen in the lower right of this image, the newly redeveloped Newark (bottom left) is clearly visible, while La Guardia (centre) perches beside the East River as it flows south from Long Island Sound.

◄ **Manhattan Island** with an area of some 23 sq miles (60 sq km) supports a population of just over 1.5 million, people giving rise to a population density of 65,200 per sq mile (25,000 per sq km), one of the highest in North America.

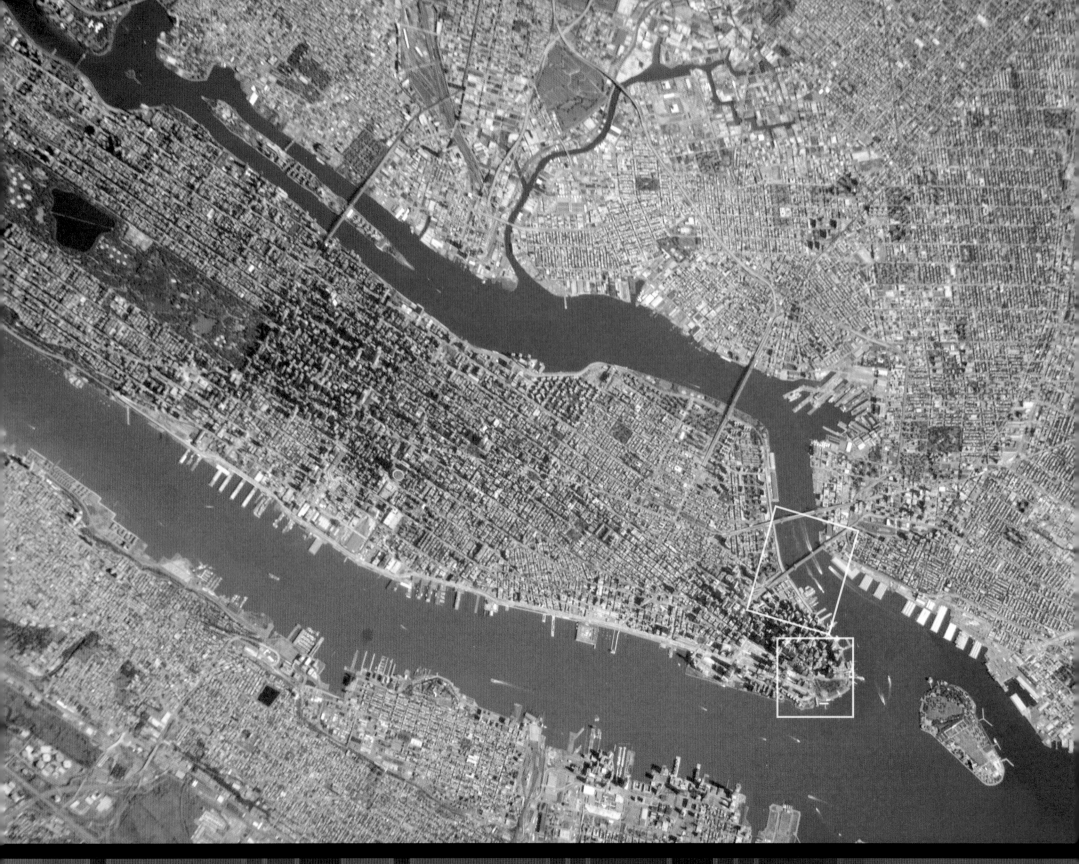

◀ **The 'green lung'** of Central Park stands out on the left, below which lie the neat long- and short-block layout of streets and avenues of Midtown and Downtown, sharply crossed by the diagonal of the ancient Native American track of Broadway. Wall Street and the commercial district lie at the southern tip of the island, where the open scars in the cityscape left at Ground Zero are clearly visible.

▶ **The Statue of Liberty** was raised on an elaborate pedestal which was once a fort dominating the entrance to the Hudson River. Liberty Island now forms part of a National Park incorporating the neighbouring former immigration depot of Ellis Island.

▼ **The towering canyons** of New York's financial district around Wall Street lie to the east of Battery Park, where the circular Castle Clinton is the city's oldest fortification.

◀ **The oldest,** and most famous of the bridges linking Manhattan to Long Island across the East River, Brooklyn Bridge, was begun in 1870 and completed in 1883.

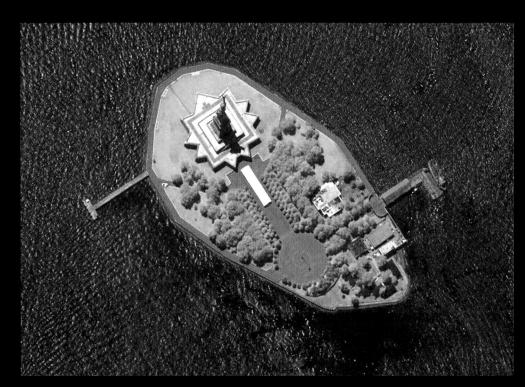

QUICKBIRD image courtesy of DigitalGlobe    **HEIGHT:** 423 MILES (681 KM)    **DATE:** 02 AUG 2002

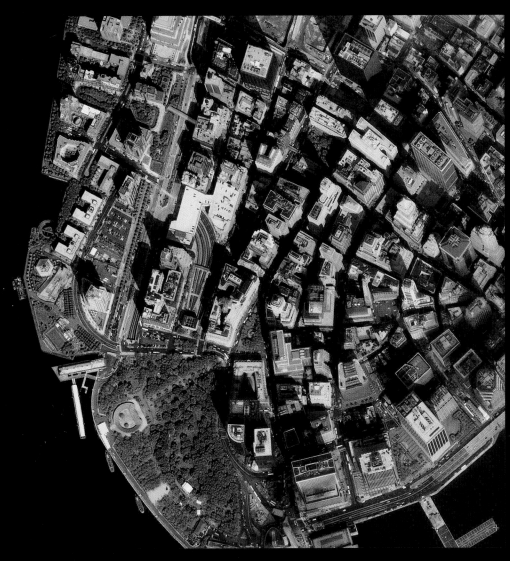

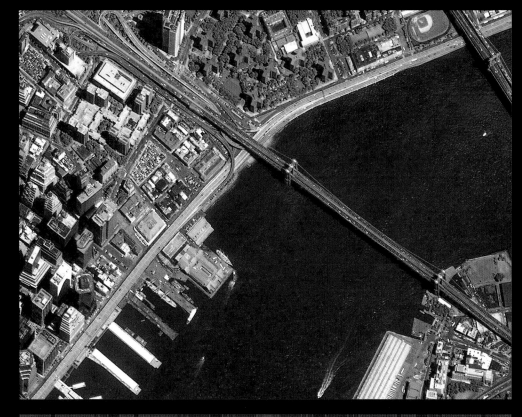

**SATELLITE:** IKONOS image courtesy of GeoEye    **HEIGHT:** 423 MILES (681 KM)    **DATE:** 04 SEP 2002

**SATELLITE:** IKONOS image courtesy of GeoEye    **HEIGHT:** 423 MILES (681 KM)    **DATE:** 30 JUN 2000

# WASHINGTON DC

## 38°54'N, 77°02'W

The capital city of the United States was purpose built as a city of government after America's first president, George Washington, selected the site in 1790. The city is home to the three branches of the United States federal government, executive, legislative and judicial. The city was designed by Pierre Charles l'Enfant and contains many iconic buildings including the White House and Capitol Building atop Capitol Hill. Just across the Potomac River to the west lies Arlington National Cemetery. Established during the American Civil War, it is the resting place of veterans from every conflict ever fought by the United States. As befits a national capital, Washington is the site of numerous national landmarks, museums and monuments making it a popular tourist destination.

SATELLITE: TERRA (EOS AM-1)   INSTRUMENT: MODIS   HEIGHT: 438 MILES (705 KM)   DATE: 2005

►► **The focal point** of Washington is a stately, almost ceremonial, architectural complex flanked by Constitution Avenue to the north, and Independence Avenue to the south. The Washington Monument is situated at the western extremity of this image. To the north is The Ellipse, and north of that The White House. Toward the east is the National Mall, lined with several major museums including the Smithsonian Institution, which rises to Capitol Hill at the eastern extremity.

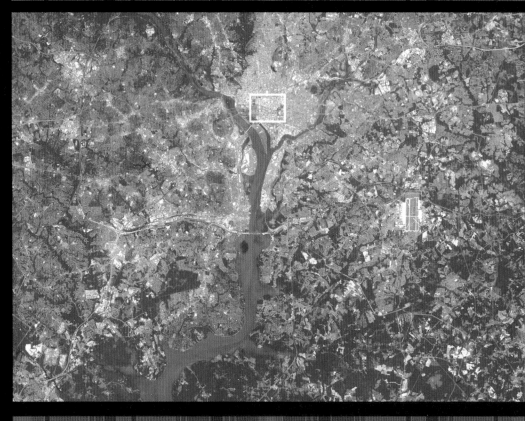

SATELLITE: LANDSAT 7   INSTRUMENT: ETM+   HEIGHT: 438 MILES (705 KM)   DATE: 05 OCT 2001

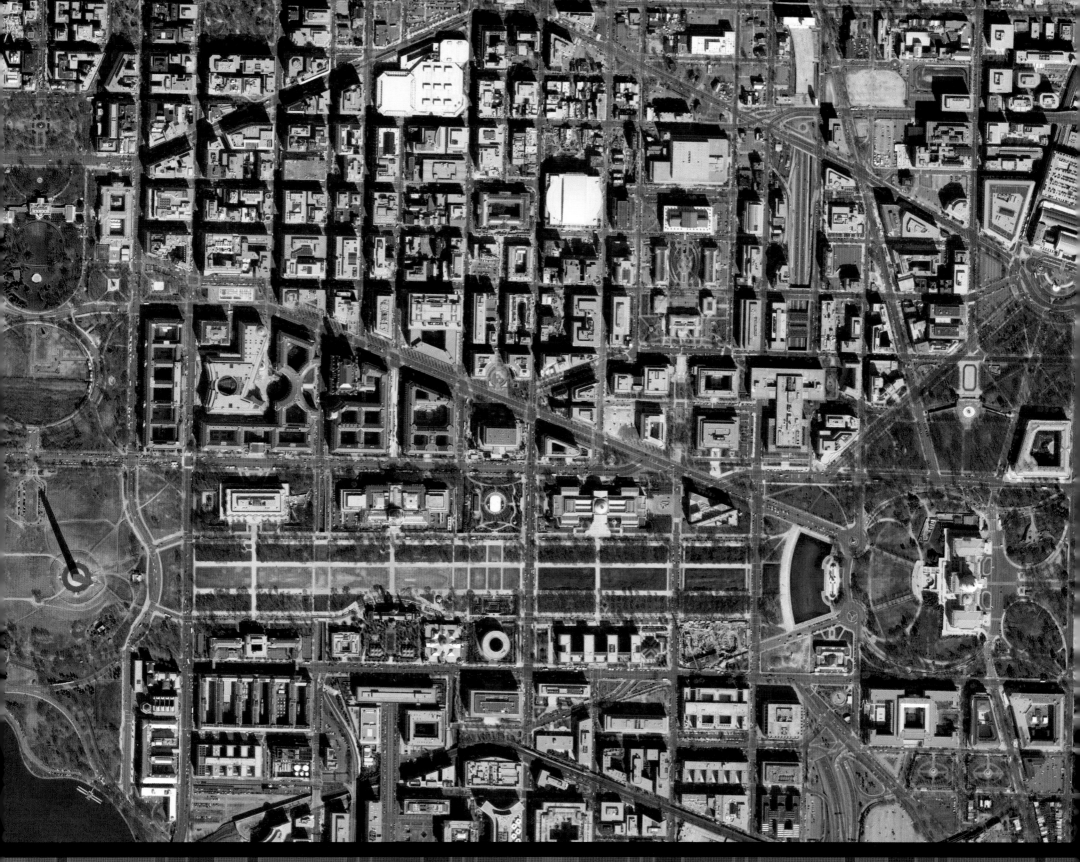

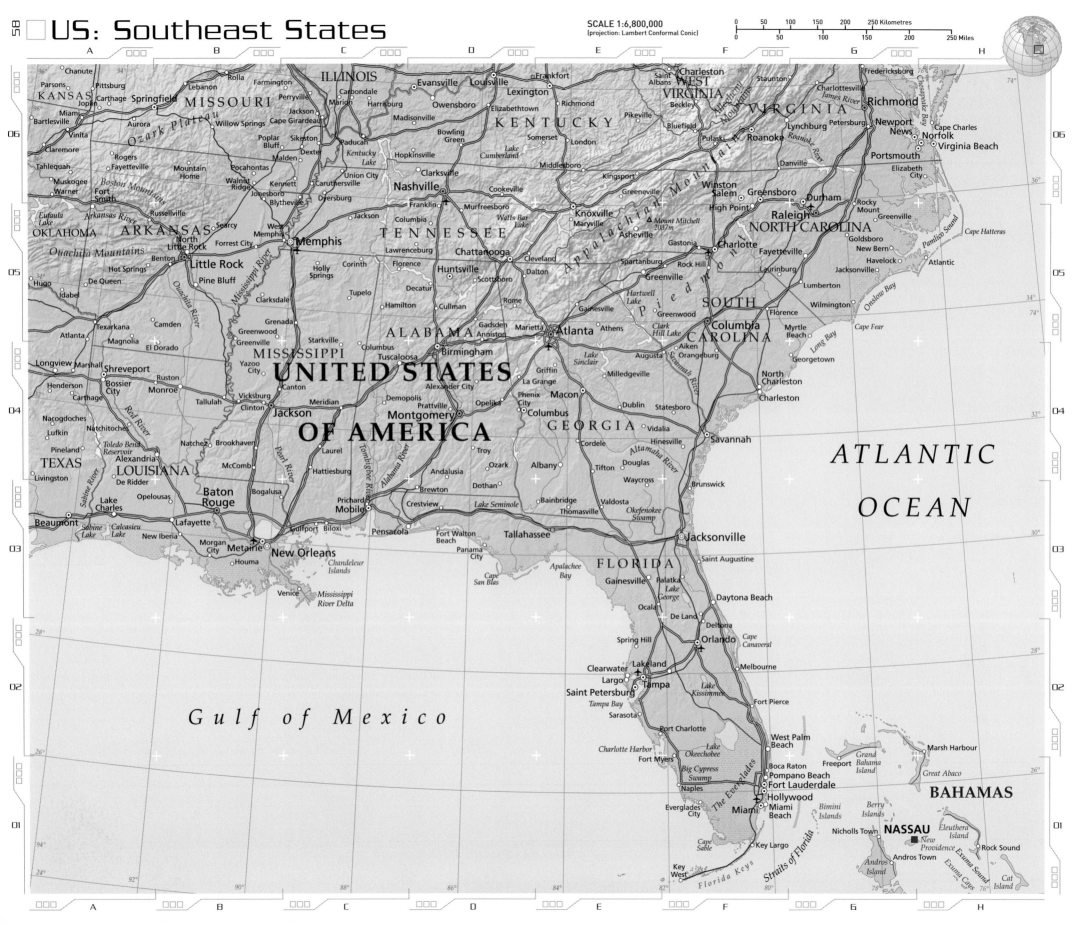

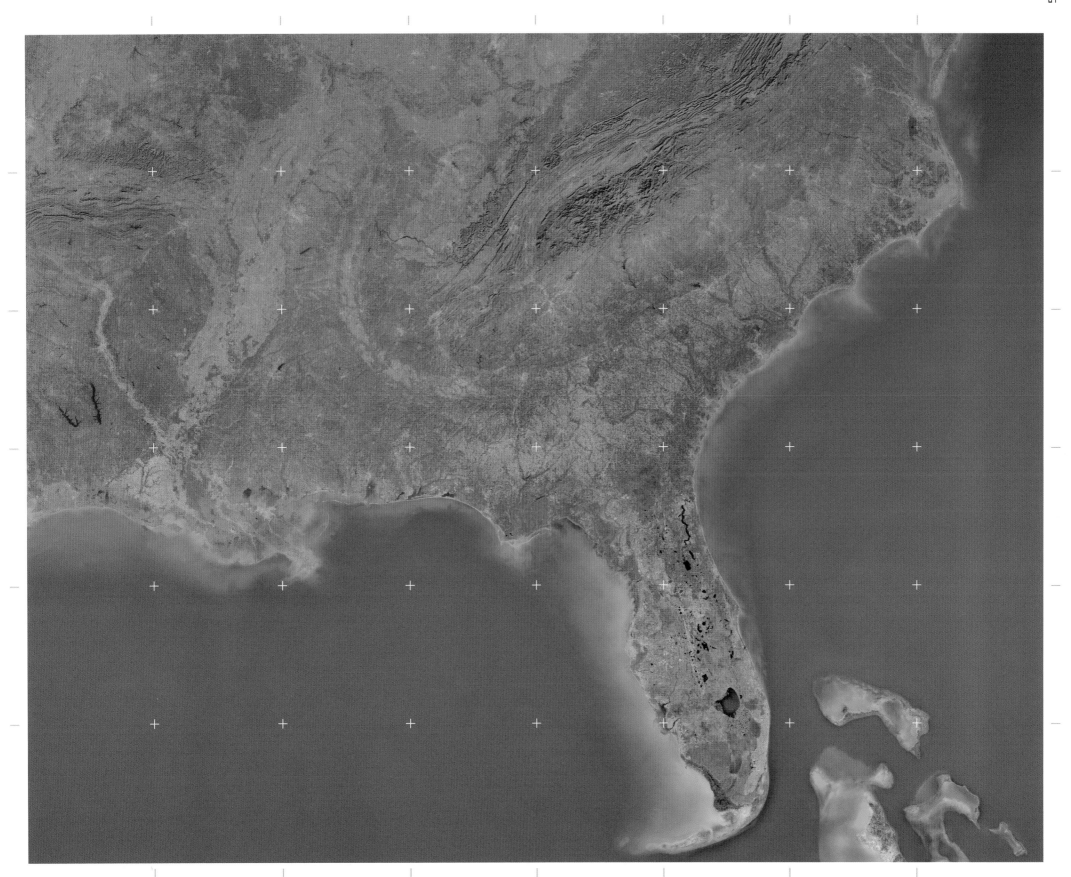

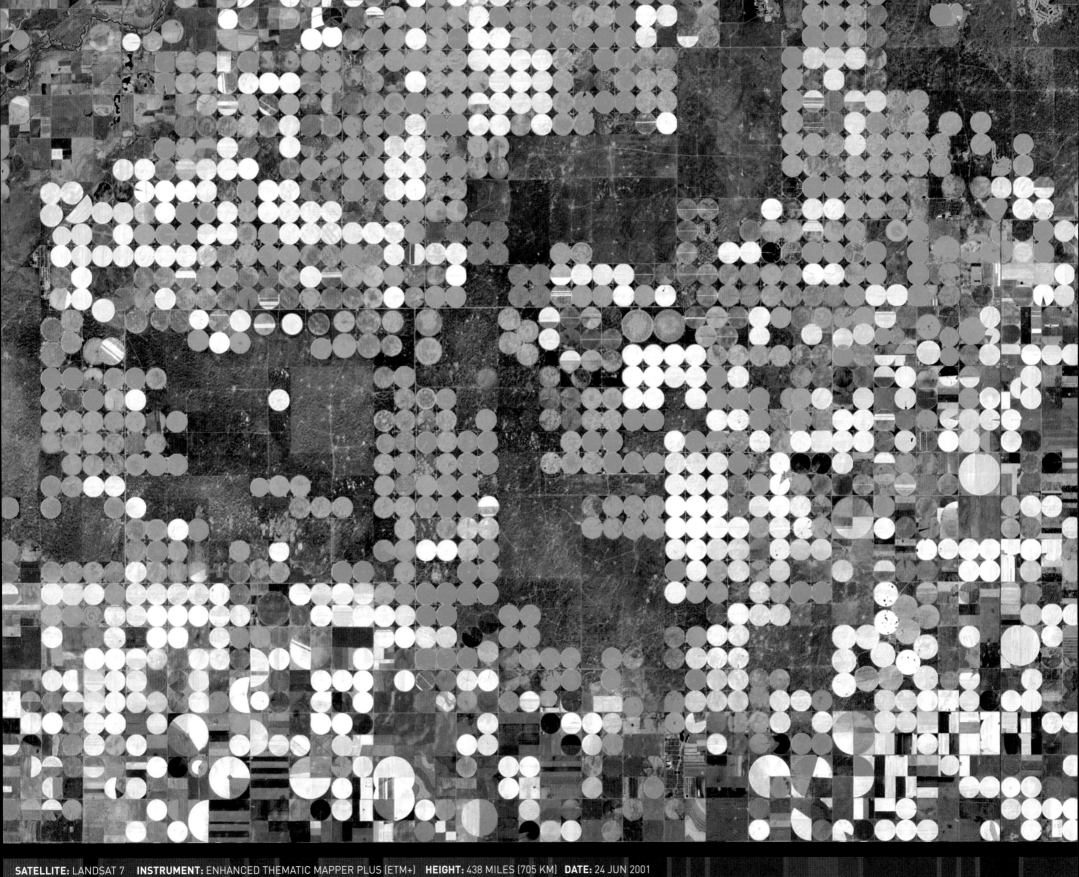

SATELLITE: LANDSAT 7   INSTRUMENT: ENHANCED THEMATIC MAPPER PLUS (ETM+)   HEIGHT: 438 MILES (705 KM)   DATE: 24 JUN 2001

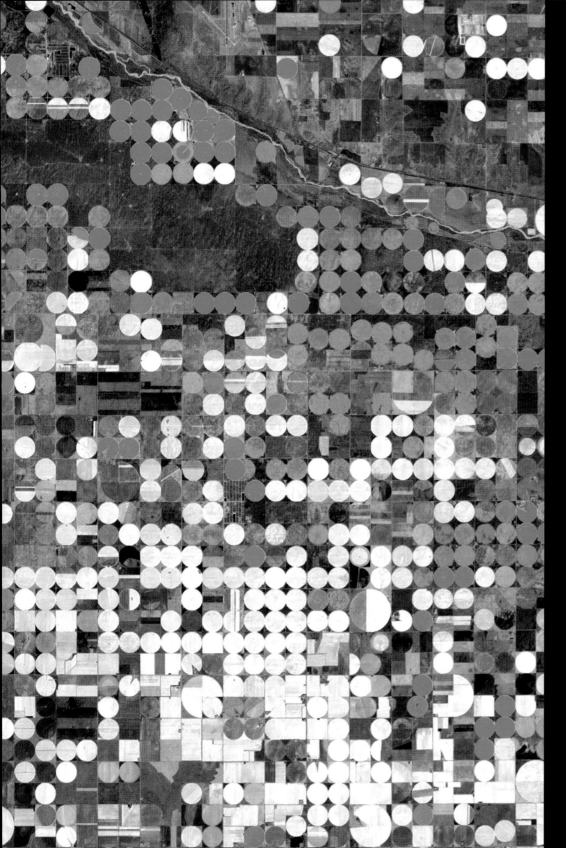

# THE GREAT PLAINS

## 37°24'N, 100°54'W

The Great Plains of North America lie west of the Mississippi Valley and run up to the foothills of the Rocky Mountains, stretching from Mexico in the south across the United States and north into Canada. A semi-arid grassland in its natural state, the plains have quite low rainfall, so irrigation is necessary to support agriculture in some areas. Near Garden City in southwestern Kansas, centre-pivot irrigation is used, producing circular field patterns. Each field is centred on a well which draws water up from a large aquifer of "fossil" water 100-330 ft (30-100 m) underground.

▼ **Infrared wavelengths** are used to monitor crops through the growing season, with vigorous vegetation appearing red in this image. Corn, wheat and sorghum are among the crops grown in the area. The smaller fields are 2625 ft (800 m) in diameter; the larger ones are 5250 ft (1600 m) across.

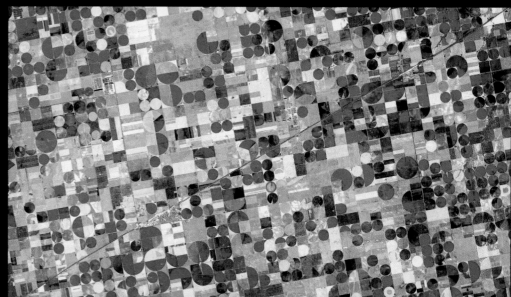

# NEW ORLEANS

## 29°57'N, 90°04'W

Hurricane Katrina struck the US gulf coast early on the morning of August 29th 2005, killing more than 1800 people and causing more than eighty billion dollars-worth of damage. New Orleans, the major city of America's Deep South, was spared the worst of the hurricane's winds, but was devastated as a 28 ft (9 m) storm surge overcame the city's flood defences. Water from nearby Lake Pontchartrain poured into the low-lying city centre, and by the end of the day 80% of its area was inundated. Although most of the population had heeded an evacuation order, some 25,000 people remained in the city and became trapped in their homes or emergency shelter sites. A year later many of the evacuees had not returned.

▶ **Katrina was downgraded** from a Category 5 hurricane, with wind speeds of 175 mph (282 kph), to Category 3 (111–130 mph (179–209 kph)) shortly before it made landfall, but it still had the storm surge of a Category 5 hurricane. 2005 was a bad year for hurricanes, with the Atlantic Ocean producing 27 named tropical storms. Meteorologists give these storms names beginning with the letters of the alphabet from A to W and they had to resort to using letters of the Greek alphabet.

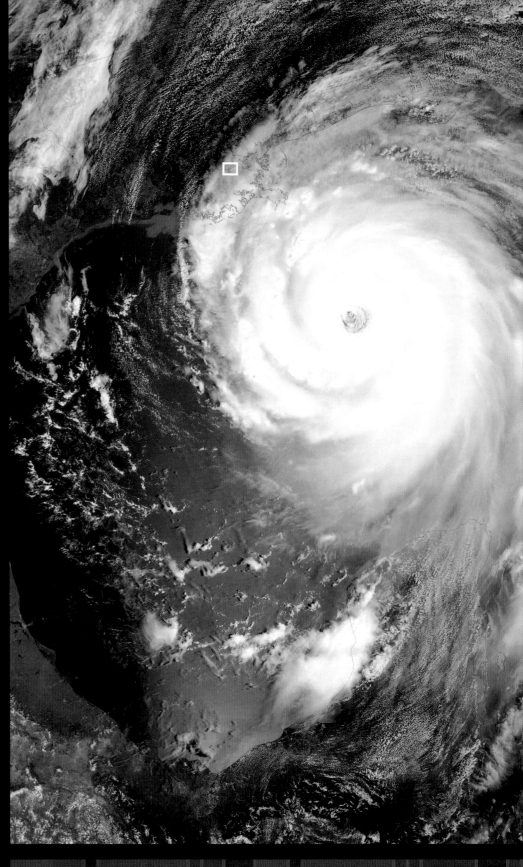

**SATELLITE:** TERRA (EOS AM-1), MODIS   **HEIGHT:** 438 MILES (705 KM)   **DATE:** 28 AUG 2005

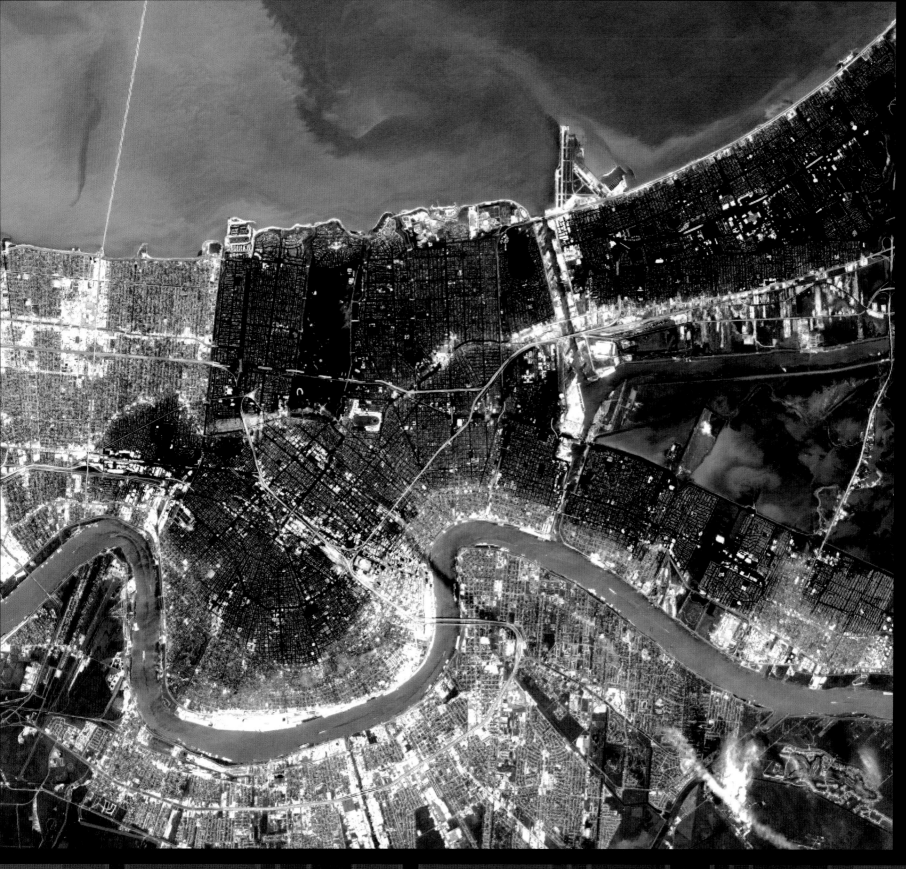

◄ **The floodwaters** appear as darker areas in this image of New Orleans taken one week after Hurricane Katrina struck. In the centre and east of the city, only elevated roads and rooftops are visible above the water. The old town nestles below sea level between a meander of the Mississippi River and Lake Pontchartrain to the north. The lake is still muddy with sediment stirred up by the hurricane.

**SATELLITE:** EARTH OBSERVING-1 (EO-1)   **INSTRUMENT:** ADVANCED LAND IMAGER (ALI)   **HEIGHT:** 438 MILES (705 KM)   **DATE:** 06 SEP 2005

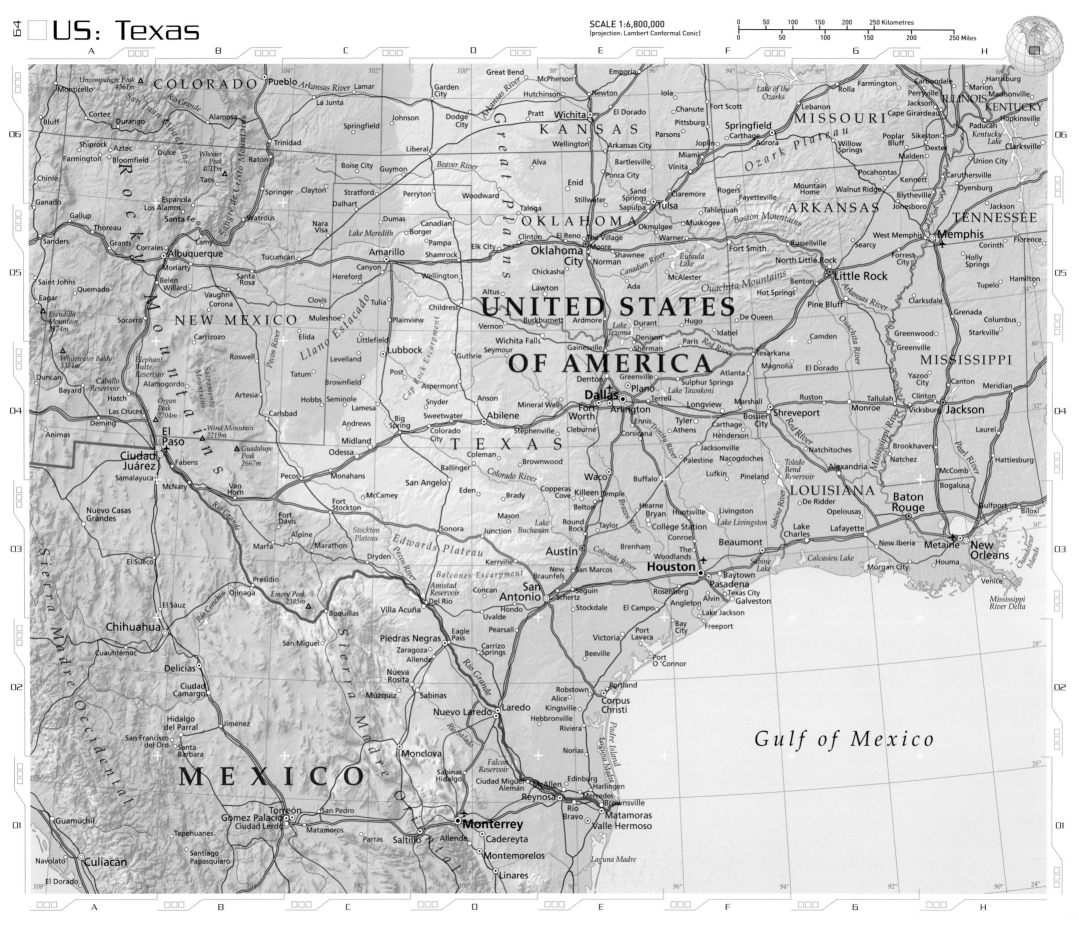

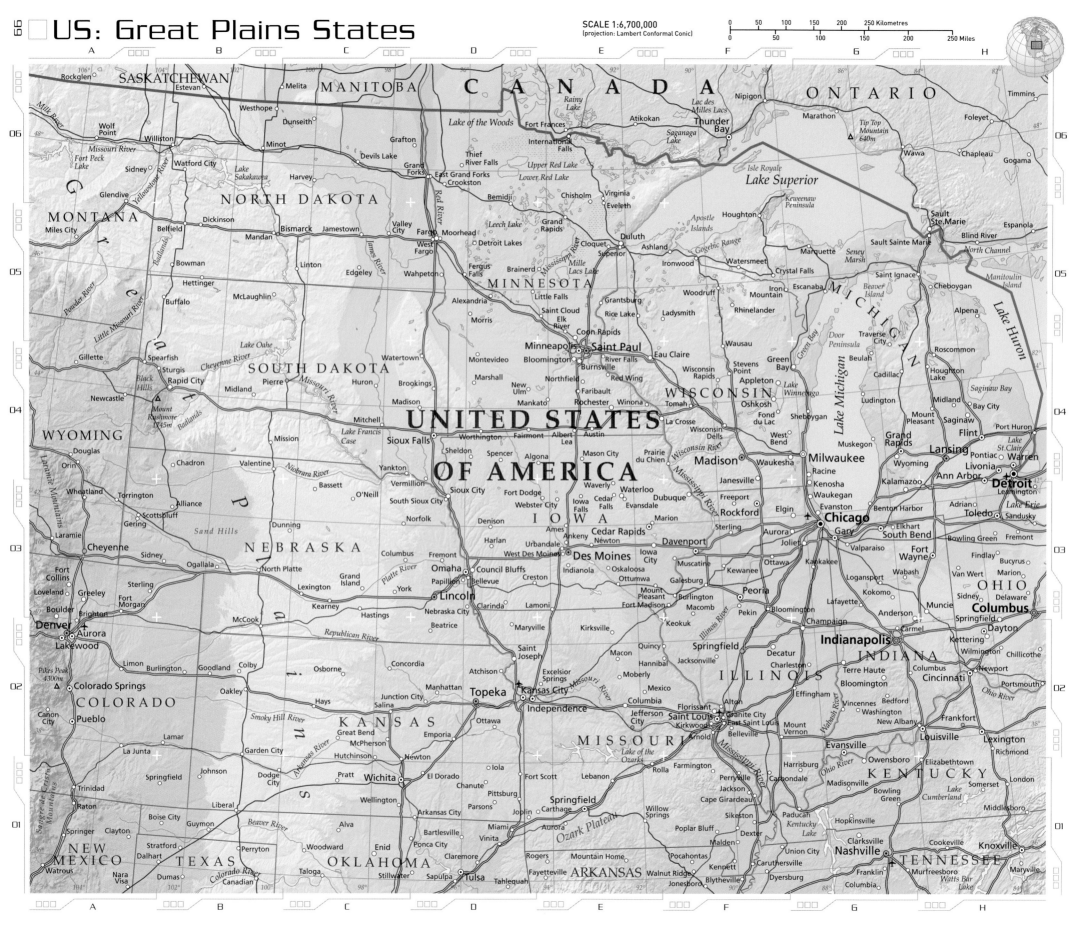

# CHICAGO

## 41°51'N, 87°39'W

The premier city of America's Midwest, Chicago developed originally as a port, sited as it is on the southern extremity of Lake Michigan in Illinois, providing a transshipment point between the St. Lawrence/Great Lakes and the Mississippi River system. At the beginning of the 19th century it was the site of the strategically important Fort Dearborn and the city developed in the 1830s. Its growth really accelerated in the following decades with the development of the continental rail network and the completion of the Illinois and Michigan Canal, which linked the city to the Mississippi River, in 1848. Chicago became an important hub for processing the agricultural produce of the Midwest, especially grain, beef and pork. The city's massive stockyards were legendary, demonstrating the first example of food processing on an industrial scale.

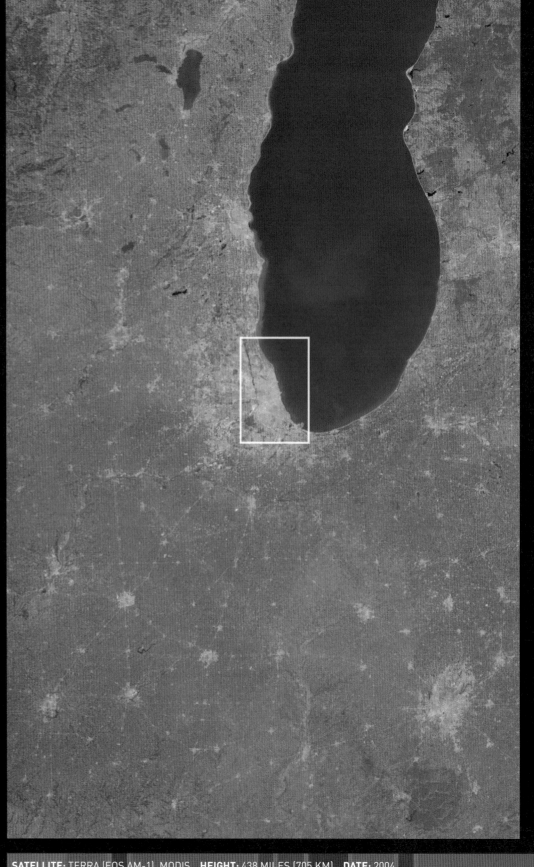

SATELLITE: TERRA (EOS AM-1), MODIS   HEIGHT: 438 MILES (705 KM)   DATE: 2004

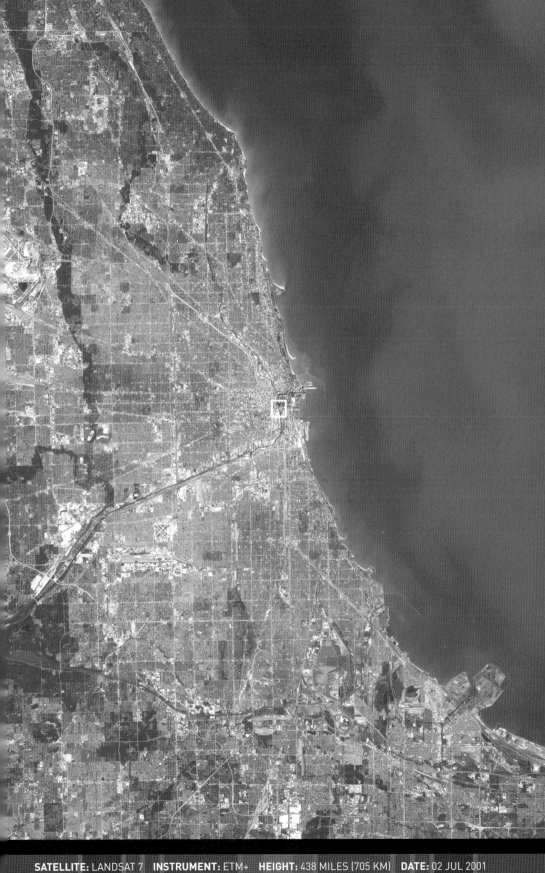

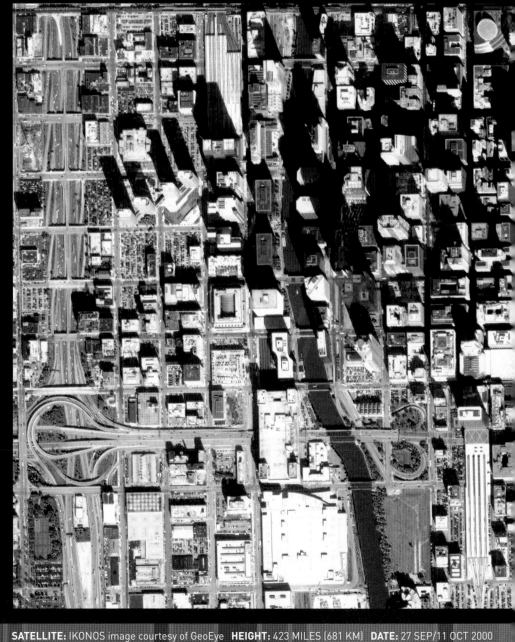

◄ **Chicago experienced** a rapid period of regeneration and growth following the Great Chicago Fire of 1871. This process included the construction of the world's first skyscraper in 1893.

▼ **The flat landscape** and extremely rapid urban development of Chicago meant that a very regular grid-pattern evolved at the city's heart, where single industrial buildings often occupy entire blocks. The deep shadows in this image illustrate the great height of some of the downtown towers.

**SATELLITE:** LANDSAT 7   **INSTRUMENT:** ETM+   **HEIGHT:** 438 MILES (705 KM)   **DATE:** 02 JUL 2001

**SATELLITE:** IKONOS image courtesy of GeoEye   **HEIGHT:** 423 MILES (681 KM)   **DATE:** 27 SEP/11 OCT 2000

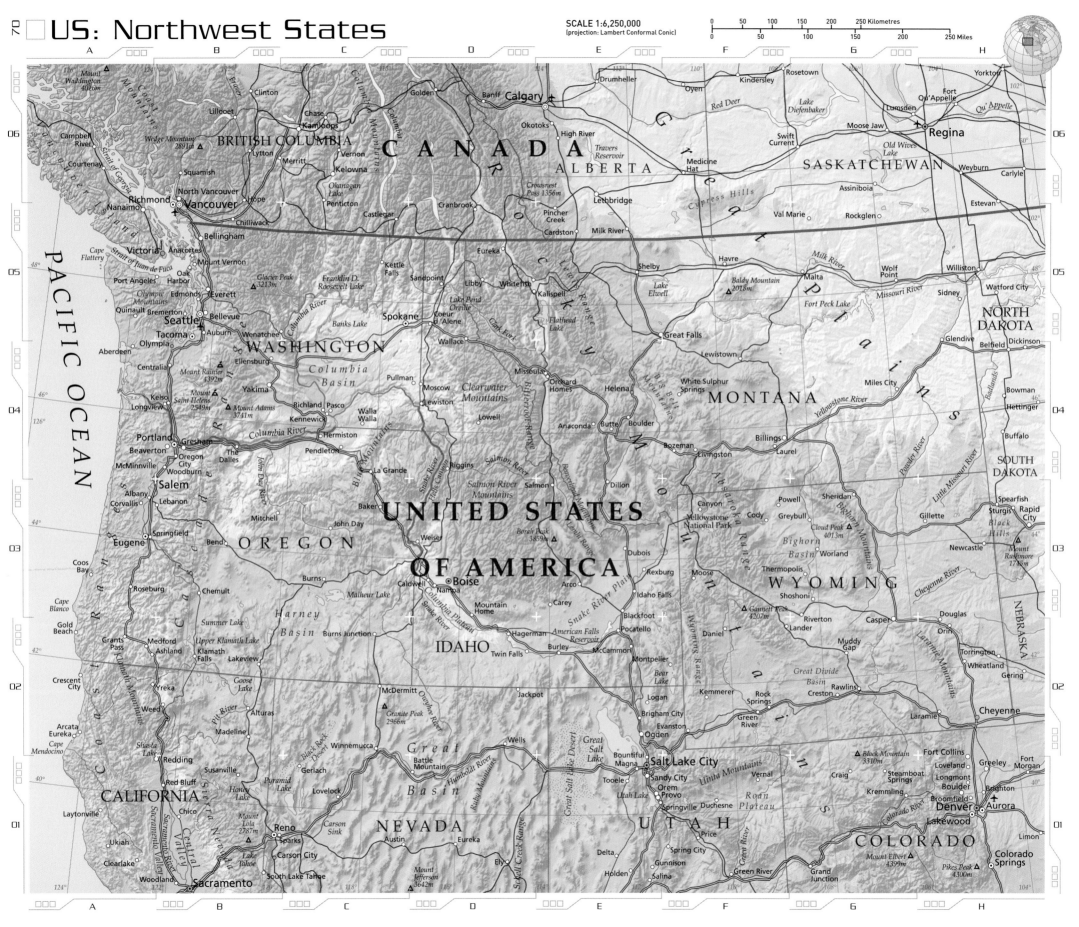

SCALE 1:6,250,000
(projection: Lambert Conformal Conic)

250 Kilometres

250 Miles

PACIFIC OCEAN

CANADA

BRITISH COLUMBIA

ALBERTA

SASKATCHEWAN

WASHINGTON

NORTH DAKOTA

MONTANA

OREGON

UNITED STATES

OF AMERICA

IDAHO

WYOMING

SOUTH DAKOTA

NEBRASKA

CALIFORNIA

NEVADA

UTAH

COLORADO

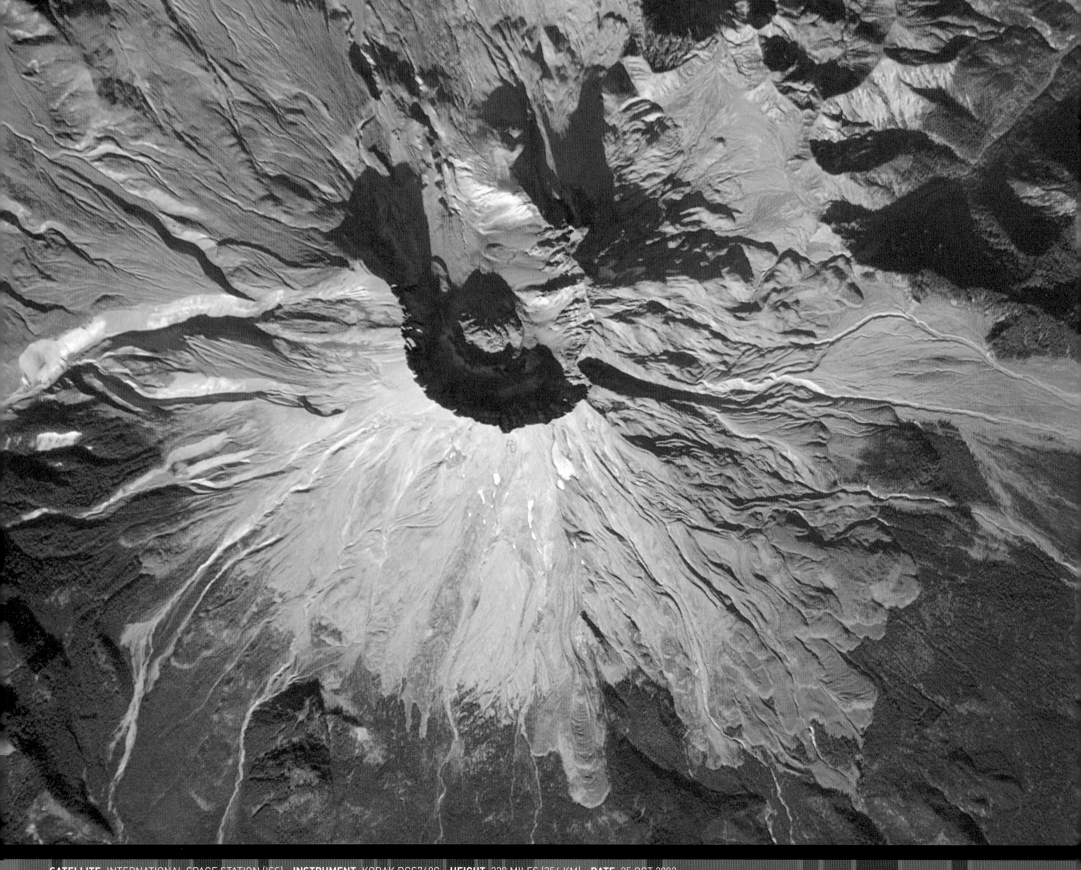

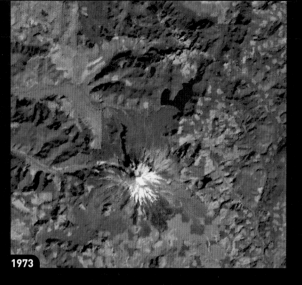
1973

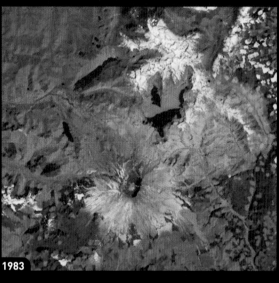
1983

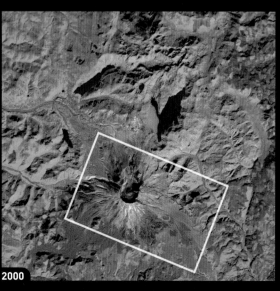
2000

# MOUNT ST HELENS
## 46°24'N, 121°49'W

Mount Saint Helens is one of a string of volcanoes in the Cascade Range of northwestern USA. A catastrophic eruption blew apart the north side of the mountain in 1980, when a landslip breached the volcano's magma chamber. A lateral blast devastated 256 sq miles (700 sq km) of the surrounding forest almost instantly and killed 57 people. The landscape was remodelled as the largest debris avalanche in recorded history swept down nearby river channels, choking some with mud, ash and pumice and creating new lakes. On the south side of the mountain, the forest remained untouched by the blast, the grey lava flows dating from previous, less-violent eruptions. A new lava dome grew at the centre of the crater through the early 1980s and was the source of ash and steam eruptions in 1990 and 2004–05.

◀ **The landscape around** Mount Saint Helens has taken a long time to recover from the 1980 eruption. This sequence of Landsat images shows the snow-topped mountain and surrounding forest seven years before the event, the large area of devastation three years after the event and vegetation re-established across much of the area by 2000. A grey 'moonscape' of pumice remains at the foot of the mountain.

**SATELLITE:** LANDSAT 1/4/7   **INSTRUMENT:** MSS/TM /ETM+
**HEIGHT:** 570/438 MILES (920/705 KM)

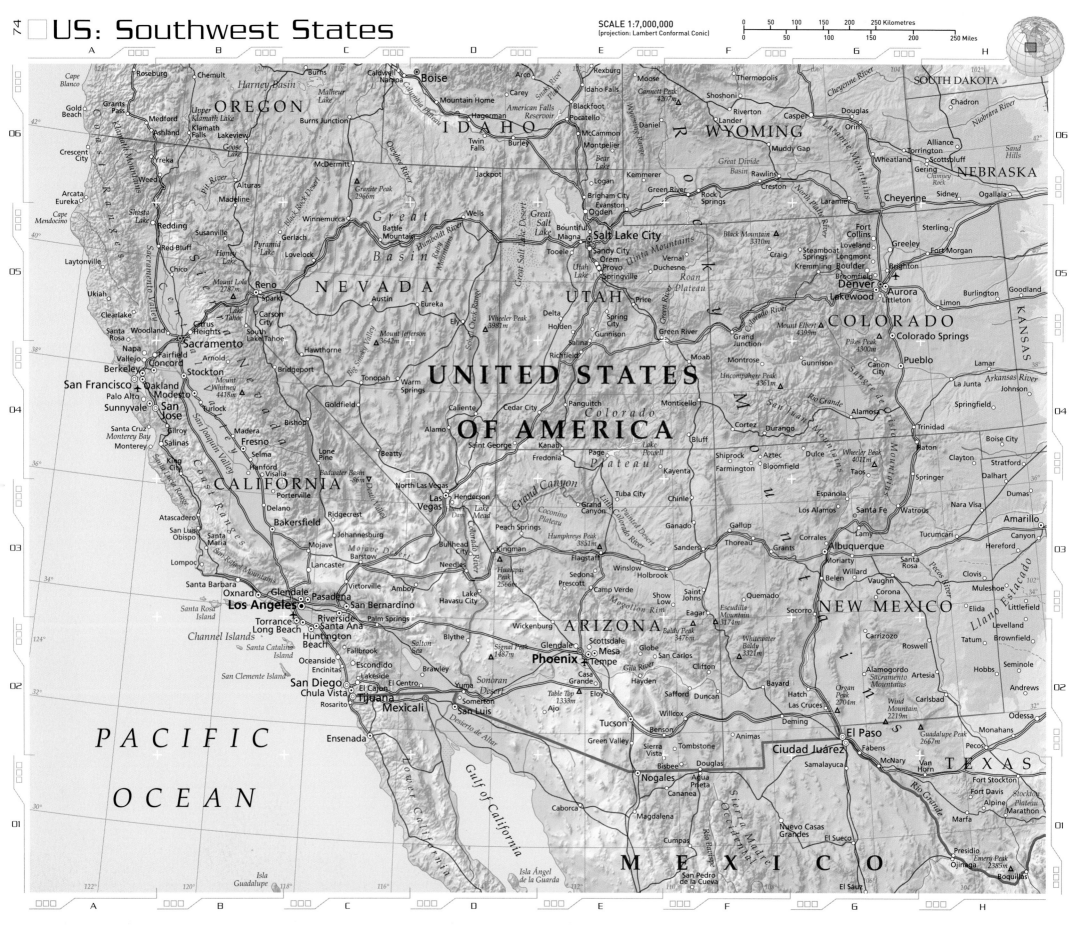

SCALE 1:7,000,000
(projection: Lambert Conformal Conic)

0 50 100 150 200 250 Kilometres
0 50 100 150 200 250 Miles

PACIFIC

OCEAN

OREGON

IDAHO

WYOMING

SOUTH DAKOTA

NEBRASKA

NEVADA

UTAH

COLORADO

KANSAS

CALIFORNIA

UNITED STATES
OF AMERICA

ARIZONA

NEW MEXICO

TEXAS

MEXICO

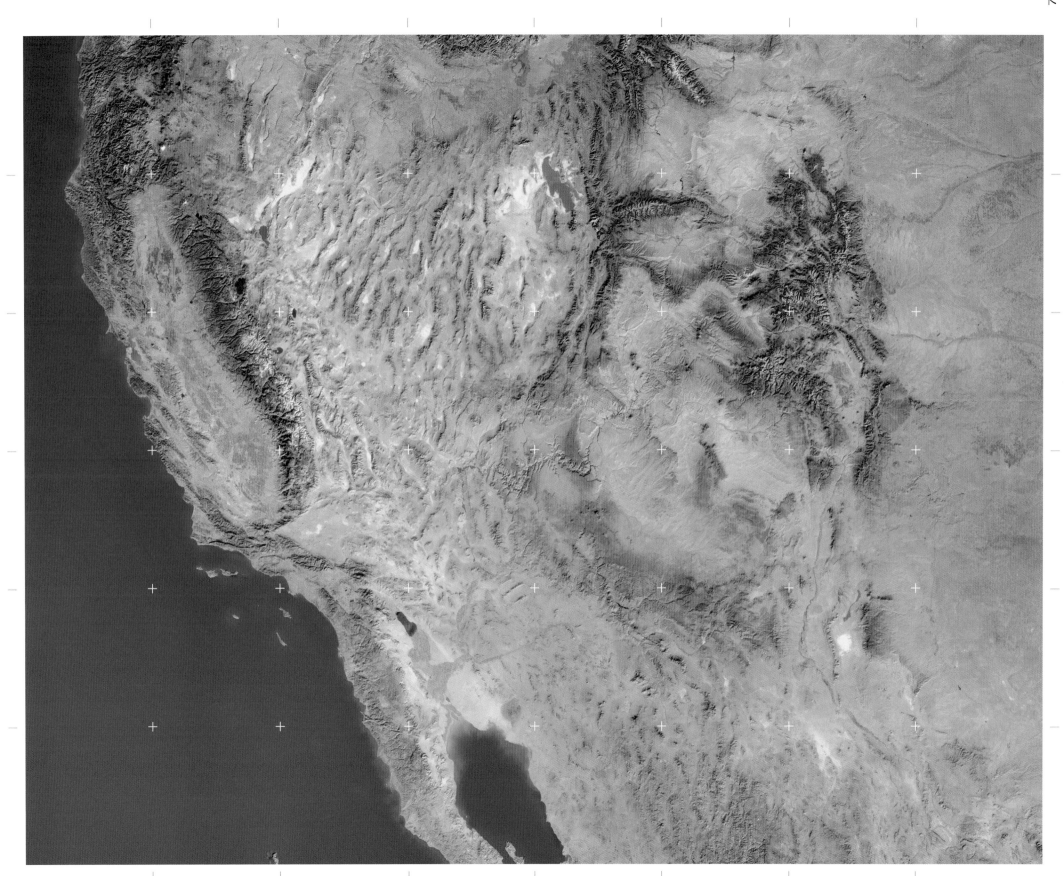

# SAN FRANCISCO

## 37°46'N, 122°25'W

America claimed California from Mexico in the 19th century, and San Francisco grew up as a port of entry to the new state, particularly after the California Gold Rush of 1848. Situated close to the San Andreas Fault, San Francisco was almost completely destroyed in 1806 by a massive earthquake but undaunted, the city was rebuilt on a grand scale. Perhaps the crowning achievement of this process was the completion of the iconic Golden Gate Bridge in 1937. Today it is the second most densely populated US city after New York (with 7.25 million people living in the Bay Area), and the main financial centre of the west coast. Across the bay, the port of Oakland is the busiest on America's western seaboard.

▶ **San Francisco Bay** is a shallow estuary lying between the Sacramento and San Joaquin rivers and the Pacific Ocean. The bay was originally ringed by extensive wetlands, many of which have been drained for urban development. Multi-coloured salt evaporation ponds occupy the southern end of the bay and some of these are being restored to tidal wetlands.

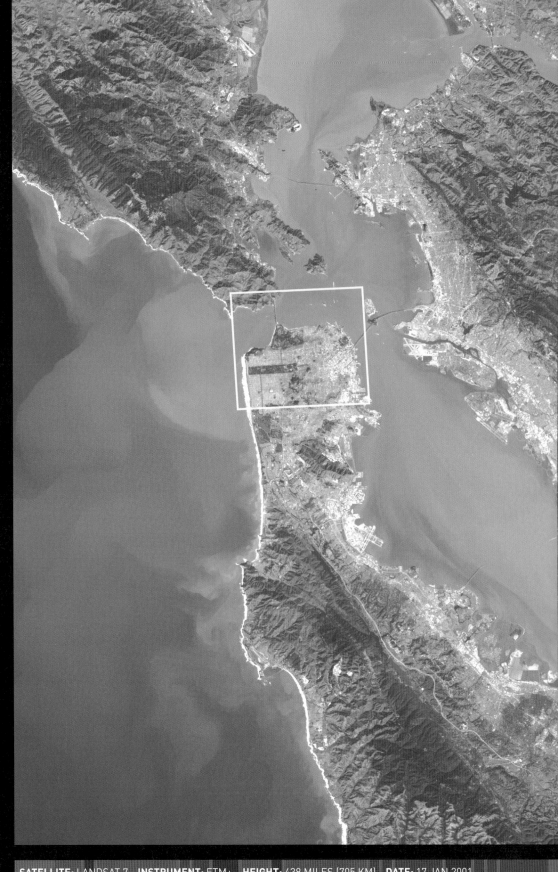

**SATELLITE:** LANDSAT 7  **INSTRUMENT:** ETM+  **HEIGHT:** 438 MILES (705 KM)  **DATE:** 17 JAN 2001

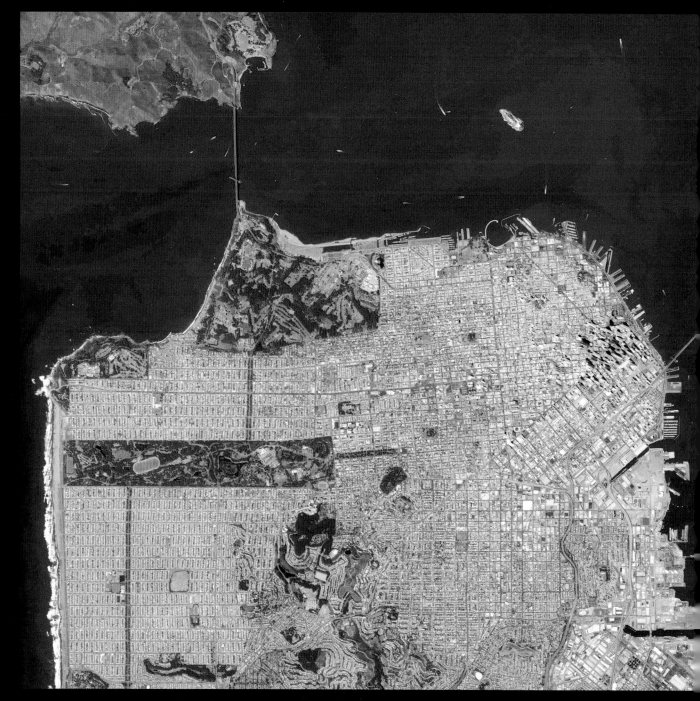

▼ **The city of San Francisco** occupies the tip of a peninsula, with Pacific Ocean rollers battering its western shore, the Golden Gate Strait to the north, and the sheltered waters of San Francisco Bay providing a natural harbour to the east. The island of Alcatraz lies between the Golden Gate Bridge and the Bay Bridge.

**SATELLITE:** IKONOS image courtesy of GeoEye   **HEIGHT:** 423 MILES (681 KM)   **DATE:** 28 AUG 2004

▼ **The Golden Gate Bridge** links San Francisco to Marin County to the north.  It was the longest suspension bridge in the world when it opened in 1937, with 4200 ft (1280 m.) between its 746 ft- (227 m-) tall towers. The striking "International Orange" colour is to help with the bridge's visibility in fog.

► **This very high-resolution** satellite image shows office buildings in San Francisco's Financial District, including Main Street and Market Street. Prominent buildings include the Transamerica Pyramid at the end of Columbus Avenue (near the top of the image), the San Francisco Ferry Building on the Embarcadero shoreline (lower right), and the Transbay Terminal (lower left).

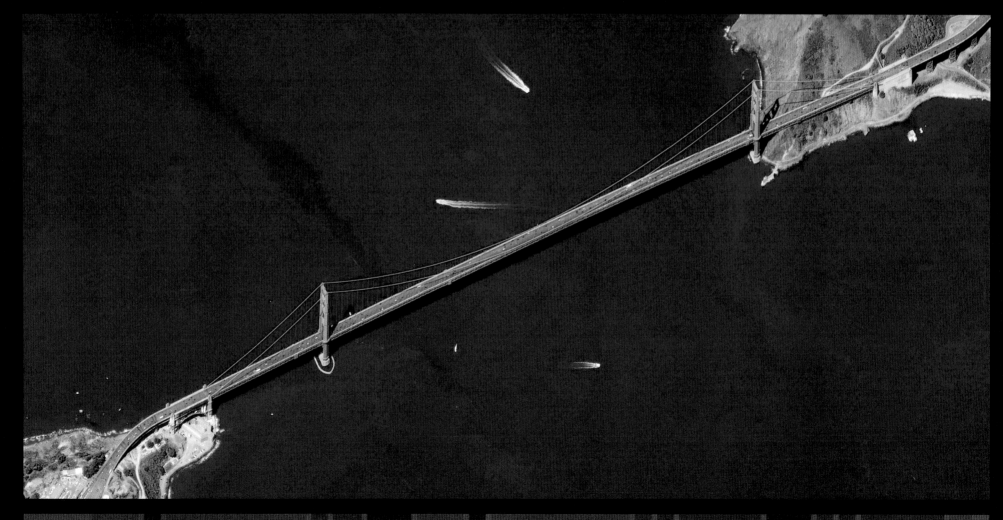

**SATELLITE:** IKONOS image courtesy of GeoEye    **HEIGHT:** 423 MILES (681 KM)    **DATE:** 28 AUG 2004

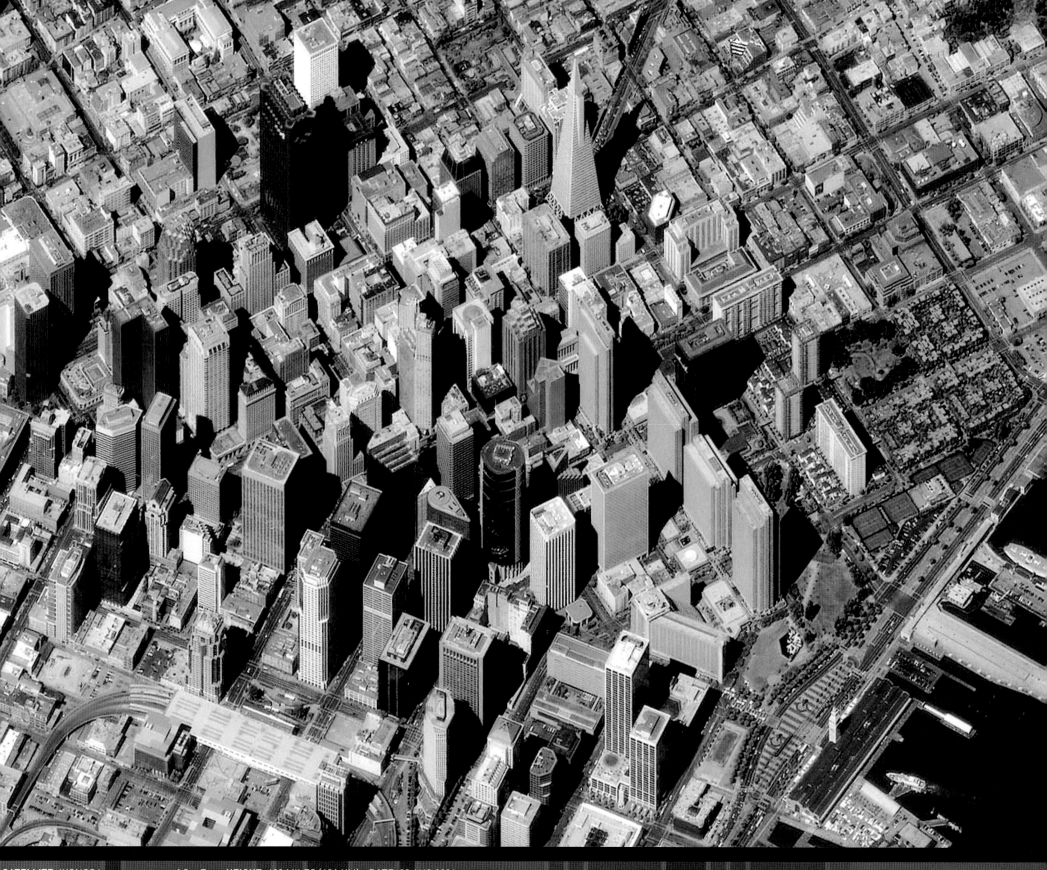

# LOS ANGELES
## 34°03'N, 118°14'W

With about 18 million people living in the city and its sprawling suburbs, Los Angeles is the second largest city in the United States. Los Angeles grew with the arrival of the Southern Pacific Railroad in 1879 and the exploitation of oil deposits in the early 20th century. Since the 1920s it has become a major centre for the aerospace industry and film production and the busiest seaport in the United States. The extensive port area is largely built on land reclaimed from the waters of San Pedro Bay. Los Angeles has one of the highest rates of vehicle usage in the world with 1.8 cars per licensed driver. Millions of commuters make a daily collective journey of about 100 million miles (160 million km) along the extensive freeway system.

▶ **The Los Angeles basin** sits between the Pacific Ocean and three mountain ranges: the Santa Monica Mountains to the northwest, the San Bernadino Mountains to the north and the Santa Ana Mountains to the east. These mountains trap chemical pollutants emitted from vehicles and exacerbate the often severe smogs that develop over the city.

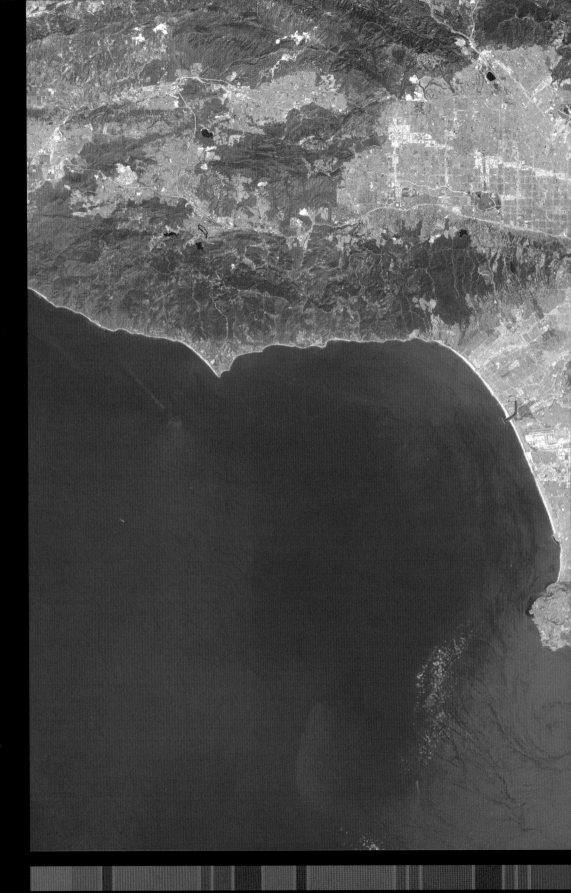

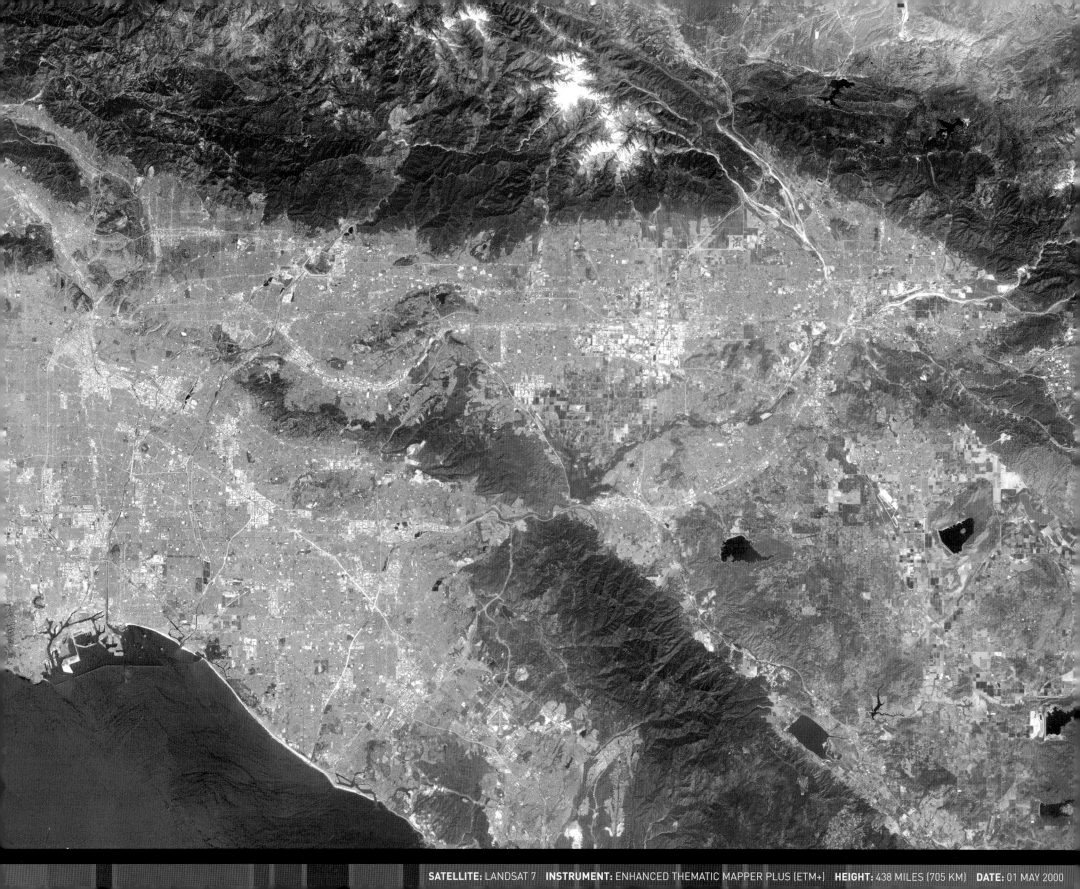

SATELLITE: LANDSAT 7    INSTRUMENT: ENHANCED THEMATIC MAPPER PLUS (ETM+)    HEIGHT: 438 MILES (705 KM)    DATE: 01 MAY 2000

# GRAND CANYON

## 36°51'N, 111°36'W

The Grand Canyon cuts more than 1 mile (1.6 km) down through the Colorado Plateau in northern Arizona. It has been created over the last five million years as the meandering Colorado River and its tributaries have eroded through layer after layer of sediment following the uplift of the surrounding area. The result is a 277 mile-long (446 km) natural wonder offering some spectacular panoramas. Stripes of brown, red, orange and grey are visible in the walls of the canyon as successively older strata are revealed. Whilst the limestone at the rim is 230 million years old, the oldest rocks on the canyon floor date from 2000 million years ago, providing one of the most complete geological columns on Earth.

▶ **The Colorado River** loops south around the Kaibab Plateau as it flows from east to west. Lying across the canyon from the main visitor centre at the South Rim, the higher land of the plateau is forested, appearing dark green in this Landsat image.

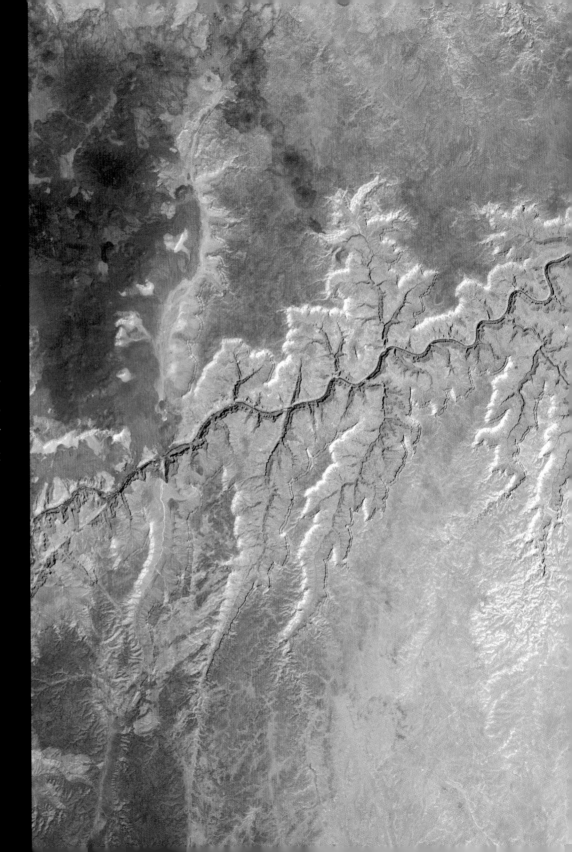

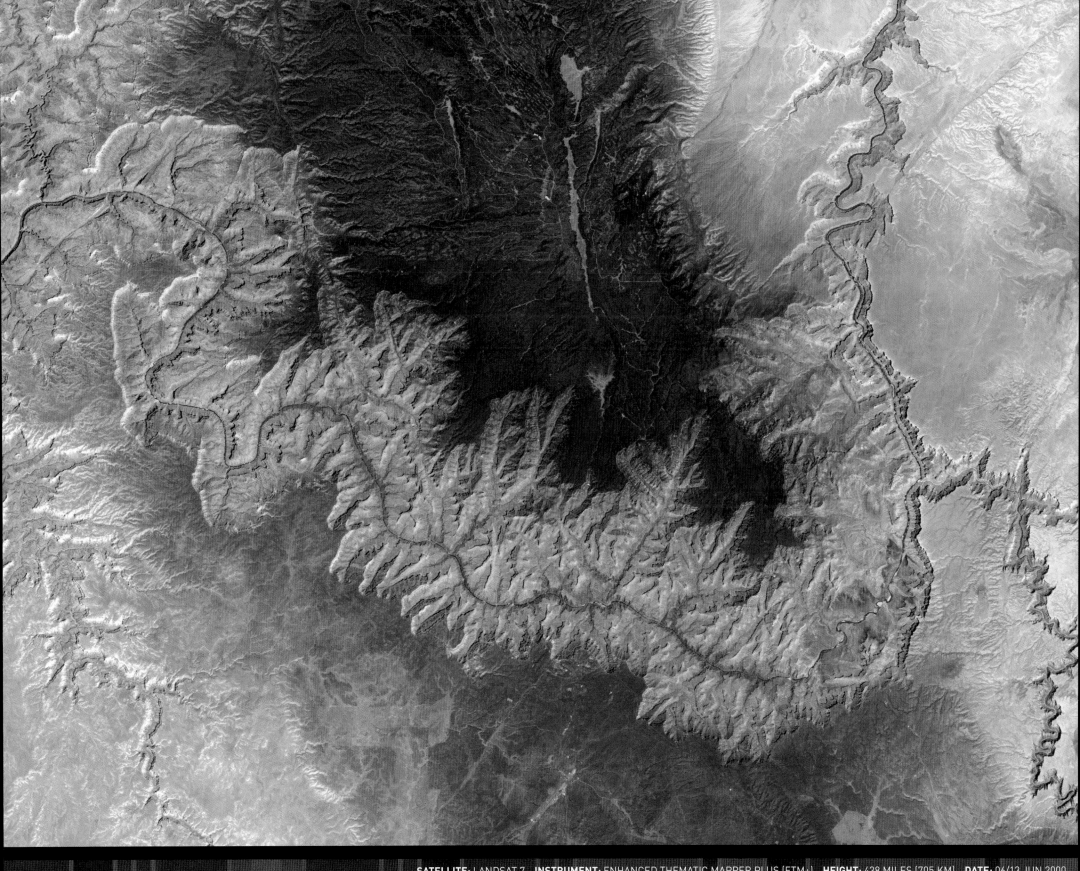

SATELLITE: LANDSAT 7   INSTRUMENT: ENHANCED THEMATIC MAPPER PLUS (ETM+)   HEIGHT: 438 MILES (705 KM)   DATE: 06/13 JUN 2000

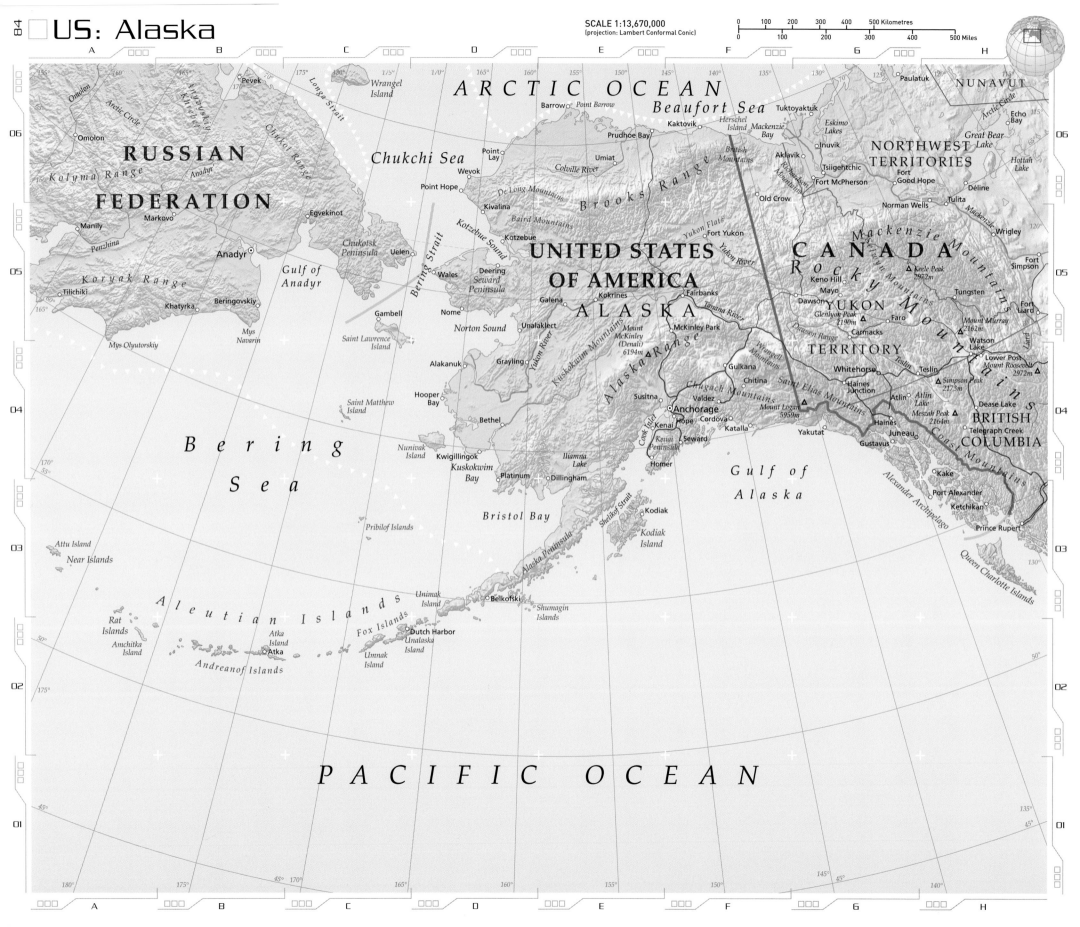

SCALE 1:13,670,000
(projection: Lambert Conformal Conic)

0 100 200 300 400 500 Kilometres
0 100 200 300 400 500 Miles

ARCTIC OCEAN

RUSSIAN
FEDERATION

UNITED STATES
OF AMERICA
ALASKA

CANADA

NORTHWEST
TERRITORIES

NUNAVUT

YUKON
TERRITORY

BRITISH
COLUMBIA

Bering
Sea

PACIFIC OCEAN

Gulf of
Alaska

Aleutian Islands

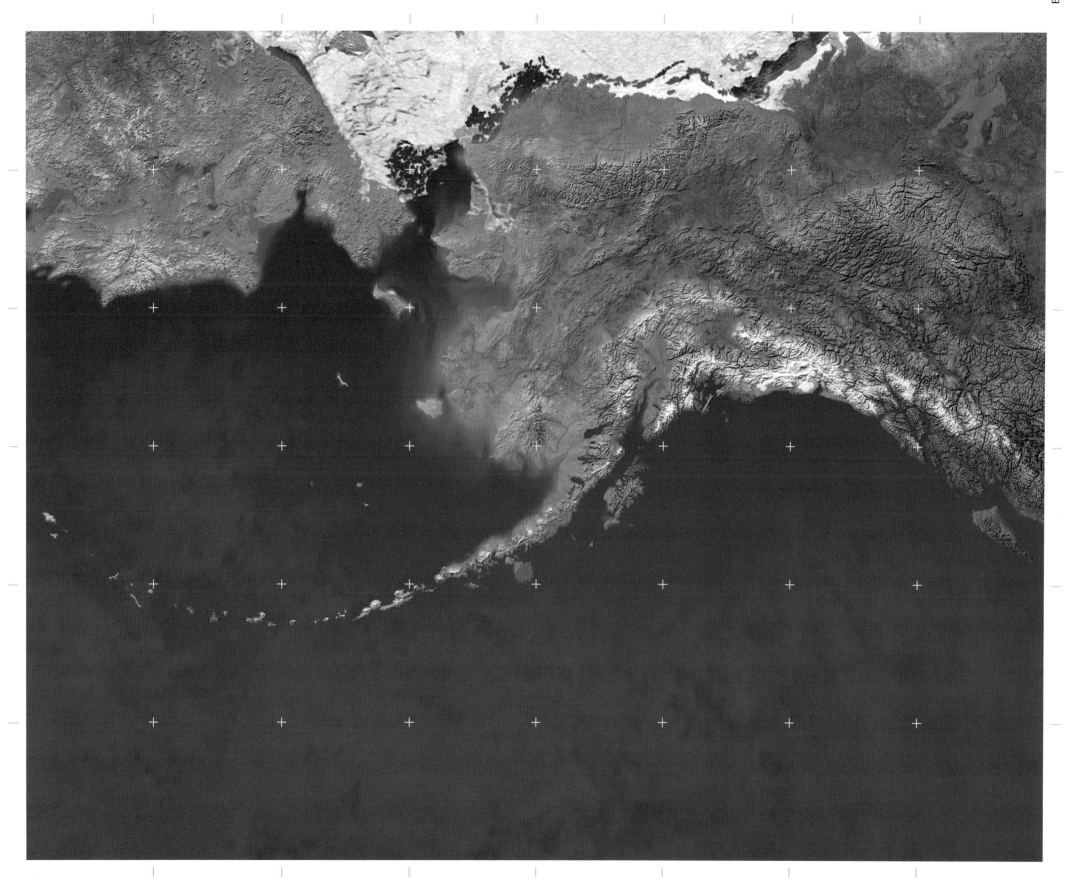

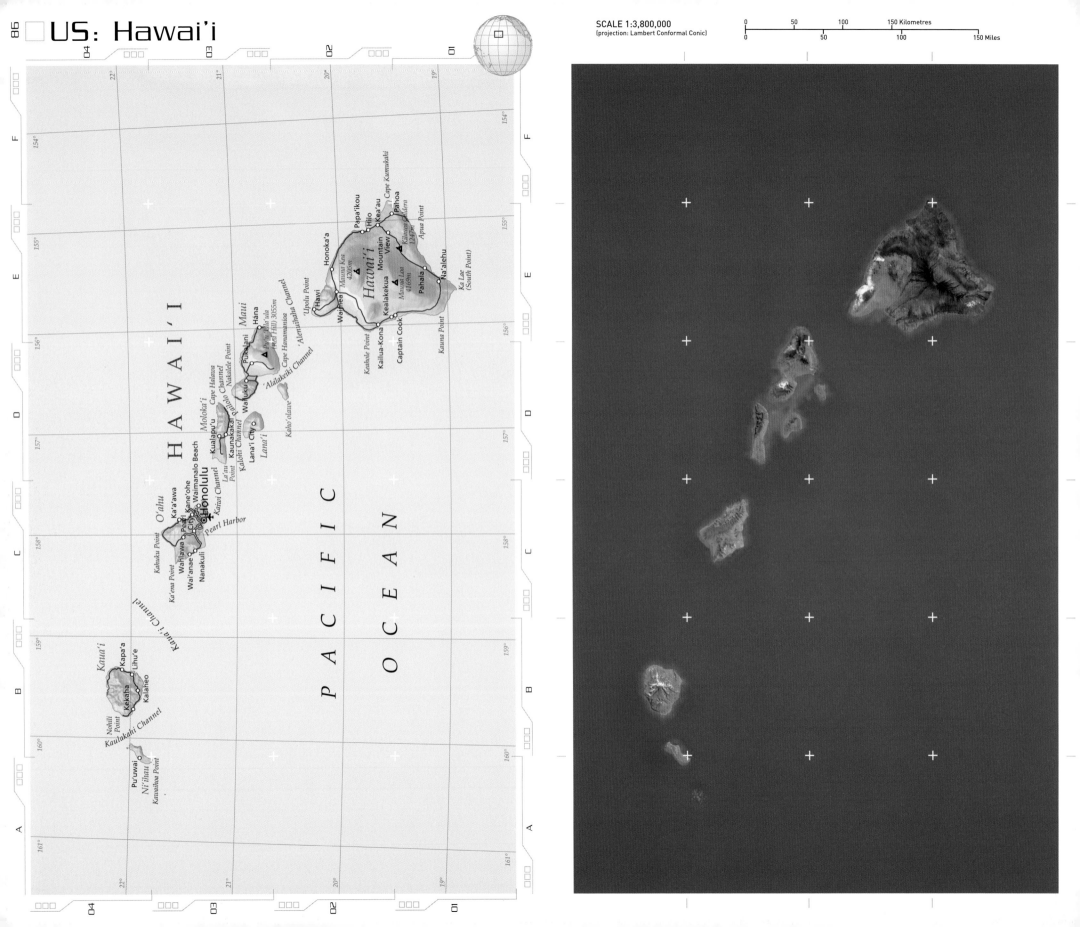

# US: Hawai'i

P A C I F I C    O C E A N

## HAWAI'I

### Kaua'i
Nohili Point
Kapa'a
Lihu'e
Kekaha
Kalaheo
Kaulakahi Channel
Kaua'i Channel

### Ni'ihau
Pu'uwai
Kawaihoa Point

### O'ahu
Kahuku Point
Ka'ena Point
Ka'a'awa
Kane'ohe
Wahiawa
Waimanalo Beach
Wai'anae
Pearl City
Nanakuli
Honolulu
Pearl Harbor
La'au Point
Ka'iwi Channel

### Moloka'i
Kualapu'u
Kaunakakai
Cape Halawa
Nakalele Point
Kalohi Channel
Pailolo Channel

### Lana'i
Lana'i City
Kaho'olawe
'Alalakeiki Channel

### Maui
Wailuku
Pu'unene
Hāna
Pu'u 'Ula'ula (Red Hill) 3055m
Cape Hanamanioa
'Alenuihaha Channel

### Hawai'i
'Upolu Point
Waimea
Hawi
Honoka'a
Honoka'a
Papa'ikou
Hilo
Kea'au
Mountain View
Mauna Kea 4205m
Mauna Loa 4169m
Kilauea Caldera 1247m
Cape Kumukahi
Pahoa
Apua Point
Keahole Point
Kailua-Kona
Kealakekua
Pahala
Na'alehu
Captain Cook
Kauna Point
Ka Lae (South Point)

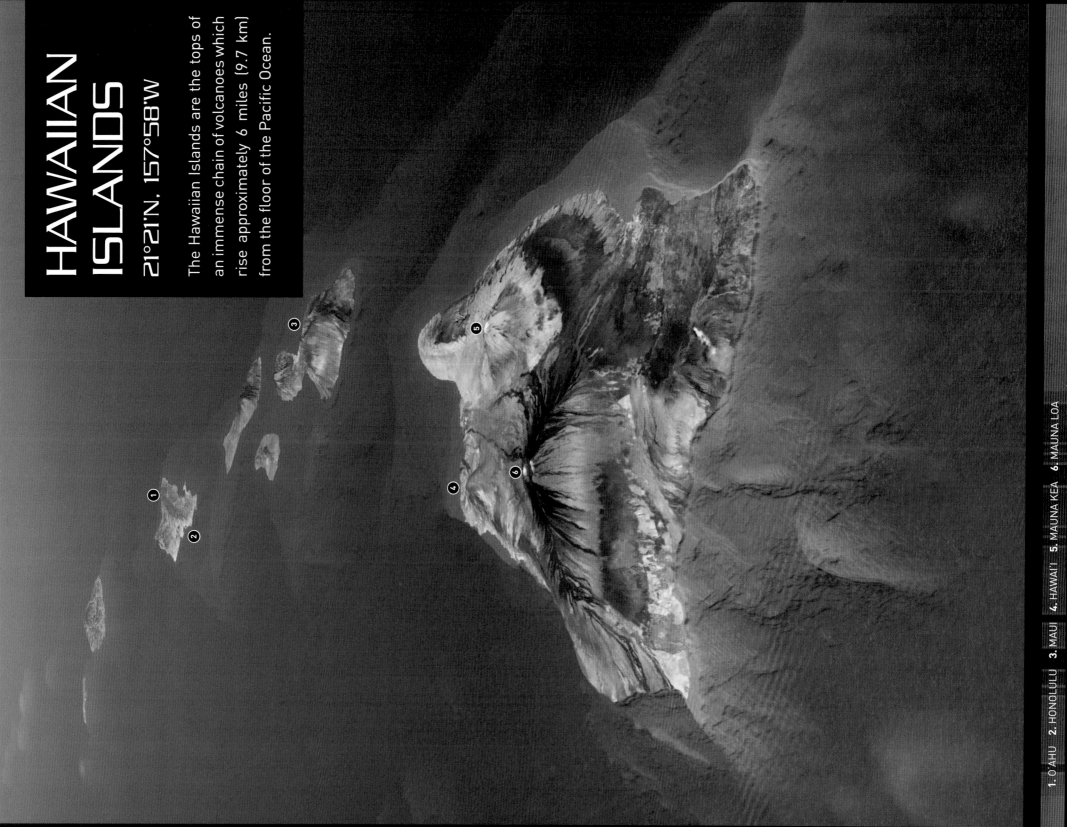

# HAWAIIAN ISLANDS

## 21°21'N. 157°58'W

The Hawaiian Islands are the tops of an immense chain of volcanoes which rise approximately 6 miles (9.7 km) from the floor of the Pacific Ocean.

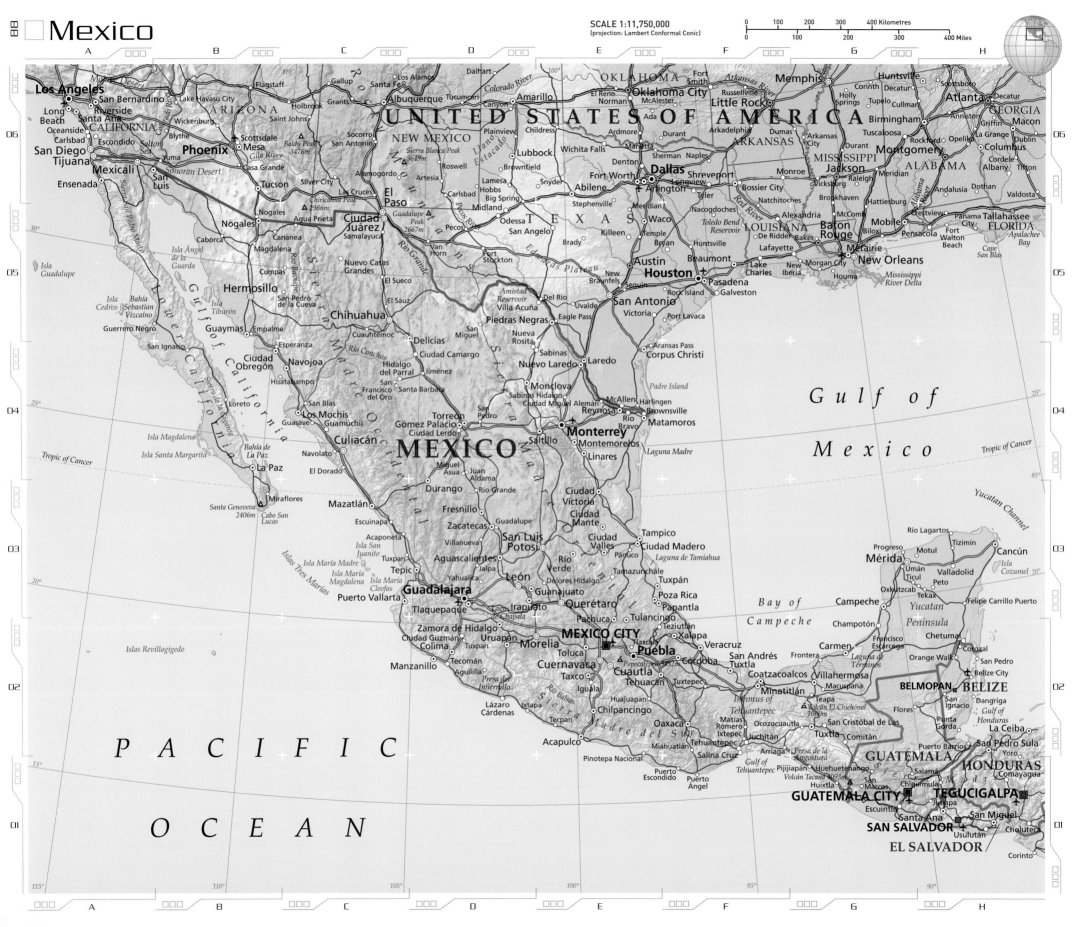

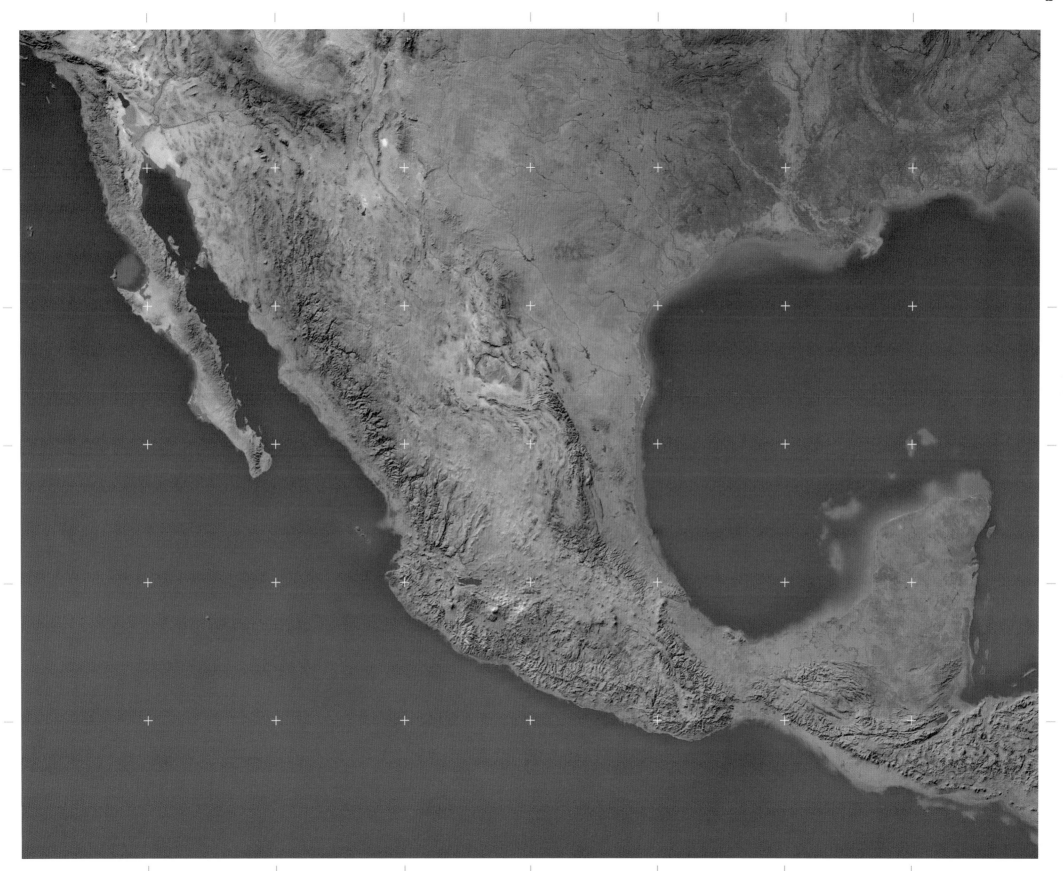

# POPOCATÉPETL

## 18°59'N, 98°37'W

Popocatépetl lies 44 miles (70 km) southeast of Mexico City, the most active of a circle of volcanoes which surround the Mexican capital. Popocatépetl means 'Smoking Mountain' in the Aztec language, and 'Popo' has been living up to its name since a major eruption in December 2000 that caused the evacuation of 10,000 people from its vicinity. To the north lies the snow-capped Iztaccíhuatl (the 'Woman in White'). This volcano has been dormant throughout recorded history and its peaks are permanently covered with snow and ice, in contrast to the ash-grey cone of Popocatépetl, where the glaciers melt during times of volcanic activity.

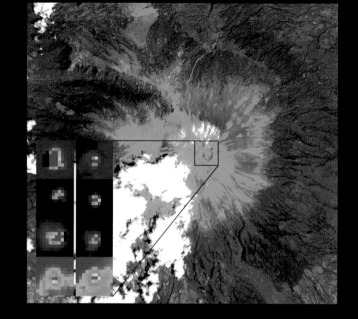

◄ **Hotspots in Popocatépetl's summit crater** are signs of a lava dome building during September 2000 – January 2001, revealed by a satellite sensor operating at thermal infrared wavelengths.

▶ **A large cloud** of steam was photographed rising from Popocatépetl's 17,887 ft (5452 m) summit by astronauts on the International Space Station in January 2001.

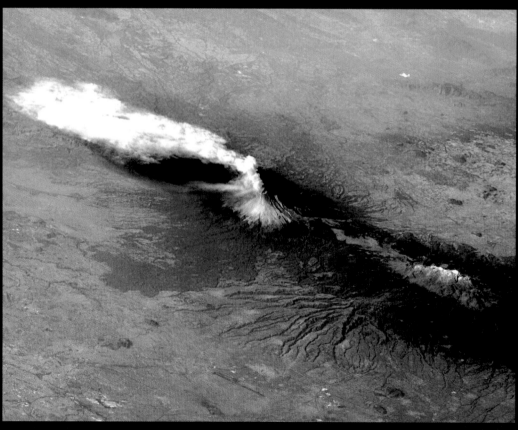

SAT: INTERNATIONAL SPACE STATION (ISS), KODAK DCS460   HEIGHT: 220 MILES (354 KM)   DATE: 23 JAN 2001

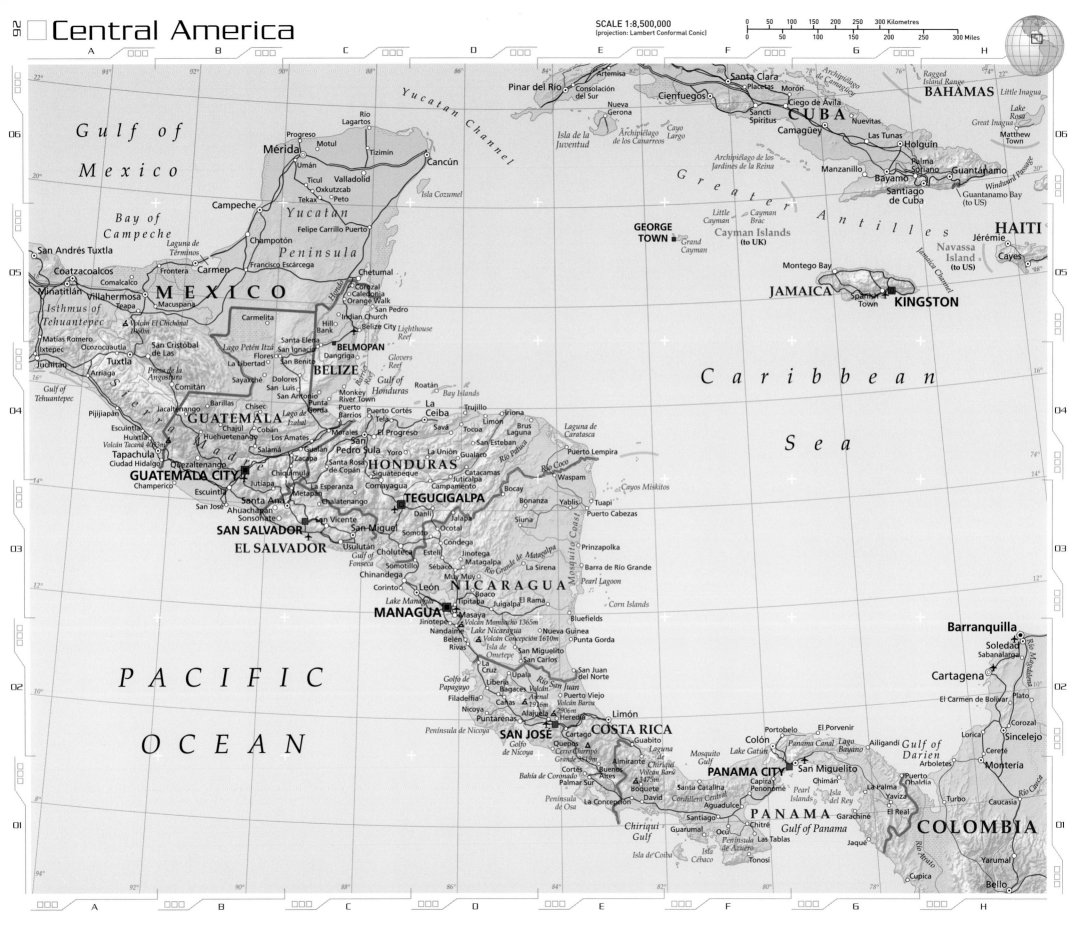

# Central America

SCALE 1:8,500,000
(projection: Lambert Conformal Conic)

0  50  100  150  200  250  300 Kilometres
0  50    100    150    200    250    300 Miles

## Map labels

**BAHAMAS** · *Little Inagua*
*Ragged Island Range*
*Lake Rosa*
*Great Inagua*
*Matthew Town*

**CUBA**
Pinar del Río · Artemisa · Santa Clara · Placetas · Morón
Consolación del Sur · Cienfuegos · Sancti Spíritus · Ciego de Ávila
Nueva Gerona · Camagüey · Las Tunas · Nuevitas · Holguín
*Isla de la Juventud* · *Archipiélago de los Canarreos* · *Cayo Largo*
Manzanillo · Palma Soriano · Guantánamo
Bayamo · Santiago de Cuba · Guantanamo Bay (to US)
*Archipiélago de los Jardines de la Reina* · *Windward Passage*

**HAITI**
Jérémie · Cayes

**JAMAICA**
Montego Bay · Spanish Town · **KINGSTON**
*Jamaica Channel*

*Yucatan Channel*
*Greater Antilles*

**GEORGE TOWN**
*Little Cayman* · *Cayman Brac*
Cayman Islands (to UK)
*Grand Cayman*
*Navassa Island (to US)*

**MEXICO**
Río Lagartos · Progreso · Motul · Tizimín · Cancún
Mérida · Umán · Valladolid · *Isla Cozumel*
Campeche · Ticul · Oxkutzcab · Peto
Champotón · Tekax · Felipe Carrillo Puerto
*Yucatan Peninsula*
San Andrés Tuxtla · *Laguna de Términos* · Frontera · Carmen · Chetumal · Corozal · Caledonia
Coatzacoalcos · Comalcalco · Francisco Escárcega · Orange Walk · San Pedro
Minatitlán · Villahermosa · Teapa · Macuspana · *Volcán El Chichónal 1060m* · Carmelita · Indian Church
*Isthmus of Tehuantepec* · Matías Romero · Santa Elena · San Ignacio · Flores · *Lago Petén Itzá* · **BELMOPAN** · Belize City · *Lighthouse Reef*
Ixtepec · Ocozocuautla · San Cristóbal de Las · La Libertad · San Benito · Dangriga · *Glovers Reef*
Juchitán · Tuxtla · Comitán · Sayaxché · Dolores · **BELIZE** · *Barrier Reef*
Arriaga · Barillas · Chisec · San Luis · San Antonio · Monkey River Town · Roatán · *Bay Islands*
Pijijiapán · Jacaltenango · Huehuetenango · Cobán · Salamá · Punta Gorda · Puerto Barrios · *Gulf of Honduras* · *Roatán*
Escuintla · *Volcán Tacaná 4093m* · **GUATEMALA** · Gualán · Morales · Puerto Cortés · La Ceiba · Trujillo · Iriona
Huixtla · Los Amates · San Pedro Sula · El Progreso · Tela · Limón · Tocoa
Tapachula · Quezaltenango · Chiquimula · Santa Rosa de Copán · Yoro · La Unión · Savá · San Esteban · Brus Laguna
Ciudad Hidalgo · **GUATEMALA CITY** · Zacapa · **HONDURAS** · Gualaco · *Laguna de Caratasca*
Champerico · Jutiapa · Siguatepeque · Comayagua · Juticalpa · Catacamas · *Río Patuca*
Escuintla · Metapán · La Esperanza · Chalatenango · **TEGUCIGALPA** · Campamento · Puerto Lempira
Santa Ana · Ahuachapán · *Río Coco* · Waspam
Sonsonate · San Vicente · Danlí · Jalapa · Bocay · Bonanza · *Cayos Miskitos*
**SAN SALVADOR** · San Miguel · Somoto · Ocotal · Siuna · Yablis · Tuapi
**EL SALVADOR** · Usulután · Choluteca · Condega · Estelí · Jinotega · Prinzapolka
*Gulf of Fonseca* · Somotillo · Matagalpa · *Río Grande de Matagalpa* · Puerto Cabezas
Chinandega · Sébaco · Muy Muy · La Sirena · Barra de Río Grande
Corinto · León · **NICARAGUA** · Boaco · *Pearl Lagoon* · *Corn Islands*
*Lake Managua* · Tipitapa · Juigalpa · El Rama · *Corn Islands*
**MANAGUA** · Masaya · Bluefields
Jinotepe · *Volcán Mombacho 1365m* · Nueva Guinea
Nandaime · Belén · *Volcán Concepción 1610m* · Punta Gorda
Rivas · *Isla de Ometepe* · *Lake Nicaragua* · San Miguelito · San Carlos
La Cruz · *Río San Juan* · San Juan del Norte
Upala · *Golfo de Papagayo* · Liberia · *Volcán Arenal 1916m* · Puerto Viejo
Bagaces · Filadelfia · Cañas · *Volcán Barva 2906m* · Limón
Nicoya · Alajuela · Heredia
Puntarenas · **SAN JOSÉ** · **COSTA RICA** · Guabito · Portobelo · El Porvenir
*Península de Nicoya* · *Golfo de Nicoya* · Quepos · Cartago · Guaitil · Colón · *Panama Canal* · *Lago Bayano* · Ailigandí · *Gulf of Darien*
*Cerro Chirripó 3819m* · *Laguna de Chiriquí* · Almirante · *Mosquito Gulf* · **PANAMA CITY** · San Miguelito
Cortés · Buenos Aires · *Volcán Barú 3475m* · Santa Catalina · Capirá · Chimán · La Palma · Yaviza
Palmar Sur · Boquete · David · Penonomé · *Pearl Islands* · *Isla del Rey* · Puerto Obaldía
*Península de Osa* · La Concepción · Aguadulce · *Cordillera Central* · **PANAMA** · El Real
*Bahía de Coronado* · Santiago · Ocú · Chitré · *Gulf of Panama* · Garachiné
*Chiriqui Gulf* · La Concepción · Guarumal · Las Tablas · Jaqué
*Isla de Coiba* · Ocú · *Península de Azuero* · Tonosí · *Isla Cébaco*

**COLOMBIA**
Barranquilla · Soledad · Sabanalarga
Cartagena · El Carmen de Bolívar · Plato
Corozal · Sincelejo · Cereté · Montería
Lorica · Arboletes · Puerto Obaldía
Turbo · Caucasia · *Río Cauca* · *Río Atrato* · *Río Magdalena*
Yarumal · Cupica · Bello

## Seas and oceans

*Gulf of Mexico*
*Bay of Campeche*
*Gulf of Tehuantepec*
*PACIFIC OCEAN*
*Caribbean Sea*
*Mosquito Coast*

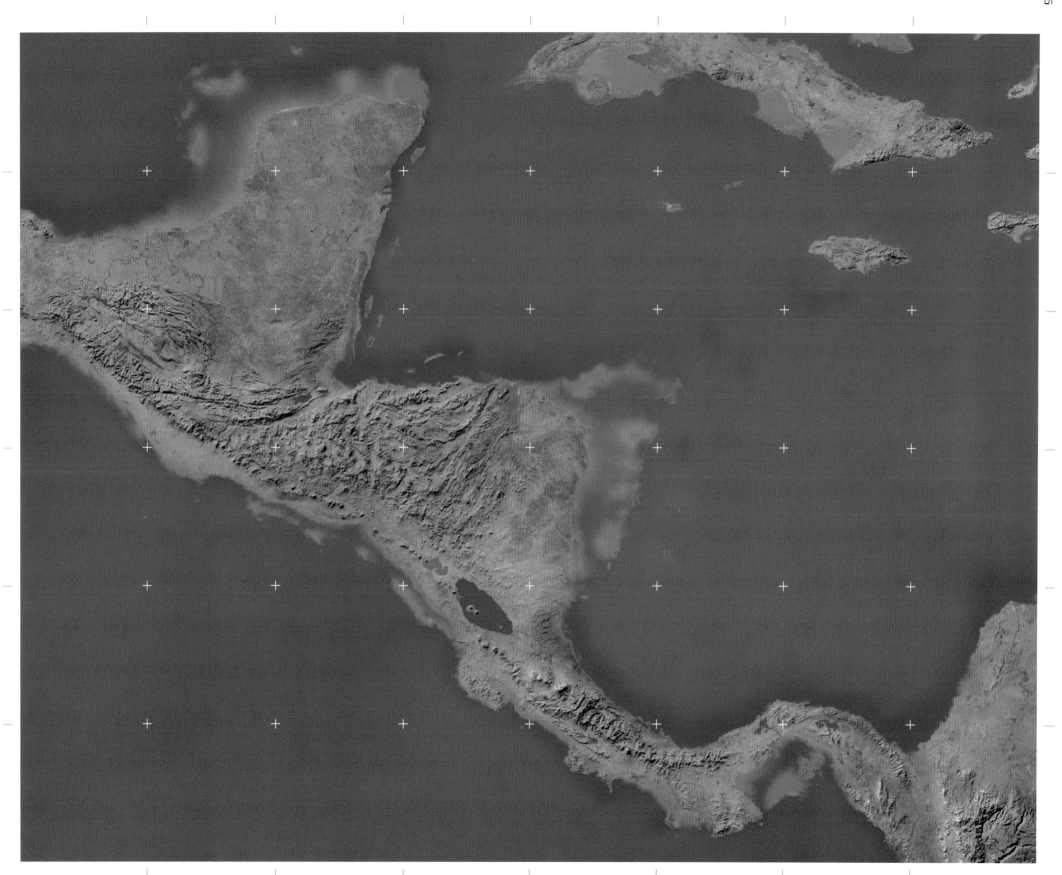

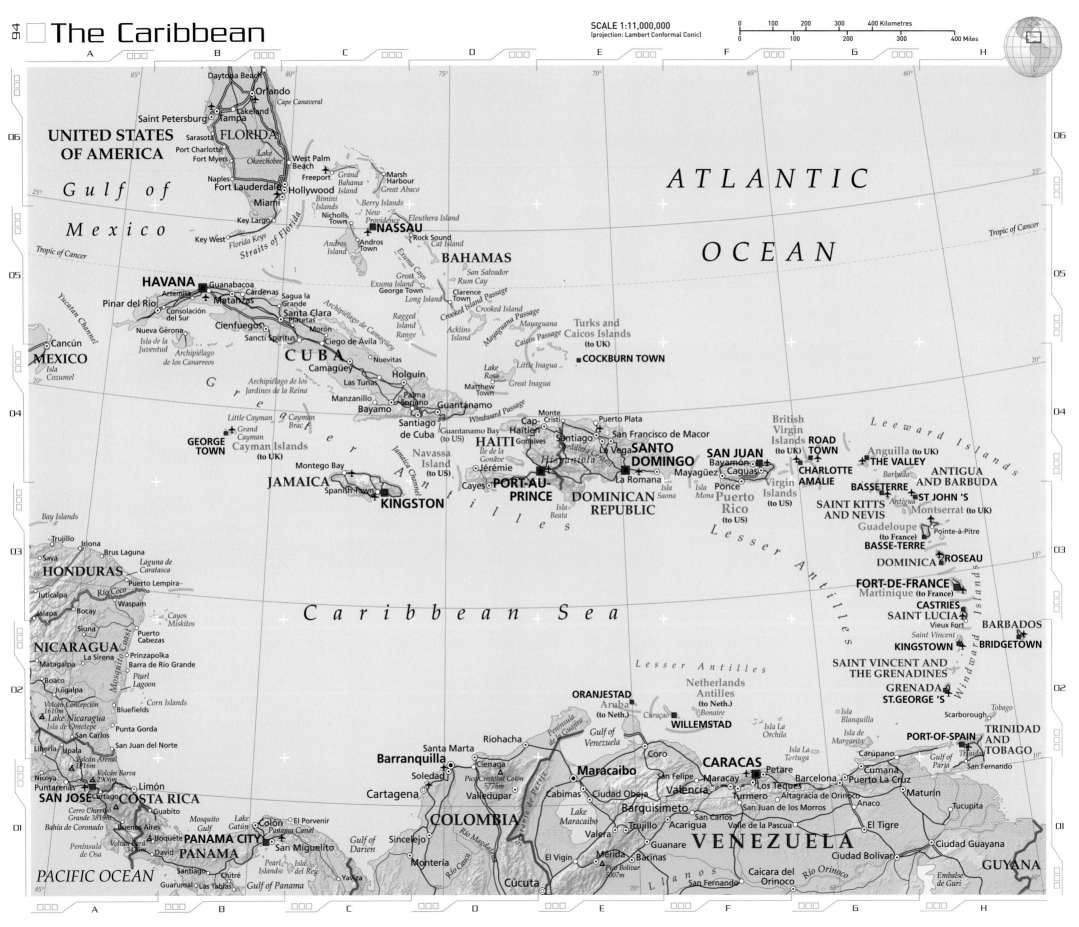

# The Caribbean

SCALE 1:11,000,000
(projection: Lambert Conformal Conic)

| 0 | 100 | 200 | 300 | 400 Kilometres |
| 0 | 100 | 200 | 300 | 400 Miles |

*A T L A N T I C*

*O C E A N*

**UNITED STATES**
**OF AMERICA**

*Gulf of*

*Mexico*

FLORIDA
Daytona Beach
Orlando
*Cape Canaveral*
Saint Petersburg
Lakeland
Tampa
Sarasota
Port Charlotte
Fort Myers
Naples
Fort Lauderdale
Hollywood
Miami
Key Largo
Key West
*Florida Keys*
*Straits of Florida*
West Palm Beach
Freeport
*Grand Bahama Island*
Marsh Harbour
*Great Abaco*
*Bimini Islands*
*Berry Islands*
Nicholls Town
*New Providence*
**NASSAU**
*Eleuthera Island*
Rock Sound
*Cat Island*

*Tropic of Cancer*

*Andros Island*
Andros Town
*Exuma Cays*
**BAHAMAS**
San Salvador
*Rum Cay*
George Town
*Great Exuma Island*
*Long Island*
Clarence Town
*Crooked Island Passage*
*Ragged Island Range*
*Acklins Island*
Crooked Island
*Mayaguana Passage*
Mayaguana
*Caicos Passage*
**Turks and Caicos Islands (to UK)**
**COCKBURN TOWN**

*Tropic of Cancer*

MEXICO
Cancún
*Yucatan Channel*
*Isla Cozumel*

HAVANA
Guanabacoa
Cárdenas
Artemisa
Matanzas
Pinar del Río
Consolación del Sur
Sagua la Grande
Santa Clara
Placetas
Nueva Gerona
Cienfuegos
*Isla de la Juventud*
*Archipiélago de los Canarreos*
Sancti Spíritus
Morón
Ciego de Ávila
*Archipiélago de Camagüey*
**CUBA**
Camagüey
Nuevitas
Holguín
Las Tunas
Manzanillo
Palma Soriano
Bayamo
Santiago de Cuba
Guantánamo
Guantanamo Bay (to US)
*Windward Passage*
*Lake Rosa*
Matthew Town
*Little Inagua*
*Great Inagua*
*Archipiélago de los Jardines de la Reina*

*G*
*r*
*e*
*a*
*t*
*A*
*n*
*t*
*i*
*l*
*l*
*e*
*s*

*Little Cayman*
*Grand Cayman*
*Cayman Brac*
GEORGE TOWN
**Cayman Islands (to UK)**
Montego Bay
Spanish Town
**JAMAICA**
**KINGSTON**
*Jamaica Channel*
*Navassa Island (to US)*
Cap-Haïtien
Gonaïves
**HAITI**
*Île de la Gonâve*
Jérémie
**PORT-AU-PRINCE**
Cayes
*Isla Beata*
Monte Cristi
Santiago
*Cordillera Central*
La Vega
San Francisco de Macorís
Puerto Plata
*Hispaniola*
**SANTO DOMINGO**
**DOMINICAN REPUBLIC**
La Romana
*Isla Saona*
*Isla Mona*
Mayagüez
Ponce
San Juan
Bayamón
Caguas
**Puerto Rico (to US)**
**SAN JUAN**
CHARLOTTE AMALIE
**Virgin Islands (to US)**
**British Virgin Islands (to UK)**
ROAD TOWN
Anguilla (to UK)
THE VALLEY
*Leeward Islands*
**ANTIGUA AND BARBUDA**
*Barbuda*
BASSETERRE
**SAINT KITTS AND NEVIS**
*Antigua*
ST JOHN'S
Montserrat (to UK)
Guadeloupe (to France)
Pointe-à-Pitre
BASSE-TERRE
**DOMINICA**
ROSEAU

*Caribbean Sea*

HONDURAS
Trujillo
Iriona
Savá
Brus Laguna
*Laguna de Caratasca*
Juticalpa
*Río Coco*
Puerto Lempira
Jalapa
Bocay
Waspam
*Cayos Miskitos*
*Bay Islands*

NICARAGUA
Matagalpa
La Sirena
Siuna
Prinzapolka
Puerto Cabezas
Barra de Rio Grande
Boaco
Juigalpa
*Pearl Lagoon*
Bluefields
*Corn Islands*
*Volcán Concepción 1610m*
*Lake Nicaragua*
*Isla de Ometepe*
Punta Gorda
San Carlos
San Juan del Norte
Liberia
Upala
*Volcán Arenal 1616m*
*Volcán Barva 2906m*
Nicoya
Puntarenas
**SAN JOSE**
Cartago
Limón
**COSTA RICA**
*Cerro Chirripó 3819m*
Guabito
*Bahía de Coronado*
Buenos Aires
*Volcán Barú 3475m*
Boquete
David
*Península de Osa*
Santiago
Chitré
Las Tablas
Guáymal
**PANAMA CITY**
**PANAMA**
Colón
El Porvenir
*Panama Canal*
*Lake Gatún*
San Miguelito
*Gulf of Darien*
*Pearl Islands*
*Isla del Rey*
Yaviza
*Gulf of Panama*

*PACIFIC OCEAN*

*Mosquito Coast*

Santa Marta
Ríohacha
Cienaga
Barranquilla
Soledad
Cartagena
Valledupar
*Península de la Guajira*
*Gulf of Venezuela*
Coro
San Felipe
**COLOMBIA**
Sincelejo
Montería
*Río Cauca*
*Río Magdalena*
*Serranía de Perijá*
Cabimas
Ciudad Ojeda
*Lake Maracaibo*
**Maracaibo**
Valera
Trujillo
*Pico Cristóbal Colón 5775m*
Acarigua
El Vigín
Mérida
*Pico Bolívar 5007m*
Barinas
Guanare
San Fernando

**VENEZUELA**
*Gulf of Paria*
Valencia
Maracay
Los Teques
**CARACAS**
Petare
Turmero
Barcelona
Puerto La Cruz
Barquisimeto
San Carlos
Valle de la Pascua
San Juan de los Morros
Altagracia de Orinoco
Anaco
El Tigre
Ciudad Bolívar
Ciudad Guayana
*Río Orinoco*
Caicara del Orinoco
San Fernando
*Embalse de Guri*

**GUYANA**

ORANJESTAD
**Aruba (to Neth.)**
*Curaçao*
**Netherlands Antilles (to Neth.)**
*Bonaire*
**WILLEMSTAD**
*Isla La Orchila*
*Isla La Tortuga*
*Isla de Margarita*
*Isla Blanquilla*
Cumaná
Carúpano
*Gulf of Paria*
San Fernando
Maturín
Tucupita

*Lesser Antilles*

**FORT-DE-FRANCE**
*Martinique (to France)*
**CASTRIES**
**SAINT LUCIA**
Vieux Fort
*Saint Vincent*
**KINGSTOWN**
**SAINT VINCENT AND THE GRENADINES**
**BARBADOS**
**BRIDGETOWN**
**GRENADA**
**ST.GEORGE'S**
*Tobago*
Scarborough
**TRINIDAD AND TOBAGO**
**PORT-OF-SPAIN**

*Windward Islands*

*L*
*e*
*s*
*s*
*e*
*r*

*A*
*n*
*t*
*i*
*l*
*l*
*e*
*s*

# HAVANA

## 23°07'N, 82°25'W

The capital of Cuba and home to just over 2.3 million people, Havana was founded by the Spanish in 1519, who used it as the gathering point for ships carrying riches from all of Spain's New World colonies. Havana flourished in the 19th century, becoming known as the 'Paris of the Antilles'. Following a long struggle for independence, Fidel Castro eventually seized power in 1959 and established a Soviet-style communist regime. Havana ia a mere 90 miles (144 km) from the Florida Keys and tensions between the US and Cuba ran high during the 1960s. More recently, Havana has become an increasingly popular tourist destination offering a rich history, colourful culture and vibrant atmosphere.

▶ **Located between the Caribbean Sea** and the Gulf of Mexico, 90 miles (144 km) south of the Florida Keys, Havana often finds itself in the path of hurricanes. It was among the cities hit by Hurricane Dennis in 2005, Cuba's worst storm for 40 years.

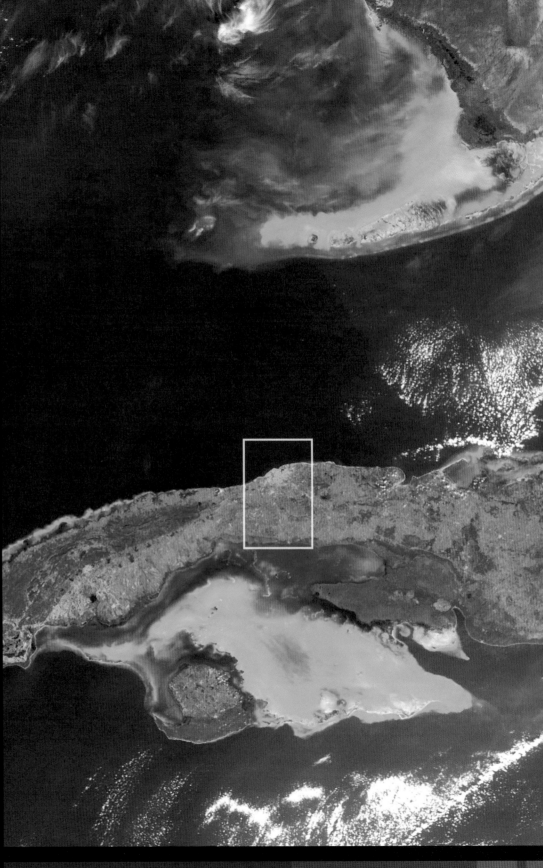

**SATELLITE:** TERRA (EOS AM-1), MODIS   **HEIGHT:** 438 MILES (705 KM)   **DATE:** 30 NOV 2002

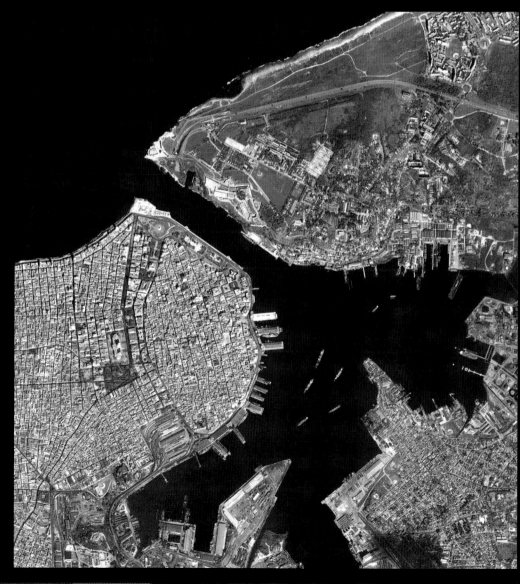

◄ **The deep blue water** of the Straits of Florida lies off Cuba's northern coast, in contrast to the light blue of the shallow Golfo dé Batabanó to the south of the island. Havana is the country's largest port, handling half of its imports and exports.

▼ **Old Havana,** on the western side of the harbour entrance, is part of a World Heritage Site which includes the city's colonial-era fortifications. To the east of the entrance, sandy beaches line the shore next to the Via Blanca. This coastal highway reaches the centre of the city through a tunnel under the harbour entrance

**SATELLITE:** LANDSAT 7   **INSTRUMENT:** ETM+   **HEIGHT:** 438 MILES (705 KM)   **DATE:** 03 APR 2001          **SATELLITE:** IKONOS image courtesy of GeoEye   **HEIGHT:** 423 MILES (681 KM)   **DATE:** JAN 2001

SOUTH AMERICA

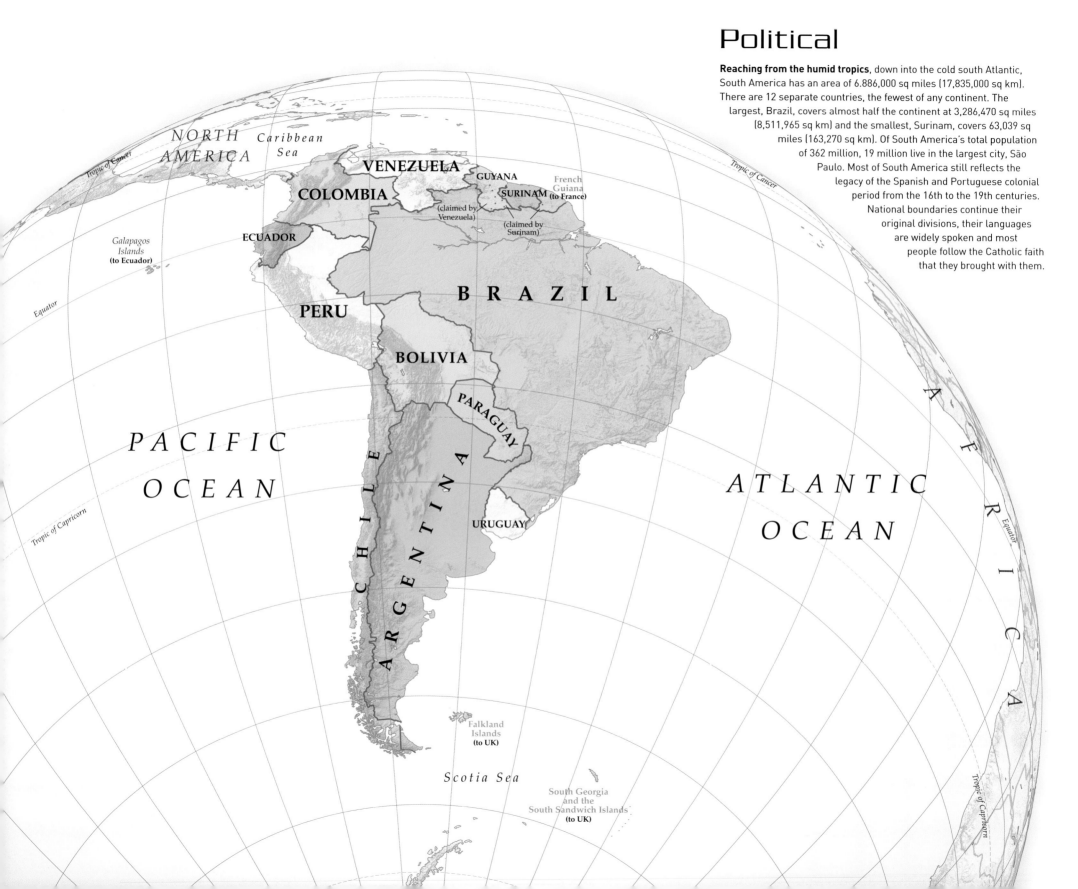

# Political

**Reaching from the humid tropics**, down into the cold south Atlantic, South America has an area of 6.886,000 sq miles (17,835,000 sq km). There are 12 separate countries, the fewest of any continent. The largest, Brazil, covers almost half the continent at 3,286,470 sq miles (8,511,965 sq km) and the smallest, Surinam, covers 63,039 sq miles (163,270 sq km). Of South America's total population of 362 million, 19 million live in the largest city, São Paulo. Most of South America still reflects the legacy of the Spanish and Portuguese colonial period from the 16th to the 19th centuries. National boundaries continue their original divisions, their languages are widely spoken and most people follow the Catholic faith that they brought with them.

NORTH AMERICA

Caribbean Sea

Tropic of Cancer

Tropic of Cancer

VENEZUELA

COLOMBIA

GUYANA

SURINAM

French Guiana (to France)

(claimed by Venezuela)

(claimed by Surinam)

ECUADOR

Galapagos Islands (to Ecuador)

Equator

Equator

PERU

BRAZIL

BOLIVIA

PACIFIC OCEAN

PARAGUAY

CHILE

ARGENTINA

URUGUAY

ATLANTIC OCEAN

AFRICA

Tropic of Capricorn

Tropic of Cancer

Falkland Islands (to UK)

Scotia Sea

South Georgia and the South Sandwich Islands (to UK)

Tropic of Capricorn

# Physical

**South America, the world's fourth largest continent**, plays host to a number of remarkable physical features. Stretching the full length of its Pacific coast is the towering Andes mountain range, second only in height to the Himalayas and sporting the world's largest volcanoes. Half way down, tucked between the mountains and the ocean is the Atacama Desert, one of the world's most parched regions. East of the Andes lies the Amazon Basin, a giant among river systems carrying an enormous volume of water from the surrounding Andes and Guiana and Brazilian Highlands, out to the Atlantic Ocean. Despite depletion by deforestation, it is still covered by a vast expanse of tropical rainforest. Elsewhere, the great grasslands of the Pampas and Llanos support extensive ranching.

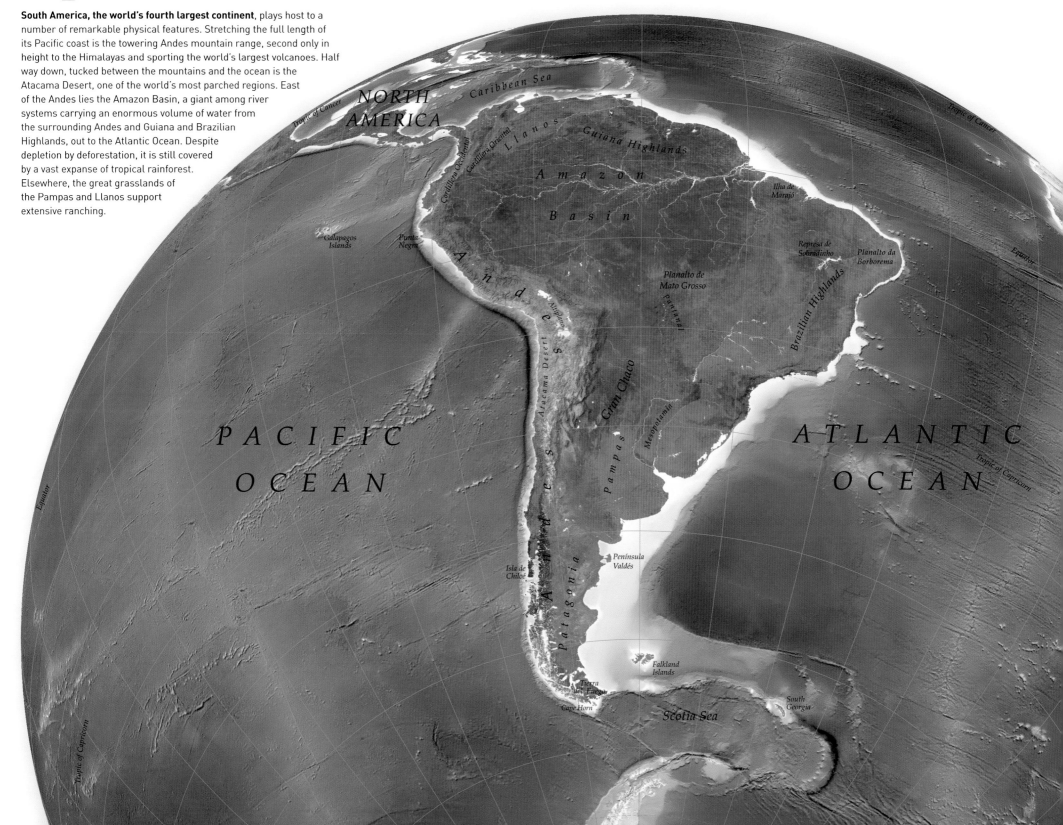

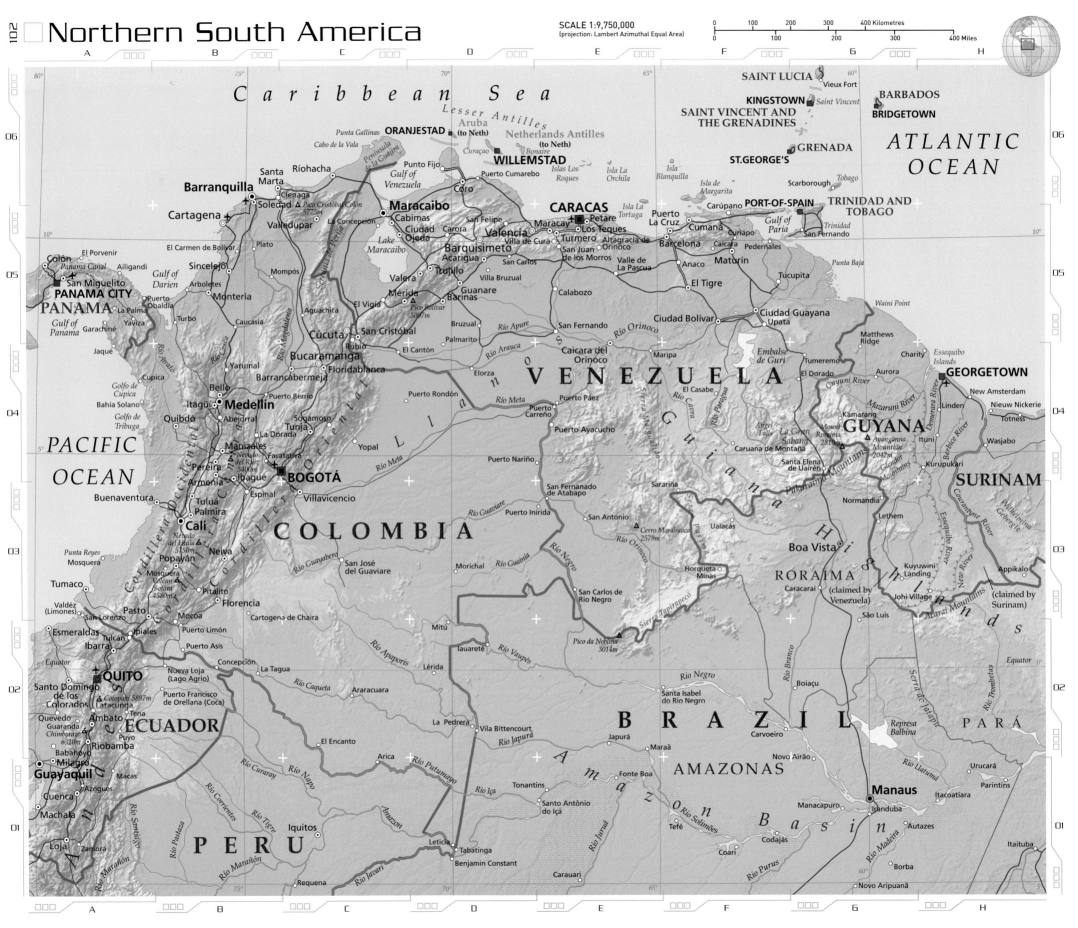

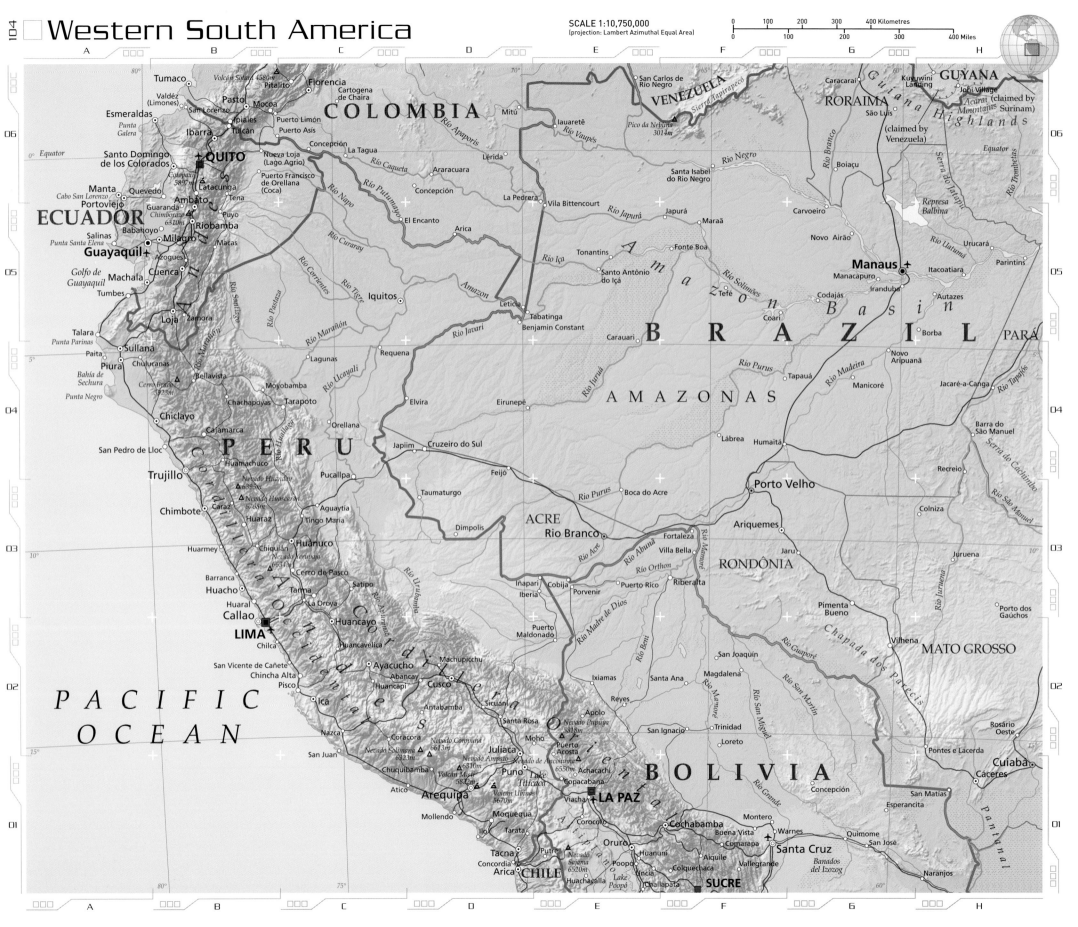

# Western South America

SCALE 1:10,750,000
(projection: Lambert Azimuthal Equal Area)

| 0 | 100 | 200 | 300 | 400 Kilometres |
| 0 | 100 | 200 | 300 | 400 Miles |

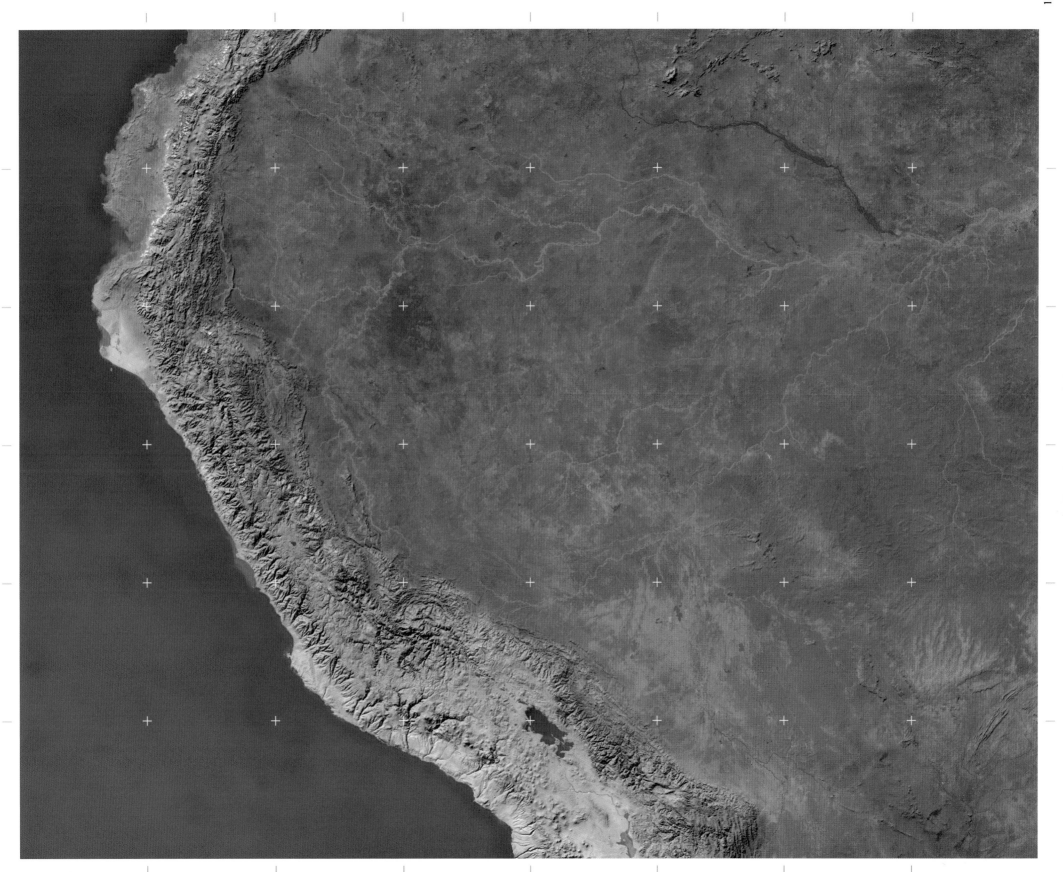

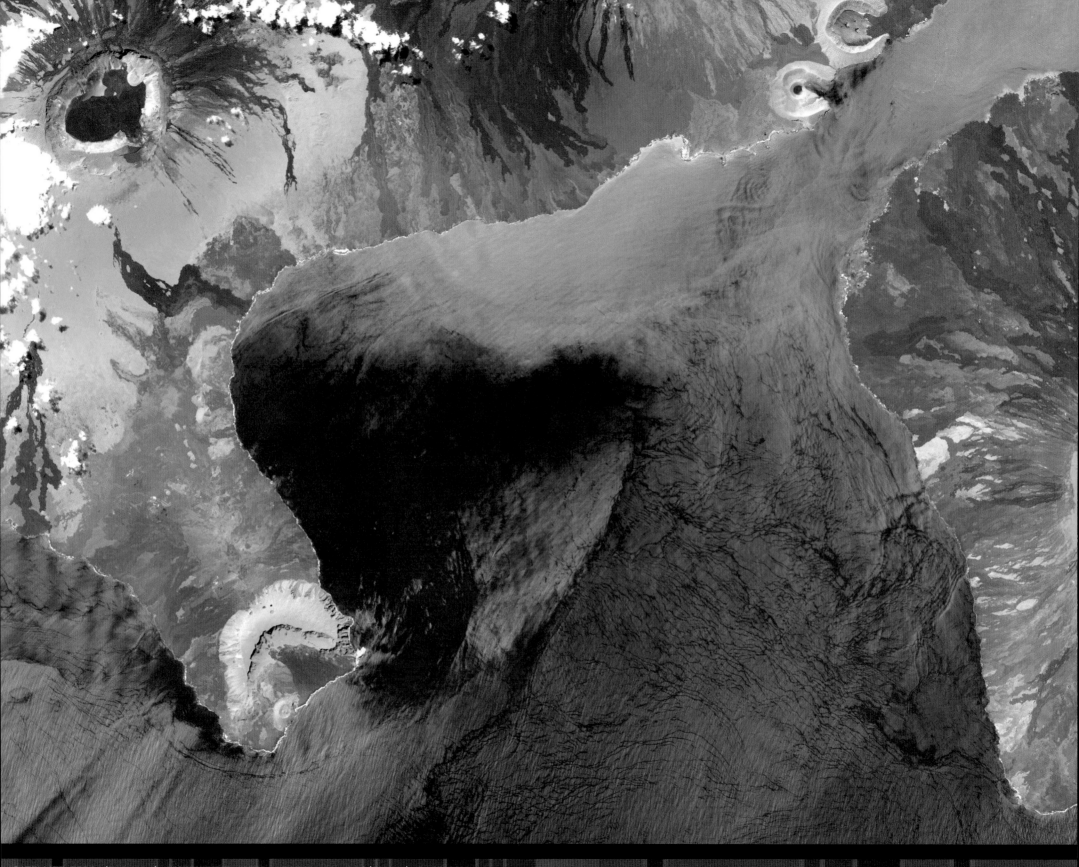

SATELLITE: TERRA (EOS AM-1)   INSTRUMENT: ASTER   HEIGHT: 438 MILES (705 KM)   DATE: 2003

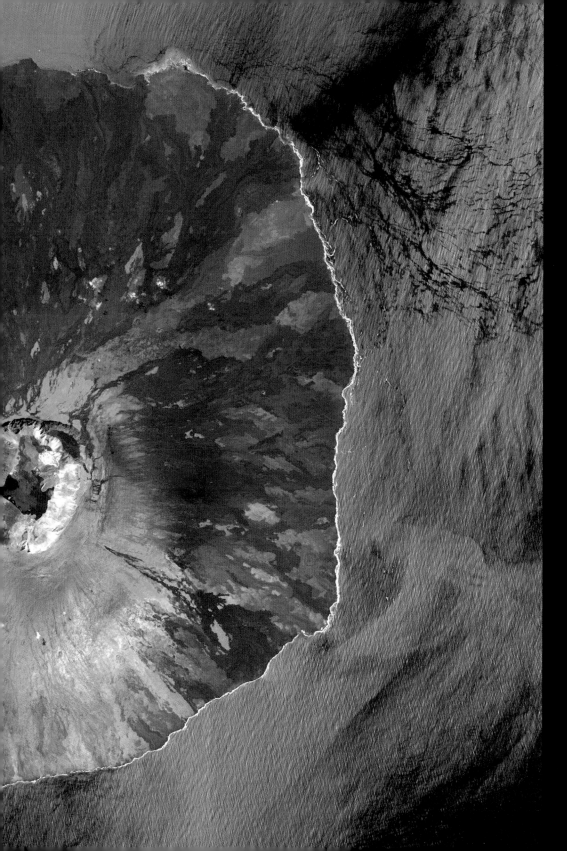

# GALAPAGOS ISLANDS

## 0°09'S, 91°28'W

Lying 650 miles (1046 km) west of Ecuador, the Galapagos Islands are a cluster of enormous volcanoes rising from the ocean floor. The islands first appeared on maps by Abraham Ortelius and Gerardus Mercator in 1570. Early visitors reported giant tortoises roaming the islands, and they take their name from the Old Spanish word for tortoise. Study of the islands' unique animal species later helped Charles Darwin formulate his theory of evolution.

◄ **This image** shows the youngest islands of the group: Fernandina, on the right (south), and part of the largest island, Isabela, to the left (north). Isabela contains at least six volcanic calderas, some of which have been active during the 20th century. The climate is very dry and the islands almost barren, although some vegetation can be seen as green areas on the upper slopes and as tiny pockets around the coast.

# MACHU PICCHU

## 13°07'S, 72°30'W

Poised high in the Peruvian Andes, northwest of Cusco, the remote remains of this remarkable Inca citadel were only discovered in 1911 by the American explorer Hiram Bingham. Set on a narrow ridge at the top of a 1970 ft (600 m) cliff, the settlements' inaccessibility helped to preserve the ruins from destruction but now the site receives about 400,000 visitors each year. Among the narrow paved streets and huddled dwellings are the remains of a temple and part of the site may have served as an astronomical observatory. Around the edge, the remnants of steeply-terraced fields can be seen, as well as the terracotta roof of the modern visitor centre. The 560 year-old site was a well-defended summer retreat for the Incan aristocracy and its name means 'The Old Mountain'.

▶ **Renowned for the stunning quality** of its stone masonry, much of the city is constructed with massive granite blocks carved so accurately that, despite the lack of mortar, it is impossible to insert even a thin knife between the stones.

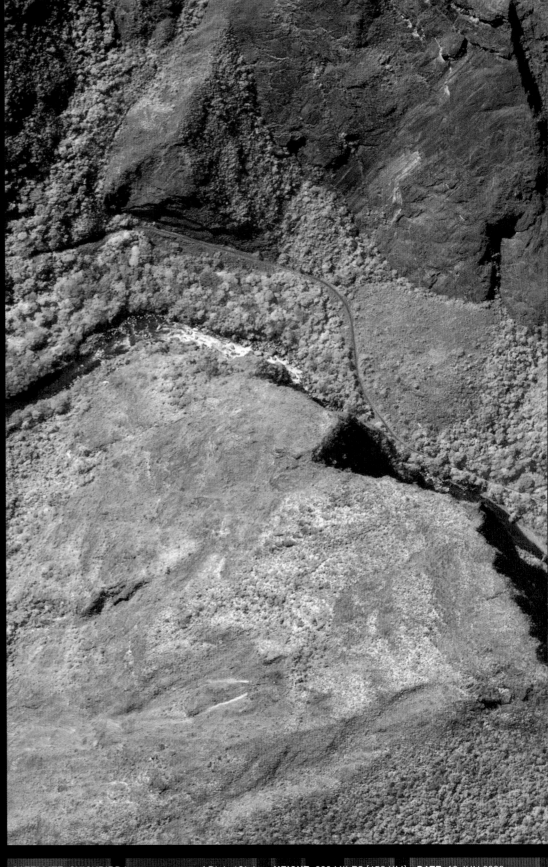

**SATELLITE:** QUICKBIRD image courtesy of DigitalGlobe   **HEIGHT:** 280 MILES (450 KM)   **DATE:** 18 JUN 2002

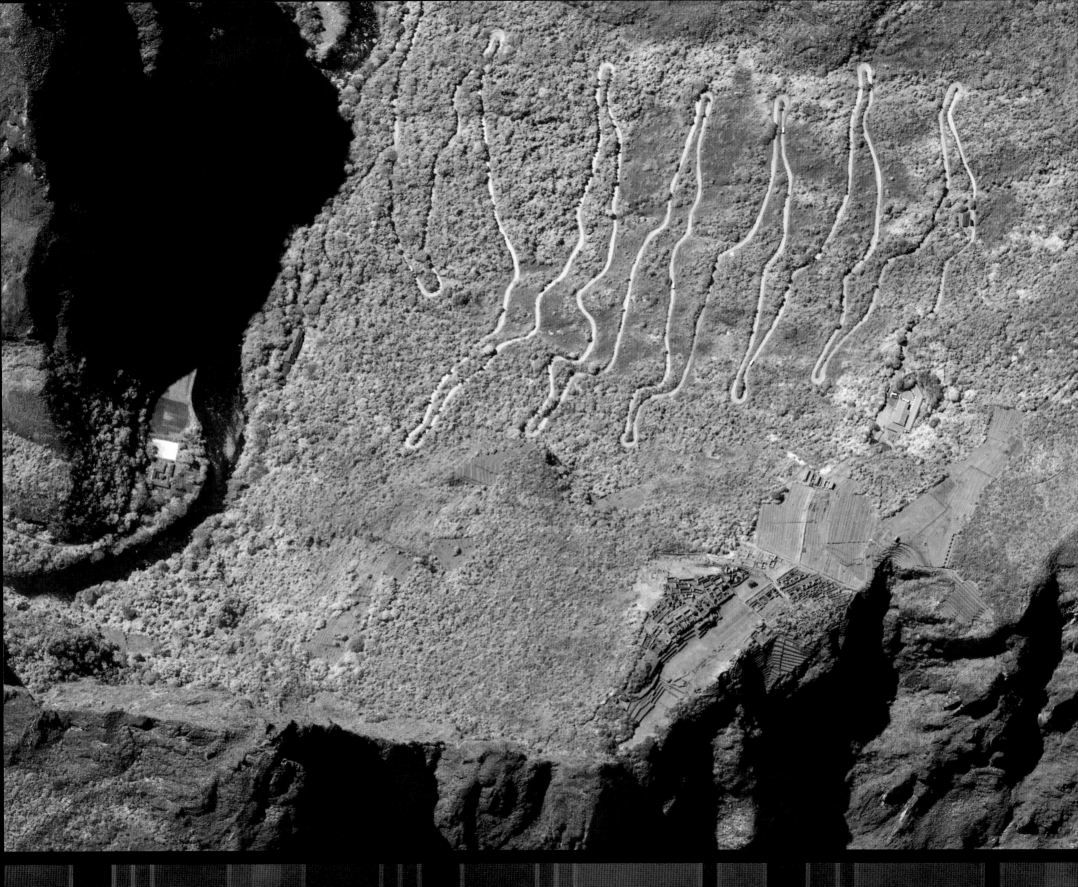

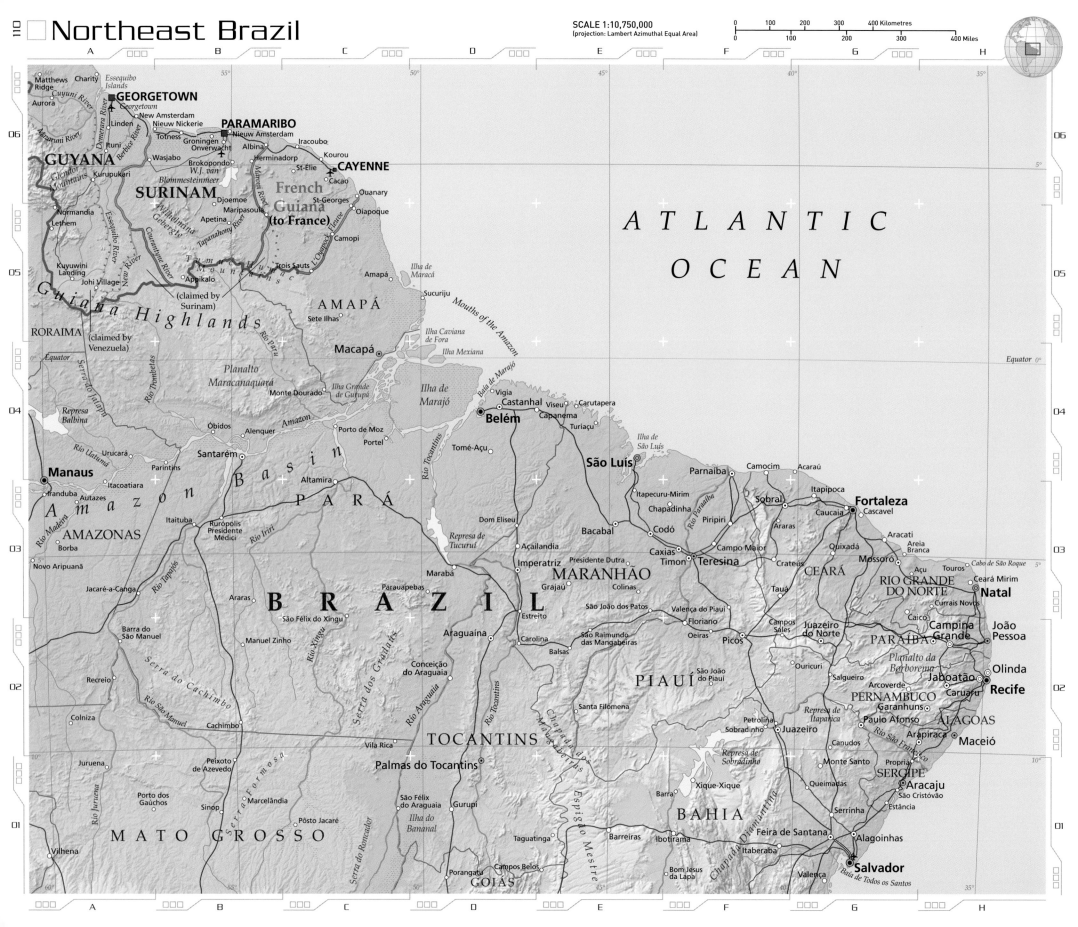

SCALE 1:10,750,000
(projection: Lambert Azimuthal Equal Area)

| 0 | 100 | 200 | 300 | 400 Kilometres |
| 0 | 100 | 200 | 300 | 400 Miles |

**ATLANTIC**

**OCEAN**

Matthews Ridge
Charity
Aurora
Essequibo Islands
Cuyuni River
**GEORGETOWN**
New Amsterdam
Linden
Nieuw Nickerie
Ituni
Totness
Groningen
Onverwacht
**PARAMARIBO**
Nieuw Amsterdam
Iracoubo
Marowijne River
Brokopondo
W.J. van Blommesteinmeer
Herminadorp
Albina
Kourou
**CAYENNE**
St-Élie
Cacao
**GUYANA**
Wasjabo
Djoemoe
**SURINAM**
Apetina
Maripasoula
St-Georges
Ouanary
Oiapoque
Normandia
Lethem
**French Guiana (to France)**
Camopi
Trois Sauts
Amapá
**Guiana Highlands**
Kuyuwini Landing
Appikalo
(claimed by Surinam)
Tumuc-Humac Mountains
Sucuriju
Johi Village
**RORAIMA**
(claimed by Venezuela)
**AMAPÁ**
Mouths of the Amazon
Ilha de Maracá
Ilha Caviana de Fora
Equator
Planalto Maracanaquará
**Macapá**
Ilha Mexiana
Ilha Grande de Gurupá
Ilha de Marajó
Baía de Marajó
Vigia
Represa Balbina
Serra do Tapajós
Rio Trombetas
Monte Dourado
Castanhal
Viseu
Carutapera
Óbidos
Alenquer
Amazon
Porto de Moz
Portel
**Belém**
Capanema
Turiaçu
Ilha de São Luís
Santarém
Tomé-Açu
**São Luís**
Parnaíba
Camocim
Acaraú
**Manaus**
Parintins
Altamira
Itacoatiara
Itapecuru-Mirim
Chapadinha
**Sobral**
Itapipoca
**Fortaleza**
Irlanduba
Autazes
Rio Madeira
**PARÁ**
Itaituba
Rurópolis Presidente Medici
Dom Eliseu
Bacabal
Codó
Piripiri
Araras
Caucaia
Cascavel
**AMAZONAS**
Borba
Rio Iriri
Represa de Tucuruí
Açailândia
Campo Maior
**CEARÁ**
Aracati
Areia Branca
Novo Aripuanã
Itaituba
Marabá
Imperatriz
Presidente Dutra
Caxias
Timon
**Teresina**
Crateús
Quixadá
Mossoró
Açu
Touros
Cabo de São Roque
Jacaré-a-Canga
São Félix do Xingu
Grajaú
Colinas
**MARANHÃO**
Tauá
**RIO GRANDE DO NORTE**
Ceará Mirim
Araras
Barra do São Manuel
**BRAZIL**
Parauapebas
São João dos Patos
Valença do Piauí
Campos Sales
Juazeiro do Norte
Currais Novos
Caicó
**Natal**
Recreio
Manuel Zinho
Araguaína
Estreito
Carolina
Floriano
Oeiras
Picos
**PARAÍBA**
Campina Grande
João Pessoa
Serra do Cachimbo
Conceição do Araguaia
São Raimundo das Mangabeiras
Balsas
Ouricuri
Salgueiro
Arcoverde
Olinda
Jaboatão
Colniza
Rio São Manuel
Cachimbo
Vila Rica
**PIAUÍ**
São João do Piauí
**Planalto da Borborema**
**Recife**
Caruaru
Santa Filomena
Petrolina
**PERNAMBUCO**
Garanhuns
Peixoto de Azevedo
Marcelândia
**TOCANTINS**
Sobradinho
Represa de Itaparica
Paulo Afonso
**ALAGOAS**
Porto dos Gaúchos
Sinop
Pôsto Jacaré
Vila Rica
**Palmas do Tocantins**
Chapada das Mangabeiras
Juazeiro
Canudos
Arapiraca
Maceió
Juruena
Serra Formosa
Rio Araguaia
Rio Tocantins
Barra
Xique-Xique
Monte Santo
Queimadas
Propriá
**SERGIPE**
**Aracaju**
São Cristóvão
Estância
**MATO GROSSO**
São Félix do Araguaia
Gurupi
Ilha do Bananal
Represa de Sobradinho
**BAHIA**
Serrinha
Vilhena
Serra do Roncador
Taguatinga
Barreiras
Ibotirama
Itaberaba
Feira de Santana
Alagoinhas
Porangatu
Campos Belos
Bom Jesus da Lapa
Valença
**Salvador**
**GOIÁS**
Espigão Mestre
Chapada Diamantina
Baía de Todos os Santos
Rio São Francisco
Rio Juruena
Rio Xingu
Rio Tapajós
Rio Tocantins

# SANTA CRUZ

## 17°30'S, 61°30'W

Agricultural clearings have left a splintered pattern of greens and browns across a large part of the Bolivian state of Santa Cruz, where once there was a continuous cover of tropical dry forest. The same area is covered by the smaller inset image, taken in 1984. Some of the early forest clearings have a distinctive radial pattern where small settlements of about thirty farmhouses were established in the 1980s. People from Bolivia's Altiplano were encouraged to relocate in an effort to develop the agricultural potential of the country's lowlands. The main cash crop in the area is soya beans. Dark lines between the larger strip fields show where trees have been left to act as windbreaks.

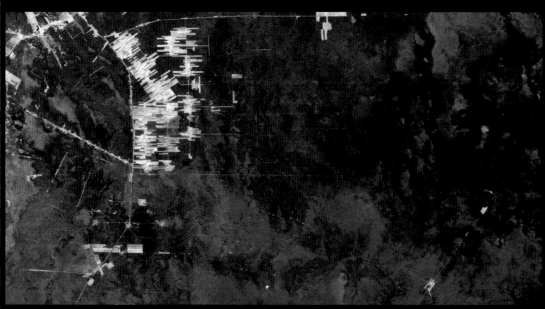

◄ **Forest clearance** on this scale occurs elsewhere in South America, notably in Bahia state, Brazil where only 0.4% of forest remains from its original area of 83,200 sq miles (215,437 sq km).

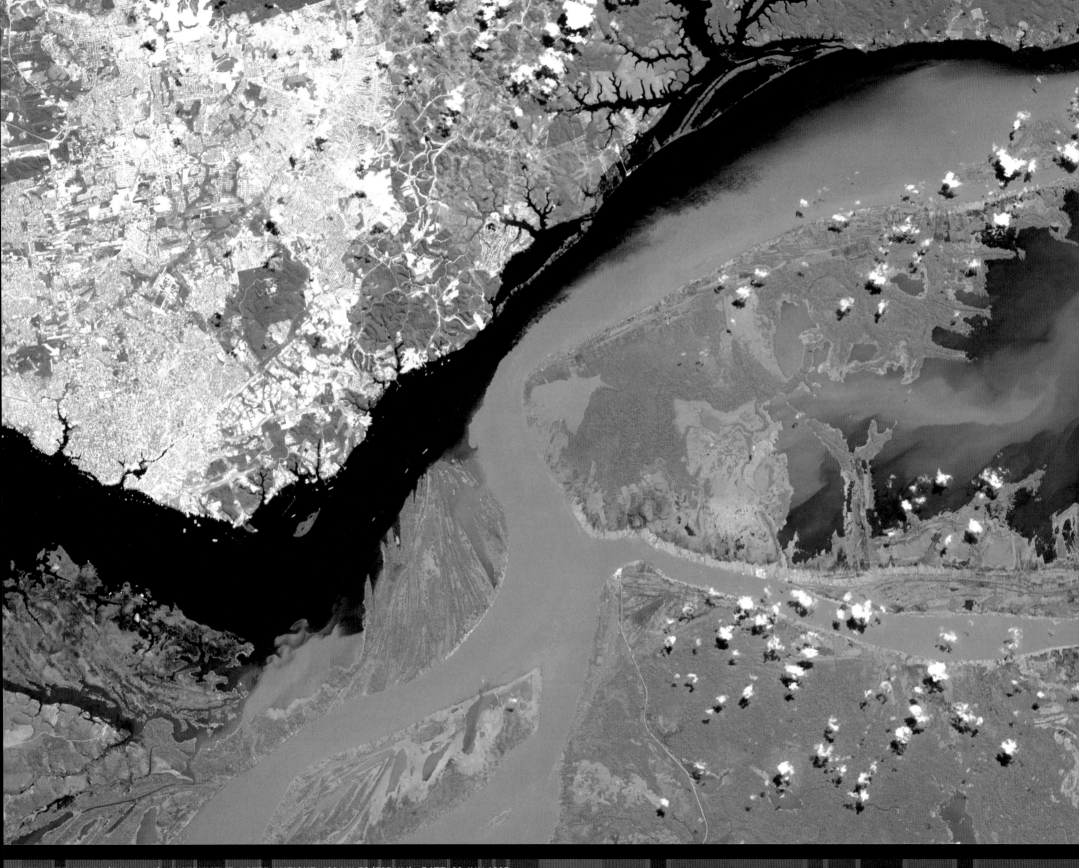

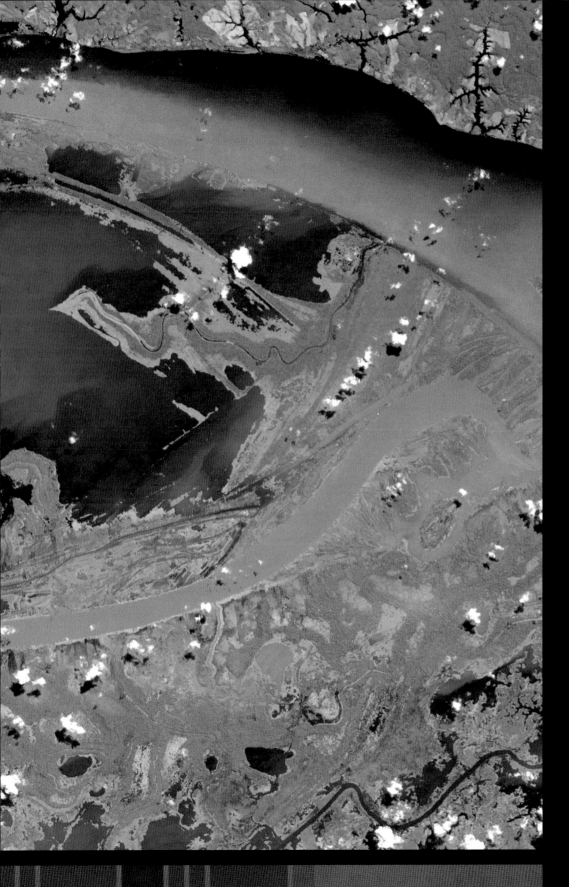

# RIO NEGRO

## 3°08'S, 59°55'W

The Rio Negro joins the Amazon from the north near the Brazilian city of Manaus, producing a stark contrast in the colour of their waters that persists for a great distance downstream. The Amazon is muddy-brown due to its heavy load of sediment eroded from the Peruvian Andes. Although the Rio Negro (Black River) also carries sediment, the load is not so great and its water is stained to a blood-red by tanins in plant debris which falls into the river along its 1430 mile (2300 km) length. The Amazon is about 3 miles (5 km) wide at the junction and Manaus is accessible to ocean-going ships. It has been an important port since the 1800s, exporting rubber, timber, nuts and fruit. Today, development interest focuses on the search for oil and mineral resources in the Amazon Basin.

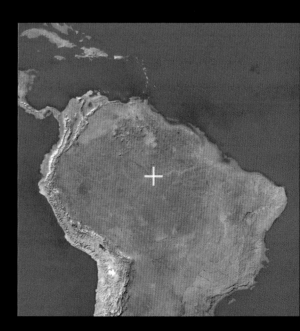

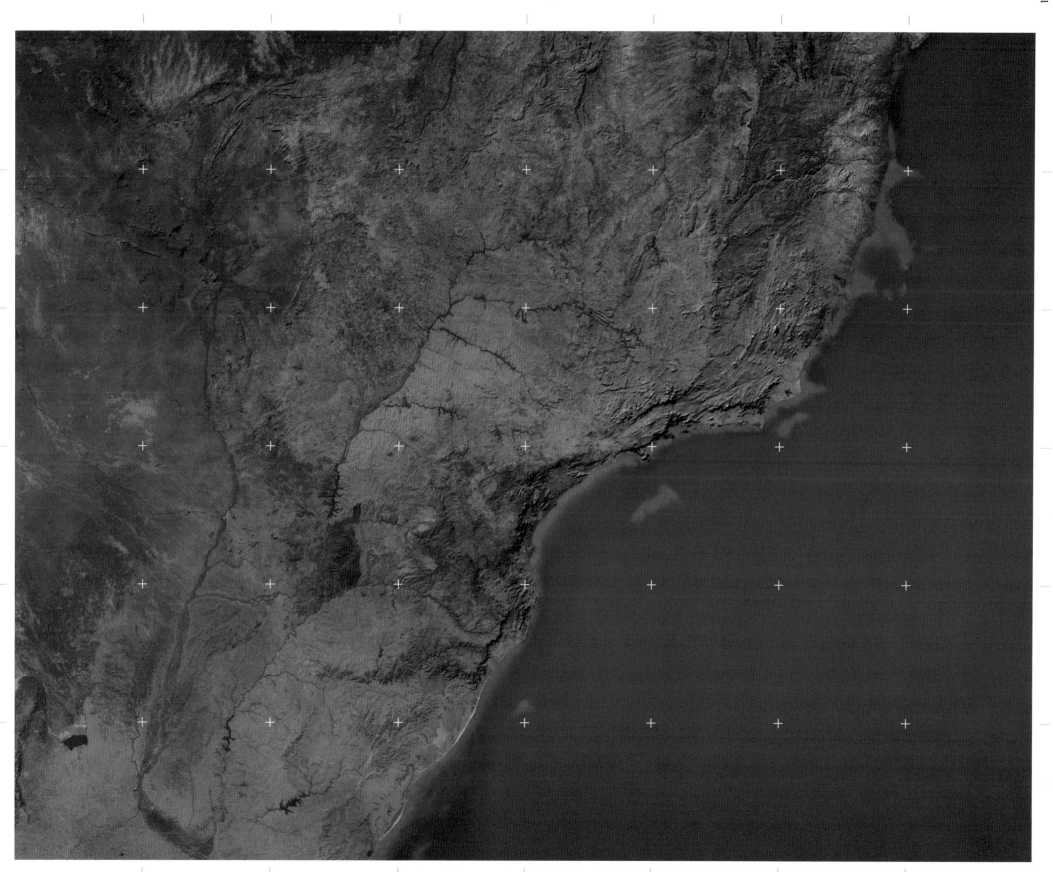

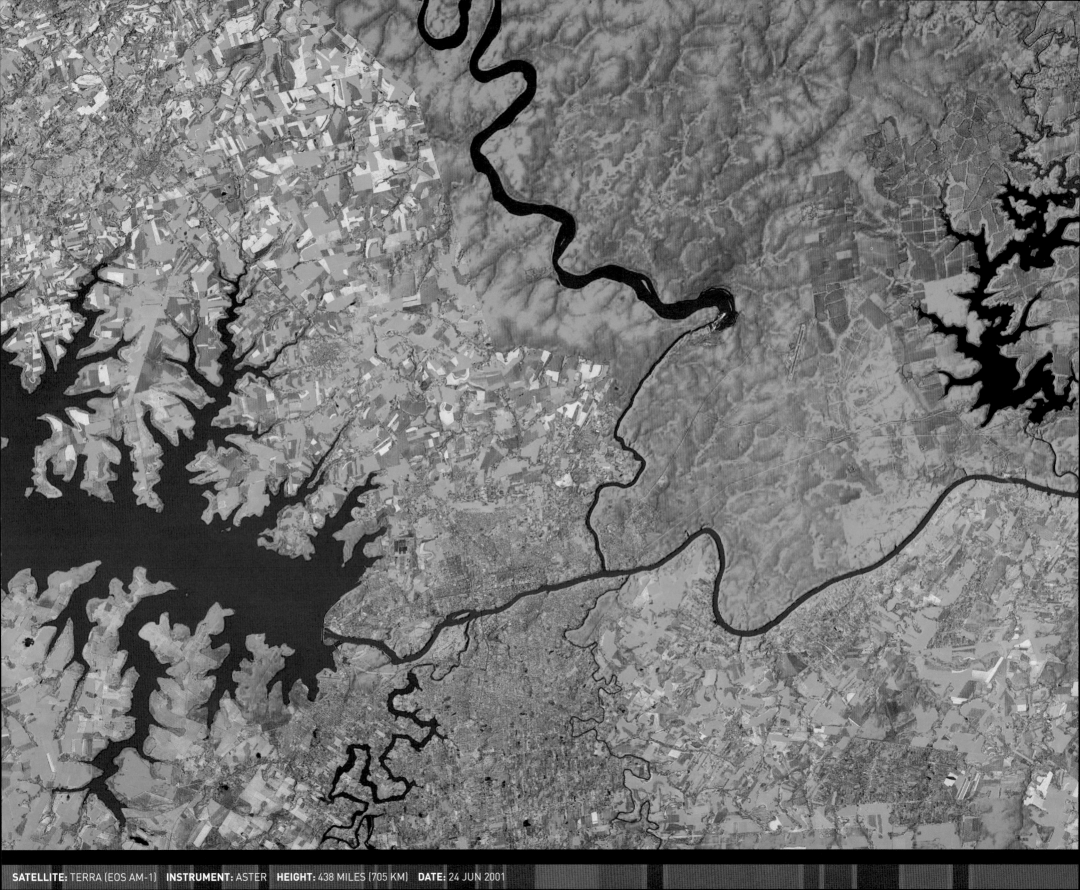

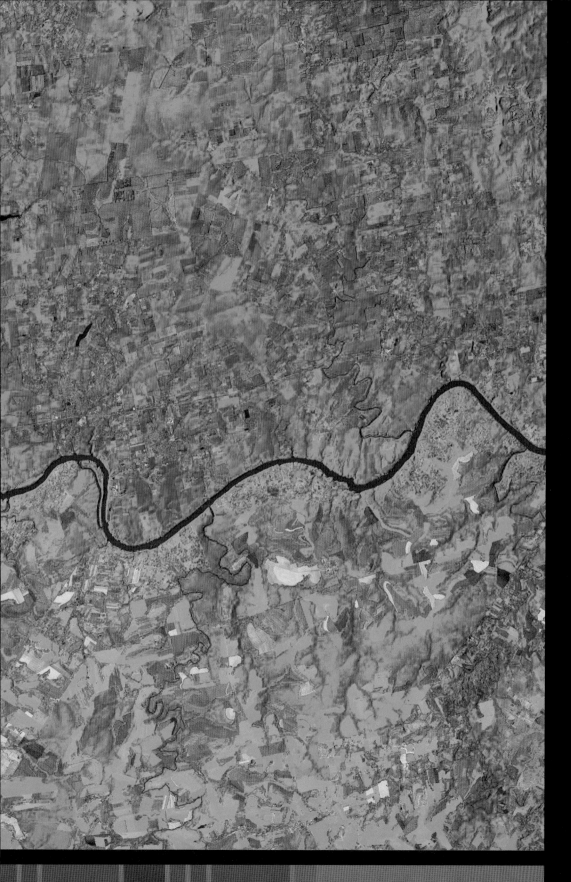

# LAKE ITAIPÚ

## 24°44'S, 54°20'W

Lake Itaipú is a large reservoir, visible on the left (northern) edge of this 150 mile (240 km) wide satellite image. It was formed in 1982 by damming the Paraná, raising the water level by 643 ft (196 m) as part of the largest hydroelectric power scheme in the world. An installed capacity of 14 gigawatts delivers 95% of Paraguay's energy needs and 24% of Brazil's. The lake now forms part of the border between Paraguay and Brazil, and downstream (to the right of the image) the Paraná forms the border between Paraguay and Argentina. An international treaty had to be concluded between the three countries before the scheme could go ahead.

◄ **Different land use patterns** are apparent in each country, with extensive field patterns on the Paraguayan side of the river, in contrast to more complete forest cover on the Argentinian side. In Brazil (top left), the forest edge has straight lines, marking the boundary of a National Park surrounding the Iguaçu Falls, which are just visible where the broad Iguaçu, running down from the top of the image, suddenly narrows.

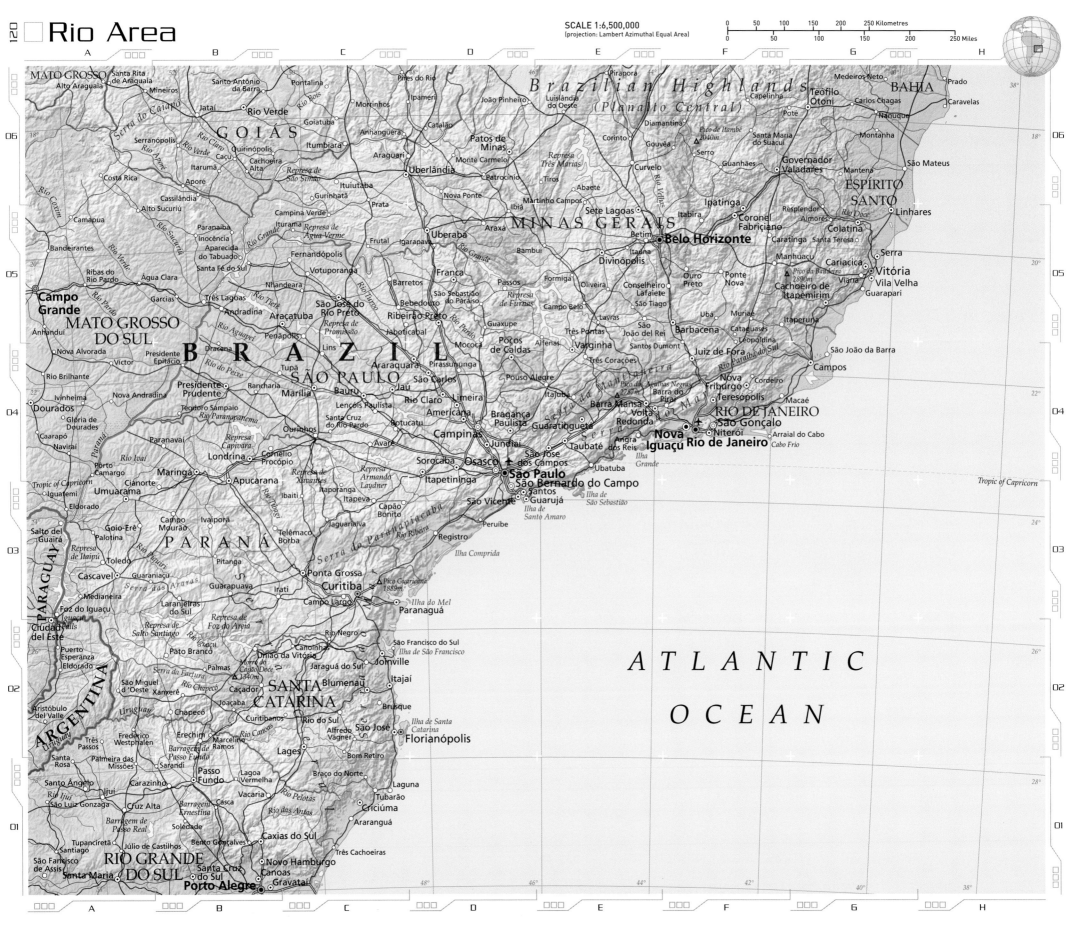

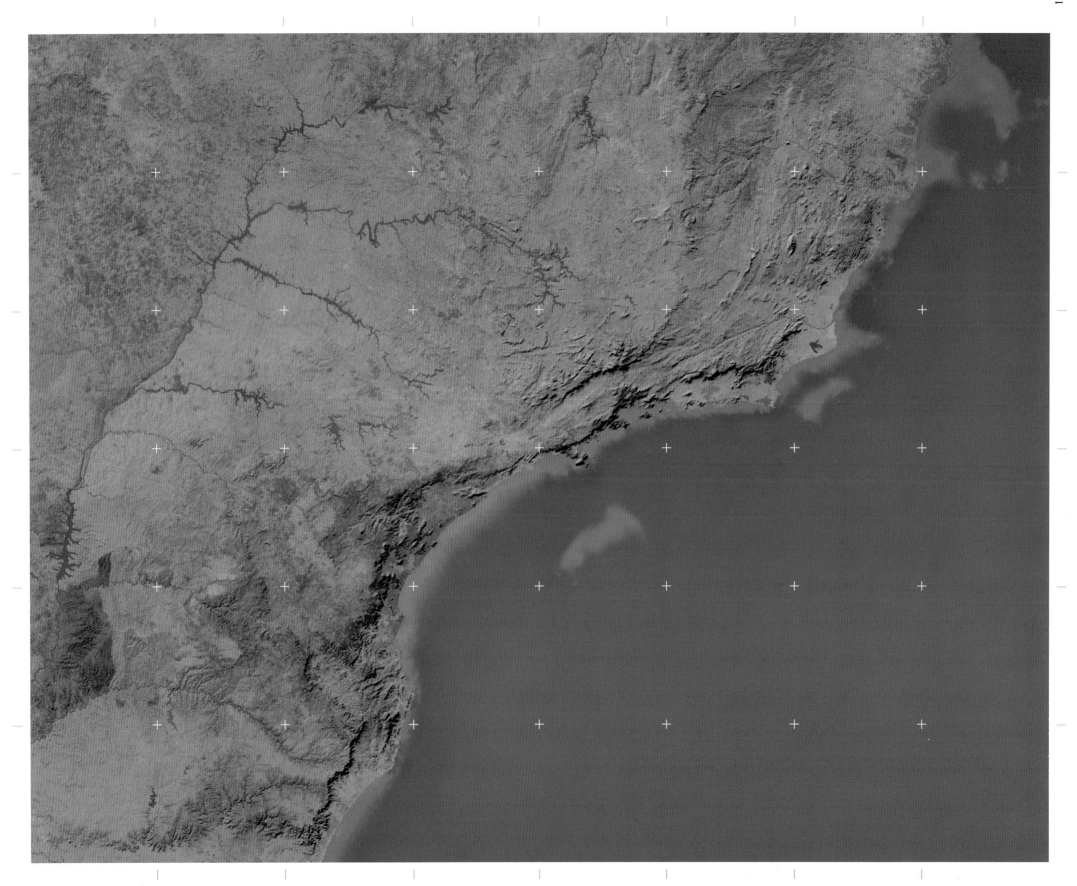

# RIO DE JANEIRO

## 22°52'S, 43°16'W

The former capital of Brazil (until 1960, when Brasília was built) occupies the southwestern fringe of the spectacular Guanabara Bay on Brazil's southeast coast. First discovered by Portuguese navigators, the bay was briefly settled by the French, until the Portuguese expelled them in 1567. Guanabara Bay is one of the largest natural harbours in the world, and 'Rio' itself is built on a plain, protected from the Atlantic by mountains at the mouth of the bay. The forests of these mountains are in turn protected as a national park, containing some of the last remnants of Brazil's fast-disappearing Atlantic rainforest ecosystem. On the other side of the mountains the city's most famous beaches, Copacabana and Ipanema, face the Atlantic Ocean.

rather than following a master plan, its sheltered position has permitted considerable development and reclamation of the shoreline such as around the Santos Dumont Airport and the naval base.

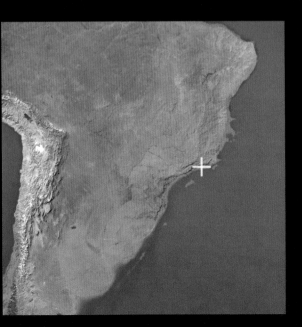

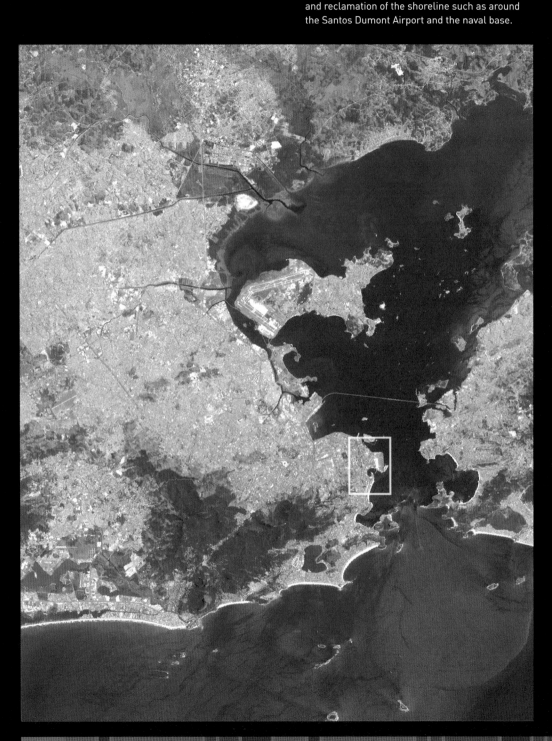

▶ **The narrow entrance** to Guanabara Bay preludes one of the most famous harbours in the world, overlooked by the iconic statue of Cristo Redentor (Christ the Redeemer), set within the forested area towards the bottom of this image.

**SATELLITE:** LANDSAT 7  **INSTRUMENT:** ETM+  **HEIGHT:** 438 MILES (705 KM)  **DATE:** 28 OCT 2001

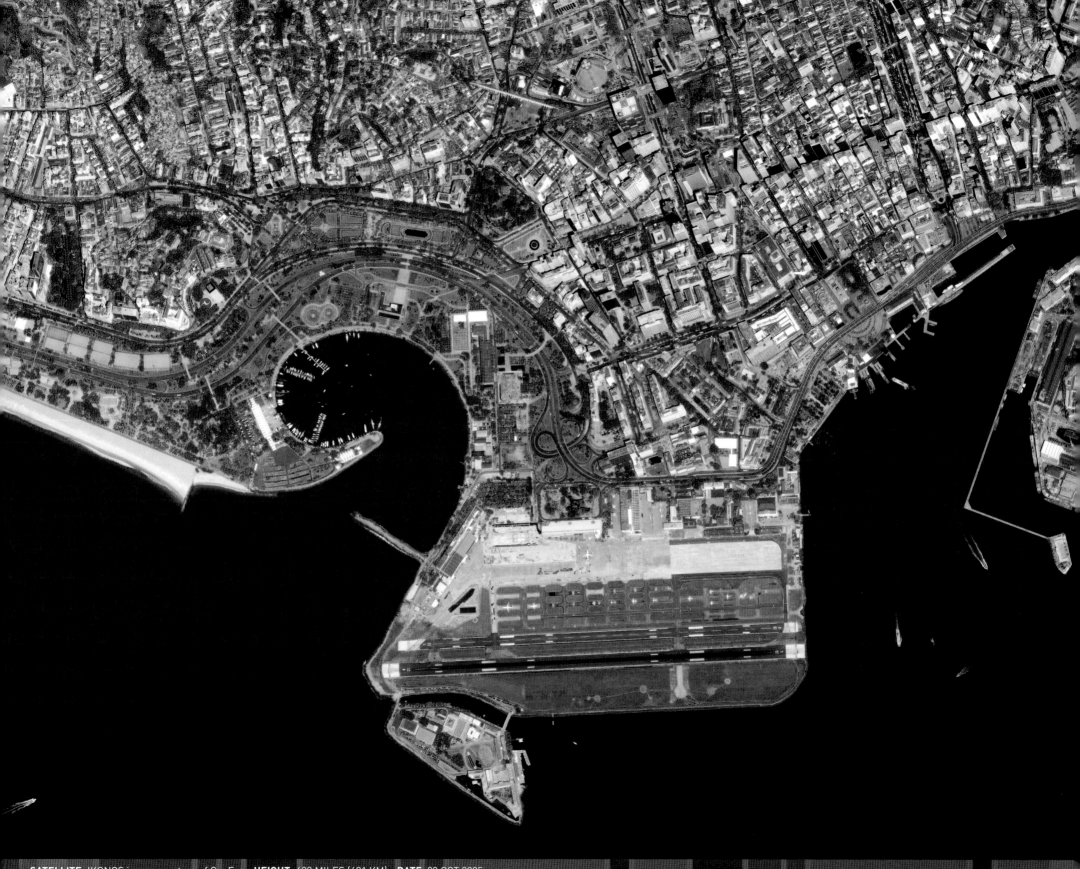

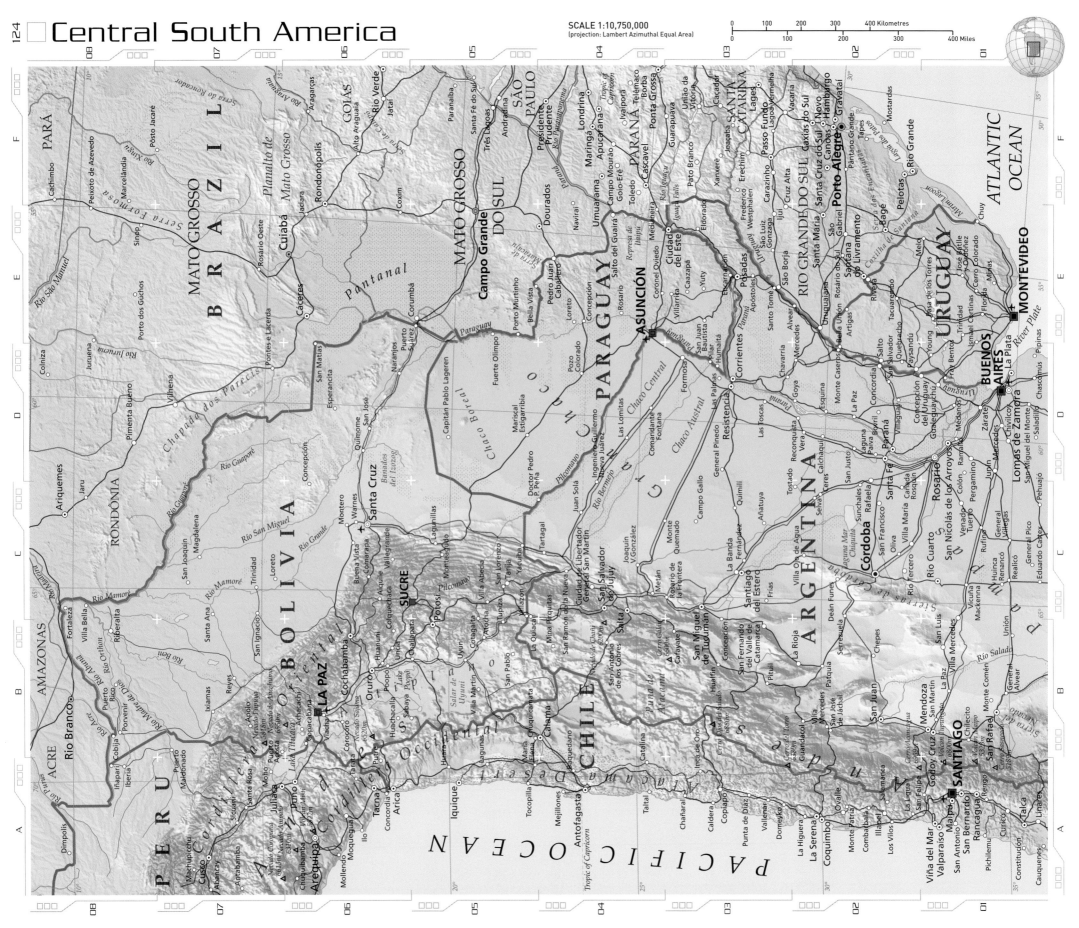

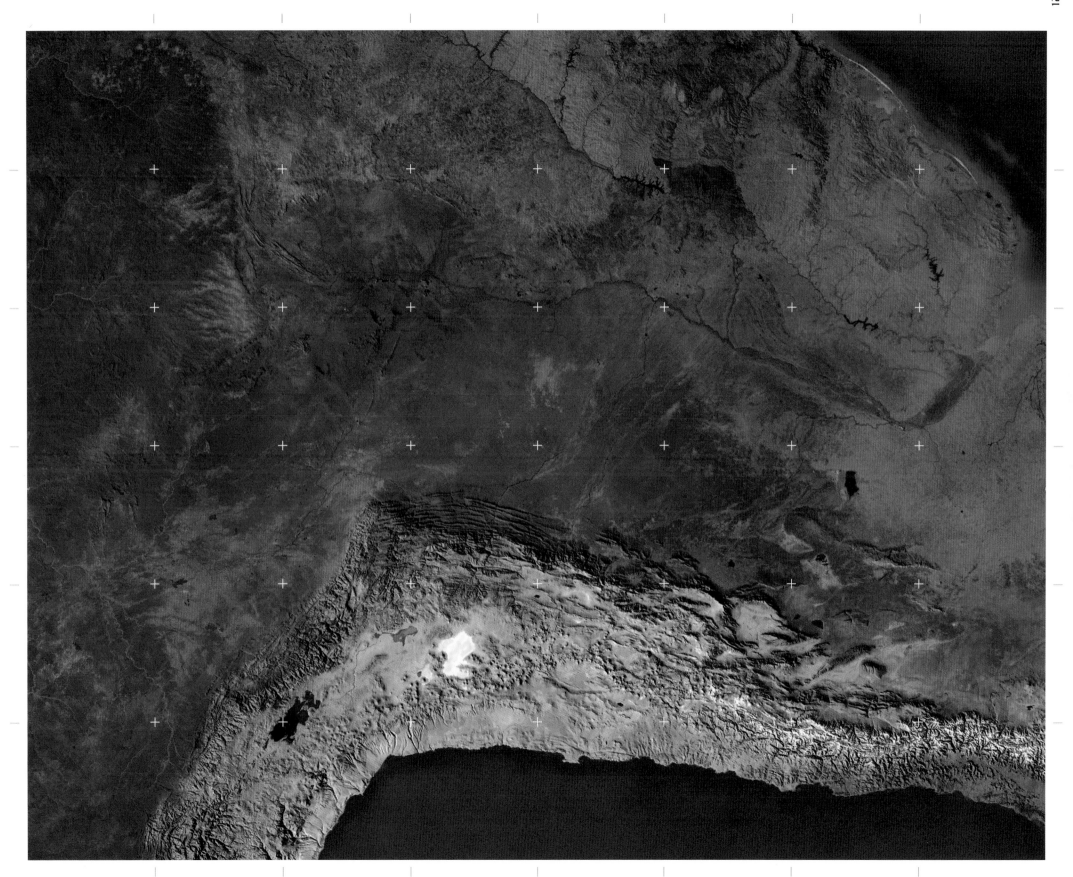

# BUENOS AIRES

## 34°40'S, 58°30'W

The capital of Argentina and, for many, Latin America's most sophisticated metropolis, Buenos Aires was founded in 1580 at the northwestern extremity of the River Plate estuary as the principal Atlantic port of the Spanish Latin American empire. Its extensive dock facilities are a testament to the city's rapid growth in the 18th and 19th centuries around meat processing (initially drying and salting), with numerous tanneries, flour mills, breweries and foundries, all fed by the extensive agricultural and mineral resources of Argentina and its neighbours. Today, with a population of over 2.75 million, and a metropolitan population four times as large, it remains the single most powerful commercial and industrial city in the South American cone.

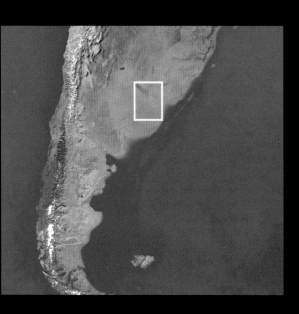

wide at this point, and as it runs southeast to the Atlantic Ocean it eventually grows to 136 miles (220 km) wide, making it the widest river in the world

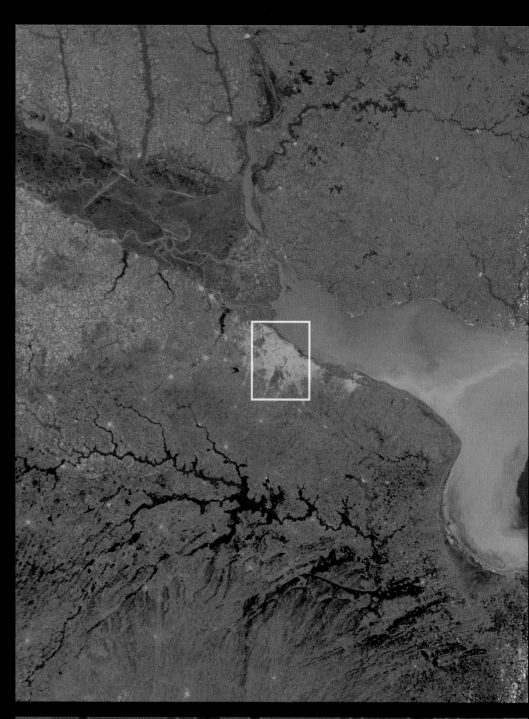

**SATELLITE:** TERRA (EOS AM-1), MODIS   **HEIGHT:** 438 MILES (705 KM)   **DATE:** 22 OCT 2001

▼ **The industrial expansion** of Buenos Aires in the 19th century meant that it profited from new European ideas about urban planning. Like many North American cities, a grid plan was imposed, intersected with discrete diagonals linking outlying districts to the city centre, which lies just behind the shoreline dockyard developments.

▼ **The original dockyard developments** of Buenos Aires are protected from the open water by a low-lying island, while breakwaters are visible protecting the modern port to the north.

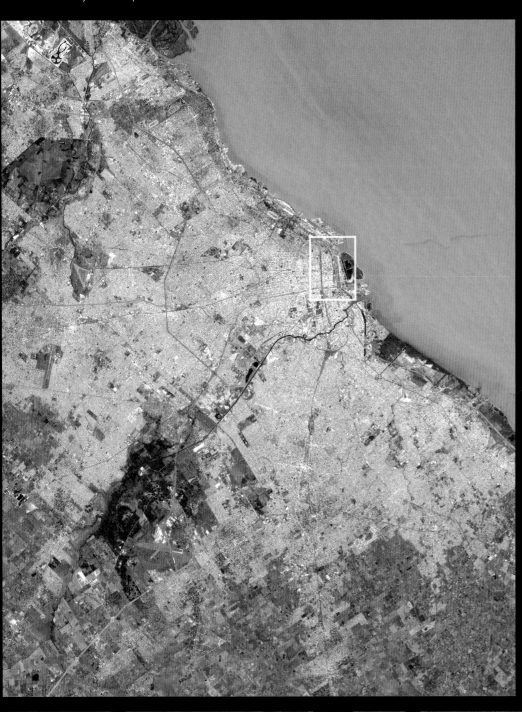

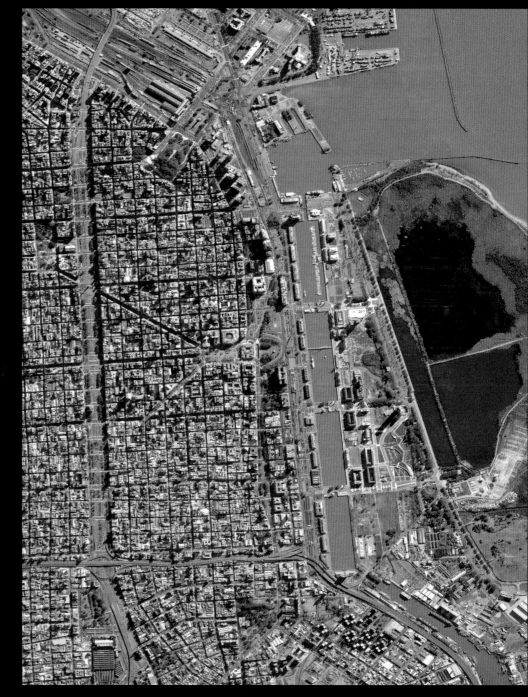

**SATELLITE:** LANDSAT 7   **INSTRUMENT:** ETM+   **HEIGHT:** 438 MILES (705 KM)   **DATE:** 20 DEC 2000

**SATELLITE:** QUICKBIRD image courtesy of DigitalGlobe   **HEIGHT:** 280 MILES (450 KM)   **DATE:** 11 AUG 2003

# ESCONDIDA MINE

## 24°16'S, 69°04'W

Situated in Chile's Atacama Desert, about 100 miles (160 km) southeast of Antofagasta, the Escondida (Hidden) Mine produces more copper than any other open-cast mine, contributing 8% of total world copper production. Gold and silver are also mined at the site. The satellite image shows an area 14 miles (23 km) across, revealing the 'hidden' mines' open pits and adjacent spoil heaps and settling ponds. Infrastructure at the site includes two ore concentrator plants, numerous access roads, an airstrip and transport ducts leading off to the west that carry copper concentrate 105 miles (170 km) to the port of Coloso. Satellites using shortwave infrared wavelengths are used to distinguish different surface rock types, which can help to locate ore deposits.

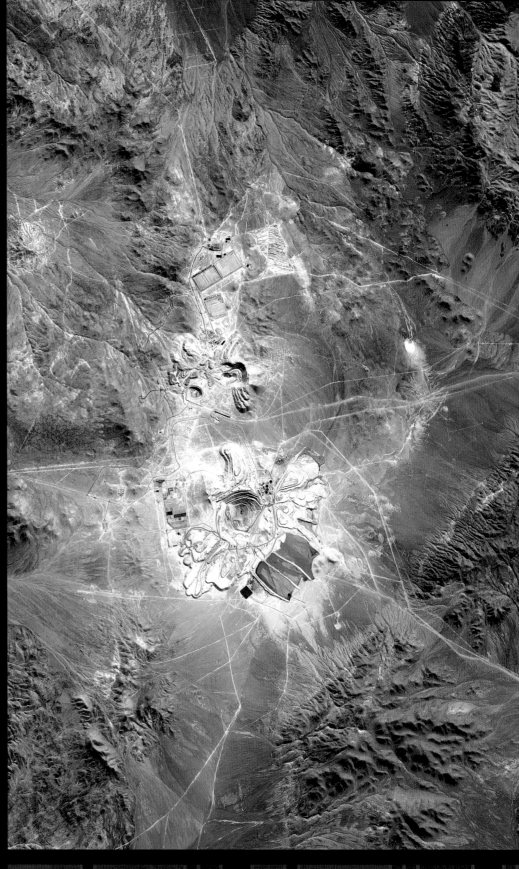

**SATELLITE:** TERRA   **INSTRUMENT:** ASTER   **HEIGHT:** 438 MILES (705 KM)   **DATE:** 23 APR 2000

# SAN QUINTIN GLACIER

46°52'S, 74°05'E

The largest glacier flowing on the north Patagonian ice field in southern Chile, the San Quintin Glacier terminates in two meltwater ponds. A semi-circular terminal moraine can be seen beyond the ponds, indicating the previous position of the snout almost 2.5 miles (4 km) further downslope.

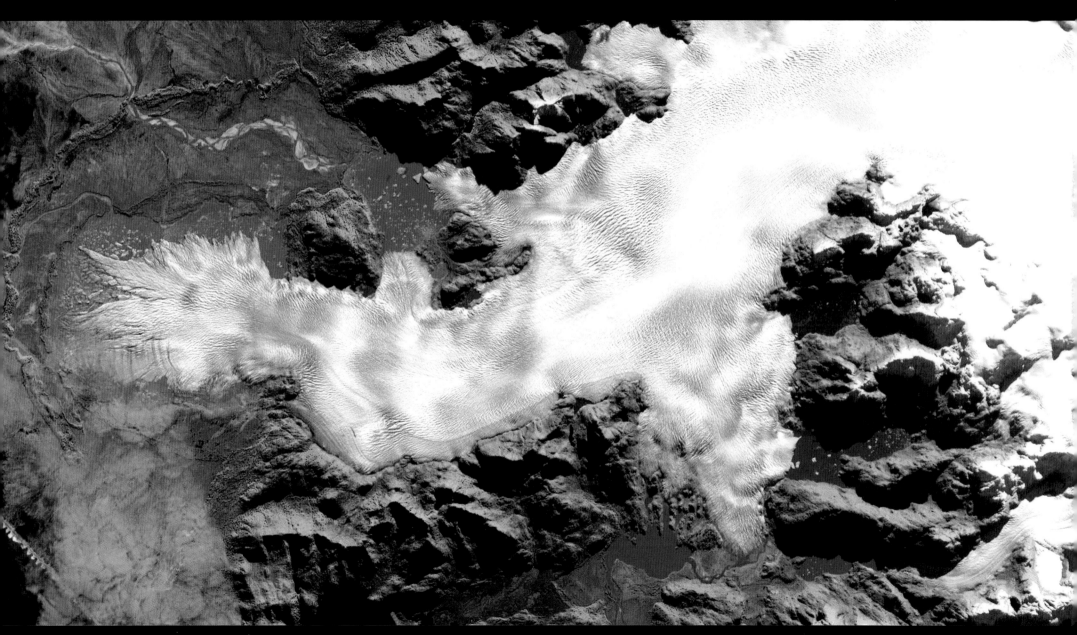

**SATELLITE:** TERRA (EOS AM-1)   **INSTRUMENT:** ASTER   **HEIGHT:** 438 MILES (705 KM)   **DATE:** 02 MAY 2000

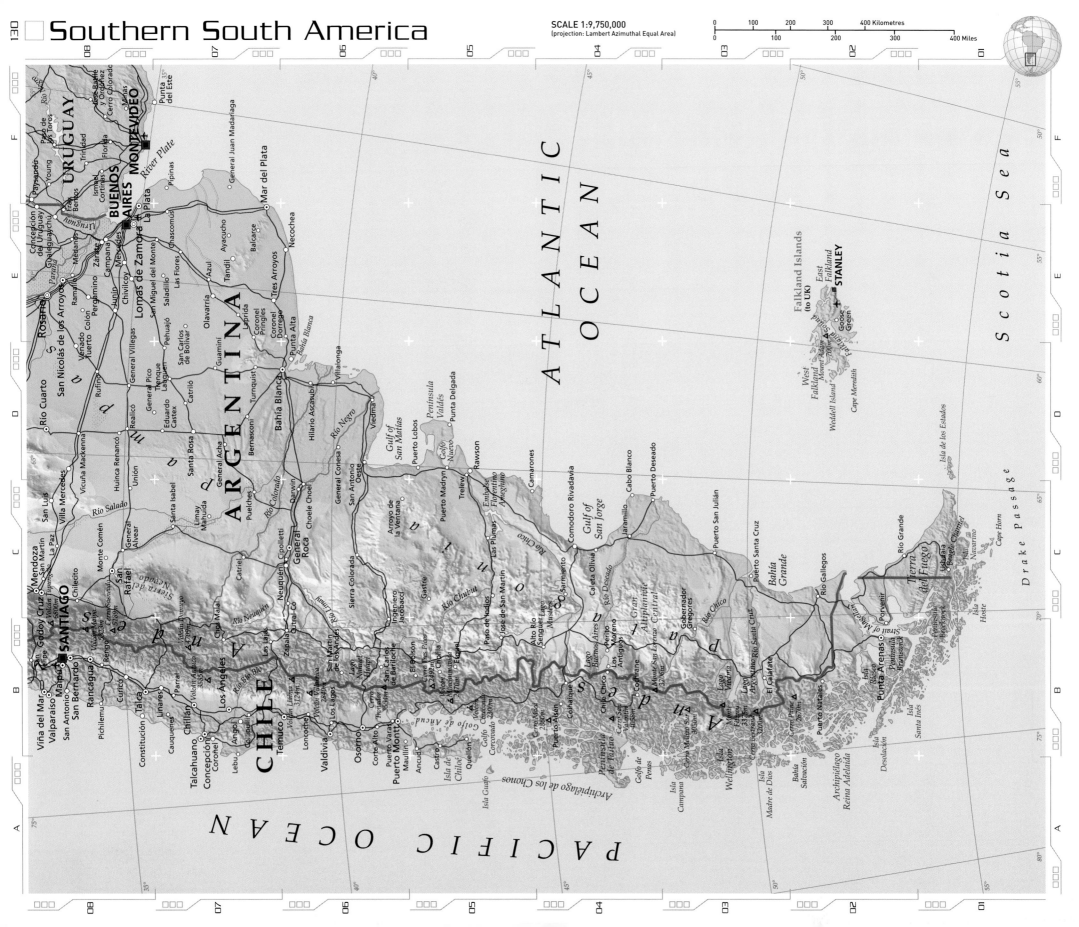

AFRICA

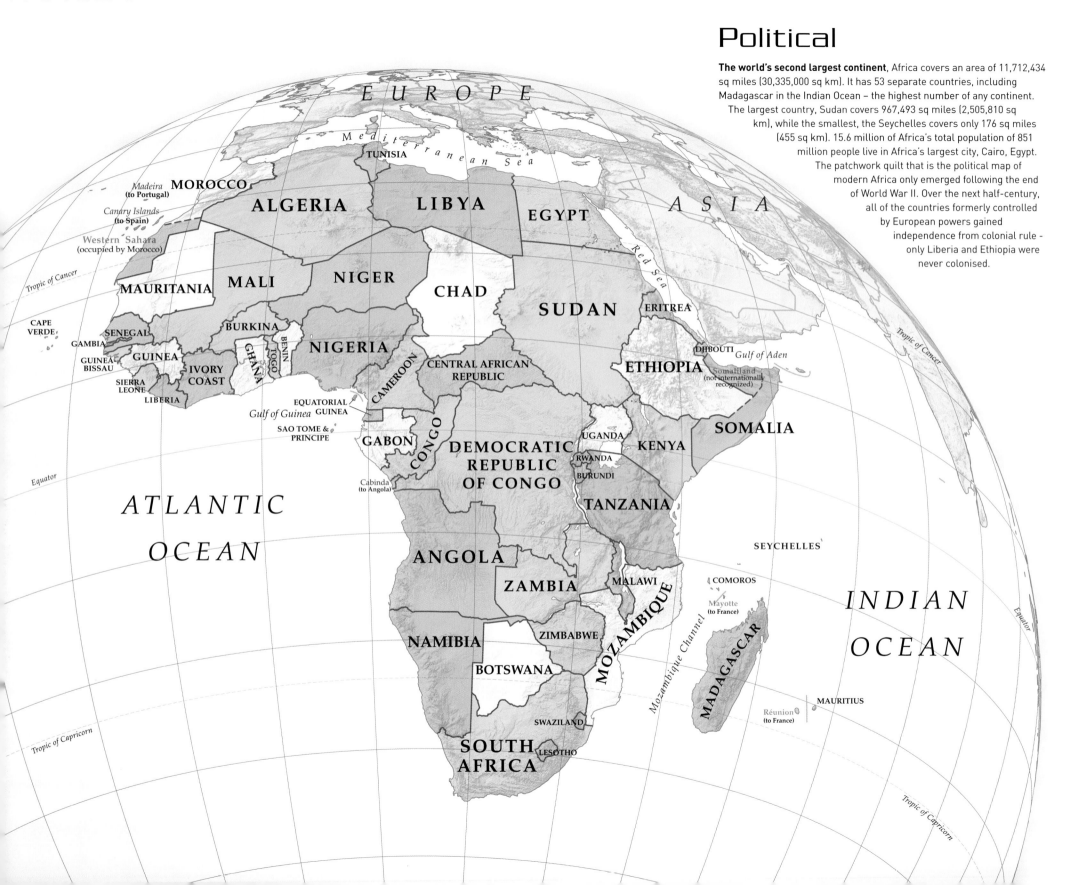

# Political

**The world's second largest continent**, Africa covers an area of 11,712,434 sq miles (30,335,000 sq km). It has 53 separate countries, including Madagascar in the Indian Ocean – the highest number of any continent. The largest country, Sudan covers 967,493 sq miles (2,505,810 sq km), while the smallest, the Seychelles covers only 176 sq miles (455 sq km). 15.6 million of Africa's total population of 851 million people live in Africa's largest city, Cairo, Egypt. The patchwork quilt that is the political map of modern Africa only emerged following the end of World War II. Over the next half-century, all of the countries formerly controlled by European powers gained independence from colonial rule – only Liberia and Ethiopia were never colonised.

EUROPE

ASIA

*Mediterranean Sea*

TUNISIA

*Madeira
(to Portugal)* MOROCCO

ALGERIA

LIBYA

EGYPT

*Canary Islands
(to Spain)*

Western Sahara
(occupied by Morocco)

*Red Sea*

*Tropic of Cancer*

MAURITANIA

MALI

NIGER

CHAD

SUDAN

ERITREA

*Tropic of Cancer*

CAPE
VERDE

SENEGAL

BURKINA

DJIBOUTI *Gulf of Aden*

GAMBIA

NIGERIA

CENTRAL AFRICAN
REPUBLIC

ETHIOPIA

Somaliland
(not internationally
recognized)

GUINEA-
BISSAU

GUINEA

GHANA

TOGO

BENIN

SIERRA
LEONE

IVORY
COAST

CAMEROON

LIBERIA

EQUATORIAL
*Gulf of Guinea* GUINEA

SOMALIA

SAO TOME &
PRINCIPE

GABON

CONGO

UGANDA

KENYA

DEMOCRATIC
REPUBLIC
OF CONGO

RWANDA

BURUNDI

*Equator*

Cabinda
(to Angola)

*Equator*

TANZANIA

ATLANTIC

OCEAN

SEYCHELLES

ANGOLA

ZAMBIA

MALAWI

COMOROS

*Mayotte
(to France)*

INDIAN

OCEAN

NAMIBIA

ZIMBABWE

MOZAMBIQUE

*Mozambique Channel*

MADAGASCAR

*Tropic of Capricorn*

BOTSWANA

MAURITIUS

*Réunion
(to France)*

*Tropic of Capricorn*

SWAZILAND

SOUTH
AFRICA

LESOTHO

# Physical

**Northern and southern Africa** are both very hot and dry. The northern part of the continent is dominated by the Sahara, the largest desert in the world. In the south, the Kalahari and Namib deserts match the Sahara for aridity if not size. Near the Equator, large areas of tropical rainforests can still be found, especially in the Congo Basin. Some of the world's great rivers drain the continent including the Congo, Niger, Zambezi and not least the Nile, the longest in the world, which flows north for 4160 miles (6695 km) from its source in East Africa, bringing a narrow fertile strip to arid Egypt. Also in East Africa, cracks in the continent form the flat-bottomed, steep-sided Great Rift Valley which stretches from the Red Sea to Lake Nyasa, bearing other large lakes on the way.

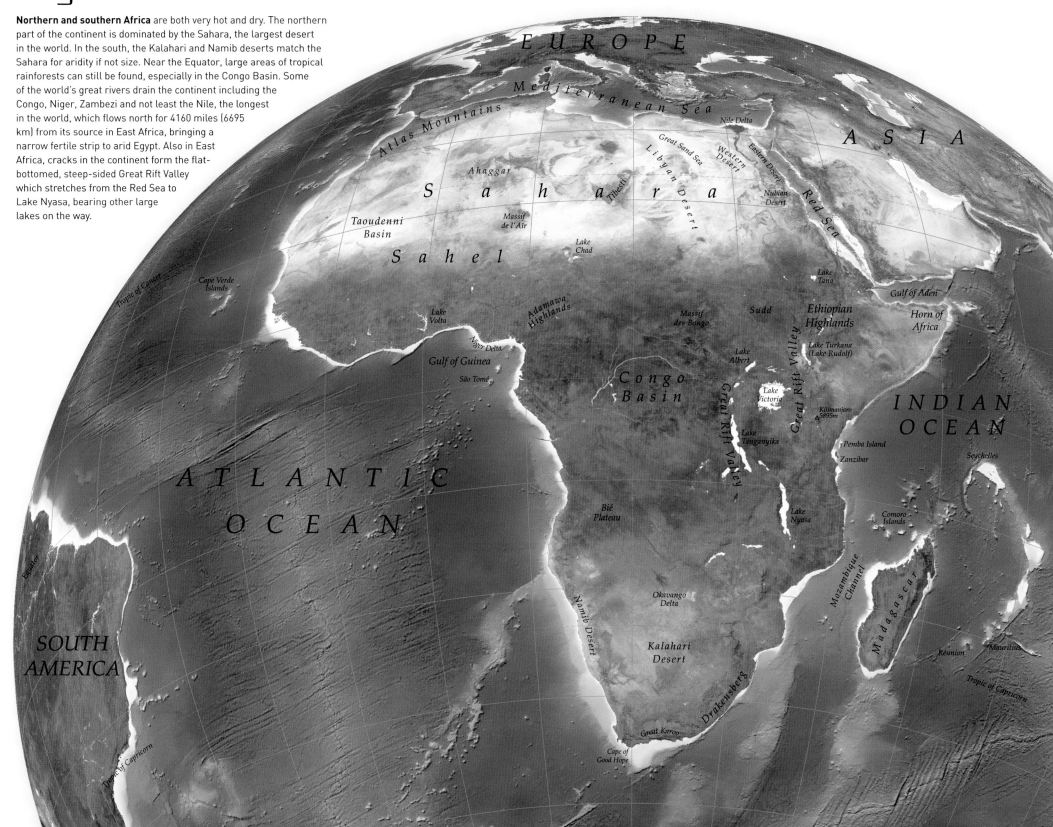

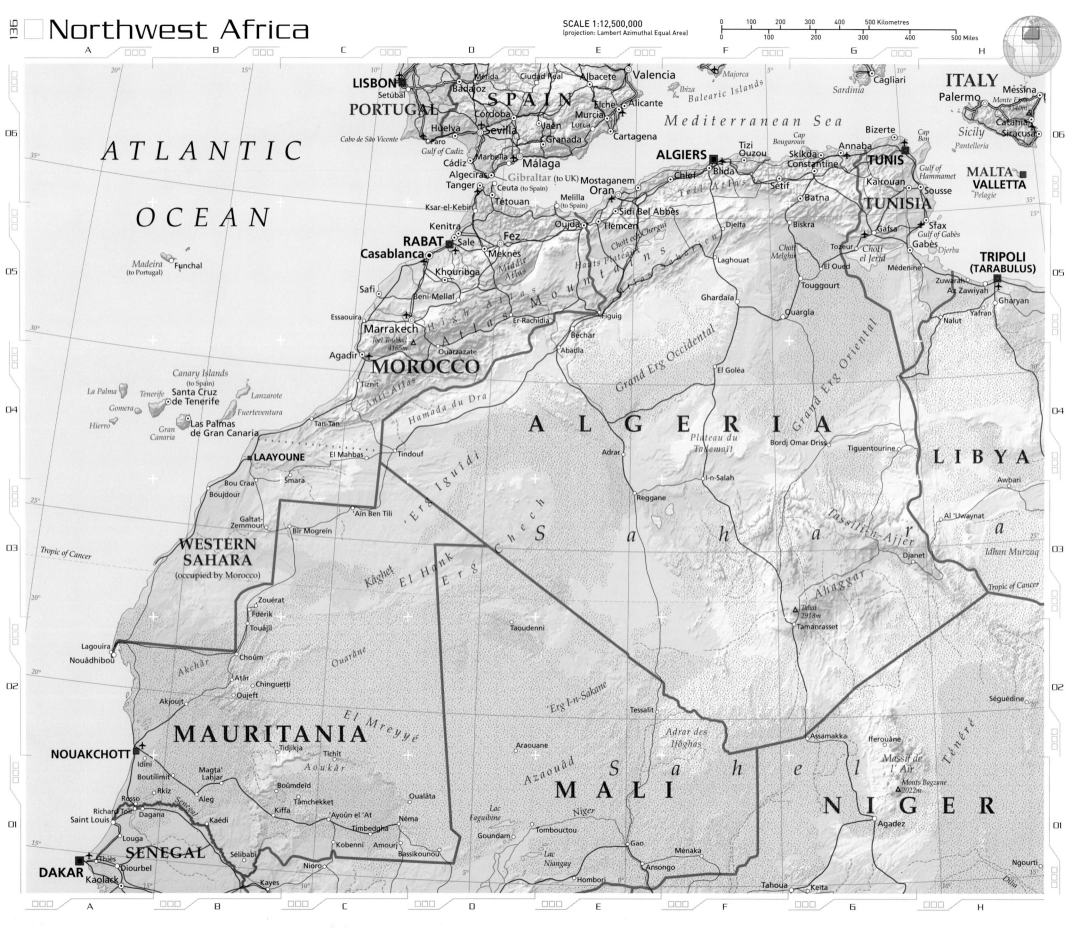

# Northwest Africa

SCALE 1:12,500,000
(projection: Lambert Azimuthal Equal Area)

| 0 | 100 | 200 | 300 | 400 | 500 Kilometres |
| 0 | 100 | 200 | 300 | 400 | 500 Miles |

ATLANTIC

OCEAN

ITALY
Messina
Palermo
Monte Etna
3340m
Catania
Siracusa
Sicily

Mediterranean Sea

LISBON
PORTUGAL
Setúbal
Badajoz
Mérida
Ciudad Real
Albacete
Valencia
SPAIN
Elche
Alicante
Ibiza
Majorca
Balearic Islands
Sardinia
Cagliari

Huelva
Córdoba
Sevilla
Jaén
Lorca
Murcia
Cartagena
Cabo de São Vicente
Gulf of Cádiz
Cádiz
Faro
Marbella
Málaga
Granada
Algeciras
Tanger
Ceuta (to Spain)
Gibraltar (to UK)
Tétouan
Melilla (to Spain)
Ksar-el-Kebir
Mostaganem
Oran
ALGIERS
Blida
Chlef
Tell Atlas
Tizi Ouzou
Skikda
Constantine
Annaba
Bizerte
Cap Bon
TUNIS
TUNISIA
Cap Bougaroun
Gulf of Hammamet
Pantelleria
MALTA
VALLETTA
Pelagie

Kenitra
Sale
RABAT
Casablanca
Fez
Meknès
Oujda
Tlemcen
Sidi Bel Abbès
Sétif
Batna
Kairouan
Sousse
Sfax
Gulf of Gabès
Gabès
Djerba
Khouribga
Middle Atlas
Hauts Plateaux
Djelfa
Biskra
Gafsa
Chott ech Chergui
Atlas Saharien
Chott Melrhir
Tozeur
Chott el Jerid

Safi
Beni-Mellal
Laghouat
TRIPOLI
(TARABULUS)
Essaouira
High Atlas
Er-Rachidia
Figuig
Béchar
Ghardaïa
El Oued
El Golea
Touggourt
Zuwarah
Az Zawiyah
Gharyan
Marrakech
Jbel Toubkal
4165m
Ouarzazate
Abadla
Ouargla
Médenine
Nalut
Yafran
Agadir
MOROCCO
Anti-Atlas
Tiznit
Hamada du Dra
ALGERIA
Grand Erg Occidental
Grand Erg Oriental
LIBYA
Awbari
Tan-Tan

Madeira
(to Portugal)
Funchal

Canary Islands
(to Spain)
La Palma
Tenerife
Santa Cruz de Tenerife
Lanzarote
Gomera
Hierro
Fuerteventura
Gran Canaria
Las Palmas de Gran Canaria

LAAYOUNE
El Mahbas
Tindouf
'Erg Iguidi
Adrar
Plateau du Tademaït
Bordj Omar Driss
Tiguentourine
Al 'Uwaynat
Bou Craa
Smara
Boujdour
Galtat-Zemmour
Aïn Ben Tili
I-n-Salah
Tassili-n-Ajjer
Djanet
Idhan Murzuq
Tropic of Cancer
WESTERN SAHARA
(occupied by Morocco)
Bîr Mogreïn
Kâghet
El Honk
Erg Chech
Reggane
Sahara
Ahaggar
Tropic of Cancer

Zouérat
Fdérik
Touâjil
Taoudenni
Tahat
2918m
Tamanrasset
Lagouira
Nouâdhibou
Choûm
Quarâne
Atâr
Chinguetti
Oujeft
Akjoujt
MAURITANIA
El Mreyyé
Erg I-n-Sakane
Adrar des Ifôghas
Assamakka
Iferouâne
Massif de l'Aïr
Ténéré
Séguédine

NOUAKCHOTT
Idini
Boutilimit
Tidjikja
Tichît
Aoukâr
Araouane
Azaouâd
Sahel
MALI
Monts Bagzane
2022m
NIGER
Rkiz
Magta' Lahjar
Boûmdeïd
Tâmchekket
Ouâlata
Lac Faguibine
Ménaka
Agadez

Rosso
Richard Toll
Dagana
Aleg
Kaédi
Kiffa
Ayoûn el 'At
Néma
Niger
Tombouctou
Goundam
Niger
Gao
Ménaka
Séguédine
Saint Louis
Louga
Sélibabi
Kobenni
Amourj
Nioro
Lac Niangay
Ansongo
Ngourti
DAKAR
Thiès
Diourbel
SENEGAL
Kaolack
Kayes
Bassikounou
Timbedgha
Homboji
Tahoua
Keïta
Dilia

# LAKE CHAD

## 13°20'N, 14°E

Lake Chad is the remnant of an ancient lake fed by the rivers of North Africa during a wetter climate millions of years ago. Today the lake is a large freshwater wetland fed largely from the south by the Chari and Logone rivers, with an area of standing water which varies with the seasons. The lake is no more than 23 ft (7 m) deep and parallel ridges of sand dunes punctuate its surface as it becomes more shallow towards the east. The climate of the Sahel region has become increasingly dry, prompting the local population to draw more water from rivers and the lake to irrigate crops, with a four-fold increase between 1983 and 1994. Low rainfall and agricultural practices have radically reduced the size of the lake, a situation not likely to ease in the near future.

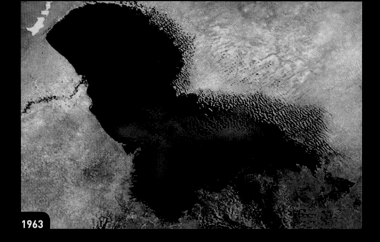

1963

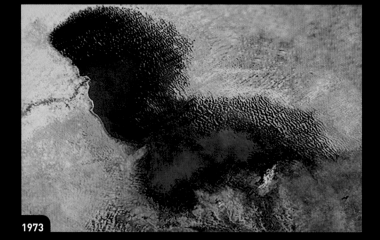

1973

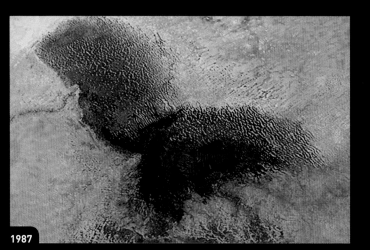

1987

◀ **Declassified data** from the Argon spy satellite allows us to see the extent of Lake Chad in 1963. Civilian Landsat observations did not start until 1972. Images from both satellites use infrared which helps discriminate water from land. Satellite observations over forty years show that the lake's area has declined dramatically since the 1960s. Originally around 9650 sq miles (25,000 sq km), it is now one twentieth of that size.

**SATELLITE:** KH5 ARGON / LANDSAT 4/5   **HEIGHT:** 438 MILES (705 KM)   **DATE:** 1963/1973/1987

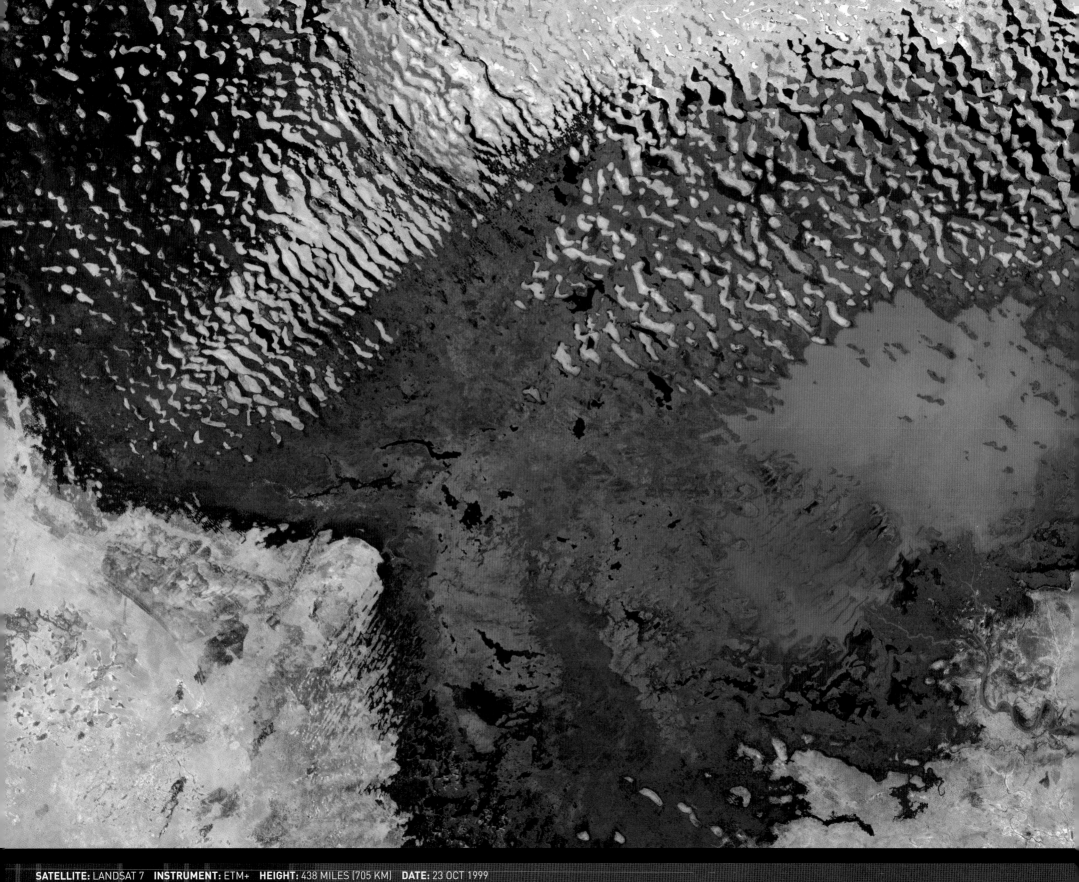

# Northeast Africa

SCALE 1:12,500,000
(projection: Lambert Azimuthal Equal Area)

| 0 | 100 | 200 | 300 | 400 | 500 Kilometres |
| 0 | 100 | 200 | 300 | 400 | 500 Miles |

*Mediterranean Sea*

**BEIRUT**
(BEYROUTH)
LEBANON
**DAMASCUS** (DIMASHQ)
Al Qunaytirah
Nahariyya
Haifa
*Syrian Desert*
**IRAQ**
Irbid
Az Zarqa'
**ISRAEL**
Tel Aviv-Yafo
'AMMAN
Turayf
**JERUSALEM**
Ma'daba
Gaza
Be'er
Sheva'
**JORDAN**
'Ar'ar
Mizpe
Ramon
Be'er Menuha
Al Jawf

**TRIPOLI**
(TARABULUS)
Zuwarah
Az Zawiyah
Al Khums
**TUNISIA**
Gabès
Médenine
*Djerba*
El Oued
Nalut
Yafran
Gharyan
Misratah

Al Bayda'
Darnah
Benghazi
(Banghazi)
*Al Jabal al Akhdar*
Tobruk
Sidi Barrani
*Nile Delta*
Alexandria
Dumyat
Port
Said
*Suez
Canal*
Isma'iliya
Suez
Elat
Al 'Aqabah
Tabuk
Tayma
An Nafud
**SAUDI ARABIA**
Ha'il
Al Jaghbub

*Gulf of Sirte*
Surt
Ajdabiya
*Wadi al Hamim*
Marsa
al Burayqah
El 'Alamein
Zagazig
**El Giza** **CAIRO**
*Sinai*
*Gebel Musa*
2285m
*Jabal ash Shifa*

Maradah
Waddan
Jalu
Siwa
*Qattara
Depression*
Beni
Suef
El Minya
Bawiti
Mallawi
Hurghada
Al Wajh

**ALGERIA**
Tiguentourine
Awbari
Sabha
Birak
Zawilah
Al Uwaynat
**LIBYA**
*Great Sand Sea*
Qasr Farafra
Asyut
Sohag
Akhmim
Qena
**EGYPT**
Luxor
Isna
El Kharga
Idfu
*Nile*
*Wadi al Hamd*
Medina

*Tassili-n-Ajjer*
Djanet
*Tropic of Cancer*
*Idhan Murzuq*
*Libyan
Desert*
Aswan
*Lake
Nasser*
(administered
by Sudan)
*Tropic of Cancer*

*Ramlat Rabyanah*
Al Khufrah
*Gilf Kebir
Plateau*
Wadi Halfa
(administered
by Egypt)
**JEDDA**
At Ta'if
Mecca

*Sahara*
Pic Bette
2286m
Jabal al 'Uwaynat
1907m
Akasha
*Wadi Oko*
*Red
Sea*

Iferouâne
*Massif de
l'Aïr*
Aozou
Bardaï
Zouar
*Tibesti*
Delgo
Argo
Dongola
*Nubian
Desert*
Abu Hamed
Port Sudan
Suakin

△ Monts Bagzane
2022m
Séguédine
Emi Koussi
3415m
Ounianga
Kébir
*Erdi*
El'Atrun
Shereik
Haiya
Tokar

*Ténéré*
*Grand Erg de Bilma*
Faya
Fada
*Ennedi*
Merowe
Atbara
Ed Damer
*Atbara*

**NIGER**
*Erg du Djourab*
Koro Toro
*Wadi Howar*
Ed Debba
Shendi
**ERITREA**
Massawa
Zula
**ASMARA**

Zinder
Gouré
Nguigmi
Ngourti
Nokou
Mao
Biltine
*Wadi el Milk*
Khartoum
North
Omdurman
**KHARTOUM**
Kassala
Teseney

Guidimouni
Hadejia
Nguru
Bol
*Lake
Chad*
Moussoro
Ati
Abéché
Goz
Beïda
Umm
Buru
*Darfur*
Sodiri
Khashm el Girba
Gedaref
*Danakil Desert*
Mek'ele

Bauchi
Hadejia
Potiskum
Maiduguri
Kousséri
**NDJAMENA**
Mongo
Mangalmé
**CHAD**
El Geneina
Kebkabiya
El Fasher
*Blue Nile*
Wad Medani
Sennar
Gonder
*Lake
Tana*
*Ethiopian*
Weldiya

**NIGERIA**
Biu
Maroua
Massenya
*Chari*
Ba Illi
Bongor
Abou-Deïa
Am Timan
*Bahr Azoum*
*Bahr Aouk*
Birao
Nyala
Ed Da'ein
El Muglad
Kadugli
Dilling
*White Nile*
Ed Damazin
Bahir Dar
*Highlands*
Abuye Meda △
4000m
Dese
Bure

Jos
Kumo
Gombi
Guider
**CAMEROON**
*Gongola*
El Obeid
Er Rahad
Umm
Ruwaba
**SUDAN**
*Blue Nile*
**ETHIOPIA**
Jos Plateau

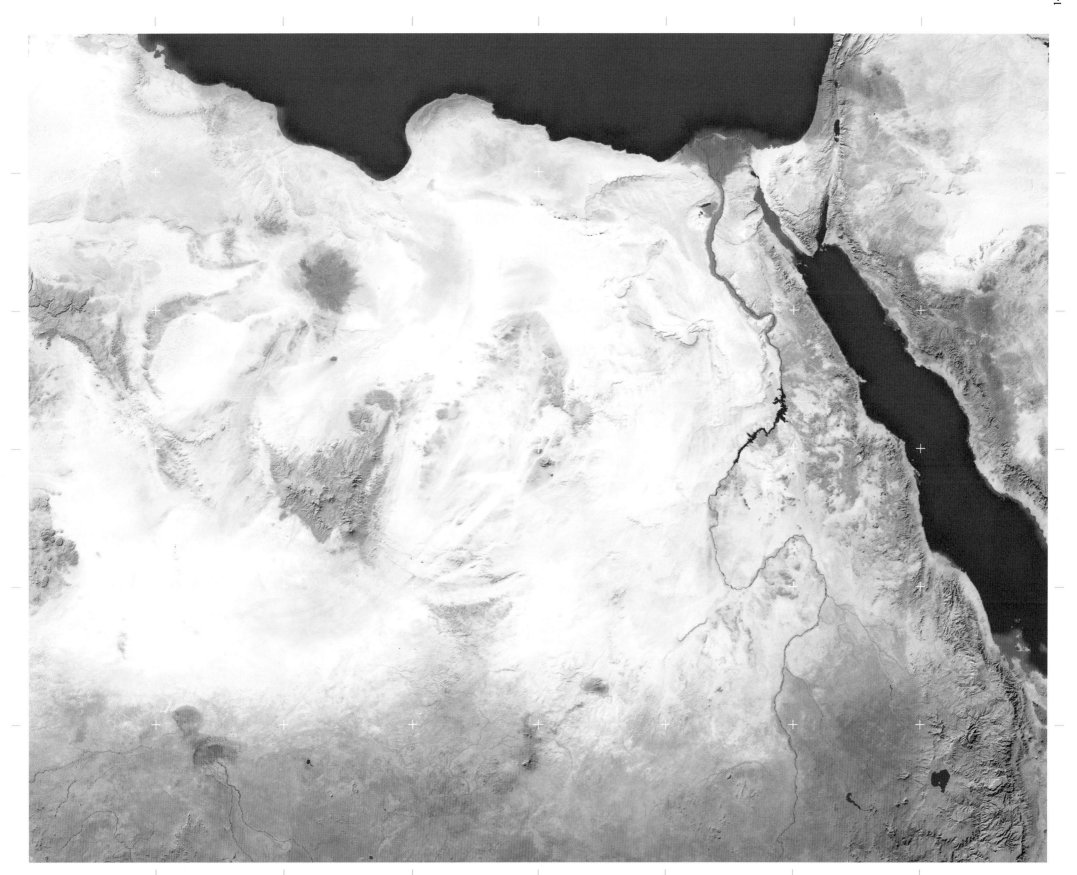

# CAIRO &
# THE PYRAMIDS
## 30°01'N, 31°18'E

The valley of the Nile, and its expansive delta fronting onto the Mediterranean Sea, clearly stands out in lush greens from the surrounding arid desert sands. The annual flooding of the Nile provides a natural cycle of inundation, irrigation and soil repletion which allows agriculture to flourish in this otherwise barren region. The Gulf of Suez separates the Sinai peninsula from the Egyptian mainland. The 101 mile (163 km) Suez Canal, built between 1859 and 1869 under the direction of the French engineer and diplomat Ferdinand de Lesseps, can be picked out to the east of the delta, linking the gulf with the Mediterranean Sea, via a series of existing lakes and marshes.

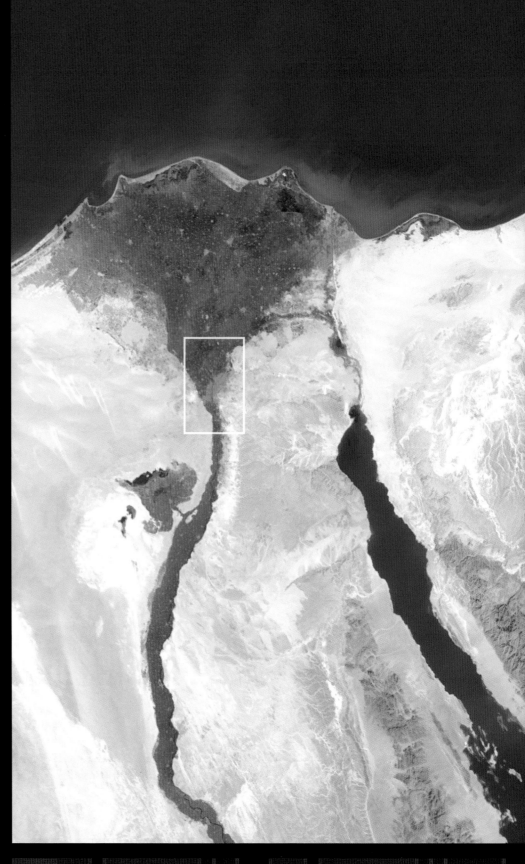

SATELLITE: TERRA (EOS AM-1) MODIS    HEIGHT: 438 MILES (705 KM)    DATE: 2004

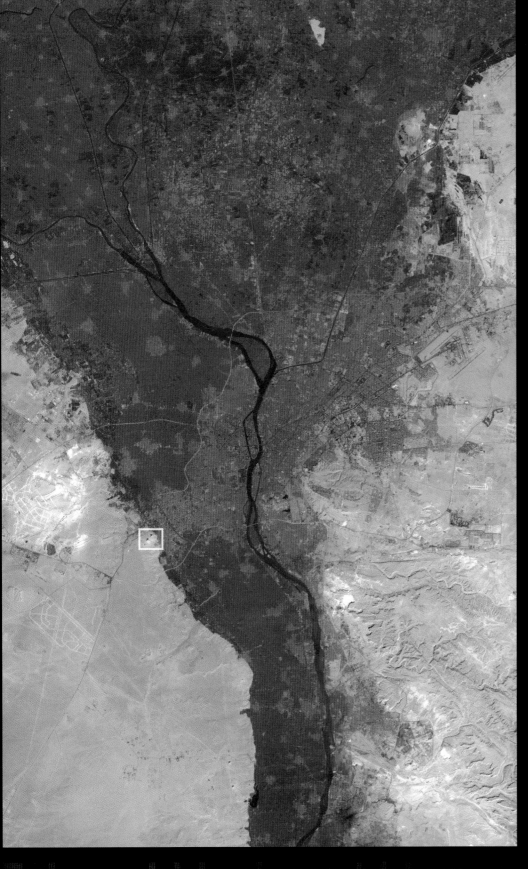

◀ **Cairo is Africa's largest city**, and with a metropolitan population of 15.6 million people, one of the most populous conurbations in the world. Sprawling from its origins as a Fatimid city founded in the mid-10th century on the eastern bank of the Nile, it has become one of the principal commercial, cultural and industrial centres of the Arab world.

▼ **The pyramids of Giza**, are probably the world's most famous ancient monuments. The Great Pyramid of Khufu (top right) was regarded by the Ancient Greeks as one of the Seven Wonders of the World. The complex was built between 2530 and 2470 BCE, and comprises three main pyramid tombs, several smaller pyramids, a cemetery, the remains of slave-workers' dwellings and the enigmatic Sphinx.

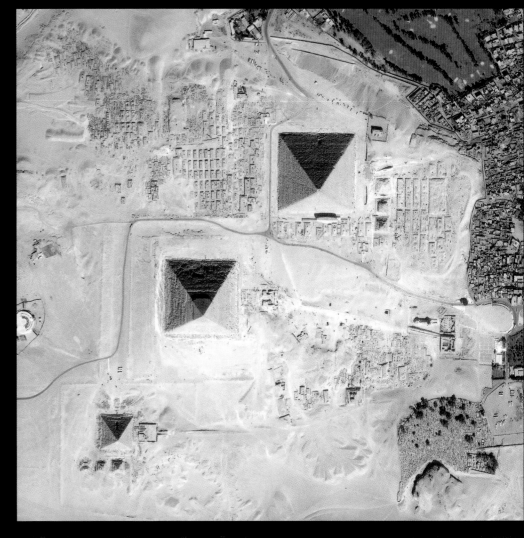

**SATELLITE:** LANDSAT 7   **INSTRUMENT:** ETM+   **HEIGHT:** 438 MILES (705 KM)   **DATE:** 11 NOV 2000

**SATELLITE:** IKONOS image courtesy of GeoEye   **HEIGHT:** 423 MILES (681 KM)

# West Africa

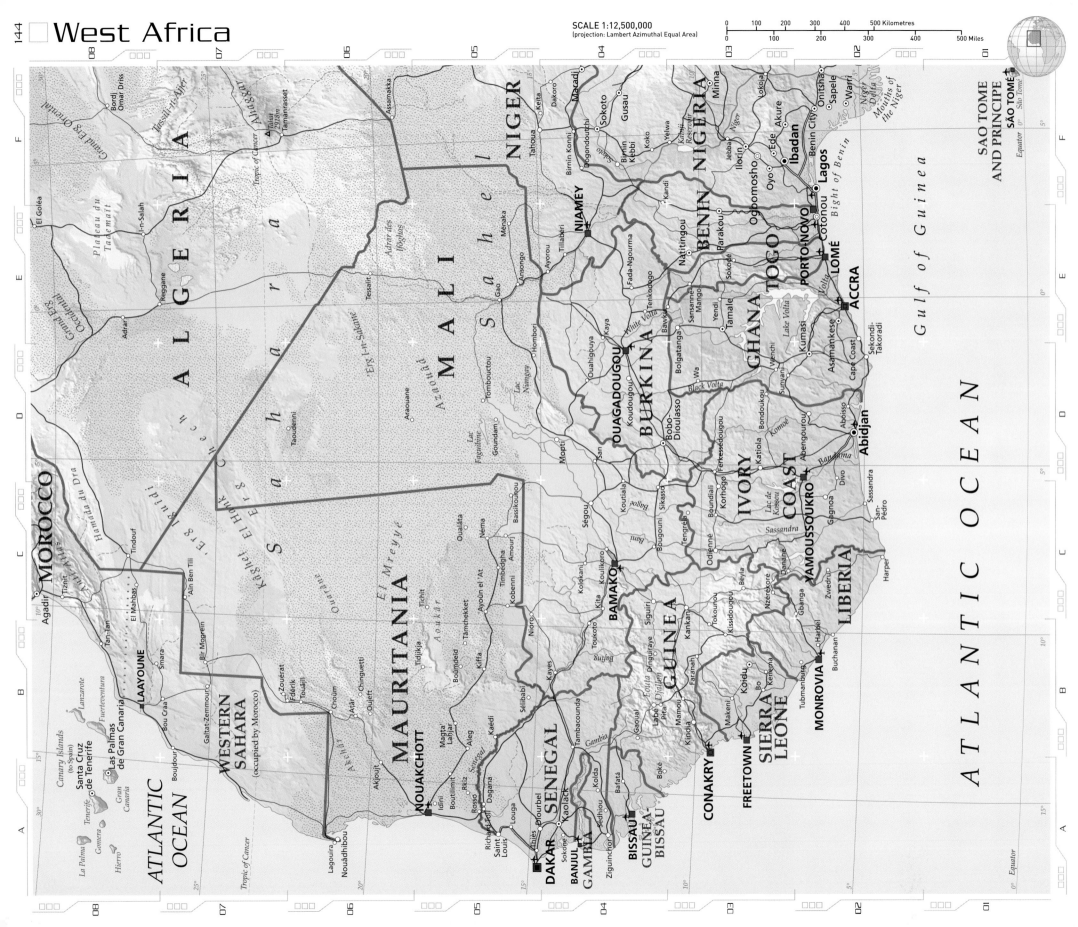

SAO TOME AND PRINCIPE

*Gulf of Guinea*

*ATLANTIC OCEAN*

NIGER

NIGERIA

BENIN

BURKINA

MALI

ALGERIA

MOROCCO

WESTERN SAHARA
(occupied by Morocco)

MAURITANIA

SENEGAL

GAMBIA

GUINEA-BISSAU

GUINEA

SIERRA LEONE

LIBERIA

IVORY COAST

GHANA

TOGO

*ATLANTIC OCEAN*

Sahara

Sahel

*Canary Islands (to Spain)*

NOUAKCHOTT
DAKAR
BANJUL
BISSAU
CONAKRY
FREETOWN
MONROVIA
YAMOUSSOUKRO
Abidjan
ACCRA
LOMÉ
PORTO-NOVO
COTONOU
Lagos
NIAMEY
OUAGADOUGOU
BAMAKO
LAAYOUNE
SAO TOMÉ

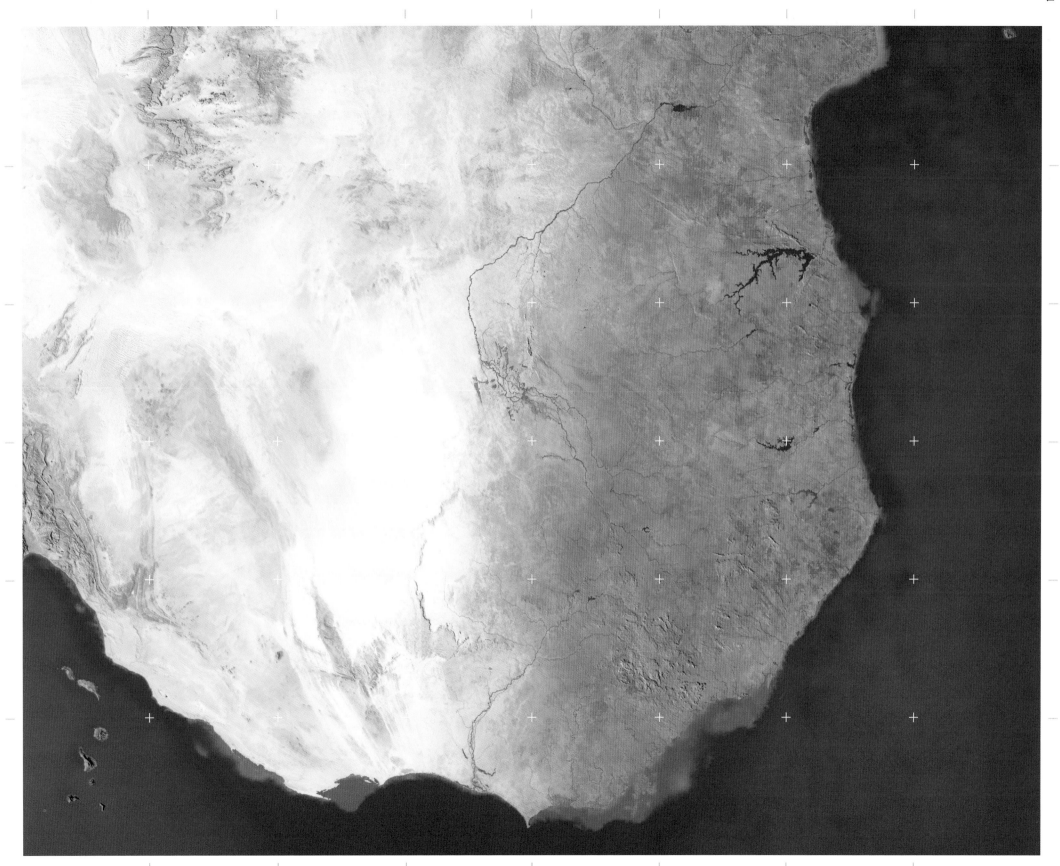

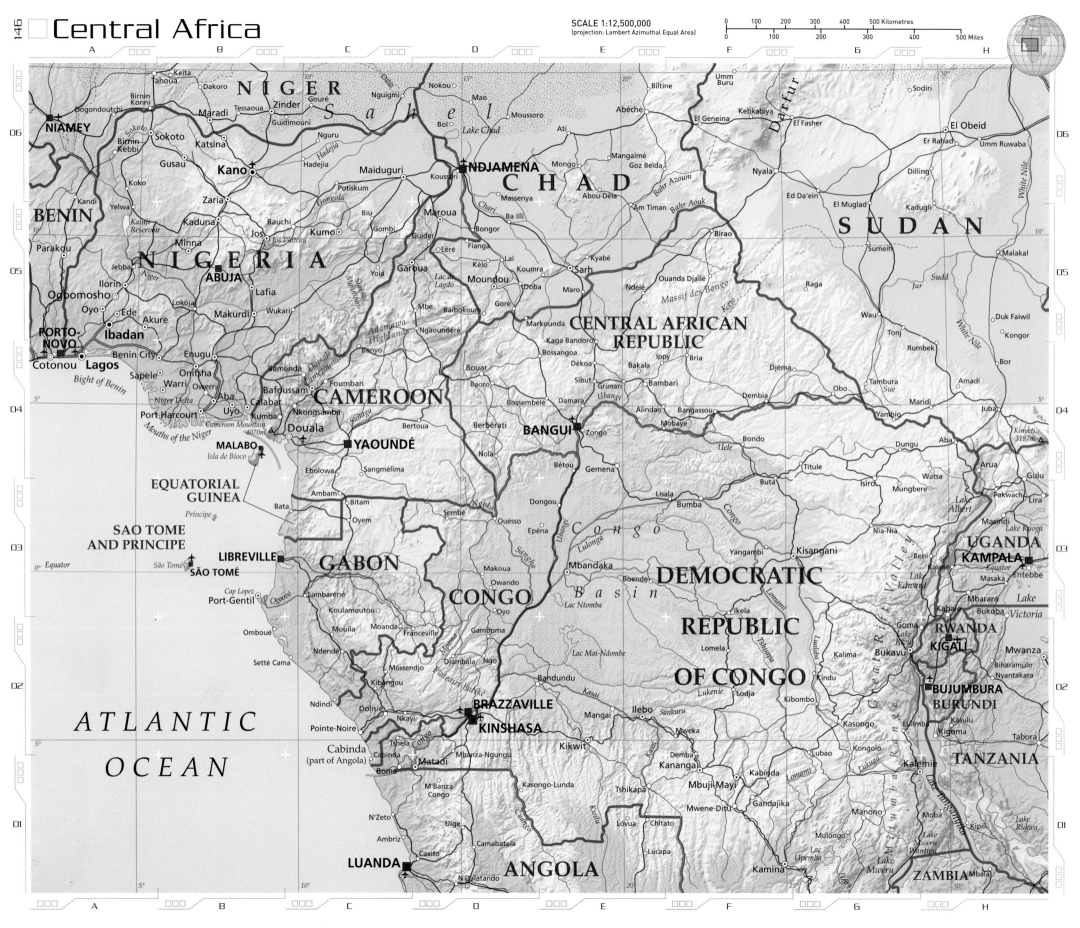

SCALE 1:12,500,000
(projection: Lambert Azimuthal Equal Area)

0  100  200  300  400  500 Kilometres
0    100    200    300    400  500 Miles

NIGER

Sahel

BENIN

NIGERIA

CHAD

SUDAN

Darfur

CENTRAL AFRICAN
REPUBLIC

CAMEROON

EQUATORIAL
GUINEA

SAO TOME
AND PRINCIPE

GABON

CONGO

DEMOCRATIC

REPUBLIC

OF CONGO

UGANDA

RWANDA

BURUNDI

TANZANIA

ATLANTIC

OCEAN

Cabinda
(part of Angola)

ANGOLA

ZAMBIA

Congo Basin

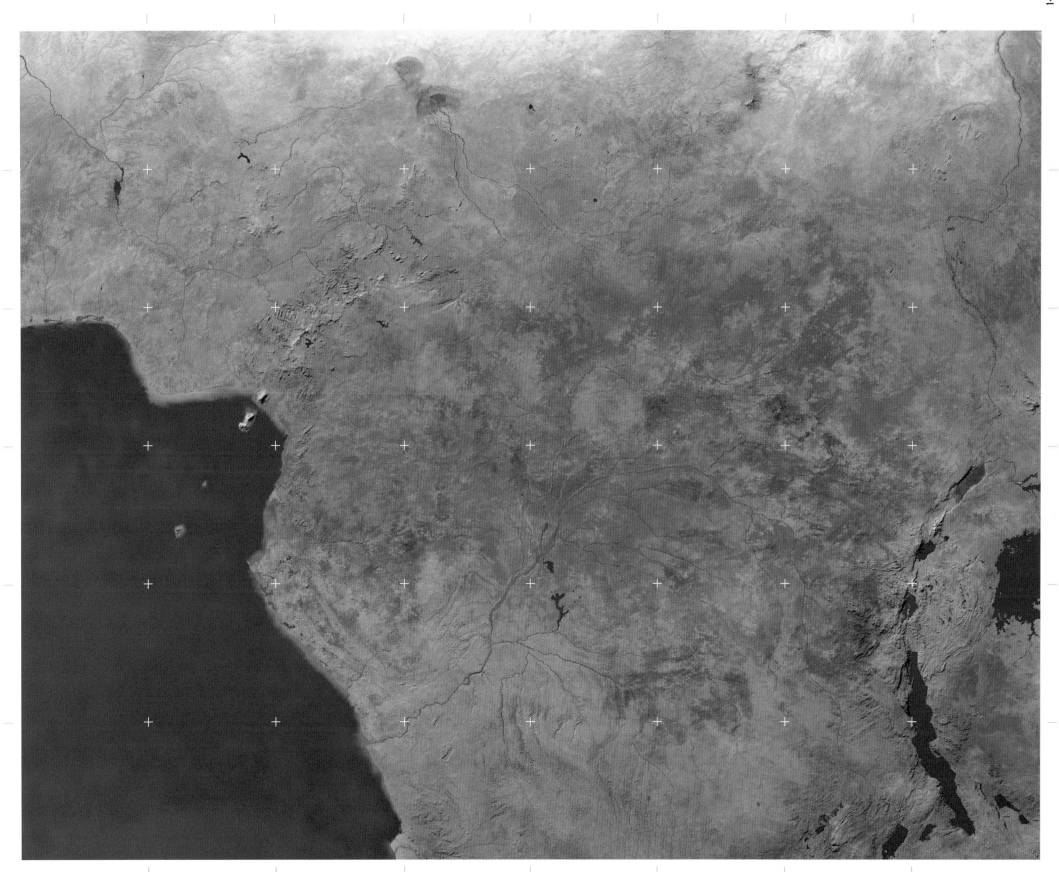

# CONGO RIVER

## 5°04'S, 12°14'E

The Congo drains a vast area of central Africa and provides the main transport corridor through the region. The cities of Brazzaville and Kinshasa, the capitals of the Republic of the Congo and the Democratic Republic of the Congo respectively, have grown on opposite banks of the river. These cities grew up around the river's lowest navigable point, at a natural widening of the river called Pool Malebo (formerly Stanley Pool, named after the nineteenth century journalist and explorer). Downstream, the river narrows and rapids (the Livingstone Falls) impede navigation to the sea. Kinshasa, on the southern banks of the river, is by far the larger city, with a population of 4.7 million, compared with Brazzaville's 1.2 million.

► **Pool Malebo,** shown in this photograph taken by astronauts on the International Space Station, is 22 miles (35 km) long and 14 miles (23 km) wide. The island of Bamu occupies a large part of its area. Brazzaville (north) and Kinshasa (south) appear as grey areas either side of the river at the western end of the pool.

SATELLITE: INTERNATIONAL SPACE STATION (ISS)  INSTRUMENT: KODAK DCS760C  HEIGHT: 220 MILES (354 KM)  DATE: 06 JUN 2003

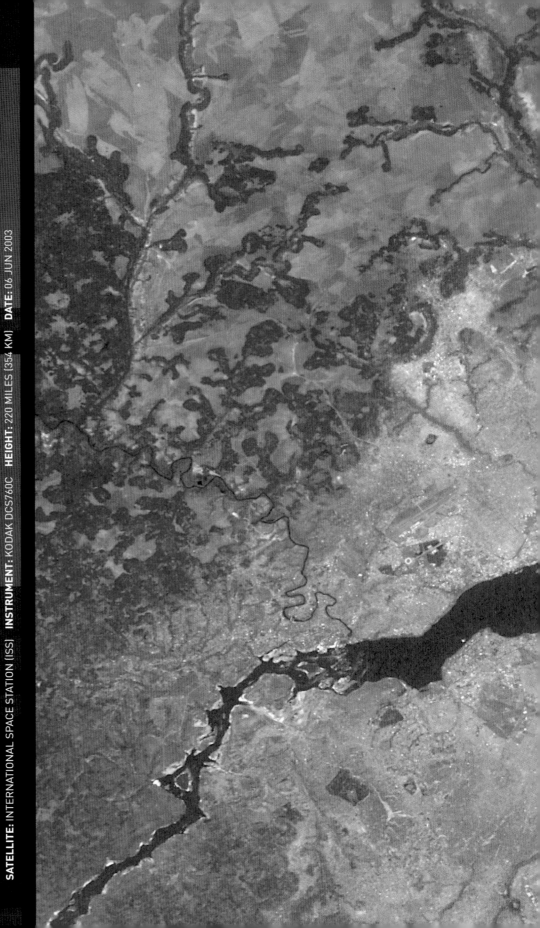

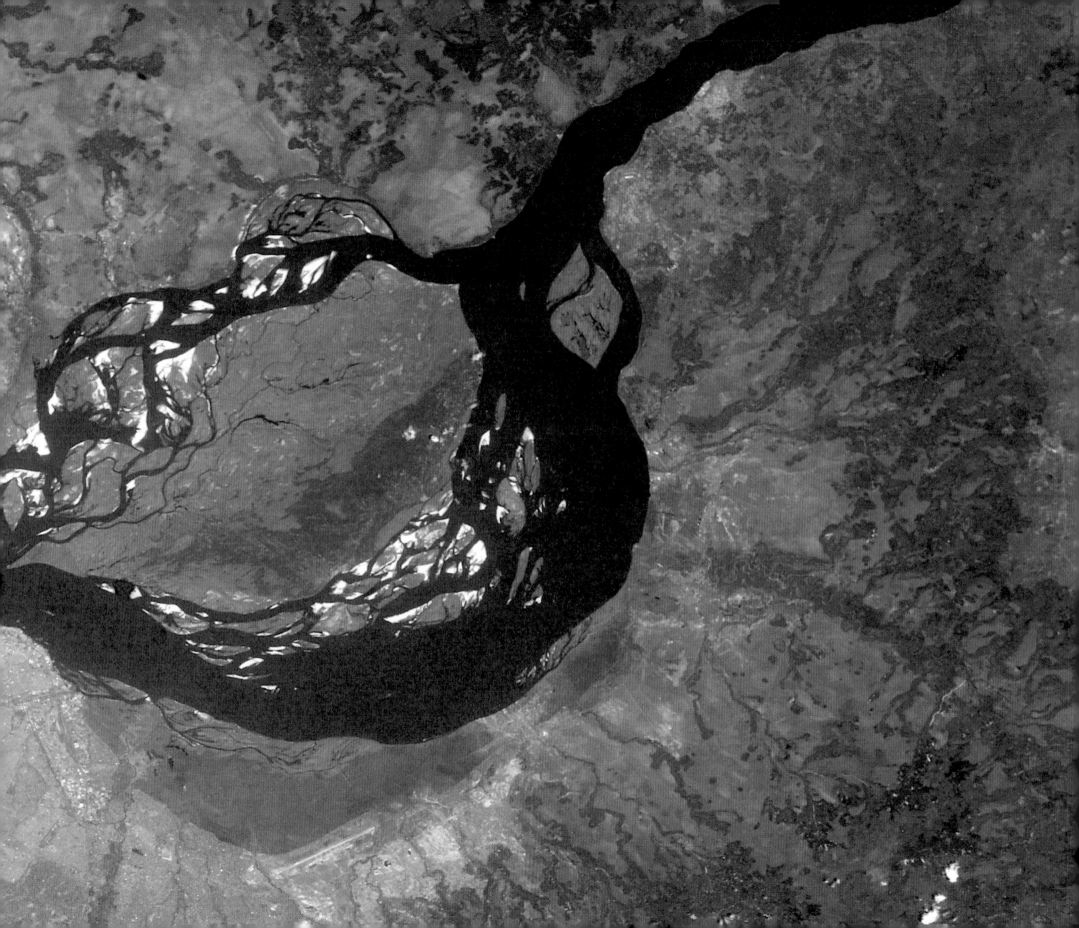

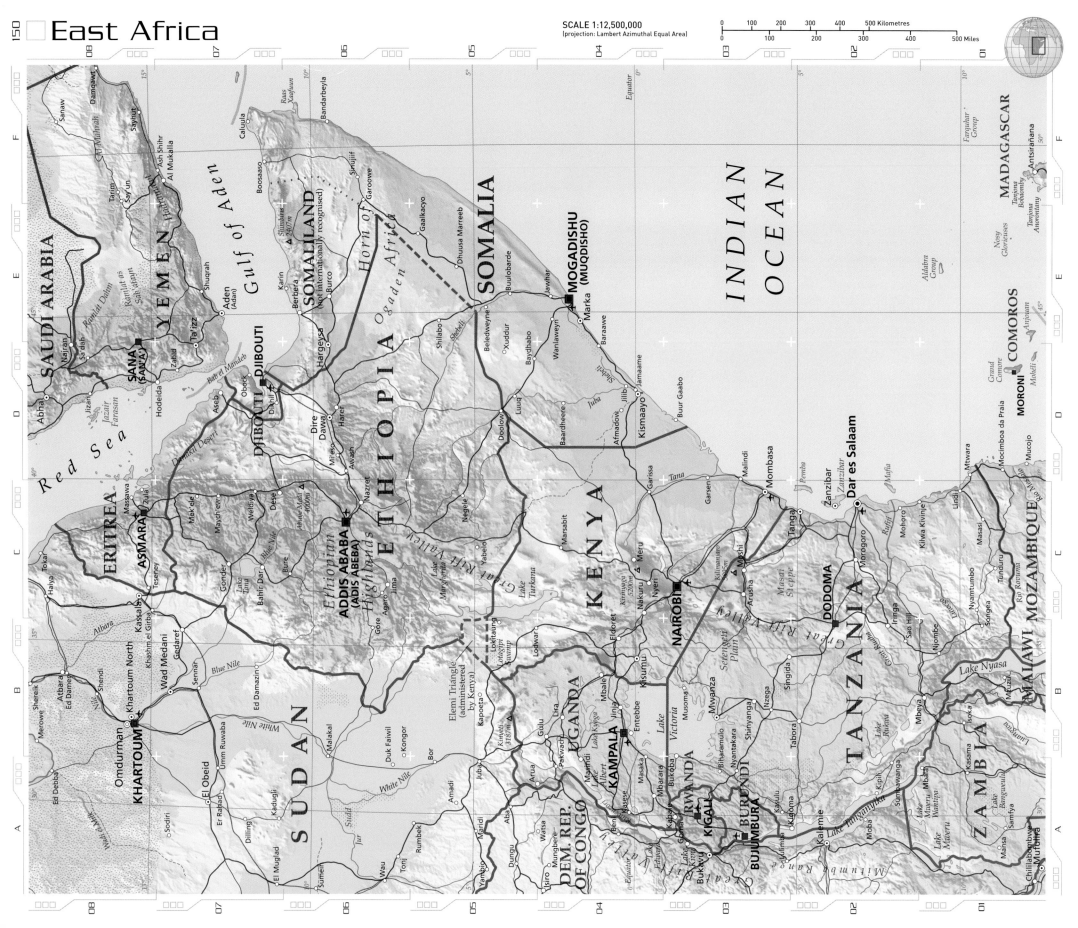

# East Africa

SCALE 1:12,500,000
(projection: Lambert Azimuthal Equal Area)

0 100 200 300 400 500 Kilometres
0 100 200 300 400 500 Miles

SAUDI ARABIA

YEMEN

Gulf of Aden

SOMALILAND
(not internationally recognised)

Horn of Africa

SOMALIA

INDIAN OCEAN

MADAGASCAR

COMOROS

MORONI

Red Sea

ERITREA

ASMARA

SUDAN

ETHIOPIA

Ethiopian Highlands

ADDIS ABABA
(ADIS ABEBA)

DJIBOUTI

Ogaden

MOGADISHU
(MUQDISHO)

Great Rift Valley

KENYA

Elemi Triangle
(administered by Kenya)

KHARTOUM

Omdurman

White Nile

Blue Nile

DEM. REP. OF CONGO

UGANDA

KAMPALA

RWANDA

KIGALI

BURUNDI

BUJUMBURA

Lake Victoria

NAIROBI

TANZANIA

DODOMA

Dar es Salaam

Zanzibar

MALAWI

MOZAMBIQUE

ZAMBIA

Lake Nyasa

Lake Tanganyika

# LAKE NATRON

## 2°25'S, 36°E

Lake Natron is a soda lake fed partly by hot springs occupying the floor of East Africa's Great Rift Valley in northern Tanzania. Daytime air temperature on the floor of the valley often exceeds 104°F (40°C), but water from the hot springs can reach a scalding 140°F (60°C). The lake's striking colour is due to micro-organisms which thrive in the hot, salty, alkaline conditions, which are hostile to most other lifeforms. The escarpment of the Great Rift Valley rises to either side of the lake, and parallel steps in the rock to the east show where the Earth's crust has pulled apart causing the central section to drop. Volcanic activity associated with the rifting process is the source of the sodium-rich soils beneath the lake, which are mainly composed of volcanic ash.

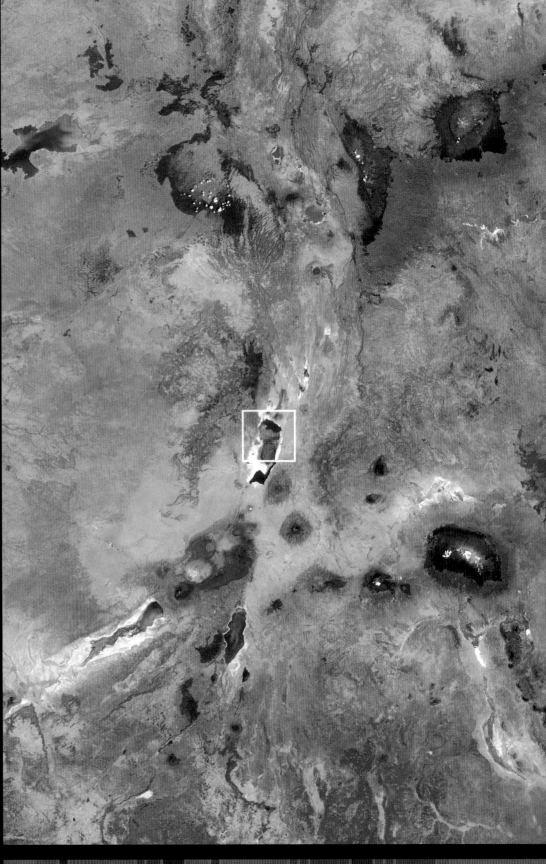

▶ **The Great Rift Valley** stretches for 3100 miles (5000 km) from Lebanon's Beqaa valley in the north to central Mozambique in the south. This image covers a 370 miles (600 km) section in East Africa, showing lakes Natron, Eyasi and Manyara on the floor of the valley, with the volcanoes Kirinyaga (Mount Kenya), Kilimanjaro and Ngorongoro on either side.

**SATELLITE:** TERRA (EOS AM-1)   **INSTRUMENT:** MODIS   **HEIGHT:** 438 MILES (705 KM)   **DATE:** 04 FEB 2003

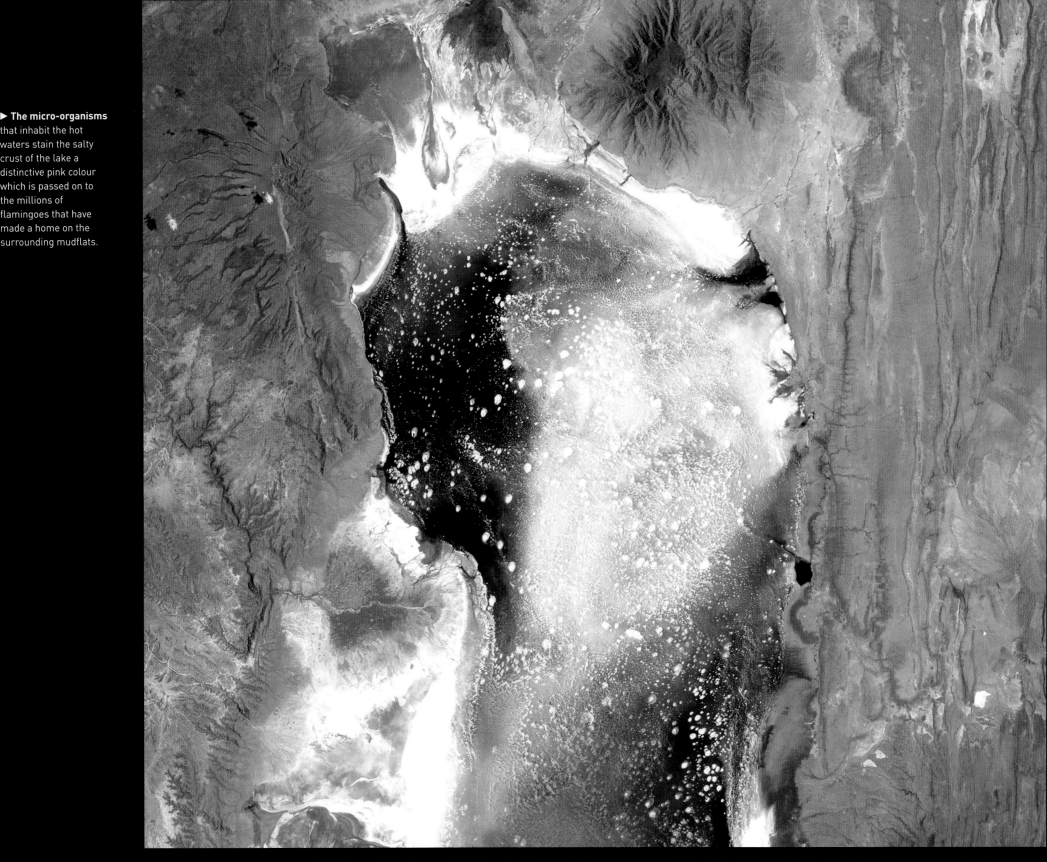

**► The micro-organisms** that inhabit the hot waters stain the salty crust of the lake a distinctive pink colour which is passed on to the millions of flamingoes that have made a home on the surrounding mudflats.

**SATELLITE:** TERRA (EOS AM-1) **INSTRUMENT:** ASTER **HEIGHT:** 438 MILES (705 KM) **DATE:** 08 MAR 2003

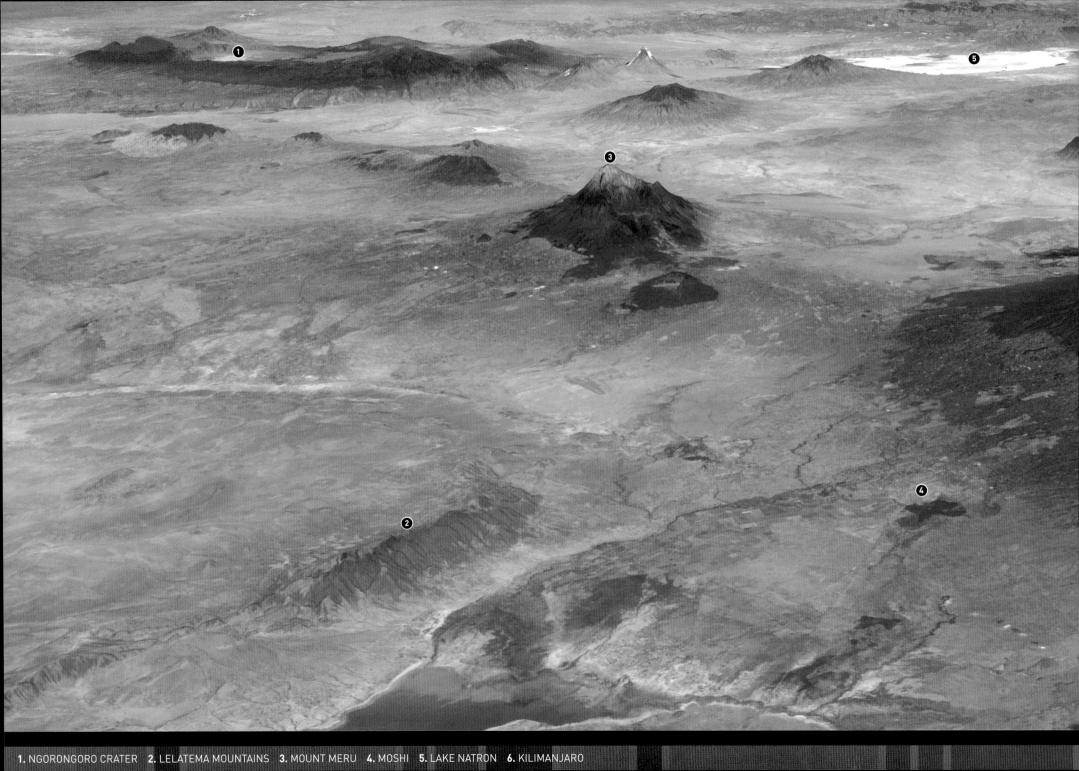

**1.** NGORONGORO CRATER **2.** LELATEMA MOUNTAINS **3.** MOUNT MERU **4.** MOSHI **5.** LAKE NATRON **6.** KILIMANJARO

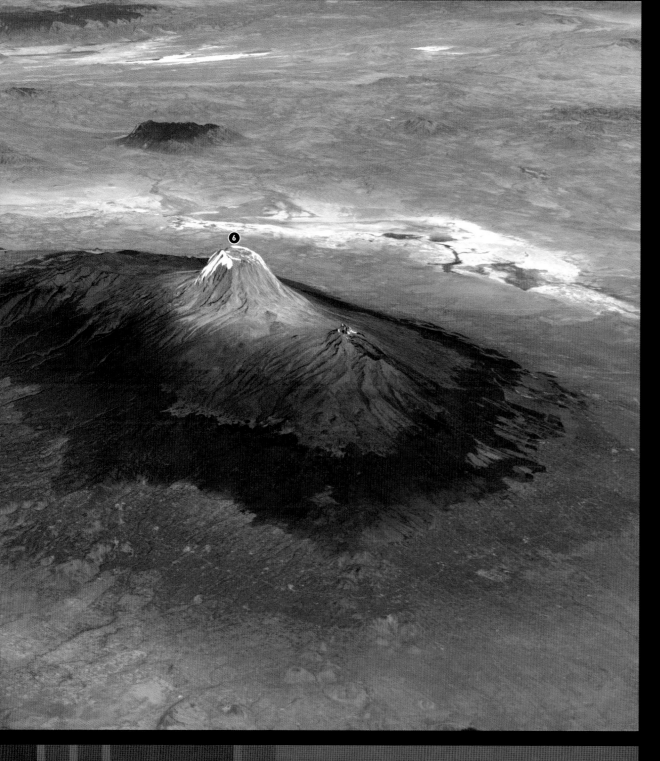

# KILIMANJARO
## 3°01'S, 37°14'E

Kilimanjaro is Africa's highest mountain. Rising to 19,340 ft (5895 m), it modifies the local climate, forcing airstreams to rise, inducing rain and, higher up, snow. The result is an altitudinal zoning of vegetation, with the savannah grasses of the surrounding plains giving way to agriculture, including coffee plantations, rainforest, moorland, mountain desert and finally the glaciers which surround the peak. These rare Equatorial glaciers have been shrinking in recent years and if they continue to melt at the same rate they may be gone by 2015.

Measuring about 62 miles (100 km) long by 40 miles (65 km) wide, Kilimanjaro is built from the overlapping cones of three volcanoes and there are active fumeroles in the crater at the main summit, Kibo. Kilimanjaro is just one of the volcanoes associated with East Africa's Great Rift Valley. Beyond 'Kili' lie Mount Meru and, on the other side of the rift, the 12 mile (20 km) wide, 2000 ft (600 m) deep crater of Ngorongoro, created three million years ago when the volcano Oldeani collapsed into its empty magma chamber.

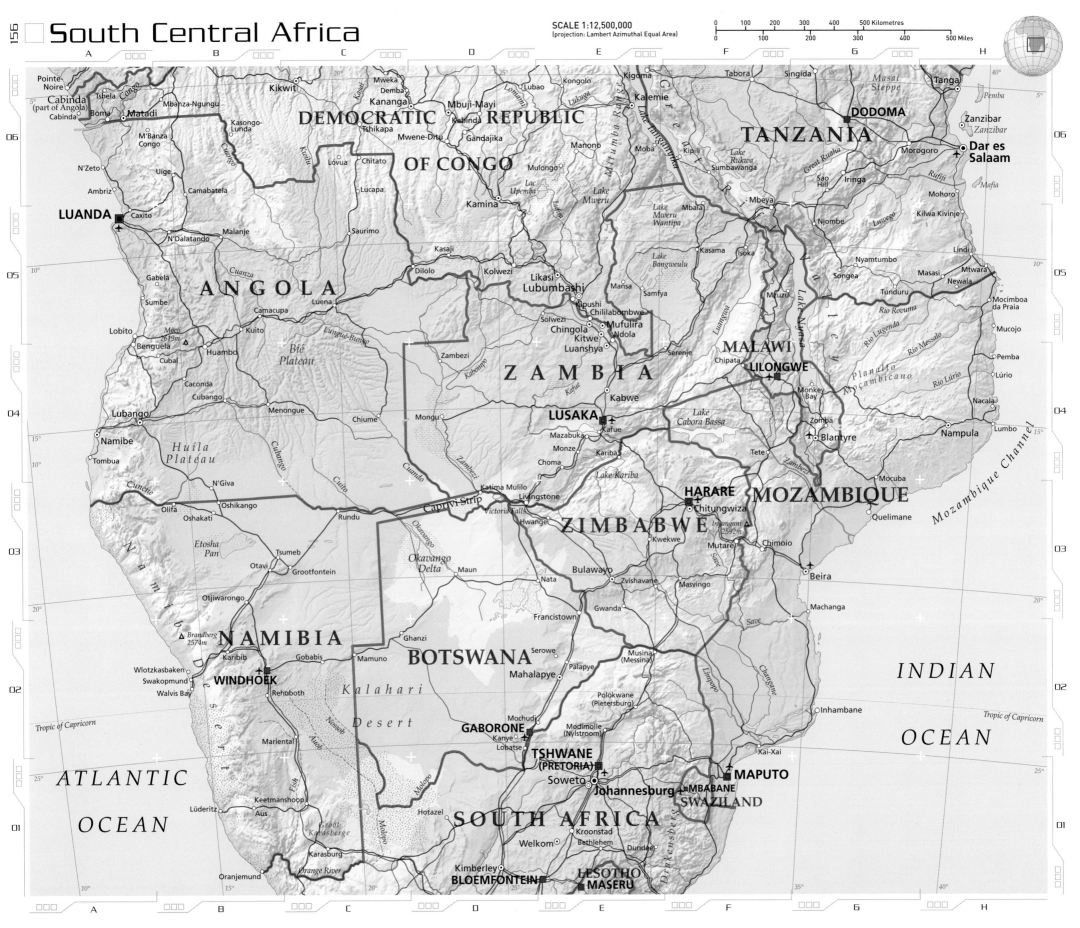

# VICTORIA FALLS

## 18°03'S, 25°50'E

Victoria Falls form part of the border between Zimbabwe to the south and Zambia to the north. At this point, the Zambezi river cuts a precipitous zigzagging gorge through large joints in the underlying volcanic basalt bedrock, to create one of the world's most famous waterfalls. Known locally as Mosi-oa-Tunya ('the smoke that thunders'), they were named after the British sovereign Queen Victoria when the Scottish explorer and missionary David Livingstone came upon them in 1855. The nearby town of Livingstone is, in turn, named after him. The falls form the centrepiece of the Victoria Falls National Park on the Zimbabwean side of the river.

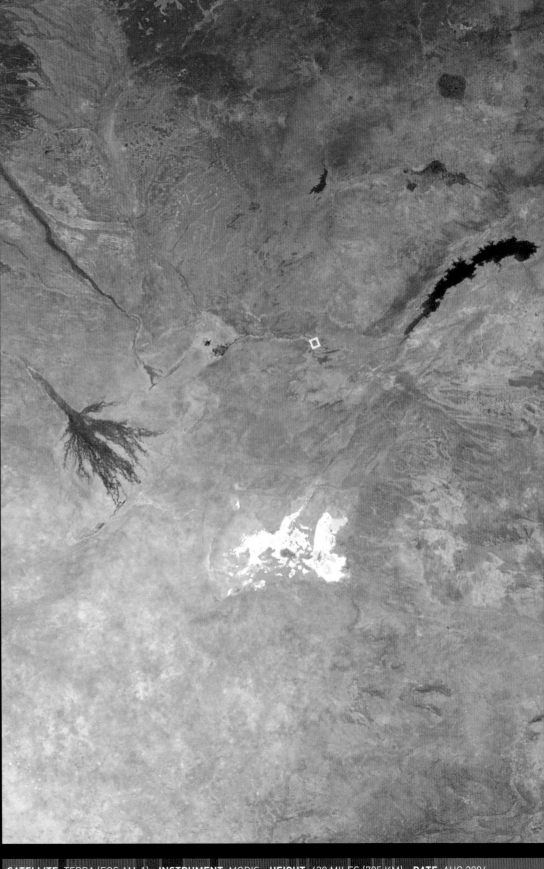

SATELLITE: TERRA (EOS AM-1)   INSTRUMENT: MODIS   HEIGHT: 438 MILES (705 KM)   DATE: AUG 2004

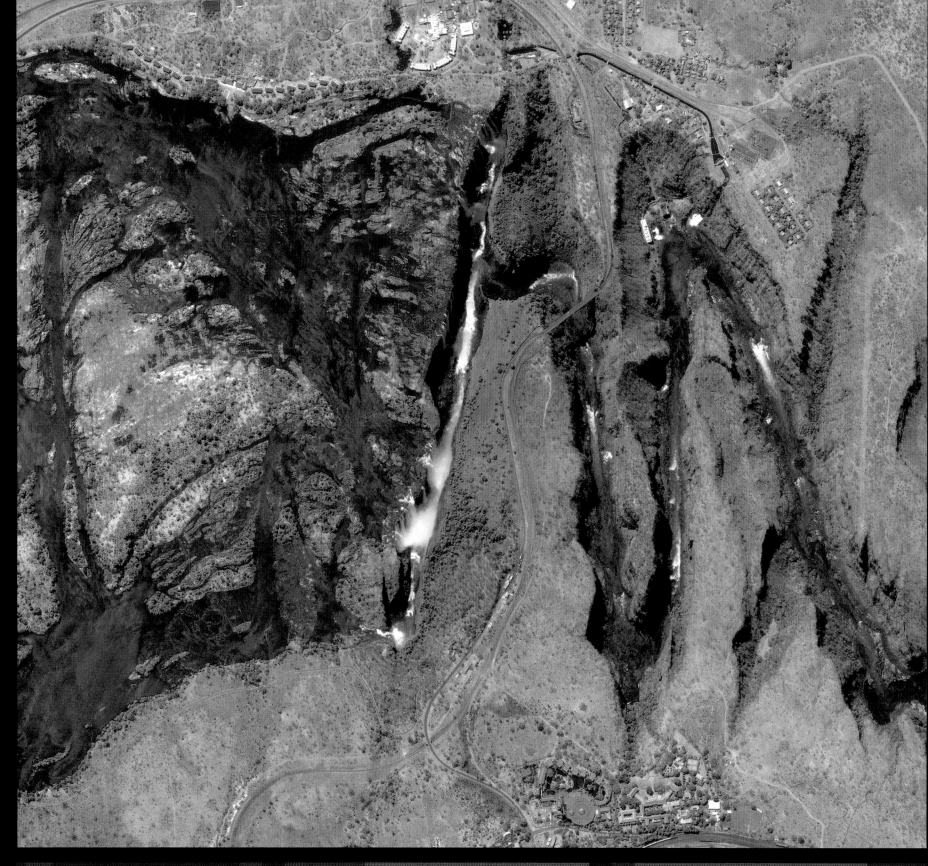

**▶ At the Victoria Falls** the waters are divided by three main islands as they plunge over the edge of the precipice. The Zambezi drops some 355 ft (108m) over the falls into a narrow chasm, ricocheting off the wall of the chasm on its way down, producing clouds of spray. The volume of the river alternates quite dramatically with the seasons but peaks at around 19 million cubic ft (538 million litres) per minute during the rainy season.

**SATELLITE:** IKONOS IMAGE COURTESY OF GEOEYE    **HEIGHT:** 423 MILES (681 KM)    **DATE:** 11 SEP 2003

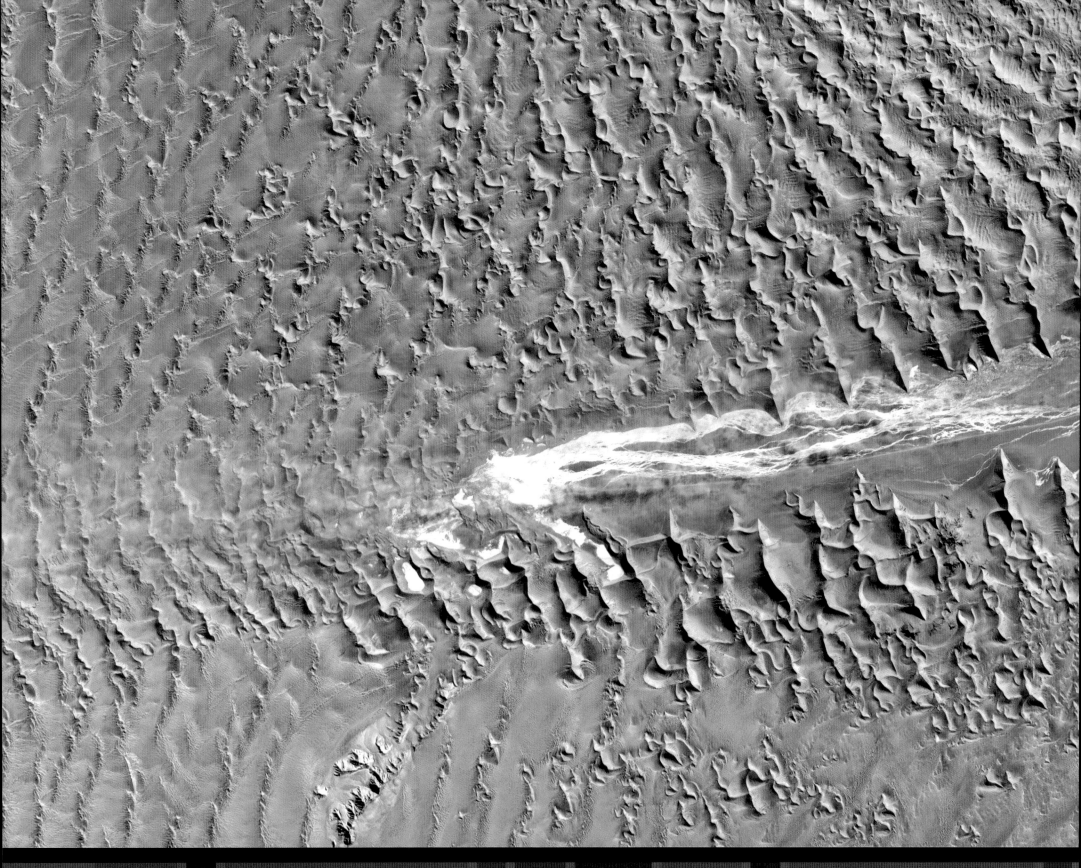

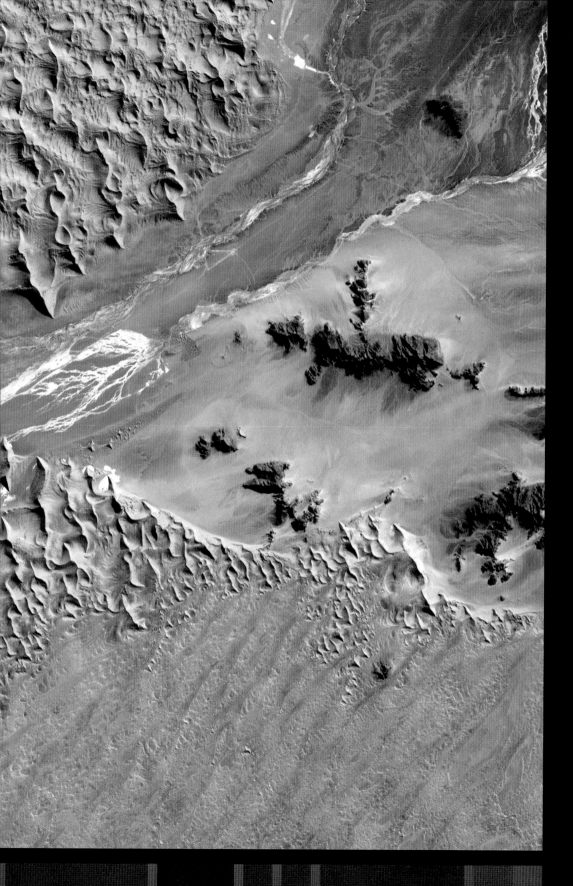

# NAMIB DESERT

## 23°S, 15°E

The sand dunes of the Namib Desert are the tallest in the world, piled up to 985 ft (300 m) above the desert floor by prevailing winds from the west. These winds are quite dry, having picked up little or no moisture as they pass over the south Atlantic's cold Benguela Current. Drainage in the area flows westwards from the nearby Naukluft Mountains, but no rivers manage to cross the desert to reach the Atlantic coast. Most of the moisture the Namib receives comes in the form fog drifting in from the ocean and a few wisps of morning fog can be seen in the cold air (left). The striking orange and red colours of the Namibian dunes are a result of oxidation of iron in the rock from which the sand originated. The longer the sand has been exposed to the atmosphere, the deeper is the colour.

◀ **Rivers in the Namib Desert** peter out into dry river beds and evaporation ponds form between the dunes.

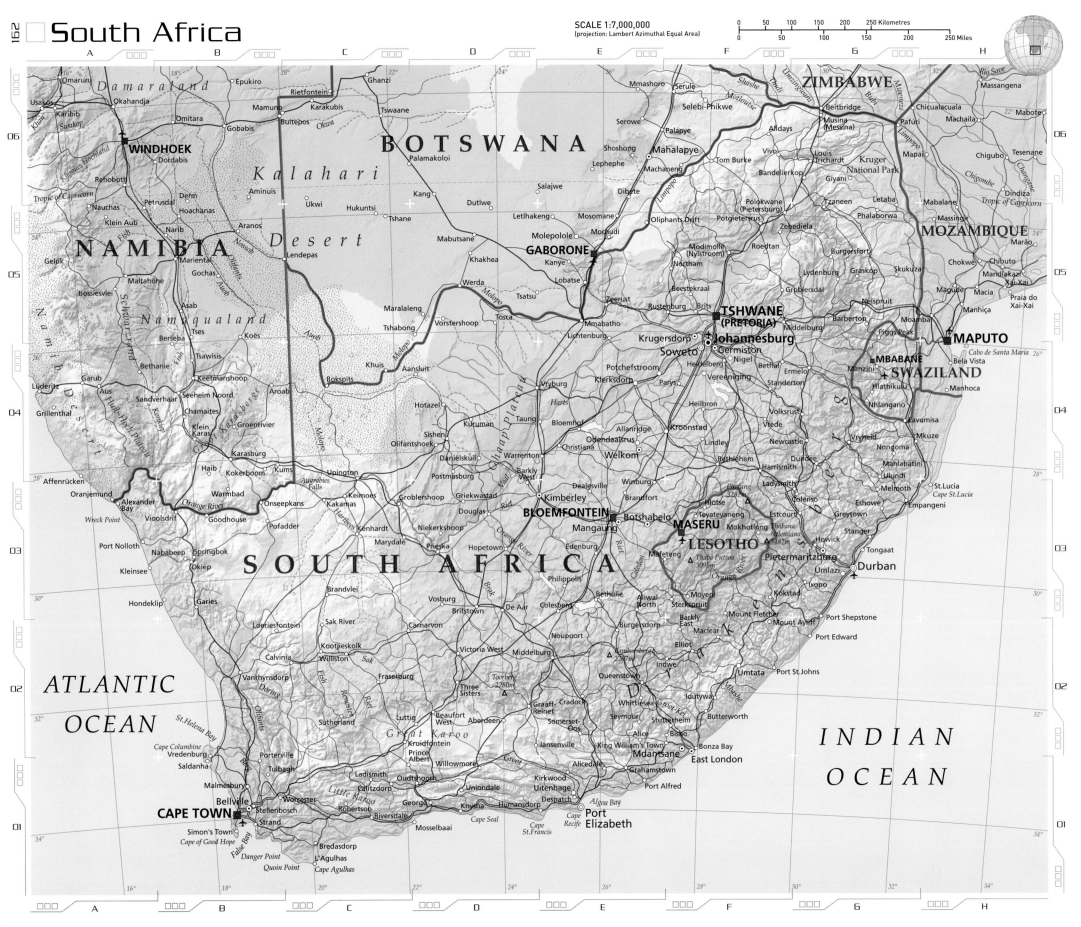

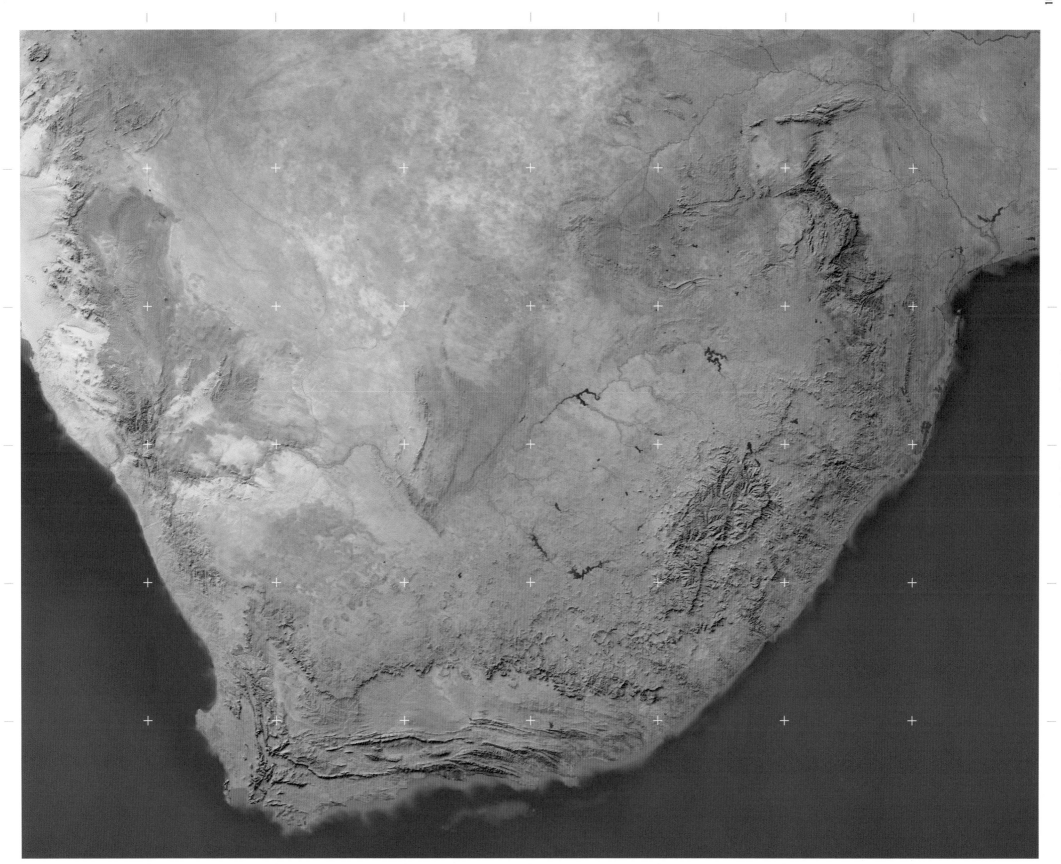

# CAPE TOWN
## 33°55'S, 18°28'E

Sited in a sheltered bay 30 miles (48 km) north of the Cape of Good Hope, Cape Town was founded in 1652 as a supply stop for Dutch ships sailing to East Africa, India and the East Indies, making it the first permanent European settlement in sub-Saharan Africa. The Cape of Good Hope is not the most southerly part of Africa, but it is much more dramatic than the actual southerly point, Cape Agulhas, which lies further to the east. Home to 3.3 million people, Cape Town is South Africa's third-largest city and the seat of the country's parliament. With a dramatic setting at the foot of Table Mountain, a pleasant Mediterranean climate and a rich cultural mix, Cape Town is South Africa's most popular destination for foreign tourists.

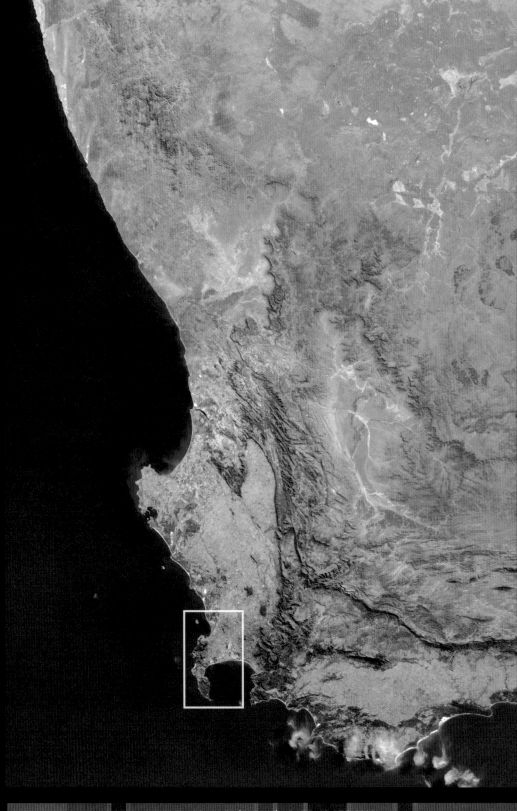

▶ **Two oceans meet** off the Cape Peninsula: the Agulhas Current carries warm water from the Indian Ocean along Africa's south coast, bringing a mild Mediterranean climate with wet winters. The rolling hills inland are well-suited to wine-growing. To the north lies the arid Atlantic coast of Namaqualand.

**SATELLITE:** TERRA, MODIS   **HEIGHT:** 438 MILES (705 KM)   **DATE:** 18 APR 2002

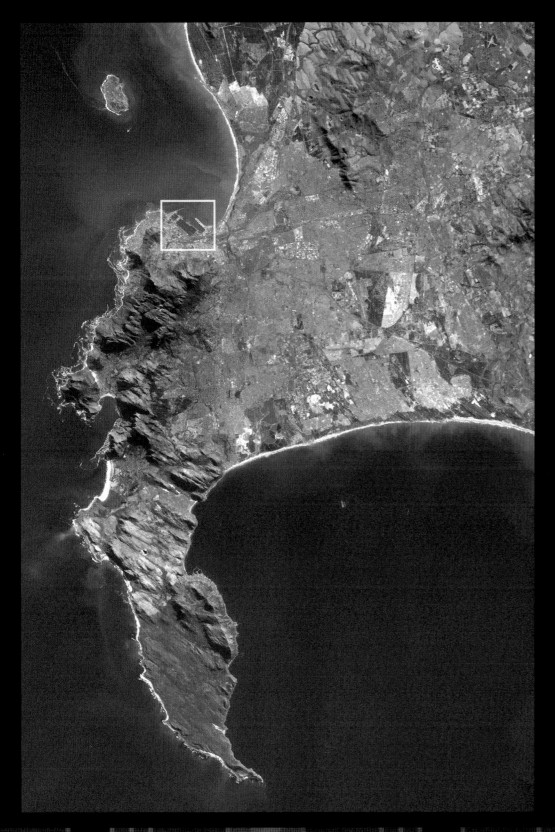

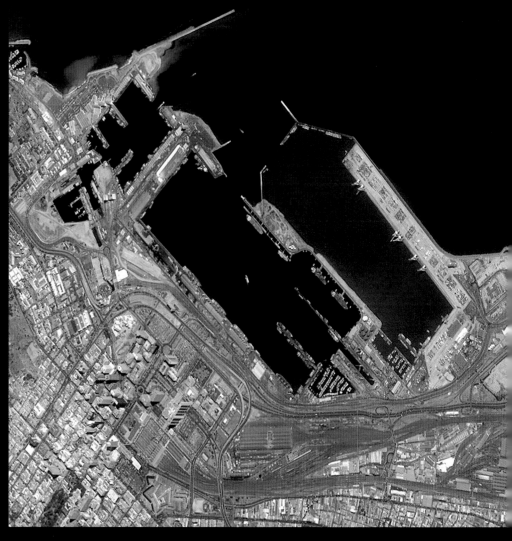

◄ **The Cape Peninsula**
stretches from Table
Mountain in the north to
the Cape of Good Hope
in the south. Inland, the
Cape Flats separate
Table Bay and False
Bay, providing space for
Cape Town's sprawling
suburbs. Some 7 miles
(12 km) offshore lies
Robben Island. Once a
leper colony and then a
prison, the island is now
preserved as a museum.

▼ **The port area**
dominates Cape Town's
waterfront and shoreside
infrastructure such as
railway marshalling
yards occupies much
of the adjacent land.
This image is detailed
enough to show dockside
cranes and the high-rise
buildings of the city's
business district.

**SATELLITE:** LANDSAT 7    **INSTRUMENT:** ETM+    **HEIGHT:** 438 MILES (705 KM)    **DATE:** 03 JUN 2002

**SATELLITE:** IKONOS image courtesy of GeoEye    **HEIGHT:** 423 MILES (681 KM)

# Madagascar

SCALE 1:8,000,000
(projection: Lambert Conformal Conic)

0    50   100   150   200   250 Kilometres

0    50   100   150   200   250 Miles

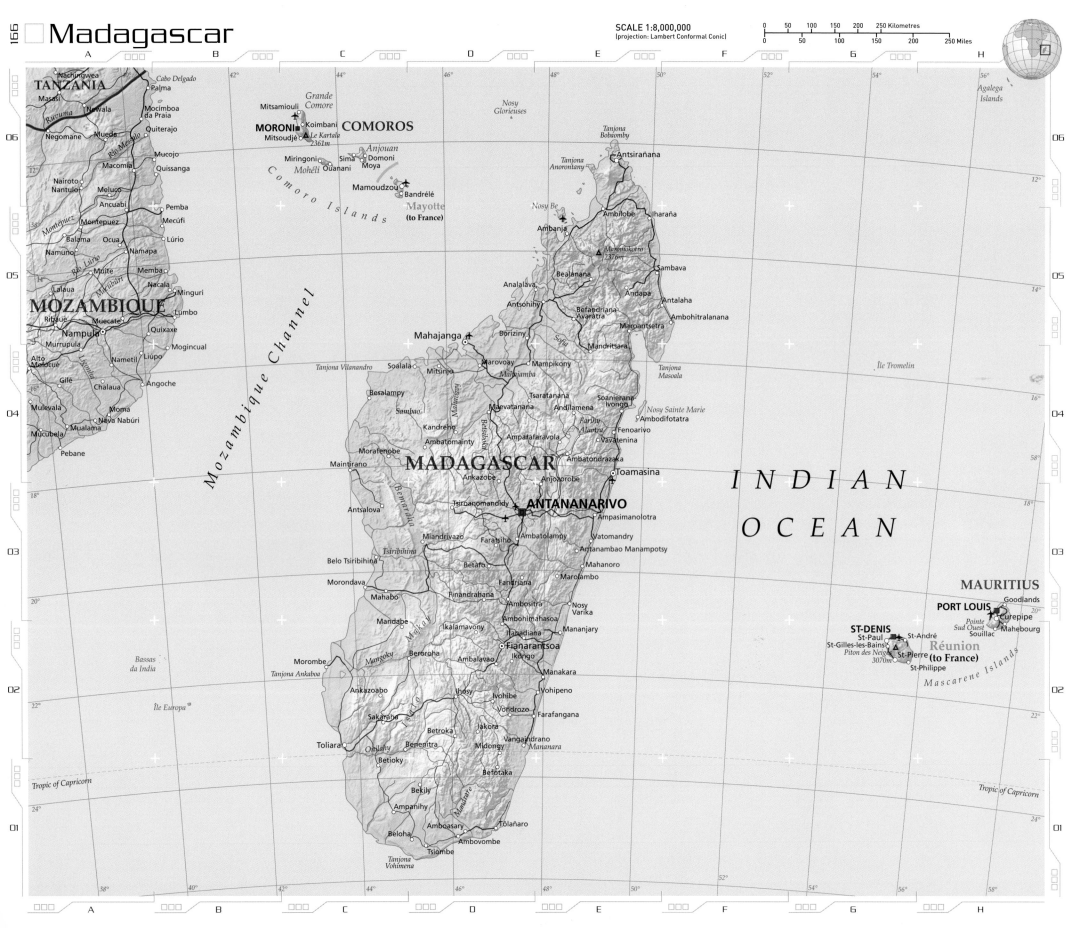

**TANZANIA**

Nachingwea
Masasi
Newala
Negomane
Mueda
Mucojo
Nairoto
Macomia
Nantulo
Quissanga
Meluco
Pemba
Balama
Mecúfi
Ocua
Montepuez
Namuno
Namapa
Múite
Memba
Minguri
Nacala
Lalaua
Lumbo

**MOZAMBIQUE**

Ribáuè
Muecate
Quixaxe
Nampula
Murrupula
Mogincual
Alto
Molócuè
Gilé
Angoche
Chalaua
Mulevala
Moma
Nova Nabúri
Mualama
Mucubela
Pebane

Cabo Delgado
Palma
Mocímboa da Praia
Quiterajo

**Mozambique Channel**

Cabo Delgado

*Grande Comore*
Mitsamiouli
**MORONI** Koimbani
Mitsoudjé  *Le Kartala 2361m*
**COMOROS**
Miringoni  Sima *Anjouan* Domoni
*Mohéli* Ouanani Moya
Mamoudzou Bandrélé
**Mayotte (to France)**

*Comoro Islands*

*Nosy Glorieuses*

*Agalega Islands*

Tanjona Bobaomby
Antsirañana
*Tanjona Anorontany*
Ambilobe  Iharaña
Ambanja
*Nosy Be*
*Maromokotro 2376m*
Bealanana  Sambava
Analalava  Andapa
Antsohihy  Antalaha
Befandriana Avaratra
Mahajanga  Ambohitralanana
Boriziny  Maroantsetra
Mandritsara
*Sofia*
Marovoay  *Tanjona Masoala*
*Tanjona Vilanandro*  Soalala  Mampikony
Mitsinjo  *Mahajamba*
Besalampy  Tsaratanana
*Sambao*  Maevatanana  Andilamena
Kandreho  Amparafaravola  *Nosy Sainte Marie*
Ambatomainty  Ambodifotatra
Morafenobe  *Farihy Alaotra* Fenoarivo
Maintirano  Vavatenina
*Ile Tromelin*
**MADAGASCAR**
Ankazobe  Ambatondrazaka
Antsalova  Anjozorobe  **Toamasina**
Tsiroanomandidy  Ampasimanolotra
**ANTANANARIVO**
Miandrivazo  Faratsiho  Ambatolampy  Vatomandry
*Tsiribihina*  Antanambao Manampotsy
Belo Tsiribihina  Betafo  Mahanoro
*Bemaraha*  Marolambo
Morondava  Fandriana
Mahabo  Finandrahana  Nosy Varika
Mandabe  Ambositra
*Makay*  Ambohimahasoa  Mananjary
Ikalamavony  Isandra
Morombe  Beroroha  **Fianarantsoa**  Manakara
*Tanjona Ankaboa*  Ambalavao  Ikongo
Ankazoabo  Ihosy
Ivohibe  Vohipeno
Sakaraha  Iakora  Vondrozo  Farafangana
Betroka
Benenitra  Vangaindrano
Toliara  *Mananara*
Betioky  Midongy
Ampanihy  Befotaka
Bekily
*Mandrare*
Ampanihy  Amboasary  Tôlañaro
Beloha  Ambovombe
Tsiombe
*Tanjona Vohimena*

*Bassas da India*

*Ile Europa*

*Ile Juan de Nova*

**INDIAN OCEAN**

*Mascarene Islands*

**MAURITIUS**
Goodlands
**PORT LOUIS**  Curepipe
*Pointe Sud Ouest*  Mahebourg
Souillac
**ST-DENIS**
St-Paul  St-André
St-Gilles-les-Bains
*Piton des Neiges 3070m*  St-Pierre
**Réunion (to France)**
St-Philippe

Tropic of Capricorn

*Mozambique Channel*

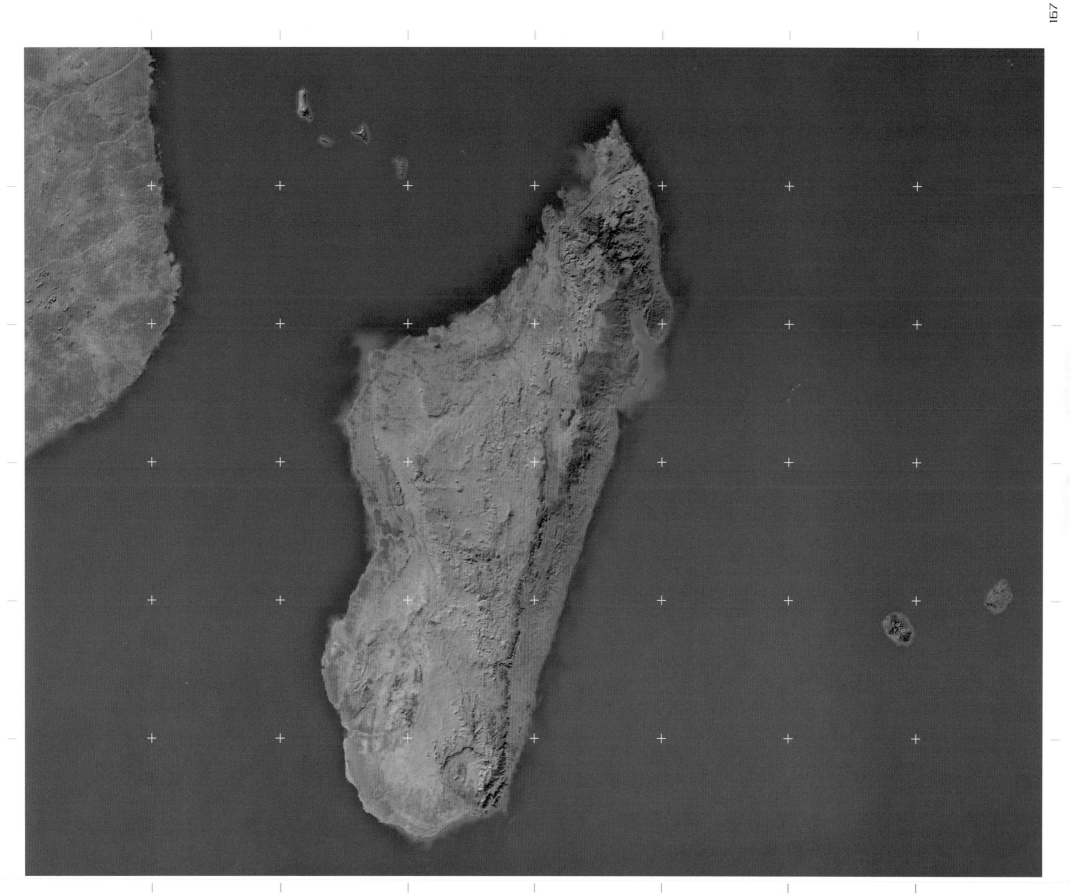

# BETSIBOKA

## 15°55'S, 46°26'E

The estuary of the Betsiboka has caught the eye of astronauts on many occasions. One has reported that it looks like the island of Madagascar is bleeding into the Indian Ocean. At 326 miles (525 km), the Betsiboka is Madagascar's second longest river, and in the rainy season its waters are red (below) with topsoil washed down from deforested areas inland. The island has lost most of its original forest cover and now suffers some of the highest soil erosion rates in the world. A lot of the sediment has been deposited in the river's estuary, building up new islands over the years and splitting the river into multiple streams (far right).

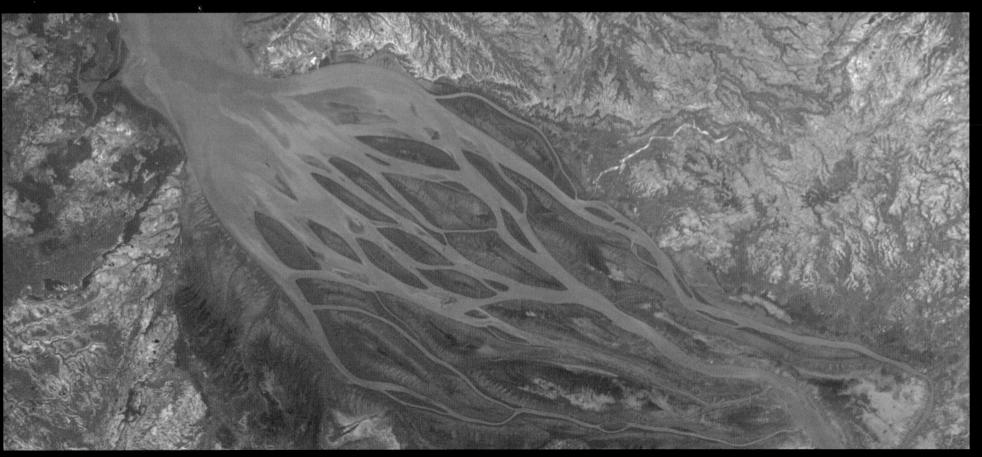

**SATELLITE:** INTERNATIONAL SPACE STATION (ISS)   **INSTRUMENT:** KODAK DCS760C   **HEIGHT:** 220 MILES (354 KM)   **DATE:** 25 MAR 2004

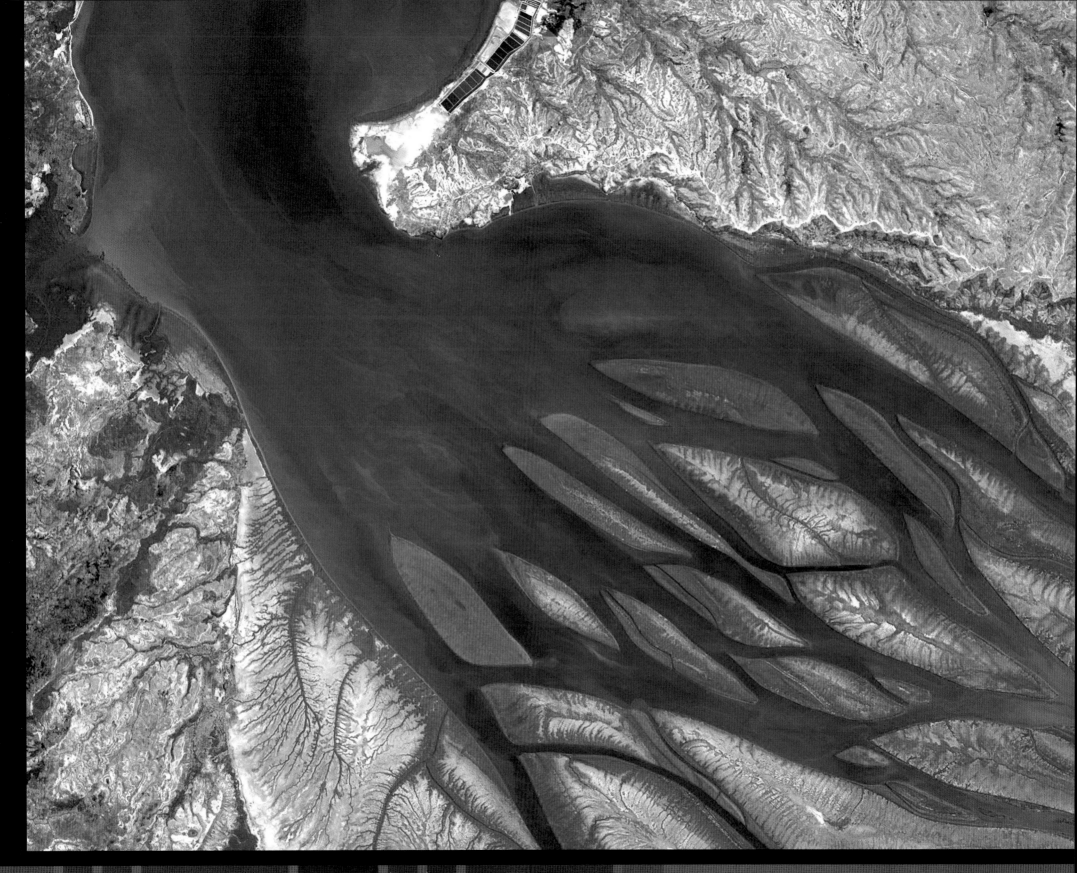

SATELLITE: TERRA (EOS AM-1)   INSTRUMENT: ASTER   HEIGHT: 438 MILES (705 KM)   DATE: 23 AUG 2000

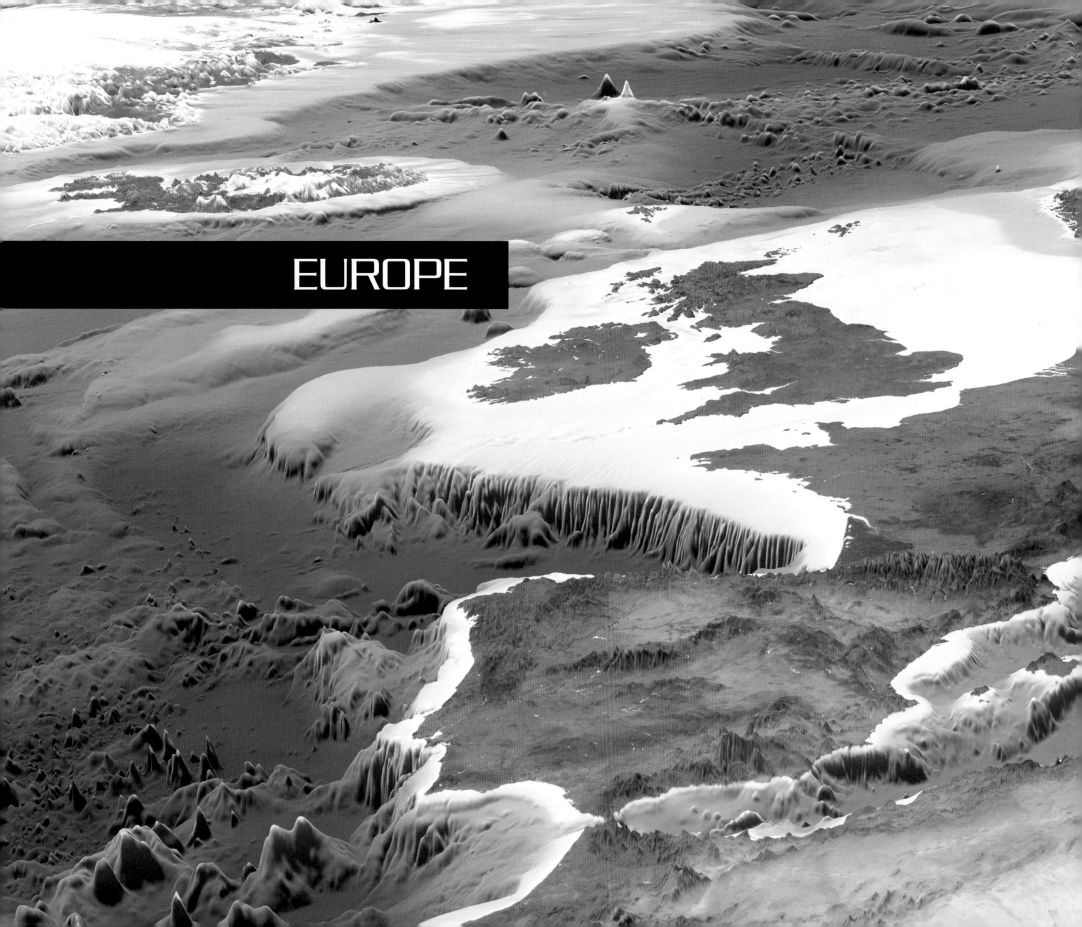

EUROPE

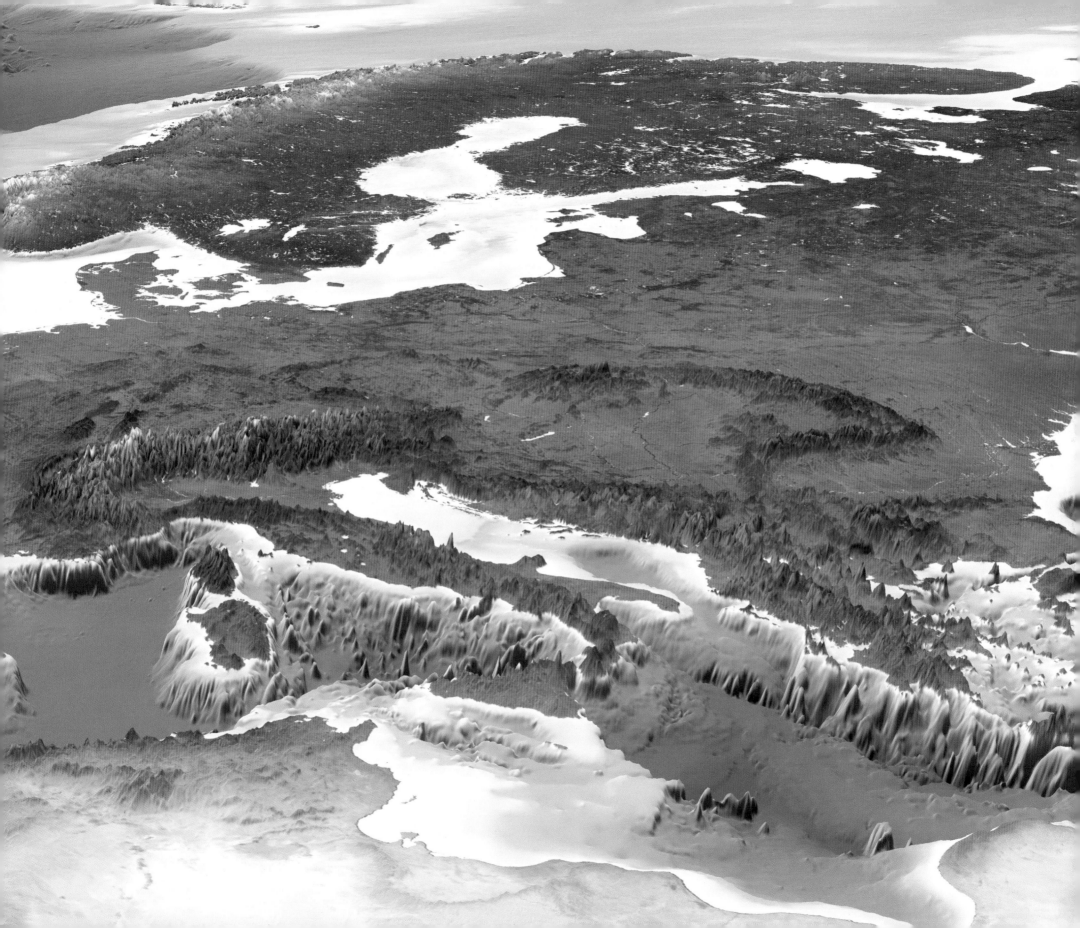

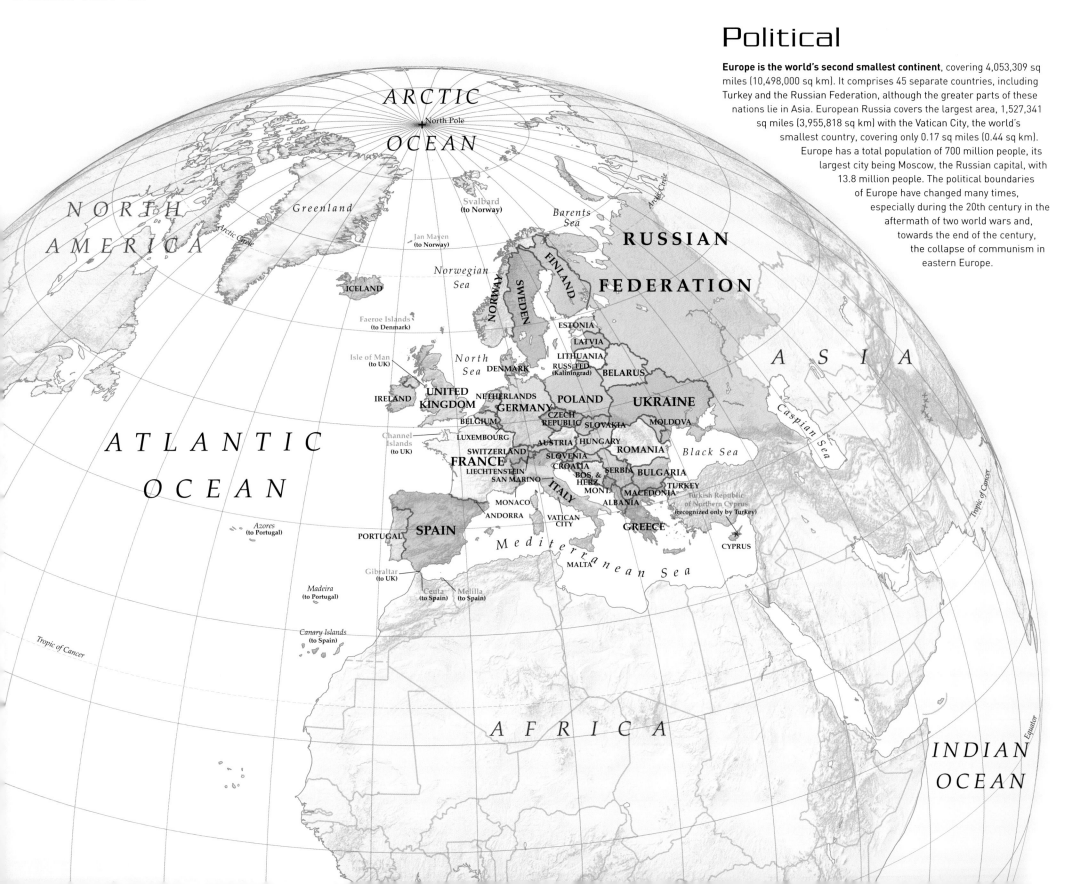

# Political

**Europe is the world's second smallest continent**, covering 4,053,309 sq miles (10,498,000 sq km). It comprises 45 separate countries, including Turkey and the Russian Federation, although the greater parts of these nations lie in Asia. European Russia covers the largest area, 1,527,341 sq miles (3,955,818 sq km) with the Vatican City, the world's smallest country, covering only 0.17 sq miles (0.44 sq km). Europe has a total population of 700 million people, its largest city being Moscow, the Russian capital, with 13.8 million people. The political boundaries of Europe have changed many times, especially during the 20th century in the aftermath of two world wars and, towards the end of the century, the collapse of communism in eastern Europe.

ARCTIC OCEAN

North Pole

NORTH AMERICA

Greenland

Svalbard (to Norway)

Barents Sea

RUSSIAN FEDERATION

Arctic Circle

Jan Mayen (to Norway)

Norwegian Sea

ICELAND

Faeroe Islands (to Denmark)

NORWAY

SWEDEN

FINLAND

ESTONIA

LATVIA

LITHUANIA

RUSS. FED. (Kaliningrad)

BELARUS

Isle of Man (to UK)

North Sea

DENMARK

IRELAND

UNITED KINGDOM

NETHERLANDS

GERMANY

POLAND

UKRAINE

ASIA

BELGIUM

CZECH REPUBLIC

SLOVAKIA

MOLDOVA

Caspian Sea

Channel Islands (to UK)

LUXEMBOURG

AUSTRIA

HUNGARY

ROMANIA

Black Sea

ATLANTIC OCEAN

SWITZERLAND

SLOVENIA

LIECHTENSTEIN

CROATIA

SERBIA

BULGARIA

FRANCE

SAN MARINO

BOS. & HERZ.

MONT.

TURKEY

ITALY

MACEDONIA

ALBANIA

Turkish Republic of Northern Cyprus (recognized only by Turkey)

Tropic of Cancer

MONACO

Azores (to Portugal)

ANDORRA

VATICAN CITY

GREECE

SPAIN

PORTUGAL

Gibraltar (to UK)

Madeira (to Portugal)

Ceuta (to Spain)

Melilla (to Spain)

Mediterranean Sea

MALTA

CYPRUS

Tropic of Cancer

Canary Islands (to Spain)

AFRICA

INDIAN OCEAN

Equator

# Physical

**The physical diversity of Europe** belies its relatively small size. In the northwest, the older, rounded Atlantic highlands of Scandinavia and the British Isles were scoured and smoothed by ice age glaciers and some of the world's oldest rocks can be found here. To the south lies a curve of ranges from the Pyrenees, through the Alps to the Carpathians. These mountains are much younger, less eroded and divide temperate northern Europe from its warmer, southerly Mediterranean fringe. Between the two lies the North European Plain which runs 2485 miles (4000 km) from eastern England all the way to Europe's eastern boundary, the Ural Mountains. In the southeast the Caucasus range also marks off the continental limits and boasts Europe's highest mountain, El'brus at 18,510 ft (5642m).

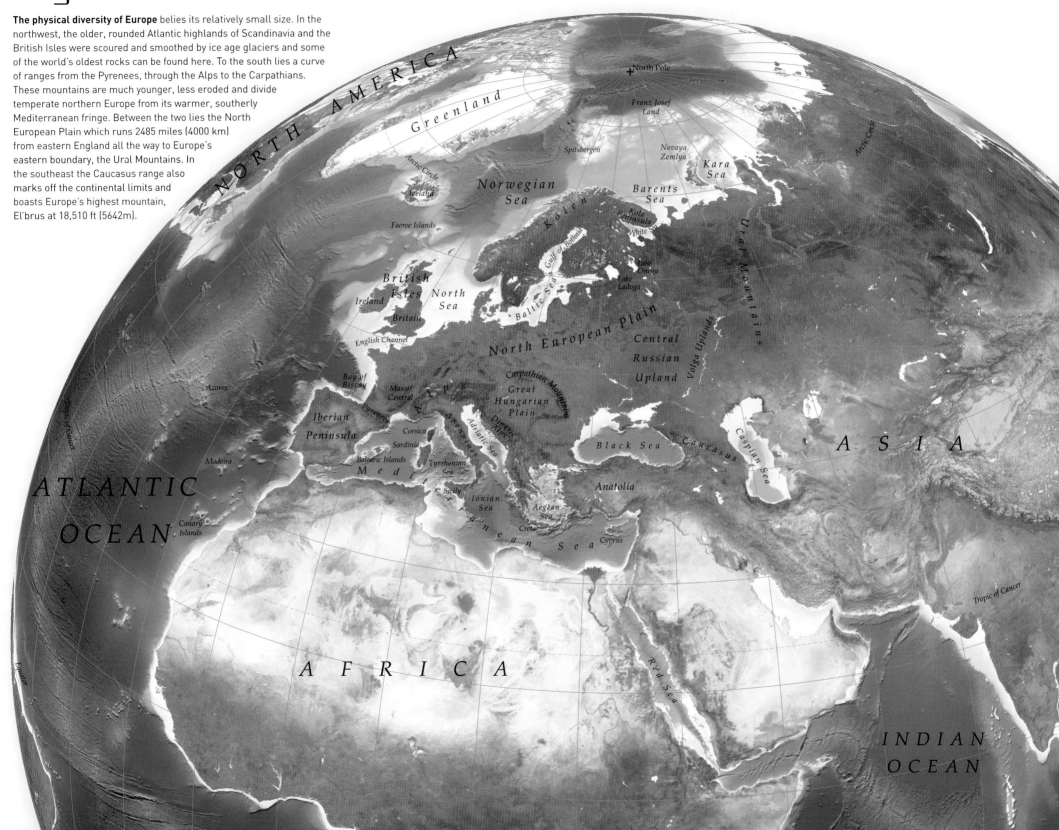

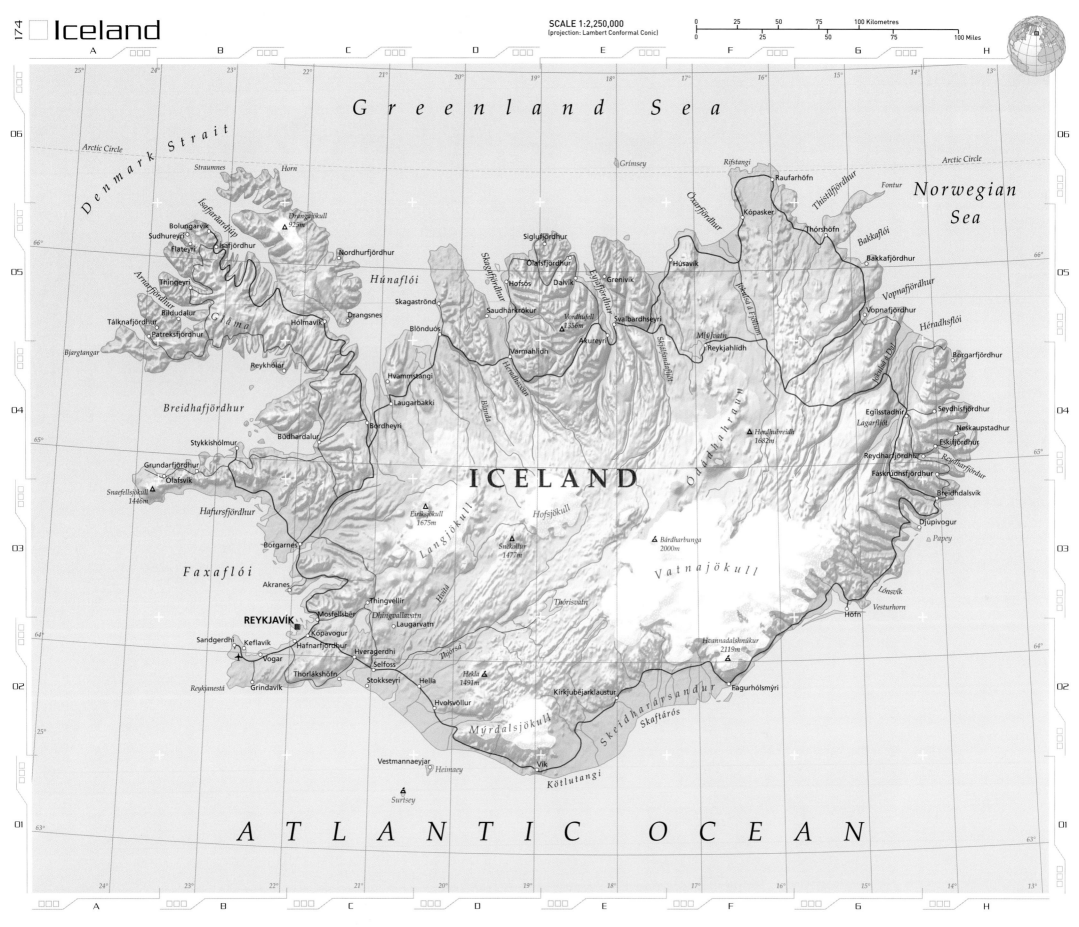

SCALE 1:7,250,000
(projection: Lambert Conformal Conic)

50  100  150  200  250 Kilometres

50  100  150  200  250 Miles

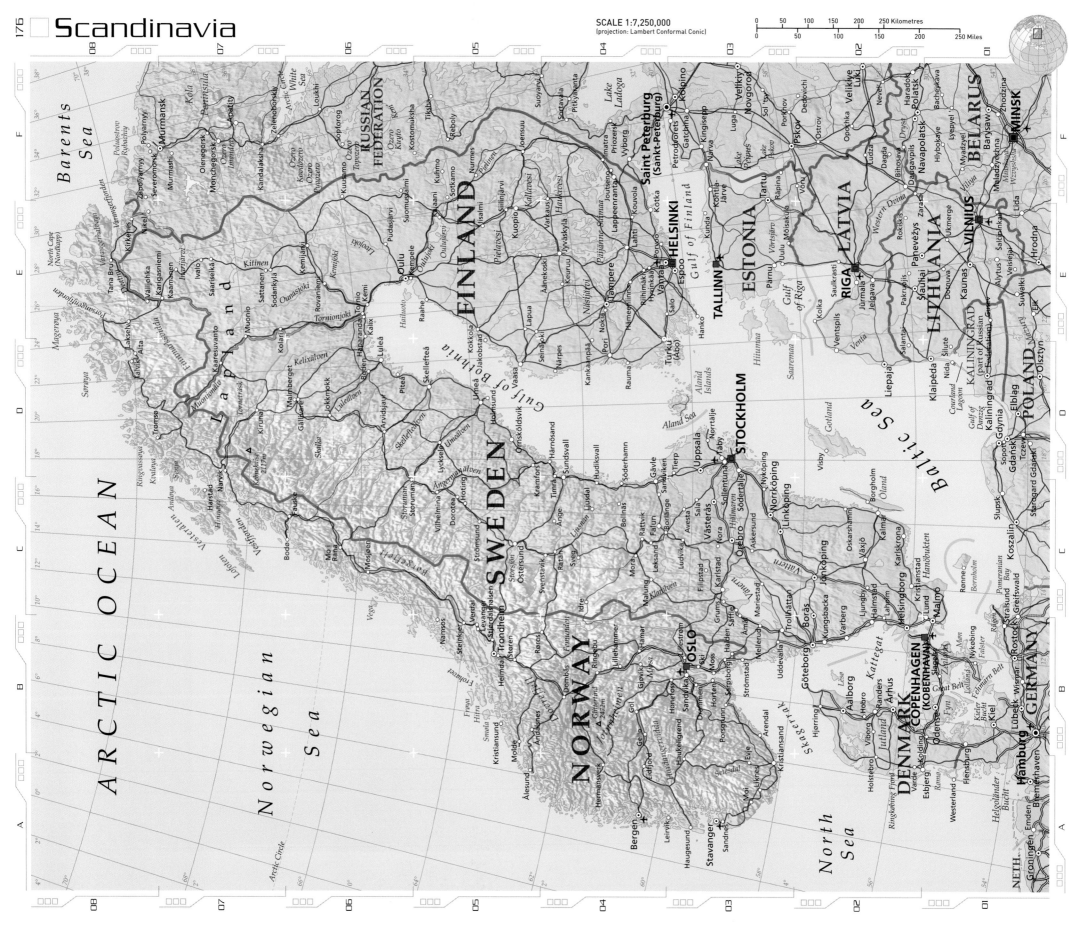

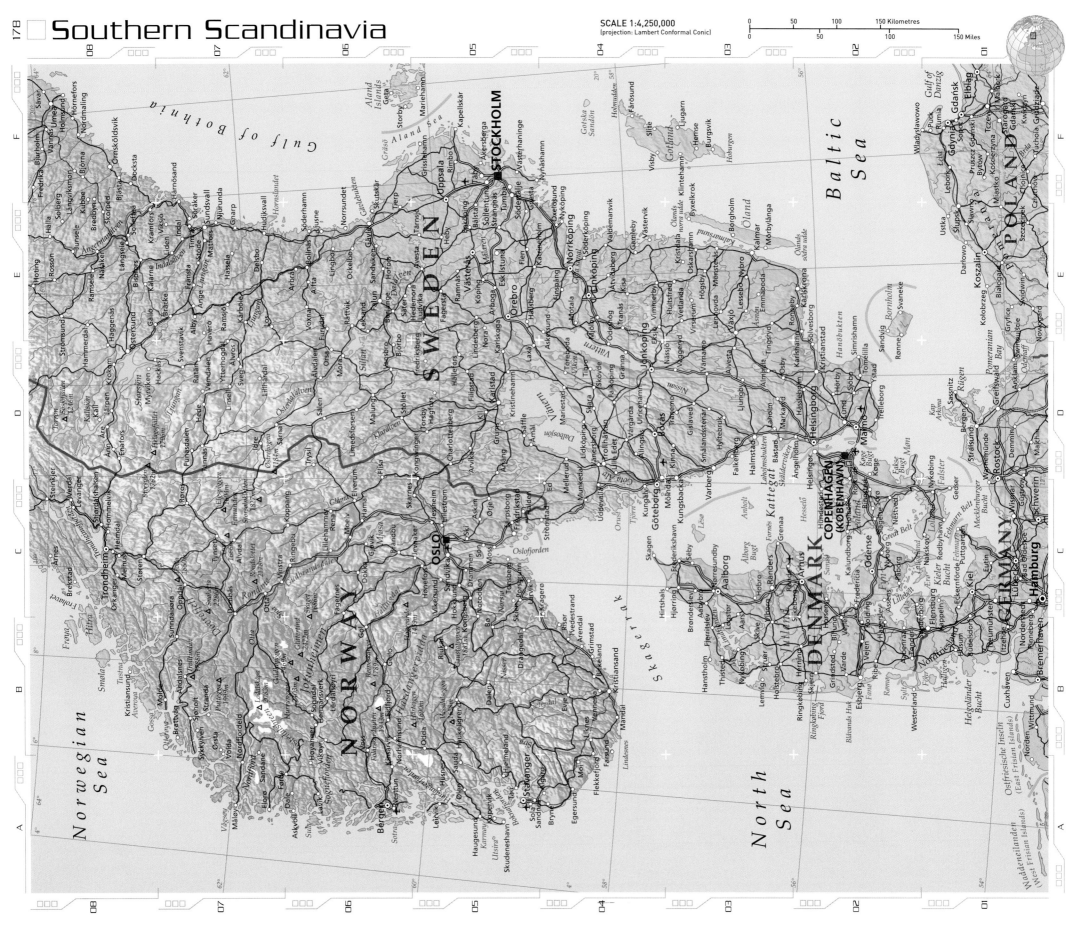

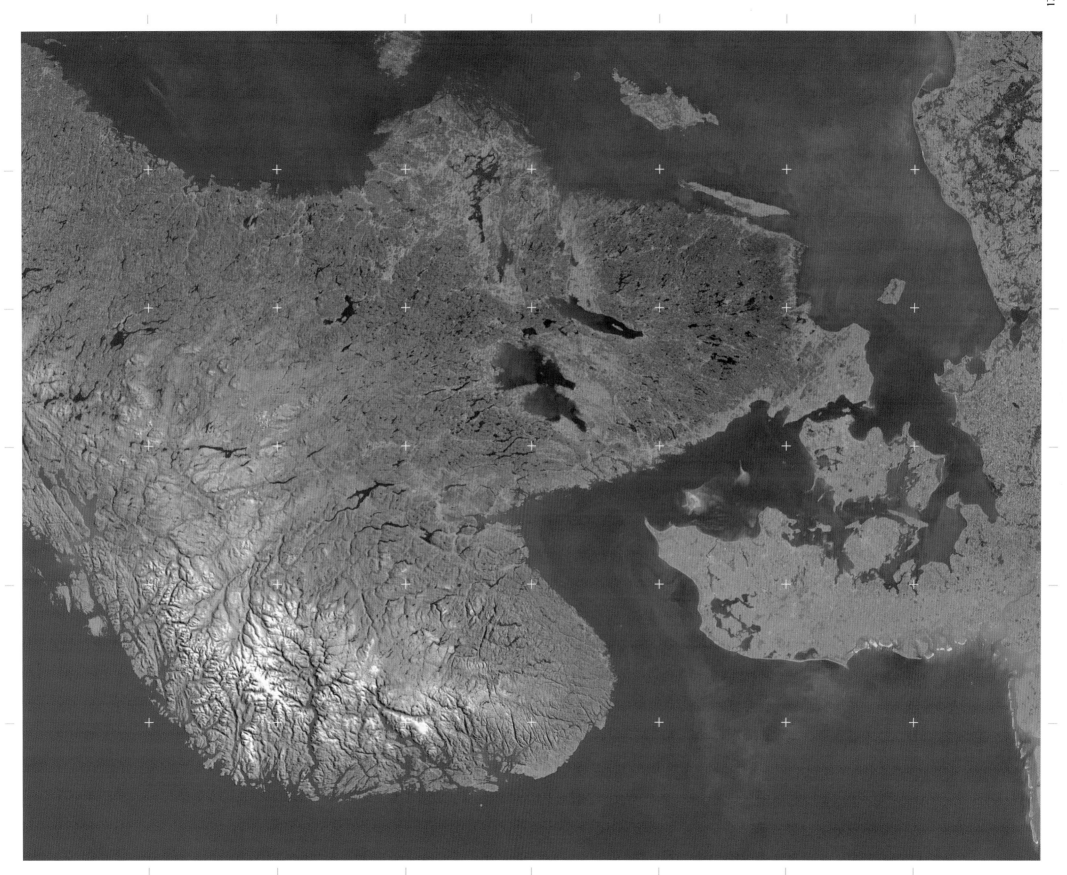

# ROSSFJORD

## 69°24'N, 18°23'E

Norway's coast was sculpted by a great ice sheet during the last ice age. With so much water locked up in the ice sheets, sea levels dropped 395 ft (120 m) lower than they are today and glaciers scoured out deep valleys at the edge of the land. The ice melted as today's warmer climate became established, and rising sea levels flooded these spectacular glacier-cut valleys. This winter image shows an area just south of Tromsø, including the fjord of Malangen where it reaches the sea between the islands of Kvaløya (to the north) and Senja (to the south). The town of Rossfjord is on the small inlet near the right of the image, which leads into a frozen lake, Rossfjordvatnet.

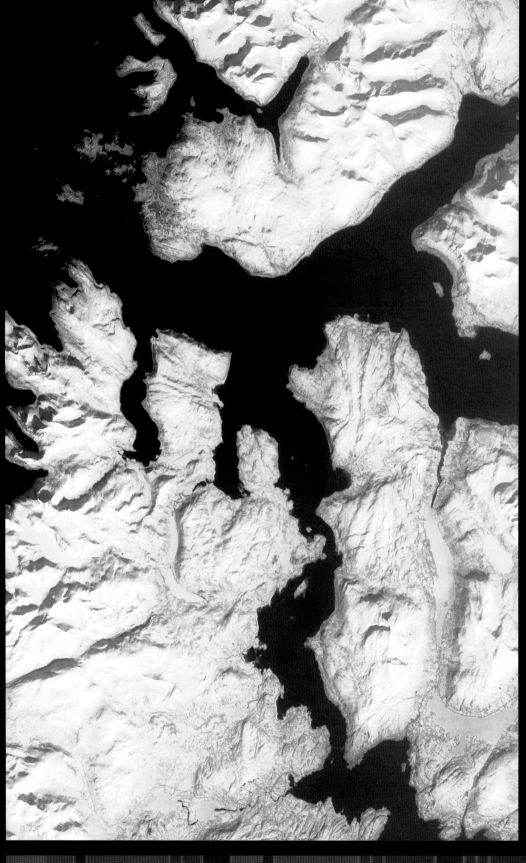

**SATELLITE:** TERRA (EOS AM-1)    **INSTRUMENT:** ASTER    **HEIGHT:** 438 MILES (705 KM)    **DATE:** 17 APR 2002

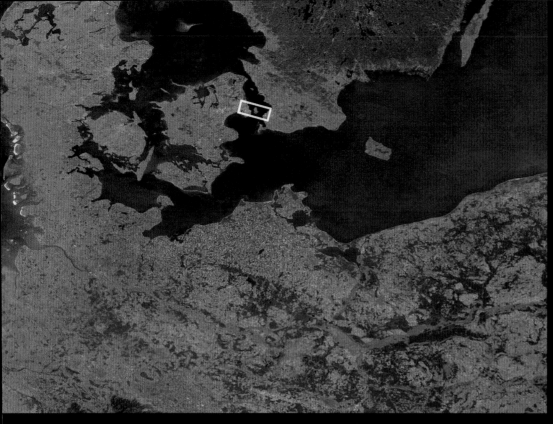

# ØRESUND LINK

## 55°36'N, 12°45'E

The Øresund (The Sound) lies between Denmark's largest island of Sjaelland and mainland Sweden. It is one of the world's busiest waterways, a fact kept in mind when it was decided to build a road and rail link, which opened to traffic in 2000. The link is 10 miles (16 km) long, but split into three parts: a tunnel runs from the Danish coast for 2.2 miles (3.5 km), leaving the sea clear for shipping. This emerges onto a 2.5 mile (4 km) long artificial island, Peberholm, then connects to Sweden by 4.9 miles (7.8 km) of cable-supported bridges.

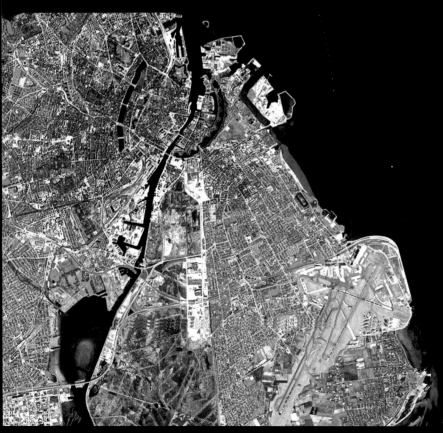
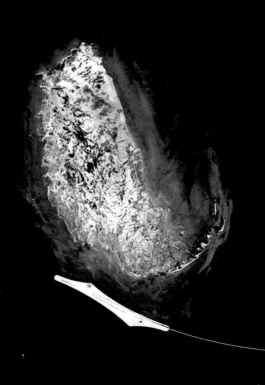
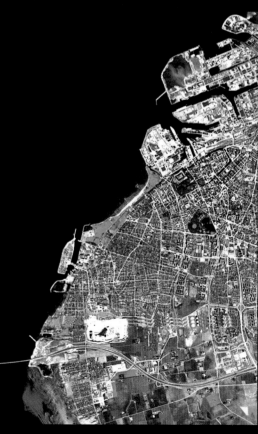

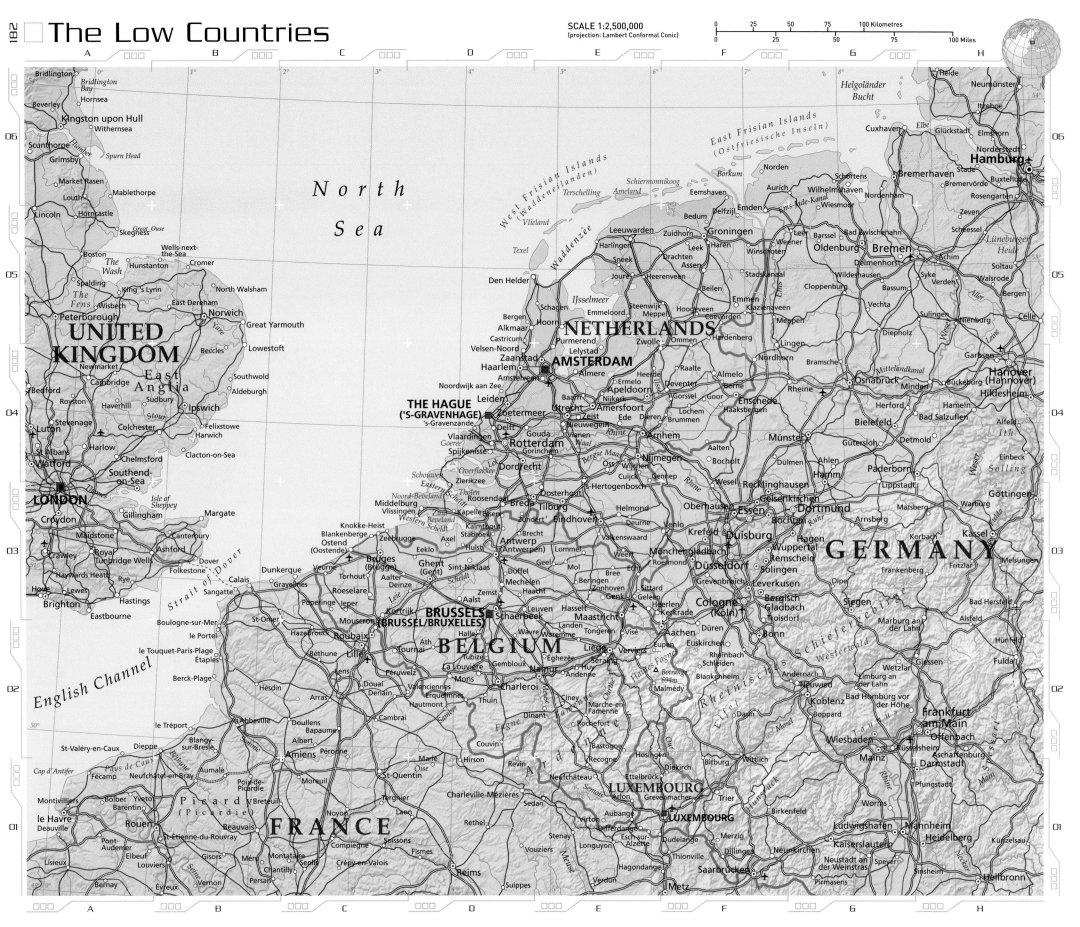

# ZEELAND

## 51°25'N, 3°45'E

For centuries the Dutch coast was at the mercy of the North Sea, with large areas of reclaimed land lying below sea level, vulnerable to flooding. Thousands died in January 1953 when a storm surge coincided with high spring tides and overwhelmed the seawalls protecting the shore. Particularly vulnerable were the islands in the delta region where the rivers of the Rhine, Maas and Scheldt reach the sea. Today, these once separate islands are connected by a series of dams which have cut some parts of the estuaries off from the sea to create new lakes. Shipping negotiates the defensive barriers through a system of locks and canals.

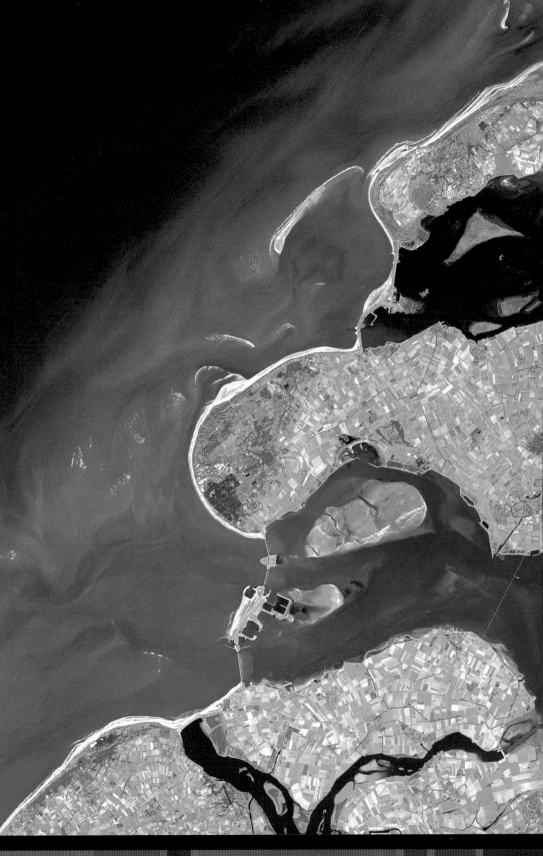

**SATELLITE:** TERRA (EOS AM-1)   **INSTRUMENT:** ASTER   **HEIGHT:** 438 MILES (705 KM)   **DATE:** 24 SEP 2002

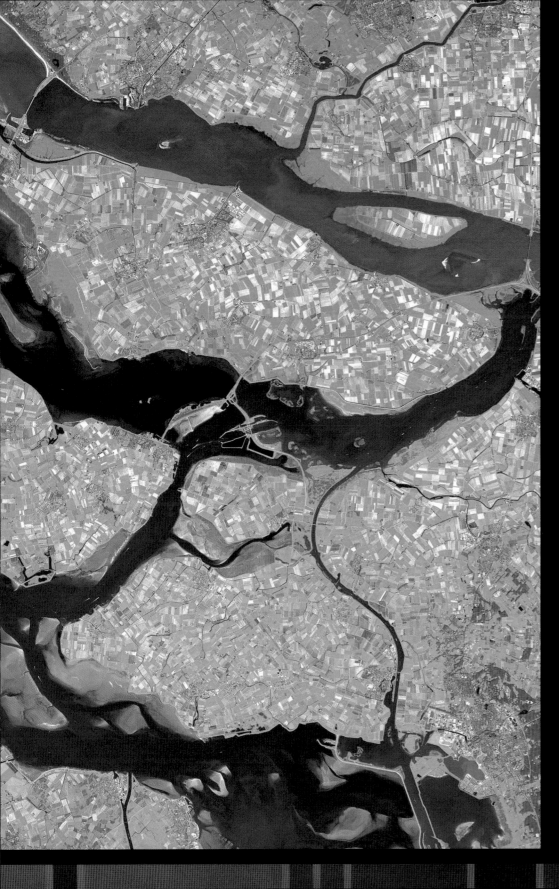

▼ **The port of Rotterdam** was becoming overcrowded by the 1960s. The solution was to re-engineer the mouths of the Rhine and Maas rivers and develop a modern new port on reclaimed land between the city and the North Sea. Europoort ('Eurogate') is accessible to the world's largest tankers, bulk carriers and container ships, and now handles more than 347 million tons (353 million tonnes) of cargo per year. Ships manoeuvring in the harbour and shore infrastructure such as oil storage tanks can be seen in this photo taken from the International Space Station.

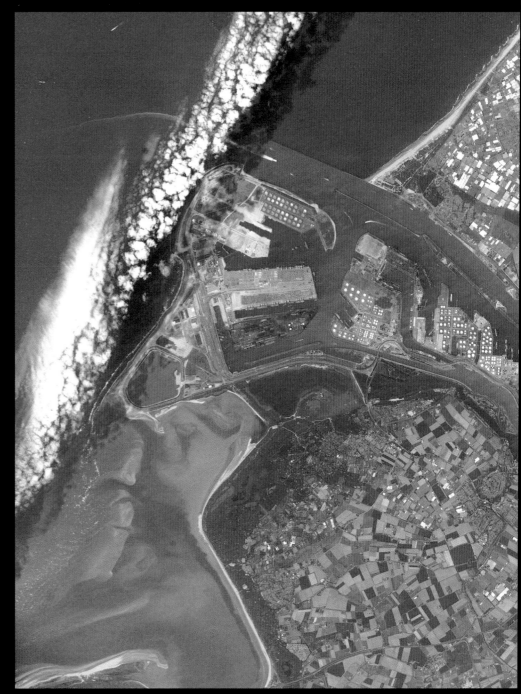

# The British Isles

SCALE 1:4,250,000
(projection: Lambert Conformal Conic)

| | 0 | 50 | 100 | 150 Kilometres |
| 0 | 50 | 100 | 150 Miles |

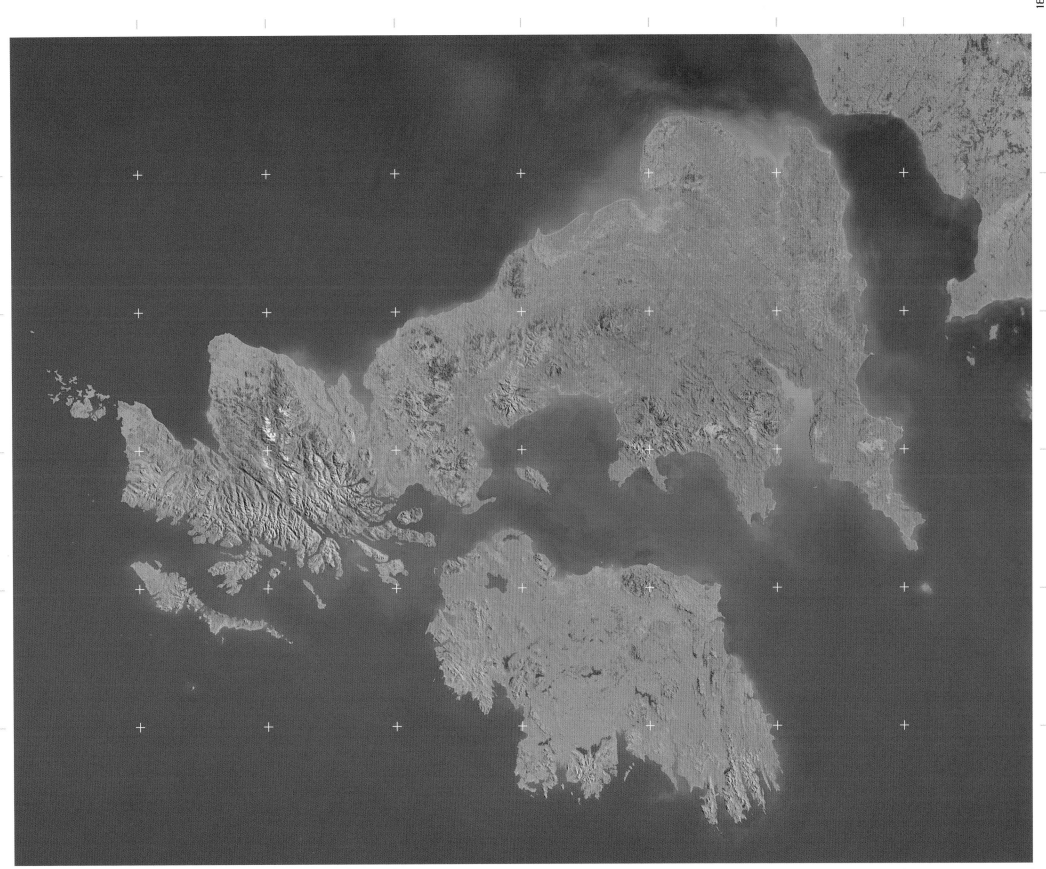

# LONDON

## 51°30'N, 0°10'W

One of the world's great metropolitan centres of culture, commerce, banking and tourism, London is a remarkably diverse urban environment. From Westminster, with the Houses of Parliament, Abbey, royal residences and parks to the 'village' districts with their own unique characteristics, London remains a wonderful case study for urban historians. Sited on the lowest fording place across the Thames, it developed as an inland port and a major Roman settlement, later becoming the seat of national power under the Normans in the 12th century. Oddly, it prospered from the destruction brought by the Great Fire of 1666, which allowed replanning and rebuilding in the old city. A further opportunity for renewal came after the German bombing of the Blitz in World War II. Modern London has continued to evolve into one of the most ethnically and culturally diverse cities on Earth.

▶ **A comprehensive view** of Greater London, from the Thames Estuary in the east, to the runways of Heathrow Airport and its nearby reservoirs in the west. The thin white string of London's busy outer ring road, the M25, can be picked out in places, framing the conurbation. The pronounced southward meander of the Isle of Dogs, upon which much of the newly-constructed Docklands business district is situated, can clearly be seen to the right of the centre of this image.

SATELLITE: LANDSAT 7   INSTRUMENT: ENHANCED THEMATIC MAPPER PLUS (ETM+)   HEIGHT: 438 MILES (705 KM)   DATE: 19 JUN 2000

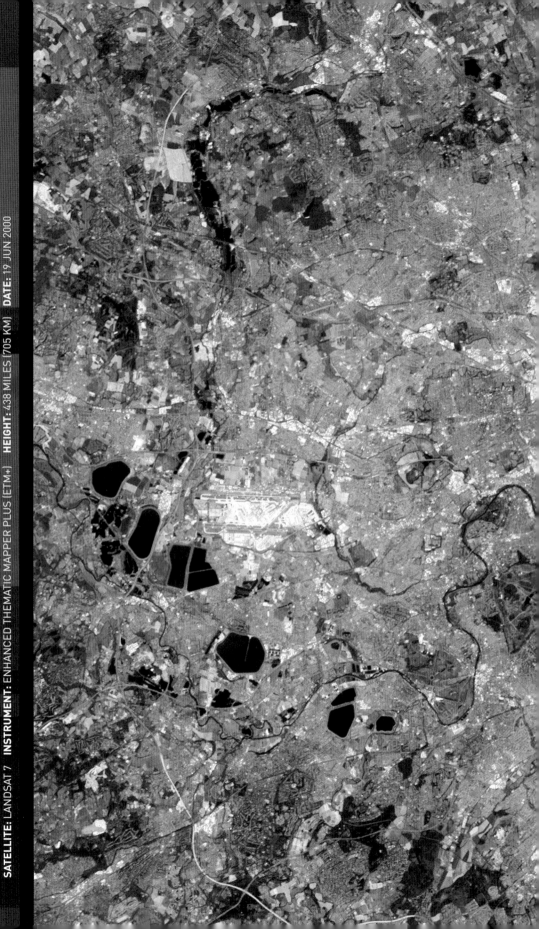

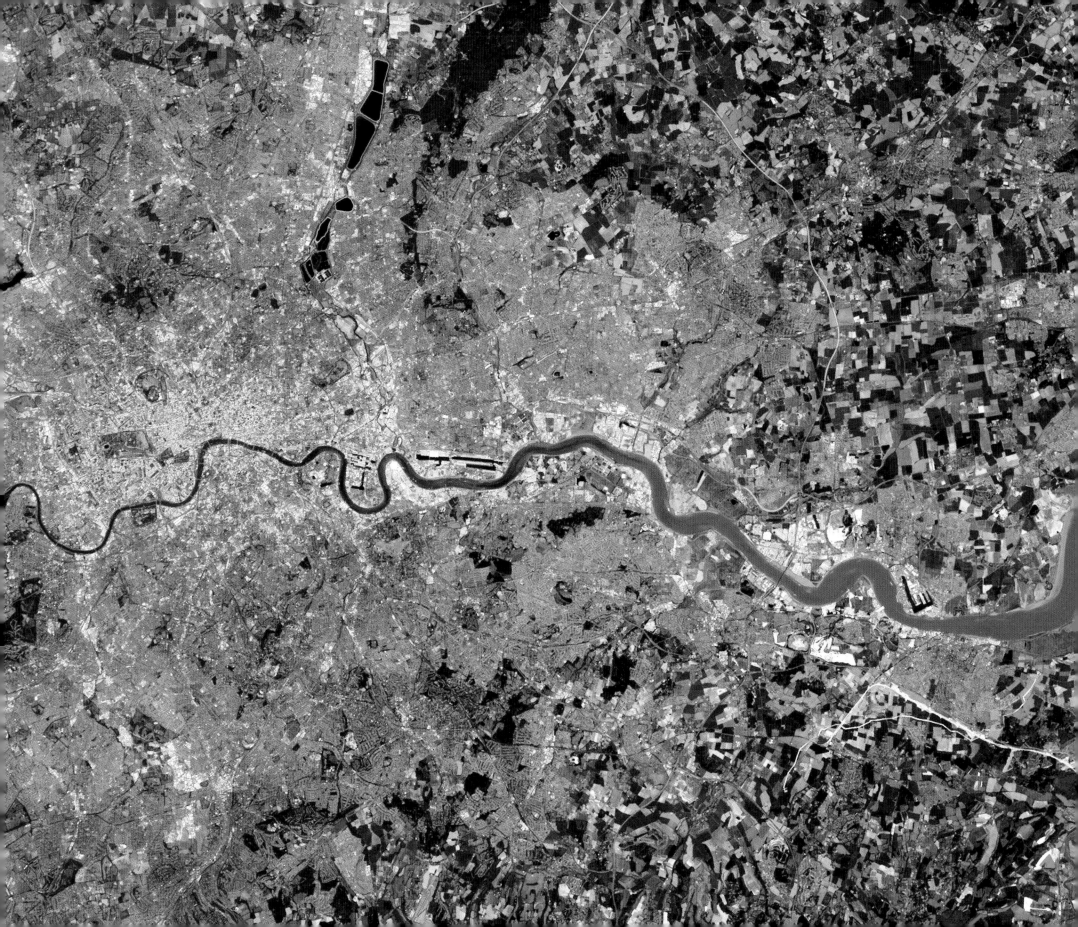

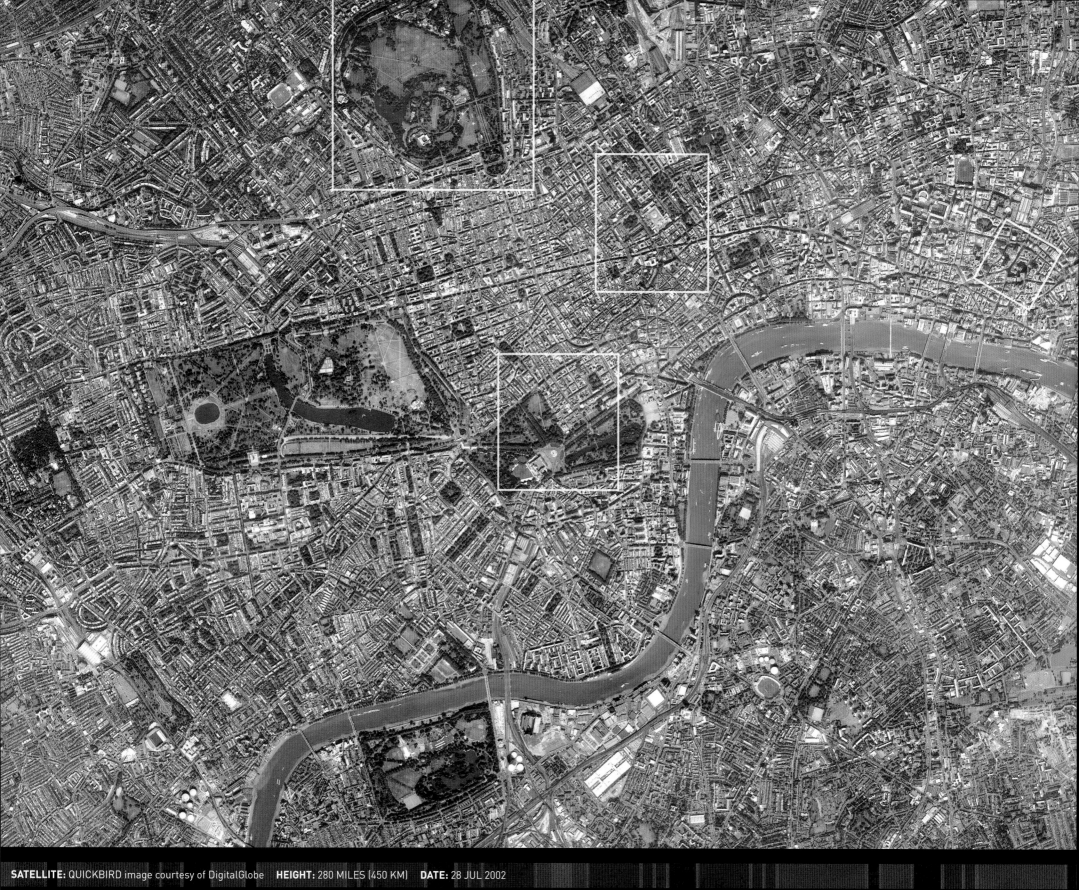

▶ **Regent's Park**
Designed by Sir John Nash in 1811, and ringed by a catalogue of fine Regency houses, the area was first acquired by Henry VIII as a hunting ground. Today, at 0.6 sq miles (1.7 sq km) the park forms the largest single recreational area in London, and contains the Zoological Gardens, an open-air theatre and numerous sports and recreational areas.

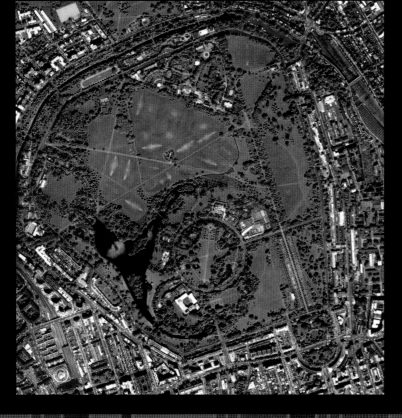

◀ **The sedate streets**
of Bloomsbury, situated to the west of the City, were laid out in the 19th century. They are dominated by the neo-classical edifice of the British Museum, its austere hauteur recently invigorated by Norman Foster's vast steel and glass roof over the 87,120 sq ft (8094 sq m) Great Court. Standing out in blue in this image, it is London's largest covered space.

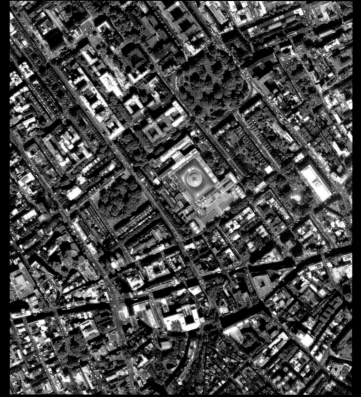

**SATELLITE:** IKONOS image courtesy of GeoEye    **HEIGHT:** 423 MILES (681 KM)    **DATE:** 07 MAY 2003

**SATELLITE:** IKONOS image courtesy of GeoEye    **HEIGHT:** 423 MILES (681 KM)    **DATE:** 07 MAY 2003

▶ **The architecturally grandiose** but undistinguished complex of Buckingham Palace benefits enormously from the regal processional planning arranged around it in the 19th century. The circular memorial to Queen Victoria is the focal point of this network positioned at the end of The Mall, one of Europe's greatest boulevards (middle to lower right). At the centre of the image are the second-string royal residences of Clarence House and St James's Palace.

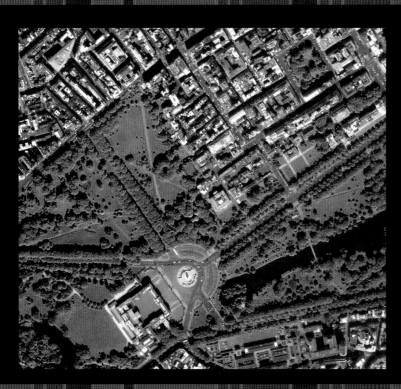

◀ **The City of London** is both the oldest part of London, the site of the earliest settlement and the newest in that much has been boldly redeveloped since the World War II. The erosion of limitations on building heights has seen this area blossom into an architectural wonderland from the 1980s onwards. The circular section of Norman Foster's innovative 30 St. Mary Axe office tower (the 'London Gherkin') can be seen under construction centre right.

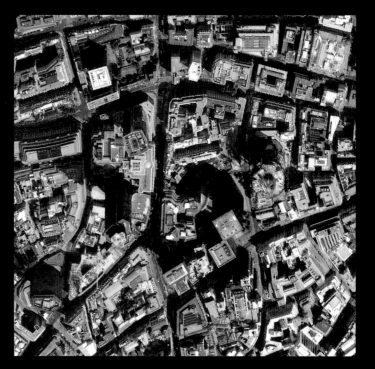

**SATELLITE:** IKONOS image courtesy of GeoEye    **HEIGHT:** 423 MILES (681 KM)    **DATE:** 07 MAY 2003

**SATELLITE:** QUICKBIRD image courtesy of DigitalGlobe **HEIGHT:** 280 MILES (450 KM)  **DATE:** 28 JUL 2002

# STRAIT OF DOVER
## 51°N, 1°30'E

The Strait of Dover links the English Channel with the North Sea, separating England and France by a mere 20 miles (33 km). About 400 vessels pass through each day, making it one of the world's busiest waterways, with westward and eastward traffic separated into two lanes. Ferries ply back and forth across the sea lanes between the ports of Dover and Calais. Sand banks are exposed off the English coast at low tide, when this image was taken.

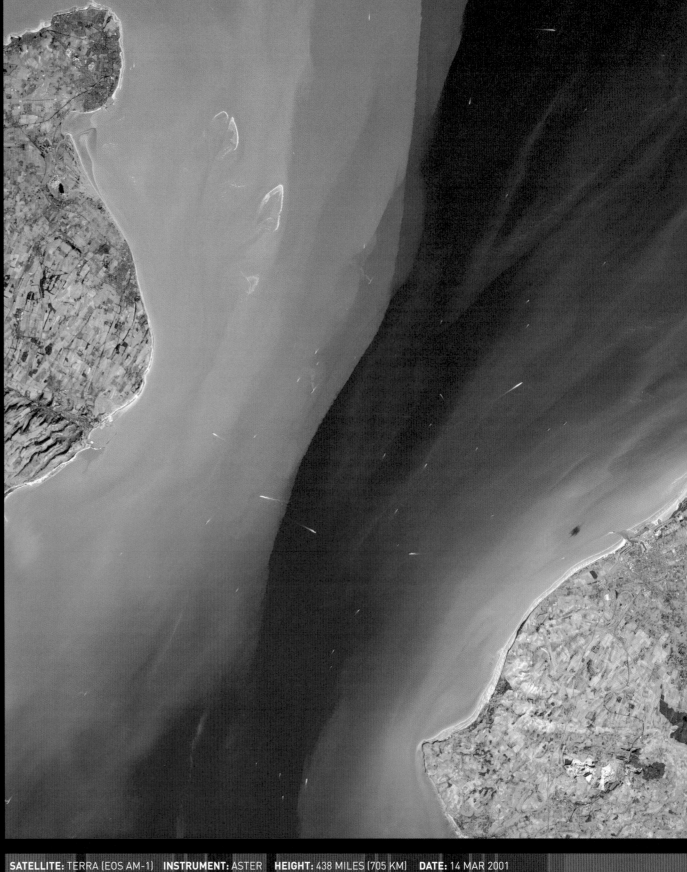

**SATELLITE:** TERRA (EOS AM-1)   **INSTRUMENT:** ASTER   **HEIGHT:** 438 MILES (705 KM)   **DATE:** 14 MAR 2001

# ATLANTIC FRINGE

## 48°N, 7°30'W

The north Atlantic has been described as Europe's 'weather kitchen', where clouds, squalls and storms are cooked up and sent eastwards by the prevailing winds. Cold air from the Arctic and warm air from the tropics are sucked in by areas of low pressure (depressions). Heat and moisture are extracted from the sea and frontal systems emerge from the tussle – spirals of cloud which barrel into the continent one after another in the winter months. The lower the atmospheric pressure, the faster the winds blow and the tighter the spiral becomes. Rain, hail or snow may result at the fronts between warm and cold air masses, with Europe's western shores bearing the brunt of the meteorological assault. The 'Emerald Isle' of Ireland, France's Brittany peninsula and Spain's Galicia all owe their green landscapes to the adjacent Atlantic Ocean.

◄ **A small low pressure system** is caught forming in the Western Approaches to the British Isles on 23rd March 2003. A tight anticlockwise-rotating spiral marks the point of lowest pressure and a long bank of cloud trails north to the west of Ireland along a front between warm and cold air.

**SATELLITE:** TERRA (EOS AM-1), MODIS    **HEIGHT:** 438 MILES (705 KM)    **DATE:** 23 MAR 2003

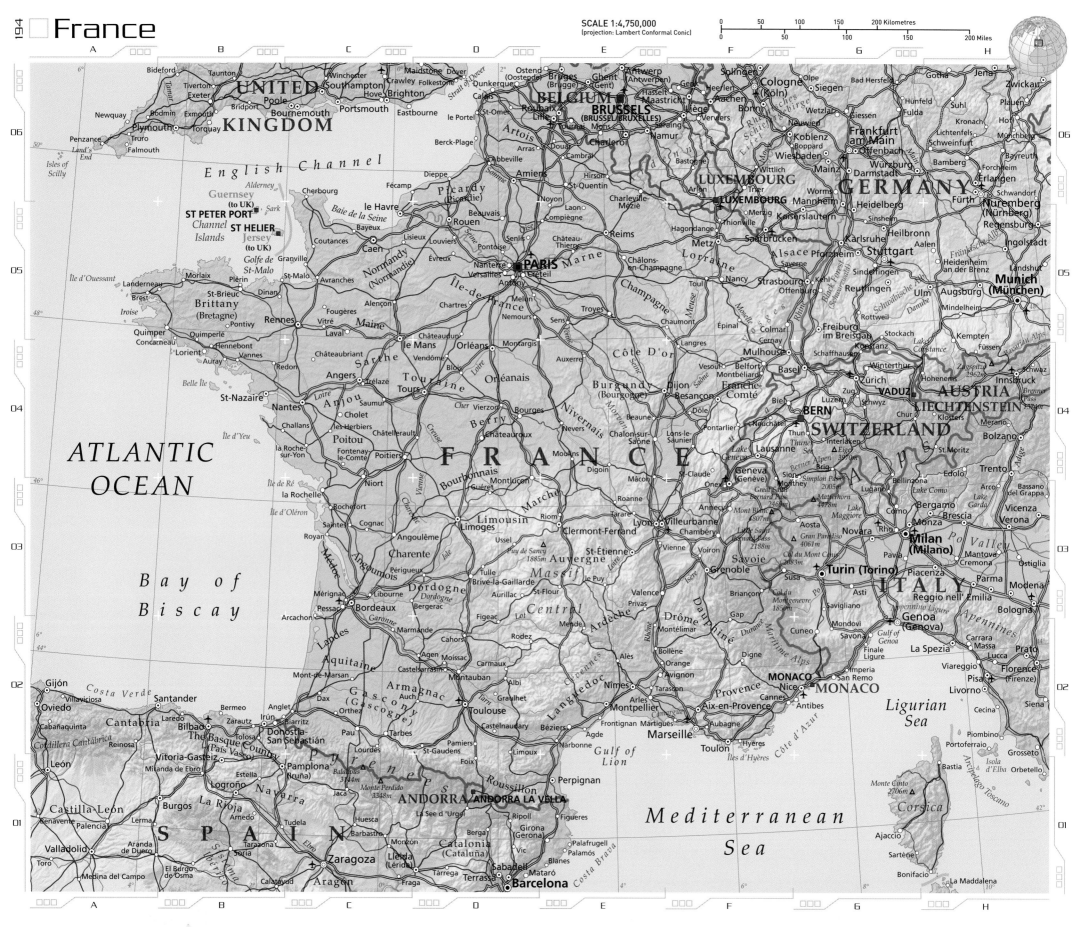

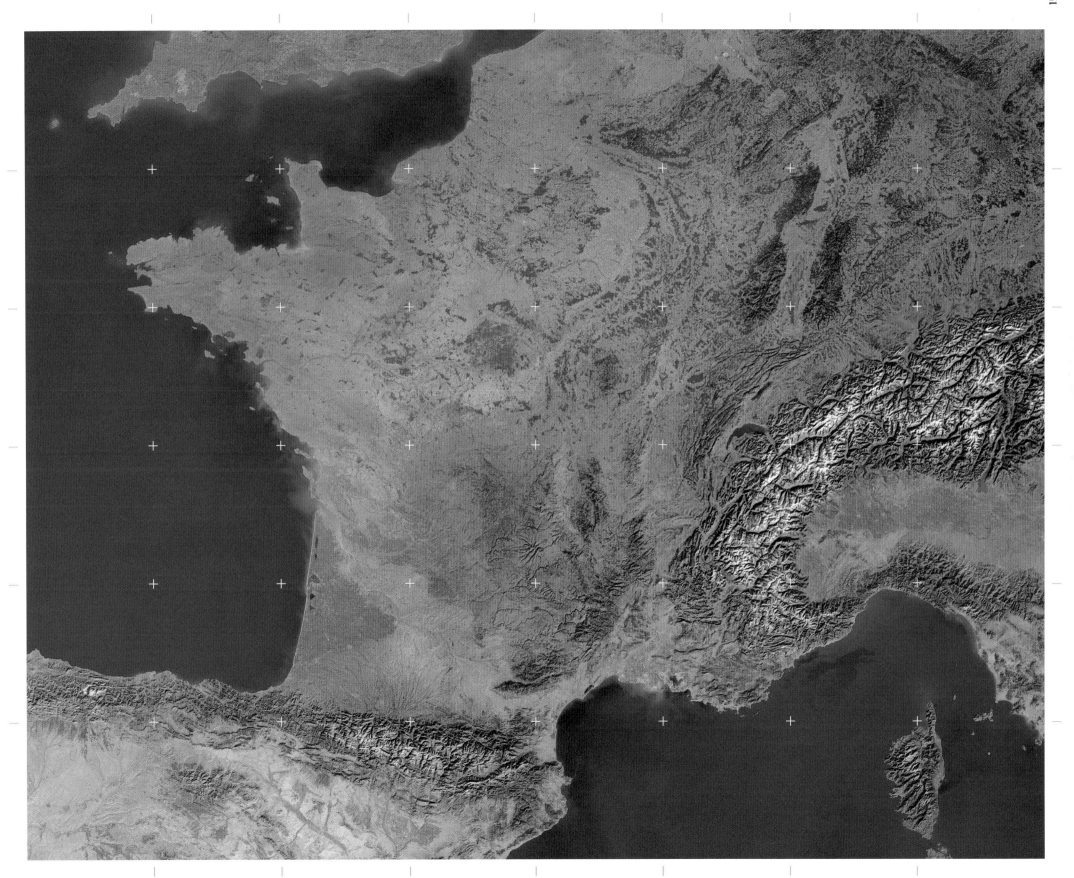

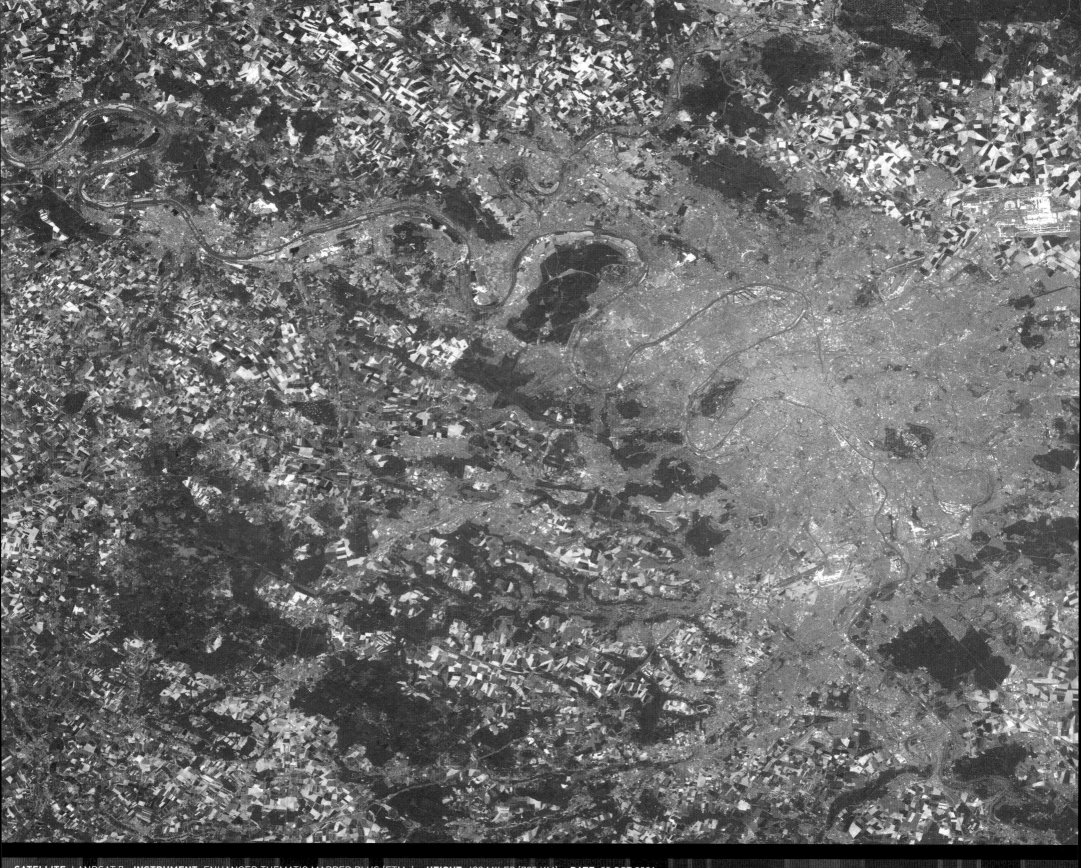

# PARIS

## 48°52'N, 2°19'E

Paris takes its name from the Parisii, one of the Celtic tribes which settled in northern France from about 420 BCE. The Romans knew this settlement, centred on an island in the Seine, as Lutetia, and it grew into a prosperous city during the 400 years of Roman rule. The capital of France since the 10th century, Paris and its metropolitan area is now home to 10 million people. Strict 19th century building laws have limited the height of buildings, contributing to the city's romantic charm, but restricting growth in the central area. As a result, the 20th century saw a sprawl of suburbs and satellite towns (the banlieues) along the Seine, Marne and Oise rivers.

◄◄ **The modern suburbs** appear red in contrast to the bright neo-classical stone buildings of central Paris. The city's international airports can be seen in this Landsat image: Orly in the southern suburbs and Charles de Gaulle in open country to the north. Paris is set in a patchwork of forest and agricultural land, with the bright chalky soils of the Champagne region lying to the east.

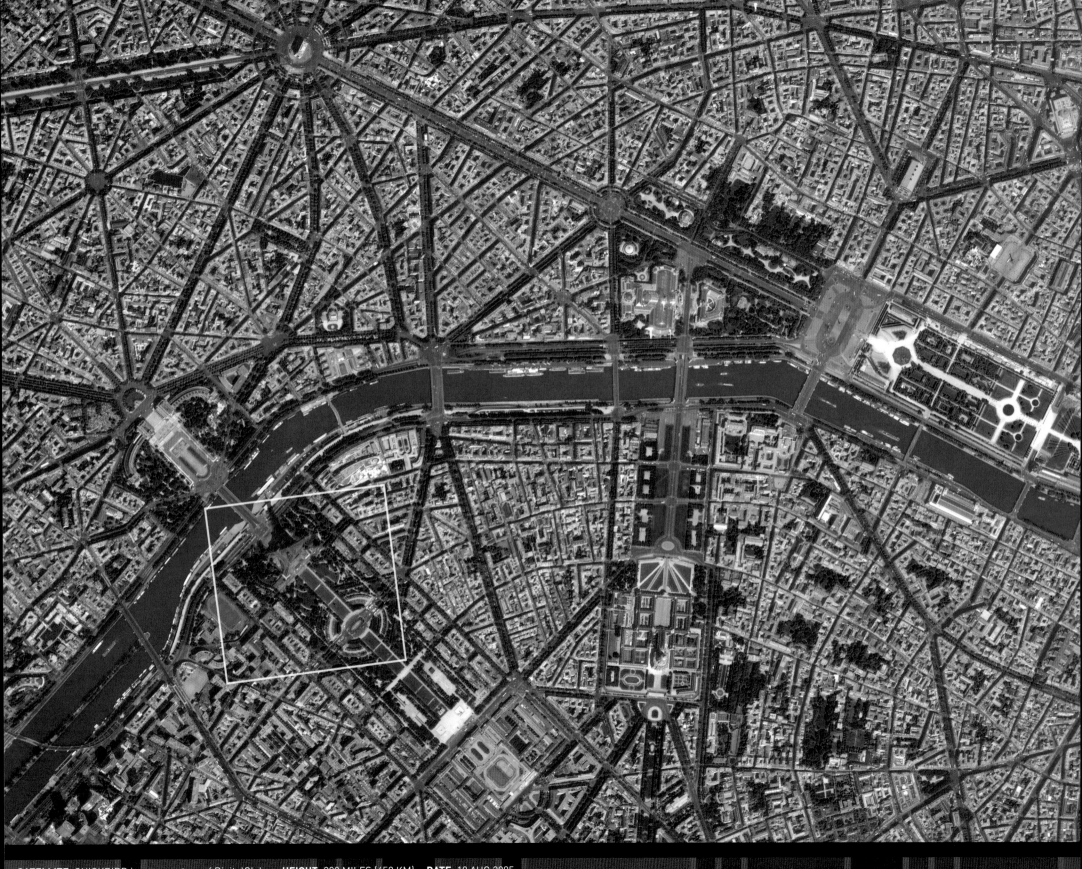

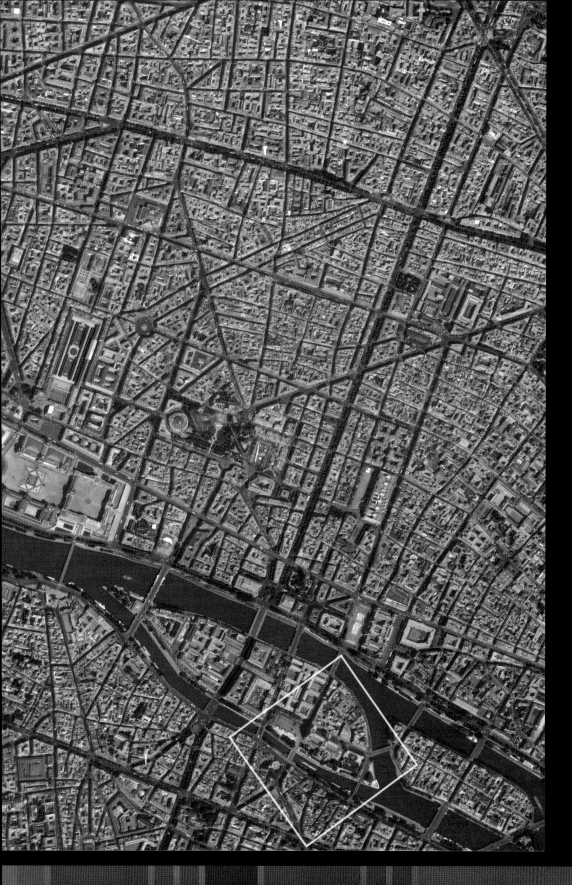

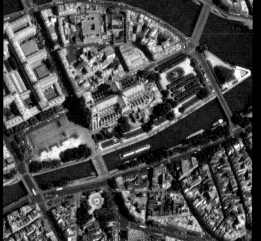

Streets radiate out in all directions from focal points in 'the City of Light' (main image). The name dates from the 19th century, when Paris was remodelled and became an early adopter of street lighting. Another 19th century industrial marvel is the Eiffel Tower (below), at 1000ft (300 m), the tallest building in the world until 1930. Surviving from an earlier age, the 12th century cathedral Notre Dame de Paris (left) is situated on the Île de la Cité.

**SATELLITE:** QUICKBIRD image courtesy of DigitalGlobe    **HEIGHT:** 280 MILES (450 KM)
**DATE:** 10 AUG 2005

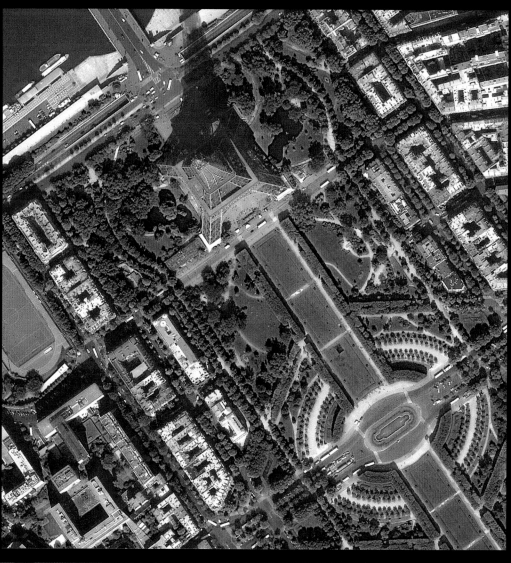

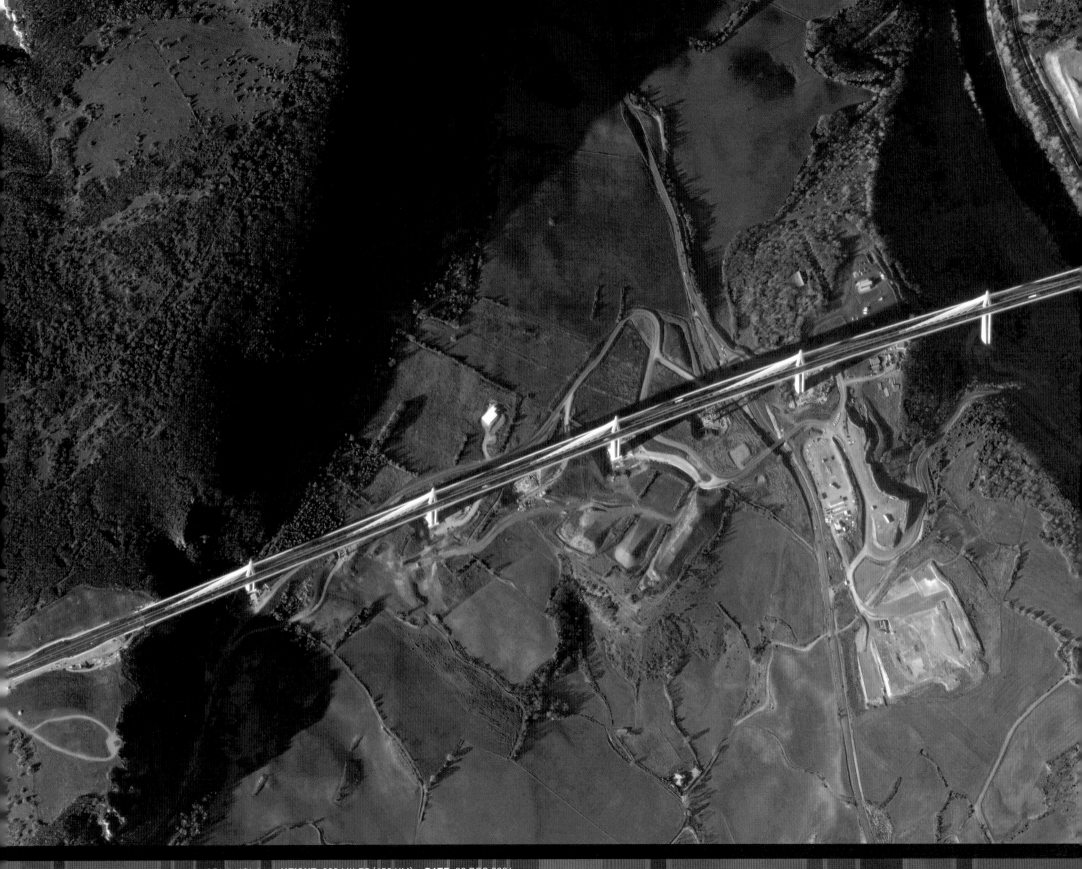

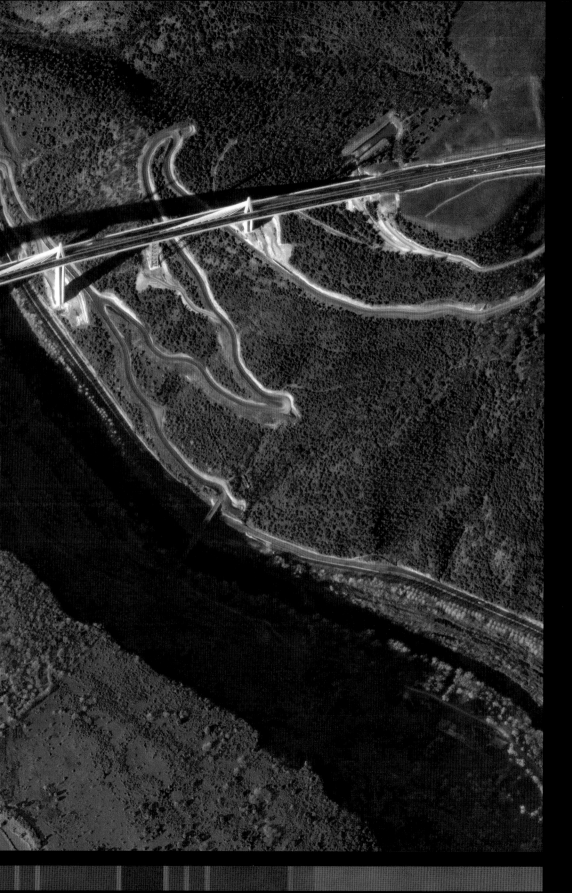

# MILLAU VIADUCT

## 44°06'N, 3°05'E

The Millau Viaduct is the world's tallest road bridge, designed by French engineer Michel Virlogeux in collaboration with British architect Norman Foster. Measuring 1125 ft (343 m) at the top of its highest pillar, the Millau Viaduct is the last link in the new A75 autoroute which links Paris with the Mediterranean coast and Spain via the Massif Central. Prior to the viaduct's completion in 2004, the old road through the nearby town of Millau became clogged with holiday traffic every summer. The bridge runs for 8071 ft (2460 m) along a slightly curved path over the valley of the Tarn river, linking the Causse Rouge plateau in the north with the Causse de Larzac in the south. Satellite positioning technology was used to precisely fit each prefabricated bridge section into place.

◄ **Orange girders** from the bridge's construction towers are visible in this satellite image taken a month after the bridge opened to traffic in December 2004. The gorge of the Tarn river is deep in winter shadow 886 ft (270 m) below the road deck.

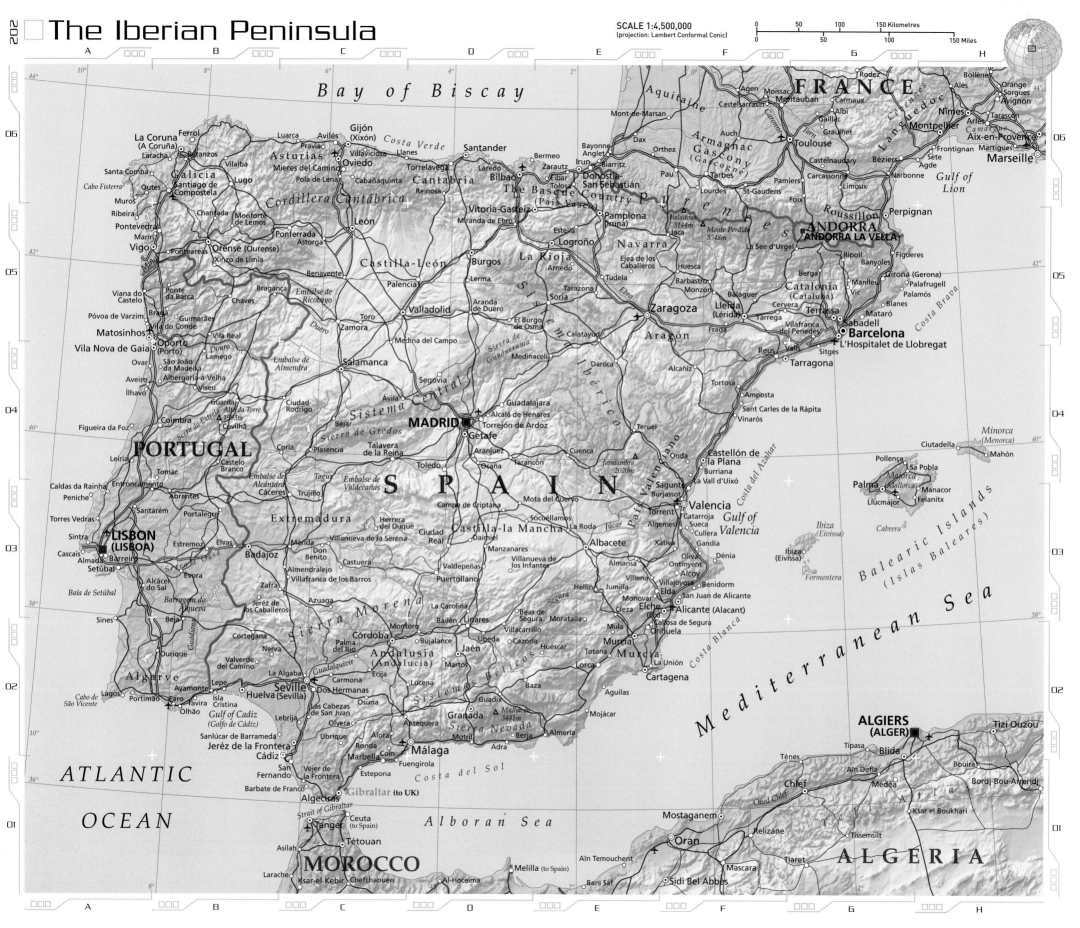

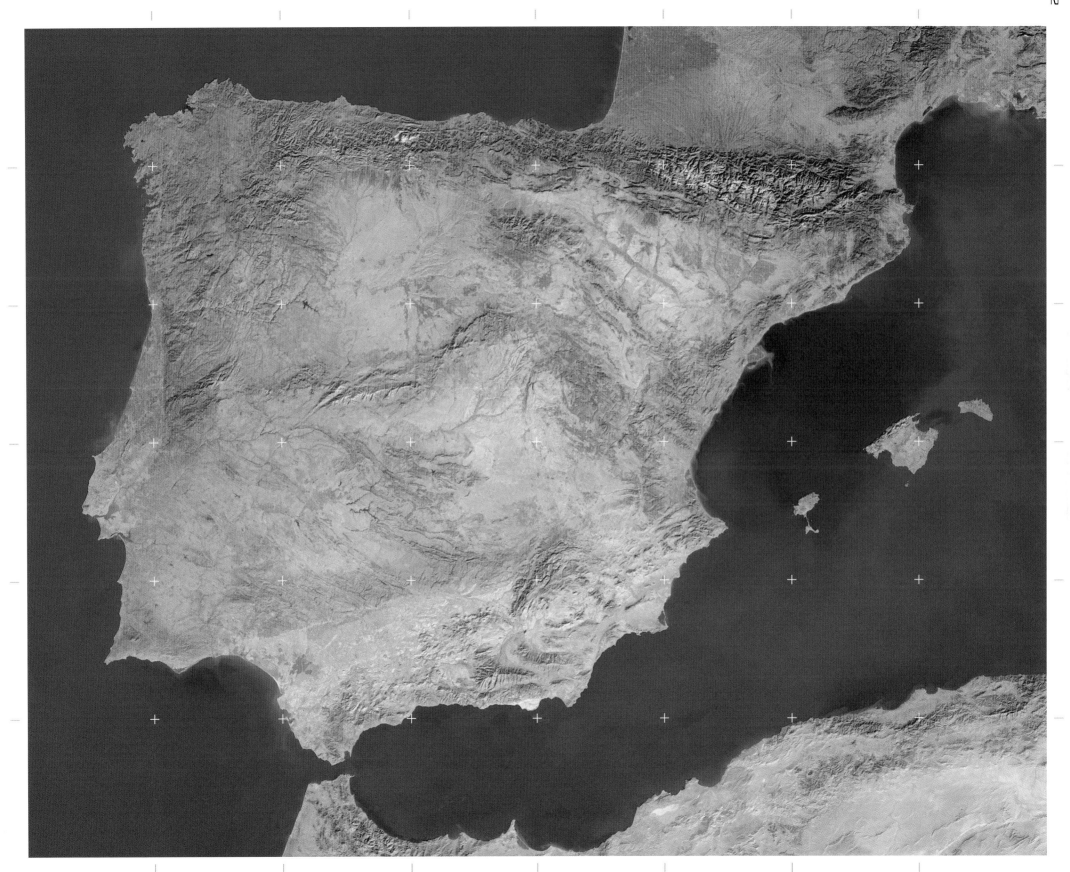

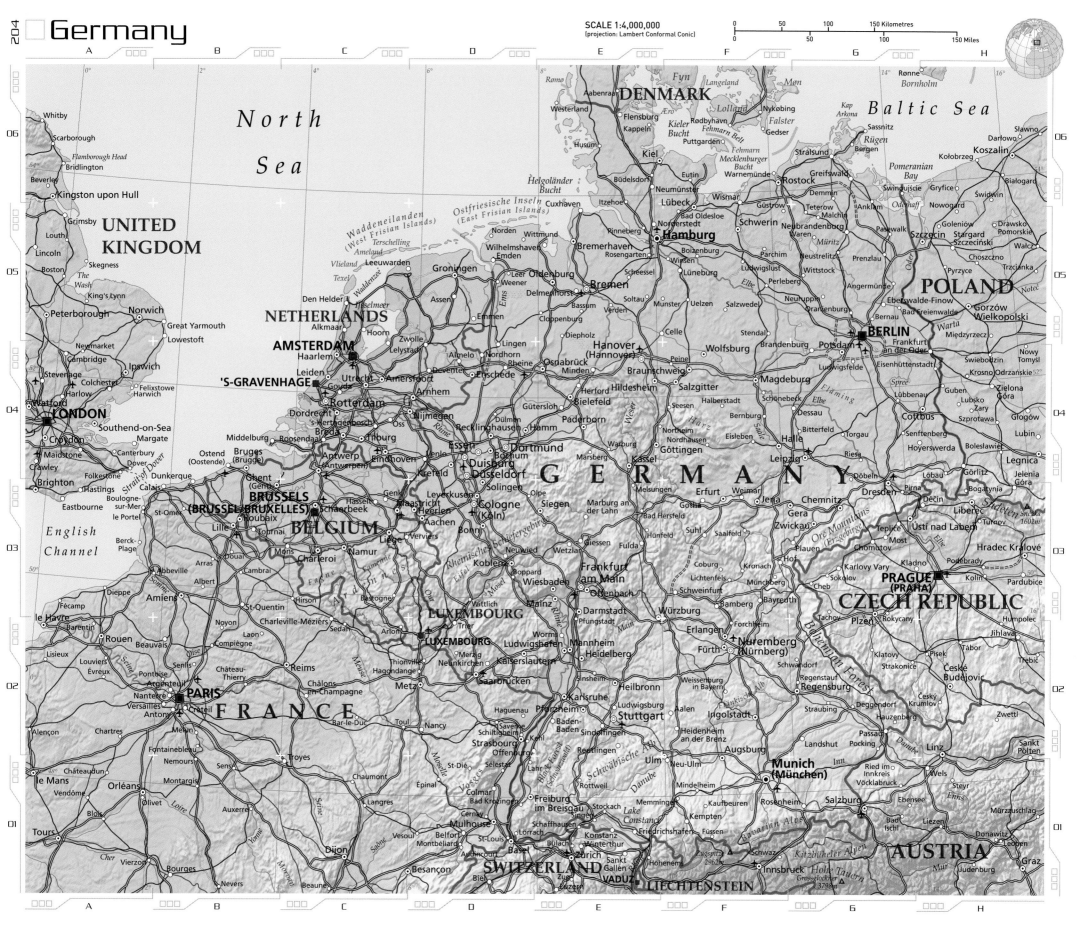

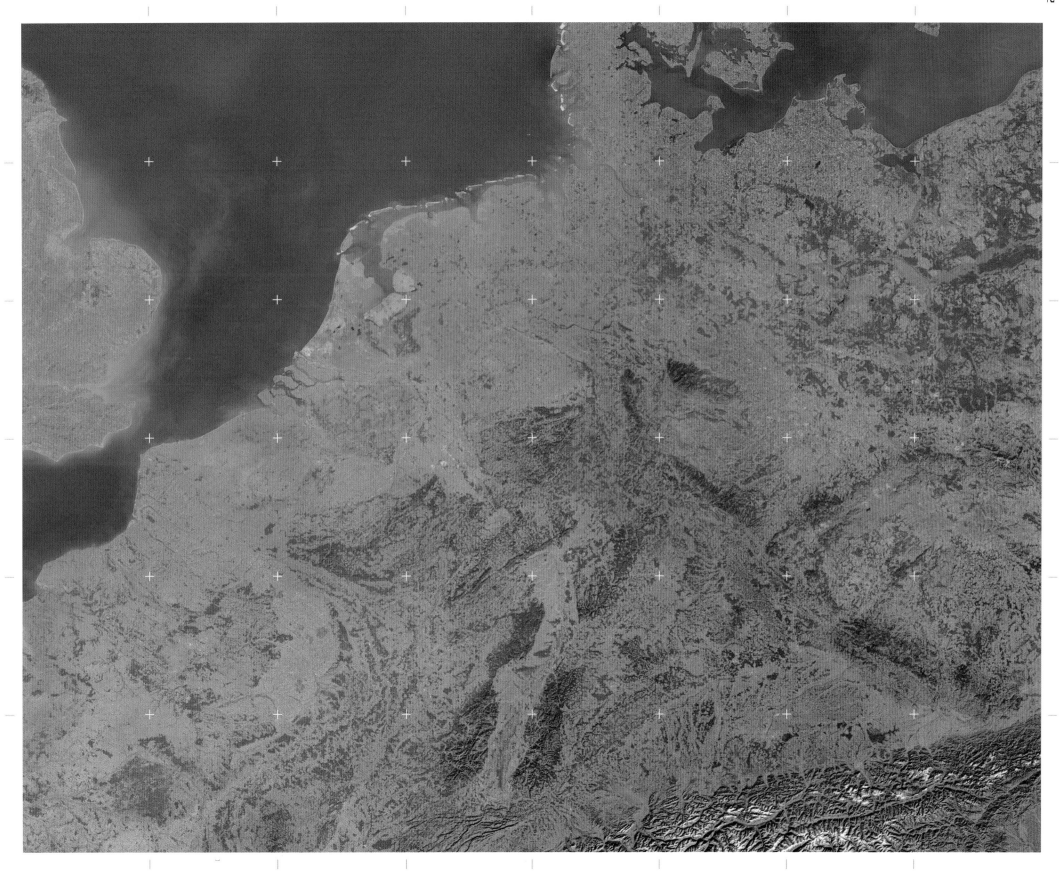

# BERLIN

## 52°31'N, 13°26'E

Originally two Wendish villages, Berlin was founded as a single city in the 13th century. It prospered as a trading centre, and eventually became the capital of Prussia in 1701. It was proclaimed the capital of Bismarck's united Germany in 1871. After the defeat of Nazi Germany in 1945 the devastated city was partitioned into four occupation zones by the Allied powers. In 1949, when Germany itself was divided into West and East, Berlin came to lay deep within Soviet East Germany and many functions of West Germany's government were transferred to Bonn. In 1990, with the fall of communism and the demolition of the infamous Berlin Wall (erected 1961), the city was once again united as the capital of a reunified Germany.

▶ **Situated in northeast Germany**, at the centre of the North German Plain, Berlin is surrounded by rich agricultural land. Although, unusually, not on a major river, the city is linked to the Elbe and Oder by an extensive canal system.

**SATELLITE:** TERRA (EOS AM-1), ASTER    **HEIGHT:** 438 MILES (705 KM)    **DATE:** 15 OCT 2005

◄ **At the end of World War II** the devastated city was partitioned into four occupation zones, American, British, French and Russian. In 1948 the Allied powers united their zones into a single entity which was blockaded by the Soviets resulting in the Berlin Airlift. The split between East and West was made manifest in 1961 with the construction of the Berlin Wall which ran through the centre of this image from top to bottom. Since 1991's historic demolition of the Berlin Wall, the restored capital has undergone extensive and dramatic reconstruction, and this image shows the famous Tiergarten park (centre left), the recently restored and reinvented Reichstag parliament building (at the northeast corner of the park) and the river Spree to the north.

**TELLITE:** QUICKBIRD image courtesy of DigitalGlobe **HEIGHT:** 280 MILES (450 KM) **DATE:** 28 MAR 2002

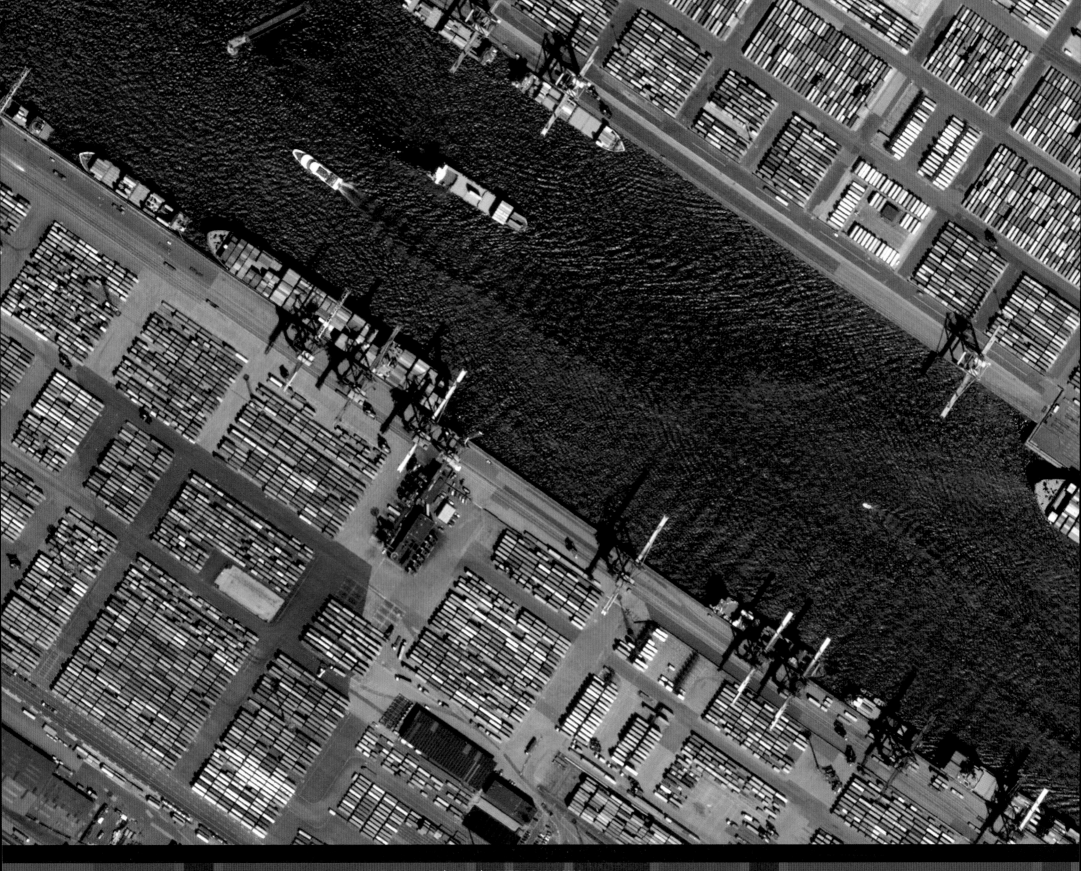

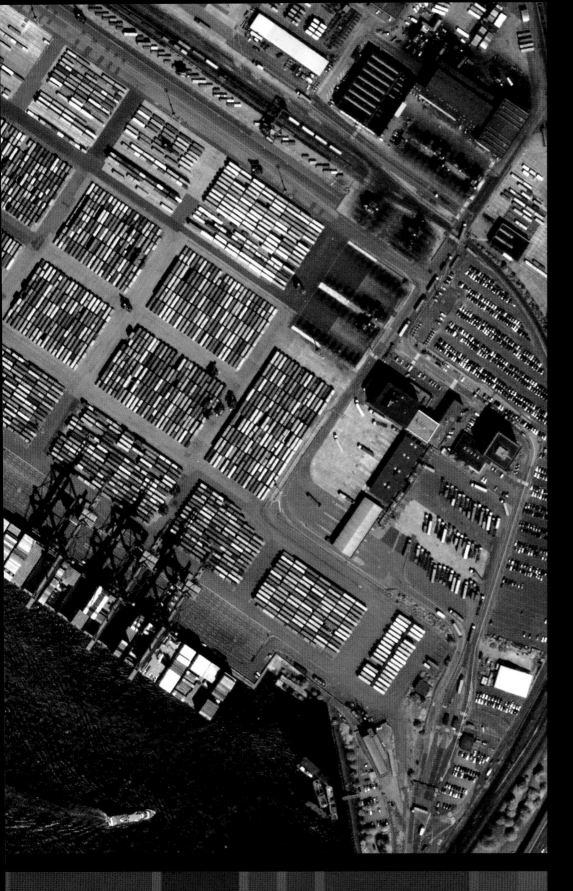

# PORT OF HAMBURG

## 53°33'N, 10°E

Hamburg is strategically situated between central Europe and Scandinavia and between the North Sea and Baltic Sea. After its foundation by the Emperor Charlemagne in 808, it quickly grew into a centre of commerce and was a founding member of the Hanseatic League of ports which controlled trade in northern Europe from the 13th to 17th centuries. The Elbe river splits into two branches at Hamburg and a harbour area covering 29 sq miles (74 sq km) has grown up along its banks. Even though it is 89 miles (144 km) from the sea, this large harbour can accommodate ocean-going ships and Hamburg is Germany's largest port, handling 114 million tons (116 million tonnes) of goods per year.

◀◀ **Multicoloured shipping containers** are stacked in neat rows in Hamburg harbour's modern container facility. At the site entrance, lorries are lined up ready to contribute to the seven million containers which pass through the port each year.

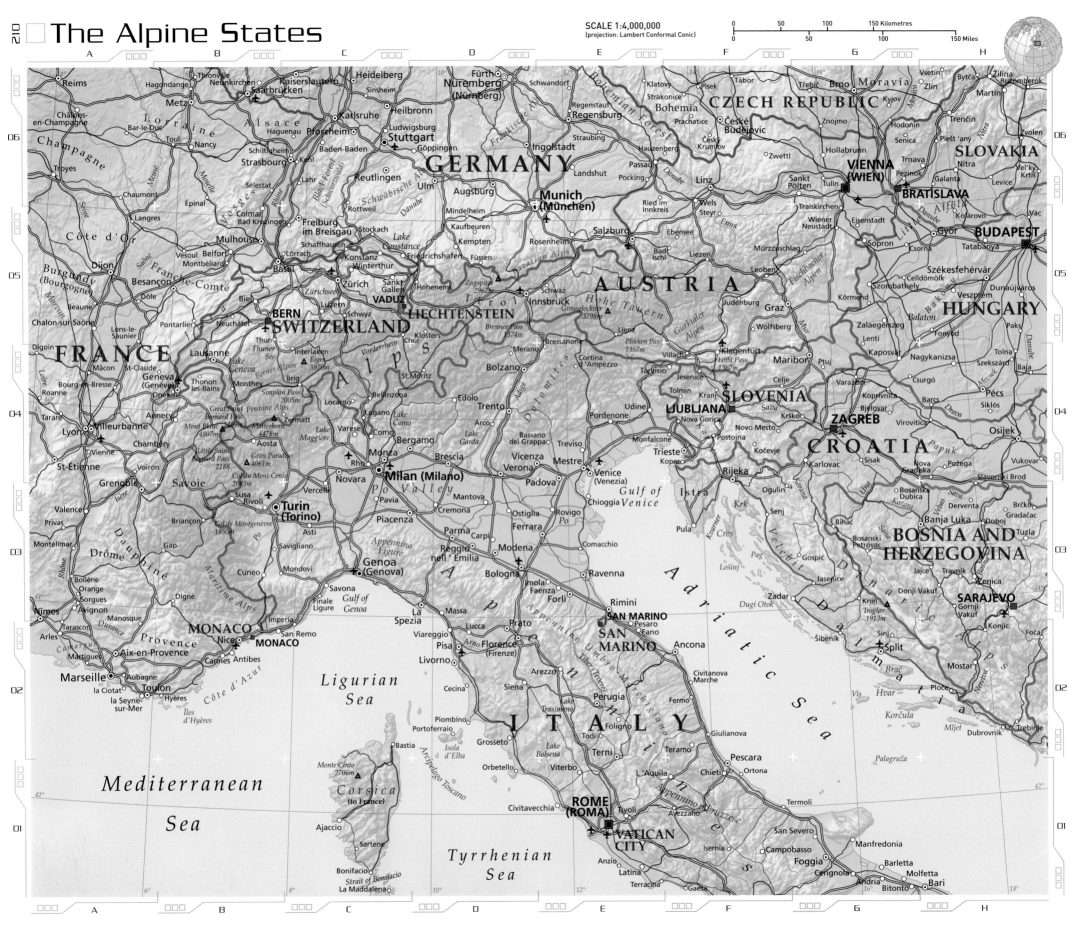

# The Alpine States

SCALE 1:4,000,000
(projection: Lambert Conformal Conic)

0   50   100   150 Kilometres
0   50   100   150 Miles

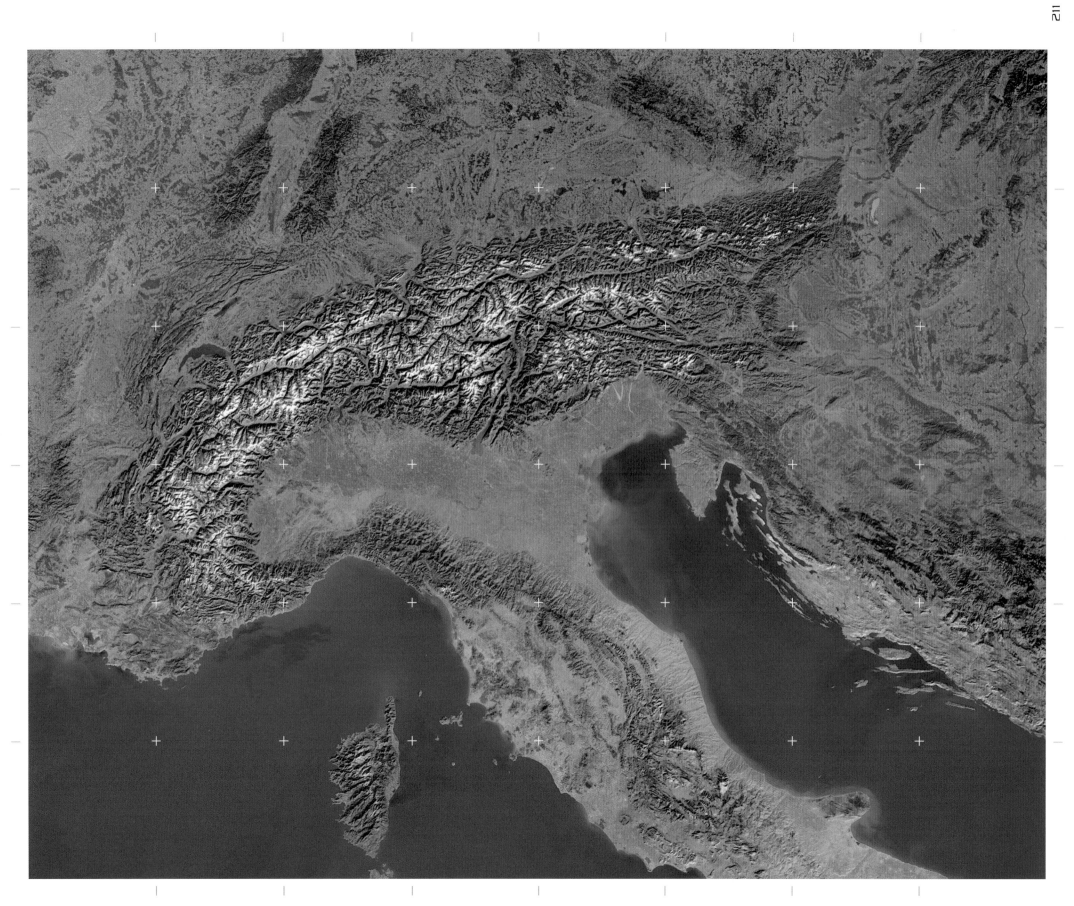

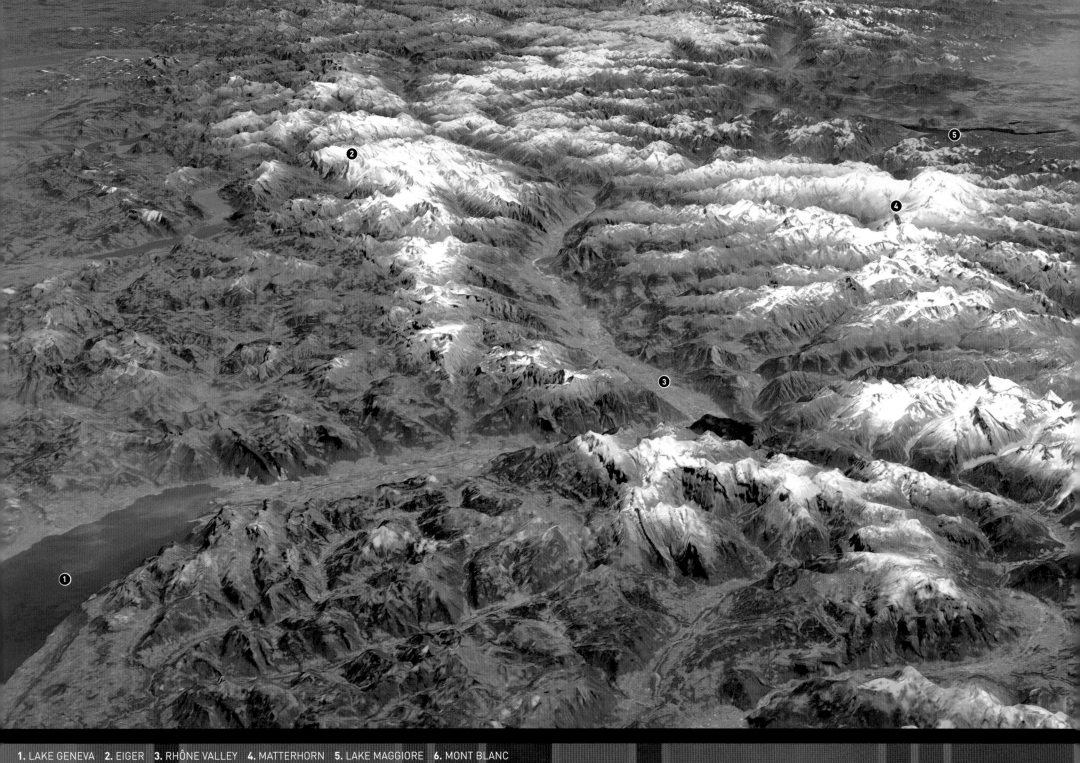

1. LAKE GENEVA   2. EIGER   3. RHÔNE VALLEY   4. MATTERHORN   5. LAKE MAGGIORE   6. MONT BLANC

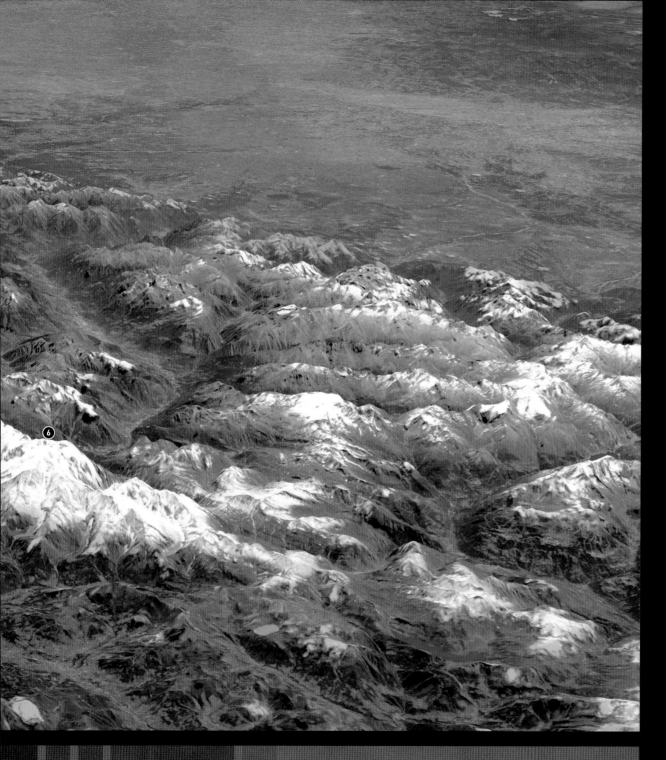

# THE ALPS
## 46°25'N, 10°E

Europe's famous mountains, the Alps, stretch across the centre of the continent from France in the west, through Italy, Switzerland and Germany, to Austria and Slovenia in the east, their ridges often forming the natural borders between these countries. The Alps are high enough to have snow and ice cover throughout the year, their tallest peak being glacier-topped Mont Blanc on the French-Italian border at 15,771 ft (4807 m).

The Alps started to form when Africa converged with Europe about 30 million years ago, uplifting and folding the bed of the ancient Tethys Sea which lay between. Glacial action during a series of ice ages over the last two million years has left them with their present form of high peaks, deep valleys and numerous lakes. Their breathtaking scenery attracts many visitors, including hill walkers and climbers in the summer and skiers in the winter.

This simulated perspective view shows the Alps from the west, looking over the Mont Blanc massif, the Bernese Alps to the north of the Rhône valley and the Pennine Alps and Aosta valley to the south.

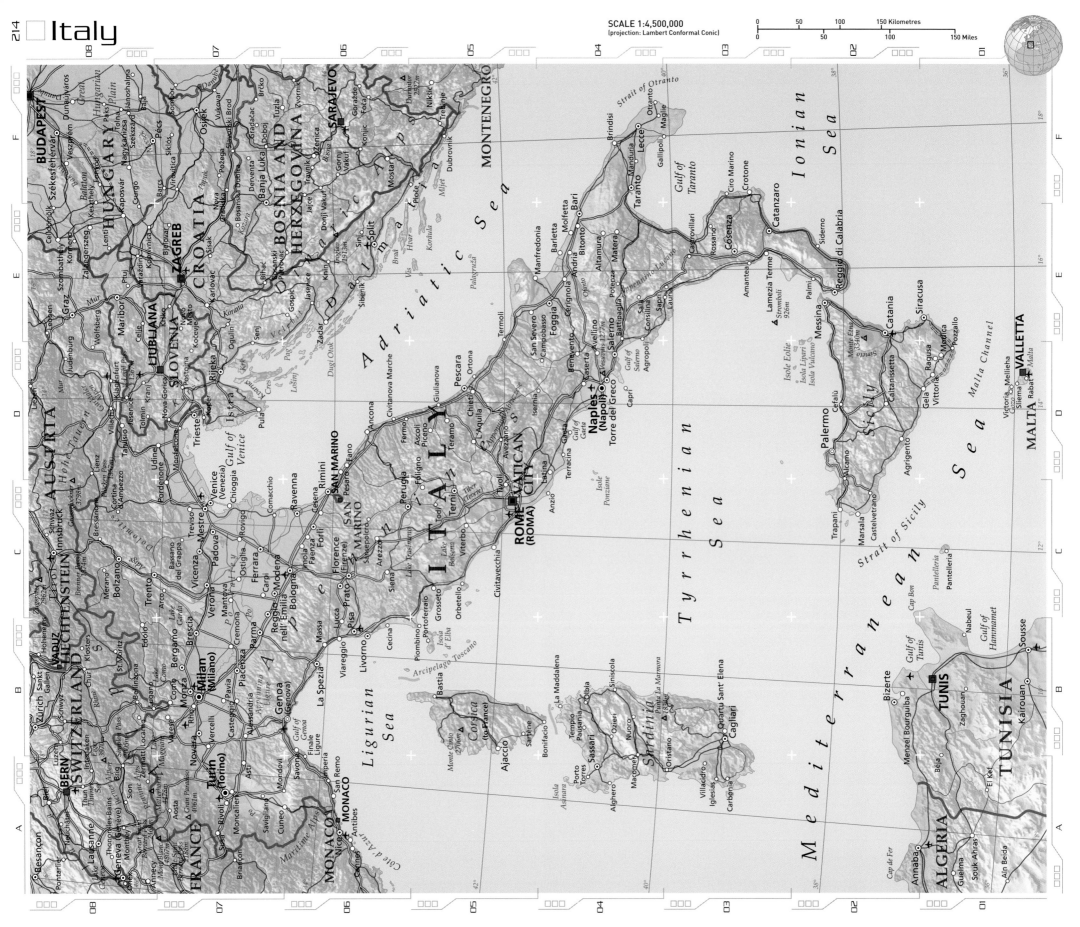

SCALE 1:4,500,000
(projection: Lambert Conformal Conic)

0   50   100   150 Kilometres
0   50   100   150 Miles

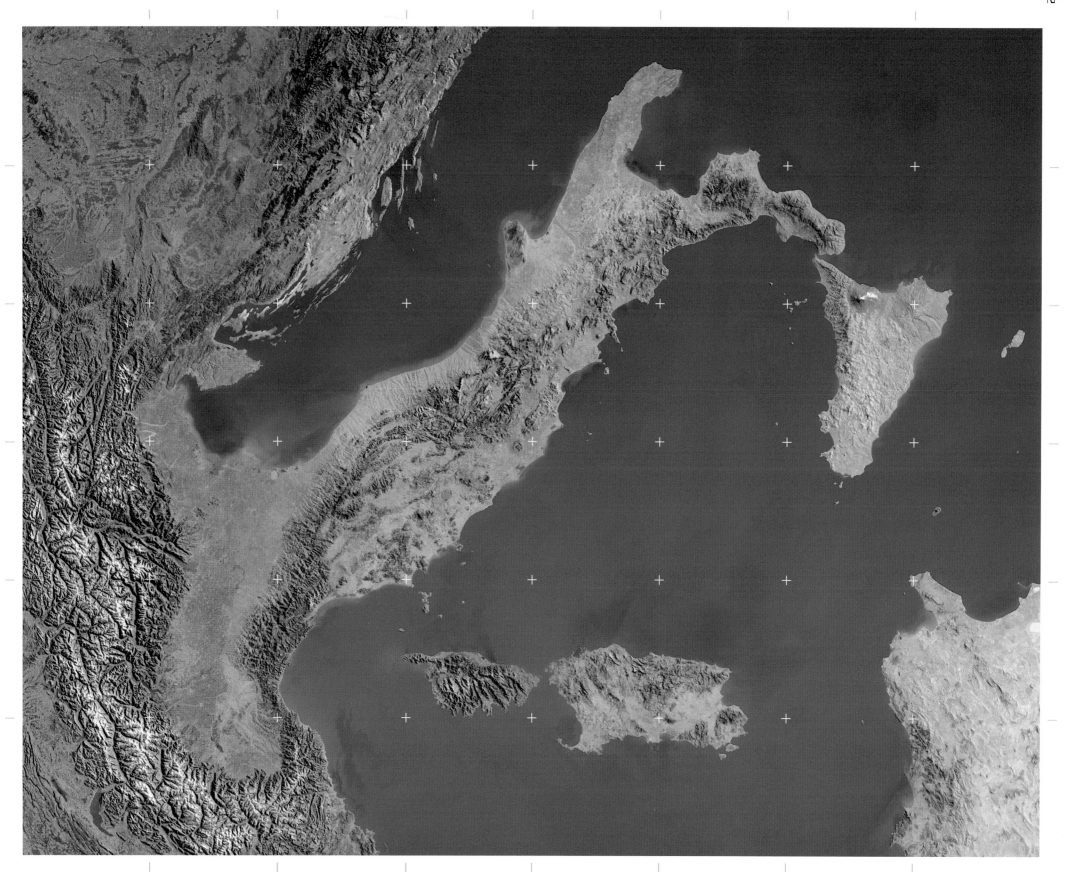

# VENICE

## 45°25'N, 12°19'E

The city of Venice occupies a group of over 100 islands in a sheltered lagoon at the northern end of the Adriatic Sea. The main city occupies the largest islands of the group, which are separated only by narrow canals, the largest of which is the Grand Canal. These islands are linked by some 400 bridges. Most traffic in the city moves by boat, although there is a 2.5 mile (4 km) road and rail causeway link to the mainland. Venice was founded in the mid-5th century CE, by refugees from successive waves of barbarians intent on invading the Roman Empire. By c.1000 CE Venice had grown in prosperity and was one of the principal European entrepôts for goods transported from Asia along the Silk Road. It remained one of Europe's most important political and commercial powers until the end of the 18th century.

Adriatic Sea to the mouth of the Po. Venice is built on a group of low mud banks scattered across the Laguna Veneta.

**SATELLITE:** TERRA (EOS AM-1), MODIS    **HEIGHT:** 438 MILES (705 KM)    **DATE:** 2003

▼ **Most buildings** are of considerable age, and foundations were raised on massive wooden piles driven into the mud. As these supports slowly decay much of Venice is gradually sinking, and the prospect of rising sea levels presents an even greater threat. The city is already subject to regular flooding from the tidal waters of the Adriatic Sea.

▼ **Known to Venetians** as the Canalezzo, The Grand Canal is a serpentine waterway which teems with gondolas, launches, ferries and water buses. The enormous colonnaded St Mark's Square, the Byzantine St Mark's Basilica it fronts and the adjacent quadrangle of the Doge's Palace can be seen just north of the mouth of the Canal.

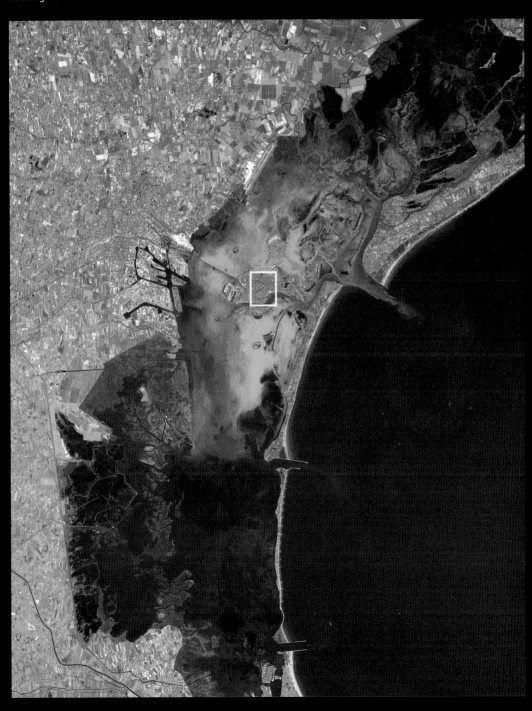

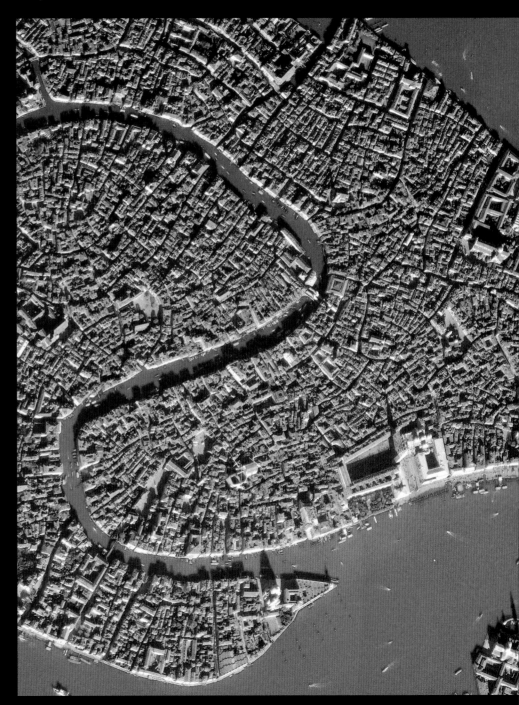

**SATELLITE:** TERRA (EOS AM-1), ASTER     **HEIGHT:** 438 MILES (705 KM)     **DATE:** 13 DEC 2001

**SATELLITE:** IKONOS IMAGE courtesy of GeoEye     **HEIGHT:** 423 MILES (681 KM)     **DATE:** 27 NOV 2000

# ROME

## 41°52'N, 12°30'E

The founding city of the Roman Empire and the hearth of the Catholic Church, Rome straddles the Tiber some 16 miles (26 km) from its mouth, half way down the western coast of the Italian Peninsula. Founded in the 8th century BCE, the city began its process of expansion and conquest some 300 years later, and by 150 BCE had come to dominate not only Italy, but the whole of the western Mediterranean. At its peak, 2000 years ago, the empire had expanded to become the largest in the world. The city grew with the empire, reaching a population of over a million by c.150 BCE, an urban mass increasingly dependent upon imports from all over Europe, Africa and Asia. By 500 CE it was largely in ruins, with successive barbarian powers fighting over the remains.

▶ **Rome's geographical location**, at the centre of the Mediterranean, its classical legacy and the establishment of the Catholic Papacy in the Vatican City provided Rome with a considerable nucleus of power which saw a revival of its fortunes in the Middle Ages and Renaissance.

▼ **The modern city** of Rome has spread far beyond its original 'Seven Hills', although these are still identifiable in the city centre, extending almost to its Mediterranean port of Ostia at the mouth of the Tiber. It is a major industrial and media centre, in addition to being one of the world's outstanding pilgrimage destinations.

▼ **Carved out of Rome's cityscape** is the world's smallest independent state, the Papal See of the Vatican City. Built originally on marshlands outside Rome's walls, the majestic basilica of St Peter's can be seen centre left, with Bernini's all-embracing colonnades enclosing the oval assembly space of St Peter's Square.

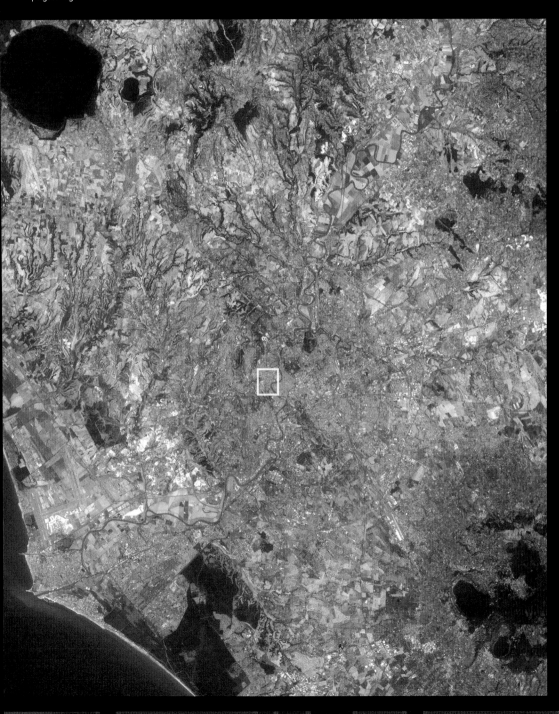

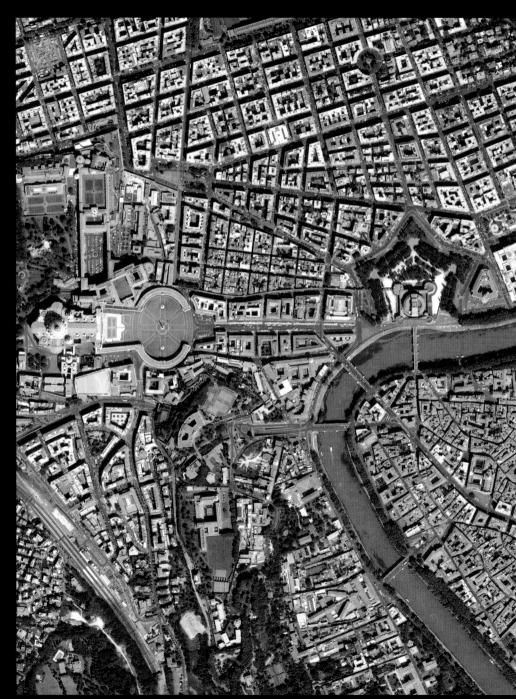

**SATELLITE:** LANDSAT 7 **INSTRUMENT:** ETM+ **HEIGHT:** 438 MILES (705 KM) **DATE:** 03 AUG 2001

**SATELLITE:** QUICKBIRD image courtesy of DigitalGlobe **HEIGHT:** 280 MILES (450 KM) **DATE:** 24 AUG 2004

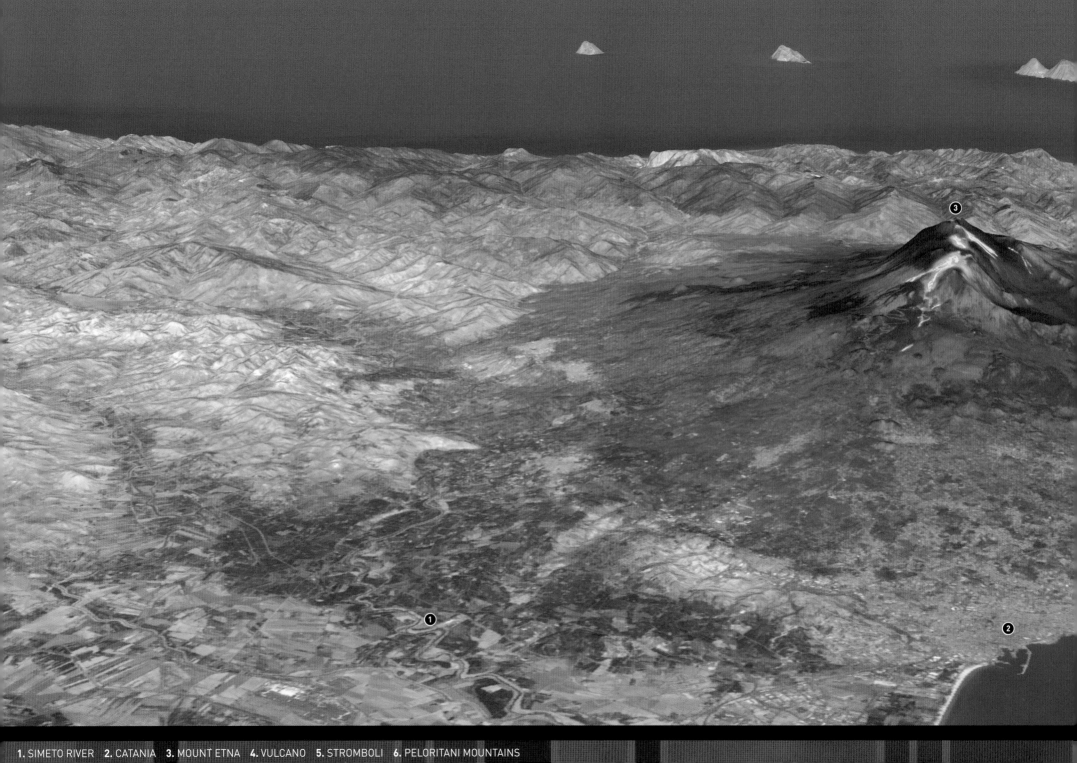

1. SIMETO RIVER   2. CATANIA   3. MOUNT ETNA   4. VULCANO   5. STROMBOLI   6. PELORITANI MOUNTAINS

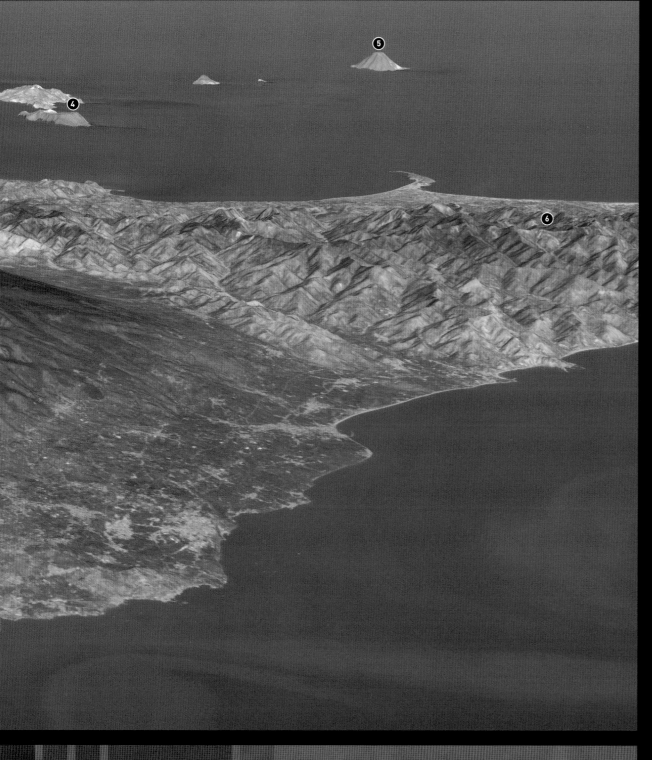

# MOUNT ETNA

## 37°46'N, 15°E

At 10,958 ft (3340 m), Mount Etna towers above the port of Catania and the hills of northern Sicily. It is the largest of Italy's active volcanoes and one of the most active in the world. Although in an almost constant state of eruption, most of the activity is not very dangerous and thousands of people live on its slopes. Recent years have seen an increase in activity, with major eruptions in 2001, 2002-2003 and continuing activity in 2006.

This simulated perspective view combines visible imagery with thermal infrared imagery showing the heat from lava flows during Etna's major eruption in July 2001. Lava flows can be seen in the vicinity of Refugio Sapienza, where the cable car station was later destroyed. Old lava flows appear as darker areas on the upper slopes and numerous secondary eruption cones can be seen on the mountain's flanks.

In the Tyrrhenian Sea to the north, the Lipari Islands include the active volcanoes of Stromboli and Vulcano. Vulcano was known to the Romans as the chimney of their god Vulcan's forge, and is the place from which the word 'volcano' is derived.

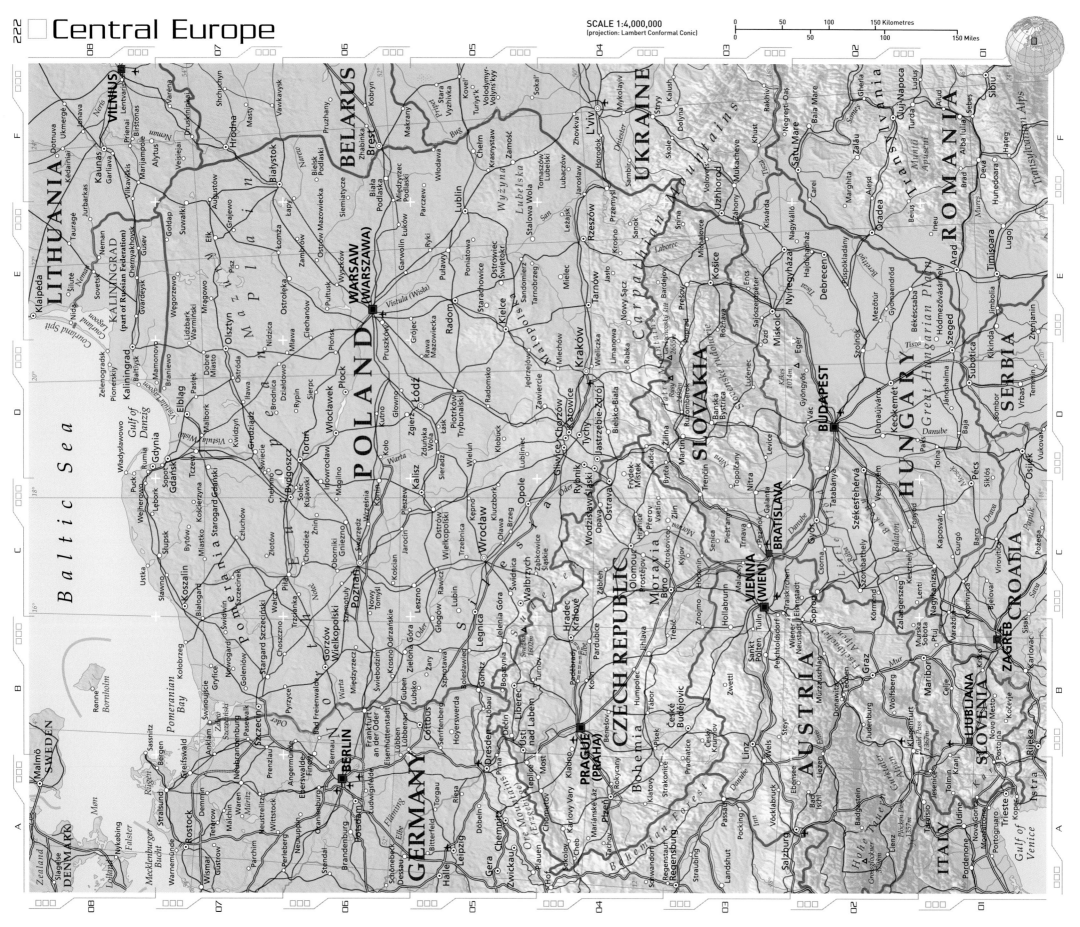

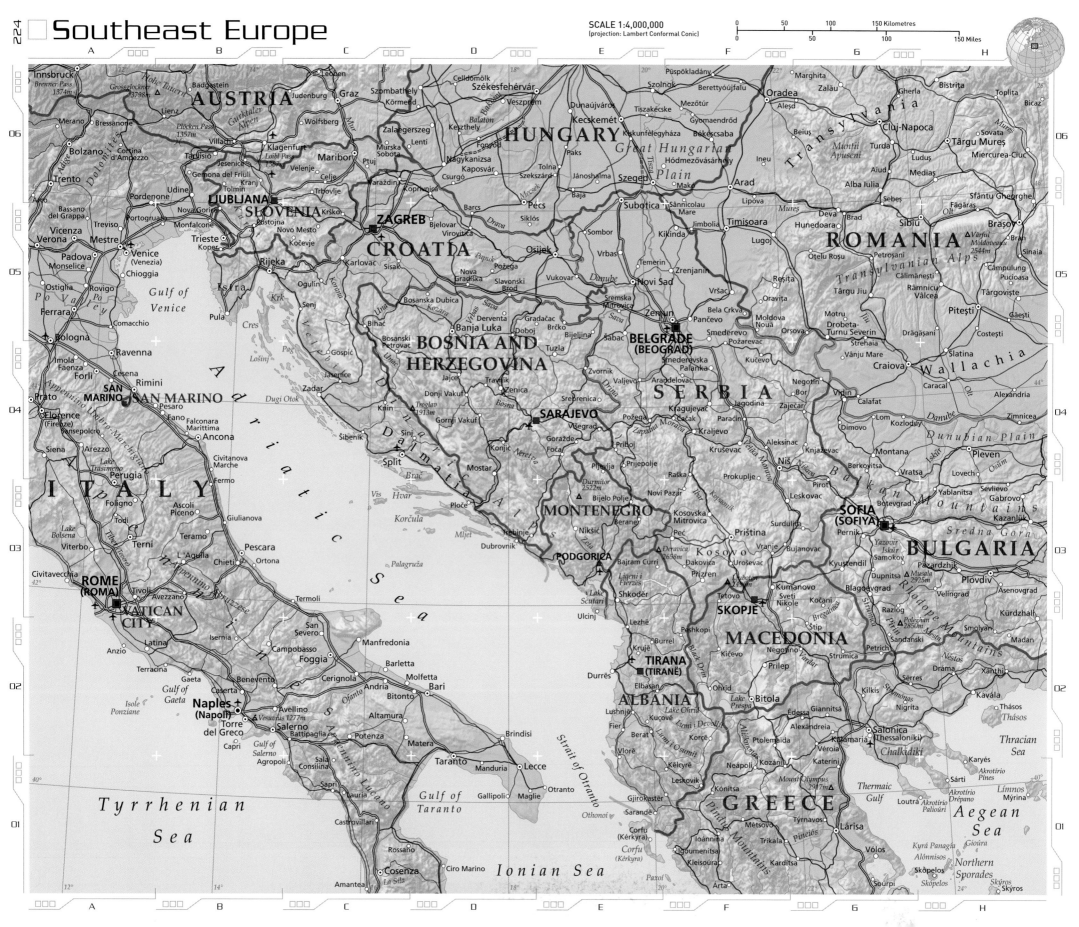

# Southeast Europe

SCALE 1:4,000,000
(projection: Lambert Conformal Conic)

| 0 | 50 | 100 | 150 Kilometres |
| 0 | 50 | 100 | 150 Miles |

**AUSTRIA**

**HUNGARY**

**SLOVENIA**

**CROATIA**

**ROMANIA**

**Transylvania**

*Transylvanian Alps*

**Wallachia**

*Danubian Plain*

**BOSNIA AND HERZEGOVINA**

**SERBIA**

**ITALY**

**SAN MARINO**

*Adriatic Sea*

**Dalmatian Alps**

**MONTENEGRO**

**SOFIA (SOFIYA)**

**BULGARIA**

*Sredna Gora*

**Balkan Mountains**

**Rhodope Mountains**

**VATICAN CITY**

**ROME (ROMA)**

**PODGORICA**

**SKOPJE**

**MACEDONIA**

*Kosovo*

**TIRANA (TIRANË)**

**ALBANIA**

**GREECE**

*Pindus Mountains*

*Tyrrhenian Sea*

*Ionian Sea*

*Gulf of Taranto*

*Strait of Otranto*

*Aegean Sea*

*Thracian Sea*

*Chalkidiki*

*Thermaic Gulf*

*Northern Sporades*

**BELGRADE (BEOGRAD)**

**ZAGREB**

**LJUBLJANA**

**SARAJEVO**

# SANTORINI

## 36°23'N, 25°27'E

Part of the Aegean volcanic arc which stretches through the southern Cyclades Islands, Santorini was blown apart around 1640 BCE in one of the largest volcanic events of the last 10,000 years. The eruption expelled 7-14 cubic miles (30-60 cubic km) of material in a cloud of ash and rock 22 miles (36 km) high, and may have contributed to the downfall of Crete's Minoan civilisation 68 miles (110 km) to the south. It left behind a flooded crater 1312 ft (400 m) deep, circled by the modern islands of Thira and Thirasia. The remains of a Minoan city have been found on Thera and some have likened the site to the 'lost city' of Atlantis. The islands' dramatic setting and vibrant nightlife make them a popular tourist destination.

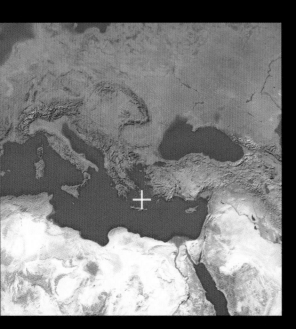

▶ **An overview of Santorini** is provided by this 11 mile (18 km) wide satellite image, showing the large island of Thira and, to the west, the smaller island of Thirasia and tiny Aspronisi.

▶ **The Kameni Islands** have formed in the centre of the lagoon from lava eruptions occurring since the 18th century, most recently in 1950. The village perched at the top of Thira's 984 ft (300 m) cliffs, reached by a zigzag path from the port at their base, offers spectacular views over the lagoon.

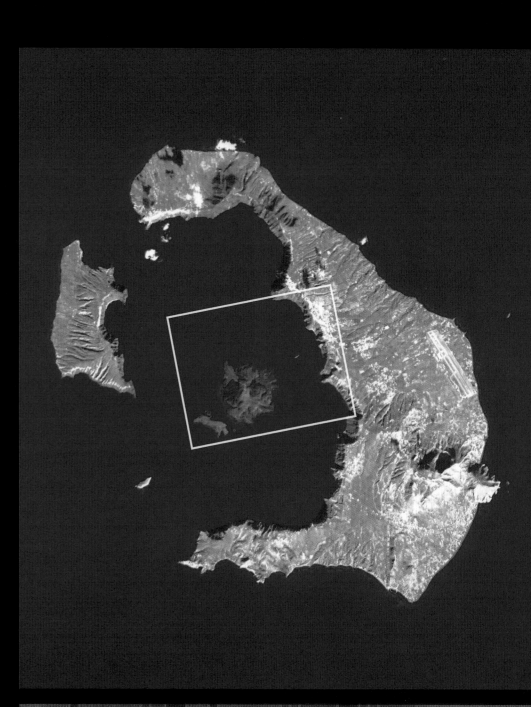

**SATELLITE:** TERRA (EOS AM-1), ASTER   **HEIGHT:** 438 MILES (705 KM)   **DATE:** 21 NOV 2000

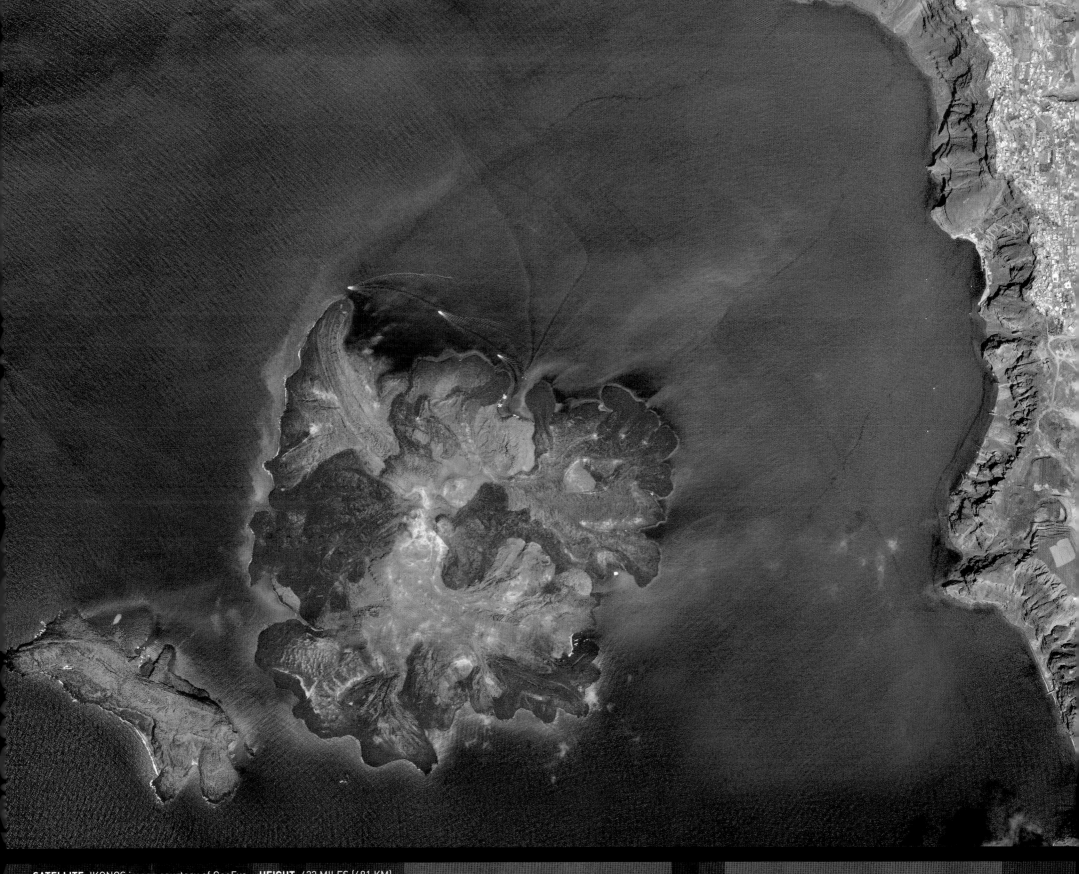

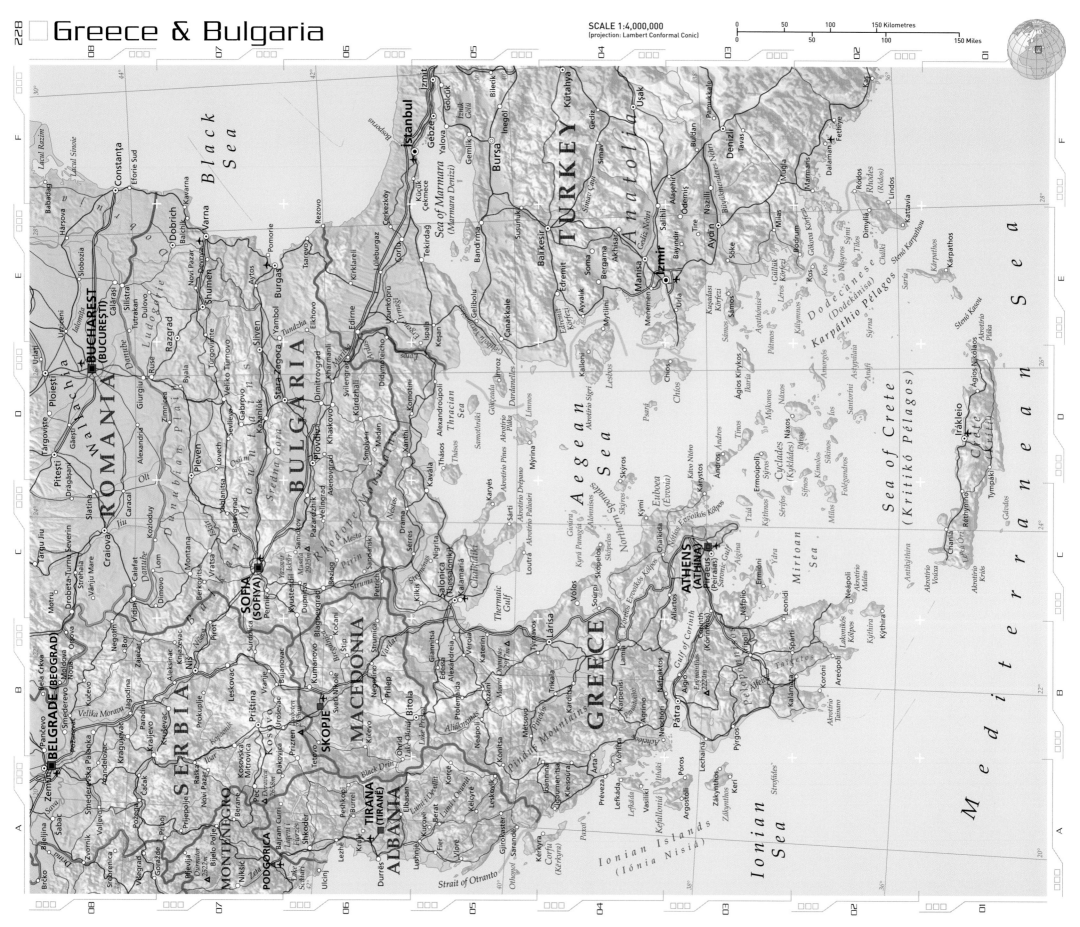

# Greece & Bulgaria

SCALE 1:4,000,000
(projection: Lambert Conformal Conic)

| 0 | | 50 | | 100 | | 150 Kilometres |
| 0 | 50 | | 100 | | 150 Miles |

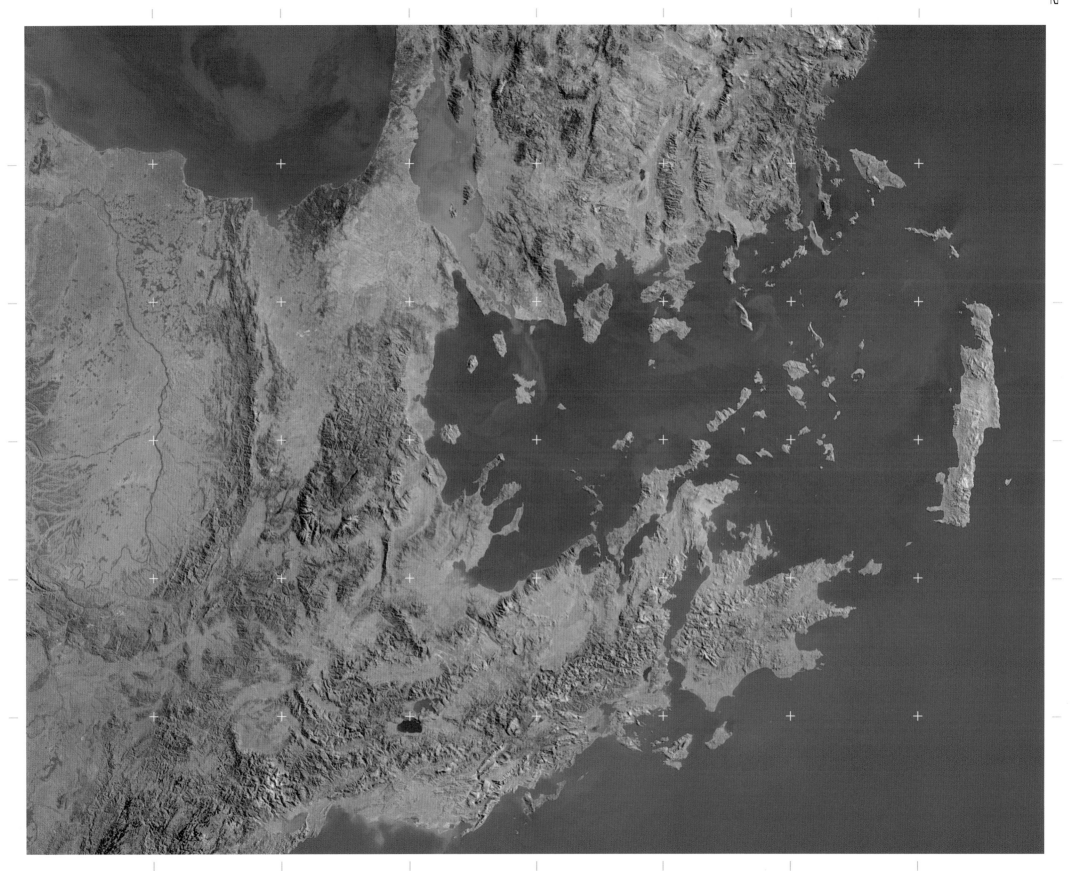

# ATHENS

## 37°58'N, 23°44'E

Regarded as the cradle of western civilisation, Athens was the most powerful city-state in ancient Greece, a centre for art and learning, and the world's first democracy. The rugged terrain of the interior produced a nation of seafarers who founded colonies across the Mediterranean and Black seas in the first millennium BCE, many of which still stand as great cities today. Appropriately enough, the city was named after the Greek goddess of civilisation and wisdom, Athena. Today, Athens is the capital of modern Greece and home to 3.5 million people – about one-third of the total population of the country. It has absorbed the port of Piraeus to the south and continues to expand to the north and northeast.

▼ **The Attica Peninsula** which provides Athens' hinterland is rugged and arid. To the north, separated from the mainland by just 130 ft (40 m), lies the greener island of Euboea, a fashionable holiday retreat for rich Athenians.

SATELLITE: TERRA (EOS AM-1), MODIS    HEIGHT: 423 MILES (681 KM)    DATE: 2005

▼ **Athens has grown** to fill a plain between three mountain ridges and the sea. This Landsat image taken in 2000 shows as bright areas the construction sites of a new airport to the west and the Attiki Odos highway cutting through the northern suburbs.

▶ **The detailed images** show Athens, ancient and modern. The Olympic Games returned to their roots in 2004, the main stadium being built in the northern suburbs (top). The Parthenon is a temple dating from the 5th century BCE, built on the Acropolis, a rocky citadel in the centre of the city (bottom).

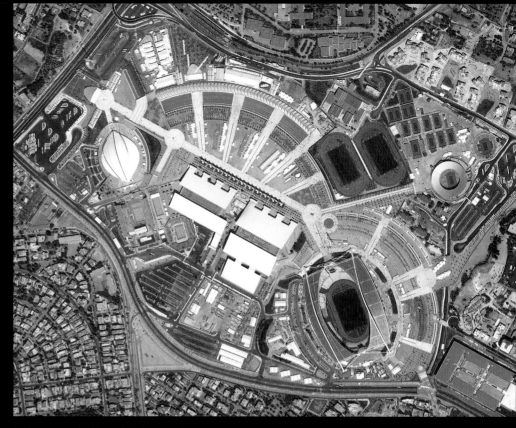

**SATELLITE:** QUICKBIRD image courtesy of DigitalGlobe  **HEIGHT:** 280 MILES (450 KM)
**DATE:** 23 AUG 2004

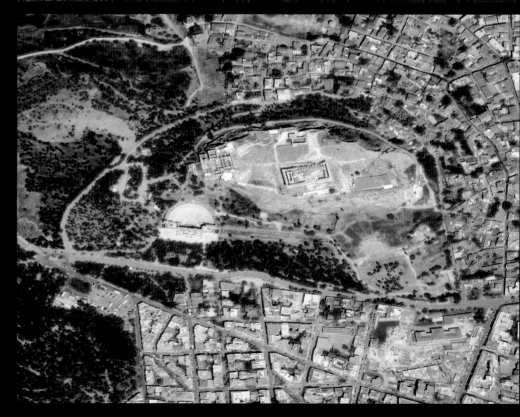

**SATELLITE:** LANDSAT 7, ETM+   **HEIGHT:** 423 MILES (681 KM)   **DATE:** 20 MAY 2000

**SATELLITE:** QUICKBIRD image courtesy of DigitalGlobe **HEIGHT:** 280 MILES (450 KM)
**DATE:** 02 MAY 2005

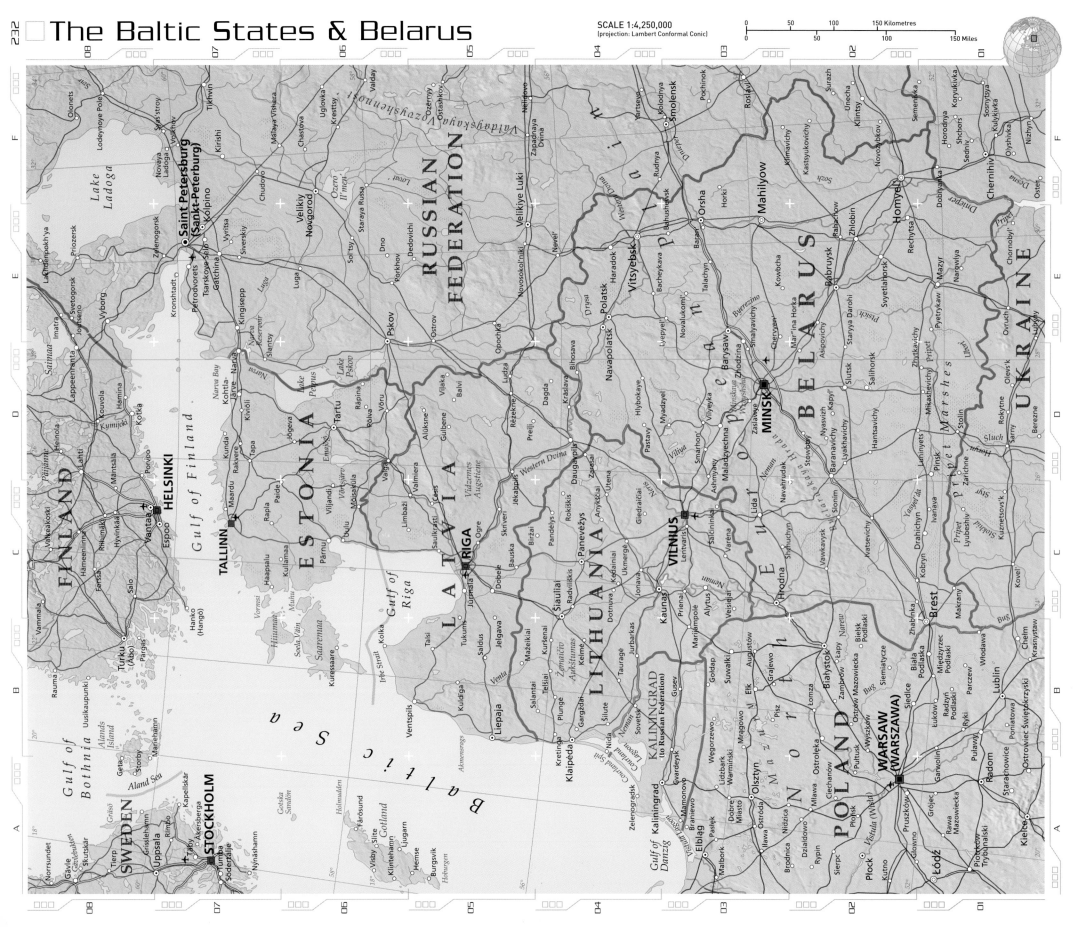

# The Baltic States & Belarus

SCALE 1:4,250,000
(projection: Lambert Conformal Conic)

0  50  100  150 Kilometres
0  50  100  150 Miles

**RUSSIAN FEDERATION**

**BELARUS**

**ESTONIA**

**LATVIA**

**LITHUANIA**

**FINLAND**

**SWEDEN**

**POLAND**

**UKRAINE**

**KALININGRAD**
(to Russian Federation)

Lake Ladoga

Gulf of Finland

Gulf of Bothnia

Åland Sea

Baltic Sea

Gulf of Riga

Gulf of Kaliningrad (Danzig)

Lake Peipus

Lake Pskov

*Valdayskaya Vozvyshennost'*

*Vidzemes Augstiene*

*Žemaičiu Aukštumas*

*Pripet Marshes*

Courland Spit

SAINT PETERSBURG (Sankt-Peterburg)

HELSINKI

TALLINN

RIGA

VILNIUS

MINSK

STOCKHOLM

WARSAW (WARSZAWA)

Smolensk

Mahilyow

Homyel

Brest

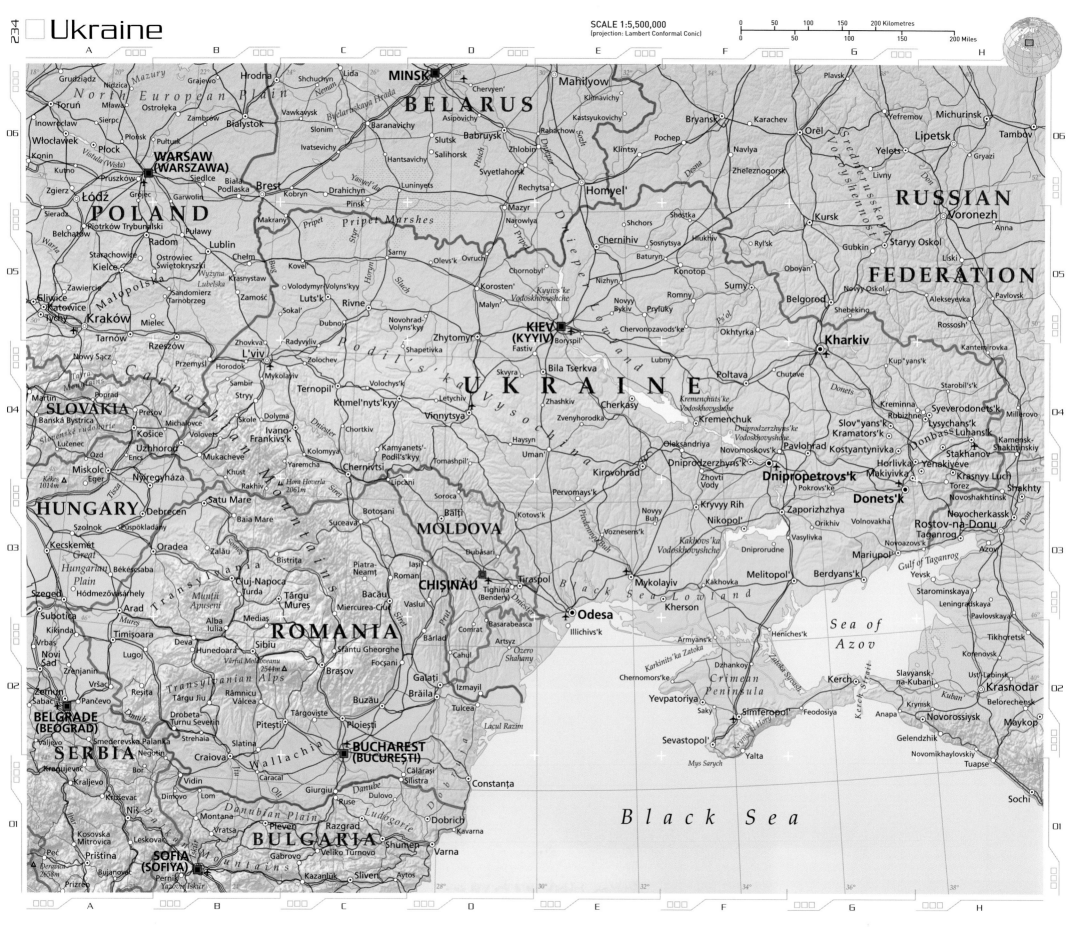

# Ukraine

SCALE 1:5,500,000
(projection: Lambert Conformal Conic)

| 0 | 50 | 100 | 150 | 200 Kilometres |
| 0 | 50 | 100 | 150 | 200 Miles |

**POLAND**

**BELARUS**

**RUSSIAN**

**FEDERATION**

North European Plain

Mazury

MINSK

Mahilyow

Bryansk

Karachev

Orël

Yefremov

Michurinsk

Plavsk

Lipetsk

Tambov

WARSAW
(WARSZAWA)

Brest

Homyel'

Kursk

Voronezh

Pripet Marshes

Chernihiv

RUSSIAN

FEDERATION

Chornobyl'

Sumy

Belgorod

L'viv

KIEV
(KYYIV)

Kharkiv

UKRAINE

Poltava

Donets

SLOVAKIA

Kremenchuk

Dnipropetrovs'k

Donets'k

HUNGARY

Kryvyy Rih

Zaporizhzhya

Rostov-na-Donu

MOLDOVA

Mykolayiv

Melitopol'

Berdyans'k

Gulf of Taganrog

ROMANIA

CHIŞINĂU

Odesa

Kherson

Sea of
Azov

BELGRADE
(BEOGRAD)

BUCHAREST
(BUCUREŞTI)

Crimean
Peninsula

Kerch

Krasnodar

SERBIA

Simferopol'

Sevastopol'

Yalta

**BULGARIA**

SOFIA
(SOFIYA)

Varna

*Black Sea*

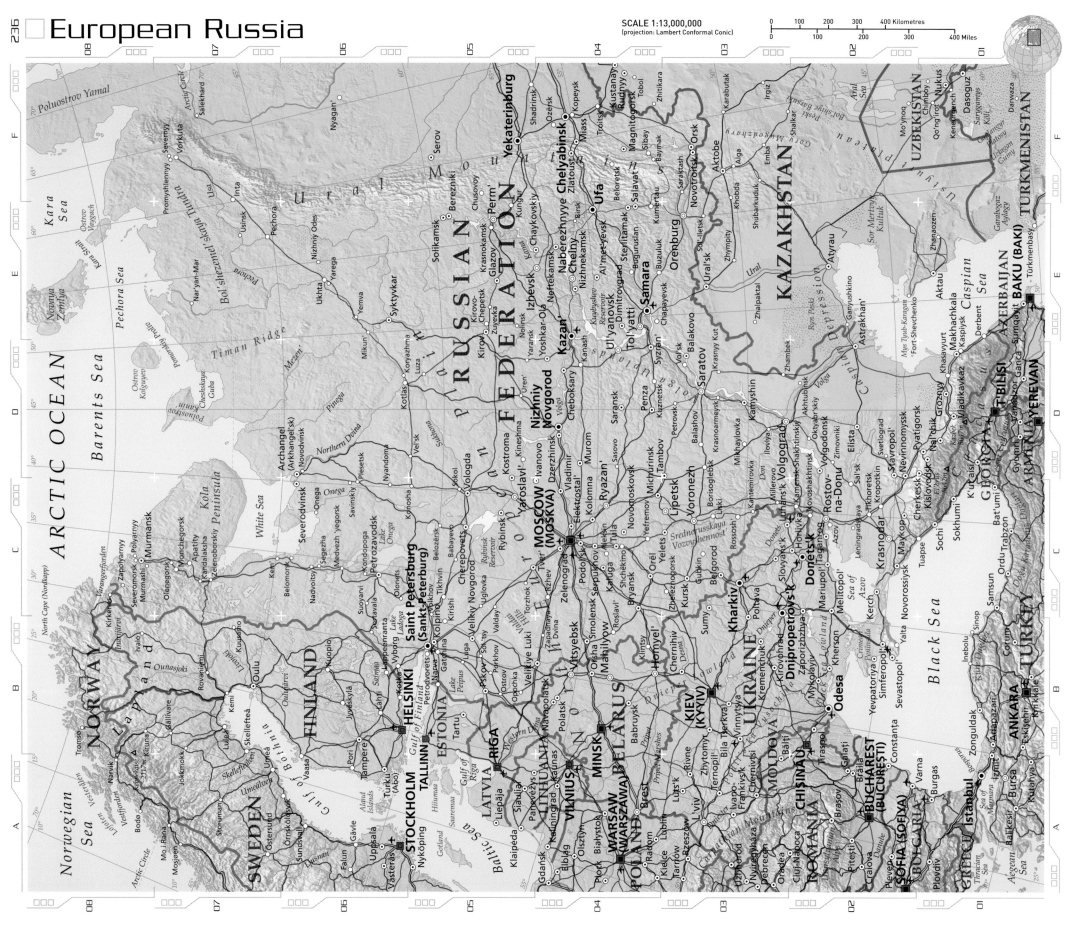

# MOSCOW

## 55°45'N, 37°42'E

Originally established as a fortified village on the banks of the Moskva river in the 12th century, Moscow became capital of the Principality of Moscow in the late 13th century, then a Russian frontier state consistently ravaged by the Tartars.

With the growth of the unified Russian state, Moscow was the national capital from 1547 until 1712, when Peter the Great founded his new, Europe-facing capital city of St Petersburg. Following the Bolshevik Revolution, Moscow once again became capital in 1918, and was rapidly developed as the administrative centre of the Soviet Union. It is Russia's largest city, and its political, cultural, economic and transport centre. Containing some 200 churches, and the Medieval fortress of the Kremlin, the greater part of the city is characterised by functional 20th century architecture and apartment blocks.

▶▶ **The Medieval centre** of Moscow straddles the Moskva, with the triangular 14th century fortress of the Kremlin, which houses the Russian parliament. The basilica of St. Basil's can be seen in Red Square to the top right of this image.

SATELLITE: TERRA (EOS AM-1)   INSTRUMENT: MODIS   HEIGHT: 438 MILES (705 KM)   DATE: 2004

SATELLITE: LANDSAT 7   INSTRUMENT: ETM+   HEIGHT: 438 MILES (705 KM)   DATE: 06 OCT 1999

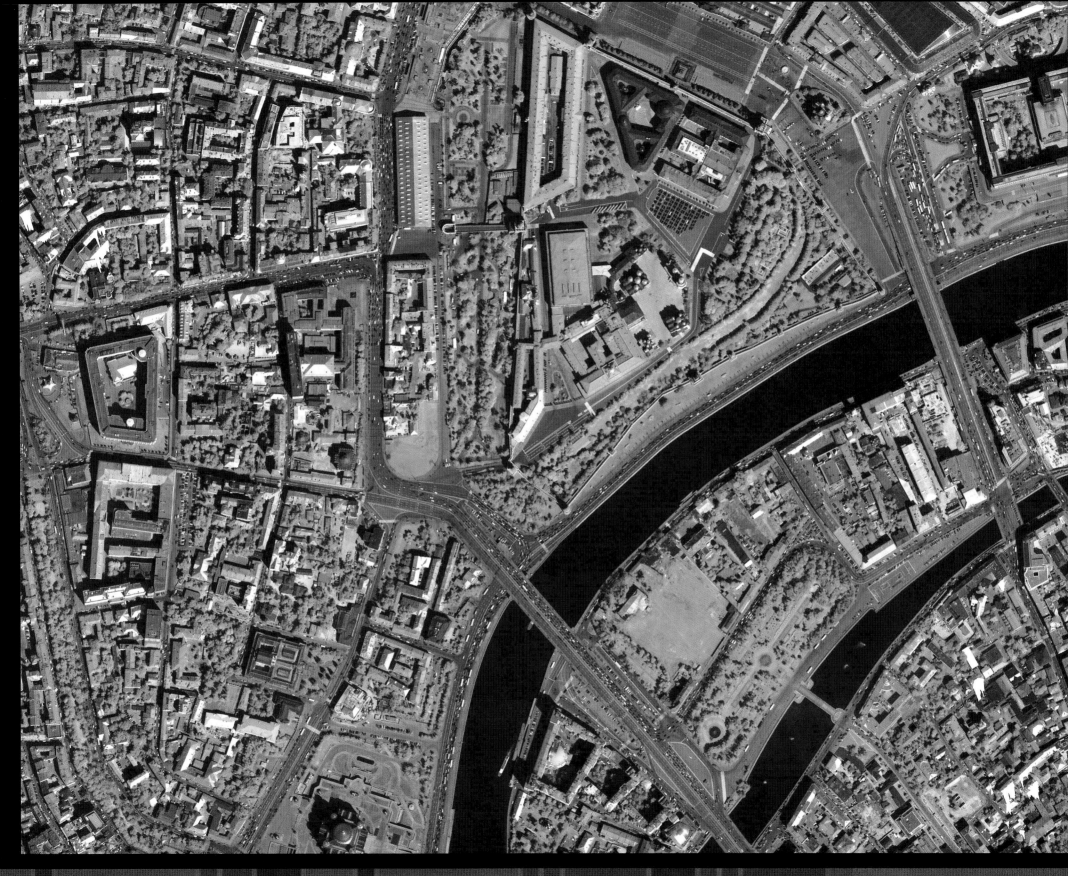

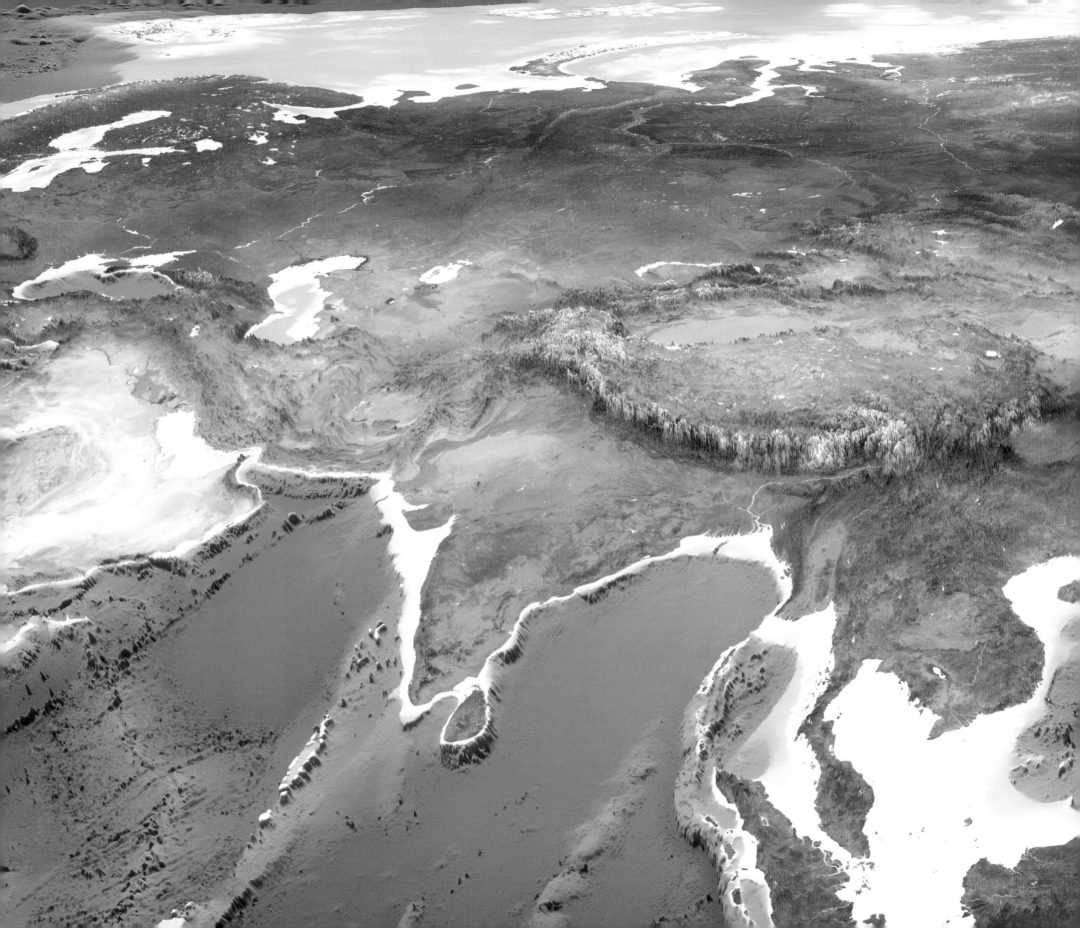

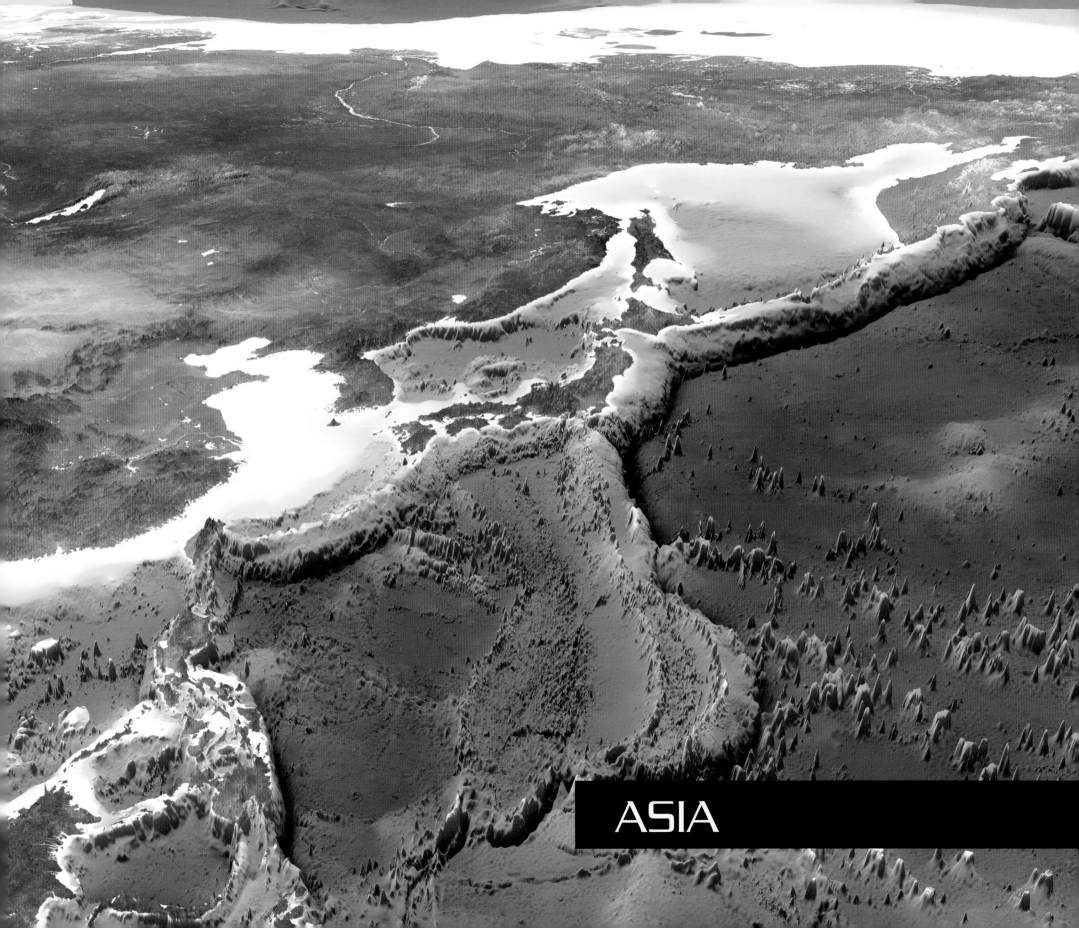

ASIA

# Political

**Asia, the world's largest continent**, covers 16,838,365 sq miles (43,608,000 sq km). It comprises 49 separate countries, including 97% of Turkey and 72% of the Russian Federation. Asian Russia covers the largest area, 5,065,471 sq miles (13,119,582 sq km), and covering an area of only 116 sq miles (300 sq km) the Maldives, the smallest. Asia has a total population of 3,866 million, 33.9 million of whom live in Tokyo, Japan. Politically, Asia is diverse. The break up of the Soviet Union produced the Central Asian republics. Southwest Asia is mainly Muslim and includes monarchies, republics and theocracies. India is the world's largest democracy, while China is a communist power regaining its economic influence in the world.

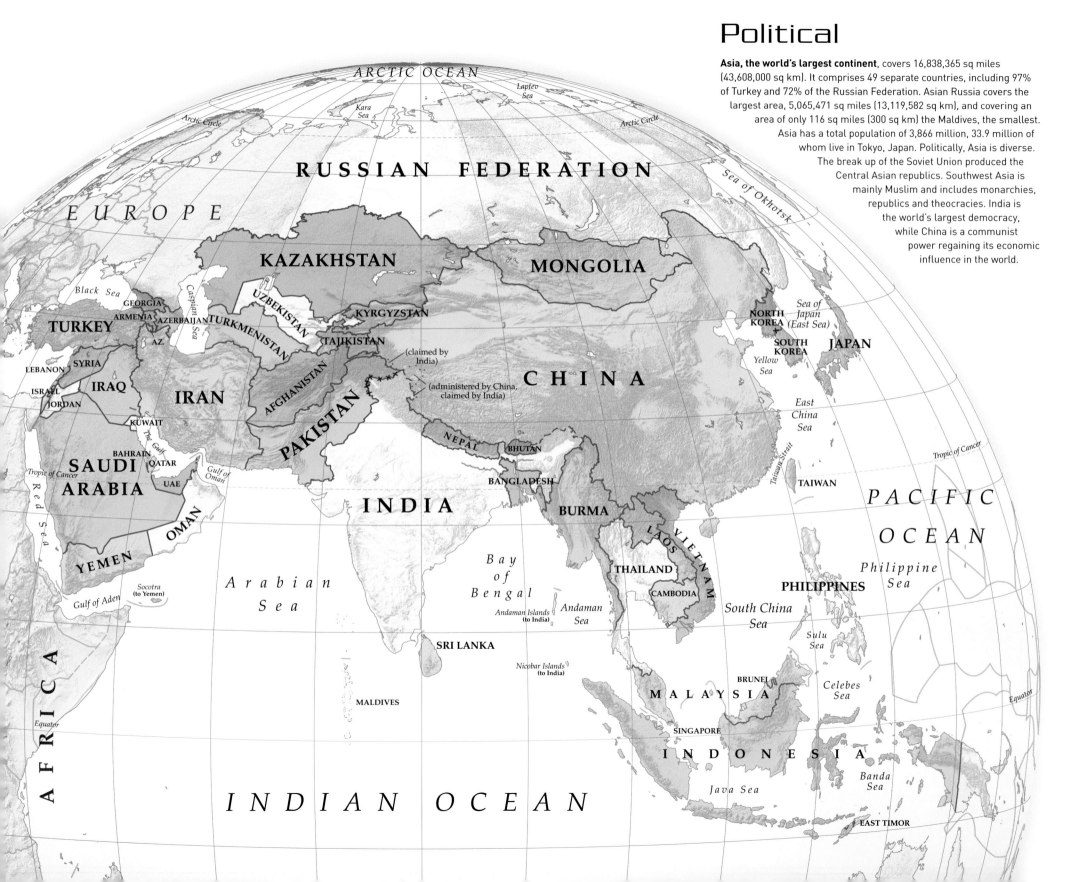

ARCTIC OCEAN

Laptev Sea

Kara Sea

Arctic Circle

Arctic Circle

RUSSIAN FEDERATION

Sea of Okhotsk

EUROPE

KAZAKHSTAN

MONGOLIA

Black Sea

GEORGIA

UZBEKISTAN

KYRGYZSTAN

NORTH KOREA

Sea of Japan (East Sea)

Caspian Sea

ARMENIA

AZERBAIJAN

TURKMENISTAN

TAJIKISTAN

(claimed by India)

SOUTH KOREA

JAPAN

TURKEY

AZ.

Yellow Sea

LEBANON

SYRIA

AFGHANISTAN

(administered by China, claimed by India)

CHINA

East China Sea

ISRAEL

IRAQ

IRAN

JORDAN

KUWAIT

PAKISTAN

NEPAL

BHUTAN

Tropic of Cancer

BAHRAIN

QATAR

SAUDI ARABIA

UAE

Gulf of Oman

BANGLADESH

TAIWAN

Tropic of Cancer

Red Sea

The Gulf

INDIA

BURMA

PACIFIC OCEAN

OMAN

LAOS

VIETNAM

YEMEN

Bay of Bengal

THAILAND

Philippine Sea

Gulf of Aden

Socotra (to Yemen)

Arabian Sea

CAMBODIA

PHILIPPINES

Andaman Islands (to India)

Andaman Sea

South China Sea

Sulu Sea

SRI LANKA

Nicobar Islands (to India)

BRUNEI

Celebes Sea

AFRICA

MALDIVES

MALAYSIA

Equator

SINGAPORE

Equator

INDONESIA

INDIAN OCEAN

Java Sea

Banda Sea

EAST TIMOR

# Physical

**The structure of Asia** can be divided into two distinct regions. Northern Asia consists of old mountain chains, plateaux and basins, like the Ural Mountains, Central Siberian Plateau and the Plateau of Tibet. In contrast, the landscapes of southern Asia are much younger, formed by tectonic activity beginning about 65 million years ago, culminating in the mighty Himalayas. These formed when the Indian Plate collided with the Eurasian Plate. North of the mountains lies a belt of deserts, such as the Gobi and the Takla Makan. In Southeast Asia, tectonic activity has formed island arcs, extending over 4000 miles (7000 km). To the west lies the Arabian Peninsula, once part of the African Plate. As it split from Africa, the Arabian Plate hit the Eurasian Plate, uplifting the Zagros Mountains.

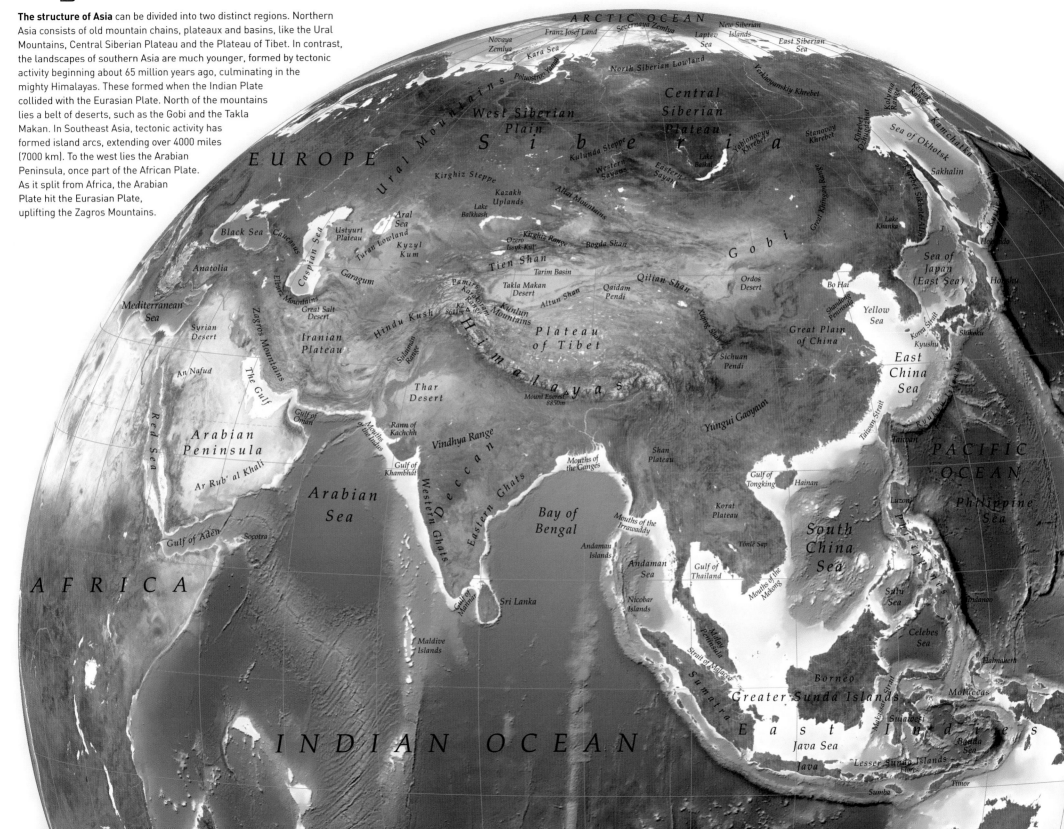

# Asian Russia

SCALE 1:24,500,000
(projection: Lambert Conformal Conic)

| 250 | 500 | 750 | 1000 Kilometres |
| 250 | 500 | 750 | 1000 Miles |

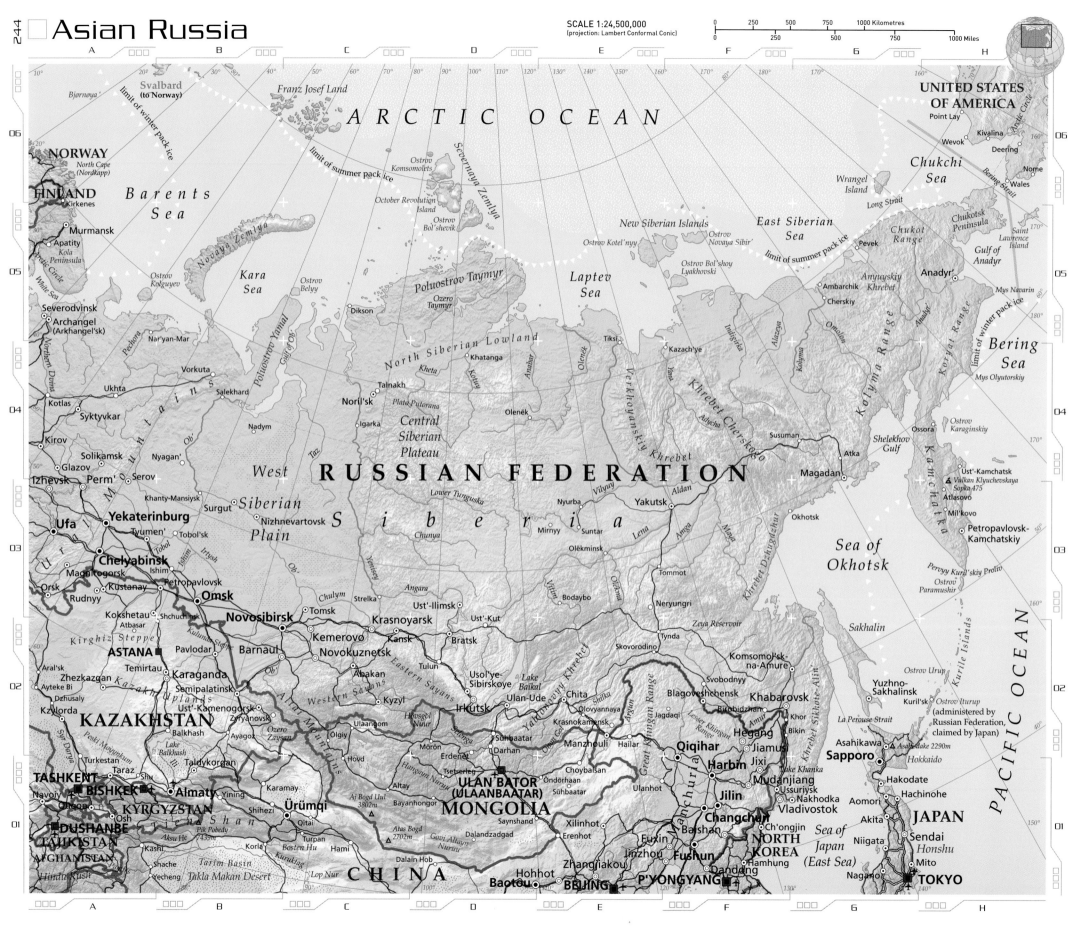

ARCTIC OCEAN

UNITED STATES
OF AMERICA

RUSSIAN FEDERATION

KAZAKHSTAN

MONGOLIA

CHINA

JAPAN

NORTH
KOREA

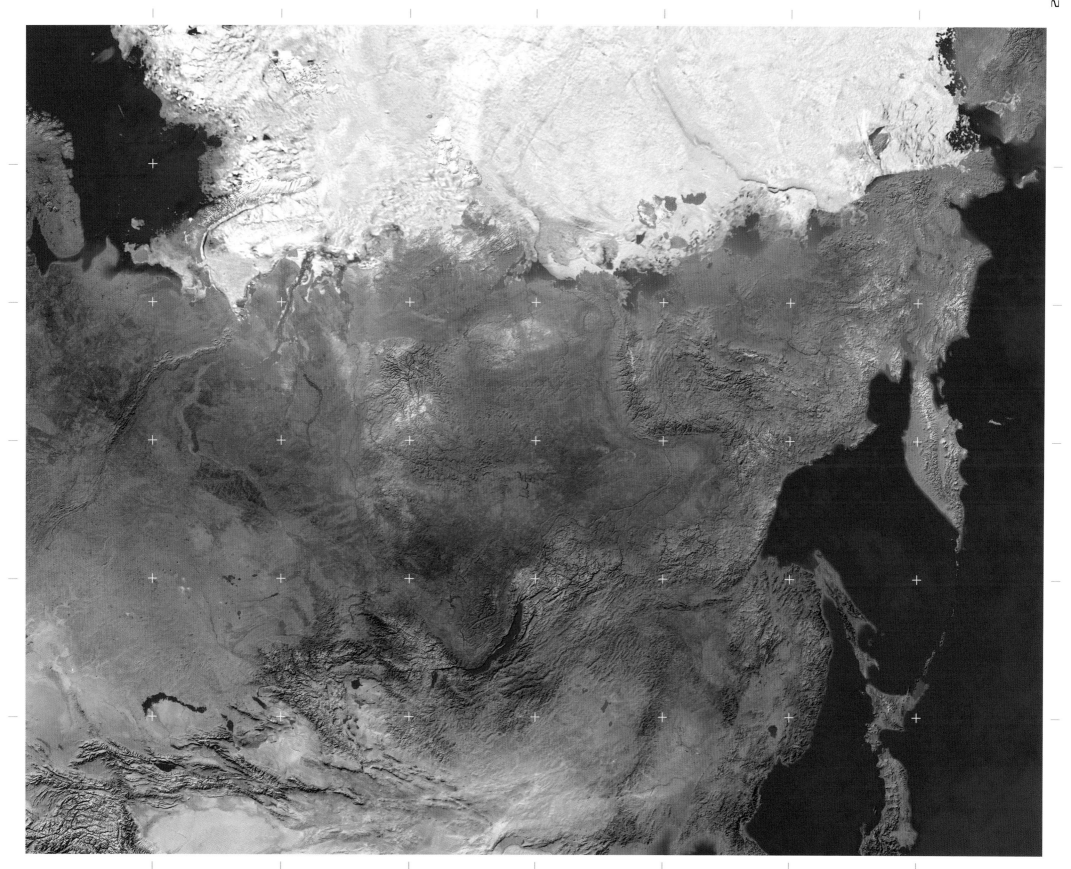

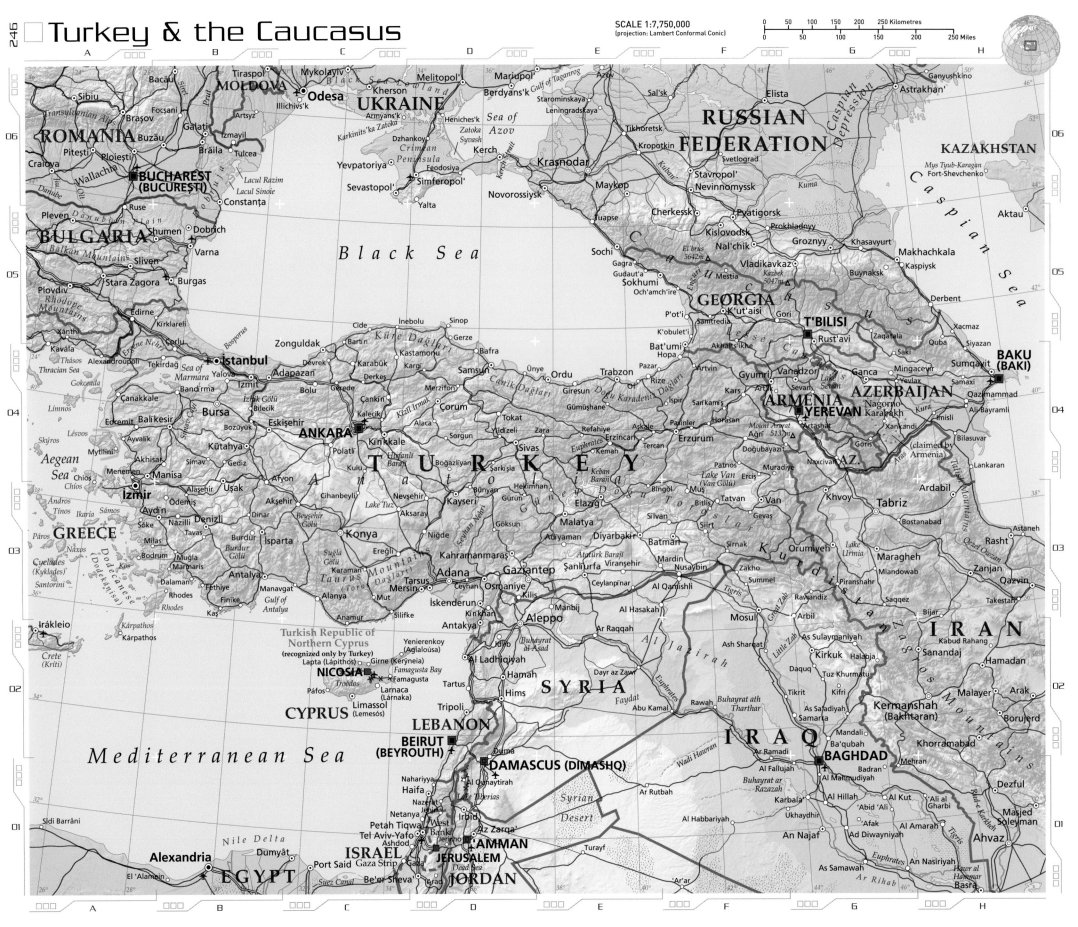

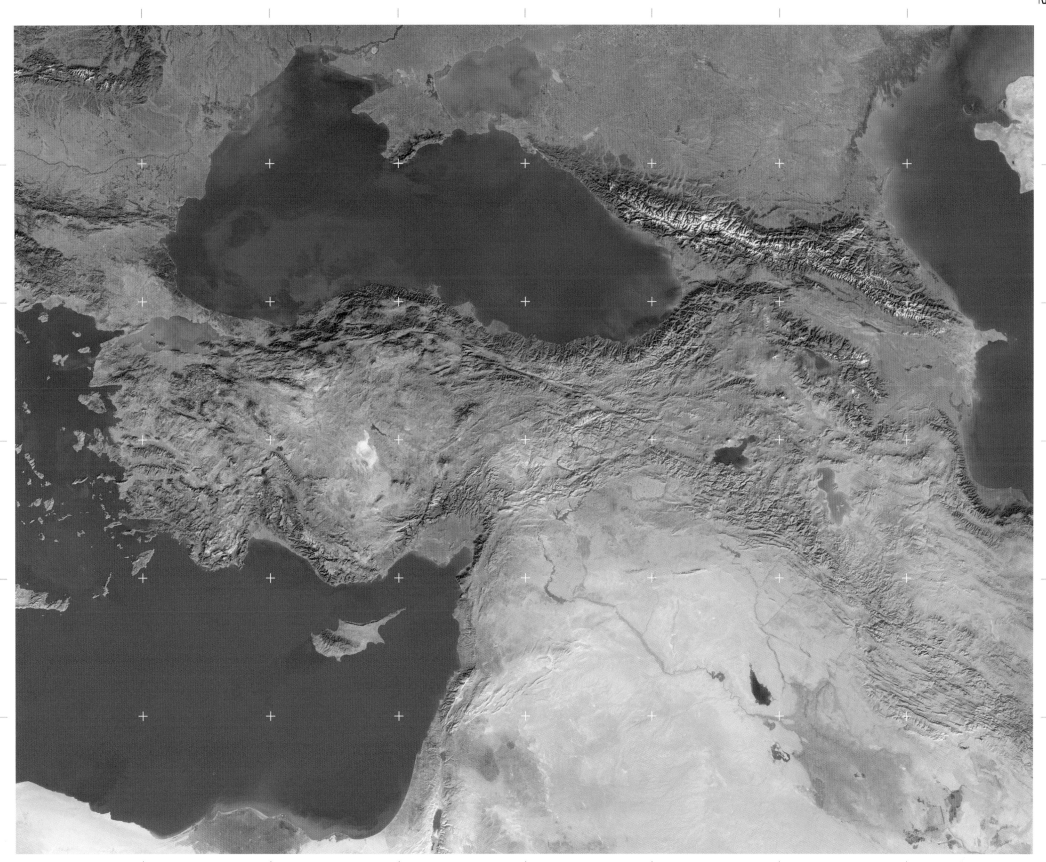

# THE BOSPORUS

## 41°03'N, 29°02'E

Europe and Asia reach out to each other across the Bosporus, the strait of water which provides the only outlet from the Black Sea. A river valley flooded by the rising waters of the Mediterranean at the end of the last ice age, the 19 mile- (30 km-) long strait links the Black Sea with the Sea of Marmara to the south, which in turn links to the Mediterranean Sea via the Dardanelles. A great city has grown up at this meeting point between east and west: the Greek colonists who founded the city in 667 BCE called it Byzantium, but as the capital of the Eastern Roman Empire from 330 CE, it was known as Constantinople. The name remained while the city was the capital of the Byzantine and Ottoman Empires, but the capital moved to Ankara with the establishment of the Republic of Turkey in 1923 and the city's name was changed to Istanbul in 1930.

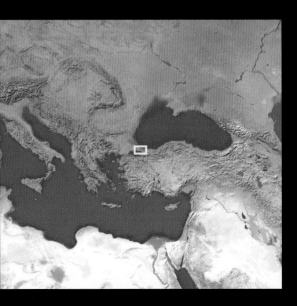

▶ **Today Istanbul** is Turkey's main sea port and home to over 8 million people, making it the second largest city in Europe. Since 1973, a suspension bridge over 3280 ft (1000 m) long has spanned the Bosporus to link the eastern and western parts of the city.

**SATELLITE:** LANDSAT 7   **INSTRUMENT:** ENHANCED THEMATIC MAPPER PLUS (ETM+)   **HEIGHT:** 438 MILES (705 KM

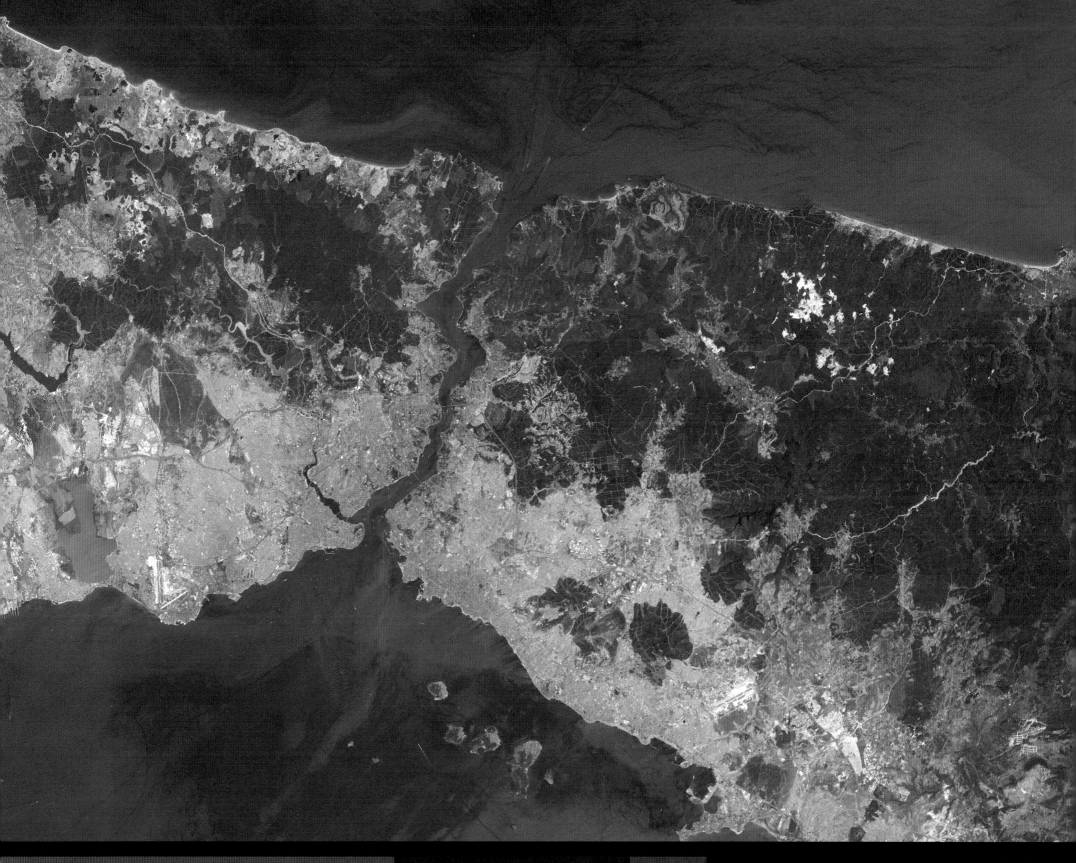

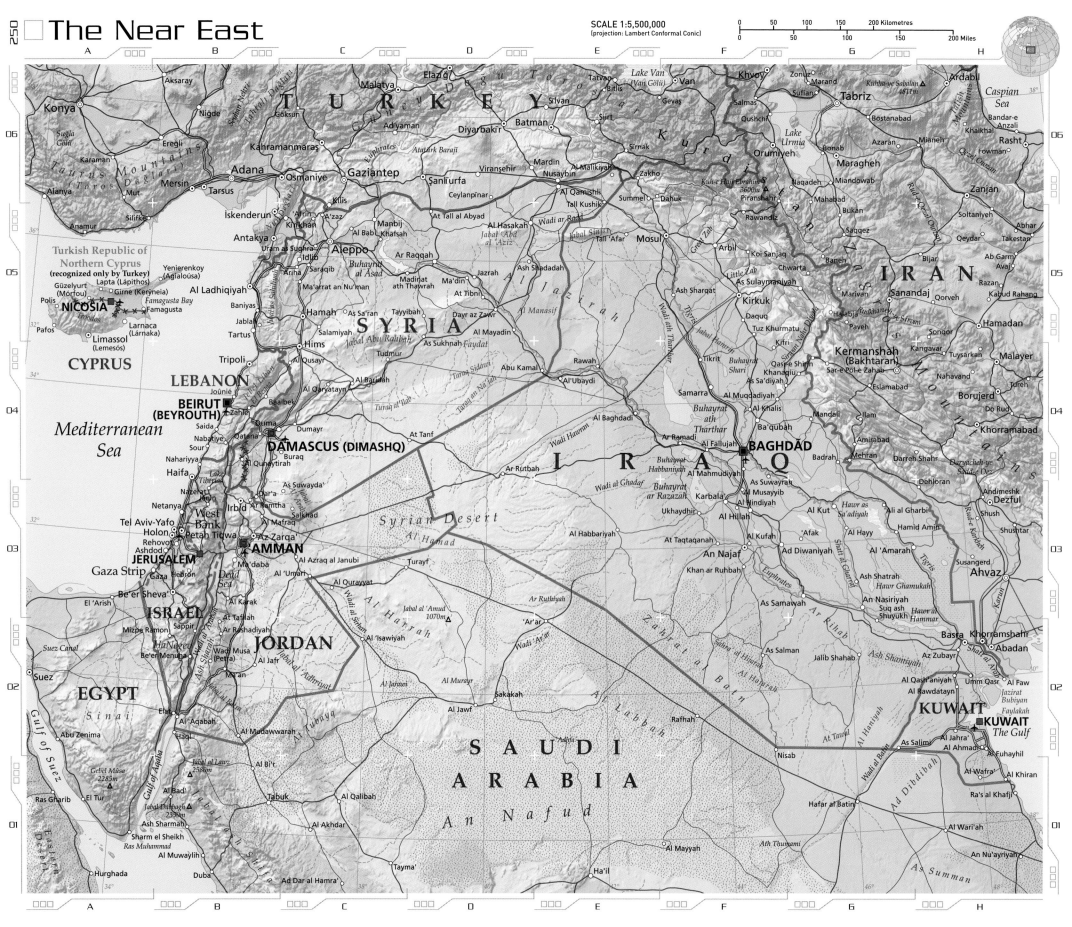

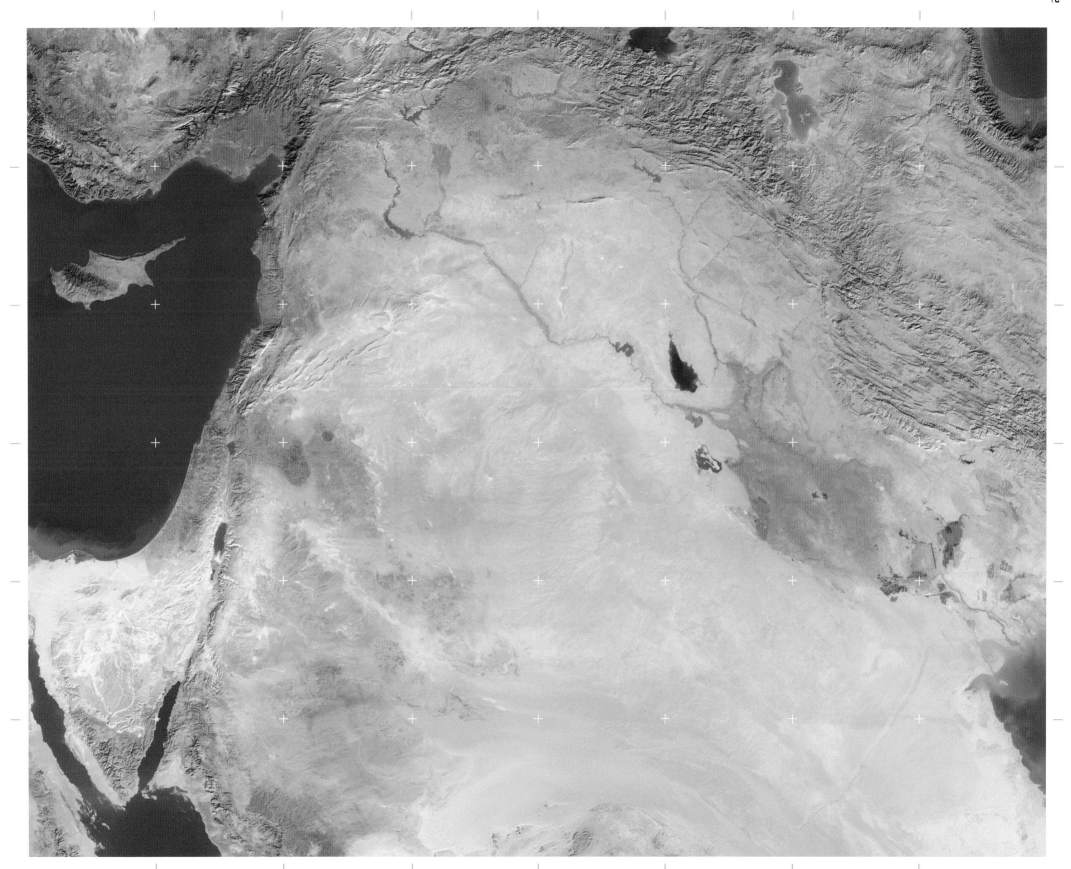

# JERUSALEM
## 31°46'N, 35°13'E

Revered as a Holy City by Jews, Christians and Muslims alike, the struggle for possession and control of this ancient city and its many venerable pilgrimage sites has characterised its history. According to tradition, it was established as the capital of his kingdom by King David, whose son Solomon built his Temple there, and fortified the walls. Later destroyed by the Persians, it was as an administrative centre under the Romans that the city saw the trial and crucifixion of Jesus Christ. Successively conquered by the Arabs, crusading Christians and the Ottomans, it was controlled by British mandate forces following the defeat of Turkey in the First World War. The city was partitioned after its capture by the newly-established nation of Israel in 1948, when it became the Israeli capital. Israeli forces wrested control of the entire city in 1967, and it was officially annexed to Israel in 1980.

**SATELLITE:** TERRA (EOS AM-1)   **INSTRUMENT:** MODIS   **HEIGHT:** 438 MILES (705 KM)   **DATE:** 2005

◀ **Jerusalem is sited** on two rocky outcrops some 2500 ft (762 m) above sea level, 35 miles (56 km) inland from the Mediterranean Sea, and 13 miles (21 km) from the Dead Sea.

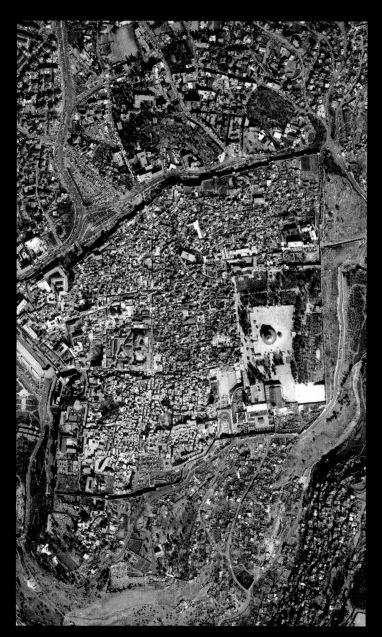

◀ **Although Jerusalem** contains numerous churches, shrines, mosques and synagogues, the basilica of the Dome of the Rock (centre right) is outstanding in two ways: it is situated on the Holy Mount within the ancient walls of the city, while the building, like the city, is revered by Christians, Muslims and Jews, the adjacent Wailing Wall being of particular significance to the latter.

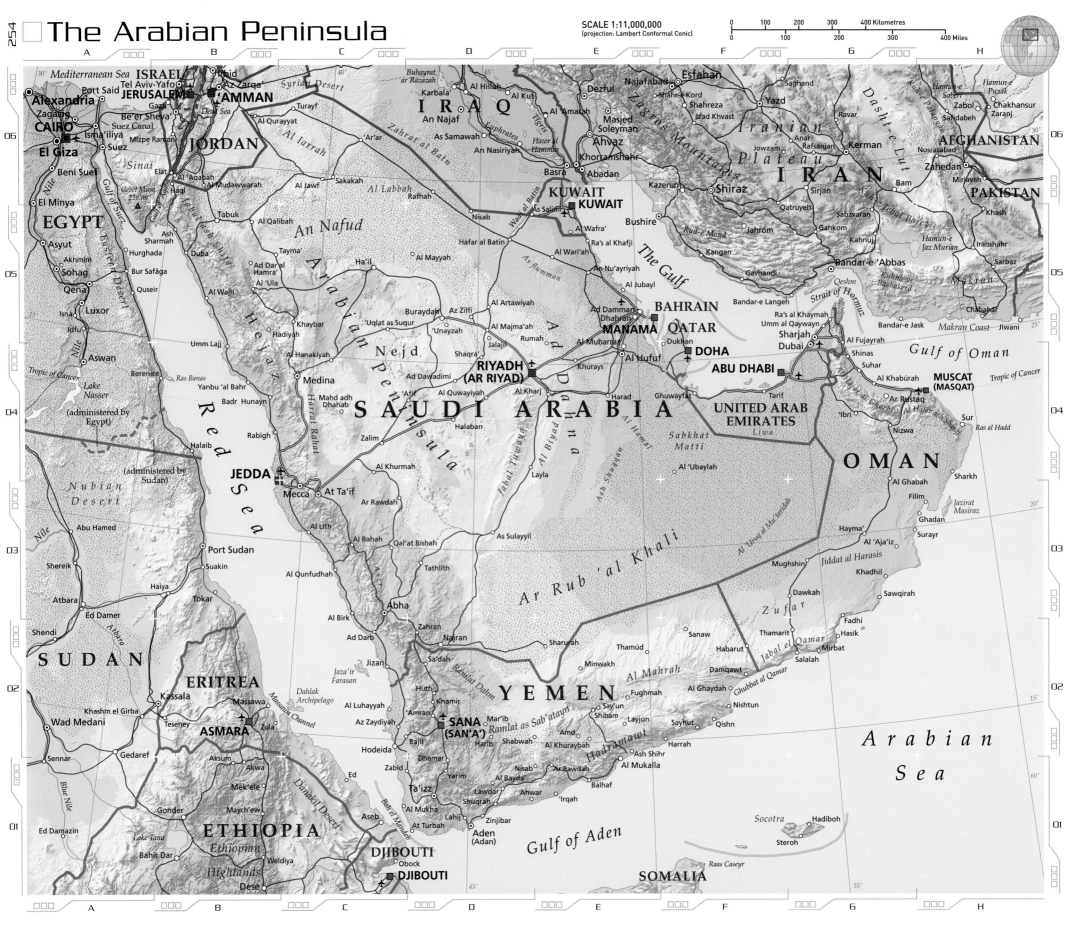

# The Arabian Peninsula

SCALE 1:11,000,000
(projection: Lambert Conformal Conic)

| 0 | 100 | 200 | 300 | 400 Kilometres |
| 0 | 100 | 200 | 300 | 400 Miles |

**Mediterranean Sea**

ISRAEL
Tel Aviv-Yafo
Port Said
JERUSALEM
Alexandria
Zagazig
CAIRO
El Giza
Beni Suef
Suez Canal
Isma'iliya
Suez
Sinai
Mizpe Ramon
JORDAN
Be'er Sheva'
EGYPT
Asyut
Akhmim
Sohag
Qena
Luxor
Isna
Idfu
Aswan
Berenice
Abu Hamed
Shereik

Irbid
'AMMAN
Az Zarqa'
Dead Sea
Jabal ash Shifa
Al 'Aqabah
Haql
Gebel Musa 2285m
Elat
Al Mudawwarah
Tabuk
Ash Sharmah
Hurghada
Bur Safâga
Quseir
Duba
Al Wajh
Umm Lajj

Turayf
Al Qurayyat
'Ar'ar
Al Jawf
Sakakah
Rafhah
Al Qalibah
Tayma'
Ad Dar'al Hamra'
Al 'Ula

**Syrian Desert**
Al Iarrah
An Nafud

Karbala
Al Hillah
An Najaf
As Samawah
An Nasiriyah
Zahrat al Batin
Hafar al Batin

**IRAQ**
Al Kut
Al 'Amarah
Euphrates
Tigris
Hawr al Hammar
Basra
Abadan
Khorramshahr

Dezful
Masjed Soleyman
Ahvaz
Nisab
Al Wafra
Ra's al Khafji

**KUWAIT**
KUWAIT
As Salim
Al Jubayl

Najafabad
Esfahan
Saghand
Shahr-e Kord
Yazd
Izad Khvast
Shahreza
Zagros Mountains
Kazerun
Bushire
Rud-e Mand
Jahrom

Saghand
Ravar
Anar
Rafsanjan
Kerman
**Iranian Plateau**
Jowzam
Qatruyeh
Gahkom
Kangan
Sabzvaran
Kahnuj

**AFGHANISTAN**
Nosratabad
Zahedan
Bam
Mirjaveh
Khash
Iranshahr
**PAKISTAN**
Sarbaz

Hamun-e Puzak
Chakhansur
Zaranj
Safidabeh

**IRAN**

Bandar-e 'Abbas
Hamun-e Jaz Murian
Qeshm
Kuhha-ye Bashakerd
Strait of Hormuz
Bandar-e Langeh
Bandar-e Jask
Makran Coast
Jiwani
Chabahar
Makran

Red Sea
Ras Banas
Yanbu 'al Bahr
Badr Hunayn
Medina
Mahd adh Dhahab
Khaybar
Hadiyah
Al Hanakiyah

Ha'il
Al Mayyah
Buraydah
Az Zilfi
Al Artawiyah
'Uqlat as Suqur
'Unayzah
Al Majma'ah
Rumah
Shaqra
Jalajil

Ad Damman
Dhahran
**BAHRAIN**
**MANAMA**
Al Mubarraz
Al Hufuf
Dukhan
**QATAR**
**DOHA**
**ABU DHABI**

Ra's al Khaymah
Umm al Qaywayn
Sharjah
Dubai
Al Fujayrah
Shinas
Suhar
**Gulf of Oman**
Al Khabûrah
**MUSCAT (MASQAT)**
Ar Rustaq

**SAUDI ARABIA**
Nejd
Hejaz
Harrat Rahat
Afif
Ad Dawadimi
RIYADH (AR RIYAD)
Al Quwayiyah
Al Kharj
Khurays
Ghuwayfat
Harad

**UNITED ARAB EMIRATES**
Liwa
'Ibri
Nizwa
**OMAN**
Tarif
Ras al Hadd

Tropic of Cancer

Rabigh
Zalim
Halaban
Al Khurmah
JEDDA
Mecca
At Ta'if
Ar Rawdah
Al Lith
Al Bahah
Al Birk

Ash Shuqqan
Jabal Tuwayq
Al Biyad
Layla
'Uqlat as Suqur
As Sulayyil
Qal'at Bishah
Tathlith

Sabkhat Matti
Al 'Ubaylah
Al Hamal
**Ar Rub 'al Khali**
Al 'Uruq al Mu'taridah
Hayma'
Jiddat al Harasis
Al Ghabah
Filim
Jazirat Masirah
Ghadan
Surayr
Al 'Aja'iz
Ras al Hadd
Sharkh

Nubian Desert
Lake Nasser
(administered by Egypt)
(administered by Sudan)
Halaib
Port Sudan
Suakin

Al Qunfudhah
Abha
Zahran
Ad Darb
Jizan
Najran
Sharurah
Thamúd
Minwakh
Mughshin
Dawkah
Khadhil
Sawqirah
Zufar
Fadhi
Hasik
Mirbat
Salalah
Habarut
Damqawt
Jabal el Qamar
Ghubbat al Qamar

SUDAN
Atbara
Ed Damer
Haiya
Tokar
Shendi

ERITREA
Kassala
Massawa
ASMARA
Zula
Khashm el Girba
Teseney
Gedaref
Wad Medani
Sennar

Dahlak Archipelago
Massawa Channel
Danakil Desert
Jaza'ir Farasan
Al Luhayyah
Az Zaydiyah
Huth
Khamir
Amran
'Amran
SANA (SAN'A')
Hodeida
Bajil
Dhamar
Zabid
Yarim
Ta'izz
Al Mukha
At Turbah
Lahij
Zinjibar
Aden (Adan)

Mar'ib
Ramlat Dahm
Sa'dah
Harib
Shabwah
Al Khuraybah
Ramlat as Sab'atayn
Say'un
Shibam
'Amd
Nisab
Ar Rawdah
Layjun
Sayhut
Sanaw
Al Ghaydah
Nishtun
Qishn
Fughmah
Al Mukalla
Ash Shihr
Harrah
Balhaf
Ahwar

**YEMEN**
Al Mahrah
Al Bayda'
Lawdar
Shuqrah
'Irqah
Hadramawt
Qishn

Bahir Dar
Lake Tana
Blue Nile
Gonder
Mek'ele
Maych'ew
Weldiya
Dese
Akwa
Aksum
Akwa
Ed
**ETHIOPIA**
Ethiopian Highlands
Bab el Mandab
**DJIBOUTI**
Obock
**DJIBOUTI**

**Gulf of Aden**
Socotra
Hadiboh
Steroh
Raas Caseyr
**SOMALIA**

**Arabian Sea**

Ed Damazin

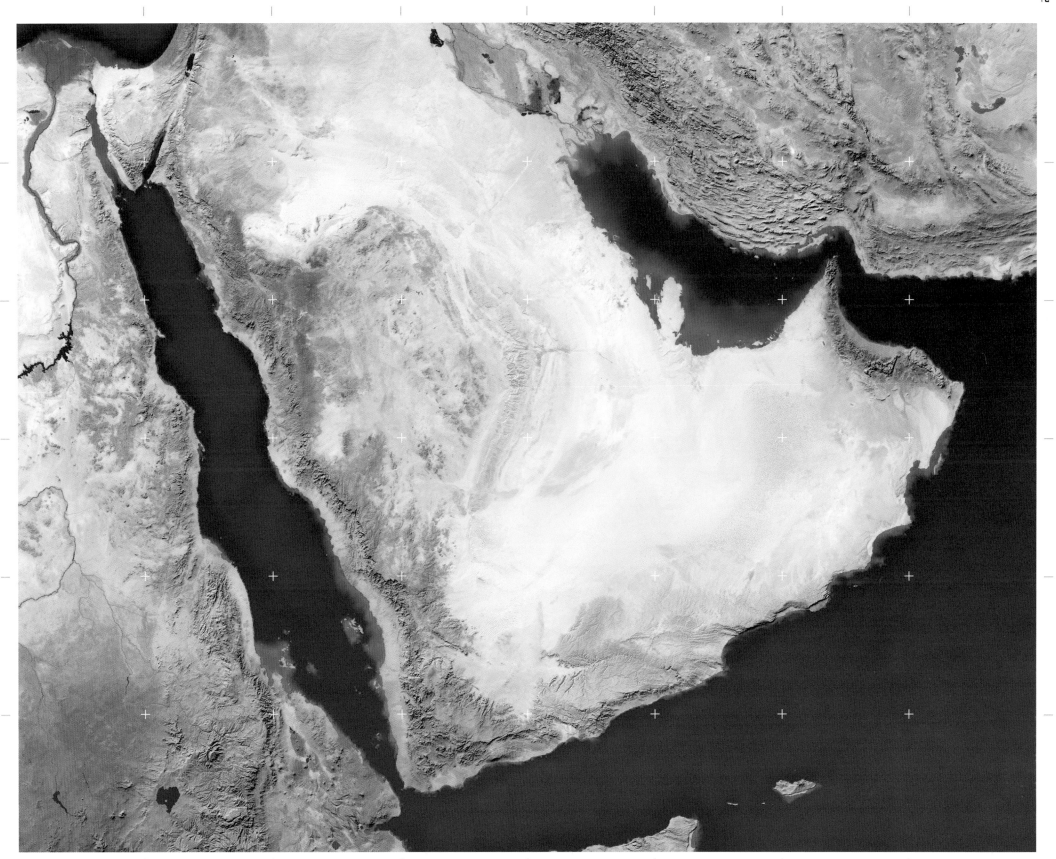

# MECCA

## 21°27'N, 39°50'E

One of the most extraordinary and important pilgrimage centres in the world, Mecca is also one of the most inaccessible. Set in a valley in the Hejaz region of Saudi Arabia, it was the birthplace of Muhammad, the founder of Islam. An important staging post on ancient trade routes from the Yemen to the Mediterranean, the city was both well established and a religious centre before the Prophet's birth in c.570 CE, but this event turned it into the centre of the Muslim world.

▶ **All Muslims should** make the Hajj, the pilgrimage to Mecca, at least once in their lifetimes. The object of their journey is a complex procession around a variety of sacred sites, beginning and ending at the Great Mosque (centre right) with its enormous courtyard containing the sacred Ka'bah. Around 2 million people take part in this ritual every year, the image shows the masses of pilgrims in and around the Great Mosque.

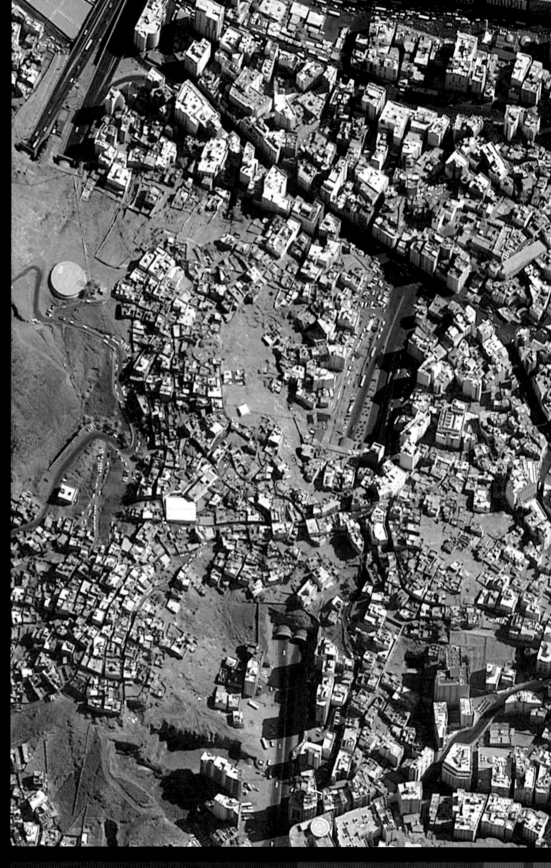

**SATELLITE:** QUICKBIRD image courtesy of DigitalGlobe    **HEIGHT:** 280 MILES (450 KM)    **DATE:** 11 FEB 2003

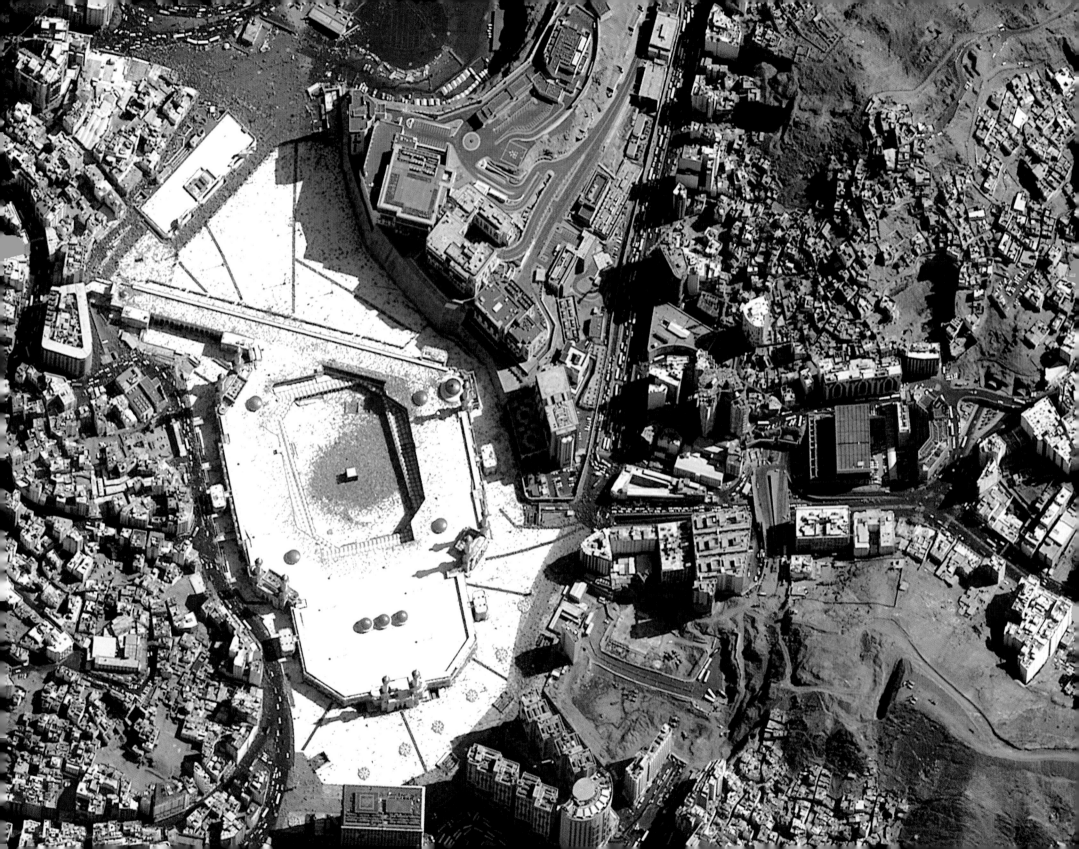

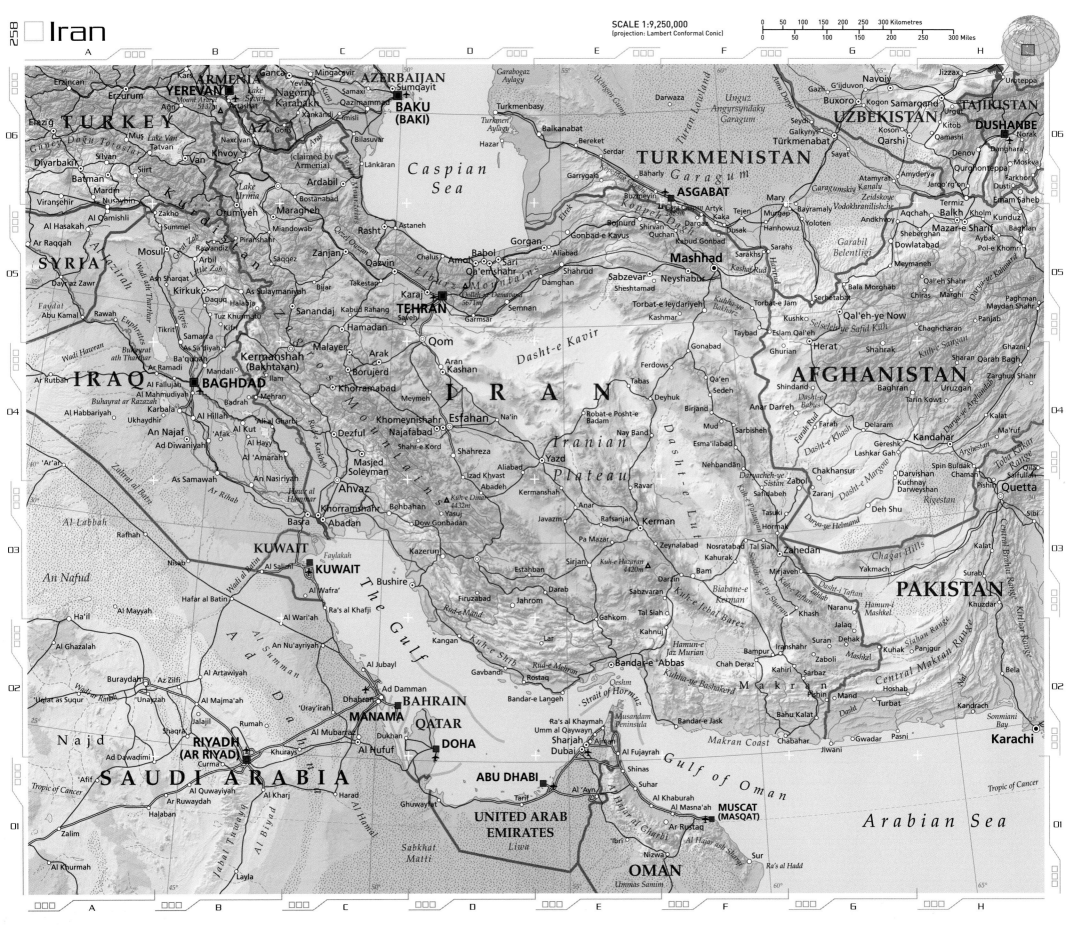

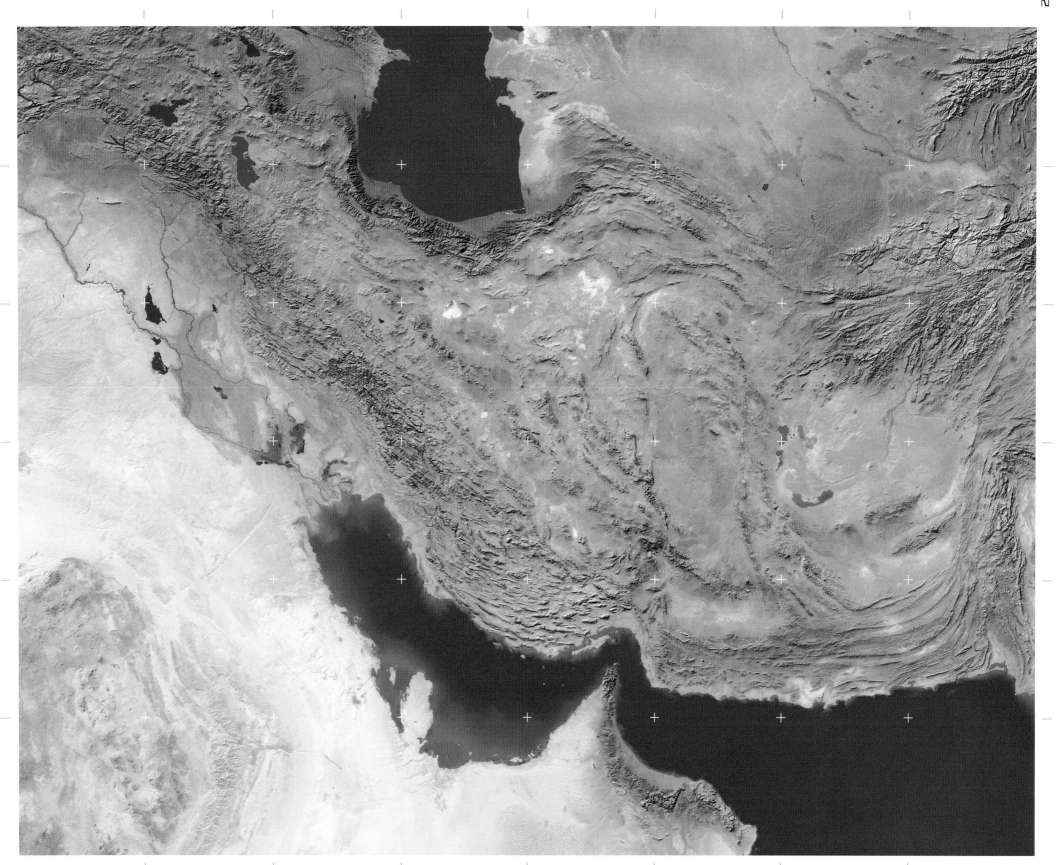

# PALM ISLAND

## 25°06'N, 55°08'E

In an ambitious landscape engineering project, a series of artificial islands are being reclaimed from the shallow waters of The Gulf off Dubai. Three islands in the shape of palm trees, and another representing the countries of the world, are being built as luxury housing developments and tourist resorts. The largest manmade islands in the world, they will add 323 miles (520 km) of beachfront to the city and berths for 40,000 yachts. The islands are built from sand dredged from the seabed and sprayed into the correct position by barges using Global Positioning Satellite (GPS) technology for guidance. The property developer's advertising makes much of the fact that the new islands are visible from space and the second Palm Island to be built will include boardwalks spelling out the words of Arab proverbs.

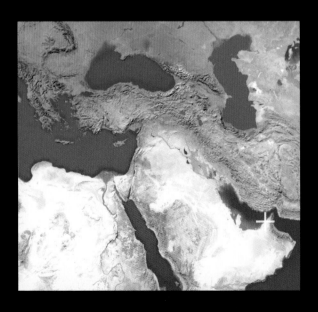

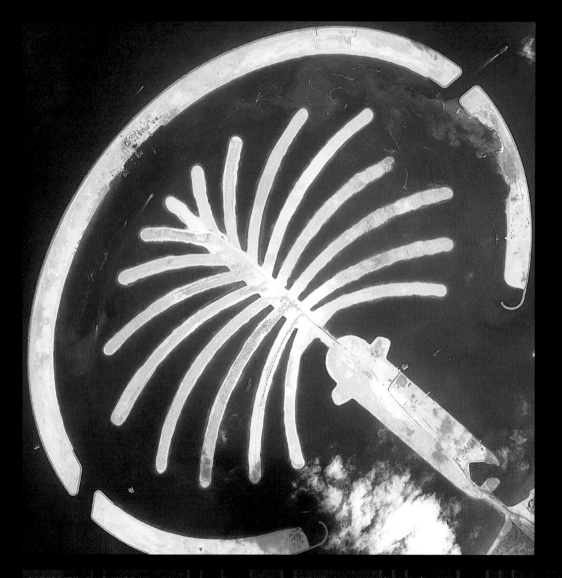

**SATELLITE:** QUICKBIRD image courtesy of DigitalGlobe   **HEIGHT:** 280 MILES (450 KM)   **DATE:** 09 SEP 2003

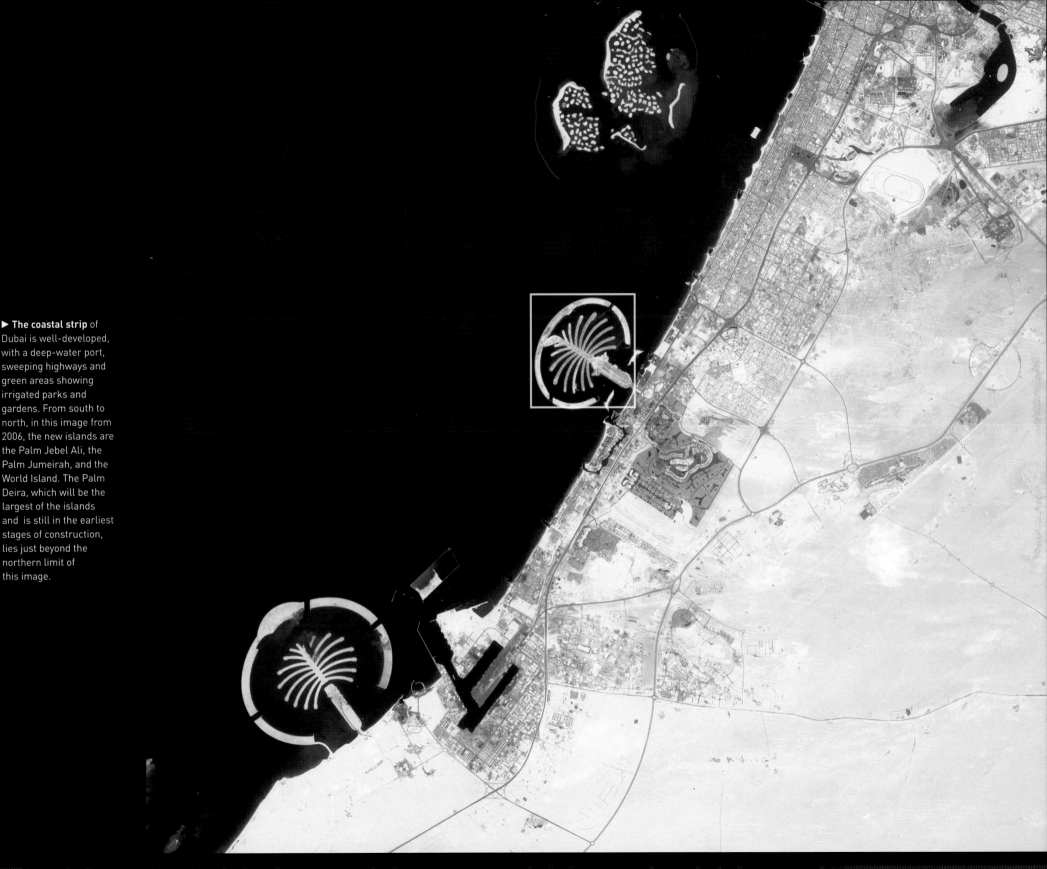

► **The coastal strip** of Dubai is well-developed, with a deep-water port, sweeping highways and green areas showing irrigated parks and gardens. From south to north, in this image from 2006, the new islands are the Palm Jebel Ali, the Palm Jumeirah, and the World Island. The Palm Deira, which will be the largest of the islands and is still in the earliest stages of construction, lies just beyond the northern limit of this image.

**SATELLITE:** TERRA (EOS AM-1)   **INSTRUMENT:** ASTER   **HEIGHT:** 438 MILES (705 KM)   **DATE:** 18 SEP 2006

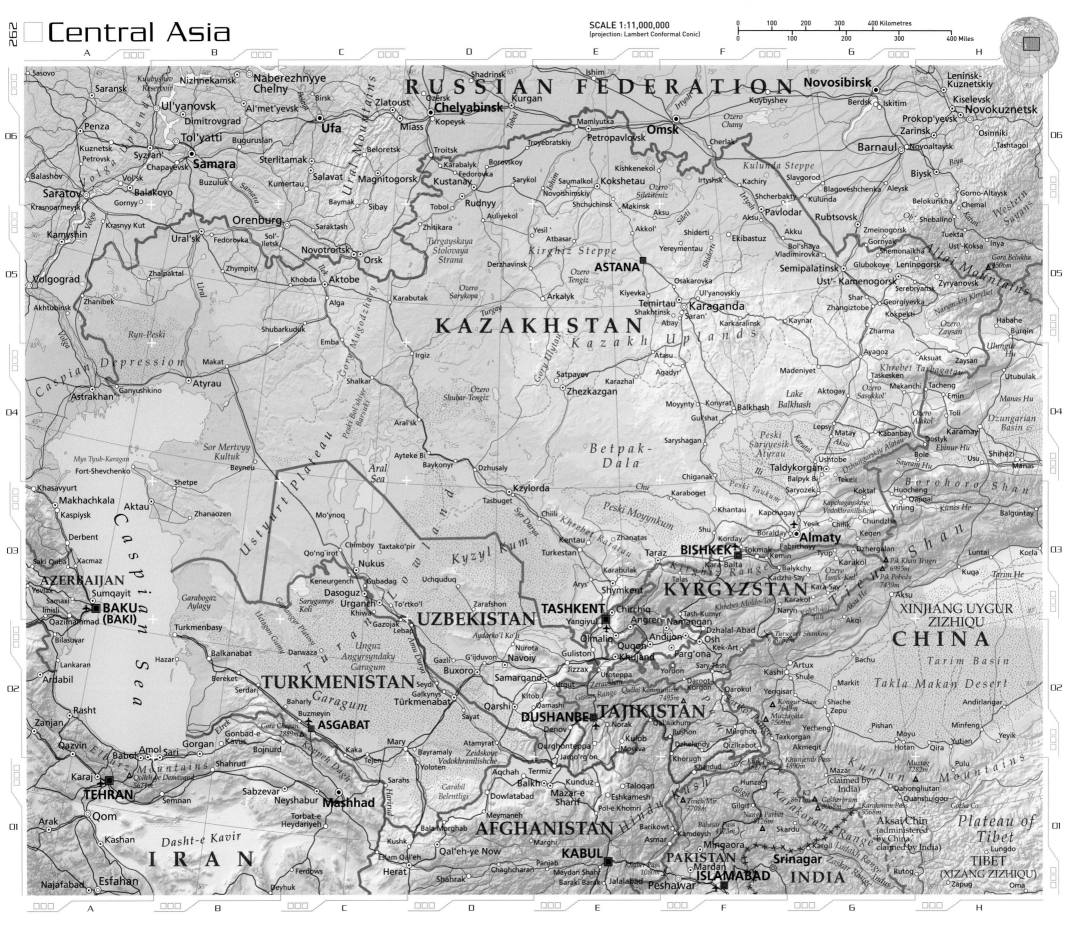

SCALE 1:11,000,000
(projection: Lambert Conformal Conic)

| 0 | 100 | 200 | 300 | 400 Kilometres |
| 0 | 100 | 200 | 300 | 400 Miles |

**RUSSIAN FEDERATION**

Sasovo
Saransk
Penza
Nizhnekamsk
Naberezhnyye Chelny
Birsk
Ufa
Zlatoust
Ozërsk
Shadrinsk
Ishim
Novosibirsk
Leninsk-Kuznetskiy
Kiselevsk
Kuznetsk
Dimitrovgrad
Al'met'yevsk
Miass
Kopeysk
**Chelyabinsk**
Kurgan
Petropavlovsk
Mamlyutka
Omsk
Cherlak
Kuybyshev
Berdsk
Iskitim
Prokop'yevsk
Novokuznetsk
Osinniki
Petrovsk
Tol'yatti
Bugur'slan
Sterlitamak
Salavat
Magnitogorsk
Troitsk
Troyebratskiy
Kustanay
Fedorovka
Kishkenekol
Kokshetau
Kachiry
Shcherbakty
Kulunda
Zarinsk
Barnaul
Novoaltaysk
Tashtagol
**Samara**
Syzran'
Chapayevsk
Buzuluk
Baymak
Sibay
Karabalyk
Borovskoy
Saumalkol
Slavgorod
Blagoveshchenka
Aleysk
Biysk
Gorno-Altaysk
Balashov
Saratov
Krasnoarmeysk
Kumertau
Rudnyy
Sarykol
Ishim
Novoishimskiy
Saryol
Akkol'
Pavlodar
Rubtsovsk
Zmeinogorsk
Belokurikha
Shemonaikha
Altai Mountains
Vol'sk
Balakovo
Orenburg
Saraktash
Zhitikara
Atbasar
Makinsk
Aksu
Shiderti
Shiderti
Ekibastuz
Bol'shaya Vladimirovka
Gornyak
Gora Belukha 4506m
Kamyshin
Gornyy
Sol'-Iletsk
Khobda
Yesil'
Derzhavinsk
Kirghiz Steppe
Ozero Siletiteniz
Yereymentau
Semipalatinsk
Ust'-Kamenogorsk
Zyryanovsk
Western Sayans
Volgograd
Krasnyy Kut
Ural'sk
Fedorovka
Alga
Karabutak
Arkalyk
Kiyevka
**ASTANA**
Osakarovka
Ul'yanovskiy
Shar
Georgiyevka
Serebryansk
Zhanibek
Akhtubinsk
Zhympity
Ryn-Peski
Shubarkuduk
Ozero Sarykopa
Ozero Tengiz
Karaganda
Temirtau
Shakhtinsk
Saran'
Karkaralinsk
Kaynar
Zhangiztobe
Kokpekti
Ozero Zaysan
Habahe
Burqin
Ulungur Hu
Astrakhan
Ganyushkino
Atyrau
Makat
Emba
Irgiz
**KAZAKHSTAN**
Abay
Agadyr'
Madeniyet
Ayagoz
Aksuat
Zaysan
Manas Hu
Caspian Depression
Gory Muğodzhary
Kazakh Uplands
Gory Ulytau
Kazakh Uplands
Atasu
Lake Balkhash
Aktogay
Ozero Sasykkol'
Makanchi
Tacheng
Emin
Utubulak
Mys Tyub-Karagan
Sor Mertvyy Kultuk
Shalkar
Satpayev
Karazhal
Karazhal
Zhezkazgan
Moyynty
Konyrat
Balkhash
Balpyk Bi
Ozero Alakol'
Toli
Dzungarian Basin
Khasavyurt
Makhachkala
Fort-Shevchenko
Shetpe
Beyneu
Ayteke Bi
Baykonyr
Aral Sea
Dzhusaly
Betpak-Dala
Chiganak
Lepsy
Matay
Aksu
Kabanbay
Karamay
Shihezi
Manas
Kaspiysk
Aktau
Zhanaozen
Ustyurt Plateau
Kzylorda
Tasbuget
Chiili
Chu
Karaboget
Peski Taukum
Ushtobe
Taldykorgan
Dostyk
Ebinur Hu
Saki Quba
Xacmaz
Mo'ynoq
Chimboy
Taxtako'pir
Kyzyl Kum
Syr Darya
Khrebet Karatau
Zhanatas
Kentau
Peski Moyynkum
Khantau
Kapchagay
Yesik
Chilik
Chundzha
Yining
Künes He
Balguntay
**AZERBAIJAN**
Yevlax
Imisli
Sumqayit
**BAKU (BAKI)**
Qazimämmäd
Nukus
Uchquduq
Turkestan
Karabulak
Taraz
Shymkent
Talas
Kara-Balta
**BISHKEK**
Tokmak
Kemin
Balykchy
Karakol
Kuga
Korla
Tarim He
Aksu
Qaraqol
Borohoro Shan
Tien Shan
Turkmenbasy
Garabogaz Aylagy
Dasoguz
Gubadag
Keneurgench
Urganch
Khiwa
To'rtko'l
Zarafshon
Karnab
**TASHKENT**
Chirchiq
Angren
Namangan
Dzhalal-Abad
Osh
**KYRGYZSTAN**
Kara-Say
Naryn
Kadzhi-Say
Tyup
Pik Khan Tengri
Pik Pobedy 7439m
Kashi
Artux
Shule
Bachu
**XINJIANG UYGUR ZIZHIQU**
**CHINA**
Tarim Basin
Hazar
Turkmenbashy
Balkanabat
Gazojak
Leban
Gazli
G'ijduvon
Navoiy
Guliston
Yangiyul
Olmaliq
Quqon
Andijon
Kek-Art
Farg'ona
Sary-Tash
Daroot Korgon
Yordon
Kashi
Kek-Art
Yengisar
Markit
Takla Makan Desert
Andirlangar
Rasht
Ardabil
**TURKMENISTAN**
Darwaza
Ungur Angyrsyndaky Garagum
Buxoro
Nurota
Samarqand
Jizzax
Uroteppa
Qorakul
Qarokul
Kongur 7649m
Muztagata 7509m
Yecheng
Pishan
Minfeng
Yutian
Yeyik
Zanjan
Serdar
Garagum
Türkmenabat
Qarshi
Qamashi
Urgut
Gissar Range
Qullai Kommunizm 7495m
**TAJIKISTAN**
Murghob
Taxkorgan
Moyu
Hotan
Qira
Qazvin
Eldurz Mountains
Baharly
Buzmeyin
**ASGABAT**
Gora Chapan 2889m
Seydi
Galkynys
Sayat
Mary
Bayramaly
Zeidskoye Vodokhranilishche
Jarqo'rg'on
Denov
**DUSHANBE**
Norak
Kulob
Moskva
Dzhelandy
Qizilrobat
Akmeqit
Muztag 7282m
Pulu
Babol
Amol
Sari
Gorgan
Gonbad-e Kavus
Bojnurd
Koppeh Dash
Kaka
Tejen
Bayramaly
Atamyrat
Termiz
Qurghonteppa
Kunduz
Khorugh
Khandud
Klik Pass 4527m
Hunza
Mazar
Gasherbrum 8068m
Karakoram Pass 5568m
Dahongliutan
Quanshuigou
Gotha Co
Karaj
Gora Chapan
Qolleh-ye Damavand 5671m
**TEHRAN**
Sabzevar
Neyshabur
**Mashhad**
Sarahs
Harirud
Garabil Belentligi
Aqchah
Balkh
Mazar-e Sharif
Pol-e Khomri
Eshkamesh
Talaqan
Murghob
Gilgit
Nanga Parbat 8126m
Gilgit
K2 8611m
Tirich Mir 7708m
Skardu
Aksai Chin (administered by China, claimed by India)
**Plateau of Tibet**
Arak
Qom
Kashan
Dasht-e Kavir
Semnan
Torbat-e Heydariyeh
Bala Morghab
Meymaneh
Dowlatabad
Marghi
Barikowt
Asmar
Babasar Pass 4173m
Kamdeysh
Mingaora
Kargil
Ladakh Range
Zaskar Range
Indus
Lungdo
Rutog
Najafabad
Esfahan
Ferdows
Deyhuk
Kushk
Herat
Shahrak
Chaghcharan
Panjab
Maydan Shahr
Baraki Barak
Jalalabad
**KABUL**
Khyber Pass 1080m
Peshawar
Mardan
**ISLAMABAD**
**PAKISTAN**
**Srinagar**
**INDIA**
Zapug
Oma
**I R A N**
Qal'eh-ye Now
Qal'eh Now
Shahrak
Bala Morghab
**AFGHANISTAN**
Qandahar
**TIBET (XIZANG ZIZHIQU)**
Hindu Kush
Karakoram Range
Kunlun Mountains

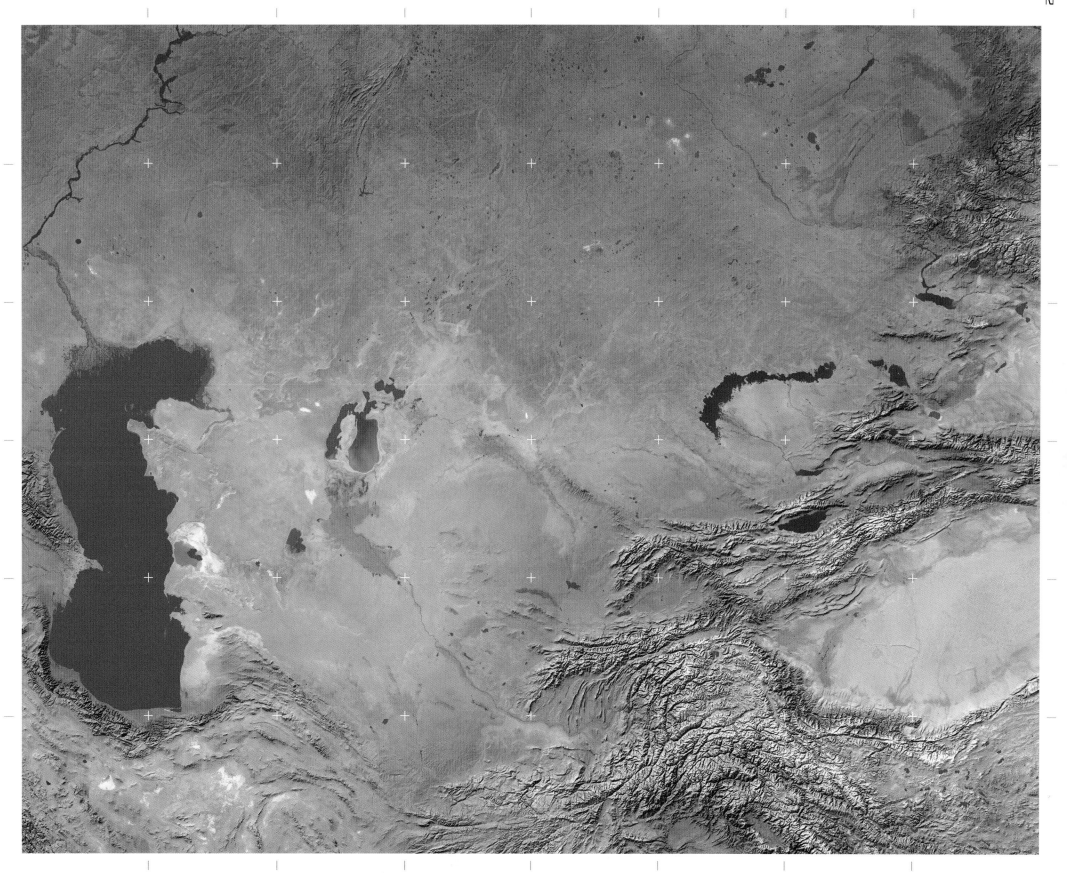

# ARAL SEA

## 45°N, 60°E

The decline of the Aral Sea is one of the largest-scale environmental disasters of modern times. From the 1930s the waters of the Syr Darya and Amu Darya rivers were diverted to irrigate the desert so that cotton and other crops could be grown. By the 1960s, the reduced inflow, combined with high concentrations of salt and fertilizer runoff, had started to poison the lake and destroy its large fishing industry. Over the last 50 years the Aral has lost more than 75% of its area and may disappear altogether by 2018. Without the modifying effect of a large body of water, the local climate has become more extreme, reducing the growing season for crops. Newly exposed land is often covered with thick salt deposits which are dispersed across the area by winds, blighting the health of the local population.

▶ Satellite observations chart the decline of the Aral Sea over forty years:
**In 1962,** the original extent is shown by declassified data from a KH-4 Corona spy satellite.

**By 1989,** a civilian weather satellite shows the newly-emerging island of Vozrozhdeniya ('Rebirth') and the smaller northern part of the sea is cut off.

**By 2006,** the northern basin has been stabilised by the building of a dam, but Vozrozhdeniya has become a peninsula all but dividing the southern basin in two.

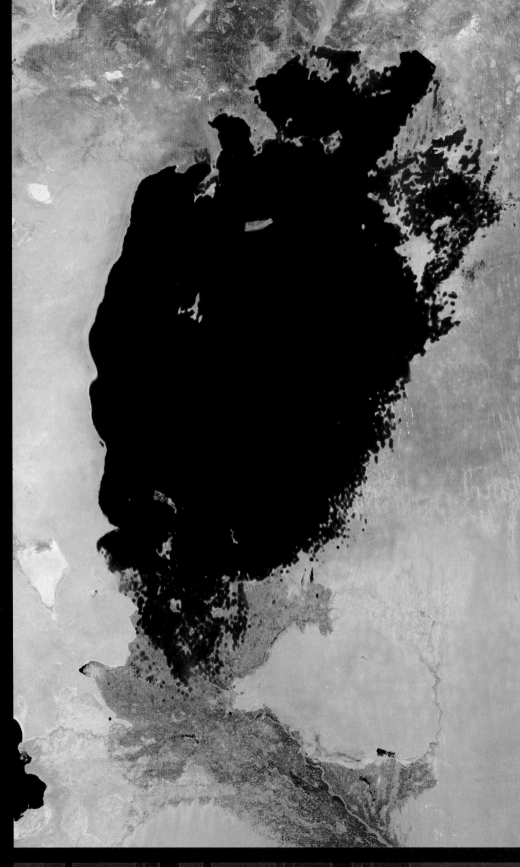

SIMLUATION BASED ON KH-4 CORONA DATA    **HEIGHT:** 114-225 MILES (183-360 KM)    **DATE:** 1962

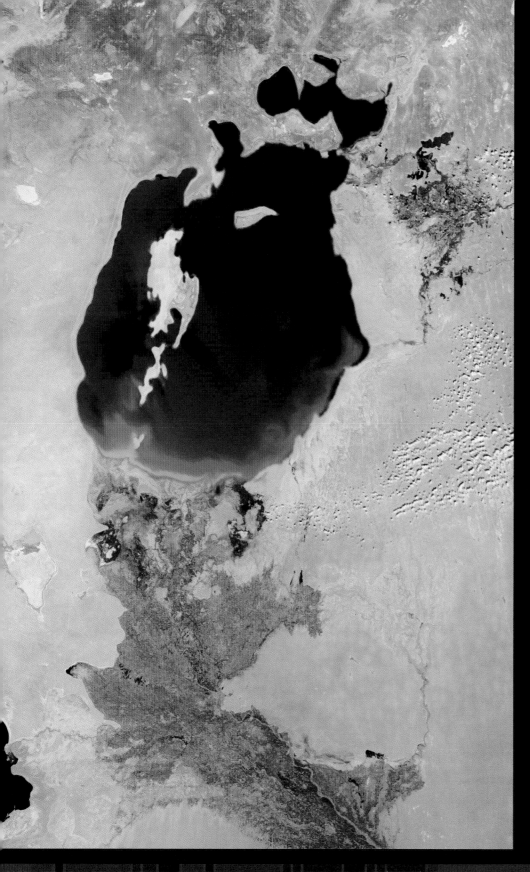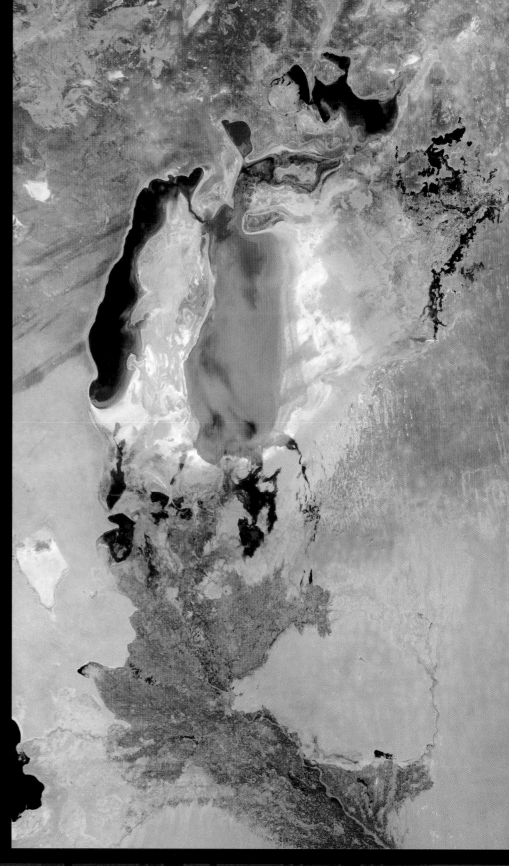

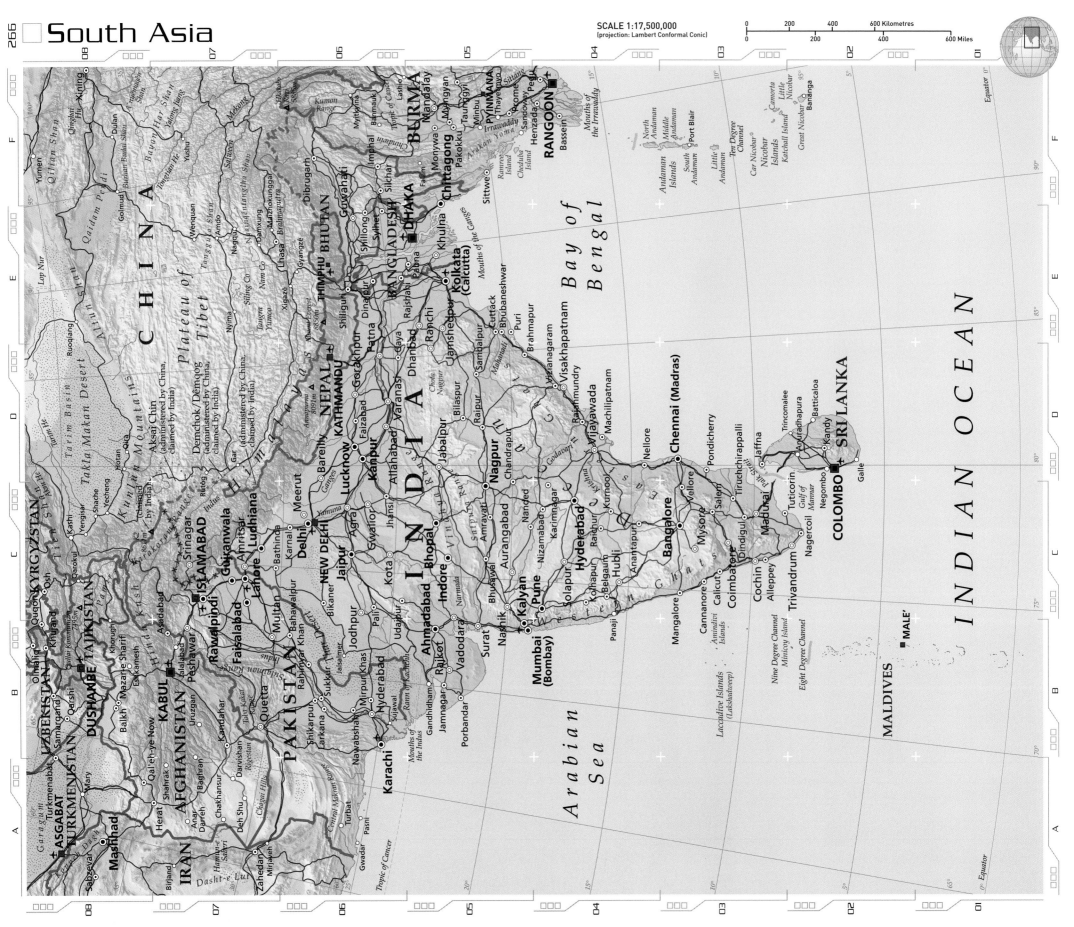

# South Asia

SCALE 1:17,500,000
(projection: Lambert Conformal Conic)

| 0 | 200 | 400 | 600 Kilometres |
| 0 | 200 | 400 | 600 Miles |

CHINA

Plateau of Tibet

Takla Makan Desert

Tarim Basin

Qaidam Pedi

Qilian Shan

Altun Shan

Kunlun Mountains

KYRGYZSTAN

TAJIKISTAN

UZBEKISTAN

TURKMENISTAN

ASGABAT

DUSHANBE

Mashhad

IRAN

AFGHANISTAN

KABUL

Hindu Kush

ISLAMABAD

Rawalpindi

Peshawar

PAKISTAN

Quetta

Karachi

Mouths of the Indus

Lahore

Amritsal

Ludhiana

NEW DELHI

Delhi

Jaipur

Jodhpur

Bikaner

Ahmadabad

Rajkot

INDIA

HIMALAYA

NEPAL

KATHMANDU

THIMPHU

BHUTAN

BANGLADESH

DHAKA

Kolkata (Calcutta)

Patna

Varanasi

Lucknow

Kanpur

Bhopal

Indore

Nagpur

Mumbai (Bombay)

Pune

Hyderabad

Bangalore

Chennai (Madras)

Bay of Bengal

BURMA

PYINMANA

RANGOON

Mouths of the Irrawaddy

Andaman Islands

North Andaman

Middle Andaman

South Andaman

Nicobar Islands

Car Nicobar

Little Nicobar

Great Nicobar

Ten Degree Channel

Arabian Sea

Laccadive Islands (Lakshadweep)

Nine Degree Channel

Eight Degree Channel

MALDIVES

MALE'

SRI LANKA

COLOMBO

Trivandrum

Cochin

Coimbatore

Madurai

INDIAN OCEAN

Tropic of Cancer

Equator

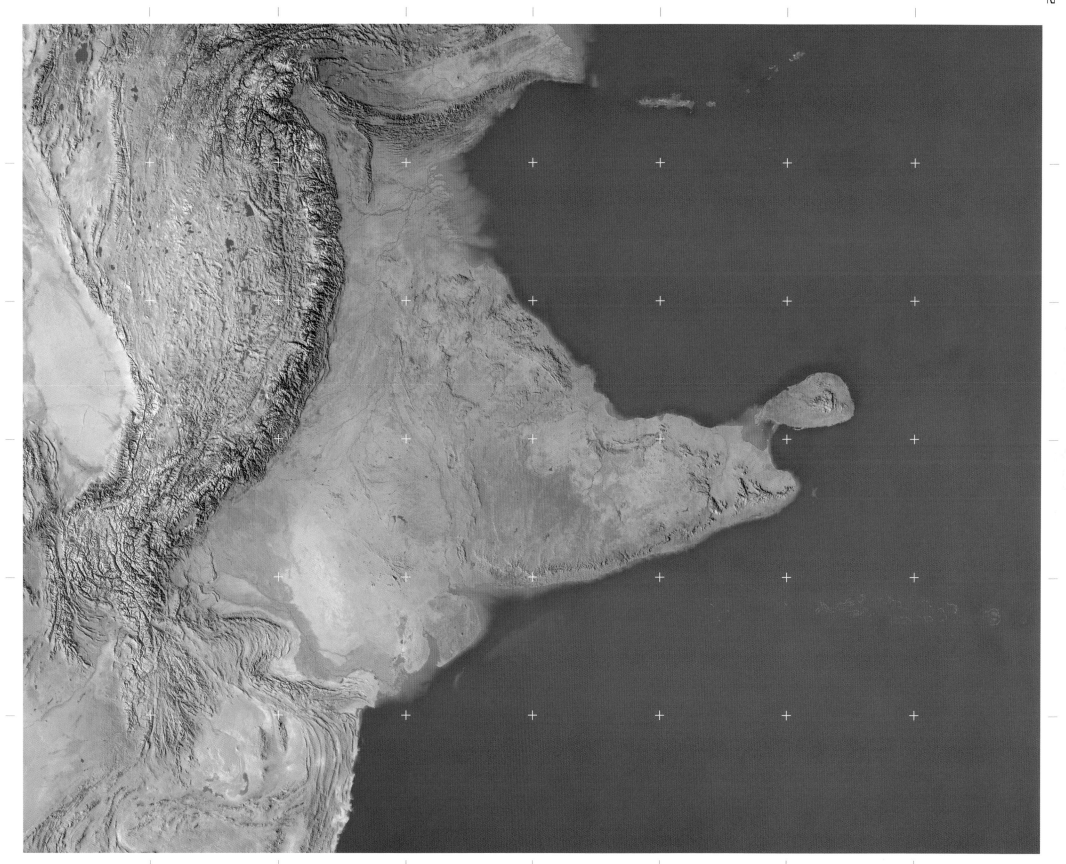

# SUNDARBANS

## 22°N, 89°E

The mouths of the Ganges and Brahmaputra rivers stretch about 217 miles (350 km) across the northern end of the Bay of Bengal. These mighty rivers split into a multitude of small channels in this low-lying delta region, which hosts the world's largest expanse of mangrove forest, the Sundarbans. A World Heritage Site protected by the governments of India and Bangladesh as a national park, the Sundarbans are home to a rich variety of wildlife and provide the largest remaining refuge of the endangered Bengal tiger, whose numbers are increasing in the area. The course of the major rivers has shifted west over the last few hundred years, so that the channels of the delta are now mostly saltwater tidal inlets.

▶ **The mangroves** help to protect the low-lying areas inland from the ravages of the Bay of Bengal's cyclones. The Indian city of Kolkata (Calcutta) lies to the northwest, and the Bangladeshi capital, Dhaka, to the northeast.

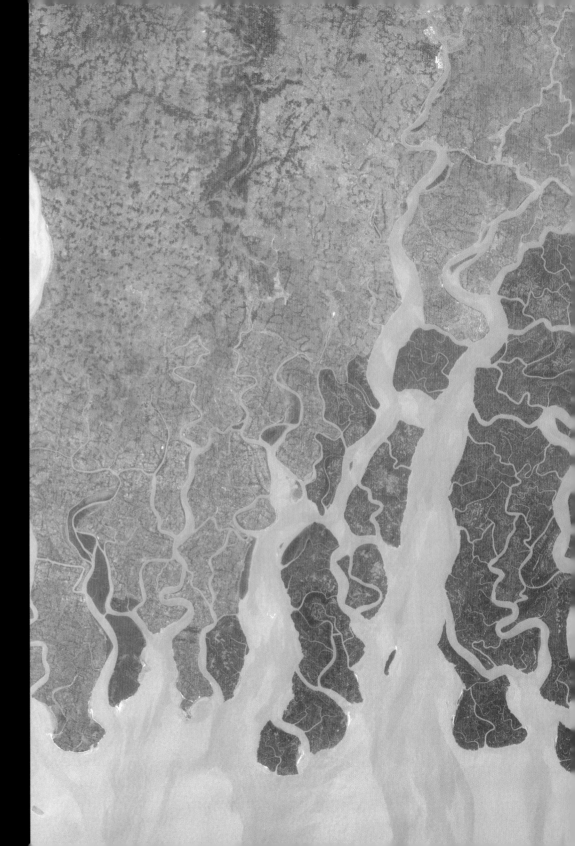

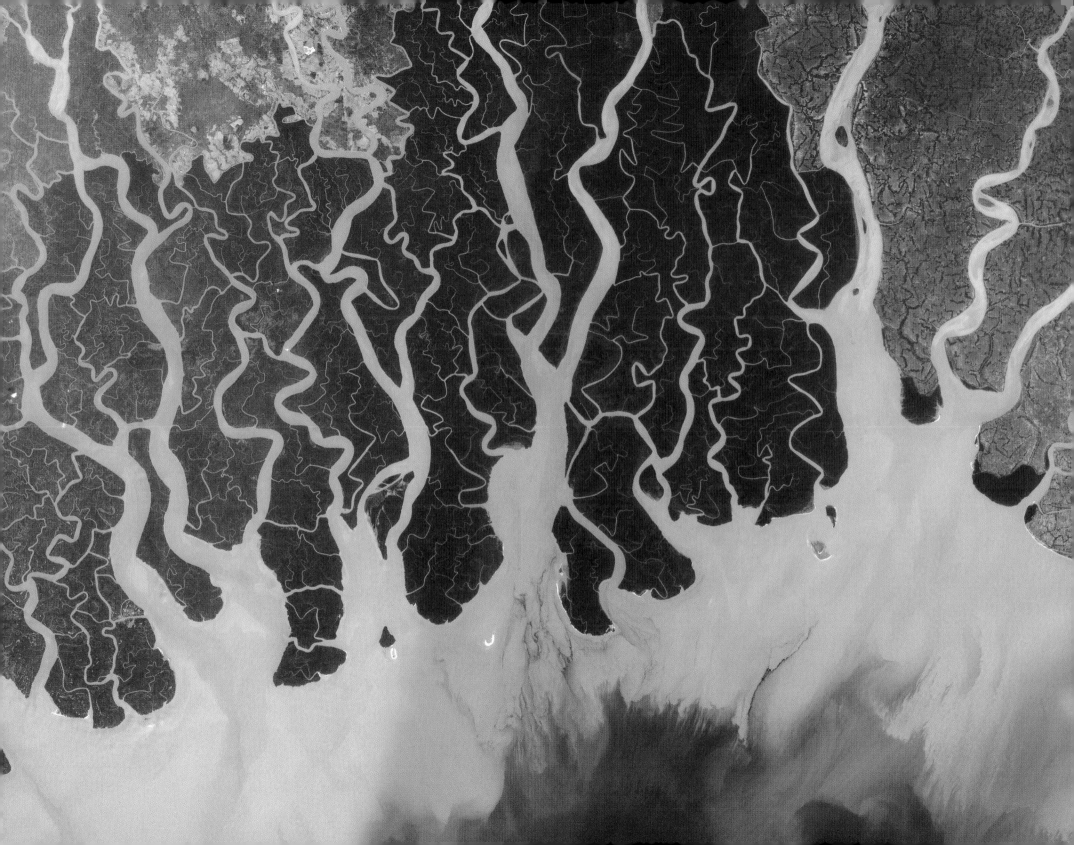

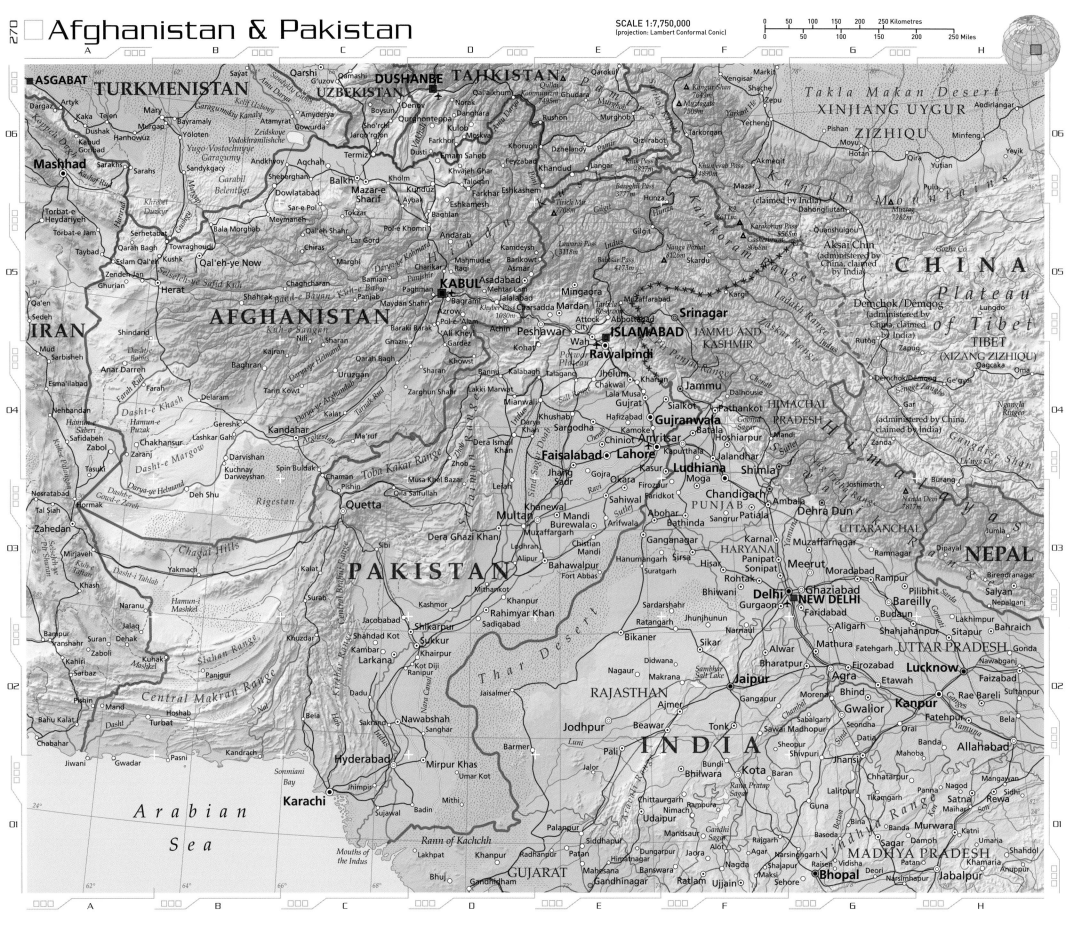

# Afghanistan & Pakistan

SCALE 1:7,750,000
(projection: Lambert Conformal Conic)

0    50    100    150    200    250 Kilometres
0    50    100    150    200    250 Miles

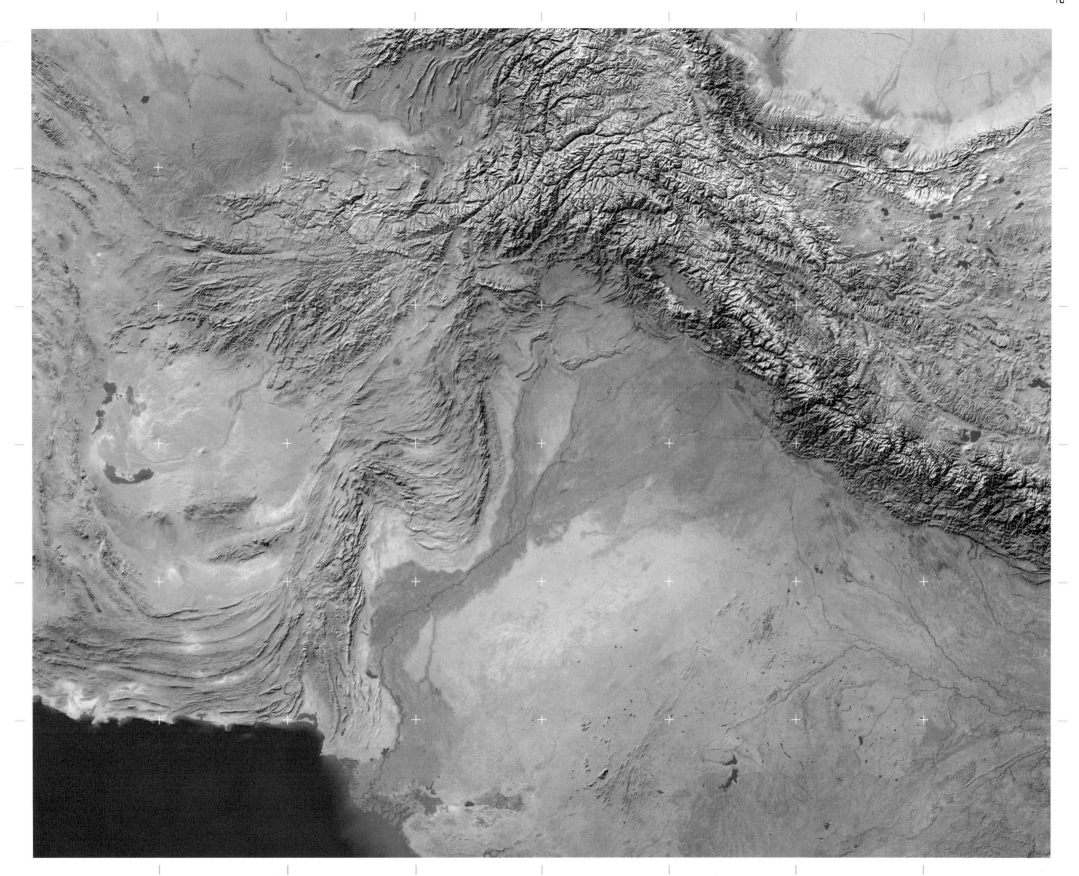

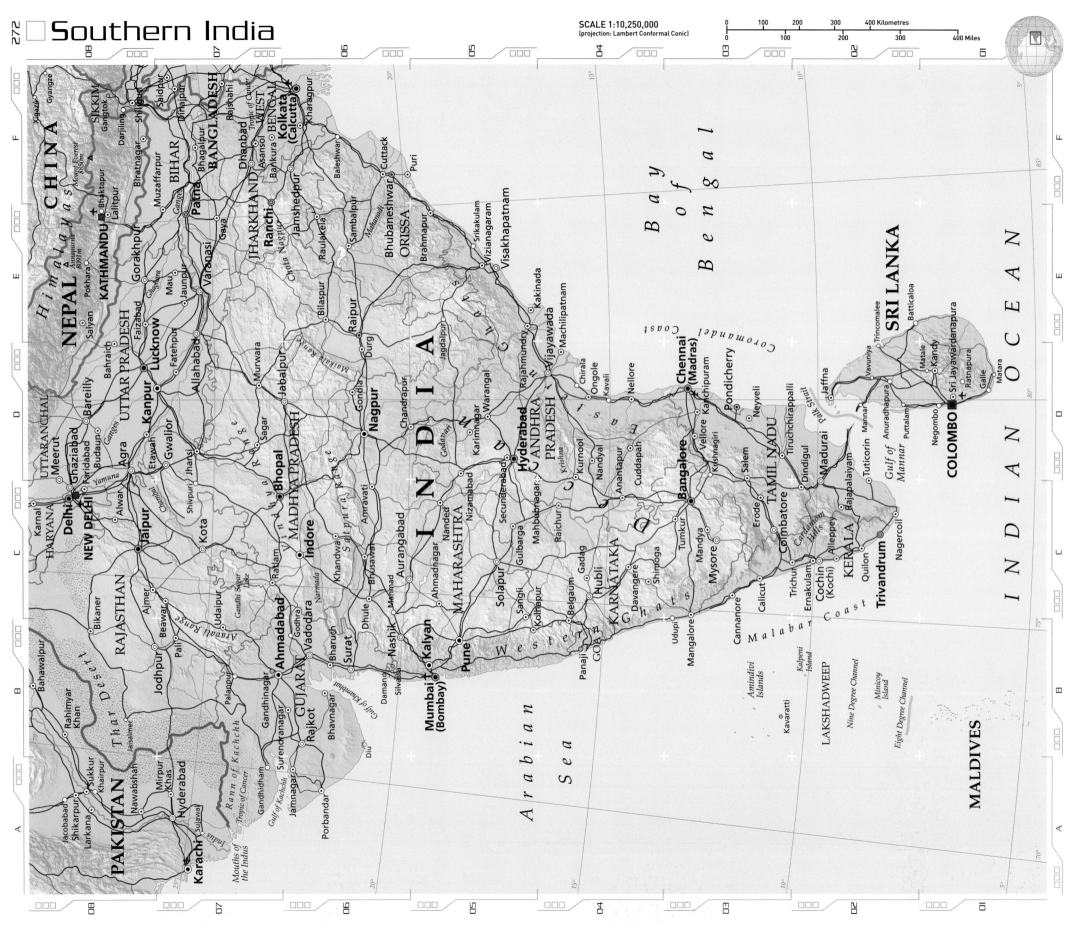

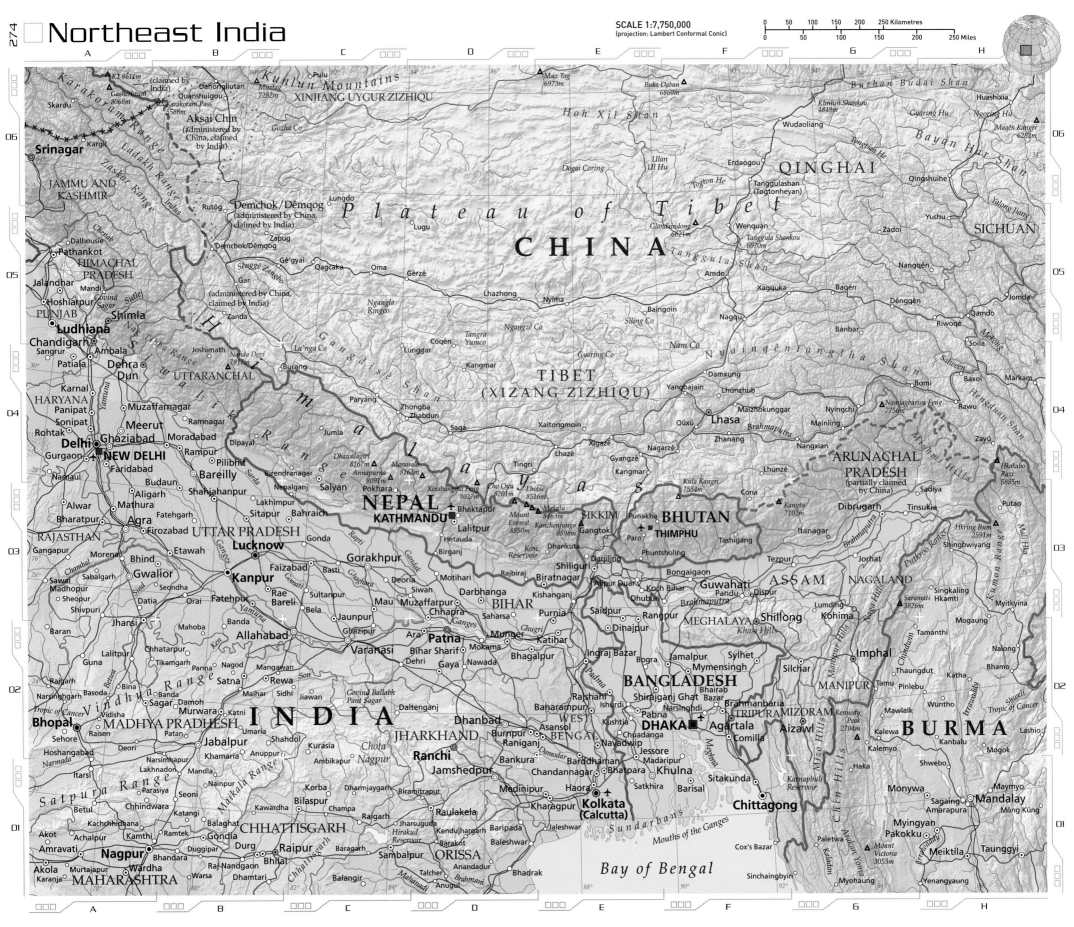

# Northeast India

SCALE 1:7,750,000
(projection: Lambert Conformal Conic)

0  50  100  150  200  250 Kilometres
0  50  100  150  200  250 Miles

A   B   C   D   E   F   G   H

K2 8611m (claimed by India)
Gasherbrum 8068m
Karakoram Pass 5568m
Skardu
Kargil
Quanshuigou
Dahongliutan
Muztag 7282m
Kunlun Mountains
Muz Tag 6973m
Buka Daban 6860m
XINJIANG UYGUR ZIZHIQU
Burhan Budai Shan
Huashixia
Kunlun Shankou 4849m
Ngoring Hu
Gyaring Hu

Srinagar
Aksai Chin (administered by China, claimed by India)
Hoh Xil Shan
Wudaoliang
Bayan Har Shan
Magên Kangri 6282m

JAMMU AND KASHMIR
Gozha Co
Ulan Ul Hu
QINGHAI
Qingshuihe

Dalhousie
Pathankot
Jalandhar
Mandi
HIMACHAL PRADESH
Demchok/Dêmqog (administered by China, claimed by India)
Rutög
Zapug
Gê'gyai
Lungdo
Lugu
Plateau of Tibet
Dogai Coring
Glandaindong 6621m
Wenquan
Amdo
Tanggulashan (Togtonheyan)
Togton He
Zadoi
CHINA
SICHUAN
Yalong Jiang

Hoshiarpur
PUNJAB
Shimla
Sênggê Zangbo
Qagcaka
Oma
Gêrzê
Ngangze Co
Lhazhong
Nyima
Baingoin
Siling Co
Nagqu
Tanggula Shan
Banbar
Dênggên
Riwoqê
Soila
Jomda
Qamdo
Mekong

Ludhiana
Chandigarh
Sangrur
Ambala
Patiala
Joshimath
Nanda Devi 7817m
Zanda
(administered by China, claimed by India)
Ngangla Ringco
Tangra Yumco
Gyaring Co
Nam Co
Nyainqêntanglha Shan
Baxoi
Markam
Salween

Karnal
Dehra Dun
UTTARANCHAL
Gar
La'nga Co
Burang
Paryang
Coqên
Kangmar
TIBET (XIZANG ZIZHIQU)
Damxung
Yangbajain
Lhünzhub
Maizhokunggar
Nyingchi
Mainling
Bomi
Hengduan Shan

HARYANA
Panipat
Muzaffarnagar
Ramnagar
Dipayal
Jumla
Zhongba
Zhabdun
Sağa
Xaitongmoin
Xigazê
Nagarzê
Lhasa
Brahmaputra
Nangxian
Namjagbarwa Feng 7756m
ARUNACHAL PRADESH (partially claimed by China)
Mishmi Hills
Rawu
Zayü

Meerut
Sonipat
Rohtak
Delhi
Ghaziabad
NEW DELHI
Gurgaon
Faridabad
Moradabad
Rampur
Pilibhit
Birendranagar
Dhawalagiri 8167m
Manaslu 8163m
Annapurna 8091m
Nepalganj
Pokhara
Tingri
Lhazê
Gyangzê
Kangmar
Kula Kangri 7554m
Lhünzê
Cona
Itanagar
Kangto 7102m
Dibrugarh
Tinsukia
Putao
Hkring Bum 2591m
Hkakabo Razi 5885m
Sadiya

Namaul
Budaun
Shahjahanpur
Bareilly
Salyan
Xixabangma Feng 8027m
Cho Oyu 8201m
Lhotse 8516m
Mount Everest 8850m
Makalu 8463m
SIKKIM
Punakha
BHUTAN
Tashigang
Tezpur
Jorhat
Shingbwiyang
Myitkyina
Kumon Range

Alwar
Mathura
Aligarh
Fatehgarh
Firozabad
Agra
UTTAR PRADESH
Sitapur
Bahraich
Lakhimpur
Gonda
KATHMANDU
NEPAL
Lalitpur
Bhaktapur
Hetauda
Birganj
Kanchenjunga 8598m
Gangtok
Paro
THIMPHU
Phuntsholing
Dhankuta
Darjiling
Alipur Duar
Koch Bihar
Bongaigaon
ASSAM
Guwahati
Pandu
Dispur
Shillong
NAGALAND
Mogaung

Bharatpur
Lucknow
Gorakhpur
Basti
Faizabad
Deoria
Siwan
Motihari
Rajbiraj
Biratnagar
Kishanganj
Dhubri
Brahmaputra
Rangpur
MEGHALAYA
Khasi Hills
Saramati 3826m
Lumding
Kohima
Singkaling Hkamti

RAJASTHAN
Gangapur
Kanpur
Rae Bareli
Sultanpur
Jaunpur
Ghaghara
Darbhanga
Chhapra
Saharsa
Purnia
Saidpur
Dinajpur
Bogra
Mymensingh
Sylhet
Silchar
Imphal
MANIPUR
Tamu
Pinlebu
Nalong

Jhansi
Mahoba
Banda
Ara
Patna
Munger
Katihar
Ingraj Bazar
Rajshahi
Shirajganj Ghat
Bhairab
Brahmanbaria
Thaungdut
Katha

Lalitpur
Guna
Gwalior
Bhind
Etawah
Fatehpur
Allahabad
Varanasi
BIHAR
Bihar Sharif
Mokama
Bhagalpur
Gaya
Nawada
WEST BENGAL
Bogra
Ishurdi
Pabna
Kushtia
DHAKA
Narsinghdi
Agartala
TRIPURA
Aizawl
MIZORAM
Kennedy Peak 2704m
Kalewa
Kalemyo
BURMA
Lashio

Baran
Sawai Madhopur
Sheopur
Shivpuri
Datia
Orai
Jhansi
Mangawan
Rewa
Satna
Maihar
Sidhi
Jiawan
Daltenganj
Dehri
BANGLADESH
Baharampur
Chuadanga
Navadwip
Narsinghdi
Comilla
Mizo Hills
Chin Hills
Haka
Mawlaik
Wuntho

Bhopal
MADHYA PRADESH
INDIA
Dhanbad
Burnpur
Asansol
WEST BENGAL
Jessore
Madaripur
Khulna
Sitakunda
Barisal
Karnaphuli Reservoir
Haka
Kalemyo
Kanbalu

Sehore
Raisen
Vidisha
Sagar
Damoh
Murwara
Katni
Govind Ballabh Pant Sagar
Son
Ranchi
Bankura
Barddhaman
Bhatpara
Madaripur
Khulna
Satkhira
Chin Hills
Mong Kung

Hoshangabad
Jabalpur
Narsimhapur
Anuppur
Kurasia
Ambikapur
Chota Nagpur
Ranchi
Jamshedpur
Chandannagar
Medinipur
Haora
Satkhira
Barisal
Monywa
Sagaing
Mandalay
Amarapura

Itarsi
Khamaria
Mandla
Nainpur
Korba
Dharmjaygarh
Biramitrapur
Raulakela
Kharagpur
Kolkata (Calcutta)
Chittagong
Cox's Bazar
Monywa
Pakokku
Myingyan

Betul
Chhindwara
Seoni
Maikala Range
Bilaspur
Champa
Raigarh
Jharsuguda
Hirakud Reservoir
Barakot
Baripada
Baleshwar
Sundarbans
Mouths of the Ganges
Sinchaingbyin
Myohaung
Meiktila
Taunggyi

Satpura Range
Kachhidhana
Balaghat
Gondia
Durg
CHHATTISGARH
Raipur
Bhilai
Dhamtari
Raj Nandgaon
Sambalpur
ORISSA
Talcher
Anugul
Balangir
Bhadrak
Bay of Bengal
Mount Victoria 3053m
Paletwa
Kaladan
Mandalay Yoma
Irrawaddy
Yenangyaung

Akot
Amravati
Akola
Murtajapur
Nagpur
Wardha
Bhandara
Warsa
Gondia
Duggipar
MAHARASHTRA
Tropic of Cancer

A   B   C   D   E   F   G   H

# NEW DELHI

## 28°40'N, 77°11'E

The city of Delhi (now often called Old Delhi) in central north India became the capital of India in the 13th century and was the seat of the Muslim Sultanate of Delhi, a materially and culturally rich centre for successive conquerors and rulers. Set on the Yamuna, a tributary of the Ganges, Delhi is strategically located on fertile plains between the arid land of Rajasthan to the west, the Himalayan foothills and the Punjab to the north and the green fields of Uttar Pradesh to the east. It was also a gateway to the rich lands of the south. Delhi is resplendent with fine Hindu and Muslim architecture, notably the commanding Red Fort and the Great Mosque, one of the largest in the world. With the advent of British control under the Raj (whose capital had been Calcutta (Kolkata)), the new administrative centre of New Delhi was constructed to the south of the old city.

▶▶ **South of the medieval city walls** of Delhi is the symmetrically planned vision of a modern city, designed and realised by the British architect Sir Edwyn Lutyens. New Delhi was inaugurated as India's capital in 1931. The strict axial planning, with broad boulevards radiating from the imposing capitol building provide vistas to carefully placed parks and neat suburban middle-class enclaves. These stand in contrast to the dense, organic pattern of the old city.

**SATELLITE:** TERRA (EOS AM-1), MODIS     **HEIGHT:** 438 MILES (705 KM)     **DATE:** 31 OCT 2003

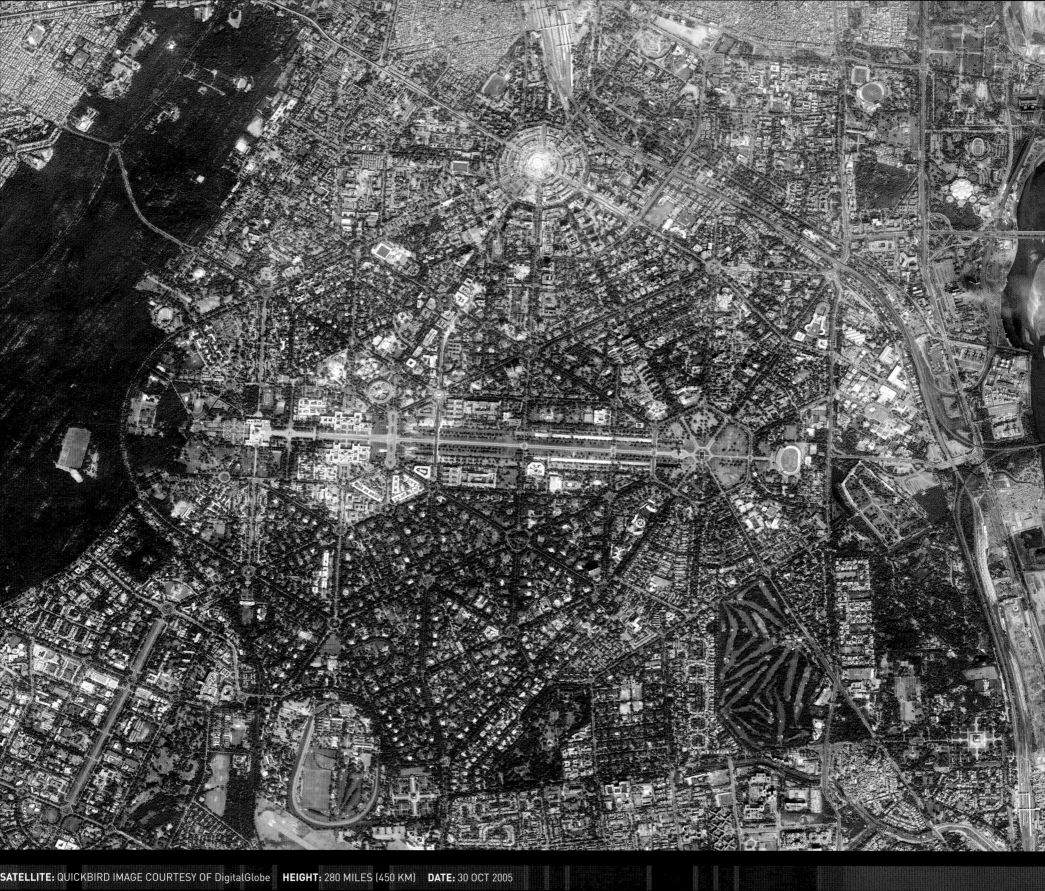

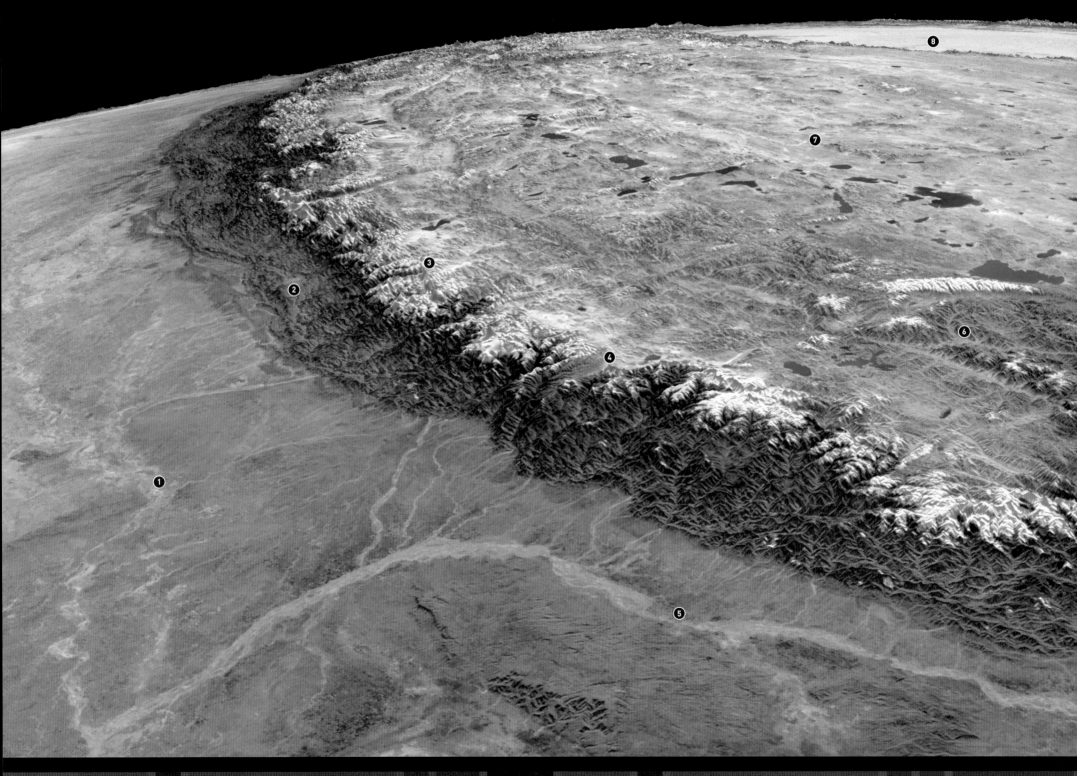

1. GANGES RIVER  2. KATHMANDU  3. MOUNT EVEREST  4. CHOMO LHARI  5. BRAHMAPUTRA RIVER  6. LHASA  7. PLATEAU OF TIBET  8. TAKLA MAKAN DESERT

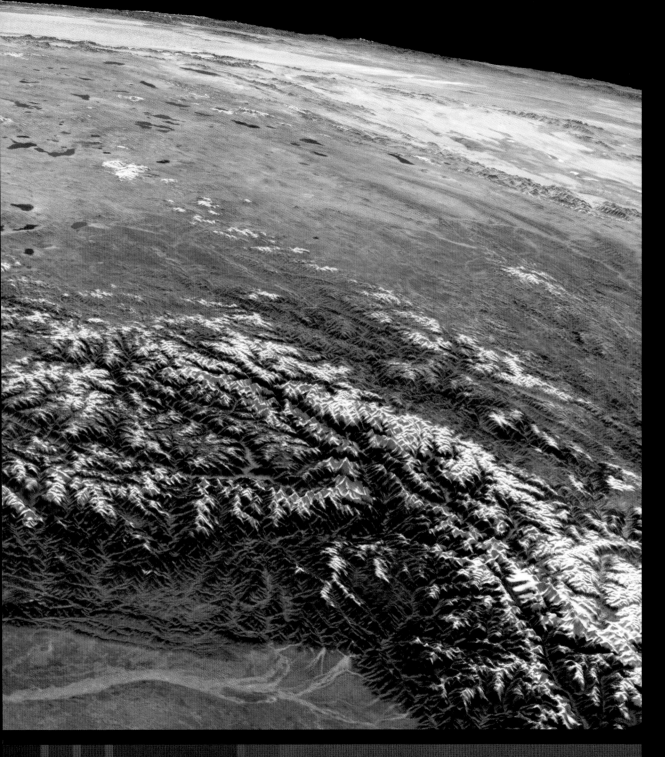

# HIMALAYAS

## 28°N, 84°E

The world's highest mountain range, the Himalayas curve 1490 miles (2400 km) across south Asia, separating the Plateau of Tibet from the low plains of northern India. The mountains and the plateau were created when the Indian subcontinent collided with Asia about 20 million years ago, thrusting the floor of the intervening ocean high up and deep inland. The Indian Plate is still moving north at about 2.5 inches (67 mm) per year, and the mountains are still rising at a rate of 0.2 inches (5 mm) per year. The Himalayas can be split into three parallel ranges, ascending in height from the plain: the sub-Himalayan Siwalik Range, consisting of material eroded from the higher mountains, the Lesser Himalaya foothills and the snow-capped Great Himalayas.

This simulated perspective view from above the Brahmaputra river in Assam shows the Himalayas and the Plateau of Tibet to its northern edge and beyond into the Takla Makan Desert. Monsoon rains from the south keep Assam and the Himalayan foothills green, but do not reach the plateau to the north, which is largely barren.

# MOUNT EVEREST

## 27°58'N, 86°57'E

The world's highest mountain at 29,035 ft (8,850 m), Mount Everest straddles the border between Nepal and the autonomous region of Tibet in China. In the absence of any local name, it was named after Sir George Everest, the Surveyor-General of India. The Tibetans call it Chomolungma, meaning "Mother of the Universe", and it is marked on 260 year-old Chinese maps as Qomolangma Feng.

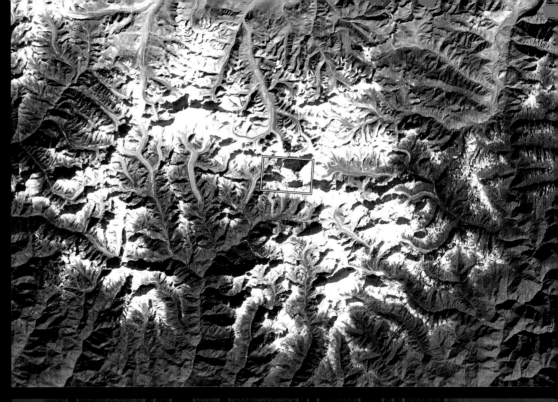

**SATELLITE:** LANDSAT 7  **INSTRUMENT:** ETM+  **HEIGHT:** 438 MILES (705 KM)  **DATE:** 05 JAN 2002

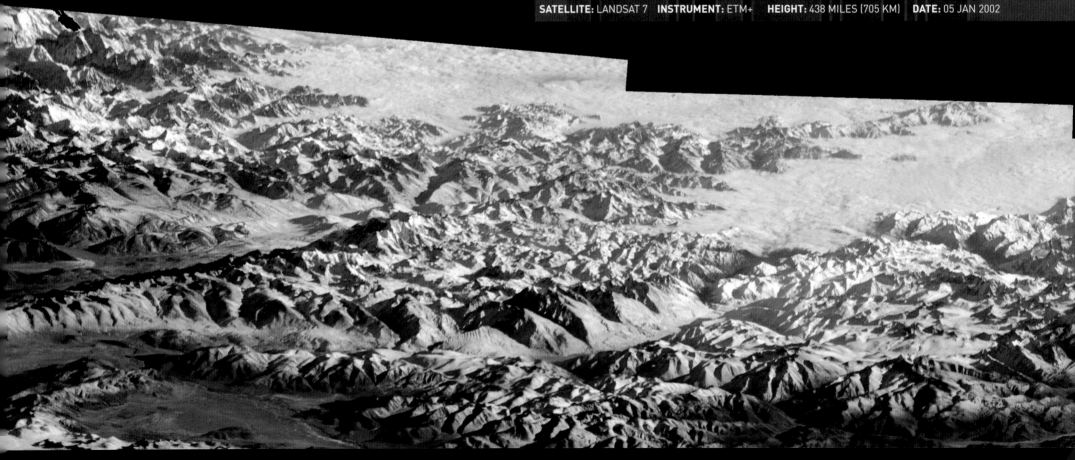

**SATELLITE:** INTERNATIONAL SPACE STATION (ISS)  **INSTRUMENT:** E4, KODAK DCS760C  **HEIGHT:** 220 MILES (254 KM)  **DATE:** 28 JAN 2004

◄ **The snow-capped Himalayas** stand out against the dry Plateau of Tibet and the lush, green foothills of Nepal. Mount Everest is in the centre of this Landsat image. Its height was first measured using theodolites sited in India, 150 miles (240 km) to the south.

▼ **The roof of the world**
This panoramic mosaic of photographs was taken from the International Space Station when it was over the Plateau of Tibet, looking south.

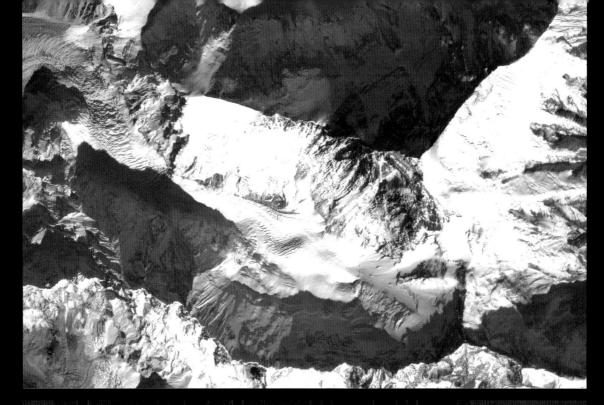

◄ **Mount Everest's sunlit southwest face** towers above the Khumbu Icefall and Western Cwm, the route followed by most attempts on the summit, in this detailed satellite image. The South Col separates Mount Everest from Lhotse, the world's fourth-highest peak (bottom right). A ridge links Lhotse to Nuptse (bottom left). The peak was first climbed by New Zealander Edmund Hillary and local sherpa Tensing Norgay on 29th May 1953, since when more than 2250 climbers have reached the summit and 186 have died trying.

**SATELLITE:** IKONOS image courtesy of GeoEye   **HEIGHT:** 423 MILES (681 KM)   **DATE:** 29 JAN 2001

Mount Everest

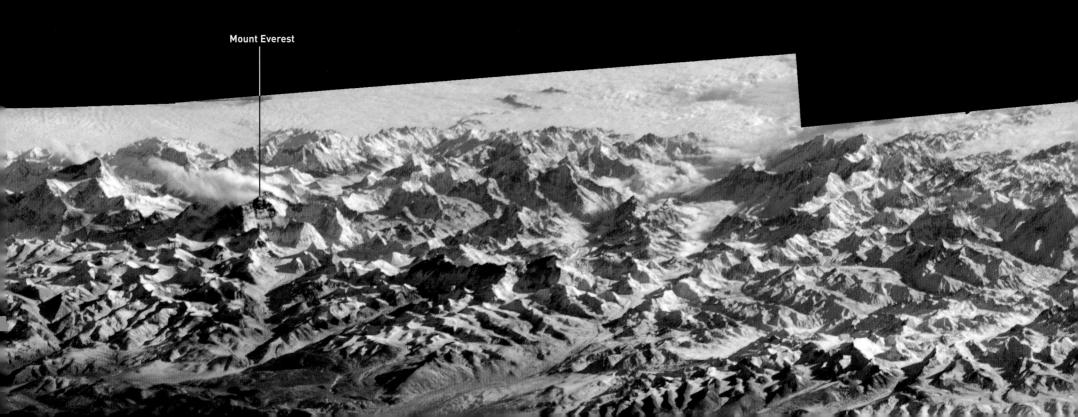

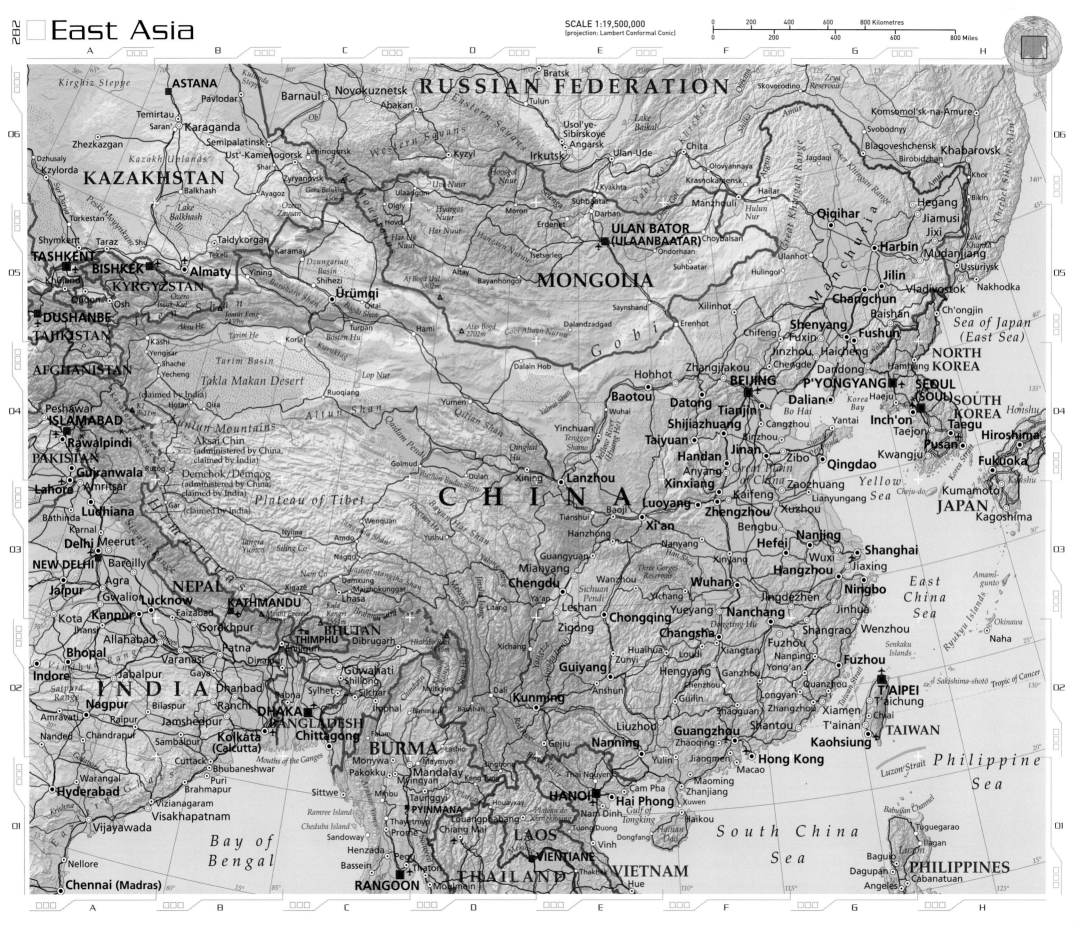

# East Asia

SCALE 1:19,500,000
(projection: Lambert Conformal Conic)

| 0 | 200 | 400 | 600 | 800 Kilometres |
| 0 | 200 | 400 | 600 | 800 Miles |

RUSSIAN FEDERATION

**ASTANA**

Pavlodar
Barnaul
Novokuznetsk
Bratsk
Komsomol'sk-na-Amure

Temirtau
Saran'
Karaganda
Abakan
Tulun
Skovorodino
Svobodnyy
Blagoveshchensk
Khabarovsk

Zhezkazgan
Semipalatinsk
Leninogorsk
Usol'ye-Sibirskoye
Angarsk
Chita
Jagdaqi
Birobidzhan
Hegang

**KAZAKHSTAN**
Ust'-Kamenogorsk
Shar
Irkutsk
Ulan-Ude
Olovyannaya
Krasnokamensk
Hailar
Manzhouli
Jiamusi
Jixi
Khor
Bikin

Dzhusaly
Kzylorda
Kazakh Uplands
Ayagoz
Gora Belukha 4506m
Hovsgol Nuur
Kyakhta
Hulun Nur
Qiqihar
Harbin
Mudanjiang
Ussuriysk

Shymkent
Taraz
Taldykorgan
Tekeli
Ulaangom
Hyargas Nuur
Moron
Darhan
**ULAN BATOR (ULAANBAATAR)**
Choybalsan
Ondorhaan
Ulanhot
Jilin
Vladivostok
Nakhodka

**TASHKENT**
**BISHKEK**
**Almaty**
Yining
Karamay
Altay
Bayanhongor
Tsetserleg
**MONGOLIA**
Suhbaatar
Hulingol
Changchun
Baishan
Ch'ongjin
Sea of Japan (East Sea)

**KYRGYZSTAN**
Osh
Ürümqi
Qitai
Aj Bogd Uul 3802m
Saynshand
Xilinhot
Shenyang
Fuxin
Baishan

**DUSHANBE**
**TAJIKISTAN**
Turpan
Hami
Atas Bogd 2702m
Govi Altayn Nuruu
Erenhot
Chifeng
Chengde
Fushun
Haicheng
**NORTH KOREA**

**AFGHANISTAN**
Kashi
Korla
Bosten Hu
Kuruktag
Dalain Hob
Gobi
Zhangjiakou
Hohhot
**BEIJING**
Dandong
**P'YONGYANG**
**SEOUL (SOUL)**

Peshawar
K2 8611m
Hotan
Qira
Ruoqiang
Lop Nur
Yumen
Baotou
Datong
Tianjin
Dalian
Korea Bay
Haeju
Inch'on
**SOUTH KOREA**
Honshu

**ISLAMABAD**
**Rawalpindi**
Aksai Chin
Altun Shan
Qilian Shan
Yabrai Shan
Wuhai
Yinchuan
Taiyuan
Shijiazhuang
Jinan
Taejon
Taegu
**Hiroshima**

**PAKISTAN**
Demchok/Dêmqog
Golmud
Dulan
Xining
Lanzhou
Handan
Xinxiang
Zibo
Qingdao
Kwangju
**Pusan**
**Fukuoka**

Lahore
Ludhiana
Plateau of Tibet
**CHINA**
Baoji
Luoyang
Zhengzhou
Xuzhou
Lianyungang
Yellow Sea
Kumamoto
**JAPAN**

Delhi
Meerut
Nam Co
Siling Co
Nagqu
Yushu
Hanzhong
Xi'an
Nanyang
Bengbu
Nanjing
Kagoshima

**NEW DELHI**
Bareilly
**NEPAL**
**KATHMANDU**
Lhasa
Chengdu
Xinyang
Hefei
Wuxi
Shanghai
East China Sea

Jaipur
Agra
Mount Everest 8850m
**THIMPHU**
**BHUTAN**
Miyanyang
Wanzhou
Three Gorges Reservoir
Wuhan
Hangzhou
Jiaxing
Ningbo

Gwalior
Lucknow
Faizabad
Gorakhpur
Dibrugarh
Leshan
Chongqing
Yueyang
Nanchang
Jingdezhen

Kanpur
Patna
**DHAKA**
Guwahati
Zigong
Changsha
Shangrao
Jinhua
Wenzhou

**INDIA**
Varanasi
Gaya
Shillong
Silchar
Guiyang
Hengyang
Fuzhou
Naha

Bhopal
Jabalpur
**BANGLADESH**
Sylhet
Imphal
Dali
**Kunming**
Anshun
Guilin
**Fuzhou**
Ryukyu Islands

Nagpur
Ranchi
**Kolkata (Calcutta)**
**Chittagong**
**BURMA**
Mandalay
Guiyang
Liuzhou
Zhangzhou
Xiamen
**T'AIPEI**
T'aichung

Hyderabad
Visakhapatnam
**RANGOON**
**PYINMANA**
**HANOI**
Hai Phong
**Guangzhou**
Macao
**Hong Kong**
**TAIWAN**
Kaohsiung

Bay of Bengal
Chiang Mai
**VIENTIANE**
**LAOS**
**THAILAND**
**VIETNAM**
Hue
South China Sea
**PHILIPPINES**

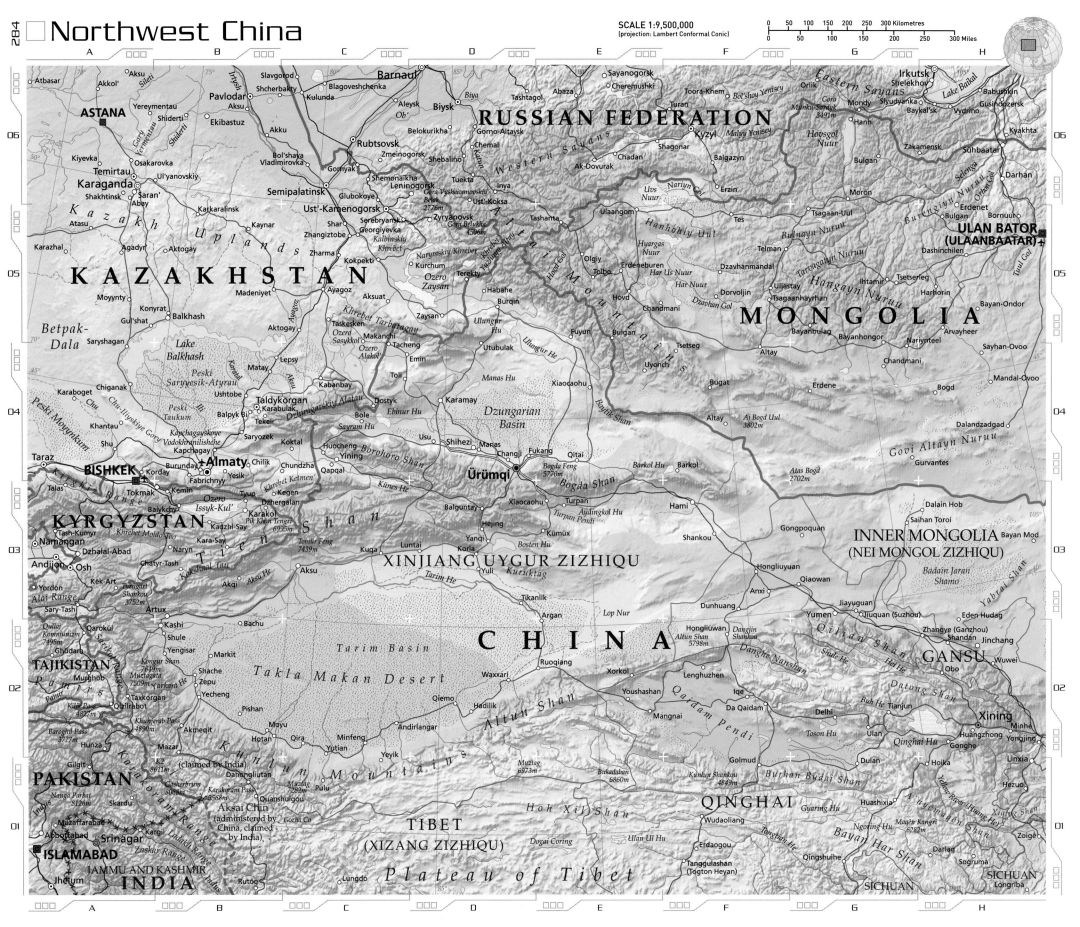

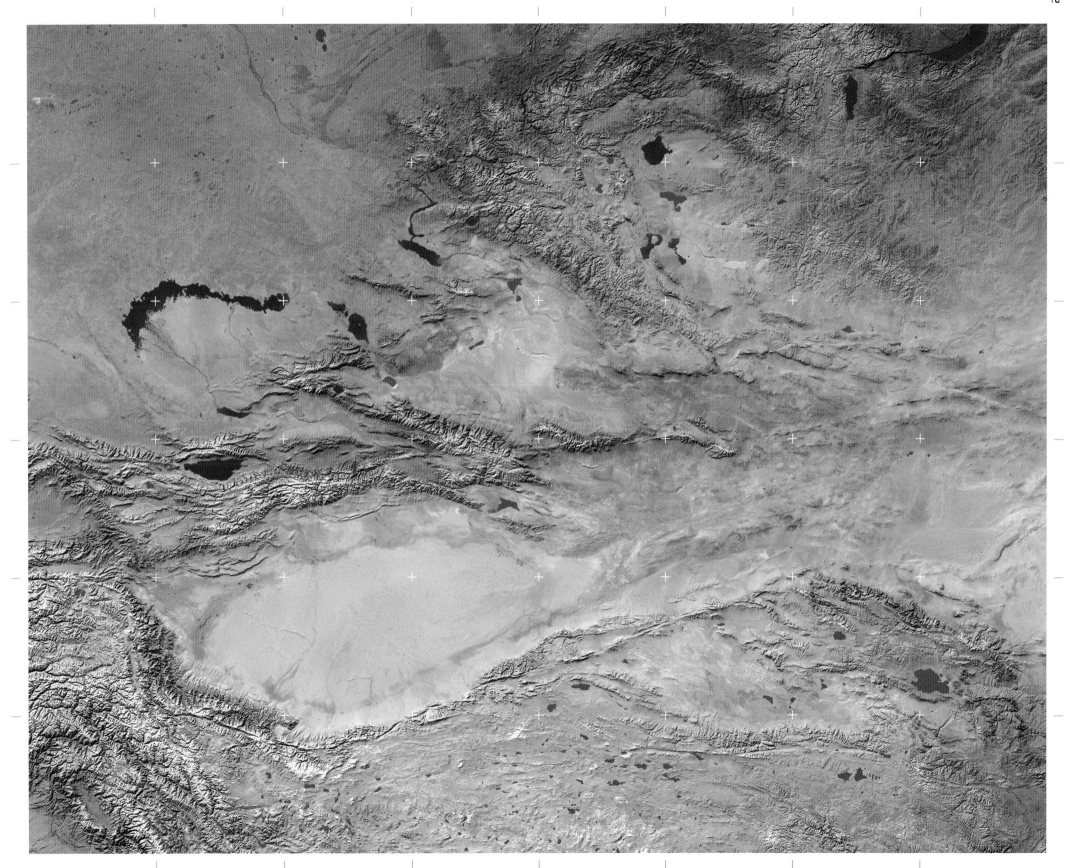

# Northeast China

SCALE 1:9,500,000
(projection: Lambert Conformal Conic)

0 50 100 150 200 250 300 Kilometres
0 50 100 150 200 250 300 Miles

**RUSSIAN FEDERATION**

Eastern Sayans

Zalari
Cheremkhovo
Usol'ye
Sibirskoye
Orlik
Angarsk
Irkutsk
Cora
Munku-Sardyk
3491m
Mondy
Hanh
Hövsgöl
Nuur
Bulgan
Moron
Shelekhov
Slyudyanka
Baykal'sk
Vydrino
Zakamensk
Babushkin
Kyakhta
Suhbaatar
Darhan

Bayanday
Ust'-Barguzin
Barguzin
Ust'-Ordynskiy
Selenginsk
Ulan-Ude
Khorinsk
Khuzhir
Turka
Bayan-Uul
Babushkin
Selenga

Romanovka
Sosnovo-
Ozerskoye
Yamarovka
Khilok
Onokhoy
Darasun
Khapcheranga

Barguzin
Bukachacha
Chita
Gornyy
Nerchinsk
Shilka
Aginskoye
Olovyannaya
Sherlovaya Gora
Borzya
Aksha
Zabaykal'sk
Manzhouli

Mogocha
Amur
Chernyshevsk
Sretensk
Kokuy
Nerchinskiy
Zavod
Priargunsk
Arxan
Hailar
Yakeshi

Tygda
Sivaki
Norsk
Shimanovsk
Svobodnyy
Seryshevo
Belogorsk

Fevral'sk
Chegdomyn
Novyy Urgal
El'ban'

Berezovyy
Solnechnyy
Komsomol'sk-na-Amure
Amursk

Tahe
Genhe
Alihe
Jagdaqi
Heihe
Raychikhinsk
Poyarkovo
Arkhara
Sunwu
Xun He
Nenjiang
Bei'an
Nianzishan
Zalantun
Fuyu
Mingshui
Suihua
Qiqihar
Daqing
Anda
Zhaodong

Blagoveshchensk
Yekaterinoslavka
Zavitinsk
Novobureyskiy
Progress
Obluch'ye
Birobidzhan
Nizhneleninskoye

Tyrma
Khabarovsk
Khor
Pereyaslavka
Vyazemskiy
Bikin

**MONGOLIA**

ULAN BATOR
(ULAANBAATAR)

Bürengiyn Nuruu
Bulgan
Erdenet
Bornuur
Dashinchilen
Khentiyn Nuruu
Tuul Gol
Bayanuur
Ihtamir
Tsetserleg
Harhorin
Bayanhongor
Arvayheer
Bayan-Ondor
Narynteel
Chandmani
Sayhan-Ovoo
Bogd
Mandalgovi

Green Diamon Nuruu
Omnodelger
Bayanmonh
Galshar
Ondorhaan
Tuvshinshiree
Erdenetsagaan

Choybalsan
Holonbuyr
Kerulen
Baruun-Urt
Halhgol
Buyr
Nuur
Menengiyn Tal

Hulun Nur.
Kerulen
Arxan

**HEILONGJIANG**
Yichun
Nancha
Hegang
Jiamusi
Shuangyashan
Hulin
Wanda Shan

Lake
Khanka
Lesozavodsk
Dal'nerechensk
Spassk-Dal'niy
Fangzheng
Didao
Jixi
Shangzhi
Acheng
Harbin

Govi Altayn Nuruu
Gurvantes
Dalandzadgad
Bayan Mod
Bayanhongor

**Gobi**
Erenhot
Mandalt
Sonid Youqi
Habirag
Baochang

Ulanhot
Hulingol
Taonan
Tongyu
Baicheng
Dehui
Pingshan
Zhaodong

Bayan Ul
Lindong
Tongliao
Xar Moron
Linxi

Mudanjiang
Jilin
**JILIN**
Changchun
Siping
Dunhua
Yanji
Tumen
Hoeryong
Najin
Huadian
Fusong
Liaoyuan
Kaiyuan
Baishan
Ch'ongjin

Vladivostok
Ussuriysk
Artem
Bol'shoy-Kamen'
Fokino
Nakhodka
Slavyanka
Kraskino
Khasan

Songhua Hu
Changbai Shan

**C H I N A**

Dalai Hob
Bayanhot
Eden Hudag
Shandan
Jinchang
Wuwei
Minhe
Xining
Lanzhou
Linxia
Lintao
Hezuo

**INNER MONGOLIA**
**(NEI MONGOL ZIZHIQU)**
Bayan Obo
Bayan Bulak
Shangdu
Jining
Xuanhua
Zhangjiakou

**Nei Mongol Gaoyuan**

Lang Shan
Linhe
Xishanzui
**Baotou**
Yin Shan
**Hohhot**
Fengzhen
Qingshuihe
**Datong**
Daixian
Xinzhou

Ulan Buh
Shamo
Wuhai
Ordos
Yulin
Shenmu

Mu Us
Shadi
Ulan

Badain Jaran
Shamo
Suhai
Bayan Hot

Tengger
Shamo
Yinchuan

Yabrai Shan
Helan Shan

**NINGXIA**
**SHAANXI**
Yinchuan
Wuhai
Guyuan
Pingliang
(Kongtong)

Huangtu Gaoyuan

Chifeng
Fuxin
Beipiao
Chaoyang
Lingyuan
Chengde
Zhangwu
Tieling

**Shenyang**
**Fushun**
Benxi
**LIAONING**
**Anshan**
Liaoyang
Haicheng
Yingkou
Liaoyang
Huludao
Jinzhou
Suizhong
Qinhuangdao

Tonghua
Huanren
Hyesan
Kanggye
Ji'an
Dandong
Sinuiju
Chongju

Kimch'aek
Kilchu
Pukch'ong
Sinp'o

Fuxian
Habirag
Baochang
Lingyuan
Jinzhou
Beidaihe
Liaodong Bandao
Liaodong
Wan

**BEIJING**
**BEIJING SHI**
Tangshan
Qinhuangdao

**Tianjin**
**TIANJIN SHI**
Baoding
Cangzhou

**HEBEI**
Wutai Shan
(Beitai Ding)
3058m

**Dalian**

Korea
Bay

**NORTH
KOREA**
P'YONGYANG
Namp'o
Sariwon
Haeju
Kaesong
Changyon
Ongjin
Paengnyong-do

Anju
Namsan-ni
Sinmi-do
Chongju
Sinp'o
Wonsan
Hamhung
Yonghung
Kosong

Sea of Japan
(East Sea)

**Taiyuan**
Jinzhong
Jiexiu
**SHANXI**
Yangquan
**Shijiazhuang**
Hengshui
Botou
Dezhou

**NINGXIA**
**SHAANXI**
Suide
Jinzhong
Xingtai
Linqing

Handan
Anyang
Hebi
Changzhi
Linfen
Houma
Yuncheng

Binzhou
Zibo
Weifang
Laizhou
Wan
Yantai
Laiyang

Bo Hai
Bohai Wan
Bohai Haixia

**Yinchuan**

Xining
Lanzhou
**QINGHAI**
Linxia
**GANSU**
Minhe
Lintao

Tongchuan
Guyuan
Pingliang

**Jinan**
Boshan
Tai'an
Qingzhou
**SHANDONG**
Zibo
Jining
Suncun
Heze
Liaocheng
Tai'an

Shandong
Peninsula
Qingdao

**Yellow
Sea**

Lanzhou
Tianshui
Hezuo
Minxian
Xiqing Shan

Sanmenxia
**Luoyang**
**Zhengzhou**
**Xinxiang**
Jiaozuo
Yuncheng
**HENAN**
Kaifeng
Shangqiu
Xianyang

**JIANGSU**
Zaozhuang
Xuzhou
Lianyungang

Chin-do
Kogum-do
Cheju-do
Cheju Strait

**SOUTH
KOREA**
SEOUL
(SOUL)
Inch'on
Ch'onan
Taejon
P'ohang
Taegu
Pusan
Masan
Kwangju
Sunch'on
Kunsan
Namwon
Mokp'o
Andong
Ulsan
Tonghae
Kangnung
Koje-do
Korea
Strait

**JAPAN**
Honshu
Masuda
Iwakuni
Shimonoseki
Hofu
Saga
Kurume
Fukuoka
Kumamoto
Sasebo
Nagasaki
Tsushima
Iki
Ko-saki
Kyushu

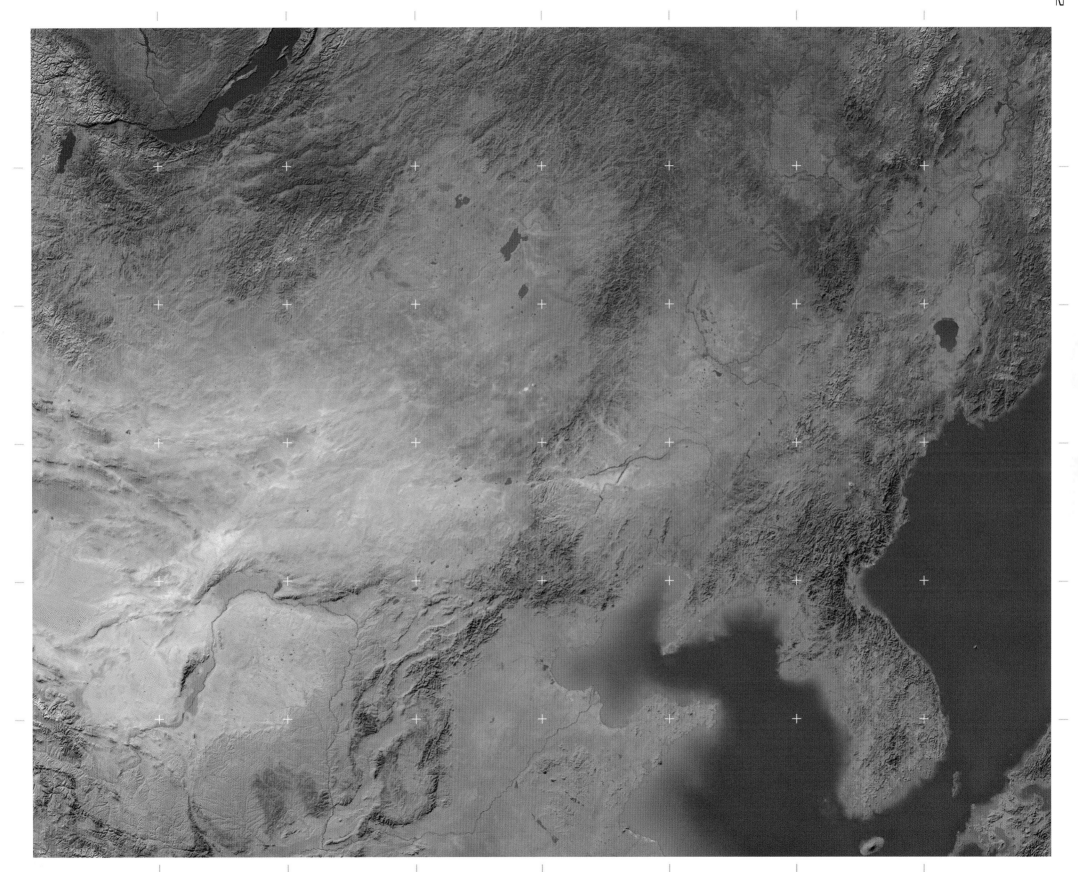

# BEIJING

## 39°58'N, 116°22'E

China's impressive capital city (previously called Peking) is situated in northeast China, on the Hai He, one of the many former courses of the Yellow River (Huang He). It was first established as an administrative centre under the Zhou Dynasty (1027-403 BCE), but gained imperial capital status (as Khanbalik) when it became the Mongol ruler Kublai Khan's seat of power in the 13th century. Since then the city has managed to maintain a position of administrative and economic supremacy. Beijing is enormous. Like several other metropolitan capitals (such as Washington DC, London and Delhi) it forms its own special administrative zone, covering 3386 sq miles (8770 sq km) with an ever-expanding population of over 12 million.

►►► **Like many cities** developed under the aegis of centralised social idealism during the 20th century, Beijing is big, bombastic and architecturally uninspiring. But at its heart, is the centuries-old rectangular complex of the Forbidden City, which was created as an exclusive domain for imperial rulers, containing magnificent palaces, temples, concubine halls, governmental offices and quarters for senior officials.

**SATELLITE:** TERRA (EOS AM-1), MODIS    **HEIGHT:** 438 MILES (705 KM)    **DATE:** 06 SEP 2002

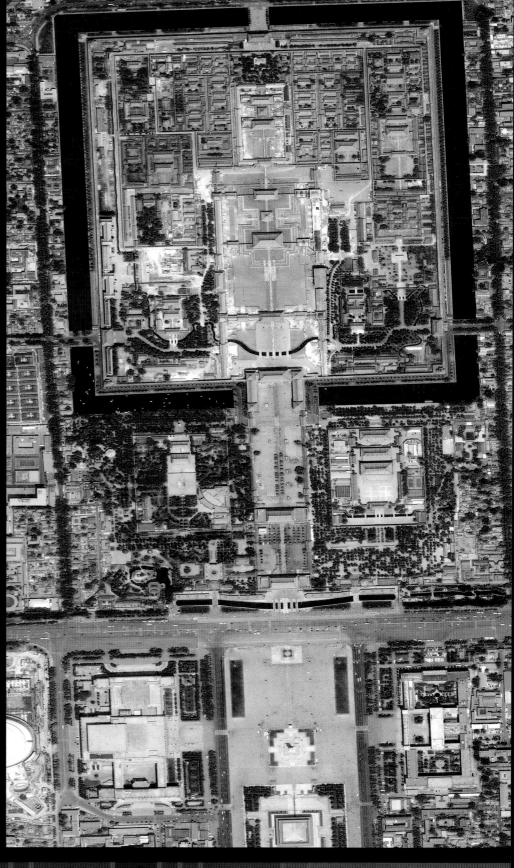

SATELLITE: LANDSAT 7, ETM+  HEIGHT: 438 MILES (705 KM)  DATE: 01 JUL 1999 22 MAY 2002

SATELLITE: QUICKBIRD image courtesy of DigitalGlobe  HEIGHT: 280 MILES (450 KM)  DATE: 07 MAY 2005

# SHANGHAI

## 31°13'N, 121°28'E

Shanghai has long been China's second city, and the country's major port of entry, providing a point of contact with the outside world for this often inward-looking and secretive nation. Founded about a thousand years ago, its location 13 miles (21 km) from the mouth of the Huangpu proved ideal for the development of extensive dock facilities. In 1842, under the Treaty of Nanking it became the first of the Treaty Ports, opening trade between China and the rest of the world. The city's fertile alluvial setting made it agriculturally self-sufficient, while its position midway between the political centre of north China and the more outward-looking and entrepreneurial regions of south China allowed Shanghai to further develop its role as a trading centre.

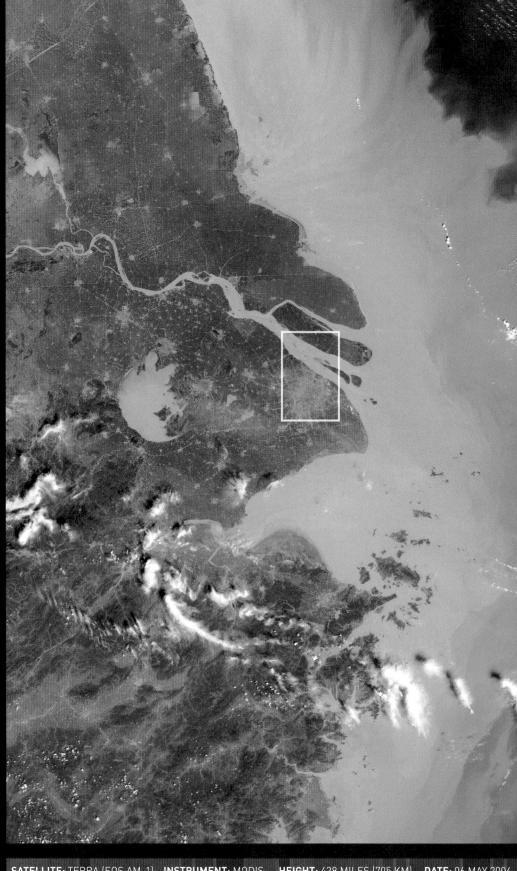

**SATELLITE:** TERRA (EOS AM-1)   **INSTRUMENT:** MODIS   **HEIGHT:** 438 MILES (705 KM)   **DATE:** 06 MAY 2004

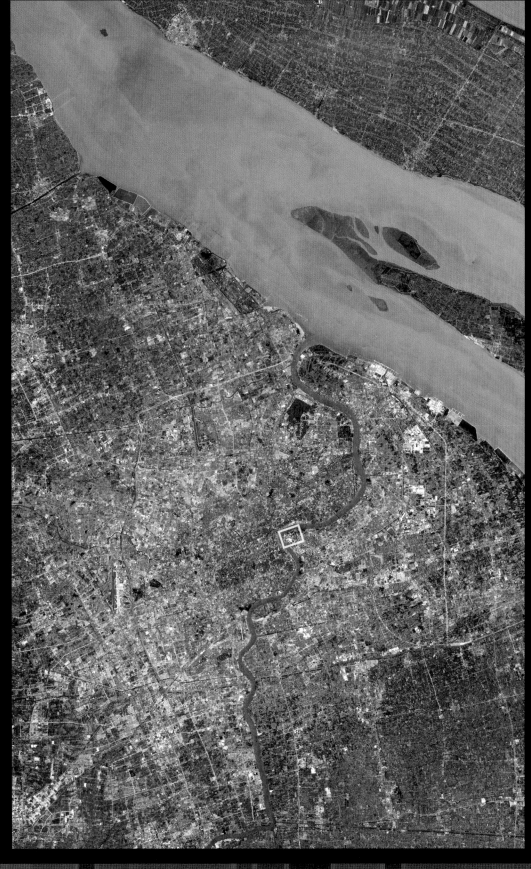

◄ **The centre of Shanghai** is set back from the dockland developments on the Huangpu estuary, although the city is so large it forms a special administrative region, with a population approaching 10 million. Its main urban development falls into two phases, rapid expansion in the 19th century as it entered the nexus of world trade, and more recently as one of China's 'windows on the world'.

▼ **The increased openness of China** has seen Shanghai transformed over the last decade into a showpiece city for trade and commerce. Huge areas of the old city centre have been redeveloped, the originally cramped streets being swept away, with open spaces and dramatic post-modern high rise developments taking their place.

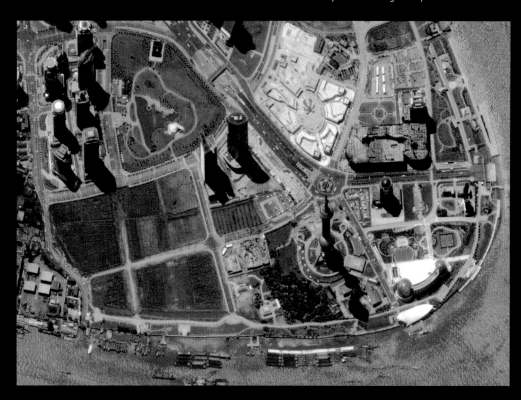

**SATELLITE:** LANDSAT 7 **INSTRUMENT:** ETM+ **HEIGHT:** 438 MILES (705 KM) **DATE:** 03 JUL 2001 14 JUN 2000    **SATELLITE:** IKONOS image courtesy of GeoEye **HEIGHT:** 423 MILES (681 KM) **DATE:** 26 MAR 2000

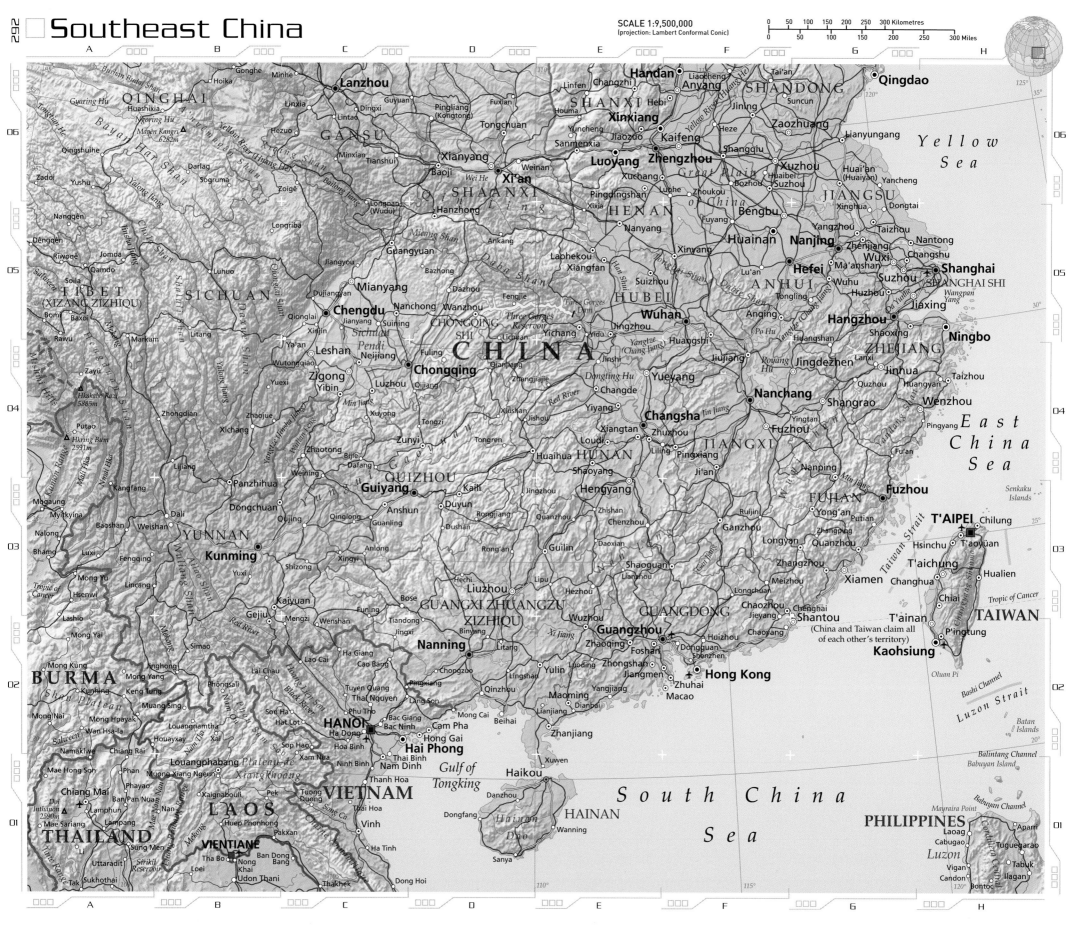

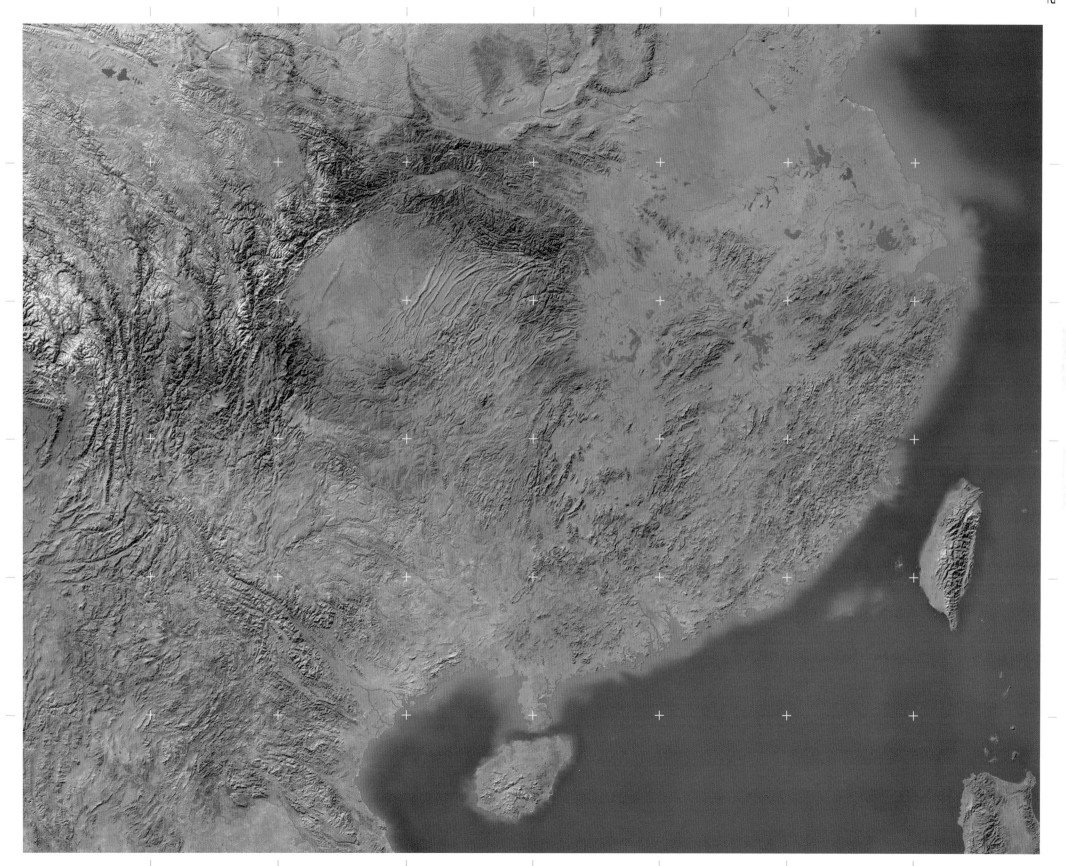

# HONG KONG

## 22°16'N, 114°09'E

The mass of islands and inlets clustered around the mouth of the Pearl (Zhu) river provided attractive sites for European entrepreneurs to establish trading bases for commerce with China. The Portuguese created the first foothold, on the island of Macao in the Canton estuary, in the middle of the 16th century but with the opening of the lucrative opium trade it was the British, in 1839, who occupied Hong Kong island with its huge natural harbour a few miles to the east, and in doing so gave birth to one of the world's greatest trading emporia. Formally ceded to Britain under the Treaty of Nanking (1842), the Kowloon Peninsula on the mainland was ceded in 1860, and a substantial area of hinterland, the New Territories, was leased to the British Crown for 99 years in 1898. When the lease expired, in 1997, the Crown Colony of Hong Kong reverted to Chinese control.

▶▶ **Victoria Harbour**
Hong Kong island is predominantly a steep rocky ridge (The Peak) rising some 1800 ft (550m) above the waters of Victoria Harbour, which separates the island from the mainland. The foreshore facing Kowloon (lower part of the image) is a narrow apron which includes some of the most expensive real estate in the world.

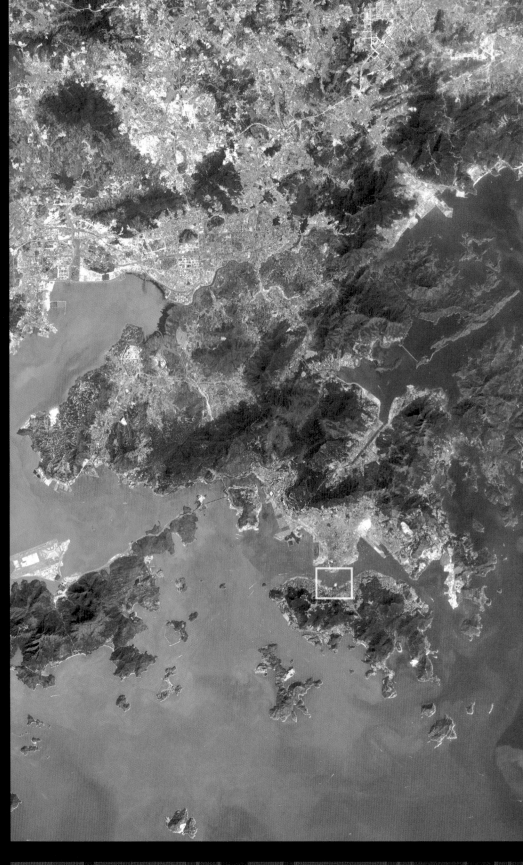

**SATELLITE:** LANDSAT 7, ETM+   **HEIGHT:** 438 MILES (705 KM)   **DATE:** 15 NOV 1999 / 14 SEP 2000 / 31 DEC 200

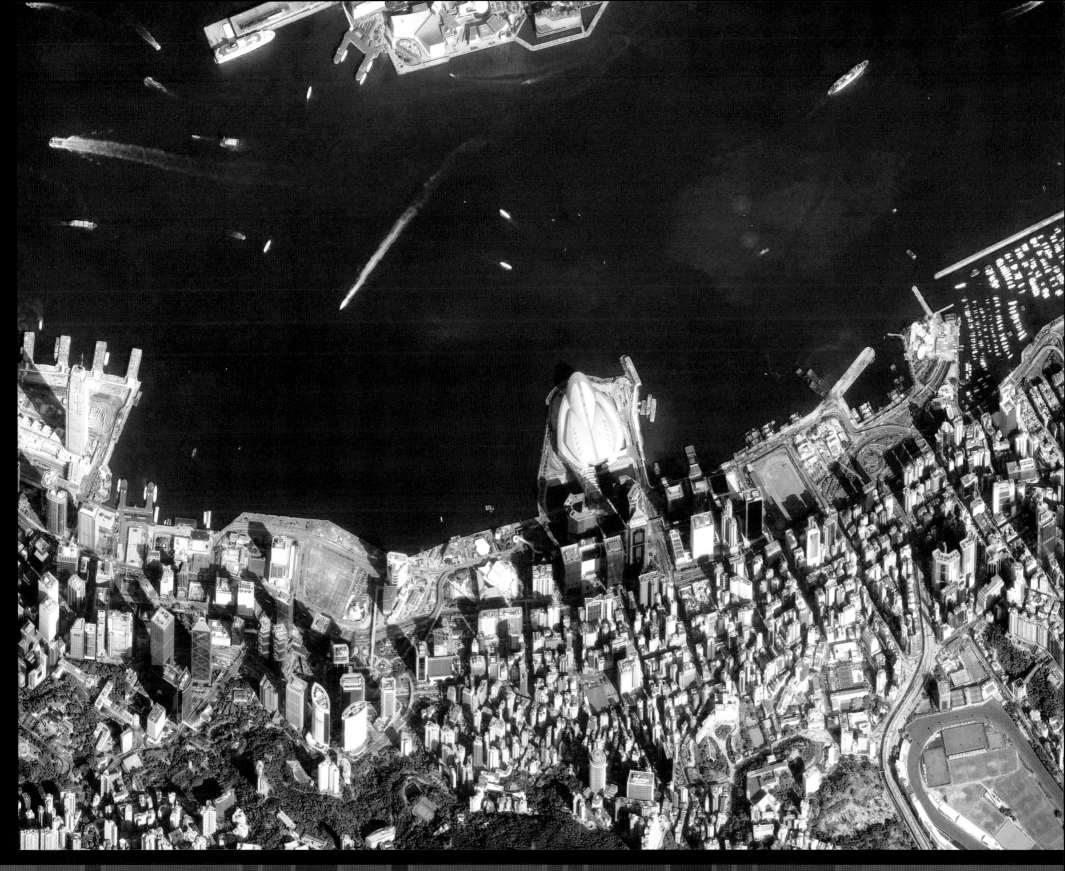

# THREE GORGES DAM

## 30°49'N, 111°E

The Three Gorges are a scenic section of the Yangtze (Chang Jiang) river, where it cuts through the Wu Shan mountains to link the Sichuan Basin with the eastern coastal plains of China. The Three Gorges Dam project is the latest and most ambitious attempt to tame the mighty Yangtze. The scheme will create an artificial lake 575 ft (175m) deep and 373 miles (600 km) long, providing a head of water for the world's largest hydroelectric scheme as well as a new inland waterway link to Sichuan. A huge dam was completed in 2006 halfway along the Xiling Gorge and water is now accumulating in the Wuxia and Qutang Gorges and their side valleys upstream.

▶ **The first stage** of the Three Gorges plan was the hydroelectric dam at Yichang, completed in 1989 and shown at the eastern end of this image, taken in 2003. The turbulent waters of the Yangtze hurtle down from the site of the new dam, under construction 25 miles (40 km) upstream to the west. It is expected that the disruption will be a price worth paying, since the Yangtze has frequently flooded its lower reaches, killing hundreds of thousands over the centuries.

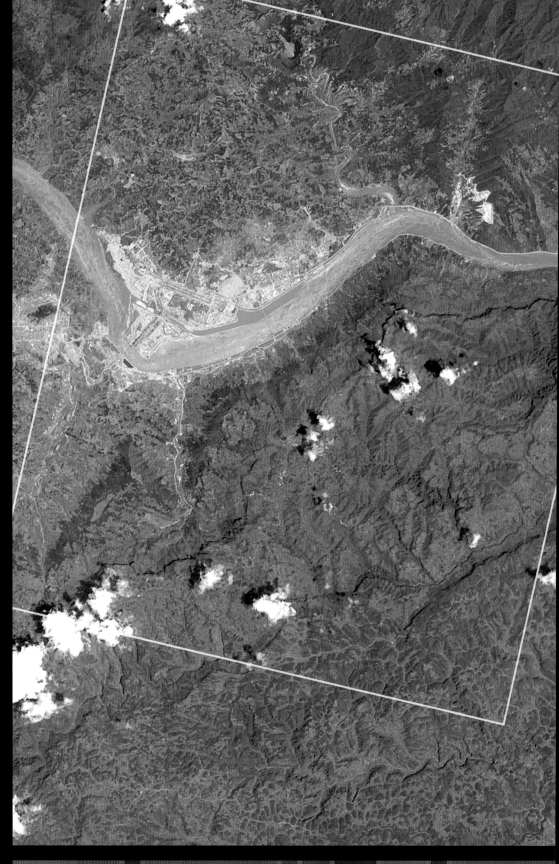

**SATELLITE:** TERRA (EOS AM-1) **INSTRUMENT:** ASTER **HEIGHT:** 438 MILES (705 KM) **DATE:** 17 JUL 2000

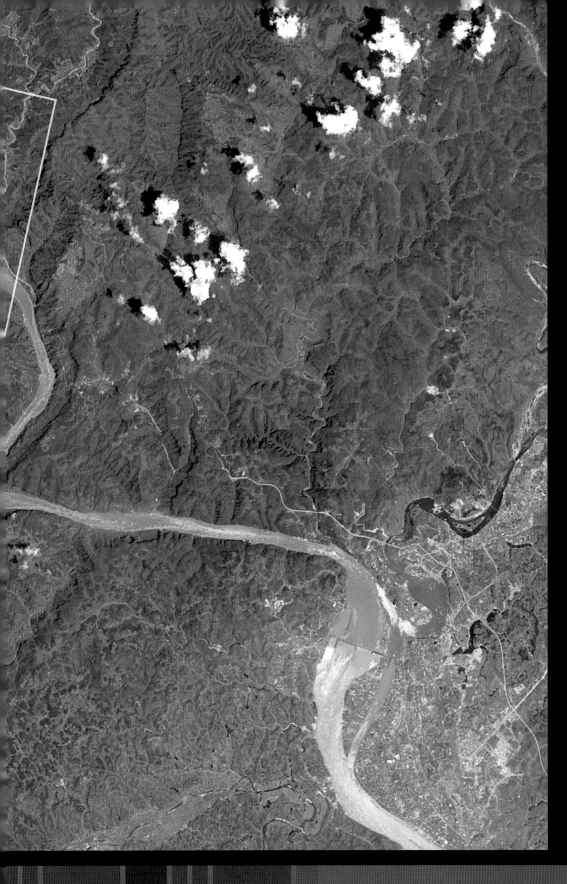

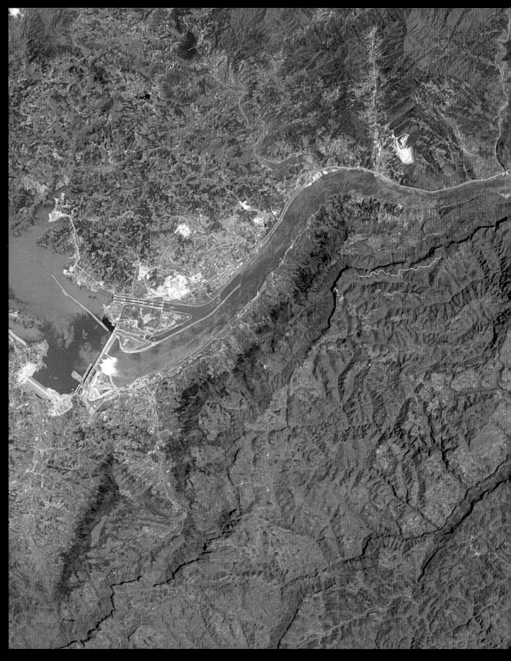

▼ **Calm blue waters** appear in this image from 2006, showing the completed dam at Sandouping, together with the adjacent ship locks and lift. As well as radically changing the landscape, the scheme has involved the relocation of almost two million people from the towns and villages that will be flooded by the new lake.

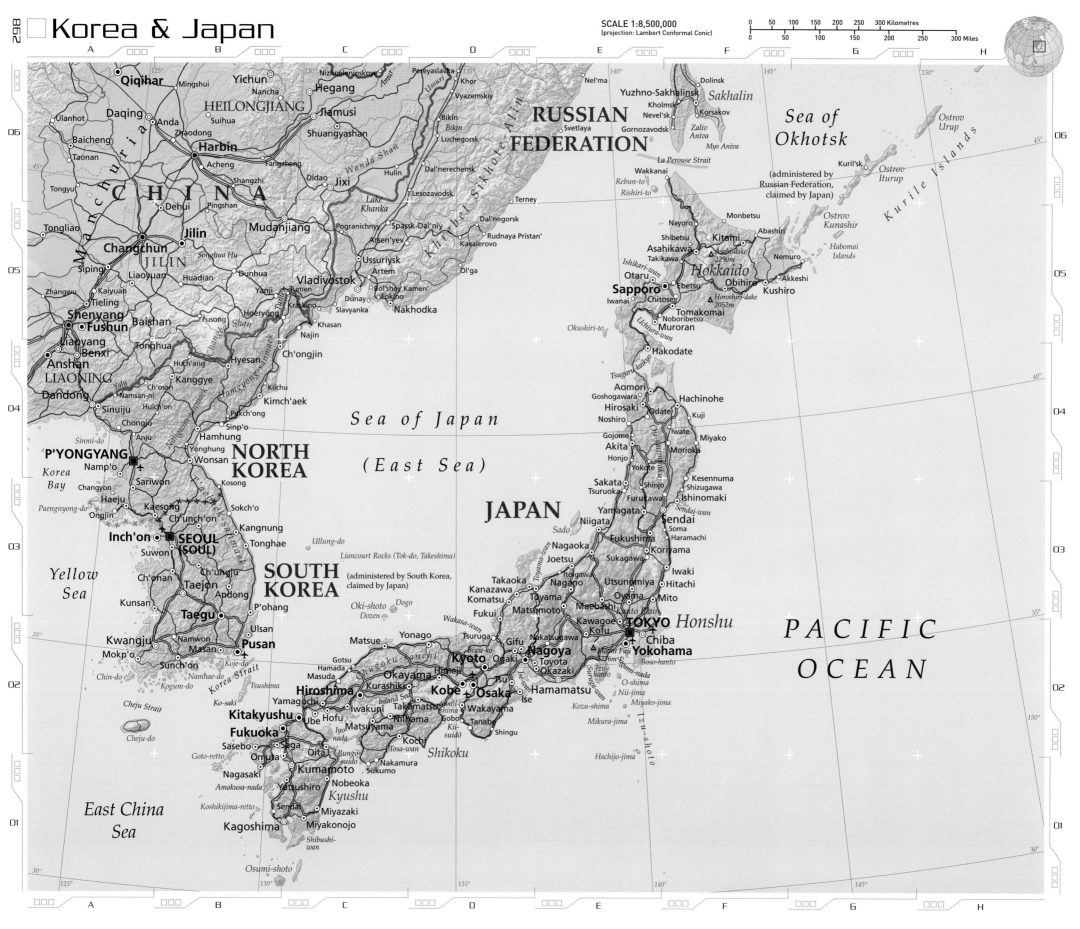

# Korea & Japan

SCALE 1:8,500,000
(projection: Lambert Conformal Conic)

0   50   100   150   200   250   300 Kilometres
0   50   100   150   200   250   300 Miles

**RUSSIAN FEDERATION**

*Sea of Okhotsk*

*Sakhalin*

Nizhneleninskoye
Amur
Pereyaslavka
Khor
Vyazemskiy
Bikin
Luchegorsk
Dal'nerechensk
Terney
Lesozavodsk
Spassk-Dal'niy
Rudnaya Pristan'
Dal'negorsk
Kavalerovo
Arsen'yev
Ol'ga

Nel'ma

Yuzhno-Sakhalinsk
Kholmsk
Nevel'sk
Korsakov
Gornozavodsk
*Zaliv Aniva*
*Mys Aniva*

Dolinsk

La Perouse Strait

*Ostrov Urup*

Kuril'sk

*Ostrov Iturup*

*Kurile Islands*

(administered by Russian Federation, claimed by Japan)

*Ostrov Kunashir*

*Habomai Islands*

**HEILONGJIANG**

Qiqihar
Mingshui
Yichun
Nancha
Hegang
Jiamusi
Suihua
Shuangyashan
Daqing
Anda
Zhaodong
Harbin
Acheng
Fangzheng
Didao
Jixi
Hulin
*Lake Khanka*
Pogranichnyy
Ussuriysk
Artem
Nakhodka
Dunay
Bol'shoy Kamen'
Fokino
Slavyanka
Kraskino
Khasan

U!anhot
Baicheng
Taonan

**CHINA**
*Manchuria*
Tongyu
Tongliao
Zhangwu
Kaiyuan
Siping
Liaoyuan
**Changchun**
**JILIN**
**Jilin**
Huadian
Dehui
Pingshan
Shangzhi
Mudanjiang
*Wanda Shan*
*Songhua Hu*
Dunhua
Yanji
Tumen
Hoeryong
*Khrebet Sikhote Alin*
*Ussuri*
Bikin
Svetlaya
Wakkanai
*Rebun-to*
*Rishiri-to*
Nayoro
Monbetsu
Shibetsu
Asahikawa
**Kitami**
Abashiri
Takikawa
*Asahi-dake 2290m*
Nemuro
Otaru
Ebetsu
**Sapporo**
*Hokkaido*
Iwanai
Chitose
Obihiro
Akkeshi
Kushiro
*Horoshiri-dake 2052m*
*Oshushiri-to*
Noboribetsu
Tomakomai
Muroran
*Uchiura-wan*
Hakodate
*Tsugaru-kaikyo*

Shenyang
Fushun
Baishan
Tonghua
Liaoyang
Benxi
**LIAONING**
Anshan
Dandong
Sinuiju
Chongju
Anju
*Yalu*
Namsan-ni
Huich'on
Kanggye
Ch'oson
Kilchu
*Changbai Shan*
Hyesan
Kimch'aek
Ch'ongjin
Najin
Tumen
Vladivostok
*Tumen*

P'ohang

*Sea of Japan*

*(East Sea)*

**NORTH KOREA**

Hamhung
Hamgyong-sanmaek
Sinp'o
Pukch'ong
Hungnam
Wonsan
Kosong
Sokch'o
Kangnung
Tonghae
**P'YONGYANG**
Namp'o
Sariwon
Changyon
Kaesong
*Korea Bay*
*Sinmi-do*
Haeju
Ongjin
*Paengnyong-do*
Ch'unch'on
**Inch'on**
**SEOUL (SOUL)**
Suwon
Ch'ungju
**SOUTH KOREA**
Ch'onan
Andong
Taejon
*Ullung-do*

Aomori
Goshogawara
Hirosaki
Noshiro
Odate
Hachinohe
Kuji
Gojome
Iwate
Miyako
Akita
Honjo
Yokote
Morioka
Sakata
Shinjo
Tsuruoka
Furukawa
Yamagata
Kesennuma
Shizugawa
Ishinomaki
*Sendai-wan*
Soma
Haramachi
Niigata
Fukushima
**Sendai**
Nagaoka
Koriyama
*Sado*
Itoigawa
Joetsu
Sukagawa
Iwaki
Takaoka
Nagano
Utsunomiya
Hitachi
Kanazawa
Toyama
Oyama
Mito
Komatsu
*Toyama-wan*
Maebashi
Fukui
Matsumoto
Kawagoe
**TOKYO**
*Honshu*
Kofu
Nakatsugawa
Chiba
Gifu
**Nagoya**
*Mount Fuji 3776m*
**Yokohama**
Ogaki
Toyota
Okazaki
*Izu-hanto*
*Boso-hanto*
*Suruga-wan*
O-shima

**JAPAN**

*PACIFIC OCEAN*

Tsuruga
Yonago
Matsue
*Oki-shoto Dozen*
*Dogo*
*Wakasa-wan*
Tsu
Hamamatsu
Ise
*Enshu-nada*
*Nii-jima*
*Kozu-shima*
*Miyako-jima*

*Liancourt Rocks (Tok-do, Takeshima)*

(administered by South Korea, claimed by Japan)

Kunsan
Namwon
**Taegu**
Masan
Ulsan
**Pusan**
Kwangju
Mokp'o
Sunch'on
*Koje-do*
*Chin-do*
*Kogum-do*
*Namhae-do*
*Korea Strait*
*Tsushima*
*Ko-saki*
Matsue
Gotsu
Hamada
Masuda
*Chugoku-sanchi*
Yonago
Okayama
Kurashiki
**Kobe**
**Osaka**
**Kyoto**
Himeji
*Biwa-ko*
Otsu
Wakayama
Tanabe
*Kii-suido*
Shingu
*Kii-hanto*

**Hiroshima**
Yamaguchi
Iwakuni
Ube
Hofu
*Iyo-nada*
Matsuyama
Niihama
Takamatsu
*Inland Sea*
*Awaji-shima*
Tokushima
*Shodo-shima*
Gobo

**Kitakyushu**
**Fukuoka**
Saga
Oita
Kochi
*Shikoku*
*Tosa-wan*
*Bungo-suido*
Sukumo
Nakamura
Sasebo
Omuta
Kumamoto
Nobeoka
Nagasaki
*Amakusa-nada*
Yatsushiro
*Kyushu*
*Koshikijima-retto*
Sendai
Miyazaki
Miyakonojo
Kagoshima
*Shibushi-wan*
*Osumi-shoto*

*Goto-retto*

*Cheju Strait*
*Cheju-do*

*Yellow Sea*

*East China Sea*

*Mikura-jima*

*Hachijo-jima*

# SEOUL
## 37°30'N, 126°57'E

The capital of the Yi Dynasty from 1392, and the capital of South Korea today, Seoul is the most developed city on the Korean peninsula, and the most populous with over 10 million inhabitants. It is situated in the north of the country, 40 miles (64 km) inland from Inch'on which acts as its port, and only 30 miles (48 km) from the border with North Korea. In 1910, when Korea was invaded by Japan, the occupying power made it their administrative centre, as did US forces following Japan's defeat in 1945. Seoul was severely damaged during the Korean War (1950-53) which left little of the old city standing, and the modern city has largely been rebuilt in the last half century – a process boosted by Seoul hosting the Olympic Games in 1988.

▶ **Since 1953 the border** between North and South Korea has been formed by a ceasefire line designated as a demilitarized zone. Situated a mere 30 miles (48 km) north of Seoul, visible as an angular linear feature in the top left of this image, the lack of human activity has turned the area into a refuge for wildlife.

**SATELLITE:** LANDSAT 4/5   **INSTRUMENT:** THEMATIC MAPPER   **HEIGHT:** 438 MILES (705 KM)   **DATE:** 1989-1991

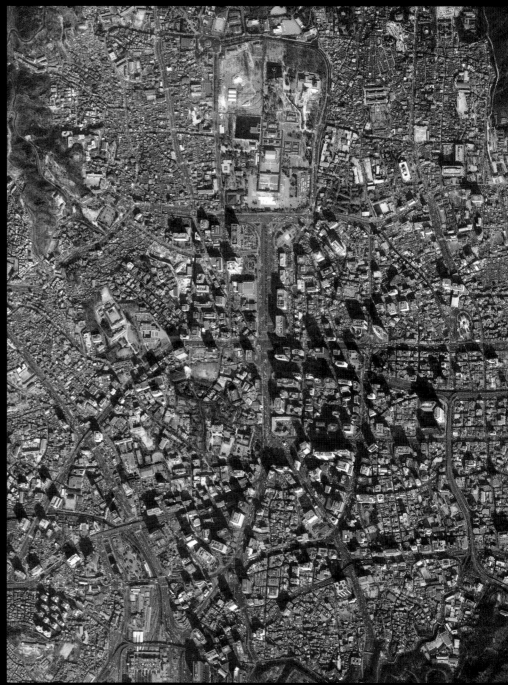

▼ **Situated just to the north** of downtown Seoul, Gyeongbok Palace was built in 1394 and, following a great deal of turmoil in its long history, is now undergoing a complete restoration. The palace provides a vivid contrast with the steel and glass modernity of the downtown area which has the highest concentration of skyscrapers in Asia.

**SATELLITE:** QUICKBIRD image courtesy of DigitalGlobe  **HEIGHT:** 280 MILES (450 KM)  **DATE:** 15 FEB 2002

# TOKYO

## 35°40'N, 139°45'E

Like London, Tokyo doesn't really exist: it is a combination of 23 wards, which combine to form one of Japan's 47 prefectures. This prefecture has a population of over 12 million (about 10 percent of the national total), although the Greater Tokyo Area, which incorporates several neighbouring prefectures has a total population of 35 million, which makes the Japanese capital one of the world's biggest megacities. Originally named Edo, it was the centre of the Tokugawa Shogunate in the Middle Ages. With the Meiji Restoration, Tokyo (which means 'Eastern Capital') replaced Kyoto as Japan's premier city in 1868. Sited on a huge natural harbour, and overlooked by the volcanic cone of Mount Fuji, the city is criss-crossed by canals.

▶▶ **The relentless growth** of Tokyo and Yokohama has forced planners to reclaim large areas of land from Tokyo Bay. Concerns have been raised over the long-term stability of this process given Japan's susceptibility to earthquakes.

**SATELLITE:** TERRA (EOS AM-1)   **INSTRUMENT:** MODIS   **HEIGHT:** 438 MILES (705 KM)   **DATE:** AUG 2004

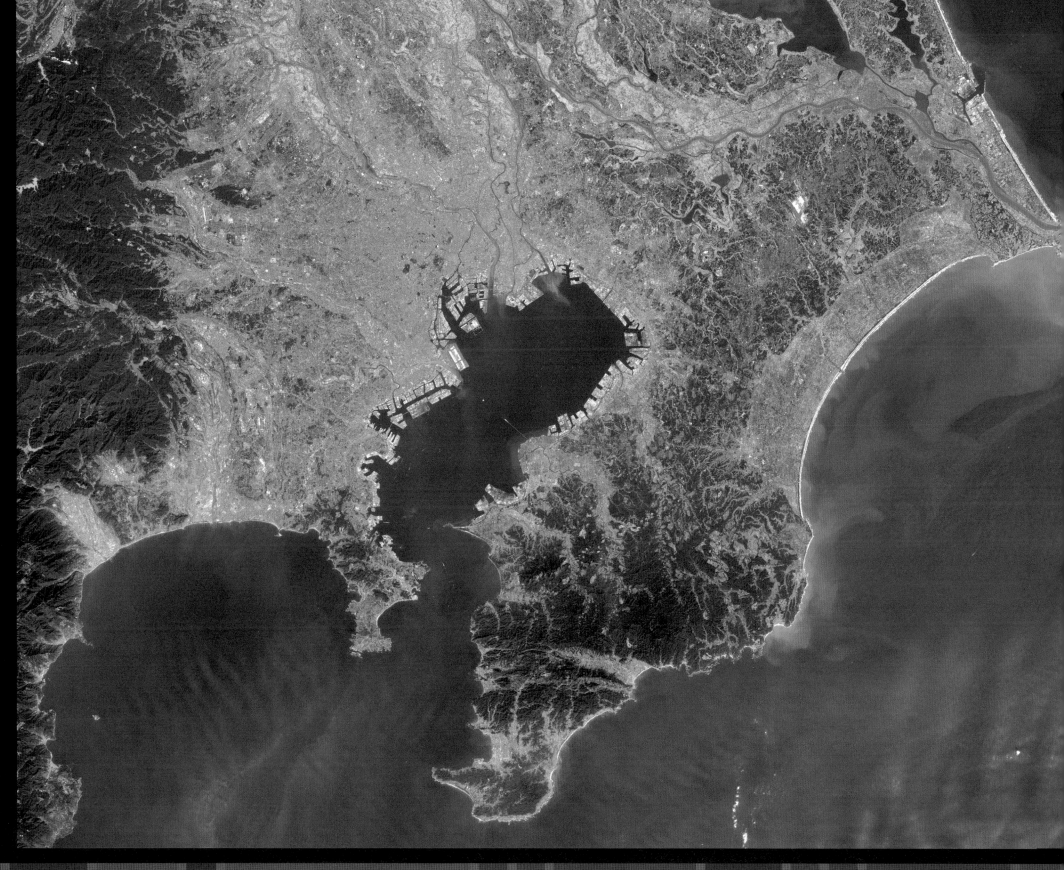

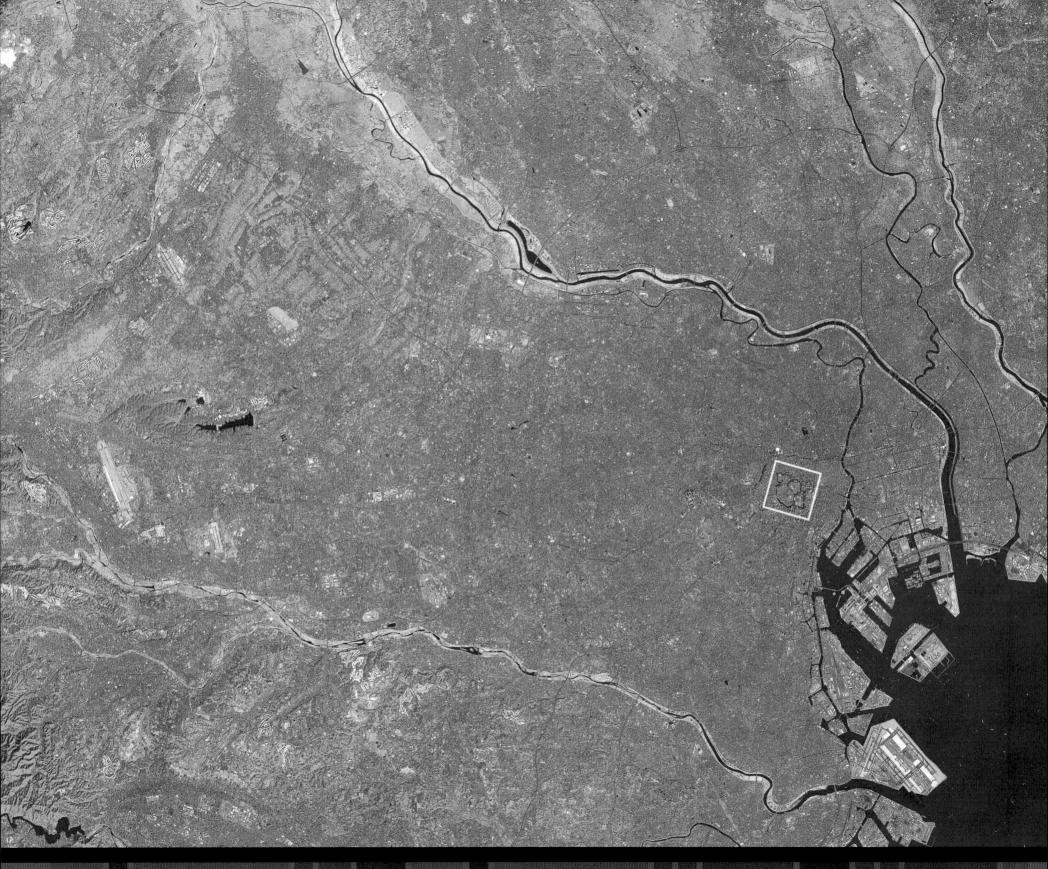

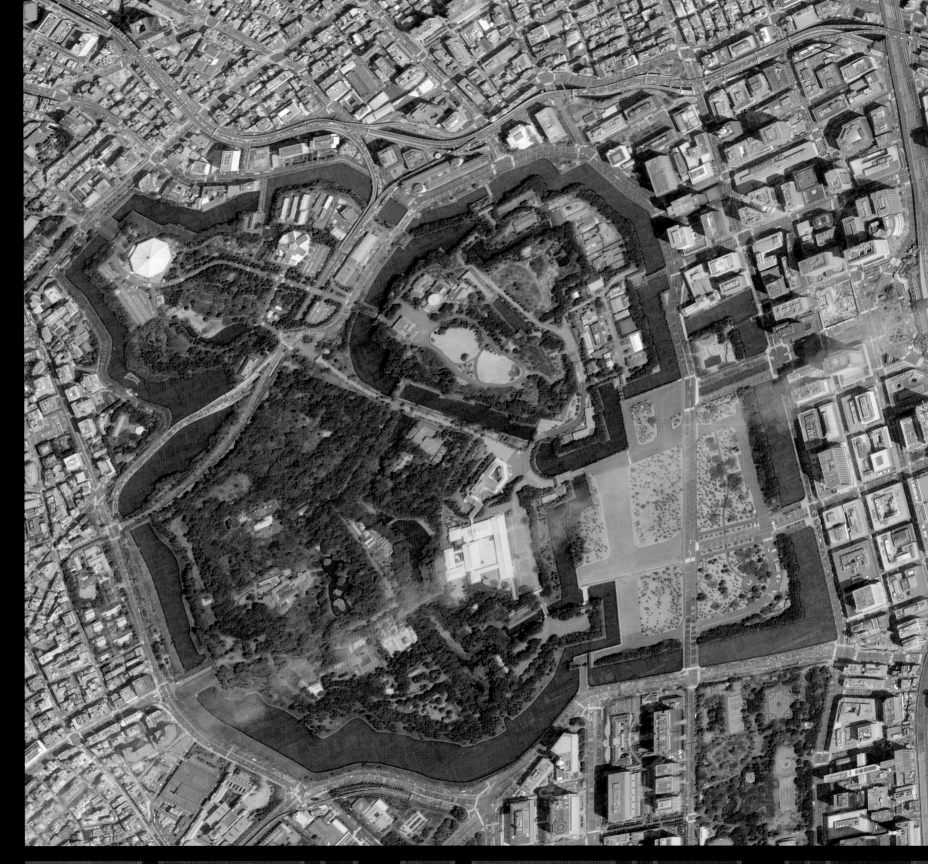

▶ **Largely destroyed by** earthquake in 1923, and fire-bombed by the Allies in 1945, most of Tokyo is strikingly modern. However, the extensive moated area of the Imperial Gardens (right) contains many historical and notable structures, including the quadrangle of the Imperial Palace (lower centre). To the north lies the National Science Museum (the hexagonal building top left) and to its west the gigantic Budokan hall (the octagonal structure overlooking the moat).

**SATELLITE:** QUICKBIRD image courtesy of DigitalGlobe    **HEIGHT:** 280 MILES (450 KM)    **DATE:** 27 MAR 2005

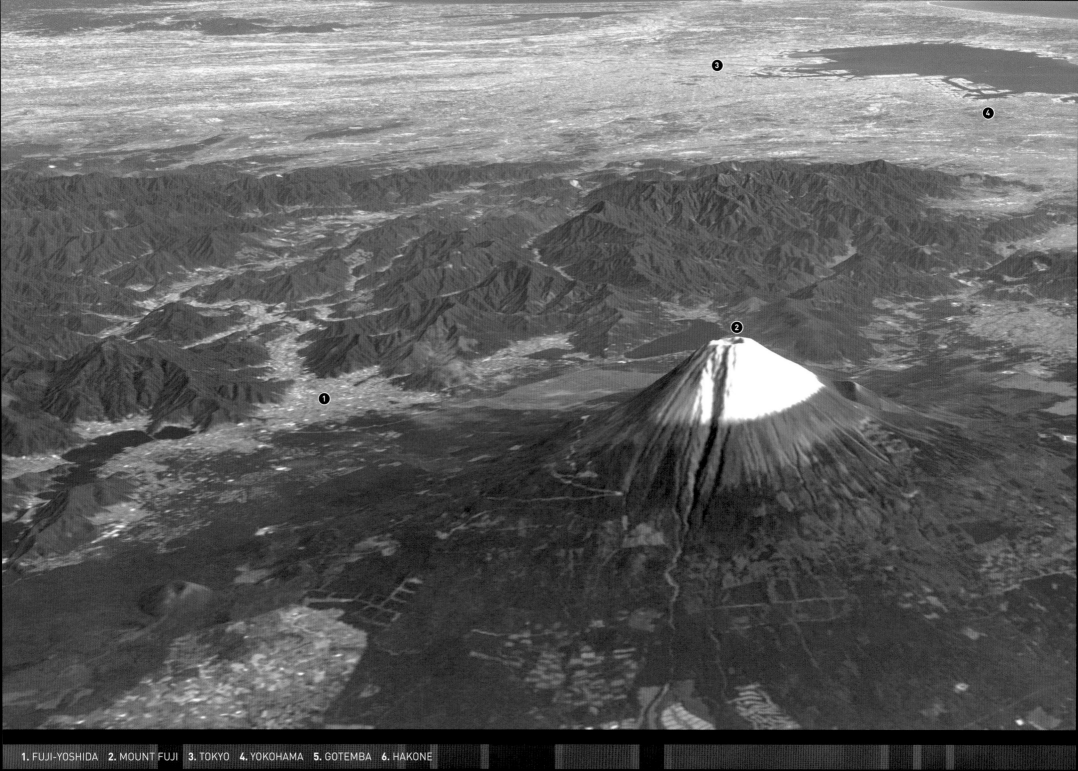

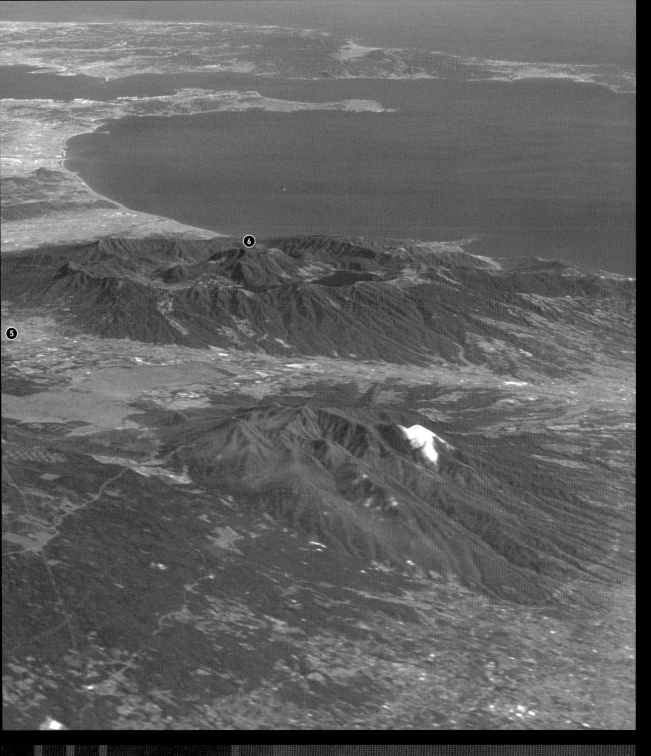

# MOUNT FUJI

## 35°23'N, 138°44'E

A steep symmetrical volcanic cone, Mount Fuji is Japan's tallest mountain at 12,388 ft (3776 m). Its flanks show distinct altitudinal variations in cover type, with forests on the lower slopes, thinner brush and grass higher up, before the bare wastes of lava and ash at the top. Snow is always present at the summit, but the snowline varies in altitude with the seasons. The summit crater is 656 ft (200 m) deep and 2625 ft (800 m) across. A relatively young stratovolcano, Fuji's last eruption was in 1707.

This simulated perspective view shows Fuji from the southwest. Beyond the mountain lies Hakone, an older volcanic centre with several peaks lying within a broad caldera 7 miles (11 km) across. Hakone last erupted in 950 BCE. In the far distance lies Tokyo Bay. To the north of Fuji (left of image) lies a popular area for outdoor recreation known as the Fuji Five Lakes.

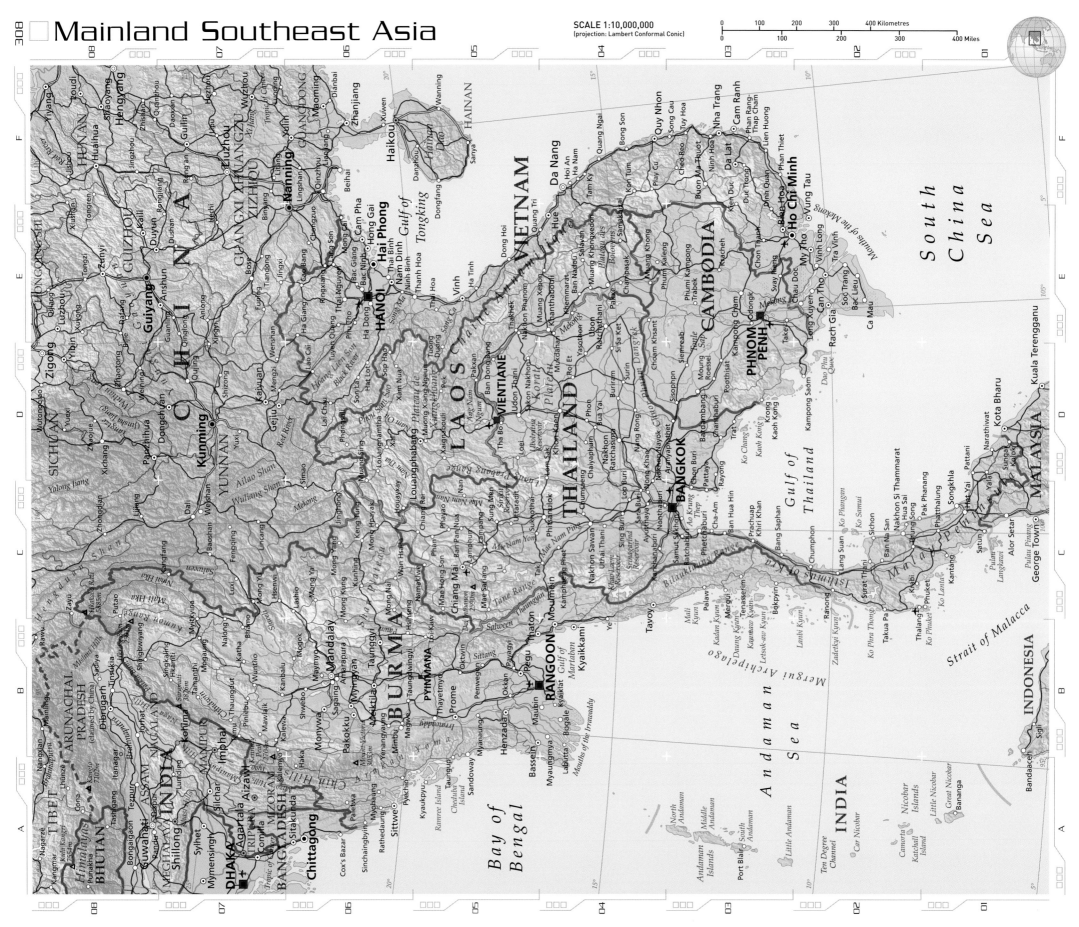

# BANGKOK

## 13°43'N, 100°30'E

Bangkok (Krung Thep in Thai, meaning 'City of Angels') has been the capital of Thailand since 1782. The previous capital of Ayutthaya fell to the Burmese in 1767 so a new capital was founded at Thonburi, on the west bank of the Chao Phraya river. However, the construction of royal residences shifted the development of the city to the east bank. Bangkok has major dock facilities. Indeed, water is an important aspect of life in the city, much of the older city being built on piles or pontoons, linked by numerous canals, although many have now been filled in to form roads. Markets are often held on the water, and visited by boat. The city has become a major centre for Southeast Asian politics and commerce, hosts the headquarters of the Southeast Asia Treaty Organization (SEATO) and is the most popular tourist destination in the region.

**SATELLITE:** TERRA (EOS AM-1)   **INSTRUMENT:** MODIS   **HEIGHT:** 438 MILES (705 KM)   **DATE:** 10 JAN 2006

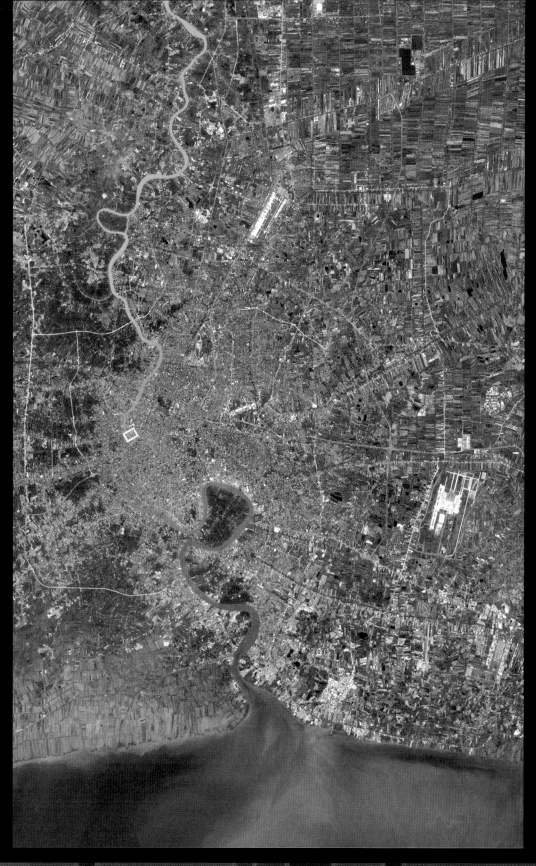

◄ **The Bangkok Metropolitan Area** is now very extensive, with a conurbation stretching to the mouth of the Chao Phraya. The city has grown enormously in the last half century, from some 2.1 million people in 1960 to over 8 million today, with a substantial immigrant and expatriate community of Chinese, Japanese, Indians, Europeans and others making up around one-sixth of the total population.

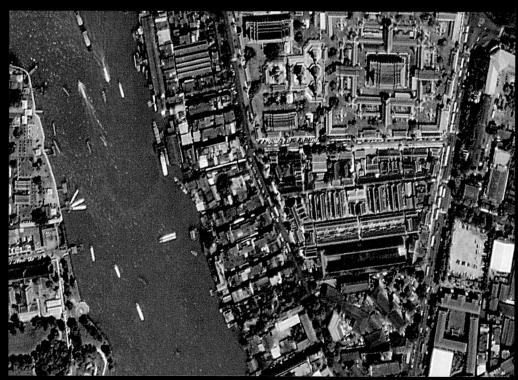

▼ **The busy docks** and foreshore on the Chao Phraya, where tourist launches and small sampans weave among the larger commercial vessels. Top centre is the original palace complex of King Rama I, the founder of Bangkok, built in 1782.

**SATELLITE:** LANDSAT 7   **INSTRUMENT:** ETM+   **HEIGHT:** 438 MILES (705 KM)   **DATE:** 02 NOV 2000 /02 SEP 2001   **SATELLITE:** IKONOS image courtesy of GeoEye   **HEIGHT:** 423 MILES (681 KM)   **DATE:** 08 MAY 2000

# The Philippines

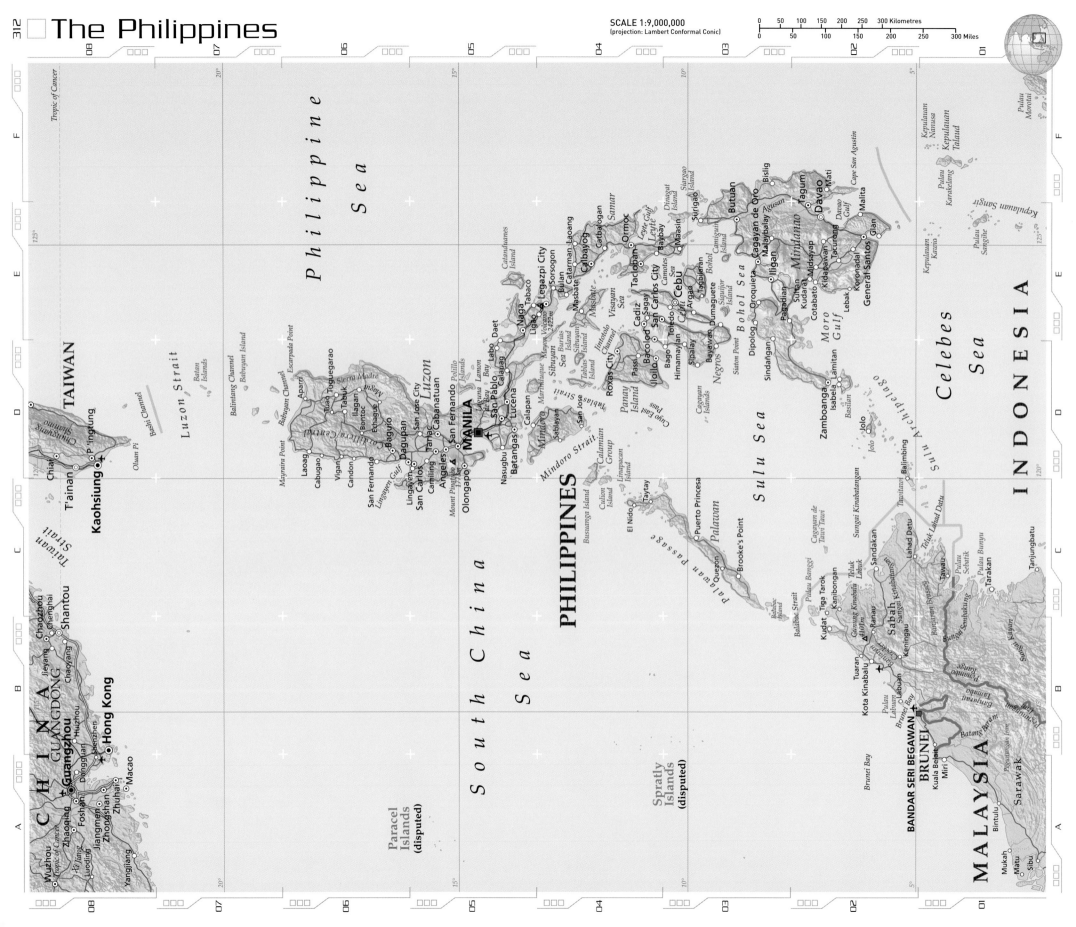

Tropic of Cancer

TAIWAN

*Philippine*

*Sea*

CHINA

GUANGDONG

Guangzhou
Hong Kong
Macao
Shenzhen
Dongguan
Foshan
Zhongshan
Zhuhai
Jiangmen
Huizhou
Shantou
Chaozhou
Chenghai
Jieyang
Chaoyang
Wuzhou
Yangjiang
Luoding
Yi'ning
Matu
Sibu
Bintulu
Mukah

Kaohsiung
T'ainan
Chiai
P'ingtung

*Luzon Strait*
*Bashi Channel*
*Taiwan Strait*

*South*

*China*

*Sea*

PHILIPPINES

Paracel Islands
(disputed)

Spratly Islands
(disputed)

MALAYSIA

Sarawak

BRUNEI
BANDAR SERI BEGAWAN
Kuala Belait
Miri

*Celebes*

*Sea*

INDONESIA

MANILA

Luzon

Mindanao

Davao

Cebu

*Sulu Sea*

*Bohol Sea*

*Moro Gulf*

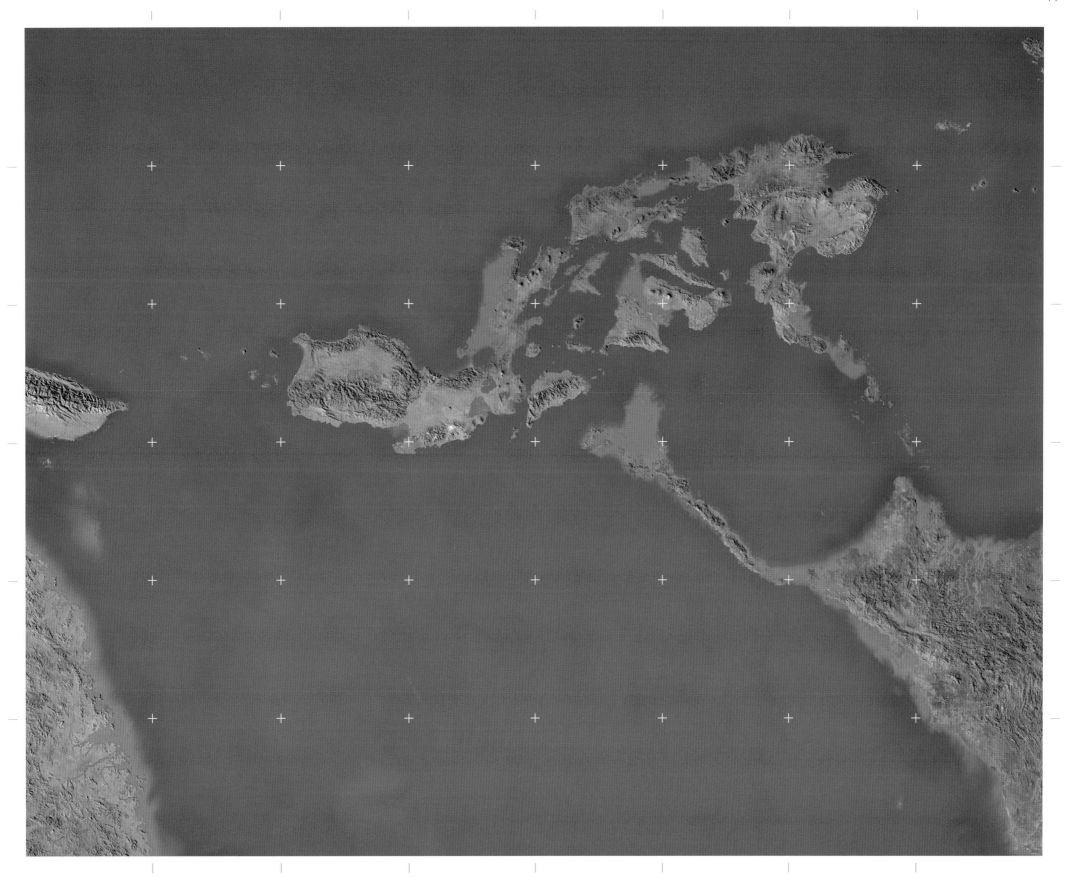

# Western Maritime Southeast Asia

SCALE 1:12,500,000
(projection: Mercator)

0  100  200  300  400  500 Kilometres
0       100     200     300    400  500 Miles

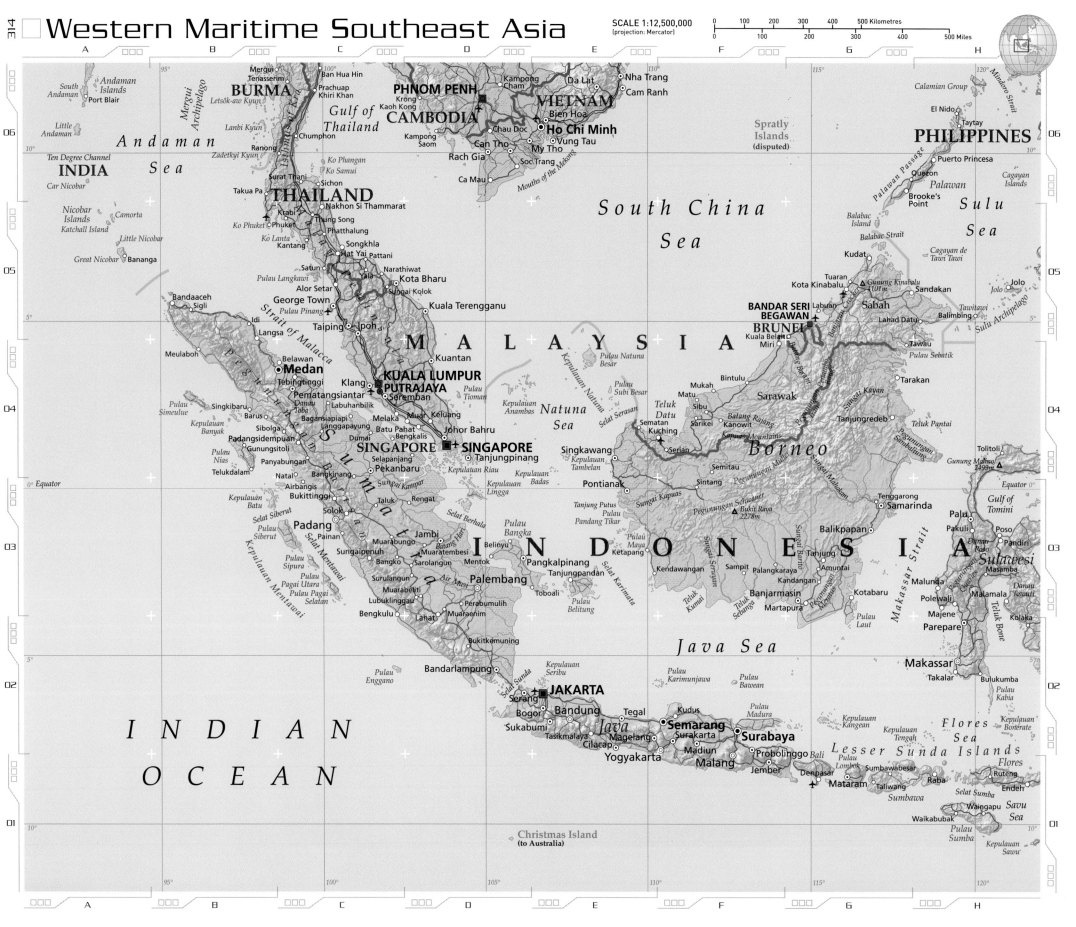

**BURMA**

Mergui
Tenasserim
Letsôk-aw Kyun
Ban Hua Hin
Prachuap Khiri Khan
Krong
Kaoh Kong
Kampong Cham
Da Lat
Nha Trang
Cam Ranh

**PHNOM PENH**
**CAMBODIA**
**VIETNAM**
Bien Hoa
**Ho Chi Minh**
Vung Tau
My Tho

South Andaman
Andaman Islands
Port Blair

*Andaman*
*Sea*

Chumphon

*Gulf of Thailand*

Chau Doc
Can Tho
Rach Gia
Soc Trang

*Mouths of the Mekong*

**PHILIPPINES**

Calamian Group

El Nido
Taytay

Little Andaman

**INDIA**

Ten Degree Channel

Car Nicobar

Surat Thani
*Ko Phangan*
*Ko Samui*
Sichon

Kampong Saom
Ca Mau

Puerto Princesa
Quezon

*Palawan*

Cagayan Islands

Nicobar Islands
Katchall Island

*Camorta*

Takua Pa
**THAILAND**
Nakhon Si Thammarat

*South China Sea*

*Spratly Islands (disputed)*

Brooke's Point

*Sulu Sea*

Great Nicobar
Bananga

Krabi
*Ko Phuket* Phuket
Thung Song
Phatthalung

Balabac Island
*Balabac Strait*

*Cagayan de Tawi Tawi*

Songkhla
Hat Yai Pattani

Kudat

Jolo Jolo

Bandaaceh
Sigli

*Pulau Langkawi*
Narathiwat
Kota Bharu
Sungai Kolok

Tuaran
Kota Kinabalu
*Gunung Kinabalu 4101m*
Sandakan

Idi

Alor Setar
Satun
Yala

Tawitawi
Balimbing

Langsa

George Town
*Pulau Pinang*
Taiping Ipoh

**BANDAR SERI BEGAWAN**
Labuan
**Sabah**
Lahad Datu

*Sulu Archipelago*

Meulaboh

*Strait of Malacca*

**M A L A Y S I A**

**BRUNEI**
Kuala Belait
Miri

Tawau

Belawan
**Medan**
Kuantan

Kota Kinabalu

*Pulau Sebatik*

Tebingtinggi

Klang
**KUALA LUMPUR**
**PUTRAJAYA**
Seremban

*Kepulauan Natuna Besar*

Mukah
Bintulu
**Sarawak**

Tarakan

*Pulau Simeulue*

Pematangsiantar
Labuhanbilik

*Pulau Tioman*

*Pulau Subi Besar*
Matu
Sibu

*Teluk Pantai*

Tanjungredeb

Barus
*Danau Toba*
Bagansiapiapi

Melaka Muar Keluang
Batu Pahat
Bengkalis

*Kepulauan Anambas*
*Natuna Sea*

*Teluk Datu*
Sematan
Kuching
Sarikei
Kanowit
*Batang Rajang*

*Kepulauan Banyak*
Singkibaru
Sibolga
Dumai
Johor Bahru

*Selat Serasan*
Serian

*Kapuas Mountains*

Padangsidempuan
Gunungsitoli

**SINGAPORE** **SINGAPORE**

Singkawang
*Kepulauan Tambelan*

Semitau

Tanjung

*Pulau Nias*

Panyabungan
Selapanjang
Pekanbaru
Tanjungpinang

Sintang
*Pegunungan Muller*

*Borneo*

*Sungai Kayan*

Telukdalam
Natal

Bangkinang

*Kepulauan Riau*
*Kepulauan Badas*

Pontianak

*Pegunungan Schwaner*

*Gunung Malino 2499m*

Tolitoli

*Equator*

Airbangis
*Sungai Kampar*

*Kepulauan Lingga*

*Sungai Kapuas*
*Bukit Raya 2278m*

Tenggarong
**Samarinda**

*Equator*

*Gulf of Tomini*

*Kepulauan Batu*
Bukittinggi
Taluk
Rengat

*Tanjung Putus*
*Pulau Pandang Tikar*

Balikpapan

Palu
Pakuli

*Pulau Siberut*

Solok
*Sungai Hari*

*Selat Berhala*

*Pulau Maya*
Ketapang

Poso
Pandiri

*Selat Siberut*

**Padang**
Painan

Muarabungo
Jambi
*Batang Hari*

Belinyu

*Danau Poso*

*Sulawesi*

*Pulau Sipura*

Muaratembesi
Sarolangun
Mentok

Kendawangan

Sampit
Palangkaraya
Kandangan
Amuntai

Malunda
Masamba

*Kepulauan Mentawai*

Sungaipenuh
Bangko

Pangkalpinang

*Selat Karimata*

**I N D O N E S I A**

*Sungai Barito*

Malamala
Polewali

*Danau Towuti*

*Pulau Pagai Utara*

Surulangun
Muarabeliti

Tanjungpandan
*Pulau Bangka*

Banjarmasin
Martapura

Kotabaru

Majene

*Teluk Bone*

*Pulau Pagai Selatan*

Lubuklinggau
Lahat
Muaraenim

**Palembang**

Toboali

*Pulau Belitung*

*Teluk Kumai*
*Teluk Sebanga*

*Pegunungan Meratus*

*Pulau Laut*

Parepare

Bengkulu

Perabumulih

*Java Sea*

**Makassar**

Bukitkemuning

Takalar
Bulukumba

*Pulau Enggano*

Bandarlampung

*Kepulauan Seribu*

*Pulau Karimunjawa*

*Pulau Bawean*

*Pulau Kabia*

*Selat Sunda*
Serang
**JAKARTA**

Kudus
*Pulau Madura*

*Kepulauan Kangean*

*Flores Sea*

*I N D I A N*

Bogor
Sukabumi
Bandung

Tegal

*Java*
Cilacap
Tasikmalaya

**Semarang**
Magelang
Surakarta
Madiun
Yogyakarta

**Surabaya**
Probolinggo

*Kepulauan Tengah*

*Lesser Sunda Islands*

*Flores*
Ruteng
Endeh

*O C E A N*

Malang
Jember

*Bali*
Denpasar
**Mataram**

*Pulau Lombok*
Sumbawabesar
Raba

Taliwang

*Sumbawa*
*Selat Sumba*

Waingapu
*Savu Sea*

Waikabubak

*Pulau Sumba*

Christmas Island
(to Australia)

*Kepulauan Sawu*

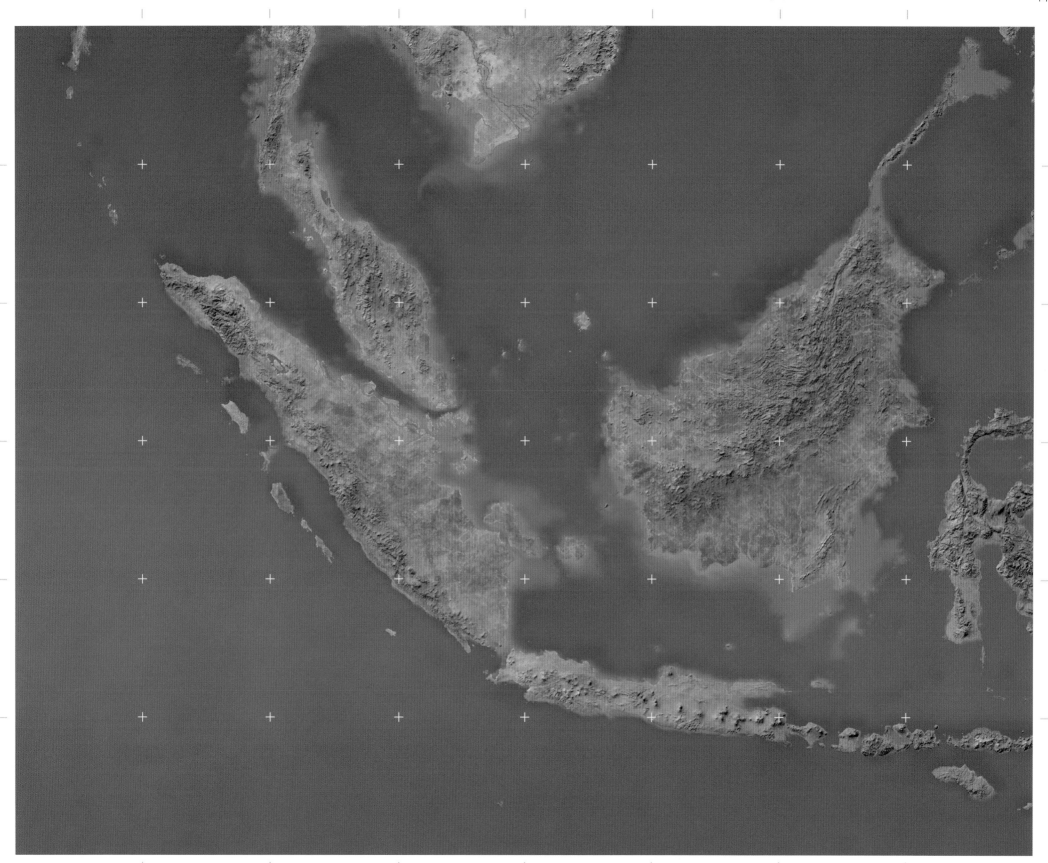

# SINGAPORE

## 1°17'N, 103°48'E

The island, city and independent state of Singapore was one of the key centres in the development of a global trading system in the 19th century. Its location, just off the southern tip of the Malay Peninsula, at the southern end of the Strait of Malacca, meant that most shipping travelling between the Indian Ocean and the South China Sea would pass through it. This explains why Stamford Raffles established a settlement on the island on behalf of the East India Company in 1819, and why today Singapore is still noted as an enormously wealthy maritime and commercial hub in Southeast Asia. Separated from the Malay mainland by the narrow Strait of Johor, the island republic fiercely defends the independence it gained from Malaysia in 1965.

► **The position of Singapore** near the Equator gives rise to a climate that is consistently hot and humid throughout the year. Clouds frequently build up though the day often resulting in heavy downpours by late afternoon.

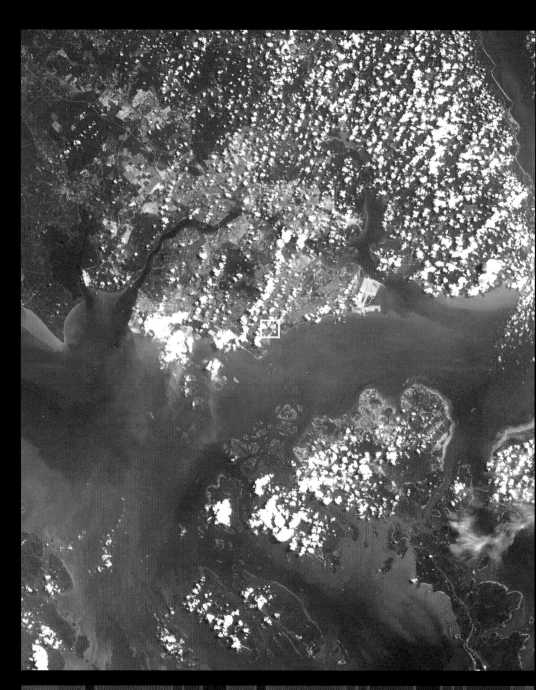

**SATELLITE:** LANDSAT 7   **INSTRUMENT:** ETM+   **HEIGHT:** 438 MILES (705 KM)   **DATE:** 28 APR 2000

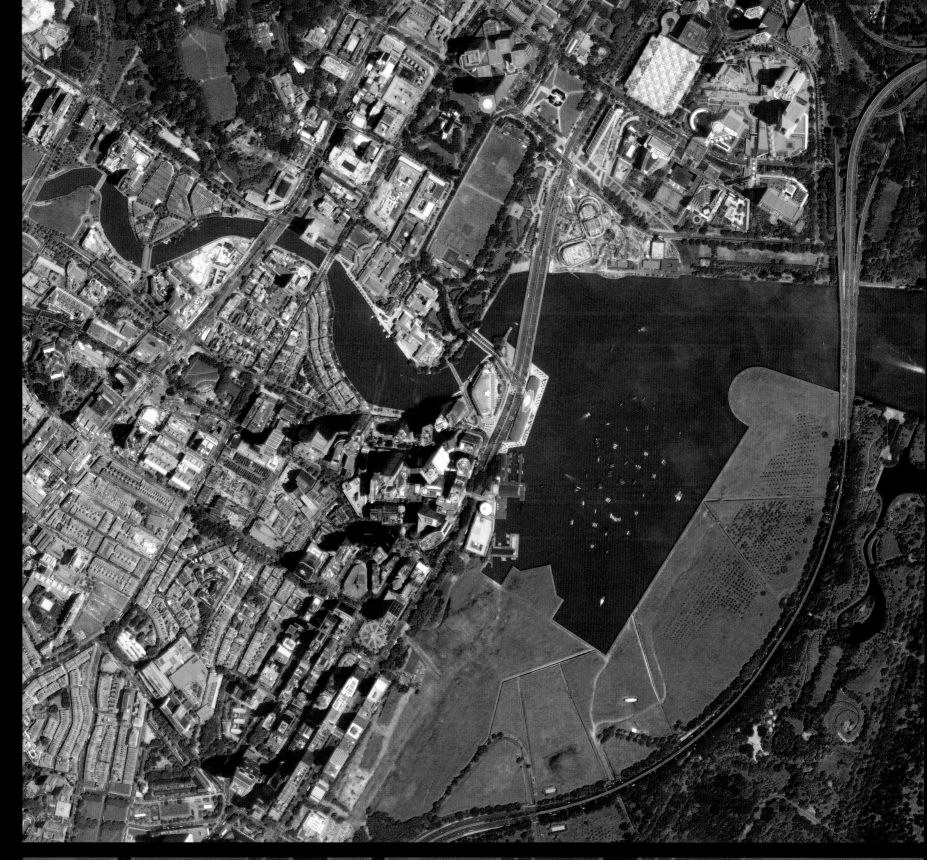

▶ **In a city of showpieces**, Marina Bay on the south shore of the island is the most striking. Drivers on the East Coast Parkway (right) are treated to an impressive panorama of high-rise hotels and futuristic office towers. The green reclaimed land on the southern and eastern shores of Marina Bay is currently in the throes of commercial and residential development. On the north shore, the two oval buildings form the Esplanade-Theatres on the Bay, a cultural centre designed to look like a pair of durian fruit, an aromatic local delicacy. Further north the white square of Suntec Convention Centre is part of the vast Suntec City commercial development.

**SATELLITE:** IKONOS image courtesy of GeoEye   **HEIGHT:** 423 MILES (681 KM)   **DATE:** 09 AUG 2000

The world's most powerful earthquake in 40 years shook the island of Sumatra on the morning of 26 December 2004. Measuring 9.1 on the Richter Scale, its epicentre was 100 miles (160 km) offshore in the Indian Ocean. There, the seabed had suddenly sprung up 16 ft (5 m) along a 750 mile (1200 km) fault, displacing a huge volume of water and sending a devastating tsunami wave out in all directions. Fifteen minutes later the wall of water hit the western coast of Sumatra. Two hours later it hit Sri Lanka on the other side of the Bay of Bengal, and by the end of the day more than 230,000 people had been killed and 1.7 million made homeless in 15 countries around the Indian Ocean.

the northern tip of Sumatra, was totally destroyed by the tsunami, with only 45 percent of residents able to survive.

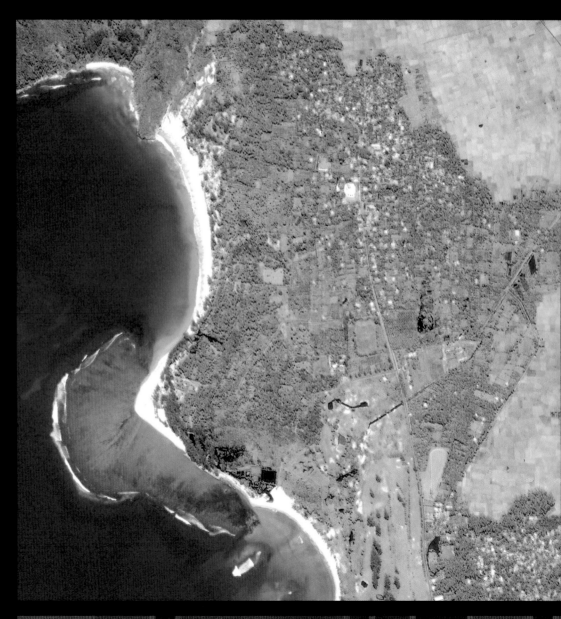

**SATELLITE:** IKONOS image courtesy of GeoEye   **HEIGHT:** 423 MILES (681 KM)   **DATE:** 10 JAN 2003

**▼ After the tsunami,** the only building standing in Lhoknga was the gleaming white edifice of the village mosque. Houses, vegetation and topsoil were scoured from the surface as a 50 ft (15 m) wave struck the shore.

**► Kalutara, Sri Lanka** (6°35'N, 80°E)
Sri Lanka suffered more than 21,000 deaths during the tsunami. This pair of images shows the western coast near Kalutara before and after the tsunami struck (top and bottom respectively). Water flooded inland with enough force to wash a train from its tracks and is seen here surging back out to sea in a trough between waves.

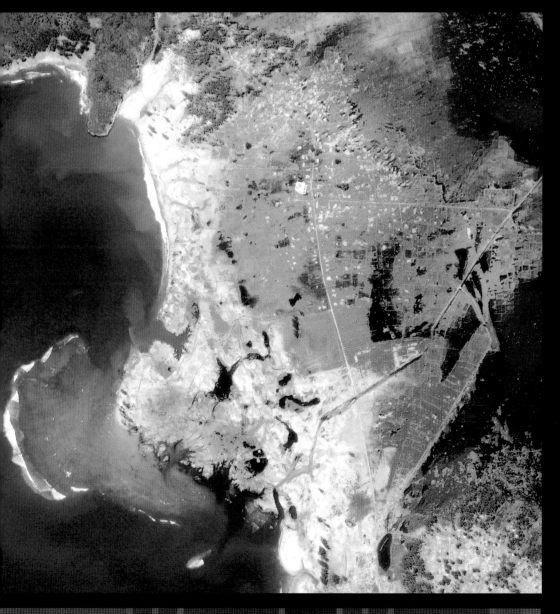

**► The Quickbird satellite** caught the tsunami in the act of hitting the Sri Lankan coast. This image shows the sea retreating about 490 ft (150 m) from the coast, exposing the sea bed. In some locations the sea can retreat up to 1.5 miles (2.5 km) from the coast ahead of the first wave of a tsunami.

**SATELLITE:** IKONOS image courtesy of GeoEye    **HEIGHT:** 423 MILES (681 KM)    **DATE:** 29 DEC 2004

**SATELLITE:** QUICKBIRD image courtesy of DigitalGlobe    **DATE:** 01 JAN 2004 (TOP), 26 DEC 2004

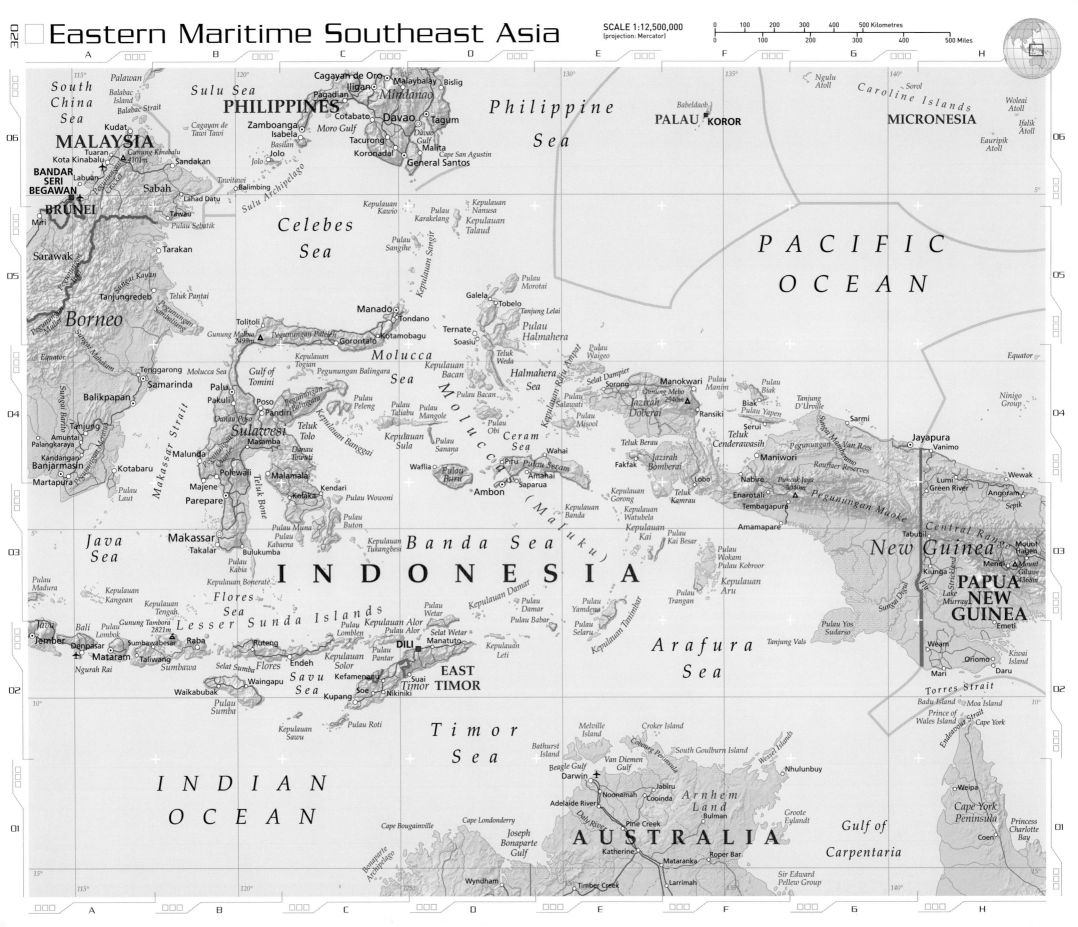

# Eastern Maritime Southeast Asia

SCALE 1:12,500,000
(projection: Mercator)

| 0 | 100 | 200 | 300 | 400 | 500 Kilometres |
| 0 | 100 | 200 | 300 | 400 | 500 Miles |

**A** **B** **C** **D** **E** **F** **G** **H**

115° 120° 130° 135° 140°

*South China Sea*

*Palawan*
*Balabac Island*
*Balabac Strait*

*Sulu Sea*

**PHILIPPINES**

Cagayan de Oro
Iligan
Malaybalay
Bislig

*Mindanao*

*Ngulu Atoll*
*Sorol*
*Caroline Islands*
*Woleai Atoll*

Kudat

**MALAYSIA**

*Cagayan de Tawi Tawi*
Pagadian
Zamboanga
Isabela
Basilan

Cotabato
Davao
Tagum

*Moro Gulf*
Tacurong
*Davao Gulf*

*Philippine Sea*

**PALAU** KOROR
*Babeldaob*

**MICRONESIA**

*Ifalik Atoll*
*Eauripik Atoll*

Tuaran
*Gunung Kinabalu 4101m*
Kota Kinabalu
Sandakan

Jolo

Koronadal
Malita

Cape San Agustin

**BANDAR SERI BEGAWAN**
Labuan

Sabah
Lahad Datu

Balimbing
*Tawitawi*

General Santos

*Sulu Archipelago*

*Celebes Sea*

*Kepulauan Kawio*
*Pulau Nanusa*

**BRUNEI**
Miri

Tawau
*Pulau Sebatik*

*Kepulauan Sangir*

*Kepulauan Nanusa*
*Kepulauan Talaud*

Sarawak

Tarakan

*Pulau Sangihe*

*Pulau Morotai*

*PACIFIC OCEAN*

*Borneo*

*Teluk Pantai*

Manado
Tondano

Galela
Tobelo

*Tanjung Lelai*

Tanjungredeb

Tolitoli
*Gunung Malino 2499m*
*Pegunungan Paleleh*
Gorontalo
Kotamobagu

Ternate
Soasiu

*Pulau Halmahera*

*Teluk Weda*

*Equator* 0°

*Sungai Kayan*

*Molucca Sea*
*Pegunungan Balingara*
*Kepulauan Togian*

*Halmahera Sea*

*Pulau Waigeo*

*Selat Dampier*

Manokwari
*Pulau Manim*

*Pulau Biak*

*Tanjung D'Urville*

*Equator* 0°

Tenggarong
Samarinda

Palu
Pakuli
Poso
Pandiri

*Gulf of Tomini*

*Kepulauan Bacan*

Sorong
*Gunung Mebo 2940m*

*Jazirah Doberai*
Ransiki

Biak
*Pulau Yapen*

Serui

Sarmi

Balikpapan

*Danau Poso*

*Sulawesi*

*Pegunungan Balingara*

*Pulau Peleng*
*Pulau Taliabu*
*Pulau Mangole*

*Pulau Salawati*
*Pulau Misool*

*Teluk Berau*

*Teluk Cenderawasih*

*Pegunungan Van Rees*

*Sungai Mamberamo*

Jayapura
Vanimo

Tanjung
Amuntai
Palangkaraya

*Sungai Barito*

Masamba

*Teluk Tolo*

*Kepulauan Banggai*

*Pulau Obi*

*Pulau Bacan*

*Ceram Sea*

Wahai

Fakfak
*Jazirah Bomberai*

*Rouffaer Reserves*

Maniwori

*Pegunungan Maoke*

Lumi
Green River

Wewak

Kandangan
Banjarmasin

*Danau Towuti*

*Kepulauan Sula*

*Pulau Sanana*

Piru
*Pulau Seram*
Amahai

Lobo

Nabire

*Puncak Jaya 5030m*

Angoram
Sepik

Martapura

Malunda

Polewali

Kolaka
Kendari

Waflia
*Pulau Buru*

Ambon
Saparua

*Kepulauan Gorong*

Enarotali
Tembagapura

Majene
Parepare

*Teluk Bone*

*Pulau Wowoni*

*Kepulauan Watubela*

*Teluk Kamrau*

Amamapare

Tabubil

*Central Range*

*New Guinea*

Mount Hagen

Makassar
Takalar

*Pulau Muna*
*Pulau Kabaena*
*Pulau Buton*

*Banda Sea*

*Kepulauan Banda*

*Pulau Kai Besar*

Kiunga

*Lake Murray*

Mendi
*Mount Giluwe 4368m*

*Java Sea*

Bulukumba

*Kepulauan Tukangbesi*

*Kepulauan Kai*

*Pulau Wokam*
*Pulau Kobroor*

**PAPUA NEW GUINEA**

5°

*Pulau Kabia*

*Kepulauan Bonerate*

**INDONESIA**

*Pulau Aru*

*Sungai Digul*

*Pulau Madura*

*Kepulauan Kangean*

*Flores Sea*

*Lesser Sunda Islands*

*Pulau Lombok*

*Kepulauan Aru*

*Sungai Fly*

Emeti

*Kepulauan Tengah*

*Pulau Lomblen*
*Kepulauan Alor*

*Pulau Damar*

*Pulau Yamdena*

*Pulau Trangan*

Weam
Oriomo

*Kiwai Island*

*Java*
*Bali*
*Gunung Tambora 2821m*
Raba
Ruteng

*Pulau Solor*
*Pulau Pantar*
*Pulau Alor*

*Selat Wetar*
Manatuto

*Pulau Yos Sudarso*

Daru

Jember
Denpasar
Mataram
Sumbawabesar
Taliwang
Sumbawa

Endeh
*Flores*

**DILI**

*Pulau Wetar*

*Pulau Damar*
*Pulau Babar*

*Pulau Selaru*

*Kepulauan Tanimbar*

Mari

Ngurah Rai

Waingapu

Kefamenanu

Suai
*Timor*

**EAST TIMOR**

*Kepulauan Leti*

*Arafura Sea*

*Tanjung Vals*

*Torres Strait*

Waikabubak
Soe
Nikiniki

Kupang

*Savu Sea*

*Badu Island*
*Moa Island*

10°

*Pulau Sumba*

*Kepulauan Sawu*

*Pulau Roti*

*Timor Sea*

*Prince of Wales Island*
Cape York

*Melville Island*
Croker Island
*South Goulburn Island*

*Wessel Islands*

*Cape York Peninsula*

*Bathurst Island*

*Van Diemen Gulf*

*Coburg Peninsula*

Nhulunbuy

*INDIAN OCEAN*

Cape Bougainville
Cape Londonderry

*Beagle Gulf*
Darwin
Noonamah
Jabiru
Cooinda

*Arnhem Land*

*Groote Eylandt*

Weipa

*Joseph Bonaparte Gulf*

Adelaide River
Pine Creek
Bulman

*Gulf of Carpentaria*

*Cape York Peninsula*

Katherine

*Daly River*

**AUSTRALIA**

*Princess Charlotte Bay*

Coen

*Bonaparte Archipelago*

Wyndham
Timber Creek

Mataranka
Roper Bar

Larrimah

*Sir Edward Pellew Group*

115° 120° 125° 130° 135° 140°

"12E".


AUSTRALASIA

# Political

**Australasia and Oceania,** covering a land area of 3,285,048 sq miles (8,508,238 sq km), takes in 14 countries including the continent of Australia, New Zealand, Papua New Guinea and many island groups scattered across the Pacific Ocean. Australia covers the largest area, 2,967,893 sq miles (7,686,850 sq km) and Nauru covers the smallest 8.1 sq miles (21 sq km). Of the total population of 32.3 million, the largest number, 4.35 million are concentrated in Sydney, Australia. Politically, the region has been strongly shaped by colonial influences since the latter part of the 18th century. Many of the islands became overseas territories of the UK, France and the US. Since the 1960s many of them have become independent nations.

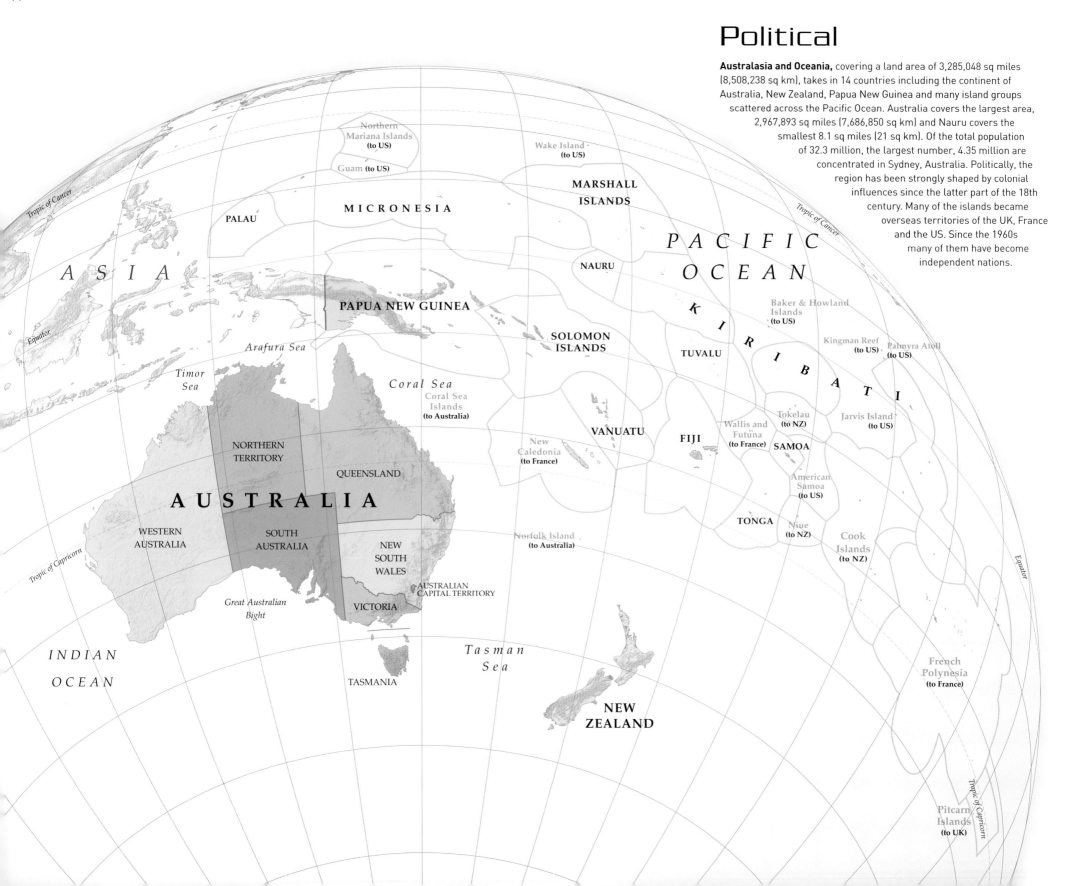

# Physical

**Australasia** is made up of Australia, New Zealand and several nearby islands. Australia itself consists of many eroded plateaus, lying firmly in the middle of the Indo-Australian Plate. It is the world's flattest continent, and the driest, after Antarctica. The mountains of the Great Dividing Range form a natural barrier between the eastern coastal areas and the flat, dry plains and desert regions of the Australian 'outback'. New Zealand comprises two large islands – South Island where tectonic activity has influenced the formation of the Southern Alps and North Island which is flatter and more volcanic in character. Oceania consists of three island chains – Melanesia which has larger islands and many volcanoes, and Micronesia and Polynesia, which are collections of coral atolls.

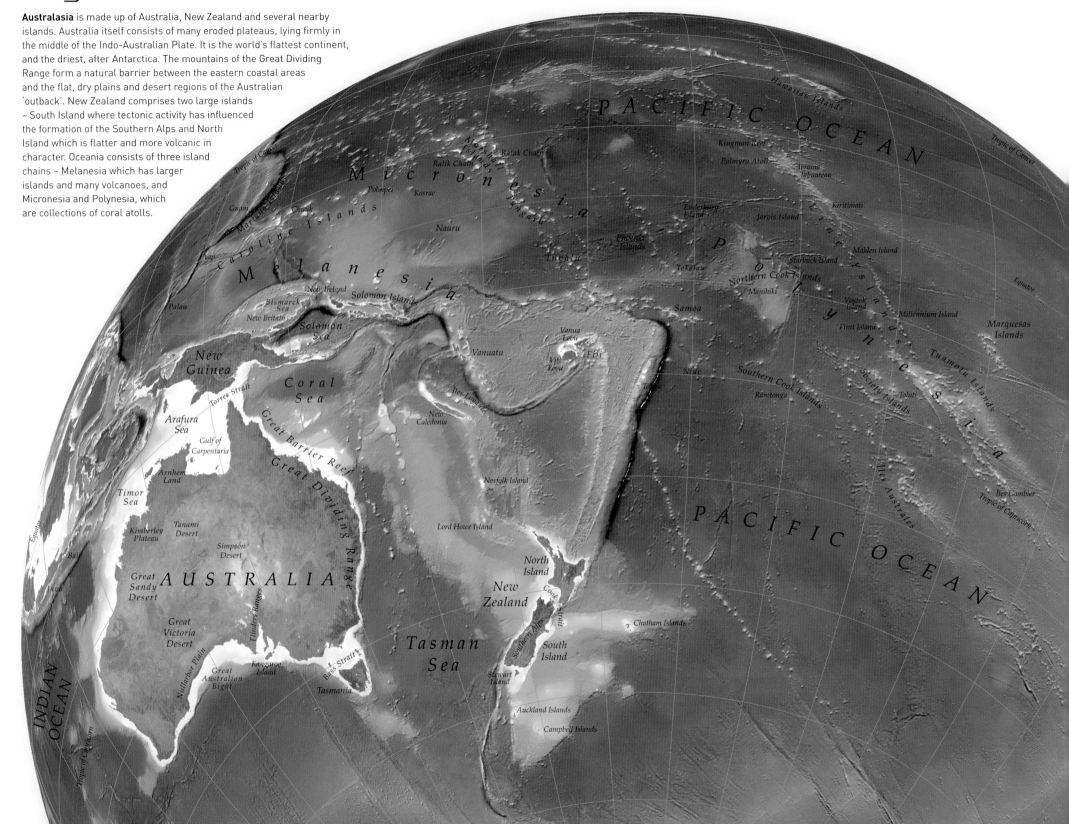

# Australia

SCALE 1:18,500,000
(projection: Lambert Conformal Conic)

| 0 | 200 | 400 | 600 | 800 Kilometres |
| 0 | 200 | 400 | 600 | 800 Miles |

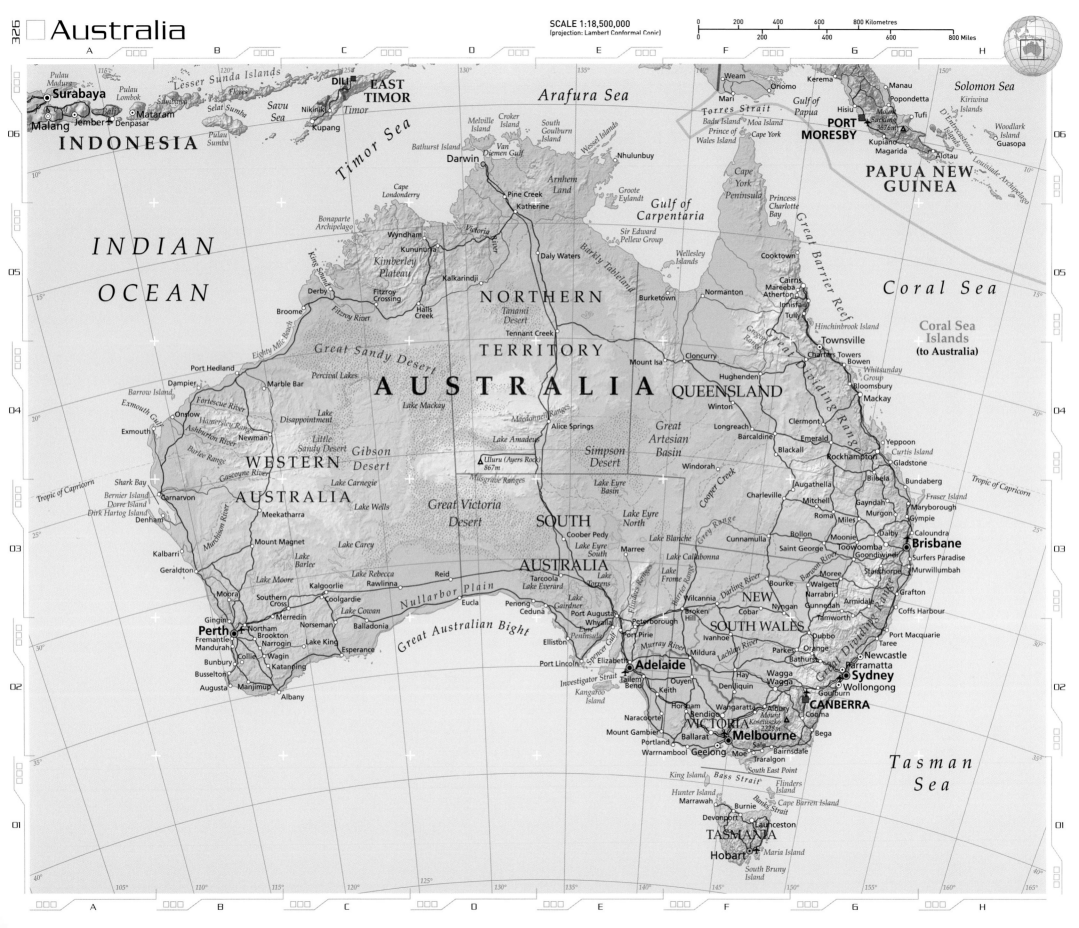

**INDONESIA**

*Pulau Madura*
Surabaya
Malang
Jember Denpasar
Mataram
*Bali* *Pulau Lombok*
*Sumbawa*
*Flores*
*Pulau Sumba*

*Lesser Sunda Islands*

DILI
**EAST TIMOR**
Nikiniki
Kupang
*Timor*

*Savu Sea*
*Selat Sumba*

*Arafura Sea*

*Torres Strait*
Weam
Oriomo
Kerema
Mari
Hisiu
Manau
Popondetta
**PORT MORESBY**
Tufi
Kupiano
Magarida
Alotau

*Solomon Sea*
*Kiriwina Islands*
*Woodlark Island*
*Guasopa*

**PAPUA NEW GUINEA**

*Timor Sea*
*Bathurst Island*
*Melville Island*
*Van Diemen Gulf*
Darwin
*Croker Island*
*South Goulburn Island*
Nhulunbuy
*Wessel Islands*

*Gulf of Carpentaria*

*Cape York*
*Cape York Peninsula*
*Princess Charlotte Bay*

**INDIAN OCEAN**

*Bonaparte Archipelago*
Wyndham
Kununurra
Pine Creek
Katherine

*Victoria River*
Daly Waters

*Arnhem Land*

*Groote Eylandt*
*Sir Edward Pellew Group*
*Wellesley Islands*
Burketown
Normanton

Cooktown
Cairns
Mareeba
Atherton
Innisfail
Tully

*Great Barrier Reef*

*Coral Sea*

**Coral Sea Islands (to Australia)**

King Sound
Derby
*Fitzroy River*
Halls Creek
Kalkarindji
Broome

*Eighty Mile Beach*

*Kimberley Plateau*
*Fitzroy Crossing*

*Great Sandy Desert*

**NORTHERN**

*Tanami Desert*
Tennant Creek

**TERRITORY**

*Barkly Tableland*
Mount Isa
Cloncurry

Charters Towers
Townsville
Bowen
*Whitsunday Group*
Bloomsbury
Mackay

*Hinchinbrook Island*

Port Hedland
Dampier
*Fortescue River*
Onslow
Newman
Marble Bar

*Percival Lakes*
*Lake Disappointment*

**AUSTRALIA**

Hughenden

*Gregory Range*

*Barrow Island*
*Exmouth Gulf*
Exmouth
*Hamersley Range*
*Ashburton River*

*Little Sandy Desert*

*Gibson Desert*

*Macdonnell Ranges*
Alice Springs

**QUEENSLAND**

Winton
Longreach
Clermont
Emerald
Rockhampton
Yeppoon
*Curtis Island*
Gladstone

*Great Dividing Range*

Shark Bay
*Bernier Island*
*Dorre Island*
*Dirk Hartog Island*
Denham
Carnarvon

*Barlee Range*
*Gascoyne River*
Meekatharra
*Lake Carnegie*

**WESTERN**

*Lake Amadeus*
△ Uluru (Ayers Rock) 867m
*Musgrave Ranges*

*Simpson Desert*

*Great Artesian Basin*

Barcaldine
Blackall
Windorah

*Cooper Creek*

Charleville
Augathella
Mitchell
Roma
Miles

Bundaberg
*Fraser Island*
Gayndah
Murgon
Maryborough
Gympie
Caloundra

**Tropic of Capricorn**

*Murchison River*
Kalbarri
Geraldton

**AUSTRALIA**

*Lake Moore*
*Lake Barlee*
Mount Magnet
*Lake Carey*

*Great Victoria Desert*

**SOUTH**

*Lake Eyre North*

Coober Pedy

*Grey Range*

Cunnamulla
Bollon
Moonie
Dalby
Toowoomba
**Brisbane**
Goondiwindi
Surfers Paradise
Stanthorpe
Murwillumbah

*Lake Rebecca*
Reid
Rawlinna

**AUSTRALIA**

*Lake Eyre South*
Marree
*Lake Blanche*
*Lake Callabonna*

Saint George

Moree
Warwick

Moora
Southern Cross
Coolgardie
Kalgoorlie
*Lake Cowan*

*Nullarbor Plain*

Tarcoola
*Lake Everard*
*Lake Torrens*
*Lake Frome*

*Barrier Range*
*Flinders Ranges*

Bourke
Cobar
Wilcannia
Nyngan

Narrabri
Walgett
Gunnedah
Armidale
Tamworth
Grafton
Coffs Harbour

**NEW**

Gingin
Perth
Fremantle
Mandurah
Northam
Brookton
Merredin
Norseman
Balladonia
Eucla
Penong
Ceduna
*Eyre Peninsula*
Whyalla
Port Augusta
Port Pirie
Peterborough
Broken Hill

Ivanhoe
Cobar

**SOUTH WALES**

Dubbo
Orange
Bathurst
Parkes
Taree
Port Macquarie

Bunbury
Busselton
Augusta
Collie
Wagin
Katanning
Narrogin
Lake King
Esperance
Elliston
Port Lincoln
Elizabeth
Adelaide
Tailem Bend
*Kangaroo Island*
*Investigator Strait*
*Spencer Gulf*
*Murray River*
Mildura
Hay
Denliquin
Wagga Wagga
Goulburn
Parramatta
**Sydney**
Wollongong
**CANBERRA**
Cooma

*Great Australian Bight*

Manjimup
Albany

*Lachlan River*
*Darling River*

Ouyen
Keith
Naracoorte
Mount Gambier
Portland
Warrnambool
Horsham
Bendigo
Ballarat
Geelong
**Melbourne**
Wangaratta
Albury
Mount Kosciuszko 2228m
Bega

**VICTORIA**

Sale
Moe
Traralgon
Bairnsdale

*South East Point*

*King Island*
*Bass Strait*
*Flinders Island*
*Cape Barren Island*
*Hunter Island*
Marrawah
Burnie
*Banks Strait*
Devonport
Launceston

**TASMANIA**

Hobart
*Maria Island*
*South Bruny Island*

*Tasman Sea*

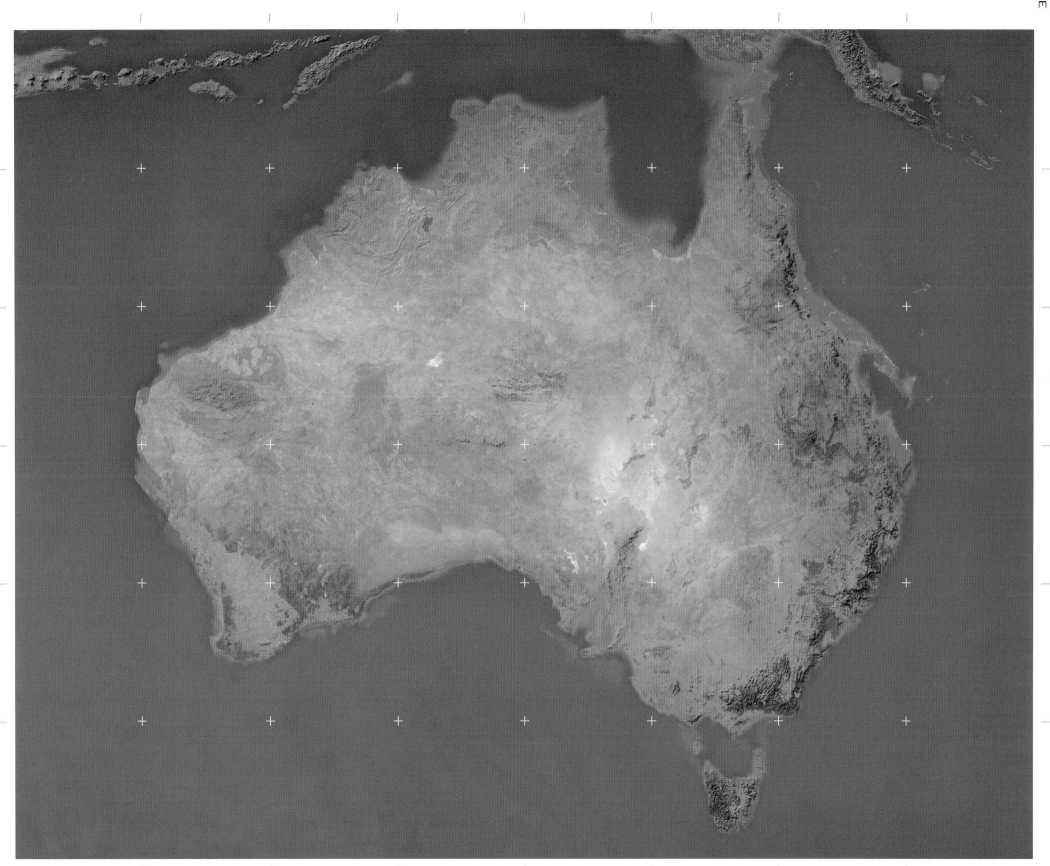

# ULURU

## 25°20'S, 130°59'E

This large outcrop is Australia's most well-known natural landmark and a sacred site for the country's Aboriginal people. Originally called Ayers Rock, after the Chief Secretary of South Australia, its traditional Aboriginal name was adopted in 1993 and both names are now used together. Standing 1142 ft (348 m) above the surrounding plain, Uluru's feldspar-rich sandstone was originally eroded from granite, making it particularly hard. Its steep sides are very resistant to erosion. Described by the first European to see it as 'a remarkable pebble', and often referred to as a monolith, the rock is in fact the tip of a much larger bedrock layer, protruding through later sediments.

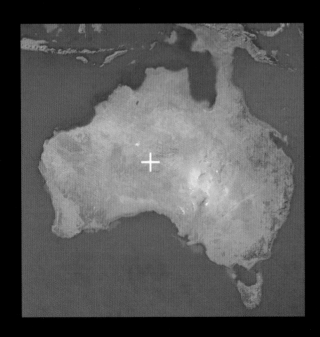

▶ **Uluru's striking red colour,** particularly prominent around sunrise and sunset, is due to oxidation of the rock surface. A small Aboriginal settlement and an airstrip can be seen near the western end of the rock in this image, which is about 5 miles (8 km) across.

**SATELLITE:** IKONOS image courtesy of GeoEye    **HEIGHT:** 423 MILES (681 KM)    **DATE:** 17 JAN 2004

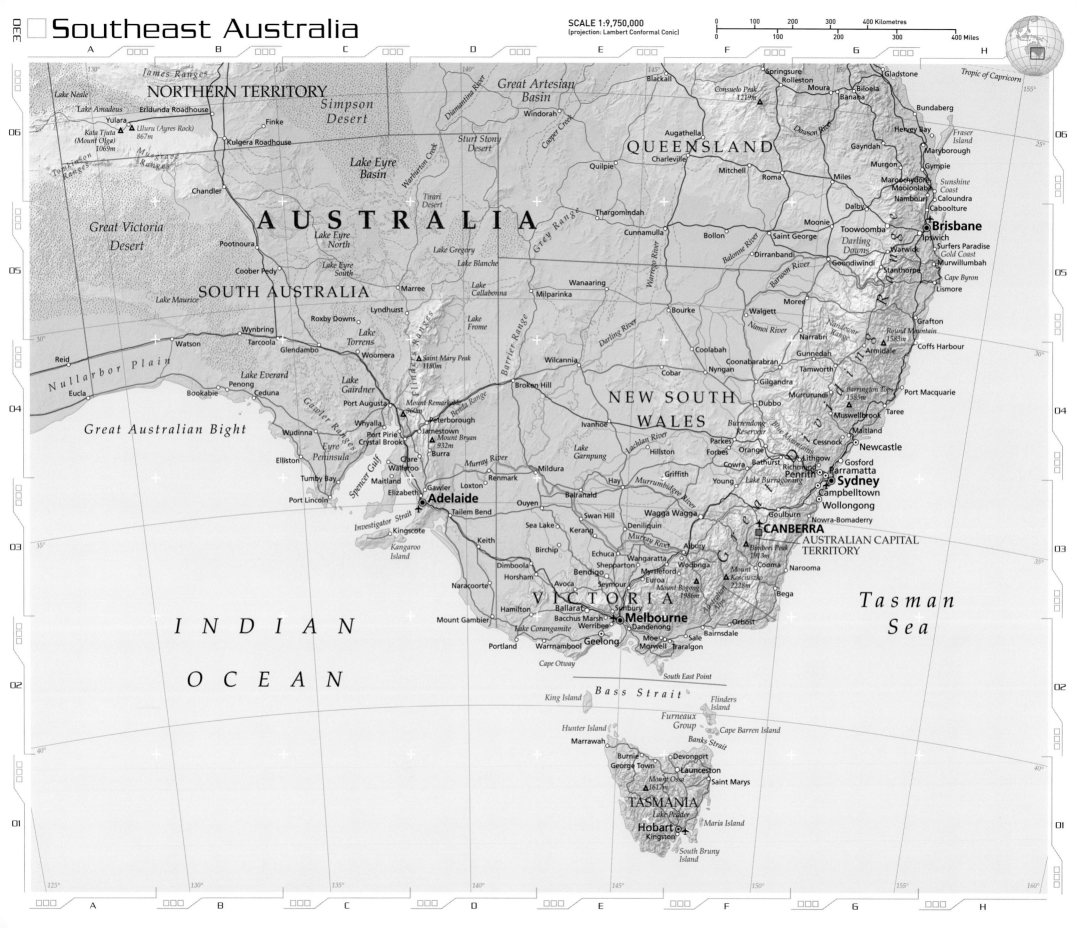

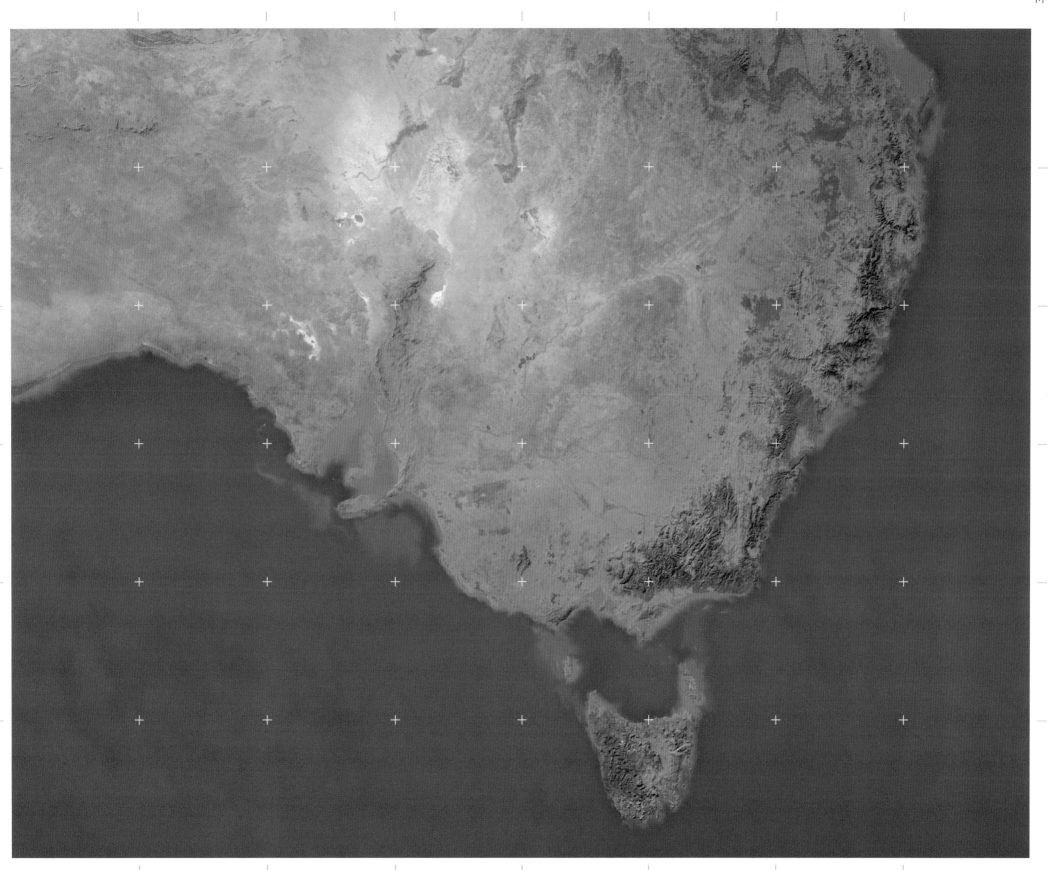

# SYDNEY
## 33°55'S, 151°10'E

The first European settlement in Australia, founded in 1788 by the administrators of a penal colony on Botany Bay, Sydney is now one of the greatest metropolitan centres of the Southern Hemisphere. Originating on the south side of the superb natural harbour of Port Jackson, at the mouth of the Parramatta river, Sydney has outstanding port facilities. The city has now expanded on the north and south shores of Sydney Harbour. The two parts of the city are linked by the Sydney Harbour Bridge, a steel arch span of 1650 ft (503 m) completed in 1932. Sydney is the capital of New South Wales.

► **The urban sprawl** of Sydney now links the jagged inlet of Port Jackson (top) with the open expanse of Botany Bay (bottom), suburbs extending across both waterways to the north and south.

► ► **This high resolution image** shows several of the features of Sydney Harbour, most famously the distinctive sail-like roofs of the Sydney Opera House, set on its promontory, which was completed in 1973.

**SATELLITE:** TERRA (EOS AM-1), ASTER   **HEIGHT:** 438 MILES (705 KM)   **DATE:** 12 OCT 2001

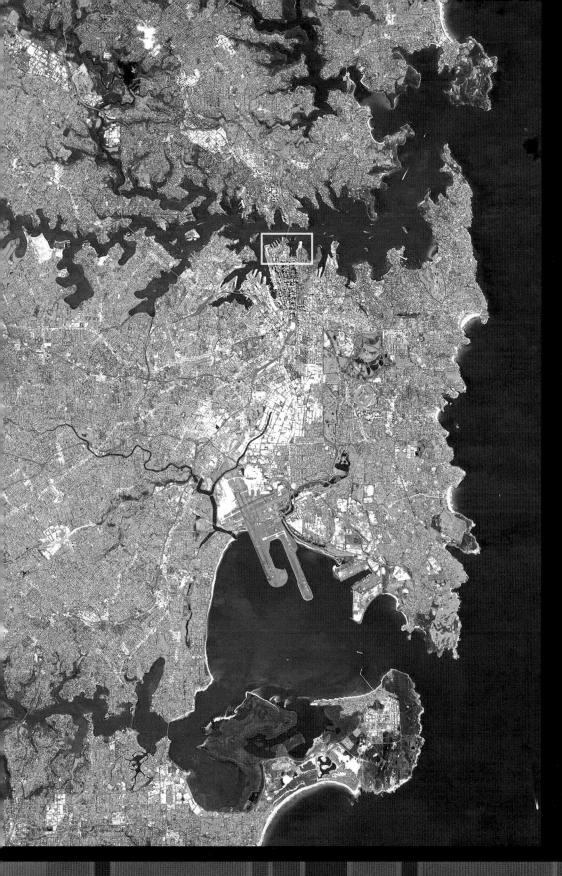
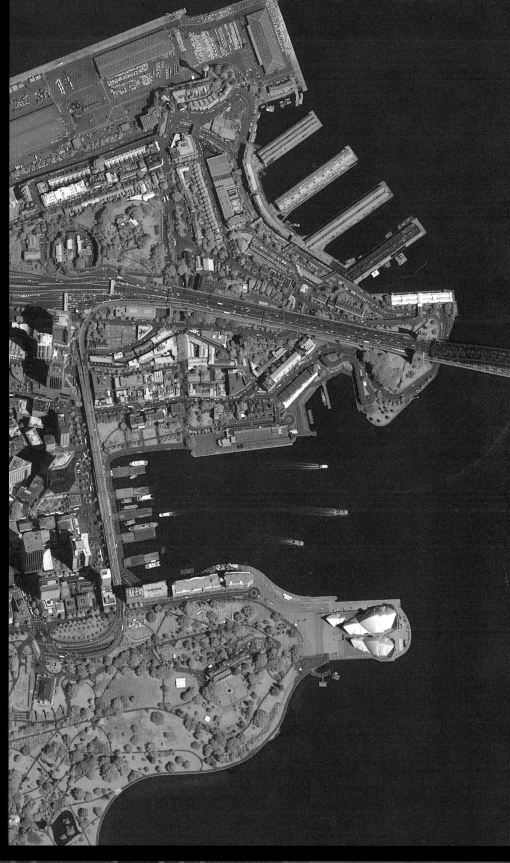

# GREAT BARRIER REEF

## 18°S, 146°50'E

A World Heritage Site for its natural beauty and biodiversity, the Great Barrier Reef stretches more than 1242 miles (2000 km) along Australia's northeast coast. Sometimes referred to as the world's largest living organism, it actually consists of thousands of individual reefs that have grown in shallow waters since the end of the last ice age. Containing some 400 species of coral and 1500 species of fish, these reefs are a very diverse, but fragile, ecosystem vulnerable to human activity and climate change. A national park has been established to protect large parts of the reef, with limited zones where diving, reef walking and other activities are allowed.

▶ **Rockingham Bay** and Hinchinbrook Island are shown in this Landsat image of individual reefs. They are located about 31 miles (50 km) offshore south of Cairns.

**SATELLITE:** LANDSAT 7   **INSTRUMENT:** ETM+   **HEIGHT:** 438 MILES (705 KM)   **DATE:** 14 AUG 1999

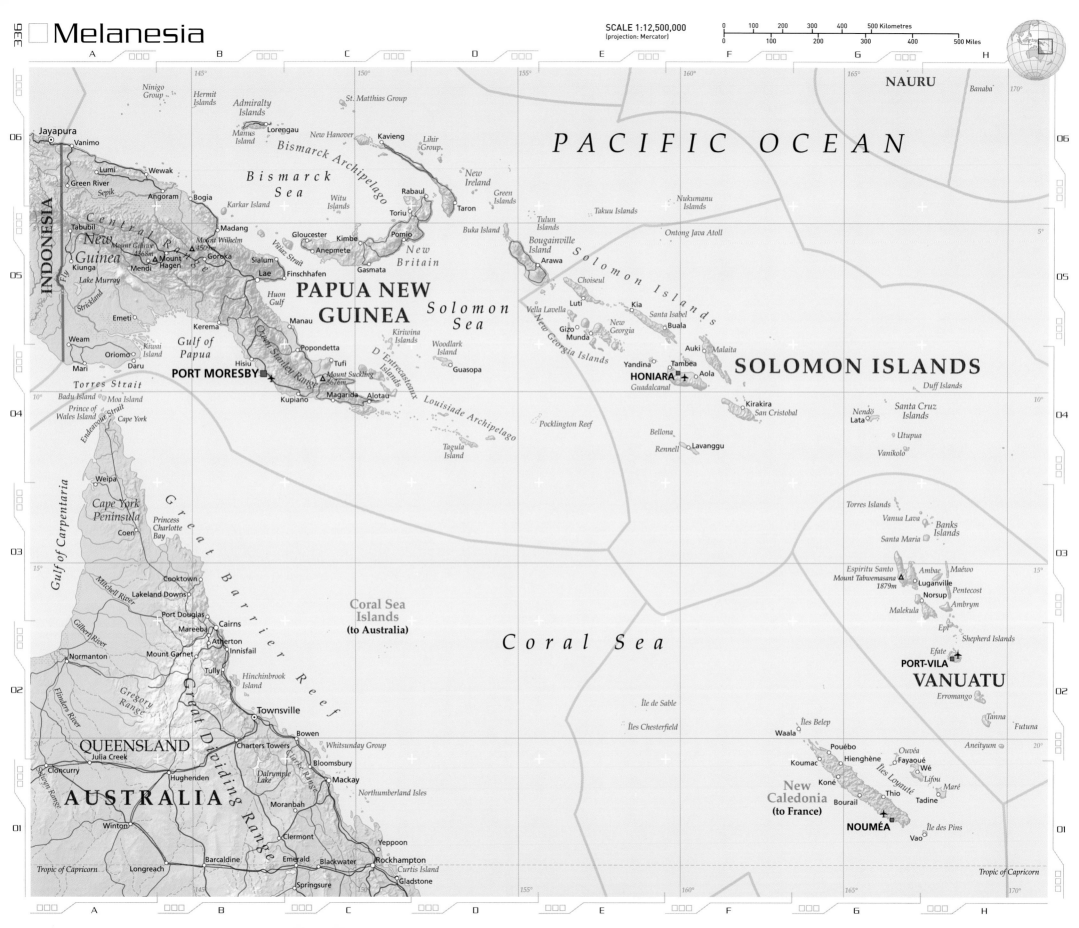

# Melanesia

SCALE 1:12,500,000
(projection: Mercator)

0 100 200 300 400 500 Kilometres
0 100 200 300 400 500 Miles

**NAURU**

*Banaba*

**PACIFIC OCEAN**

*Ninigo Group*
*Hermit Islands*
*Admiralty Islands*
*St. Matthias Group*
*Nukumanu Islands*

Jayapura
Vanimo
Lumi
Wewak
Green River
Sepik
Angoram
Bogia
Madang
Tabubil
Mount Giluwe 4368m
Mount Wilhelm 4509m
Mount Hagen
Mendi
Goroka
Kiunga
Lake Murray
Sialum
Strickland
Lae
Finschhafen

**INDONESIA**

*Central Range*
*New Guinea*

*Fly*

Emeti
Weam
Mari
Oriomo
Daru

*Kiwai Island*

Manau
Kerema

*Gulf of Papua*

*Owen Stanley Range*

Hisiu
**PORT MORESBY**
Kupiano
Popondetta
Tufi
Mount Suckling 3676m
Magarida
Alotau

*Torres Strait*
*Badu Island*
*Moa Island*
Prince of Wales Island
Cape York
*Endeavour Strait*

Lorengau
*Manus Island*

New Hanover
Kavieng
*Lihir Group*

Bismarck Archipelago
*Bismarck Sea*
*Karkar Island*
*Witu Islands*
Gloucester
Kimbe
Anepmete
Gasmata

Rabaul
Toriu
Pomio
**New Britain**
New Ireland
Taron

*Green Islands*

Buka Island
*Tulun Islands*
*Takuu Islands*
*Ontong Java Atoll*

Bougainville Island
Arawa

**PAPUA NEW GUINEA**

*Solomon Sea*

*Kiriwina Islands*
Woodlark Island
Guasopa

*D'Entrecasteaux Islands*
*Louisiade Archipelago*
Tagula Island

*Pocklington Reef*

Choiseul
Luti
Kia
Vella Lavella
Gizo
Munda
New Georgia
*New Georgia Islands*
Santa Isabel
Buala

*Solomon Islands*

Auki
Malaita
Yandina
Tambea
**HONIARA**
Aola
Guadalcanal

**SOLOMON ISLANDS**

*Duff Islands*

Kirakira
San Cristobal
Bellona
Rennell
Lavanggu

*Nendö*
Lata
*Santa Cruz Islands*
*Utupua*
*Vanikolo*

*Torres Islands*
*Vanua Lava*
*Banks Islands*
*Santa Maria*

Espiritu Santo
Mount Tabwemasana 1879m
Luganville
Norsup
*Ambae* *Maéwo*
*Pentecost*
*Malekula*
*Ambrym*
*Epi*
*Shepherd Islands*

**Efate**
**PORT-VILA**
*Erromango*

**VANUATU**

*Tanna*
*Futuna*
*Aneityum*

Weipa
*Cape York Peninsula*
Coen
*Princess Charlotte Bay*

Cooktown
Lakeland Downs
Port Douglas
Mareeba
Cairns
Atherton
Innisfail
Mount Garnet
Tully

*Great Barrier Reef*
*Hinchinbrook Island*

Normanton

*Gulf of Carpentaria*

*Mitchell River*
*Gilbert River*
*Flinders River*

*Gregory Range*
*Selwyn Range*

Cloncurry
Julia Creek
Hughenden
Winton
Longreach
Barcaldine
Clermont

**QUEENSLAND**
**AUSTRALIA**

Charters Towers
Townsville
Bowen
Bloomsbury
Mackay
Moranbah
*Clarke Range*
*Dalrymple Lake*
*Whitsunday Group*
*Northumberland Isles*

Yeppoon
Emerald
Blackwater
Springsure
Rockhampton
Gladstone
*Curtis Island*

**Coral Sea Islands (to Australia)**

**Coral Sea**

*Île de Sable*
*Îles Chesterfield*

Waala
*Îles Belep*
Pouébo
Koumac
Hienghène
*Ouvéa*
*Fayaoué*
*Wé*
*Lifou*
*Îles Loyauté*
Koné
Thio
Bourail
Tadine
*Maré*

**New Caledonia (to France)**

**NOUMÉA**
*Île des Pins*
Vao

*Tropic of Capricorn*

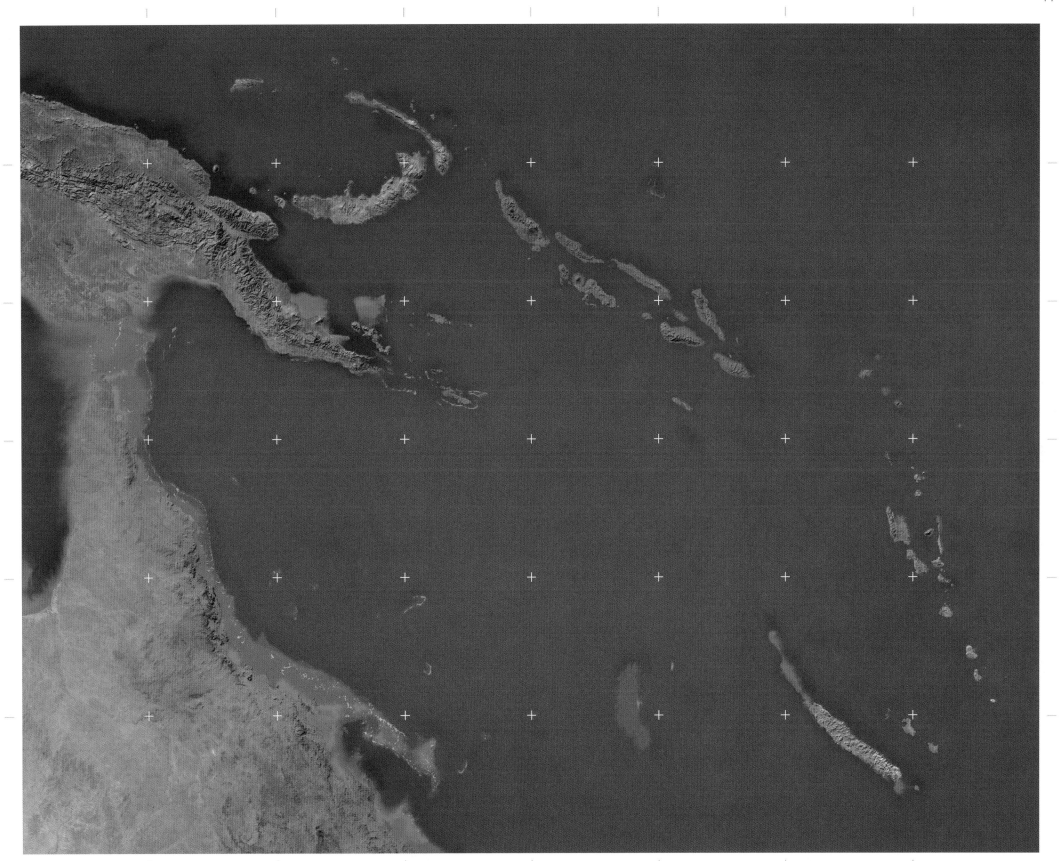

# GRASBERG MINE

## 4°03'S, 137°06'E

The Jayawijaya Mountains are the western part of the Central Range, which stretches across the island of New Guinea. Their highest peaks are the incongruous setting for one of the largest gold and copper mining operations in the world. The Grasberg Mine (also known as the Freeport Mine) is sited at an altitude of 13,860 ft (4225 m), close to the top of Puncak Jaya, the highest mountain in maritime southeast Asia and Oceania. The mine's open pit is 2.5 miles (4 km) wide and its tailings, covering an area of 3 sq miles (8 sq km), are 885 ft (270 m) deep in places.

▶ **Underground workings** link the Grasberg Mine's open pit to an ore concentrating plant 1968 ft (600 m) below, just visible in the shadows at the foot of the mountain in this astronaut photograph.

**SAT:** INTERNATIONAL SPACE STATION, KODAK DCS760C  **HEIGHT:** 220 MILES (354 KM)  **DATE:** 25 JUN 2005

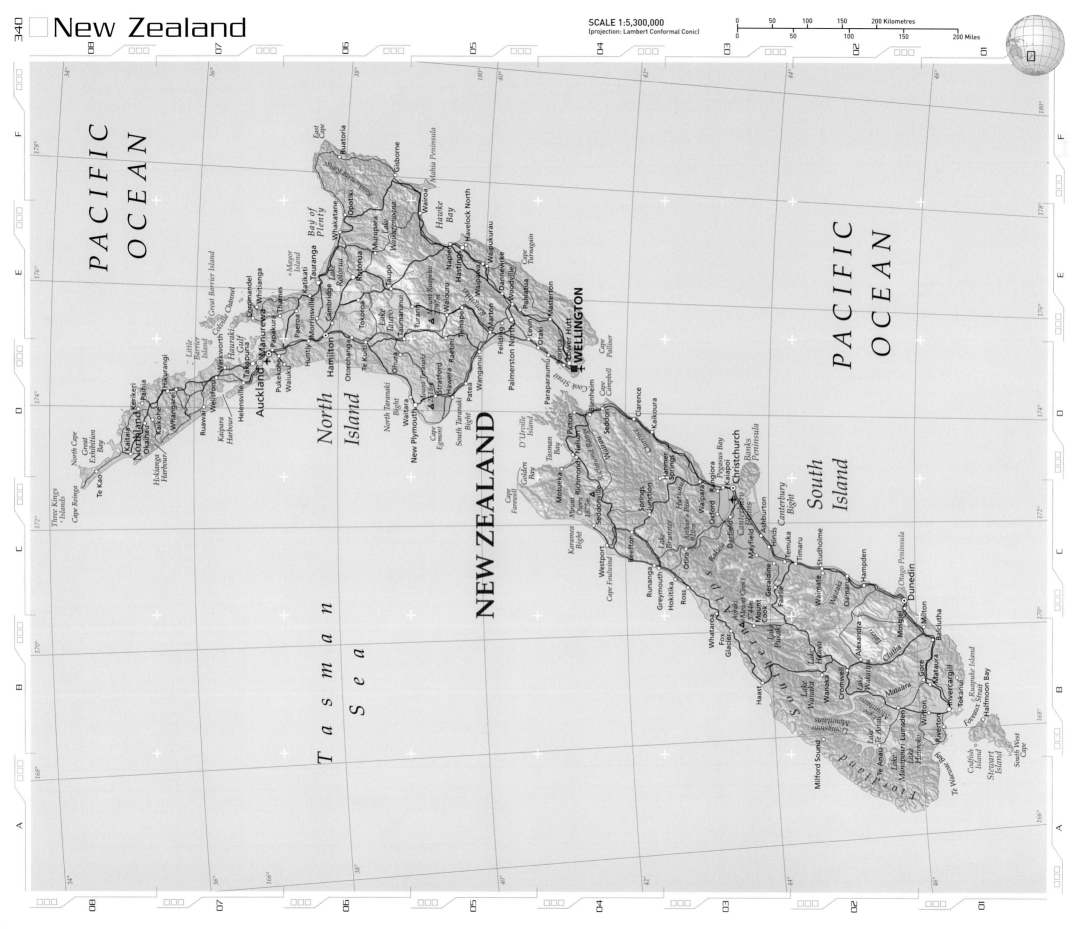

# New Zealand

SCALE 1:5,300,000
(projection: Lambert Conformal Conic)

50   100   150   200 Kilometres
50   100   150   200 Miles

PACIFIC OCEAN

PACIFIC OCEAN

Tasman Sea

**NEW ZEALAND**

North Island

South Island

North Cape
Cape Reinga
Three Kings Islands
Te Kao
Great Exhibition Bay
Kaitaia
Okaihau
Kerikeri
Paihia
Kaikohe
Hikurangi
Whangarei
Northland
Ruawai
Hokianga Harbour
Kaipara Harbour
Dargaville
Wellsford
Warkworth
Helensville
Takapuna
Auckland
Manurewa
Papakura
Pukekohe
Waiuku
Little Barrier Island
Great Barrier Island
Coromandel
Whitianga
Thames
Paeroa
Coromandel
Hauraki Gulf
Colville Channel
Mayor Island
Katikati
Tauranga
Bay of Plenty
Whakatane
Opotiki
Ruatoria
East Cape
Gisborne
Mahia Peninsula
Wairoa
Hawke Bay
Havelock North
Napier
Hastings
Waipukurau
Waipawa
Dannevirke
Woodville
Pahiatua
Cape Turnagain
Masterton
Morrinsville
Cambridge
Hamilton
Huntly
Te Kuiti
Otorohanga
Ohura
Stratford
New Plymouth
North Taranaki Bight
Waitara
Mount Taranaki 2518m
Cape Egmont
South Taranaki Bight
Hawera
Patea
Wanganui
Raetihi
Taihape
Mount Ruapehu 2797m
Waiouru
Turangi
Taumarunui
Lake Taupo
Taupo
Tokoroa
Rotorua
Lake Rotorua
Murupara
Lake Waikaremoana
Kawerau
Kaimanawa Range
Feilding
Marton
Palmerston North
Levin
Otaki
Paraparaumu
Porirua
Lower Hutt
**WELLINGTON**
Cape Palliser
Cook Strait
Cape Campbell
Blenheim
Picton
Seddon
Nelson
Motueka
Richmond
D'Urville Island
Golden Bay
Cape Farewell
Tasman Bay
Mt Owen 1875m
Owen Richmond Range
Karamea Bight
Seddonville
Westport
Cape Foulwind
Reefton
Springs Junction
Murchison
Lake Rotoiti
Hanmer Springs
Nelson Lakes
Clarence
Kaikoura
Hurunui
Waipara
Rangiora
Kaiapoi
Christchurch
Banks Peninsula
Pegasus Bay
Oxford
Darfield
Arthur's Pass 920m
Otira
Greymouth
Runanga
Hokitika
Ross
Southern Alps
Mount Cook 3744m
Aoraki (Mount Cook)
Whataroa
Fox Glacier
Franz Josef
Haast
Lake Wanaka
Lake Hawea
Wanaka
Cromwell
Lake Wakatipu
Queenstown
Lake Te Anau
Lake Manapouri
Milford Sound
Fiordland
Livingstone Mountains
Te Anau
Lumsden
Eyre Mountains
Mataura
Gore
Winton
Wyndham
Riverton
Invercargill
Foveaux Strait
Ruapuke Island
Codfish Island
Stewart Island
South West Cape
Halfmoon Bay
Tokanui
Te Waewae Bay
Mossburn
Clutha
Balclutha
Milton
Mosgiel
Dunedin
Otago Peninsula
Waikouaiti
Hampden
Oamaru
Waimate
Studholme
Timaru
Temuka
Geraldine
Fairlie
Lake Pukaki
Lake Tekapo
Rakaia
Ashburton
Hinds
Canterbury Bight
Canterbury Plains
Mayfield
Alexandra
Rangitata
Waitaki
South Island

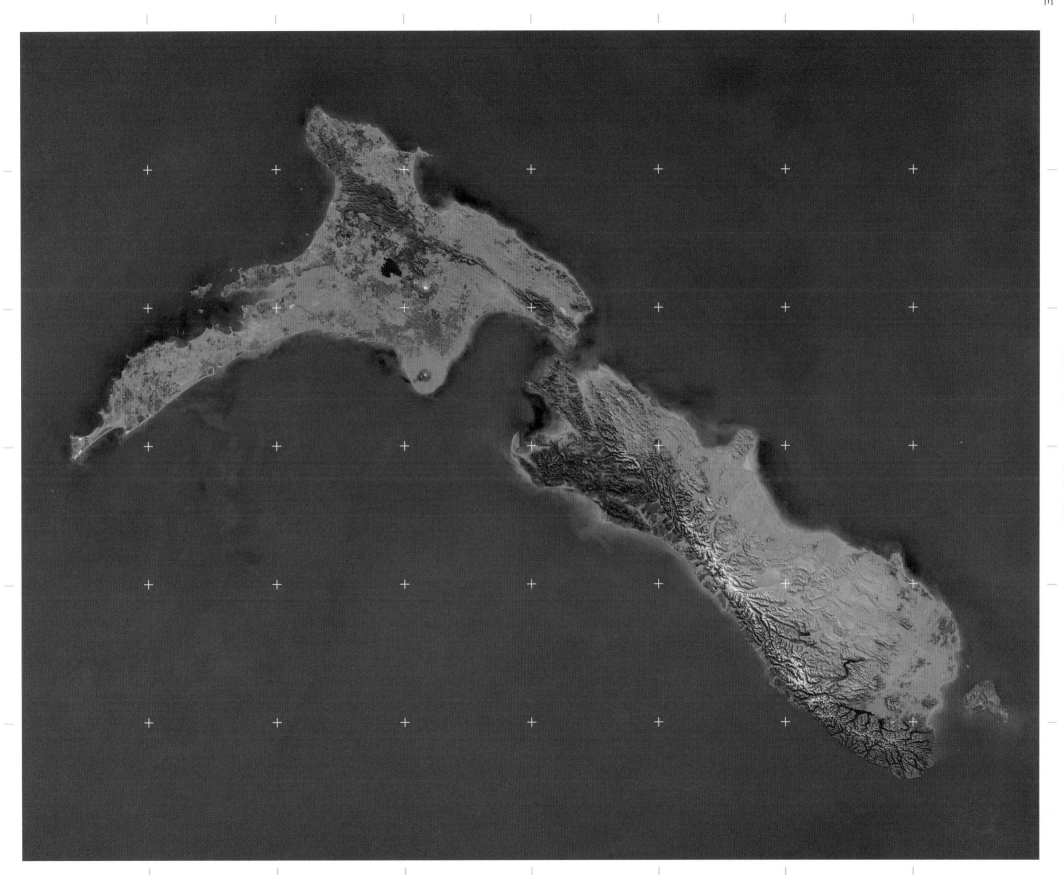

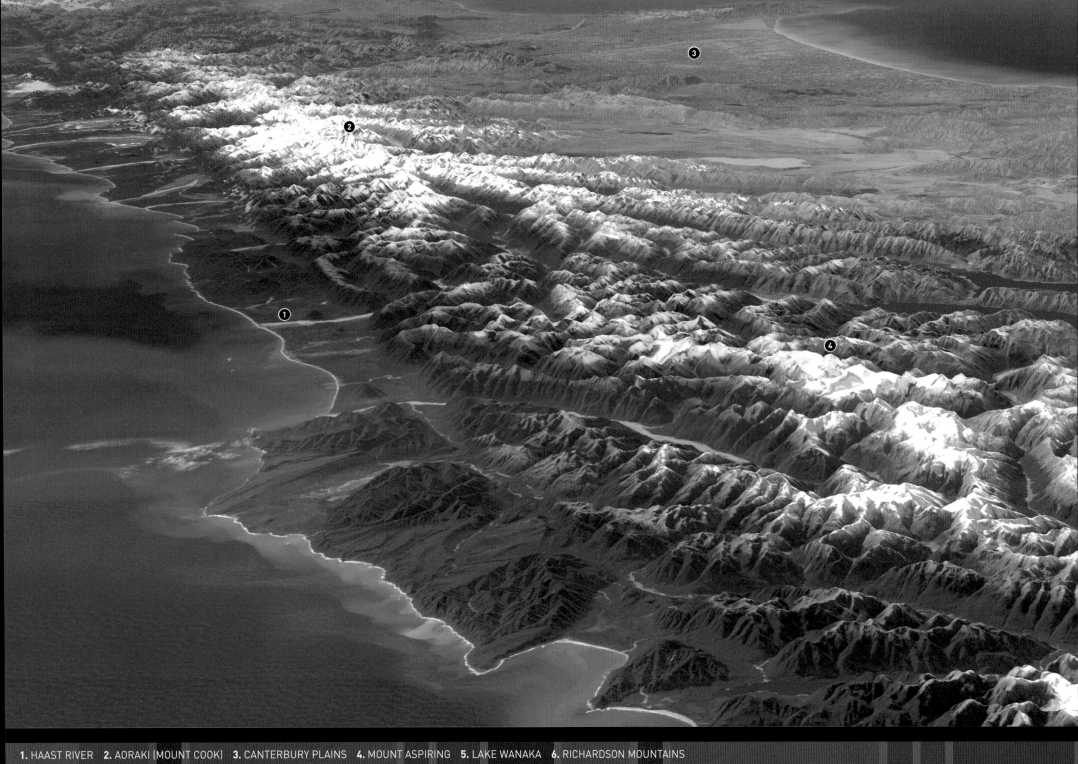

**1.** HAAST RIVER   **2.** AORAKI (MOUNT COOK)   **3.** CANTERBURY PLAINS   **4.** MOUNT ASPIRING   **5.** LAKE WANAKA   **6.** RICHARDSON MOUNTAINS

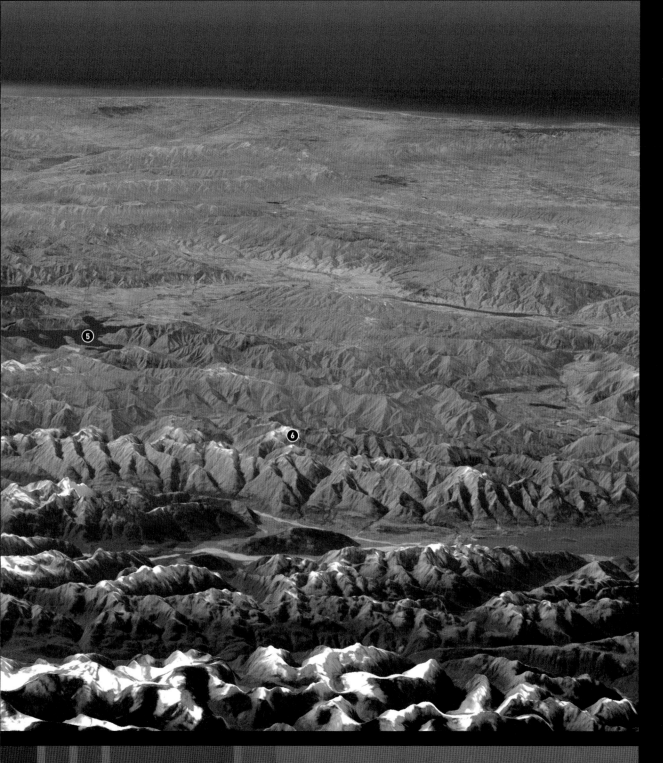

# SOUTHERN ALPS
## 43°30'S, 170°30'E

Not quite as high as their European namesakes, the Southern Alps reach 12,283 ft (3744 m) at Mount Cook, which is also known by its Maori name of Aoraki. The mountains run almost the full length of New Zealand's South Island along a transform boundary between two plates of the Earth's crust. Their western edge is marked by this boundary, whose surface expression is the remarkably straight Alpine Fault. Lying on the Australian Plate to the west, the coastal strip is flat and low-lying in contrast to the rugged mountains, which lie on the edge of the Pacific Plate.

Prevailing westerly winds bring moist air from the Tasman Sea which must rise up over the mountains, giving up its moisture in the process. The coastal mountains are thus festooned with temperate rainforest and their peaks often snow-capped, but there is a pronounced rain-shadow so that the eastern mountains and the rest of the island are relatively dry. Many of the rivers running to the east feed long lakes scoured out by glaciers during the ice age. Some of these lakes are a very pale blue colour due to suspended particles of finely-ground rock, indicating they are still predominantly fed by glacier meltwater.

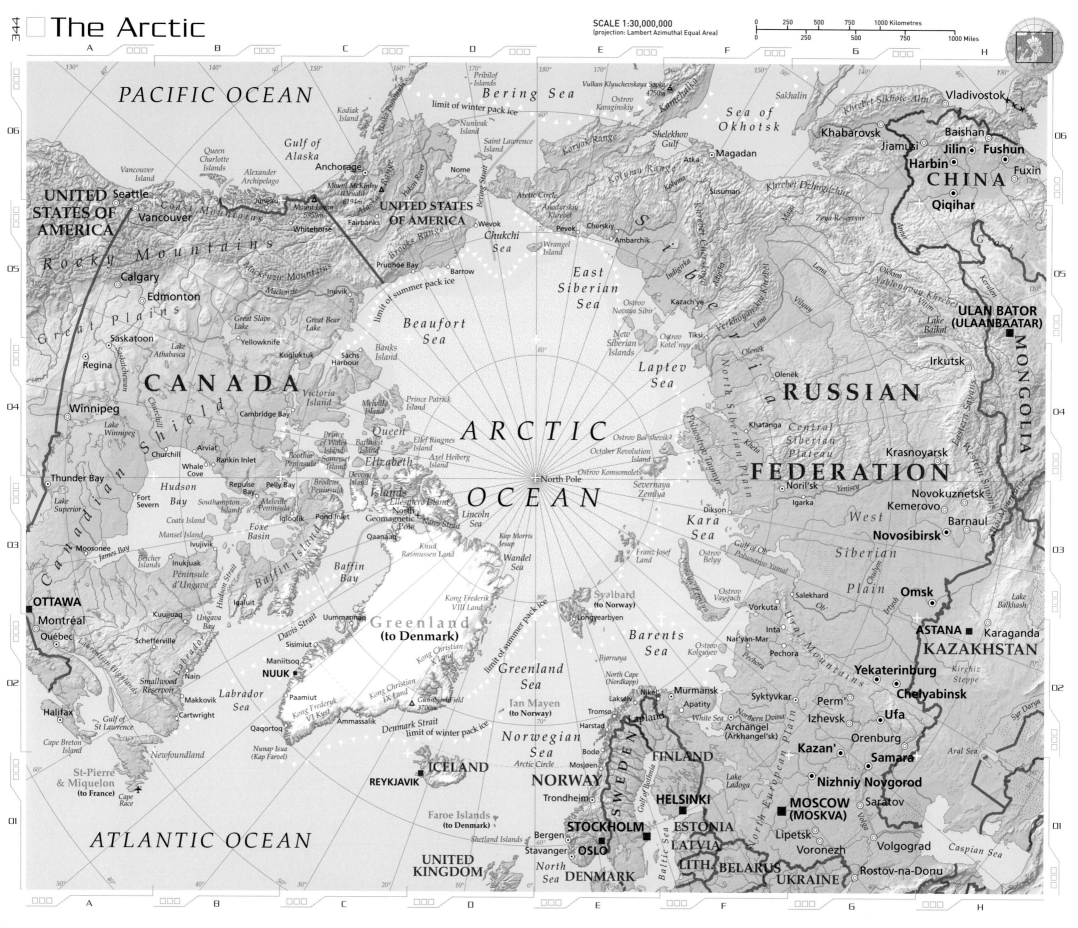

# The Arctic

SCALE 1:30,000,000
(projection: Lambert Azimuthal Equal Area)

| 250 | 500 | 750 | 1000 Kilometres |
| 250 | 500 | 750 | 1000 Miles |

**PACIFIC OCEAN**

*Bering Sea*

Vulkan Klyuchevskaya Sopka
4750m

*Sea of
Okhotsk*

Sakhalin

Khabarovsk
Jiamusi
Baishan
Jilin
Fushun

Harbin
Fuxin
Qiqihar

**CHINA**

Vladivostok

*Khrebet Sikhote-Alin*

Kodiak
Island

Pribilof
Islands

Nunivak
Island

Saint Lawrence
Island

Ostrov
Karaginskiy

Shelekhov
Gulf

Koryak Range

Magadan

Atka

Kamchatka

*Queen
Charlotte
Islands*

*Gulf of
Alaska*

Anchorage

Nome

Bering Strait

Kolyma Range

Susuman

Khrebet Dzhugdzhur

Magí

Zeya Reservoir

**ULAN BATOR
(ULAANBAATAR)**

*Vancouver
Island*

*Alexander
Archipelago*

Mount McKinley
(Denali)
6194m

Juneau

**UNITED STATES
OF AMERICA**

Wevok

Arctic Circle

Anadyrskiy
Khrebet

Cherskiy

Kolyma

Kazach'ye

Tiksi

Oleněk

Irkutsk

Lake
Baikal

**MONGOLIA**

*Coast Mountains*

Seattle

**UNITED
STATES OF
AMERICA**

Vancouver

Whitehorse

Fairbanks

Pevek

Ambarchik

Indigirka

Adycha

*Chukchi
Sea*

Wrangel
Island

Lena

Olkma

Yablonovyy Khrebet

Vitim

Kerulen

*Rocky Mountains*

Calgary

Edmonton

Mackenzie Mountains

Inuvik

Prudhoe Bay

Barrow

*Brooks Range*

*East
Siberian
Sea*

Ostrov
Novaya Sibir'

Ostrov
Kotel'nyy

Verkhoyanskiy Khrebet

*RUSSIAN*

Noril'sk

Yenisey

Novokuznetsk

Kemerovo

Barnaul

**Novosibirsk**

*Great
Plains*

Saskatoon

Lake
Athabasca

Yellowknife

Great Slave
Lake

Great Bear
Lake

Kugluktuk

Sachs
Harbour

Banks
Island

*Beaufort
Sea*

*New
Siberian
Islands*

*Laptev
Sea*

Oleněk

Olenëk

**FEDERATION**

Khatanga

*Central
Siberian
Plateau*

**Krasnoyarsk**

Mackenzie

Winnipeg

Regina

Lake
Winnipeg

*Canadian Shield*

Churchill

Arviat

Rankin Inlet

Whale
Cove

Repulse
Bay

Pelly Bay

Victoria
Island

Cambridge Bay

*Prince of
Wales
Island*

Boothia
Peninsula

Somerset
Island

*Melville
Island*

*Prince Patrick
Island*

**CANADA**

*Queen*

*Elizabeth*

Ellef Ringnes
Island

Axel Heiberg
Island

Bathurst
Island

Devon
Island

**ARCTIC**

Ostrov Bol'shevik

October Revolution
Island

*Severnaya
Zemlya*

Ostrov Komsomolets

Dikson

Igarka

*West*

*Siberian*

*Plain*

**Omsk**

Lake
Balkhash

Thunder Bay

Lake
Superior

Fort
Severn

Hudson
Bay

Southampton
Island

Coats Island

Mansel Island

Igloolik

Melville
Peninsula

Foxe
Basin

*Baffin
Island*

Pond Inlet

*Elizabeth*

*Islands*

Ellesmere Island

North

Geomagnetic
Pole

Nares Strait

Lincoln
Sea

North Pole

**OCEAN**

Kap Morris
Jesup

Wandel
Sea

Franz Josef
Land

Ostrov
Belyy

*Kara
Sea*

Gulf of Ob

Poluostrov Yamal

Ostrov
Vaygach

Salekhard

Ob'

Vorkuta

Irtysh

*Ural Mountains*

Chulym

**ASTANA**

Karaganda

**KAZAKHSTAN**

Moosonee

James Bay

Belcher
Islands

Inukjuak

Ivujivik

*Péninsule
d'Ungava*

*Baffin
Bay*

Iqaluit

Hudson Strait

Qaanaaq

Knud
Rasmussen Land

Kong Frederik
VIII Land

*Greenland
(to Denmark)*

*Svalbard
(to Norway)*

Longyearbyen

Poluostrov Taymyr

*Barents
Sea*

Ostrov
Kolguyev

Nar'yan-Mar

Pechora

Inta

**Yekaterinburg**

*Kirghiz
Steppe*

**OTTAWA**

Montréal

Québec

Kuujjuaq

Ungava
Bay

Schefferville

Nain

*Labrador
Highlands*

Labrador

*Labrador
Sea*

Sisimiut

Uummannaq

Davis Strait

Maniitsoq

Kong Christian
X Land

Kong Christian
IX Land

*Greenland
Sea*

Jan Mayen
(to Norway)

*Norwegian
Sea*

North Cape
(Nordkapp)

Bjørnøya

Niker

Murmansk

Lakselv

Apatity

*White Sea*

Syktyvkar

Perm'

**Chelyabinsk**

**Ufa**

Izhevsk

Orenburg

Halifax

Gulf of
St Lawrence

*Cape Breton
Island*

Smallwood
Reservoir

Makkovik

Cartwright

**NUUK**

Paamiut

Kong Frederyk
VI Kyst

Ammassalik

Gunnbjørn Field
3700m

Denmark Strait

limit of winter pack ice

Tromsø

Harstad

Bodø

Lapland

*Northern Dvina*

**Kazan'**

**Samara**

Aral Sea

*Newfoundland*

Cape
Race

St-Pierre
& Miquelon
(to France)

Qaqortoq

Nunap Isua
(Kap Farvel)

**ICELAND**

**REYKJAVIK**

Arctic Circle

Mosjøen

Finland

Lake
Ladoga

**Nizhniy Novgorod**

Syr Darya

Trondheim

**NORWAY**

**SWEDEN**

Gulf of Bothnia

**HELSINKI**

**MOSCOW
(MOSKVA)**

Saratov

**ATLANTIC OCEAN**

Faroe Islands
(to Denmark)

Shetland Islands

Bergen

Stavanger

**STOCKHOLM**

**OSLO**

Baltic Sea

**ESTONIA**

**LATVIA**

Lipetsk

*Caspian Sea*

Volgograd

*Volga*

**UNITED
KINGDOM**

*North
Sea*

**DENMARK**

**LITH.**

**BELARUS**

Voronezh

Rostov-na-Donu

**UKRAINE**

limit of winter pack ice

limit of summer pack ice

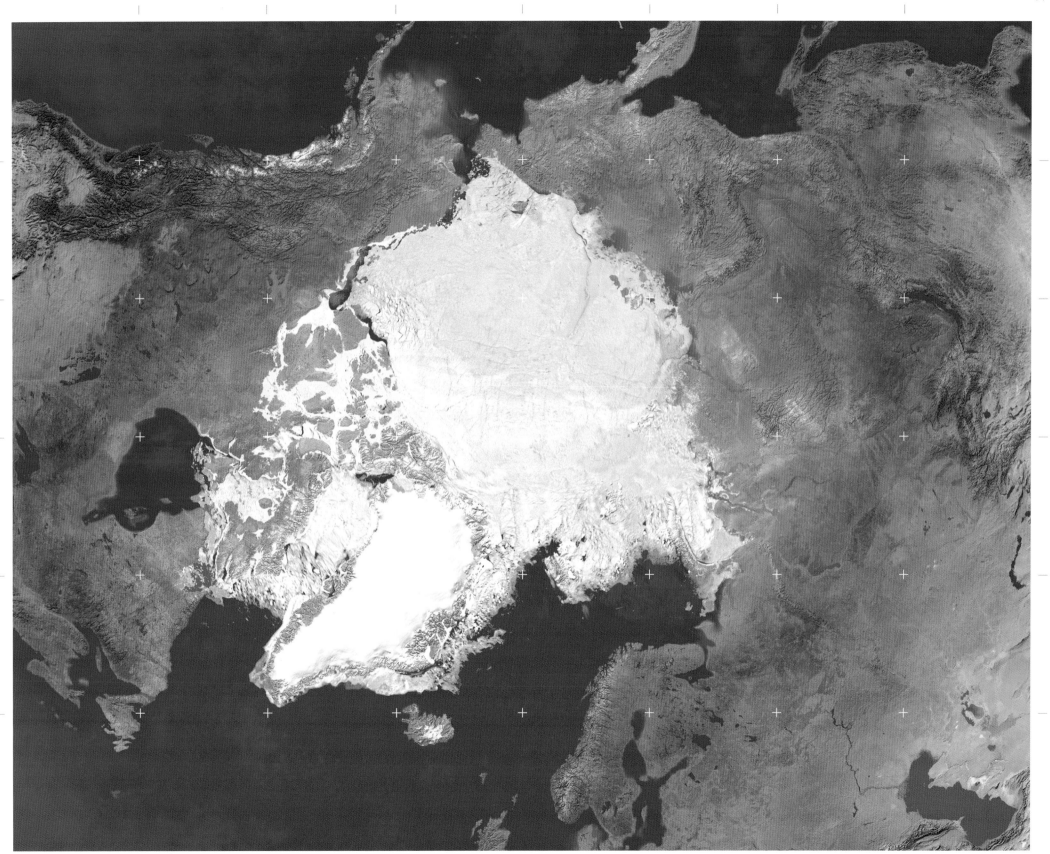

# GREENLAND

## 72°N, 40°W

A vast ice sheet covers 80% of the surface of Greenland. Its average thickness is more than 1.25 miles (2 km), and if it all melted, global sea levels would rise by about 23 ft (7 m). Satellite observations since 1979 show the area of surface ice melting each summer has been increasing. The ice loss seems to be accelerating as melting in turn helps the coastal glaciers move more quickly. Estimates of ice loss suggest that Greenland is losing 26-53 cubic miles (110-220 cubic km) of ice each year. Concern about the resulting sea level rise will ensure that the area remains the focus of intense scrutiny to see whether the changes are due to a long-term warming of the climate or a short-term fluctuation.

▶ **Satellite images** from Landsat (right) and Terra (far right) show blue meltwater pools and darker areas of old ice where the winter snow cover has melted on the lower slopes of the Greenland Ice Sheet.

**SATELLITE:** TERRA (EOS AM-1) **INSTRUMENT:** MODIS **HEIGHT:** 438 MILES (705 KM) **DATE:** 07 JUL 2002

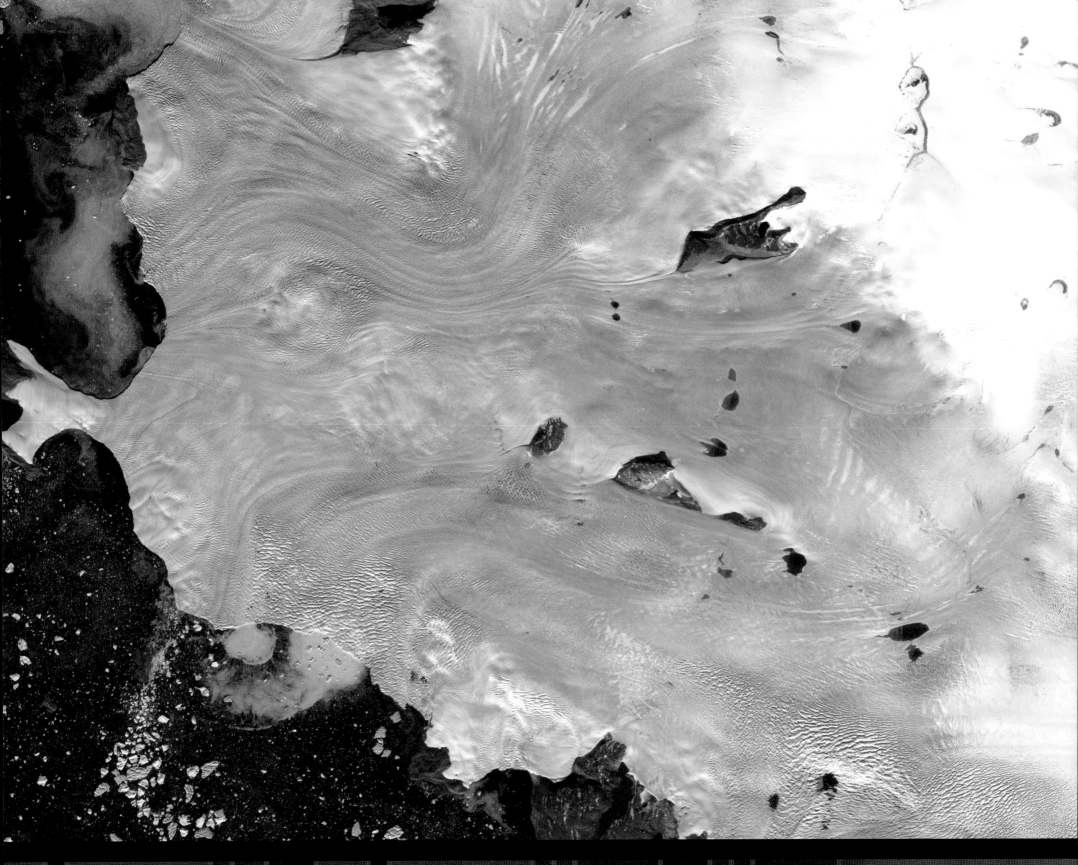

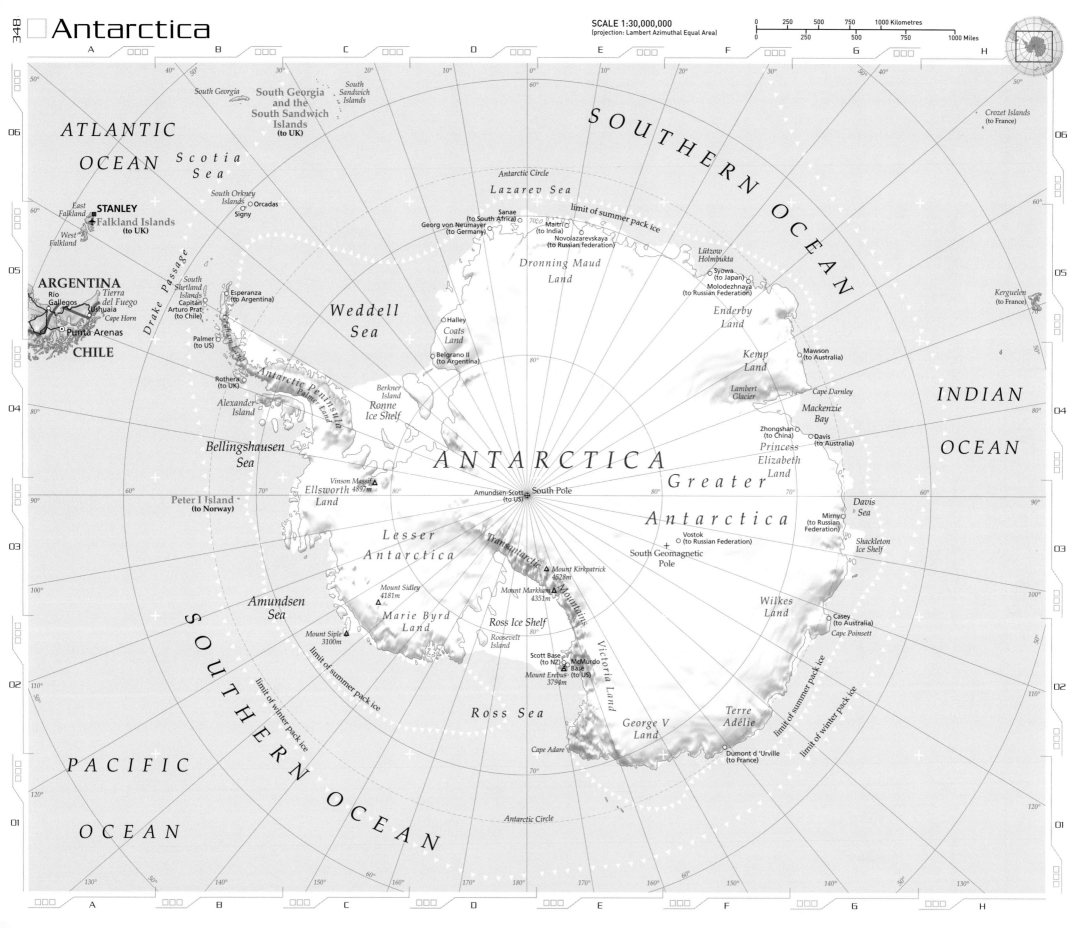

# Antarctica

SCALE 1:30,000,000
(projection: Lambert Azimuthal Equal Area)

250   500   750   1000 Kilometres
0
0    250   500   750   1000 Miles

**SOUTHERN OCEAN**

*Crozet Islands*
*(to France)*

*South Georgia*

**South Georgia
and the
South Sandwich
Islands
(to UK)**

*South Sandwich
Islands*

**ATLANTIC**

*Scotia
Sea*

**OCEAN**

*Antarctic Circle*

*Lazarev Sea*

*limit of summer pack ice*

*South Orkney
Islands*   ○ Orcadas

○ Signy

Sanae ○
(to South Africa)

Maitri ○
(to India)

Novolazarevskaya ○
(to Russian federation)

Georg von Neumayer ○
(to Germany)

Syowa ○
(to Japan)

Molodezhnaya ○
(to Russian Federation)

*Kerguelen*
*(to France)*

**STANLEY**

*East
Falkland*

**Falkland Islands
(to UK)**

*West
Falkland*

*Dronning Maud
Land*

*Lützow
Holmbukta*

**INDIAN**

**ARGENTINA**

*Río
Gallegos*

*Tierra
del Fuego*

Ushuaia

*South
Shetland
Islands*

Esperanza ○
(to Argentina)

Capitán
Arturo Prat ○
(to Chile)

*Weddell
Sea*

Halley ○

*Coats
Land*

Belgrano II ○
(to Argentina)

*Enderby
Land*

Mawson ○
(to Australia)

*Kemp
Land*

**OCEAN**

*Cape Horn*

Punta Arenas

**CHILE**

Palmer ○
(to US)

*Berkner
Island*

*Lambert
Glacier*

*Cape Darnley*

*Mackenzie
Bay*

Rothera ○
(to UK)

*Ronne
Ice Shelf*

*Alexander
Island*

*Bellingshausen
Sea*

**ANTARCTICA**

*Princess
Elizabeth
Land*

Zhongshan ○
(to China)

○ Davis
(to Australia)

*Greater*

Vinson Massif △
4897m

*Ellsworth
Land*

Amundsen-Scott ⊕ South Pole
(to US)

*Antarctica*

*Davis
Sea*

Peter I Island ○
(to Norway)

+ South Geomagnetic
Pole

Mirny ○
(to Russian
Federation)

*Shackleton
Ice Shelf*

*Lesser
Antarctica*

Vostok ○
(to Russian Federation)

*Amundsen
Sea*

Mount Sidley △
4181m

Mount Kirkpatrick △
4528m

Mount Markham △
4351m

*Wilkes
Land*

Mount Siple △
3100m

*Marie Byrd
Land*

*Ross Ice Shelf*

Casey ○
(to Australia)

*Cape Poinsett*

*Roosevelt
Island*

*limit of summer pack ice*

*limit of winter pack ice*

Scott Base ○
(to NZ)

○ McMurdo
Base
(to US)

Mount Erebus △
3794m

**SOUTHERN OCEAN**

*Ross Sea*

*George V
Land*

*Terre
Adélie*

*limit of summer pack ice*

*limit of winter pack ice*

Cape Adare

Dumont d'Urville ○
(to France)

**PACIFIC**

*Antarctic Circle*

**OCEAN**

*Antarctic Peninsula*   *Palmer Land*

*Transantarctic*   *Mountains*

*Victoria Land*

*Drake Passage*

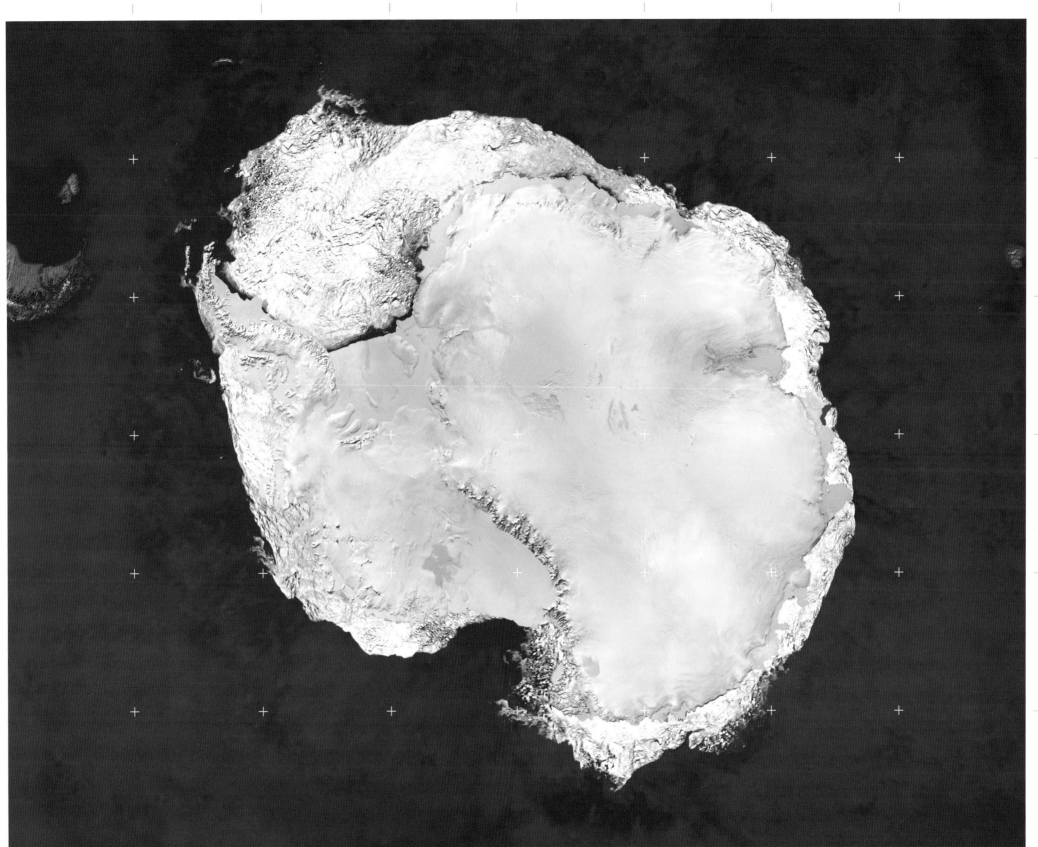

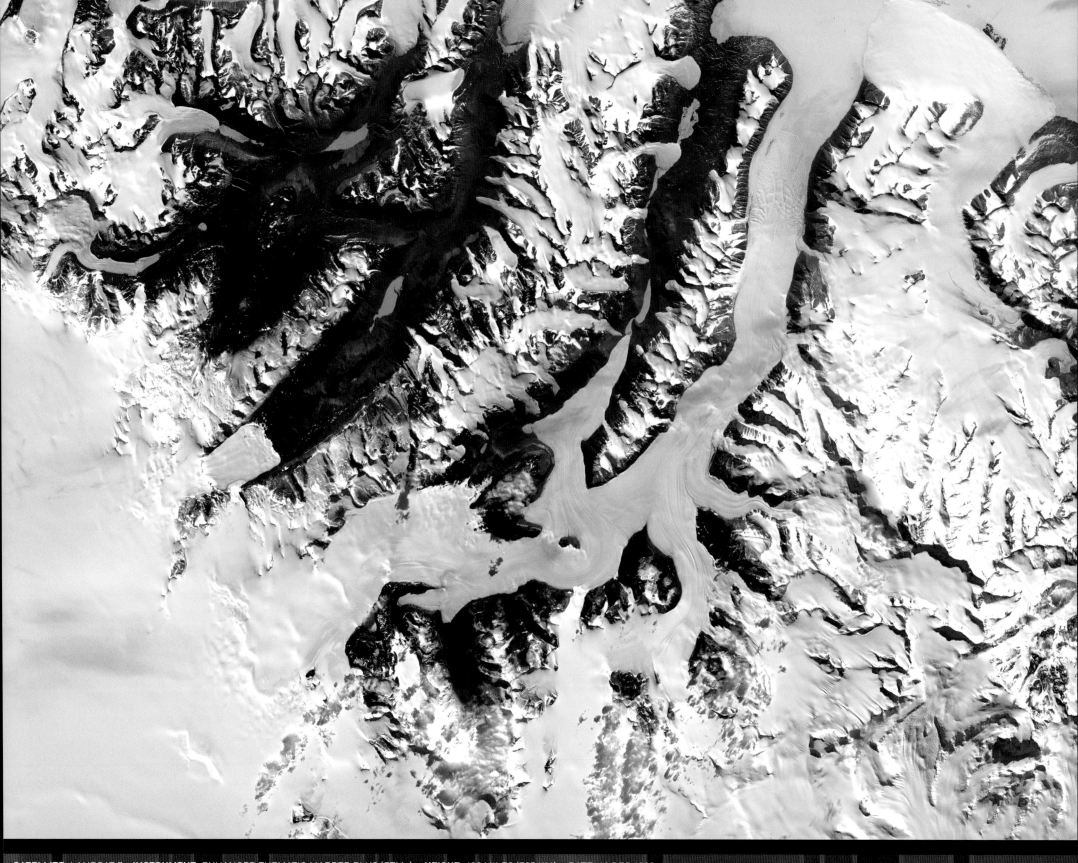

SATELLITE: LANDSAT 7   INSTRUMENT: ENHANCED THEMATIC MAPPER PLUS (ETM+)   HEIGHT: 438 MILES (705 KM)   DATE: 18 DEC 1999

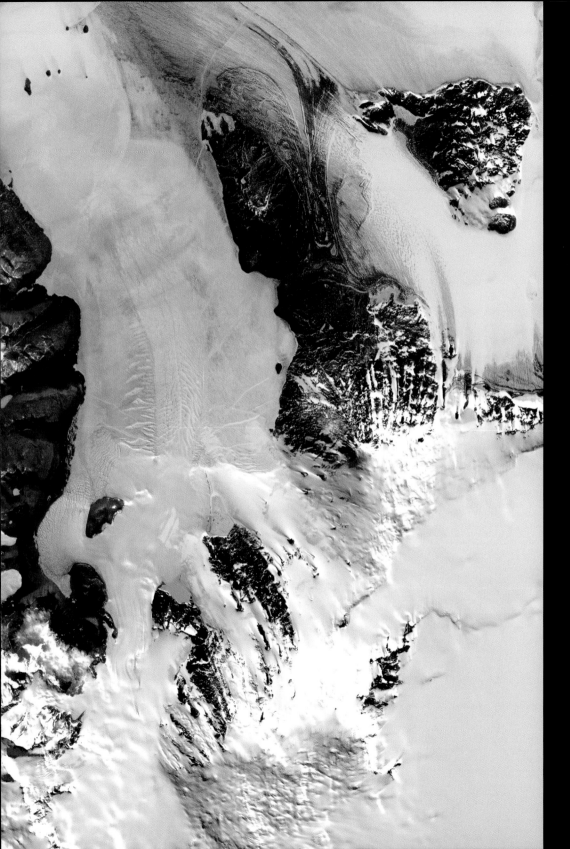

# DRY VALLEYS

## 80°S, 158°E

Despite its thick ice sheet, Antarctica is technically a desert. Snowfall is very low all across the continent, but in some places it is extremely low indeed. The largest expanses of snow- and ice-free land in Antarctica are the McMurdo Dry Valleys in Victoria Land. Cut by glaciers when the Antarctic icecap was thicker, the floors of the valleys are bare because the reduced volume of ice is no longer capable of flowing through this part of the Transantarctic Mountains. Several glaciers terminate in the valleys and their floors contain freshwater lakes. This part of Antarctica has been cooling over the last 15 years and the ice crust on these lakes is thickening.

◀ **Ice flows** from the high interior ice sheet (bottom) toward the sea (top), channelled by mountain ridges into glaciers which bypass the Dry Valleys.

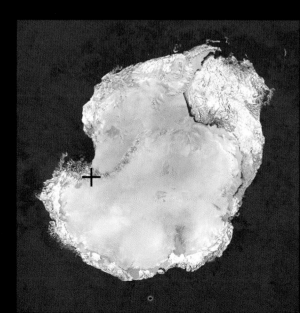

# LARSEN ICE SHELF

## 67°30'S, 63°W

Ice shelves are floating extensions of a continental ice sheet, continually pushed out to sea by the weight of accumulated snow, typically advancing for several decades before the front breaks off under its own weight as a tabular iceberg. This natural cycle has been broken on the east coast of the Antarctic Peninsula, where the Larsen Ice Shelf has suffered a series of catastrophic collapses in recent years. The northern section (Larsen A) disintegrated during a storm in 1995 and the larger central section (Larsen B) followed in 2002. To the south, Larsen C seems stable for now, although it too lost a large section in 1986. The Antarctic Peninsula has experienced a warming of 4.5°F (2.5°C) over the last 50 years, which has contributed to the weakening of the ice shelves in the region.

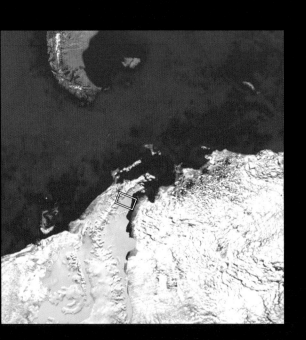

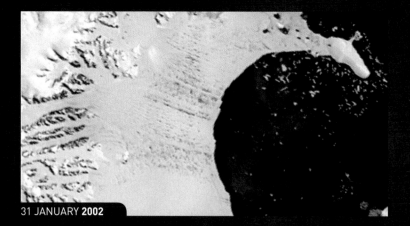

31 JANUARY **2002**

◀ **Weather satellites** provided regular images of the 2002 collapse, starting with the appearance of widespread meltwater pools in January (top). The front of the shelf has started to break up into large icebergs by February (middle), ahead of the disintegration of the remainder of the shelf into many thousands of fragments in March (bottom).

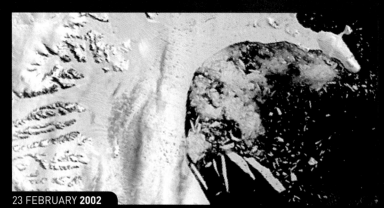

23 FEBRUARY **2002**

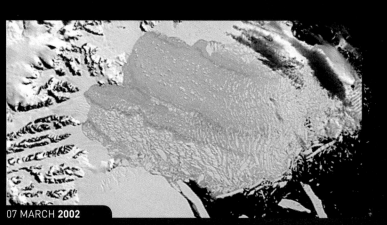

07 MARCH **2002**

▶ **Pools of meltwater** are clearly visible in this Landsat image of part of the Larsen Ice Shelf. The weight of melted water is thought to have helped push crevasses right through the 720 ft (220 m) thick ice shelf.

**SATELLITE:** TERRA (EOS AM-1)  **INSTRUMENT:** MODIS  **HEIGHT:** 438 MILES (705 KM)  **DATE:** 2002

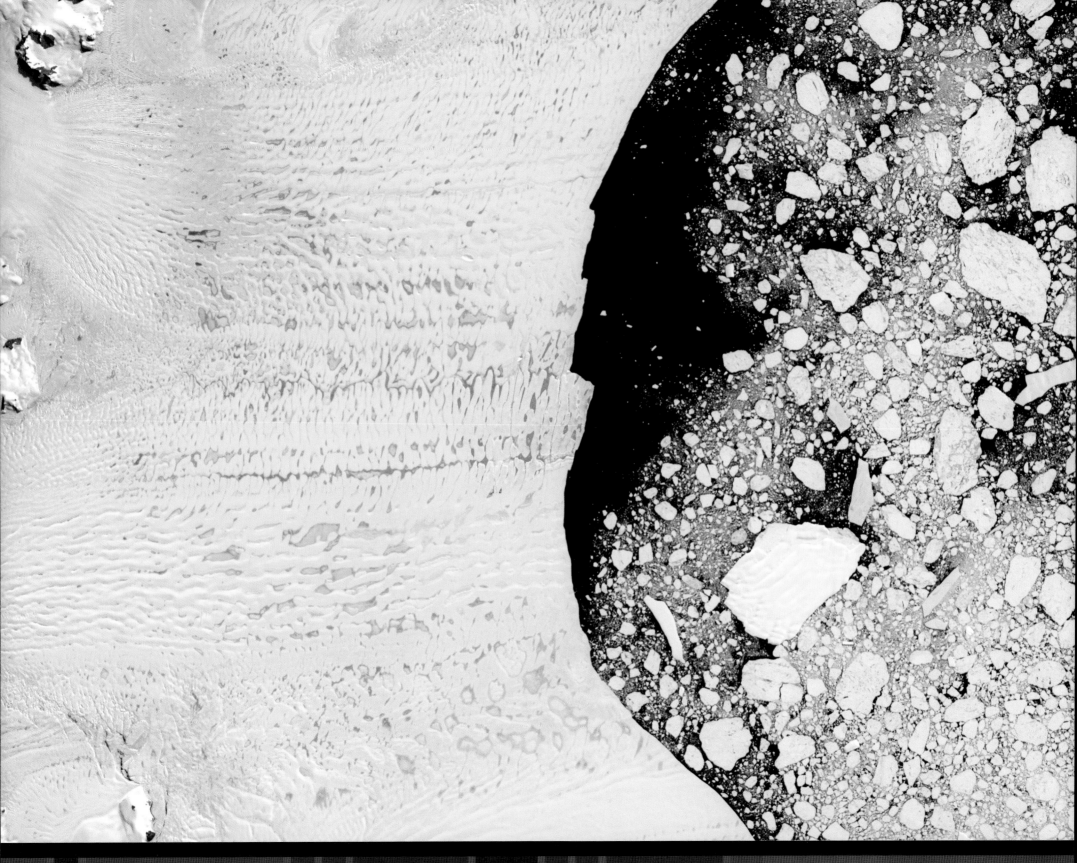

# Index

A selection of major
settlements and features

---

◆ Country ● Country Capital ◇ Dependent Territory ◎ Dependent Territory Capital ◆ Administrative Region ▲ Mountain Range ▲ Mountain ☒ Volcano ♒ River ◎ Lake or Reservoir

◆ Country  ● Country Capital  ◇ Dependent Territory  ◎ Dependent Territory Capital  ◇ Administrative Region  ▲ Mountain Range  ▲ Mountain  ☒ Volcano  ↔ River  ◎ Lake or Reservoir

◆ Country   ● Country Capital   ◇ Dependent Territory   ○ Dependent Territory Capital   ◆ Administrative Region   ▲ Mountain Range   ▲ Mountain   ▲ Volcano   ⌇ River   ◎ Lake or Reservoir

# Index

---

◆ Country   ● Country Capital   ◇ Dependent Territory   ○ Dependent Territory Capital   ◆ Administrative Region   ▲ Mountain Range   ▲ Mountain   ℛ Volcano   ⤳ River   ⊚ Lake or Reservoir

# Index

◆ Country ● Country Capital ◇ Dependent Territory ○ Dependent Territory Capital ◇ Administrative Region ▲▲ Mountain Range ▲ Mountain ⍨ Volcano ↝ River ◎ Lake or Reservoir

**CREDITS** Satellite maps, images and 3D graphics provided by Planetary Visions www.planetaryvisions.com
Quickbird images courtesy of DigitalGlobe. Ikonos images courtesy of GeoEye. Landsat data courtesy of the University of Maryland Global Land Cover Facility. Satellite Imagemap of the World © 1996-2006 Planetary Visions Limited, based on NOAA/AVHRR data from USGS EROS Data Center. Satellite Imagemap of North America © 2006 Planetary Visions, based on Terra/MODIS data from NASA Goddard Space Flight Center. Satellite Imagemap of Europe © 2005 Planetary Visions / German Aerospace Center (DLR), based on Terra/MODIS data from DLR, with thanks to Thomas Ruppert and Robert Meisner.

Boston University and NASA/GSFC 15
DigitalGlobe 55tr, 108, 109, 190, 191br, 199tr, 208-209, 219r, 231tr, 258-259, 260br, 319tr,br
DigitalGlobe / Eurimage 37, 198-199, 200-201, 207, 301br
DigitalGlobe / Getty Images 57, 127r, 199br, 231br, 239, 277, 289r, 305
GeoEye 43r, 48-49, 55bl, 55br, 77r, 78, 79, 97r, 123, 161, 165r, 217r, 253r, 281tl, 291r, 311r, 328-329, 333r, 335
GeoEye / European Space Imaging 191tl,tr,bl, 227
GeoEye / Centre for Remote Imaging, Sensing and Processing (CRISP), Singapore 317, 318
GeoEye / Space Imaging Asia 295
GeoEye / Space Imaging Middle East 145r
NASA Earth Observatory 278, 279, 302r, 334r, 339
Jesse Allen: 38-39, 76-77, 265r, 270-271, 300-301
Robert Simmon: 335, 350, 351
Reto Stockli: 12t, 13t, 22, 160r
NASA Johnson Space Center Science & Analysis Laboratory 52-53, 54, 72, 90br, 150-151, 168b, 185r, 280-281b, 338
NASA Jet Propulsion Laboratory / Caltech 156-157, 212-213, 220-221, 306-307, 342-343
NASA Goddard Space Flight Center (GSFC) EO-1 Mission Science Office Lawrence Ong: 63
NASA/GSFC Laboratory for Atmospheres 23, 24b,l, 25b

NASA/GSFC Landsat 7 Team 280tr, 334r
NASA/GSFC Landsat Project Science Office 76-77
NASA/GSFC/METI/ERSDAC/JAROS, and U.S./Japan ASTER Science Team 61br, 90tr, 106-107, 114-115, 116-117, 128r, 129, 155, 169, 181b, 184-185, 192r, 206br, 217r, 226r, 261, 296-297, 297br, 304, 332
NASA/GSFC MODIS Rapid Response Project 62r, 96r, 126r, 154, 164r, 193l
Jacques Descloitres: 20bl, 21bl, 288r, 290r, 346r
Jeff Schmaltz: 276r
NASA/GSFC Oceans and Ice Branch and the Landsat 7 Science Team 350, 351
NASA/GSFC Scientific Visualization Studio 21bc,br, 24cr, 24tr, 25tl,tr, 69br, 73l, 113bl, 138r, 352l, 353
NASA/GSFC SeaWiFS Project 14, 18, 19
NOAA National Geophysical Data Center 10-11, 16-17
NOAA NESDIS 265l
NOAA National Snow and Ice Data Center 20tc,tr,bc,br, 21tc,tr
Planetary Visions 2-3, 6-7, 8-9, 10-11, 16-17, 22, 26-27, 29, 36, 42r, 56tr,br, 68r, 69l, 80-81, 82-83, 86, 97l, 98-99, 101, 122r, 127l, 132-133, 135, 139, 144r, 145l, 156-157, 165l, 170-171, 173, 188-189, 196-197, 206br, 212-213, 216r, 218r, 219l, 220-221, 230r, 231l, 238tr,br, 240-241, 243, 248-249, 252r, 253l, 278-279, 289l, 291l, 294r, 303, 306-307, 310r, 311l, 316br, 322-323, 325, 342-343
US Geological Survey EROS Data Center 180r, 264r
Ron Beck: 91
US Geological Survey National Center for Earth Resources Observation and Science and NASA Landsat Project Science Office 60-61, 112-113, 146-147, 347

The following images, image mosaics and 3D graphics were generated using Landsat data courtesy of the University of Maryland Global Land Cover Facility 36, 38-39, 43l, 56br, 69l, 80-81, 82-83, 86, 97l, 122r, 127l, 139, 145l, 165l, 188-189, 196-197, 206tr, 219l, 231l, 238br, 248-249, 253l, 270-271, 289l, 291l, 294r, 303, 311l, 316br, 339